Guide to Modern Japanese Woodb

Guide to Modern Japanese Woodblock Prints: 1900–1975

Helen Merritt and Nanako Yamada

University of Hawai'i Press

Honolulu

Paperback edition 1995

06 05 04 03 02 01 8 7 6 5 4 3

Library of Congress Cataloging-in-Publication Data

Merritt, Helen.
 Guide to modern Japanese woodblock prints : 1900–1975 / Helen
Merritt and Nanako Yamada.
 p. cm.
 Includes bibliographical references.
 ISBN 0–8248–1286–7
 1. Color prints, Japanese—20th century. I. Yamada, Nanako.
1939– . II. Title.
NE1323.M46 1992
769.952'09'04–dc20
 91–40576
 CIP

ISBN 0–8248–1732–X (pbk)

University of Hawai'i Press books are printed on acid-free paper and
meet the guidelines for permanence and durability of the Council on
Library Resources.

Designed by Paula Newcomb

To Osamu Ueda

in appreciation of his vast knowledge of

Japanese woodblocks, old and new

CONTENTS

PREFACE

We compiled this information as a supplement to our earlier book, *Modern Japanese Woodblock Prints: The Early Years*, because to date collectors and students of modern Japanese prints have been largely limited to Japanese language sources. Although the information pertains primarily to modern Japanese woodblock prints and printmakers, it should be noted that it is also relevant to modern Japanese artists in general since many of the print artists were painters, illustrators, designers, sculptors, or craftsmen as well as printmakers. In terms of time the parameters are from 1900 through the mid-1970s. Among the biographies, the earliest are for Meiji artists who were still active after the turn of the century and the latest are for artists born before the end of World War II with a few exceptions in cases of individuals born shortly after 1945 but well established by the mid-1970s. To the artists who perhaps should have been included but were not we express our apologies.

Assembling all this information has been like the solving of a vast and complex mosaic from scattered bits and pieces. The prints themselves are firm data, but signatures and seals on prints have sometimes proved unreadable and published sources are sometimes contradictory. There is no neat border to indicate that the mosaic is complete. Since there are also lacunae here and there, we can only hope that the omissions and misinterpretations are few and minor and will eventually be filled in or corrected by other researchers.

The issue of dating is especially problematic. If the reader finds discrepancies with other sources, it is not because we have failed to seek out original prints and documents whenever possible and otherwise checked and rechecked the information. The problems remain because prints often were not dated, and there are numerous instances in which different accounts of the same event assign different dates. Such discrepancies, usually differences of one or two years, are probably the result of confusions between traditional Japanese and Western dating systems. Rather than clutter the text with innumerable arguments for and against multiple choices, in disputed cases we have either presented our best judgment or simply omitted the date.

Among the biographical notes and the seals and signatures are the names of a few artists about whom we know next to nothing. These names are included so that others who have searched in vain for information on these artists will know that they are not alone. Perhaps others can someday expand on our meager knowledge.

We are pleased to express our appreciation to the many people who have

assisted with this research, especially the museum personnel who have made prints and magazines available for our study and the generous private collectors and scholars—particularly Felix and Helen Juda, Ernest Kay, Phillip H. Roach, Jr., H. E. Robison, Osamu Ueda, Theodore W. Van Zelst, and the late James Bliss Austin—who have shared their prints and knowledge with us. We are also grateful for travel and research assistance from the Helen and Felix Juda Foundation and from the Graduate School of Northern Illinois University. Especially, we take this opportunity to express appreciation to Laureen Reu, Dan Grych, and other members of the art photo staff of Northern Illinois University whose patient and long-suffering assistance with the signatures and seals was invaluable.

Introduction

THE WOODBLOCK TECHNIQUE is an ancient craft in Japan dating back at least to the Nara period when, in the year 770, one million small wooden pagodas, each containing a woodblock-printed selection from a sutra, were completed as ordered by the retired Empress Kōken. From Heian times woodblock prints, both illustrations and texts, were extensively used in the service of Buddhism—not unlike the use of woodblocks to illustrate Christian doctrine in medieval Europe. But in the seventeenth century European and Japanese practices took dramatically different paths. In Europe metal type and metal-plate engraving replaced woodblocks for day-to-day printing. In Japan, however, woodblock printing flourished as the primary technology. Cut off from practically all contact with Europe, Japanese artisans perfected the old woodblock technique and developed it into sophisticated multicolor printing that was used extensively for popular broadsheets. When large numbers of the multicolor prints arrived in Europe in the late nineteenth century, Europeans embraced them as exotic works of art. In the European context they were valued as multiple originals; back in Japan, they were regarded as reproductions for the popular market. Mainstream Japanese publishers, eager to catch up with the technology of Europe, pushed aside the old technique and forged ahead with "advanced" European equipment. Only a few conservative publishers, along with carvers and printers in whose sensibilities *mokuhan* (woodblock printing) was deeply embedded, persisted in keeping the art of woodblock alive.

By the early twentieth century, Western-oriented Japanese artists were adopting the European focus on personal expression. Having learned through European art magazines that printmaking could be a means of expression as well as reproduction, they eagerly embraced woodblock printing as an expressive medium. Meanwhile, conservative scholars, publishers, and artisan carvers and printers clung to the idea that woodblock printing was first and foremost a means of reproduction. Soon a clear distinction developed between publishers who kept the old woodblock technique alive and Western-oriented artists who directed the medium toward new types of personal expression.

The conservative publishers promoted woodblock reproductions of paintings and copies of *ukiyo-e* from recut blocks. These reproductions or facsimile prints are known in Japanese as *fukusei hanga*. Among the publishers were some who developed modern prints in the *ukiyo-e* tradition. These prints, known as *shin-hanga*, were principally for export. Publishers of *fukusei hanga* and *shin-hanga* adapted the tradi-

tional *ukiyo-e* system of the Edo (1610–1868) and Meiji (1868–1912) periods. In Edo and early Meiji times, an artist presented a sketch to a publisher who bought the right to make the print and then directed a carver to create a key block. On prints from the key block the artist designated the desired colors. With supervision and coordination from the publisher, the carver in turn carved the required blocks for the colors and a printer mixed the colors and printed the blocks. Thus, the full-color *ukiyo-e* image did not exist except through the combined work of publisher, artist, carver, and printer, each of whom played a vital role in its creation.

The more standard practice in the early twentieth century, however, was to make woodblock facsimile copies of existing paintings. From the 1890s reproductions were made of *ukiyo-e* prints from freehand copies of the prints or from what the Japanese call wet negative photographs. A carver then determined the needed colors and carved the necessary blocks. A printer mixed and applied pigment in the traditional way. The same procedure was used to make woodblock facsimiles of paintings. Woodblock multicolor facsimiles produced around 1910 were among the best color reproductions available in the world at that time. Such woodblock prints *(moku-hanga)* were commonly used from about 1905 until 1920 as frontispieces in novels and until about 1935 in albums of artists' works. A woodblock facsimile of a Japanese painting appeared in every issue of the art magazine *Kokka* until the mid-1950s. Such facsimile prints are still being made in limited numbers.

Quite aside from the reproductive work of publishers, *sōsaku-hanga* (creative print) artists used the woodblock process in personally expressive ways. While publishers in the *fukusei* and *shin-hanga* streams carried on within the traditional framework, *sōsaku-hanga* artists rebelled against the publisher/artist/artisan system by carving and often printing their own designs and by personally controlling the artistic decisions. Until the 1930s woodblock illustrations were still in common use for popular novels. These were sometimes designed by Japanese-style artists and carved and printed by artisans. Alternatively, they were designed and carved by *sōsaku-hanga* artists and printed mechanically.

Westerners tend to limit the term "woodblock print" to handmade prints, but in Japan the use of woodblock as a creative medium, even by the early *sōsaku-hanga* artists, was closely related to commercial printing processes. This is reflected in the fact that all prints in which wood plays a part are called *moku-hanga*, literally "wood prints," irrespective of whether they were printed mechanically or by rubbing the back of the paper by hand with a flat round disk called a *baren*. Yamamoto Kanae, usually credited as the originator of the *sōsaku-hanga* movement, was trained in a five-year wood engraver's apprenticeship which enabled him to reproduce gradations of value in European-type illustrations. Although he was keenly interested in using woodblocks creatively, he took it for granted that any available technology could be used to reproduce created images. *Hōsun*, the landmark magazine of the early years of the *sōsaku-hanga* movement, routinely printed creative woodblock images by mechanical means.

The *sōsaku-hanga* movement flourished from about 1904 until World War II as a vast but unrecognized grass roots network of artists. Many of the top-ranking artists

of the period were struggling to master alien Western-style painting techniques but sought more authentic self-expression in the old, familiar, and inherently Oriental woodblock medium. In addition, hundreds of amateurs were passionately interested in expressing their own feelings in *moku-hanga*. All of this activity attracted little attention beyond circles of enthusiasts until members of the American occupation forces discovered *sōsaku-hanga* in 1946.

Artists who participated comfortably in publisher/artist/artisan relationships were in general trained in Japanese-style painting while *sōsaku-hanga* artists were in general trained as Western-style painters. The demarcation between the two, however, was not always clear-cut. A few *shin-hanga* artists worked successfully both with *shin-hanga* publishers and as *sōsaku-hanga* artists. Leading *sōsaku-hanga* artists, although quite outspoken about carving and printing their own works, often employed publishers, carvers, and printers. The major difference in the latter cases was that artistic control was in the hands of the artists rather than the publishers.

With encouragement from enthusiastic American collectors *sōsaku-hanga* artists, many of whom had been honing their skills for twenty years or more, produced splendidly through the immediate postwar years, the movement reaching a climax about 1960. The prints of this period were predominantly woodblocks. But as younger artists came to maturity in the late 1950s they turned increasingly to Western media such as lithography, etching, and serigraphy. They also combined woodblock printing with photoengraving, mimeograph, and other techniques so that the original medium seemed eclipsed by Western techniques. By the 1970s woodblock artists, who had predominated in the long germinating period of the modern print movement, found themselves outnumbered by lithographers, serigraphers, and metal-plate artists. Although it is perhaps too soon to say, at present it appears from a revival of old *sōsaku-hanga* names for organizations and exhibitions and the number of people making woodblock prints that Japanese artists are looking afresh at the time-honored woodblock technique.

Chapter 2 deals with biographical information on woodblock artists. The number of Western-style painters who made *sōsaku-hanga* far exceeded the number of Japanese-style painters who made *shin-hanga*. A far greater number of Japanese-style painters, however, commissioned or permitted facsimile reproduction of their paintings by woodblock. Many of the latter artists have quite properly thought of themselves as painters rather than print artists, but since this book is a guide to woodblock prints, it is appropriate to include them because facsimiles are presented as woodblock prints in exhibitions, discussed as woodblock prints in books, and sold as woodblock prints.

Some *sōsaku-hanga* artists, such as Onchi Kōshirō and Hiratsuka Un'ichi, were primarily woodblock artists. Many other artists active in the Taishō and early Shōwa periods, regarding themselves primarily as painters, made *sōsaku-hanga* for a limited time or as a sideline. The *sōsaku-hanga* movement also included a vast network of amateurs about whom little is known except that their names appear on membership lists of print associations and their works are included in *dōjin* (coterie) magazines. Although these artists usually are not listed in Chapter 2, their names

may be found in Chapter 4 in conjunction with the magazines to which they contributed.

Chapter 3 deals with art schools, art organizations, and exhibitions in which print artists participated. In general, artists growing up early in the century either studied directly with a master or attended various preparatory schools, the Tokyo School of Fine Arts (Tokyo Bijutsu Gakkō), or one of the Kyoto art schools. Of the latter, the Kyoto City Specialist School of Painting (Kyoto Shiritsu Kaiga Senmon Gakkō) most closely corresponded to the Tokyo School of Fine Arts. Aspiring artists could study either a Japanese-style or a Western-style curriculum in either Tokyo or Kyoto, but in general there was a stronger emphasis on *Nihon-ga* (Japanese-style painting) in Kyoto and *yōga* (Western-style painting) in Tokyo. In 1944 the Tokyo School of Fine Arts was renamed the Tokyo College of Fine Arts (Tokyo Bijutsu Daigaku). After World War II the visual art division of Tokyo University of Art (Tokyo Geijutsu Daigaku) replaced the Tokyo College of Fine Arts and Kyoto City University of Arts (Kyoto Shiritsu Geijutsu Daigaku) replaced the Kyoto City Specialist School of Painting. With the proliferation of art schools and art departments in universities, the preparation of artists became more diverse.

Artists' organizations play a much greater role in Japan than in the West. In the twentieth century they have promoted certain styles and values much as the traditional schools of painting functioned in earlier times. Membership in an organization indicates identification with the group's position in relation to traditional and Western styles and to conservatism and experimentation. The group's exhibitions reflect its character, and artists declare their perceptions of themselves as artists through their affiliations. Artists are often judged as much by the associations to which they belong as by the character or quality of their work.

Shin-hanga artists habitually belonged to organizations for Japanese-style painters. Since most *shin-hanga* were exported and their sale was managed by publishers, there was little emphasis on exhibiting. Before the 1950s, the status of painting was so much higher than that of prints that many *sōsaku-hanga* artists liked to think of themselves as painters with primary affiliations with organizations for Western-style painters. They frequently, however, also maintained membership in a print group.

In 1907 the Ministry of Education began sponsoring yearly exhibitions. These shows have been known by various names, the first of which was Bunten. Bunten exhibitions were open to paintings and sculpture but not to prints because the exhibition officials viewed prints as reproductions and therefore not works of art. This distinction did not hamper *shin-hanga* artists because their prints were being marketed abroad by publishers. But *sōsaku-hanga* artists, who thought of their prints as creative works, repeatedly proposed that they should be granted full status in general exhibitions. The government exhibitions, nonetheless, held out until 1927 before allowing prints. Meanwhile Nihon Sōsaku-Hanga Kyōkai, an organization for creative print artists, had formed in 1918 and held its first show in 1919 to be followed by almost yearly exhibitions until the present. Shun'yōkai and Kokugakai, two major Western-style art organizations, opened "print rooms" where print artists could exhibit beginning in 1928, but Kokugakai withheld full status for prints until 1931

and Shun'yōkai held out until 1951. From 1918 until the early 1950s, Nihon Sōsaku-Hanga Kyōkai and its successor Nihon Hanga Kyōkai were the only organizations devoted exclusively to prints. Then in 1952 Munakata Shikō launched a new group called Nihon Hanga-in (Banga-in) which attracted a number of artists. In 1960 a third group, Nihon Hangakai (Nippankai), also sponsored by Munakata Shikō, further weakened Nihon Hanga Kyōkai. The resulting splintering of Nihon Hanga Kyōkai, coupled with increased opportunities for exhibiting after World War II, marked the transition from a fairly unified *sōsaku-hanga* movement to more diversity and independence.

Chapter 4 is devoted to the small magazines—the principal means by which hundreds of people exhibited their prints from about 1905 to the mid-1930s. These magazines were published by individuals or coteries of like-minded people *(dōjin)*. Many of the *dōjin* magazines or folios consist of collections of prints with a few sentences or a poem, usually by the artist, accompanying each print. Some present essays about aspects of nature or prints as well. Others have only prints without commentary and could perhaps more properly be categorized as sets of prints. In many of the magazines, all the prints are handmade; in others, mechanically printed *hanga* are interspersed. In some the pages are fastened together; in others loose prints are assembled in an envelope or folder. Most of the prints are in black and white, but there are also many in two or three colors and an appreciable number in many colors. Some *dōjin* magazines appeared in only one issue; others came out at regular intervals over prolonged periods. Drawing contributors from both prominent printmakers and little-known amateurs, the magazines established a communication network among print enthusiasts throughout the country. There were, in addition, art, literary, and satirical journals which featured woodblock illustrations. Several of these are mentioned in Chapter 8.

In Chapter 5 publishers, carvers, and printers are listed along with limited information about them. Chapter 6 deals with selected series of prints and, in some cases, the complete oeuvres of important artists. It was customary in both *shin-hanga* and *sōsaku-hanga* circles to issue prints in series. This chapter names many of the series and the prints that compose them. It also records all the prints of a few artists made during certain periods or under special circumstances.

Chapter 7 presents a selection of seals and signatures of use in identifying the artist or publisher of a print. Practices in signing prints varied greatly. In general, Japanese-style artists used their given names rather than family names. They may, however, have used art names or *gō* and seals either alone or in addition to signatures. *Sōsaku-hanga* artists, however, often showed their Western orientation by signing all or parts of their names in romanized script. As Chapter 7 shows, artists were as creative with signatures as with prints.

Chapter 8 is a chronology of important events, exhibitions, and publications in the world of woodblock prints between 1900 and 1975. The book concludes with a glossary of key Japanese terms related to woodblock and an Index of Alternate Names. The reader can consult any chapter or the Index of Alternate Names independently or follow a specific line of inquiry through each section of the book.

Biographical Notes

NAMES ARE LISTED HERE in the Japanese manner with the family name preceding the given name. When only one name is known, that name is included in the appropriate alphabetical place. Characters for the names are included along with the most common readings and, when appropriate, alternate readings. The "n" which stands alone in the Japanese syllabary is rendered as "n" rather than "m" when preceding "b," "p," or "m" as in the word *shinbun* rather than *shimbun* or the proper name *Henmi* rather than *Hemmi*. Since Japanese artists have been prone to use art names or *gō*, and writers have often reversed Japanese names when writing in Western languages, a name by which an artist is known may be different from the name under which the artist is included in these biographical notes. The reader who knows an artist by one name but cannot find that name is urged to consult the Index of Alternate Names at the end of the book. Full names of the exhibitions abbreviated here can be found in Chapter 3.

Abe Jirō 阿部治良

B. 1910. Exhibited *moku-hanga* ca. 1931–1932 in conjunction with proletarian art movement using the names Muro Junji and Saitō Jirō as well as Abe Jirō.

Abe Kōji 阿部好二

B. 1939 in Tokyo. Grad. 1962 Saitama University. Exhibited at Nichidō 1979–1981, Shell 1981, Nihon Hanga Kyōkai 1981 and 1983, and solo exhibitions. Among his works are series of nonrepresentational prints entitled *Work*, 1979–1982, and *Drawing*, 1983. Sometimes printed with oil-base ink.

Abe Kōun 阿部功雲

B. 1908 in Yamagata prefecture. Grad. Tokyo Higher Technical School. Studied with Munakata Shikō and the sculptor Katō Kensei. Took the second character of Shikō and used it as the first character of his own art name, Kōun. Member of Banga-in. Active in printmaking circles in Yamagata. Subjects of his prints include customs of the Ainu, Yamagata scenery, and a series of illustrations in 1983 for Bashō's *The Narrow Road to the North (Oku no hosomichi)*.

Abe Sadao 阿部貞夫

1910–1969. B. Tokyo. Studied Western-style painting at Hongō Painting Institute. Exhibited painting with New Century Art Association. Studied

woodblock with Sekino Jun'ichirō and Hirai Kōichi. Exhibited with Nihon Hanga Kyōkai and Nippankai. Many *moku-hanga* designs of Hokkaido scenery reproduced on postcards.

Abo Hiroshi　阿保浩

B. 1919 in Aomori prefecture. Studied with Munakata Shikō and in France. Member of Banga-in exhibiting with that group from 1961. Member of International Fine Arts Association; represented in exhibitions in Barcelona, Paris, Venice, and Athens in the 1970s. Subjects of prints include fanciful night scenes.

Ai-Ō　靉嘔

B. 1931 in Ibaraki prefecture. Original name Iijima Takao. Grad. 1954 from art department of Tokyo University of Education. Has held more than 50 solo exhibitions of paintings and prints beginning in 1955. Represented at Tokyo, São Paulo, Krakow, Ljubljana, and Venice biennales. Taught at University of Kentucky 1968–1969. Made various kinds of prints before winning wide recognition for serigraphs in rainbow colors.

Akagi Yasunobu　赤木泰舒

1889–1955. B. Shizuoka prefecture; went to Tokyo in 1906. Studied watercolor at school of Taiheiyōgakai and with Ōshita Tōjirō and Maruyama Banka. Exhibited painting at Bunten from 1909. In 1913 a founding member of Japan Watercolor Society. Exhibited also with Nikakai and Kōfūkai. Taught watercolor painting at Bunka Gakuin 1921–1946. From the Taishō period made self-carved *moku-hanga*, lithographs, and etchings.

Akamatsu Rinsaku　赤松鱗作

1878–1953. B. Okayama prefecture; lived in Osaka. Studied Western-style painting under Yamanouchi Gusen. Grad. Western-style painting division of Tokyo School of Fine Arts. In 1906 began publication of *Osaka Puck (Osaka pakku)* and is known for his *manga* dealing with customs and manners on night trains. Member of Kōfūkai. In 1903 announced his intention to design *Thirty-six Views of Osaka* and finally completed the series in 1947. Worked for *Osaka Asahi shinbun.* Also illustrated books published by Bun'endō. Contributed to *Pictures of Famous Places in Osaka and Kobe (Hanshin meisho zue)*, 1916. Founded the Akamatsu Western Painting Institute in Osaka.

Akiyama Iwao　秋山巌

B. 1921 in Oita prefecture. Grad. school of Taiheiyōgakai in 1956. Began artistic career as an oil painter; moved to etching and eventually to *mokuhan*. From 1959 to 1966 studied printmaking with Munakata Shikō. Exhibited with Taiheiyō Bijutsukai and Banga-in and at Gendai and Nitten. Member of Taiheiyō Bijutsukai and Banga-in until 1970. Akiyama's images are frequently of birds or animals printed in black, sometimes accented with red, on rough paper.

Akiyama Shizuka 秋山静

B. 1932 in Ibaraki prefecture. Grad. Tochigi Prefecture Masaoka Business High School. Shifted from oil painting and metal-plate prints to *moku-hanga*. *Hanga* techniques self-taught. Member of Shin Kōzōsha and exhibited with that group from 1963. Member of Shūdan Han. Traveled in Europe in 1975. Prints made with oil-base pigments from pieces of wood cut into desired shapes, assembled on plywood bases, and printed by a press using various rollers and oil-base ink to achieve *bokashi* effects. Early prints were often in black and white or earth colors; plates of the 1970s were typically fanciful landscapes in which a reclining nude suggests contours of the land with entire prints in carefully graded tints and shades of blue.

Akiyama Taikei 秋山泰計

B. 1927. Member of Nihon Hanga Kyōkai 1964–1973. Style often involves figure/ground reversal.

Amano Kazumi 尼野和三

B. 1927 in Takaoka, Toyama prefecture. Studied furniture design at Toyama Prefectural School of Crafts at Takaoka; grad. 1945. Began making *hanga* ca. 1950. Studied with Munakata Shikō ca. 1952. Exhibited from 1953 with Nihon Hanga Kyōkai; member 1962–1966. Member of Kokugakai. Moved to Tokyo in 1955 and exhibited in many international print biennales including Northwest, Krakow, Ljubljana, Lugano, São Paulo, Paris, and Tokyo. Traveled to U.S. in 1971; taught at Augustana College in Rock Island, Ill., and Marycrest College in Davenport, Iowa. *Resting Bird*, representative of his prints of the 1950s, is a roughly cut image printed in black, reflecting the influence of Munakata. Later works are elegantly clean-cut abstractions inspired by a feeling for machinery and furniture design.

Amano Kunihiro 天野邦弘

B. 1929 in Hirosaki, Aomori prefecture. Grad. Aomori Prefectural Technical School. *Hanga* self-taught. First exhibited with Nihon Hanga Kyōkai in 1955 and Kokugakai in 1956. Member of Nihon Hanga Kyōkai from 1957 and Kokugakai. Exhibited in first through fourth Tokyo Biennales, 1957–1964. Represented in international exhibitions including Krakow, Pistoia, Buenos Aires, Frechen, Bradford, Ljubljana, Lugano, Paris, and São Paulo. In early prints he often used exposed wood grain with images of fantastic birds or fish. Later works include large bold abstractions of simple shapes in intense red and green as well as elegant small prints of fanciful birds.

Amemiya Issei 雨宮一正

B. 1934 in Nagano prefecture. Grad. Tokyo University of Fine Arts. Studied in Paris. Sculpture shown in international exhibitions. Published a *moku-hanga* collection entitled *Women with Red Flowers (Shuge no Onna)*.

Aoki Shigeru　青木繁

1882–1911. B. Kurume, Fukuoka prefecture. Studied first at Fudōsha and later with Kuroda Seiki at Tokyo School of Fine Arts; grad. 1904. While still a student exhibited with Hakubakai. Yamamoto Kanae carved Aoki Shigeru's designs for a cover and illustrations for *Hōsun* and illustrations for *Sabiono* (Stained Ax), a collection of poems by Kanbara Ariake. Active in the Japanese romantic movement at the end of the Meiji period; took his themes from ancient Japanese history or myths. Style influenced by Pre-Raphaelites and impressionism.

Aoki Sō　青木蕭

B. 1921 in Tokyo. Original name Kurata Hiroaki. A *manga* artist and member of Japan Caricature Artists Society. Began making *moku-hanga* in 1970 and became a member of Banga-in. Admired primitive arts. Landscapes of Beijing, the Great Wall, festivals, Tokyo street scenes, and a series entitled *Soldier (Heitai)*, 1971–1974, are representative of his *moku-hanga*.

Aoyama Masaharu　青山正治

See Aoyama Seiji.

Aoyama Seiji　青山正治

1893–1969. B. Saitama prefecture. Also known as Aoyama Masaharu. Studied ink painting at Tokyo School of Fine Arts. Served in Imperial Household Museum until his retirement in 1936. Exhibited in Teiten and in the Nihon Sōsaku-Hanga Kyōkai show in 1929. Self-carved blocks. Some self-printed; others produced with assistance from the publisher Ishiyama and printers in his employ. Works of the 1950s included a view of gulls over rippling water. Prints sometimes signed Seiji and sealed Ao with the first character of his family name.

Arai Kōji　新居広治

See Nii Hiroharu.

Arai Tōru　荒井東留

Also known as Matsuki Tōru and Sueki Tōru. Active in Shin Hanga Shūdan; founding member of Zōkei Hanga Kyōkai. Exhibited with Nihon Hanga Kyōkai and Shun'yōkai. Contributed to *Shin hanga* in 1935 and *Kitsutsuki* in 1931. Prints sometimes signed TO carved in the blocks.

Arishima Ikuma　有島生馬

1882–1974. B. Yokohama. Original name Arishima Mibuma. Gō Ikuma. Grad. Tokyo Foreign Language School. A novelist and essayist of note, he contributed an influential article on Cezanne to *Shirakaba*. Studied painting under Fujishima Takeji and abroad. Exhibited painting at Inten and Nitten. Founding member of Nikakai; member of Japan Watercolor Society; became member of Japan Art Academy in 1937. Expressionist *moku-hanga* ca. 1910 influenced by Fujishima Takeji. Later made metal-plate prints.

Asada Benji 麻田辨次

1899–1984. B. Kyoto. Original name Nakanishi Benji. Took surname Asada in 1927 in honor of two painters of that name whom he admired, one a Japanese-style painter and the other Western-style. In 1914 entered Kyoto City School of Fine Arts and Crafts; grad. 1924 Kyoto City Specialist School of Painting. In 1928 participated in publication of the magazine *Han* with Hiratsuka Un'ichi, Maeda Masao, Azechi Umetarō, Munakata Shikō, and others. In 1929 became founding member of Kyoto Sōsaku-Hanga Kyōkai. About this time also began studying Japanese-style painting with Nishimura Goun. Exhibited at Kokuga-kai, Shun'yōkai, Teiten, and Nitten. In 1930 he was a member of the group that published *Kitsutsuki*; in the same year with Tokuriki Tomikichirō and Asano Takeji he also published *Creative Prints of Twelve Months in New Kyoto (Sōsaku-hanga shin Kyoto jūnikagetsu)*. Participated in publication of *Taishū hanga* in 1931 and *Tsuge* in 1933. Member of Nihon Hanga Kyōkai from 1932. Contributed to *One Hundred Views of New Japan (Shin Nihon hyakkei)* in 1939. After World War II he abandoned *moku-hanga* and devoted his full energy to Japanese-style painting, exhibiting at Nitten. He was the father of Asada Takaji (Japanese-style painter and lithographer) and Asada Hiroshi (Western-style painter and etcher).

Asaga Manjirō 朝賀卍廊

1885–1965. B. Kyoto; lived in Kyoto. Second elder brother of Maekawa Senpan. Beginning 1944 he created ca. 200 prints of *nō* drama and other traditional Japanese subjects including a set of 10 prints based on *Ōtsu-e*. Frequently signed his prints Manjirō in *kanji*.

Asahara Hiroya 浅原洋哉

B. 1944 in Niigata prefecture. Grad. 1968 economics department of Risshō University. Studied printmaking with Takahashi Shin'ichi. Exhibited with Nihon Hanga Kyōkai and Kokugakai from 1969 and in group and solo exhibitions. Member of Nihon Hanga Kyōkai from 1977. Subjects of *moku-hanga* include palaces, inns, and abstractions.

Asahi Masahide 旭正秀

1900–1956. B. Kyoto. Took the name Yasuhiro in 1936. After graduating from junior high school he entered the Asahi newspaper company. Studied at Kawabata Painting School. Member and strong supporter of Nihon Sōsaku-Hanga Kyōkai; founding member of Nihon Hanga Kyōkai; member of Shun'yōkai. Publisher of several small magazines including *Hanga*, *Shi to Hanga*, and *Dessan*. Contributed prints to *HANGA*, *Han geijutsu*, and *One Hundred Views of New Japan*. In addition to numerous articles in *hanga* magazines and books on *hanga* technique he wrote an article on printmaking in *Art of the World Encyclopedia: Western Print Section (Sekai bijutsu zenshū seiyō hanga hen)* in 1930. Accompanied the Nihon Hanga Kyōkai exhibition to Paris in December 1933 and to other European cities and the U.S. in 1936. Worked at Northeast Asia Culture Promotion Center in Manchuria in 1945. Among his works are *New Edition of Modern*

Women's Styles (Shinpan imayō onna fūzoku), 1930, and prints related to his travels abroad.

Asahi Yasuhiro 旭泰宏

See Asahi Masahide.

Asai Chū 浅井忠

1856–1907. B. Edo. Studied with Antonio Fontanesi. Founding member of Meiji Bijutsukai in 1888. Studied in Paris ca. 1899–1902. On his return moved to Kyoto; taught at Kyoto City School of Fine Arts and Crafts; directed Kansai Bijutsuin (Kansai Academy of Fine Arts). A very influential teacher of, among others, Ishii Hakutei, Umehara Ryūzaburō, and Yasui Sōtarō. Also a leading painter of his time, working in the Barbizon style he had learned from Fontanesi. Made numerous lithographs and illustrations for satirical magazines reproduced in *Fifty Modern Genre Scenes Compared in Verse (Tōsei fūzoku gojūban uta awase)*, 1907. A related book, posthumously published, *Fifty Modern Genre Scenes Compared in Pictures (Tōsei fūzoku gojūban e awase)*, 1909, is illustrated with *moku-hanga*.

Asai Kiyoshi 朝井清

1902–1968. B. Hiroshima prefecture. Studied painting with Saitō Yori and Nakazawa Hiromitsu. Exhibited paintings at Bunten, Teiten, and with Tōkōkai. Member of Tōkōkai. Showed *moku-hanga* with Nihon Sōsaku-Hanga Kyōkai in 1929 and frequently with Nihon Hanga Kyōkai. Member of Nihon Hanga Kyōkai 1938–1960. Joined Nippankai in 1960.

Asano Takeji 浅野竹二

B. 1900 in Kyoto. Grad. Kyoto City School of Fine Arts and Crafts in 1919 and Kyoto City Specialist School of Painting in 1923. Studied Japanese-style painting with Tsuchida Bakusen. Active in the formation of Kyoto Sōsaku-Hangakai in 1929. In 1930 participated with Tokuriki Tomikichirō and Asada Benji in creating the series *Creative Prints of Twelve Months in New Kyoto (Sōsaku-hanga shin Kyoto jūnikagetsu)* published by Uchida. Also contributed to other series of landscapes in 1930s. Created the self-carved, self-printed series *Noted Views in the Kyoto-Osaka Area (Kinki meisho fūkei)* in 1947. Contributed to *Taishū hanga*. Associate member of Nihon Hanga Kyōkai 1955–1960. Excelled as a carver. Sometimes signed his landscape prints with the *kanji* "Takeji *tō*" (Takeji carved). His late prints from the 1970s and 1980s are simple, seemingly naive, humorous, and signed T.A. preceded by an apostrophe and the year.

Ashikaga Shizuo 足利静男

Bird and flower subjects published by Uchida. Seal: Shizu

Ashikawa Tamotsu 芦川保

B. 1927 in Niigata prefecture. Grad. 1951 English literature department of Waseda University. In 1973 studied *mokuhan* with Ono Tadashige. Exhibited at

solo exhibitions and yearly with Han no Kai, a print society organized by Ono Tadashige, beginning 1973. Prints are generally figurative.

Atomi Yutaka　跡見泰

1884–1953. B. Tokyo. Studied with Kuroda Seiki and Wada Eisaku; grad. 1904 Tokyo School of Fine Arts. Studied in France 1922–1924. Exhibited paintings in Bunten and Teiten. Member of Kōfūkai. Designed woodblock illustrations.

Atsumi Daidō　渥美大童

B. 1911. Met Munakata Shikō in 1949. Became Munakata's teacher of calligraphy and from him learned the art of woodblock printing. Participated with Munakata in formation of Banga-in.

Atsumi Tetsuyata　渥美徹弥太

Grad. Tokyo Business Crafts School. Exhibited at 7 Nihon Hanga Kyōkai shows 1932–1943; associate member from 1944.

Awazu Kiyoshi　粟津潔

B. 1929 in Tokyo. Attended Hōsei University. Became leading graphic designer exhibiting widely in Japan, New York, and Europe. In 1979 the Riccar Museum in Tokyo made arrangements for Awazu, who ordinarily creates with advanced technological equipment, to design for woodblock. The prints, a series of fanciful flowers for backs of playing cards, were executed by Adachi Hanga Kenkyūsho and exhibited at the Riccar.

Ay-Ō　靉嘔

See Ai-Ō.

Azechi Umetarō　畦地梅太郎

B. 1902 in Uwajima, Ehime prefecture. Studied painting by correspondence before moving to Tokyo in 1920. Forced to return to his parents' home after the 1923 earthquake but returned to Tokyo in 1925 and obtained work in a government printing office where he began making prints by scratching on scraps of lead plate which he then inked and printed by using a teacup as a *baren*. Met Hiratsuka Un'ichi who urged him to exhibit with Nihon Sōsaku-Hanga Kyōkai. Largely self-taught as a printmaker but encouraged by Hiratsuka, Onchi Kōshirō, and Maekawa Senpan for whom he worked from time to time as an artisan printer. Exhibited with Nihon Sōsaku-Hanga Kyōkai from 1927, Shun-'yōkai from 1928, and Kokugakai from 1931. Member of Nihon Hanga Kyōkai from 1932; member of Kokugakai from 1943. Contributed to *Ichimokushū, Recollections of Tokyo (Tokyo kaiko zue), Kitsutsuki, Kitsutsuki hangashū, One Hundred Views of New Tokyo (Shin Tokyo hyakkei), Hōsun hanga, Jissen hanga,* and *Han*. Represented in São Paulo, Lugano, and Tokyo biennales. His prints in the late 1920s and 1930s, including numerous cityscapes and *Ten Scenes of Iyo (Iyo jikkei),* 1936, were strongly influenced by Hiratsuka Un'ichi. After World War II he developed highly individual prints of mountains and mountaineers with simpli-

fied forms and flat areas of color. Well known in Japan as an essayist on subjects related to mountains.

Azuma Kazuo　東一雄

B. 1910 in Toyama prefecture. Studied painting with Ishikawa Toraji and took a short course in *mokuhan* with Ono Tadashige in 1938. Exhibited with Zōkei Hanga Kyōkai beginning in 1935. Member of Ōgenkai 1949–1957; after that became independent. Professor at Toyama Junior Woman's College. Decorated a large wall by *mokuhan* at Kurehayama Hall in Toyama. Subjects of prints frequently taken from folk customs or fishing or farming villages. In the 1930s he sometimes used the letter "A" in a circle carved in the block as a signature.

Azuma Masahiro　吾妻正弘

B. 1938 in Yamagata. Grad. Yamagata University. Teacher in Numazu City. Member of Shizuoka artists' league and Shizuoka Hanga Kyōkai. Exhibited in CWAJ show in 1966 and with Kokugakai in 1975.

Baba Kashio　馬場檮男

B. 1927 in Tokyo. Member of Nihon Hanga Kyōkai from 1967 and Shun'yōkai. Held more than 30 solo shows in Tokyo. Represented in Nihon Hanga Kyōkai exhibition in the U.S., International Miniature, and Florence (all in 1968) and Ibiza 1975. Combines woodblock with etching; also makes lithographs. Lecturer at Tokyo University of Art and Design.

Baba Shigeomi　馬場重臣

B. 1933 in Gifu prefecture. Grad. 1955 Musashino College of Fine Arts. Studied painting with Hayashi Takeshi and Yasui Sōtarō; studied *mokuhan* with Ono Tadashige. Member of Japan Watercolor Society and International Fine Art Association. Exhibited with Independent Fine Art Association in 1964, Nichidō in 1971, Shell in 1973, and in various solo, group, and international shows. Subjects include old temples, Buddha images, and landscapes.

Baidō Hōsai　梅堂豊斎

1848–1920. Original name Takenouchi Hidehisa; also known as Utagawa Kunisada III, Kunimasa IV, and Toyokuni IV. Studied *ukiyo-e* under Kunisada II; used the *gō* Kunimasa IV and Baidō Hōsai early in life. Took the *gō* Kunisada III in 1889; late in life claimed to be Toyokuni IV but was in fact Toyokuni V. Prints include woodblock fashion plates, illustrations, and Russo-Japanese War prints.

Ban Tetsugorō　萬鉄五郎

See Yorozu Tetsugorō.

Ban Yō　伴鷗

B. 1939 in Yokohama. Studied with Nakamura Masayoshi, Itō Shinsui, and Noguchi Kōmei. Various solo exhibitions. His images, including depictions of small children and Jizō images, are derived from folk art.

Bannai Kōkan 坂内宏観

B. 1900 in Fukushima prefecture. Given name Sadao. Studied Japanese-style painting with Bannai Seiran. Exhibited paintings of *Fifty-Three Stations of the Tōkaidō* in 1927. Three of these, *Hakone*, *Nihonbashi*, and *Nagoya Castle*, published as prints by Watanabe Shōzaburō in 1930.

Banri 萬里

Russo-Japanese War prints published by Narazawa Kenjirō in 1904.

Bartlett, Charles William

1860–1940. Born in Bridgeport, Dorsetshire, England. Studied painting at the Royal Academy in London and in Paris. Known in Europe for oils, watercolors, and etchings of scenes in Brittany and Holland. From December 1913 he traveled and painted in India and China before arriving in Japan in 1915. In 1916 Watanabe Shōzaburō produced 21 prints from his travel paintings. Bartlett left Japan in 1917 intending to return to England via Hawaii and the U.S., but remained in Hawaii for the rest of his life. According to Watanabe's records he made a total of 38 Bartlett prints, with the latest, *Hour of Prayer, India*, dated 1925. Some are undated and some are of Hawaiian subjects. Blocks at Watanabe's shop were destroyed during the fire following the 1923 earthquake; other blocks were scored after Bartlett's death so that no further prints could be made.

Beniyoshi 紅吉

See Otake Kazue.

Bihō 美邦

Also known as Yoshikuni. Designed Russo-Japanese War prints published by Matsuki Heikichi in 1904.

Bihō 美宝

Designed *Figures of the Eastern Region (Azuma Sugata)*, ca. 1910; published by Akiyama Buemon. Also made *kachō*.

Bitō 美稲

Prints of *maiko* published by Satō Shōtarō in Kyoto ca. 1924 are signed Bitō or Mitō.

Capelari, Fritz

Austrian watercolor painter. In spring 1915 Watanabe Shōzaburō saw an exhibition of Capelari's paintings and, thinking his style suitable to woodblock printing, asked him to provide a design for a print. Both were pleased with the collaboration and continued working together through 1915 producing 12 prints. Watanabe produced another Capelari print in 1918 and another in 1920. The subject of the first print was schoolchildren in rain; other subjects included women and children, genre scenes, and landscape details.

Chieko 千恵子

See Minagawa Chieko.

Chii Kōun 地井紅雲

B. 1937 in Yamagata prefecture. Grad. 1960 Hōsei University. Studied with Munakata Makka and Abe Kōun. Member of Banga-in exhibiting yearly with that group and in international and group shows. Prints, mostly in black and white, deal with Buddha images, temples and shrines, mythology, folk tales, and the Japanese landscape.

Chikanobu 周延

See Toyohara Chikanobu.

Chūjō Tatsuo 中条たつを

B. 1892 in Hakodate. Produced several sets of *hanga* including *Fish of Silver (Gin no sakana)* and *Swamp of Smiles (Hohoemi no numa)*.

Daidōji Tōru 大道寺達

B. Tochigi prefecture. Also known as Daidōji Tatsu. Studied with Kawakami Sumio. Exhibited with Zōkei Hanga Kyōkai. Contributed to *Katana* in 1930. Professor at Kansai Gakuin University.

Daigō 大業

The name of this artist can be read Daigō, Taigyō, or Daigyō. For seal and signature see Chapter 7.

Dobashi Jun 土橋醇

1910–1978 B. Fukushima prefecture. Grad. Tokyo School of Fine Arts in mid-1930s. Went to Paris shortly thereafter; returned to Paris in 1953 and remained for a prolonged period showing paintings and prints at Salon de Mai, École de Paris, Salon d'Automne, and other exhibitions. Member of Nihon Hanga Kyōkai; represented in Tokyo International Biennale. Lithographs and etchings as well as woodblocks characterized by an abstract decorative style.

Dōmoto Inshō 堂本印象

1891–1975. B. Kyoto. Given name Sannosuke. Grad. 1910 Kyoto City School of Fine Arts and Crafts. Worked as textile designer for Nishijin Tatsumura studio. In 1918 entered Kyoto City Specialist School of Painting; grad. 1924. Studied with Nishiyama Suishō. Taught at Kyoto City School of Fine Arts and Crafts 1930–1936 and at Kyoto City Specialist School of Painting 1936–1941. Exhibited paintings with Teiten and Shin Bunten. Made wall paintings at Shitennō-ji (Osaka) and in central pagoda at Kongōbu-ji on Mt. Kōya. Appointed member of Japan Art Academy in 1950. *Hanga* include *Eight Views of Kyoto*, 1928, *First Makeup of the New Year*, 1934, published by Baba Nobuhiko, and a collection of 12 Buddhist woodcuts entitled *Inshō butsuga shū*, 1941. Received Order of Cultural Merit in 1961. Four abstractions were published as *moku-hanga* after his death.

Ebata Hōichi 江端芳市
See Ebata Yoshiichi.

Ebata Yoshiichi 江端芳市
Also known as Ebata Hōichi. Joined Shin Hanga Shūdan in 1935 while teaching in Aichi prefecture. Also exhibited with Zōkei Hanga Kyōkai and Nihon Hanga Kyōkai. Contributed to *Kitsutsuki hangashū* in 1943. Works include print of a child in a large wicker chair, 1935. Used the signature Y. Ebata.

Eijirō 永二郎
1870–1946. Prints, including scenes of the Sumida River, published by Nishinomiya Yosaku ca. 1910. For seal see Chapter 7.

Enan Shirō 江南史朗
B. 1901. Participated in first Nihon Hanga Kyōkai exhibition in 1931. Contributed intermittently to *Shiro to kuro* 1931–1934 and *Han geijutsu* 1932–1934. Member of Han no Kai, the greeting card exchange group led by Takei Takeo. Prints include landscapes of Tokyo or Musashino and toys.

Endō Kyōzō 遠藤教三
1897–1970. B. Tokyo. Grad. 1921 Japanese painting section of Tokyo School of Fine Arts. Studied with Matsuoka Eikyū. Active in founding Shinkō Yamato-e Kai. Exhibited with that association, Teiten, and Shin Bunten. Taught at Women's College of Fine Arts. Prints carved by Yamagishi Kazue. Published by Shin Yamato-e Moku-Hanga Kankōkai. Subjects include depictions of fish.

Etō Masao 江藤正雄
B. 1919 in Fukuoka. Studied with Munakata Shikō. Worked for railways. Member of Banga-in and active in Kyushu Hanga-in. Member of Taiheiyō Bijutsukai. Prints are usually landscapes.

Etō Masutarō 江渡益太郎
See Ewatari Masutarō.

Etō Yukio 江藤幸男
B. 1927 in Kita Kyushu. Grad. 1944 Kokura Technical School. Studied *hanga* with Fukita Fumiaki. Exhibited with Modern Art Association from 1965; member from 1977.

Ewatari Masutarō 江渡益太郎
B. 1913 in Aomori prefecture. Grad. 1934 Aomori Normal School. Studied etching with Kon Junzō. Exhibited with Nihon Hanga Kyōkai from 1954 and with Kokugakai. An officer in Japan Education Print Association 1959–1965. Sometimes sealed his prints with the character "Masu" from his name.

Foujita Tsuguji 藤田嗣治
See Fujita Tsuguharu.

Fujii Tatsukichi 藤井達吉

1881–1964. B. Aichi prefecture. In 1899 began studying cloisonné; in 1905 went to U.S. where he had entered a cloisonné piece in a Portland exhibition. In 1906 returned to Japan and investigated a broad field of crafts. Exhibited 7 embroidered tapestries at the Fyūzankai show in 1913. Became active in printmaking in 1914 and contributed self-carved *moku-hanga* to *Geibi*, a publication of the art shop Mikasa. In later life he taught papermaking. Donated 2,000 items to the Aichi culture center.

Fujiki Kikumaro 藤木喜久磨

Studied with Hashiguchi Goyō. Participated in the first two Nihon Sōsaku-Hanga Kyōkai exhibitions in 1919 and 1920. Contributed to *HANGA* in 1924.

Fujimaki Yoshio 藤牧義夫

1909–1935. B. Tatebayashi, Gunma prefecture. In 1930 began studying printmaking from Hiratsuka Un'ichi's book on technique, *Hanga no gihō*. In 1931 moved to Tokyo and obtained work at a design company in Ginza. Became one of the first artists to use *shina* plywood, probably because it was less expensive than conventional cherry or *katsura*. Exhibited at Teiten and with Shun'yōkai and Nihon Hanga Kyōkai 1931–1935. Became close associate of Ono Tadashige and founding member of Shin Hanga Shūdan in 1932. From that time exhibited principally with Shin Hanga Shūdan and contributed to *Shin hanga*. While living in poverty along the banks of the Sumida and suffering from depression, he disappeared probably by drowning himself in the river. *Picture Scroll of the Sumida Riverbank (Sumida gawa kishi emaki)* was unfinished at time of his death. He sometimes carved YO.FU preceded and followed by small triangles as a signature. Strongly patterned style influenced by German expressionism.

Fujimori Shizuo 藤森静雄

1891–1943. B. Kurume, Fukuoka prefecture. In 1910 enrolled in school of Hakubakai; in 1911 entered Tokyo School of Fine Arts; grad. 1916. Studied with Kuroda Seiki and Fujishima Takeji. He was inspired by Aoki Shigeru, a native of Kurume and 9 years his senior. Fujimori worked on *Tsukubae* with Onchi Kōshirō in 1913–1914 and while still a student contributed a total of 37 prints. Took part in the first Nihon Sōsaku-Hanga Kyōkai exhibition in 1919. Taught in middle schools on Taiwan and in Fukuoka. Moved to Tokyo in 1922 to be a full-time artist; returned to Fukuoka in 1939 and remained until his death. Member of Nihon Sōsaku-Hanga Kyōkai and founding member of Nihon Hanga Kyōkai. Exhibited with Shun'yōkai annually 1926–1937. He was the principal editor of *Shi to hanga* and contributed to *Shin hanga, Han geijutsu, Kasuri, Jissen hanga, Kaze, Bijutsu-han,* and *One Hundred Views of New Tokyo (Shin Tokyo hyakkei),* 1929–1932. Also produced the series *Twelve Views of Great Tokyo (Dai Tokyo jūnikei),* 1933–1934, and woodblock illustrations for *Dōwashū* (a collection of fairy stories) and for the newspaper serialization of a novel by Chikamatsu Shūkō in the newspaper *Fukuoka nichi nichi shinbun*. His style, affected by the

loss of his right thumb in an accident as a child, was strongly expressionist especially in the *Tsukubae* years. Sometimes used the signature SIZ on early prints.

Fujisawa Tatsuo 藤沢龍雄

Prints include a dance series, 1930, and a *bijin-ga* probably from the late 1930s or early 1940s.

Fujishima Takeji 藤島武二

1867–1943. B. Kagoshima. Studied Shijō-style painting and Taoist philosophy as a child. In Tokyo continued study of Shijō-style painting with Kawabata Gyokushō while also studying oil painting with Soyama Yukihiko, Nakamura Seijūrō, Matsuoka Hisashi, and Yamamoto Hōsui. Came into prominence ca. 1900 with Western-style paintings which were more conceptual and decorative than the prevailing Kuroda Seiki style. Exhibition of his *Butterfly*, 1904, at Hakubakai is considered the height of Japanese romanticism. Fujishima's illustrations in *Myōjō* were admired by early *sōsaku-hanga* artists and by Takehisa Yumeji. Studied in Europe 1905–1910 with Fernand Cormon in Paris and Carolus Duran in Rome. His woodblock prints, which deal with scenes of everyday life, date from ca. 1905. Simply carved and printed, they suggest that he produced the prints himself. After his return to Japan, taught at Tokyo School of Fine Arts. Appointed to membership in Imperial Fine Art Academy in 1924; received Order of Cultural Merit in 1937, the initial year of that award.

Fujita Fumio 藤田_____

B. 1933. Grad. oil painting division of Musashino College of Fine Arts. Made *moku-hanga* from 1963. Among his prints is a series on white-bark trees.

Fujita Kenji ふじたけんじ

B. 1939 in Aomori prefecture. Produced *moku-hanga* from 1970. Exhibited in Obihiro, Hakodate, Aomori, and other cities in northern Japan. Known as a poet and novelist as well as *mokuhan* artist. Subjects often taken from landscapes, customs, and folklore of Aomori region and depicted principally in black and white.

Fujita, Leonard 藤田 Leonard

See Fujita Tsuguharu.

Fujita Tsuguharu 藤田嗣治

1886–1968. B. Tokyo. Second son of a general in army medical corps. Also known as Fujita Tsuguji, Foujita Tsuguji, and Leonard Foujita. Took the name Leonard in 1959 when he was baptized a Catholic. Traveled to China and Manchuria in 1906; grad. 1910 Western-style painting department of Tokyo School of Fine Arts. In 1910 exhibited with Hakubakai. Went to France in 1913 and to London in 1914 where he worked as a restorer for an antique dealer and as a dress designer at Selfridge's. Returned to Paris in 1915. Became friendly with Modigliani and Soutine. Exhibited at the Salon d'Automne in 1919 and after and at Salon des Indépendants in 1922 and 1923. Designed etchings and litho-

graphs from about 1925. Returned to Japan in 1929 and exhibited 70 works in a solo exhibition in Tokyo. In 1930 returned to Paris. Spent 1931, 1932, and part of 1933 traveling in South America and the western U.S. before returning to Japan. Except for a trip to France via the U.S. in 1939–1940 and assignments in China, Manchuria, Singapore, and Indonesia as artistic attaché to various military units, he stayed in Japan until 1949. After teaching for several months at a Brooklyn art school, returned to France for the final time in 1950. In 1955 he became a French citizen and in 1957 was made an officer of Legion of Honor and in 1958 an associate member of Belgian Royal Academy. After his death he was awarded the Order of the Holy Treasure by the Japanese government. His *mokuhanga* were published in Japan by Takamizawa Mokuhansha and Katō Hanga Kenkyūsho.

Fujita Tsuguji　藤田嗣治

See Fujita Tsuguharu.

Fujita Yoshika　藤田吉香

B. 1929 in Fukuoka prefecture. Grad. 1955 Tokyo University of Arts. Exhibited oil painting with Kokugakai and in international and solo shows. Member of Kokugakai. Traveled in Spain in 1962. *Moku-hanga* include still lifes and flowers.

Fujiwara Kōi　藤原向意

B. 1932 in Hyōgo prefecture. Grad. Musashino College of Fine Arts. Began making *moku-hanga* in 1960. Exhibited at many group and solo shows including Gendai 1966 and 1975, and Krakow 1976 and 1978. His works, often hard-edged and geometric in style, symbolize communication between machines and people.

Fukagawa Kōtarō　深川好太郎

Lived in Tokyo. Exhibited with Nihon Hanga Kyōkai 1932–1947; associate member from 1944. Contributed to *Hanga za* in 1932.

Fukamizu Shōsaku　深水正策

1900–1972. B. Nagano prefecture. Attended Sophia University in Tokyo and Columbia and Harvard in U.S.; studied in Europe for 6 years. Member of Taiheiyōgakai; member of Hanga Konwakai from 1954. Made woodcuts and etchings of traditional buildings in seasonal settings.

Fukasawa Gunji　深沢軍治

See Fukazawa Gunji.

Fukazawa Gunji　深沢軍治

B. 1943 in Yamanashi prefecture. In 1971 completed graduate studies at Tokyo University of Arts. Exhibited *moku-hanga* and monotypes with Nihon Hanga Kyōkai from 1971 and in four-person shows in 1972, 1973. His monotype technique involves paper stencils and paper block relief printing, sometimes combined with woodcut.

Fukazawa Sakuichi 深沢索一

1896–1947. B. Niigata prefecture. Went to Tokyo ca. 1920 and began making *moku-hanga* under the guidance of Suwa Kanenori. From 1922 exhibited with Nihon Sōsaku-Hanga Kyōkai; member from 1928 and founding member of Nihon Hanga Kyōkai in 1931. From 1928 exhibited with Shun'yōkai. Contributed poetry and *hanga* to several *dōjin* magazines including *Minato, Kaze, HANGA, Shi to hanga, Han, Sen, Shiro to kuro, Dessan, Hanga shi, Hōsun hanga, Mura no hanga, Han geijutsu, Kasuri,* and *Jissen hanga.* Contributed 13 prints to *One Hundred Views of New Tokyo (Shin Tokyo hyakkei).* With Kawabata Ryūshi and Nakagawa Kazumasa made woodcuts for use on book covers. A commemorative exhibition of his works was held by Nihon Hanga Kyōkai in 1947 together with works of Yamamoto Kanae, Taninaka Yasunori, Henmi Takashi, and Koizumi Kishio. Fukazawa's style is characterized by a soft, lithographic quality achieved by use of a round knife and very shallow carving. He was proud of his carving but nervous about printing which he sometimes turned over to Katō Junji.

Fukazawa Shirō 深沢史朗

1907–1978. B. Tochigi prefecture. Studied at Kawabata Painting School 1926–1930 and with Umehara Ryūzaburō from 1935. Exhibited paintings at Teiten. Concentrated on prints from 1959 and exhibited with Nihon Hanga Kyōkai from 1965. Exhibited at Tokyo Biennale in 1966 and 1968; showed at Ljubljana, Krakow, Frechen, and other international competitions in subsequent years. Made serigraphs, etchings, and woodcuts. Known particularly for a series based on actor prints by Sharaku.

Fukita Fumiaki 吹田文明

B. 1926 in Tokushima prefecture. Grad. 1940 Tokushima Higher Normal School. Studied oil painting at Tokyo University of Fine Arts for one year. Taught art in elementary school 1947–1968. First exhibited with Nihon Hanga Kyōkai in 1957; member from 1958. Also member of Modern Art Association. Participated in numerous international biennales including Grenchen 1958, Krakow, Ljubljana 1969, Northwest 1965, Shell 1959, and Tokyo 1960–1968, and awarded a major prize at São Paulo in 1967. Became the first regular professor of printmaking in a Japanese art school at Tama College of Fine Arts in 1968. Prints are characteristically large and printed with oils over water-base pigment. Abstract subjects suggest energy and dramatic activities among galaxies.

Fukiya Kōji 蕗谷虹児

1898–1979. B. Niigata prefecture. Given name Kazuo. Went to Tokyo as apprentice to the Japanese-style painter Otake Chikuha and through the introduction of Takehisa Yumeji obtained work as illustrator. Began to use the art name Kōji and to establish a reputation in the early 1920s. Studied in France 1926–1930. Active as illustrator of newspaper novels in 1930s and as juvenile illustrator and moviemaker after World War II. Particularly known for illustrations of the nov-

els for young girls by Yoshiya Nobuko. His softly colored delicate style was strongly influenced by Yumeji. Woodblocks probably carved and printed by artisans.

Fukuda Bisen 福田眉仙

1875–1963. B. Hyōgo prefecture. Given name Shūtarō. Studied Japanese-style painting with Kubota Beisen and Hashimoto Gahō. Studied the works of Tao Chi (Daoji) in China in 1909. Produced screens for Daikaku-ji and Jingo-ji in Kyoto and a ceiling painting for Minatogawa-jinja in Kobe. Contributed to *A General View of China (Shina taikan)*, 1915, a collection published by Bun'endō and involving various types of printing including woodblock.

Fukuda Heihachirō 福田平八郎

1892–1974. B. Oita. Japanese-style painter; studied at Kyoto City School of Fine Arts and Crafts; grad. 1918 Kyoto City Specialist School of Painting. Exhibited paintings at Teiten. From 1936 taught at Kyoto City Specialist School of Painting. Appointed member of Japan Art Academy in 1947; received Order of Cultural Merit in 1961.

Fukuda Suikō 福田翠光

1895–1973. B. Kyoto. Grad. Kyoto City School of Fine Arts and Crafts. Studied Japanese-style painting with Nishiyama Suishō. Exhibited paintings with Teiten and Shin Bunten. Woodcut of a hawk on a pine branch is dated 1936.

Fukuda Toshiaki 福田利秋

B. 1911 in Fukushima prefecture. Studied *hanga* with Hiratsuka Un'ichi. Instructor at a Fukushima high school; active in promoting *hanga* in Fukushima prefecture. Participated in Chinese-Japanese exchange exhibition. Member of Shūdan Han.

Fukudō 福童

See Utagawa Kunimatsu.

Fukui Heinai 福井平内

B. 1920 in Aomori prefecture. Grad. 1943 Aomori Higher Normal School. Began making *moku-hanga* with children while teaching at an elementary school in 1948. Exhibited with Banga-in and regional shows. Member of Banga-in from 1972. Prints include landscapes depicted with strong contrast of light and dark.

Fukuoka Seiran 福岡青嵐

1879–1954. B. Kumamoto prefecture. Given name Yoshio. Grad. 1903 from Japanese-style painting department of Tokyo School of Fine Arts. Became teacher at Osaka Art School in 1927. Member of Seiryūsha from 1935. Contributed to *New Portraits (Shin Nigao-e)*, a collection carved by Igami Bonkotsu.

Fukushima Ichirō 福島一郎

1920–1975. B. Kanagawa prefecture. From 1938 studied oil painting with Kumaoka Yoshihiko. After World War II was represented at Krakow and won

recognition in several exhibitions in East Germany. Member of Nihon Hanga Kyōkai from 1969. Works include a triptych, *Going Out Fishing*, 1967, and *Nanzen-ji Temple, Kyoto*, 1970.

Fukushima Jōsaku　福島常作

Member of the Aomori Sōsaku-Hanga Study Society. Contributed to *Mutsu*, 1931, *Chōkokutō*, 1932, *Mutsu goma*, 1934–1935, and *Kikan Aomori hanga*, 1939.

Funasaka Yoshisuke　船坂芳助

B. 1939 in Gifu prefecture. Son of the watercolor painter Funasaka Masayoshi. Grad. 1962 from painting division of Tama College of Fine Arts. Began making woodblock prints about 1966. In 1976–1977 studied in England and the U.S. under a Japanese government fellowship. Member of Nihon Hanga Kyōkai from 1969 and Shun'yōkai. Exhibited at international print biennales at Pistoia, Ljubljana, Bradford, Grenchen, Frechen, and elsewhere as well as Tokyo. Early prints were made with linoleum blocks; later woodblocks were combined with silkscreen. From 1957 until mid-1970s he consistently included the shape of a lemon in his imagery. After abandoning the lemon he combined small brightly colored shapes, printed with woodblocks, onto large areas of silkscreened color.

Funasaki Kōjirō　船崎光治郎

See Funazaki Kōjirō.

Funazaki Kōjirō　船崎光治郎

B. 1900 in Hyōgo prefecture. Studied *Nihon-ga* and later *moku-hanga*. Exhibited with Nihon Hanga Kyōkai 1931–1935. Member of Nihon Hanga Kyōkai 1932–1941. Contributed to *One Hundred Views of New Japan (Shin Nihon hyakkei)* in 1938. Sometimes signed flower and landscape prints with Kōjirō in *kanji* carved in the block.

Furukawa Ryūsei　古川龍生

1893–1968. B. Hagawa, Tochigi prefecture. Given name Tatsuo. Studied Japanese-style painting under Yūki Somei at Kawabata Painting School. Grad. 1924 from Japanese-style painting division of Tokyo School of Fine Arts. *Sōsaku-hanga* techniques were self-taught. Exhibited with Nihon Sōsaku-Hanga Kyōkai and Nihon Hanga Kyōkai from 1924 until forced by illness to stop carving in 1936. Among his prints of this period is an insect caricature series of 9 prints. Exhibited with Shun'yōkai from 1928. Became member of Nihon Hanga Kyōkai in 1932. Prints exhibited at Berlin Olympics in 1936. Contributed to *HANGA*, *Shosō*, and *Han geijutsu*. In 1928 became teacher of painting at Honmoku middle school in Yokohama. Evacuated to his native village in 1943 and did not carve because of demands of farming and village life during the war. On New Year's day 1951 he determined to surmount all difficulties and return to producing *moku-hanga*. Worked furiously to prepare for Shun'yōkai exhibit the following April, usually making only one copy of each print. In 1953 at age 60 he returned to Tokyo to live. Became member of Shun'yōkai in 1954. Late prints include fan-

ciful landscapes in a strong but delicate wood engraving technique, seasonal flowers, grasses, and still lifes. Memorial exhibitions of his work were held at Riccar Museum in 1972 and Tochigi Prefecture Art Museum in 1975.

Furukawa Tatsuo　古川龍生

See Furukawa Ryūsei.

Furusawa Iwami　古沢岩美

B. 1912 in Saga prefecture. Attended Kurume Business High School. In 1928 boarded at the home of Okada Saburōsuke and attended Hongō Painting Institute. Worked as *manga* artist and illustrator under the name Noro Bonsuke. Was active in the formation of Fine Art and Culture Association in 1939 and a pioneer in Japanese surrealism. Exhibited at Tokyo Biennale. Made etchings and lithographs as well as *moku-hanga*.

Furuya Shin　古家新

1897–1977. B. Hyōgo prefecture. Grad. Kyoto City School of Fine Arts and Crafts. Studied with Nabei Katsuyuki. Founding member of Action Art Association. Received Osaka art and culture prizes. Active illustrator before World War II.

Furuya Taiken　古屋台軒

Studied with Kaburagi Kiyokata and Kawai Gyokudō. Watanabe Shōzaburō published 4 prints by him in 1922 and others in 1936.

Fuse Chōshun　布施長春

1904–1946. B. Tokyo. Studied with Itō Shinsui and Igawa Sengai. Among his works are illustrations, *manga*, and actor prints.

Fuse Shintarō　布施信太郎

1898–1965. B. Miyazaki prefecture. Studied with Nakamura Fusetsu and at school of Taiheiyōgakai where he later taught. Exhibited at Teiten. Contributed to *New Era Print Collection (Shin jidai hanga shū)*, 1936. Also made South Sea Islands prints.

Fuyō　扶楊

See Narazaki Eishō.

Gessō　月荘

See Yoshimoto Gessō.

Getsuzō　月三

Several Russo-Japanese War prints published by Matsuki Heikichi used the name Ensei on his seal.

Gima Hiroshi　儀間比呂志

B. 1923 in Okinawa prefecture. Studied oil painting at Osaka Municipal Art Institute and *mokuhan* with Ueno Makoto. Exhibited oil paintings and *mokuhanga* in the Osaka area, in a China-Japan show 1964, in Leipzig 1959, and the

Tokyo Biennale 1968. Works include *Natural Features of Okinawa in Prints (Hanga fudoki Okinawa)*, 1966, and *Okinawa Prints (Hanga Okinawa)*, 1974, as well as other *hanga* collections and picture books for children. In 1971 he received the Mainichi publishing company culture prize for *Funahiki Tarō*, a children's book with illustrations designed by woodblock.

Gosho Kikuo　五所菊男

B. 1943 in Fukuoka prefecture. Grad. Kokugakuin University. Became interested in *mokuhan* while at university. Later studied with a *ukiyo-e* printer for 2 years beginning 1970. Exhibited with Nihon Hanga Kyōkai. Images in his prints suggest bundles of finely tooled dimensional lumber.

Gotō Sadanosuke　後藤貞之助

Contributed *Early Spring at Lake Biwa* and *Autumn Scene at Lake Chūzenji* to *Twelve Views of Japan (Nihon jūnikei)* published by Unsōdō in 1947. Carvers Nagashima Michio and Shibamura Shin'nosuke; printer Shinmi Saburō. Used seal of bird with two heads.

Gotō Tadamitsu　後藤忠光

Studied with Tobari Kogan. Exhibited with Nihon Sōsaku-Hanga Kyōkai in 1922; also with Zōkei Hanga Kyōkai and Ōgenkai.

Gotō Yoshikage　後藤芳景

1894–1922. Given name Seijirō. Also used the *gō* Hōsai. Originally from Osaka; also worked in Tokyo. Follower of Utagawa Yoshitaki.

Hagiwara Hideo　萩原英雄

B. 1913 in Kōfu, Yamanashi prefecture. Spent childhood in Korea and Manchuria where his father held various government jobs. Returned to Japan 1929. Studied with Hiratsuka Un'ichi in the extracurricular course at Tokyo School of Fine Arts; grad. 1938. Worked as foreman in charge of quality control at Takamizawa Mokuhansha. Immediately after World War II he spent 3 years in bed with tuberculosis. During that time began making creative prints. His first show at the Yōseidō gallery in 1956 was of figurative prints. This was followed by other figurative prints including a Greek mythology series in 1965, but his most widely acclaimed works are abstractions which he began producing in 1958. Member of Nihon Hanga Kyōkai from 1958. Received awards at several international competitions including the second and fifth Tokyo biennales, Krakow, Ljubljana, Banska, and Lugano. In 1967 taught at University of Oregon. In his abstractions he visualizes ideas and then carves directly and spontaneously without preliminary sketches. Achieves a sensual and richly evocative quality by printing on back of the paper to enrich the image on the front.

Hagiwara Kichiji　萩原吉二

1915–1957. B. Aomori. Exhibited with Zōkei Hanga Kyōkai, Kokugakai, and continuously with Nihon Hanga Kyōkai from 1937; became a member in 1952. Before World War II he was head of the Iwata Art League.

Hagiwara Rakuichi 萩原楽一

B. Tokyo. Studied with the painter and *manga* artist Kitazawa Rakuten. Member of Nihon Hanga Kyōkai from 1954. Exhibited with Nikakai and Kokugakai as well as Nihon Hanga Kyōkai. At one time ran a private children's painting school in Asakusa. Known as a *manga* artist.

Hagiwara Tsuneyoshi 萩原常良

B. 1936 in Hokkaido. Grad. 1957 Hokkaido University of Education. Studied with Kawakami Sumio. Member of Hokkaido Print Society and exhibited in numerous solo and group shows. Subjects of prints include still lifes or scenes of Hokkaido.

Hamada Josen 浜田如先

B. 1875 in Tokyo. Given name Keisaku or Esaku. Studied with Tomioka Eisen. Contributed to *New Ukiyo-e Beauties*, 1924.

Hamaguchi Kei 浜口恵

B. 1936 in Tokushima. Given name Megumi or Megumu. Grad. 1962 from art education department of Tokushima University. Member of Modern Art Association; exhibited yearly 1962–1980. Also exhibited in New York. Prints usually abstractions created in series.

Hanpo 半圃

See Yasuda Hanpo.

Hara Ken 原健

B. 1942 in Nagoya. Also known as Hara Takeshi. Grad. 1969 from graduate school of Tokyo University of Fine Arts; subsequently taught there. Apparently made *moku-hanga* but abandoned the medium in favor of lithography and serigraphy. Images are abstract and geometric and sometimes suggest large flat strokes of color.

Hara Seiichi 原精一

1908–1986. B. Kanagawa prefecture. Studied at Kawabata Painting School under Yorozu Tetsugorō. Member of Shun'yōkai and Kokugakai.

Hara Takeshi 原健

See Hara Ken.

Harada Taiji 原田泰治

B. 1940 in Suwa, Nagano prefecture. Crippled by polio in infancy. Grad. 1963 from graphic design department of Musashino College of Fine Arts. Finding it impossible to work in Tokyo because of commuting in crowded trains, he returned to Suwa and struggled to make a living from design work in that remote location. In 1973 he read an article in the newspaper about naive art in Yugoslavia and set to work painting the scenes he knew and loved in Nagano. At the same time he adopted the famous Yugoslav naive painter Ivan Rahuzin as his mentor. The *Asahi shinbun* featured a few of his paintings on the front

page of its Sunday editions. These proved so popular that the publisher engaged Harada to make enough paintings for Sunday editions for 2½ years. By that time Harada was a well-established naive painter. A series of 5 limited-edition woodblock facsimile prints was published in 1989 by Kōdansha. These were carved by Ōkura Hanbei and printed by Takagi Shōji.

Harada Tsunao　原田維夫

B. 1939 in Tokyo. Grad. 1962 from design department of Tama College of Fine Arts. In 1964–1965 he operated an art studio with Yokoo Tadanori and Uno Akira. Harada published through Kōetsudo a limited edition of 50 sets of 12 self-carved, self-printed *moku-hanga* illustrations for the famous novel *Kinpeibai* in 1977 and 35 sets of self-carved, self-printed illustrations for *Genji Monogatari* in 1979.

Harikae Shōji　張替正次

B. 1914 in Tokyo. Studied at school of Taiheiyōgakai; studied with Chōkai Seiji. Member of Kokugakai. Works are predominantly serigraphs but also *moku-hanga*. Act. 1970s. Images include large abstract forms in flat color.

Harumura Tadao　春村ただを

Lived in Kobe; active in *sōsaku-hanga* movement in Kansai. Exhibited with Nihon Sōsaku-Hanga Kyōkai 1922–1929. Member of Nihon Hanga Kyōkai 1932–1933. With Kawanishi Hide founded Sankōkai in 1929. Contributed landscape prints to *HANGA* and to the third set of *Kitsutsuki* in 1931.

Hasama Inosuke　硲伊之助

See Hazama Inosuke.

Hasegawa Haruko　長谷川春子

1895–1967. B. Tokyo. Studied Japanese-style painting with Kaburagi Kiyokata and Western-style painting with Umehara Ryūzaburō. Illustrator and *manga* artist. Also an essayist.

Hasegawa Katsusaburō　長谷川勝三郎

Studied *hanga* with Kawakami Sumio while a junior high student in Utsunomiya. Grad. Tokyo Higher Crafts School. Contributed to *Satoporo*, *Han*, and *Hanga*. Exhibited with Nihon Hanga Kyōkai in 1932.

Hasegawa Kiyoshi　長谷川潔

1891–1980. B. Yokohama. Grad. Meiji University; then studied painting with Fujishima Takeji, Okada Saburōsuke, and Kuroda Seiki. Actively participated with Nagase Yoshio and Hiroshima Shintarō in producing *moku-hanga* for *Kamen* in 1913 and organizing Nihon Hanga Club and Kamen exhibition in 1916. In 1918 went to France; remained for the rest of his life and distinguished himself as an etcher. Maintaining close ties with his friends in Japan, he retained membership in Shun'yōkai and Nihon Hanga Kyōkai and regularly sent prints to exhibitions. Was influential in urging the uniting of Yōfū Hangakai and

Nihon Sōsaku-Hanga Kyōkai into Nihon Hanga Kyōkai in 1931 in order to make one strong association to represent modern printmakers for the first exhibition of *sōsaku-hanga* in Paris in 1934. Arranged for that show and wrote the catalog. In 1936 awarded Legion of Honor by the French government.

Hasegawa Konobu　長谷川小信

B. 1914. Eldest son of Hasegawa Sadanobu III. Given name Tokutarō. Studied with his father who worked in *ukiyo-e* style. Prints include depictions of boys and girls in seasonal activities. Published by Uchida in Kyoto. Used the name Konobu on his seal.

Hasegawa Saburō　長谷川三郎

1906–1957. B. Yamaguchi prefecture. Studied at Tokyo University. Traveled in U.S. and Europe 1929–1932 and China in 1938. In 1944 moved to Nagahama in Shiga prefecture. Known chiefly as *sumi-e* painter and calligrapher but also created woodcuts and monotypes.

Hasegawa Sadanobu III　長谷川貞信 III

1881–1963. B. Osaka. Given name Nobutarō. Studied with his father Sadanobu II. Prints of *maiko* published by Uchida.

Hasegawa Tatsuko　長谷川多津子

B. 1901 in Tokyo. Given name Tatsuko with a different character for Tatsu. Wife of Hasegawa Tsuneo, proprietor of Nihon Hangasha. Grad. Women's Specialist School of Fine Arts. Studied with Okada Saburōsuke. Exhibited in print division of Teiten. Member of Nihon Hanga Kyōkai 1932–1937. Prints of the 1930s include depictions of the glass industry and a public bath.

Hasegawa Tomisaburō　長谷川富三郎

B. 1910 in Himeji, Hyogo prefecture. Grad. 1936 Tottori Normal School. Studied with Kawai Kanjirō and Munakata Shikō. Member of Kokugakai and Banga-in. Also exhibited with Nitten and in solo shows in Kobe, Osaka, Hiroshima, and Nagoya. His prints, which include landscapes, people, and Buddhist subjects, often reflect influence of Munakata.

Hashiguchi Goyō　橋口五葉

1880–1921. B. Kagoshima. Son of Hashiguchi Kanemizu, a samurai and amateur painter in the Shijō style. Given name Kiyoshi. Reported to have taken the name Goyō while in art school because of fondness for the five-needle pine (*goyō matsu*) in his father's garden. The elder Hashiguchi engaged a teacher of Kanō-style painting for his son when Kiyoshi was 10 and in 1899 encouraged him to study Japanese-style painting under Hashimoto Gahō in Tokyo. Goyō shifted to Western-style painting under Kuroda Seiki at Tokyo School of Fine Arts; grad. 1905. In 1905 he designed the layout and illustrations for Natsume Sōseki's novel *I Am a Cat* and this led to design of other books by Futabatei Shimei, Uchida Roan, Morita Sōhei, Tanizaki Jun'ichirō, Nagai Kafū, and Izumi Kyōka. Won recognition for an oil painting in the first Bunten show in 1907 but was disap-

pointed in public acceptance of his oil paintings in future shows. Became member of Museikai. In 1911 won recognition for an *ukiyo-e* poster designed for the forerunner of the present Mitsukoshi department store and thereafter became a serious student of *ukiyo-e*. From 1914, while generally in frail health and suffering from beri-beri, he contributed articles on various *ukiyo-e* studies to *Art News* (*Bijutsu shinpō*) and *Ukiyo-e* magazine. Watanabe Shōzaburō, aware of Goyō's *ukiyo-e* poster and his study of *ukiyo-e*, urged him to design a print for artisans to produce under Watanabe's direction. Accepting this challenge, Goyō designed *Bathing (Yuami)*, 1915. Watanabe wanted to continue the collaboration but Goyō did not. Instead, he worked in 1916–1917 as supervisor of reproductions for 12 volumes called *Japanese Color Prints (Yamato nishiki-e)* and in the process became thoroughly familiar with the functions of artisan carvers and printers. At the same time he was drawing from live models. From 1918 until his death he personally supervised the carving, printing, and publication of his own works. His total production, including *Bathing*, numbers 14 prints. After his death a few more of his designs were developed into prints by his heirs. These are listed in Chapter 6.

Hashimoto Kansetsu 橋本関雪

1883–1945. B. Kobe. Original name Hashimoto Kan'ichi. Studied with his father, a scholar of Chinese literature, and, beginning in 1911, with Takeuchi Seihō. Went to China in 1913 and to Europe in 1921. Exhibited Japanese-style paintings at Bunten and Teiten. Member of Art Committee of the Imperial Household; in 1934 appointed member of Imperial Art Academy. Received Asahi Culture Prize in 1939.

Hashimoto Kōhō 橋本高鳳

1893–1961. B. Ehime prefecture. Studied with Noda Kyūho. Exhibited with Teiten.

Hashimoto Kunisuke 橋本邦助

1884–1953. B. Tochigi prefecture. Son of the Japanese-style painter Hashimoto Gahō. Grad. 1903 from Western-style painting division of Tokyo School of Fine Arts and studied at school of Hakubakai. Exhibited painting at Bunten in 1907. Went to Paris in 1911. During World War II lived in Nagano prefecture and promoted art in that area. Woodcuts, carved by Igami Bonkotsu, appeared in *Kōfū*, the magazine of Hakubakai.

Hashimoto Meiji 橋本明治

1904–1991. B. in Shimane prefecture. Grad. from Tokyo School of Fine Arts. Studied with Matsuoka Eikyū. Exhibited in Teiten from 1929 and in Shin Bunten. Member of Imperial Fine Art Academy. For 10 years, beginning in 1940, he copied the wall paintings at Hōryū-ji. Blocks for *moku-hanga* cut by Ōkura Hanbei, published by Takamizawa. Received Order of Cultural Merit in 1974.

Hashimoto Okiie 橋本興家

B. 1899 in Tottori prefecture. Studied art education and oil painting at Tokyo School of Fine Arts; grad. 1924. Studied with Tanabe Itaru and Hirata Shōdō. Attended short course with Hiratsuka Un'ichi in 1936. He and Hiratsuka, who had grown up in the same region of Japan, developed a strong friendship and Hashimoto became member of Hiratsuka's circle, Yoyogi-ha. Exhibited at Shin Bunten, Nitten, and Shun'yōkai; member of Nihon Hanga Kyōkai from 1940 and Kokugakai. Contributed to *Kitsutsuki hangashū* in 1943 and to *Ichimokushū*. Beginning 1925 he taught art at a middle school until he became assistant principal of Tokyo First Women's High School; remained until he retired in 1955 to devote full time to printmaking. Participated in various international exhibitions. Especially known for large, strong, colorful prints of gardens and ruined castles; published several albums including *Picture Collection of Japanese Castles (Nihon no shiro gabun shū)*, 1944, *Ten Views of Old Castles (Kojō jikkei)*, 1946, both published by Katō Junji, and *Picture Collection of Famous Castles of Japan (Nihon no meijō gashū)*, 1962, published by Nihon Jōkaku Kyōkai. He used seals with characters "Oki" and "Hashi." Late works include a large nude in 1983.

Hashimoto Sōsuke 橋本総介

B. 1914 in Tokushima prefecture. Acquainted with Munakata Shikō through the Japan Folk Art Association. Produced *moku-hanga* from 1954. Exhibited with Banga-in yearly from 1955 making about 20 new prints each year. Prints frequently deal with Zen or ancient Buddhist figures and landscapes of his native place.

Hashimoto Yaoji 橋本八百二

1903-1979. B. Iwate prefecture. Grad. 1929 Tokyo School of Fine Arts. Studied with Wada Eisaku. Western-style painter and sculptor. Contributed to *One Hundred Views of Great Tokyo (Dai Tokyo hyakkei)* published by Japan Scenery Print Society (Nihon Fūkei Hangakai) in 1932.

Hasumi Yukio 蓮見幸夫

B. 1927 in Omiya, Saitama prefecture. Employed as teacher in Omiya elementary school. Exhibited with Modern Art Association from 1965; member from 1967. Represented at Xylon and Northwest. Prints deal with imaginary landscapes in a world of dark space.

Hasumoto Miyuki 蓮本みゆき

B. 1944 in Tokyo. Grad. 1964 Musashino College of Fine Arts Junior College. Studied with Kidokoro Shō. Exhibited at Kanagawa Hanga Andepandan and with Shun'yōkai and Nihon Hanga Kyōkai. Book designer and illustrator as well as *mokuhan* artist. People are her principal subjects. Vigorous lines and texture reflect the influence of Kidokoro Shō.

Hata Tsuneharu 幡恒春

B. 1883 in Miyazu, Hyogo prefecture. Given name Harumichi. Studied with Inano Toshitsune. Designed prints for *Pictures of Famous Places in Osaka and Kobe (Hanshin meisho zue)*, 1916.

Hatano Orizō 畑野織蔵

B. 1908 in Kanagawa prefecture. Studied design at Kanagawa Technical School and *mokuhan* with Azechi Umetarō. Began making *moku-hanga* in 1930. Exhibited with Nihon Hanga Kyōkai 1935–1937, Shin Hanga Shūdan, Zōkei Hanga Kyōkai, and Kokugakai. Works include *Anchored Ships*, 1942.

Hatsuyama Shigeru 初山滋

1897–1973. B. Asakusa district of Tokyo. Given name Shigezō. Studied Kanō school painting as a child with Araki Tanrei and Japanese genre painting with Igawa Sengai. Apprenticed first to a goldsmith and then to a fabric dyer in whose workshop he remained for 5 years. Seriously interested in the theater as a young man; tried acting in the "new theater" *(shingeki)* and worked for awhile for the *kabuki* actor Bandō Shunchō. Wrote poetry under the pen name Columbus (Koronbusu). In 1919 began working as an illustrator for a children's magazine. Over the next 20 years he produced a prodigious number of illustrations for both adults and children. Began making *moku-hanga* as a hobby in the late 1920s, often printing from a single block of *katsura* wood, carving progressively before each new printing stage. Contributed to *Han geijutsu* in 1932. Finding the wartime pressure to create propaganda pictures for children intolerable, he abandoned illustration and devoted himself to *hanga*. Member of Nihon Hanga Kyōkai from 1944, Ichimokukai, and Japan Children's Picture Association. Contributed to *Ichimokushū*. After the war he returned to illustration but continued to exhibit *hanga* regularly. In 1956 awarded Gold Seal as selection of the national school library. In 1967 created the self-carved, self-printed children's picture book *Shrike (Mozu)*. His prints are often of fanciful and gently humorous subjects, delicately drawn, and subtly colored.

Hattori Kōhei 服部光平

B. 1899 in Okayama prefecture. Painted in oil and watercolor in junior high school. Grad. medical school of Hokkaido University; taught there and opened a clinic. Later a physician in Tokyo. Member of the group that started *Satoporo* in 1925. Continued making expressionist woodcuts and etchings until 1957; then concentrated on pottery. Did not like to exhibit; unaffiliated with a group.

Hayami Gyoshū 速水御舟

1894–1935. B. Tokyo. Original name Makita Ryōzō. In 1914 took his mother's family name, Hayami. Studied with the Japanese-style painter Matsumoto Fūko. In 1914 founded Sekiyōkai with Imamura Shikō. Traveled to Europe and Egypt in 1930. Exhibited in Inten. Woodblock prints include *Amusement on a Pond (Chijō yūgi)*.

Hayashi Shūji　林秋路

1903–1974. B. Toyama prefecture. Painted *bijin-ga* in the 1920s. Later produced prints of customs of his native place. After his death a collection of *hanga* on the *Bon* dance entitled *Etchu Owarafū no bon* was published in 1979 by Miraisha.

Hayashi Tadaichi　林唯一

1895–1972. B. Kagawa prefecture. Studied with Matsunaga Gosaburō and Tokunaga Hitone ca. 1925. Worked as illustrator for novels and magazines for girls in the 1930s.

Hayashi Yoshio　林義雄

B. 1905 in Tokyo. Studied Japanese-style painting with Tsutaya Ryūkō. Later became an artist for children. In 1962 assisted Takei Takeo in reestablishing Japan Children's Picture Society (Nihon Dōga Kyōkai) which had been dissolved in 1941.

Hazama Inosuke　硲伊之助

1895–1977. B. Honjō district of Tokyo. Studied with Ōshita Tōjirō at school of the Japan Watercolor Society. Exhibited paintings with Fyūzankai in 1912 and Nikakai 1914–1918. Became associate member of Nikakai 1919. Studied in France 1921–1929. Made both woodblocks and lithographs in France and was particularly active in *hanga* in the early 1930s after his return to Japan. Member of Shun'yōkai, Nihon Sōsaku Hanga Kyōkai, Yōfū Hangakai, and charter member of Nihon Hanga Kyōkai. Returned to France 1933–1935 and studied with Henri Matisse. In 1935 withdrew from Nikakai and became founding member of Issuikai. In 1949 he became assistant professor in the Western-style painting division of Tokyo University of Arts. Left the university in 1950 and visited France. Later lived in Ishikawa prefecture and worked on decoration of Kutani porcelain. Served as adviser to Banga-in; in 1959 instituted a pottery section in Issuikai. Prints strongly influenced by his experience in France and his study with Matisse.

Henmi Nagisa　逸見渚

B. 1932 in Tokyo. Grad. Jōchi University. Studied with Hiratsuka Un'ichi. Exhibited with Nihon Hanga Kyōkai; associate member from 1972. Graphic designer at Lion Toothpaste Company. Worked with silkscreens as well as woodblocks. Print designs sometimes characterized by contrast of textures beneath large moons.

Henmi Takashi　逸見享

1895–1944. B. Wakayama. Grad. Tokyo Municipal Higher Crafts School. Worked as accountant. Began making *hanga* ca. 1915 after seeing posthumous exhibition of works by Tanaka Kyōkichi; both men were from Wakayama. Henmi exhibited at the first Nihon Sōsaku-Hanga Kyōkai show in 1919. Member of Nihon Sōsaku-Hanga Kyōkai and founding member of Nihon Hanga Kyōkai. Exhibited with Shun'yōkai from 1928. Contributed to *Shi to hanga*,

Kasuri, Shosō, Kaze, and *One Hundred Views of New Tokyo (Shin Tokyo hyakkei).* Very active and important amateur printmaker. Prints often depict people in landscape settings.

Hibi Matsusaburō _____

1886–1947. B. Japan; lived in California. Interned in an evacuation camp in Utah in 1942. Prints include *Departure for Evacuation Camp, A Mountain Lion,* and *Topaz in Winter—Camp in Utah,* all 1942. Signed his prints M. Hibi.

Higashiyama Kaii 東山魁夷

B. 1908 in Yokohama. Given name Shinkichi. Entered Tokyo School of Fine Arts in 1926; studied with Kobori Tomone, Kawai Gyokudō, and Matsuoka Eikyū; grad. 1931. After graduate study at Tokyo School of Fine arts, studied in Germany 1933–1935. Exhibited Japanese-style landscape paintings, including scenes on *byōbu* and *fusuma,* at Teiten, Shin Bunten, and Nitten receiving special recognition from Nitten. In 1965 appointed member of Japan Art Academy; in 1969 received Order of Cultural Merit. *Mokuhan* facsimile prints published by Kōdansha.

Higuchi Tomimaro 樋口富麻呂

1898–1981. B. Osaka. Grad. Kyoto City Specialist School of Painting. Studied with Nishiyama Suishō; also with Kitano Tsunetomi in Osaka. Exhibited paintings at Bunten, Teiten, and Inten. Made *mokuhan* covers for the satirical poetry magazine *Dai Osaka* in the 1920s. Specialized in prints of Buddhist dignitaries and people from China, Korea, and India. *Ōhara Spring,* showing a woman in traditional dress of the Ōhara region, was published by Unsōdō in 1955.

Hirafuku Hyakusui 平福百穂

1877–1933. B. Akita prefecture. Son of the painter Hirafuku Suian. Given name Teizō. Studied with Kawabata Gyokushō. Grad. 1899 from Japanese-style painting division of Tokyo School of Fine Arts. Founding member of Museikai in 1900 and Kinreisha in 1917. Exhibited paintings at Bunten and Teiten. As a young man he designed lithograph, woodblock, and mixed-media illustrations for *Heitan, Hōsun,* and the socialist newspaper *Heimin shinbun.* Published *A Tour of Fuji (Fuji isshū),* 1907, and *Travel Notes on Mountains and Sea (Sansui zuien ki),* 1914; in both, woodblock prints are mixed with other media. Also known for sketches of *sumō* wrestlers and caricatures. Designed book illustrations and covers. Later concentrated on Japanese-style painting. Appointed to Imperial Fine Art Academy in 1930. Taught at Tokyo School of Fine Arts from 1932. Also well known as *waka* poet of the Araragi School.

Hirai Baisen 平井楳仙

1889–1969. B. Kyoto. Original name Hirai Hidezō. Grad. Kyoto City School of Fine Arts and Crafts. Japanese-style painter. Exhibited at Bunten.

Hirai Hiroyuki 平井弘之

B. 1936 in Sendai, Miyagi prefecture. Exhibited with Nippankai, Ōgenkai, and Banga-in. Member of Nippankai.

Hirakata Ryōzō 平方亮三

B. 1941 in Nagasaki. Studied with Munakata Shikō. Member of Banga-in. Lives in Hakodate; active in Hokkaido print circles. Prints include a stylized depiction of waves.

Hirakawa Seizō 平川清藏

1897–1964. B. Kure, Hiroshima prefecture. Exhibited with Nihon Sōsaku-Hanga Kyōkai from 1920. Member of Nihon Sōsaku-Hanga Kyōkai from 1928 and founding member of Nihon Hanga Kyōkai. Also exhibited *hanga* at Teiten and with Shun'yōkai. Contributed to *HANGA* and *Han geijutsu*. Interested in proletarian art movement but not actually a member of Shin Hanga Shūdan or Zōkei Hanga Kyōkai. Style influenced by fauvism and surrealism. Prints often depict rural scenes, laborers, or tramps but also include urban scenes and *Young Girl Playing the Mandolin*, 1926. Sometimes used the letters "S.H." carved in the block as a signature.

Hirakawa Toshio 平川敏夫

B. 1924 in Aichi prefecture. Active as a *sumi-e* painter in Aichi. Member of Sōga-kai. *Moku-hanga* include dramatic landscapes with rocks, sea, old trees, and sometimes traditional Buddhist structures.

Hirano Hakuhō 平野白峰

1879–1957. B. Kyoto. Self-taught *ukiyo-e* style painter. Prints of *bijin-ga* were usually published by Watanabe Shōzaburō; signed Hakuhō *ga* and sealed Hirano. *Bijin-ga* include *After a Bath* and *Before the Mirror*, both 1932.

Hirata Kō 平田康

B. 1917. Grad. Women's Specialist School of Fine Arts. Exhibited with Shun'yō-kai. Member Nihon Hanga Kyōkai 1949–1960.

Hirata Yasu 平田康

See Hirata Kō.

Hirata Yorikazu 平田自一

B. 1929 in Tokyo. Grad. 1955 Kyoto City College of Fine Arts. Later taught at Kyoto City University of Arts. Exhibited at Nichidō in 1971, Hong Kong, and Paris. Also works with stencils. Among his prints are fanciful images suggestive of fairy tales.

Hiratsuka Un'ichi 平塚運一

B. 1895 in Matsue, Shimane prefecture. Grad. Matsue Commercial College. Took a short course in watercolor from Ishii Hakutei in Matsue in 1913. Encouraged by Hakutei's praise, he moved to Tokyo in 1915 and assisted Haku-tei with the business of Nikakai. Although he studied formally with Okada

Saburōsuke, Ishii Hakutei was his mentor. At Hakutei's suggestion he studied woodblock carving with the master carver Igami Bonkotsu for 10 months in 1915. Exhibited his first *moku-hanga* with Nikakai in 1916. Returned to Matsue in 1918; remained until 1920. In 1921, back in Tokyo, he began work for the magazine *Travel and Culture (Ryokō to Bungei)*. After the 1923 earthquake he learned to carve and construct frames for oil painters and in 1924 taught frame making in conjunction with Yamamoto Kanae's farmers' art movement. Member of Nihon Sōsaku-Hanga Kyōkai and founding member of Nihon Hanga Kyōkai. From 1931 served as head of the print section of Kokugakai. Created several series of prints including *Scenes of Tokyo after the Earthquake (Tokyo shinsai ato fūkei)*, 1923–1927, and *Scenes of Azuchi (Azuchi Fūkei)*, 1931, and contributed to numerous group series. In 1939 exhibited 100 pieces of his collection of old Buddhist prints at the Tokyo Folk Art Museum. Contributed to *Shi to hanga, Han, Shiro to kuro, HANGA, Dessan, Kasuri, Mura no hanga*, and *Han geijutsu*. Supervised publication of *Kitsutsuki* in 1930–1931 and later *Kitsutsuki hangashū* in 1942–1943. Highly respected as pioneer of the creative print movement and teacher of many *sōsaku-hanga* artists in short courses throughout Japan; taught extracurricular course at Tokyo School of Fine Arts 1935–1944. His early prints are principally color landscapes; later, from mid-1930s, black and white with influences from ancient Buddhist prints and early *ukiyo-e*. In 1962 moved to Washington, D.C., where he continued producing and exhibiting; works of this period include a series of 100 nudes. Used various *kanji* signatures; also, in mid-1920s, the letters "UN" carved in the block.

Hirayama Ikuo　平山郁夫

B. 1930 in Hiroshima. Grad. 1952 from Japanese-style painting department of Tokyo University of Arts. Studied with Maeda Seison. Exhibited at Inten from 1953. Became member of Saikō Nihon Bijutsuin, the sponsoring group of Inten, in 1964. Since 1958 his subjects have been taken from Buddhism. In the late 1960s he traveled to Buddhist sites in India, the Middle East, Central Asia, and China. His interpretation of Buddhist themes is strongly affected by having witnessed the atomic bomb in Hiroshima as a schoolboy.

Hirayama Rōkō　半山樓紅

B. 1915 in Tokyo. Japanese-style painter and printmaker specializing in portraits of women. Prints include *A maiko Powdering Her Face*, ca. 1950.

Hirezaki Eihō　鰭崎英朋

1881–1968. B. Tokyo. Studied *ukiyo-e* and Japanese-style painting. Cofounder of Ugōkai with Kaburagi Kiyokata in 1901. Illustrator for novels and newspapers. Specialized in pictures of *sumō* wrestlers. Contributed to *New Ukiyo-e Beauties*, 1924.

Hirezaki Hidetomo　鰭崎英朋

See Hirezaki Eihō.

Hirokawa Matsugorō　広川松五郎

1889–1952. B. Niigata prefecture. Grad. 1913 Tokyo School of Fine Arts. Active in *sōsaku-hanga* 1913–1915. Published *Kamen* as a vehicle for his own prints and those of others. Charter member of Nihon Hanga Kyōkai; withdrew in 1939. Contributed to *Shiro to kuro* 1932–1934, *Han geijutsu* in 1933, and *Shin hanga* in 1935. Judge and exhibitor of dyed textiles at Bunten and Teiten.

Hirokawa Shōgorō　広川松五郎

See Hirokawa Matsugorō.

Hironaga Takehiko　広長威彦

B. 1935 in Fukushima prefecture. Studied at technical high school attached to Nihon University. Prints include farm houses of northern Japan and other traditional buildings. Exhibited at CWAJ shows.

Hironobu　廣延（広延）

Works include *Hodogaya in Snow*, 1924, and brightly colored scenes at Ōshima published in 1930s by Nishinomiya. Sometimes used bird emblem on seal.

Hiroshima Kōho　広島晃甫

See Hiroshima Shintarō.

Hiroshima Shintarō　広島新太郎

1889–1951. B. Tokushima. Took the name Kōho after 1920. Grad. 1912 from Japanese-style painting division of Tokyo School of Fine Arts. Studied Western-style painting at the school of Hakubakai. Began making *moku-hanga* in 1914; contributed to *Kamen* and the one exhibition of the short-lived Nihon Sōsaku-Hanga Club in 1916. Member of Nihon Sōsaku-Hanga Kyōkai and Nihon Hanga Kyōkai from 1933. In later years concentrated on painting. Exhibitor and juror at Teiten and Nitten.

Hirota Shigeru　広田滋

B. 1938 in Tochigi prefecture. Grad. 1962 from architecture department of Musashino Industrial College. Studied with Sasajima Kihei and Ōhashi Hiroaki. Exhibited at Metropolitan art exhibition in 1970 and with Banga-in from 1977. Member of Banga-in. Principal subject is landscape, sometimes boldly treated as design.

Hisaizumi Kyōzō　久泉恭三

Contributed to *Hanga* in 1927. Also made single-sheet prints of fish.

Hiwasaki Takao　日和崎尊夫

See Hiwazaki Takao.

Hiwazaki Takao　日和崎尊夫

B. 1941 in Kochi City, Kochi prefecture. Grad. 1963 from Western-style painting department of Musashino College of Fine Arts. Also took a short course in *mokuhan* from Azechi Umetarō. Learned wood engraving from books and exper-

imentation. Member of Nihon Hanga Kyōkai from 1969. Showed at CWAJ, Tokyo Biennale in 1968, and Florence in 1970. Makes etchings as well as woodblocks. Prints include subjects related to cycles of time and flower motifs.

Hiyoshi Mamoru 日吉守

B. Tokyo. Grad. Tokyo School of Fine Arts. Studied with Okada Saburōsuke. Exhibited paintings with Hakubakai. Works from early 1950s include woodblocks of Korean customs published by Kyoto Hanga-in. They are signed M. Hiyoshi with a stylized seal of Mamoru.

Hodō 蒲堂

See Nishimura Hodō.

Hokuto 方久斗

See Tamamura Hokuto.

Honda Shingo 本田真吾

B. 1944 in Niigata prefecture. Attended Tama College of Fine Arts, oil painting section. Studied with Saitō Yoshishige. Exhibited prints through the 1970s with Gendai, CWAJ, and CCAC. Among his works are depictions of people with geometric shapes in a technique combining woodcut with etching.

Honda Shōtarō 本田庄太郎

1893–1939. B. Hamamatsu. Studied at the school of Taiheiyōgakai. Illustrator of children's books from about 1912.

Hori Shinji 堀進二

1890–1978. B. Tokyo. Studied sculpture at the school of Taiheiyōgakai with Shinkai Taketarō. Showed at Bunten and Teiten. Member of Taiheiyōgakai. Studied *mokuhan* and etching from ca. 1912. Contributed one print to the fifth issue of *Tsukubae* in 1915. After World War II became a trustee of Nitten.

Horie Ryōichi 堀江良一

B. 1943 in Aichi prefecture. Grad. 1966 Tokyo University of Arts. Studied *mokuhan* with Itō Ren. Exhibited with CWAJ yearly from 1973. Also exhibited at Nichidō and with Nihon Hanga Kyōkai. Member of Nihon Hanga Kyōkai from 1974. Among his prints are precise geometric straight and rounded shapes in solid or gradually graded color.

Horiuchi Masakazu 堀内正和

B. 1911 in Kyoto. Grad. Tokyo Higher Crafts School. Exhibited sculpture at Nikakai. Taught at Kyoto City College of Fine Arts making *hanga* in his spare time and after retirement.

Hoshi Jōichi 星襄一

1913–1979. B. Niigata prefecture. Grad. Tainan Normal School in Taiwan; worked as a teacher in Taiwan for 13 years. Returned to Japan after World War II and enrolled in the oil painting department of Musashino College of Fine Arts;

grad. 1956 at age 43. *Mokuhan* self-taught. First exhibited with Nihon Hanga Kyōkai in 1948; member from 1952. Also exhibited with Kokugakai and Graphic Arts Club. Represented at Tokyo Biennale in 1960, 1962, and 1964 and São Paulo in 1967. Hoshi was strongly attracted to universal elements of nature and produced elegantly carved images of stars and constellations in the 1960s. Focused on trees in his later years.

Hosokibara Seiki 細木原青起

1885–1958. B. Okayama prefecture. Studied *hanga* with Kurosaki Shūsai. Grad. Japan Art Academy (Nihon Bijutsuin). From ca. 1912 worked as illustrator of newspaper novels and ladies' magazines.

Hōtei 芳亭

Signature and seal on a print of a black bird on a cherry branch can be read Hōtei. See Chapter 7.

Ichikawa Sadao 市川禎男

B. 1921 in Tokyo. Grad. 1940 Kawabata Painting School. Active in stage design for children's theater 1939–1947. Exhibited with Nihon Hanga Kyōkai from 1951; member 1952–1973. Also made lithographs. Represented in Krakow. Recipient of Children's Culture Prize.

Ichiryūsai 一龍齋（一龍斉）

See Utagawa Kunimatsu.

Ida Shōichi 井田照一

B. 1941 in Kyoto. Grad. 1965 Kyoto City College of Fine Arts. A collage and *hanga* artist, he works with *mokuhan*, silkscreen, and lithography. Regards prints as interaction between forces for which he is the catalyst, a view reflected in series titles such as *Surface Is the Between—Between Vertical and Horizontal*. Has participated in many individual and group shows in Japan and international competitions in Ljubljana, Paris, Tokyo, and Vancouver.

Ide Gakusui 井出岳水

B. 1899 in Yamanashi prefecture. Studied Japanese-style painting with Yamanouchi Tamon and Araki Kanpo. Lived in China 1929–1946. After 1949 he concentrated on *moku-hanga*. Bird and flower prints, especially pictures of large cranes, were published by Watanabe Shōzaburō.

Idō Masao 井堂雅夫

B. 1945 in Manchuria. Studied with Yoshida Kōhō and Ōtsubo Shigechika in Kyoto. Unaffiliated with a *hanga* group. Prints include close-up details of landscapes and traditional Japanese subjects.

Igawa Etsunosuke 井川鍼之介

B. 1931 in Niigata prefecture. Began his career as a dyeing artist but shifted to oils and *mokuhan*. Exhibited with Banga-in and Modern Art Association.

Igawa Sengai 井川洗匡（崖）

1876–1961. B. Gifu prefecture. Studied with Tomioka Eisen. Illustrator for *Miyako shinbun*. Later graduated from the school of Taiheiyōgakai and became member of Taiheiyōgakai. Exhibited at Teiten. Contributed to the series *New Ukiyo-e Beauties (Shin ukiyo-e bijin shō)* ca. 1924. Used the signature Sengai.

Igawa Yasuo 井川泰雄

B. 1941 in Osaka. Grad. Osaka University of Education. Studied *mokuhan* with Gima Hiroshi. Published a series of woodcuts on Osaka scenery.

Ihara Usaburō 伊原宇三郎

1894–1976. B. Tokushima. Grad. Tokyo School of Fine Arts. Studied with Fujishima Takeji. Before World War II made woodblock illustrations for newspaper novels.

Iijima Takao 飯島孝雄

See Ai-Ō.

Iino Nobuya 飯野農夫也

B. 1913 in Ibaraki prefecture. In 1931 went to Tokyo; in 1936 entered classes sponsored by proletarian art movement. Began making woodblocks in 1937 under the guidance of Suzuki Kenji. Exhibited with Zōkei Hanga Kyōkai in 1940. In 1948 and 1964 he showed in China-Japan exchange exhibitions and in 1961 in an exhibit of Japanese prints sponsored by a Russian artists union. His prints, often in black and white, deal with landscapes and workers in rural scenes. Also wrote poetry.

Ikeda Eiji 池田永治

1889–1950. B. Kyoto. Studied wood engraving with his father, a professional. Studied at the school of Taiheiyōgakai under Nakamura Fusetsu, Ishii Hakutei, and Mitsutani Kunishirō. Exhibited oil paintings at Bunten and Teiten and Japanese-style paintings with Sangokai. Taught at the school of Taiheiyōgakai. Founding member with Okamoto Ippei of Japan Cartoon Artists Society in 1915. Early *sōsaku-hanga* artist active in Taishō period.

Ikeda Masuo 池田満寿男

B. 1934 in Fenglien, China. In 1945 returned to his mother's native place in Nagano. Went to Tokyo ca. 1952. Represented in international competitions in Tokyo 1957–1964, Venice, Krakow, Ljubljana, and Paris; solo exhibition at Museum of Modern Art in New York 1965. Works in various media; better known for etching and serigraphy than woodblock. His realistic and fantastic images effectively mix Western chiaroscuro with flat decorative pattern.

Ikeda Shōen 池田蕉園

1886–1917. B. Tokyo. Original name Sakakibara Yuriko. Studied from age 16 with Mizuno Toshikata and then with Kawai Gyokudō. In 1911 married Ikeda Terukata, also a painter. Exhibited paintings at Bunten beginning 1907; she and

her husband, in an allusion to a symbol of conjugal happiness, were called the mandarin duck painters at Bunten. Founding member of Ugōkai. Also an illustrator in a contemporary *ukiyo-e* style. Among her subjects are young women in a mixture of Japanese and Western dress. Series entitled *Young Beauties of Layered Mist*, 1906, published by Akiyama Buemon; *bijin-ga* published posthumously in the series *New Ukiyo-e Beauties (Shin ukiyo-e bijin awase)*.

Ikeda Shūzō　池田修三

B. 1922 in Kisakata-machi, Akita prefecture. Grad. 1945 Tokyo Higher Normal School. Taught in Akita 1946–1955; then worked in Tokyo as *hanga* artist. Member of Nihon Hanga Kyōkai 1958–1977, Hanga Konwakai, and Ōgenkai. Carefully employing the texture of wood, he frequently depicted stylized large-eyed women or children with birds, flowers, insects, sacred stone images, or native dolls. Sometimes signed S. Ikeda.

Ikeda Terukata　池田輝方

1883–1921. B. Tokyo. Given name Seishirō. Husband of Ikeda Shōen. Studied with Mizuno Toshikata and then with Kawai Gyokudō. Exhibited paintings at Bunten. Participated with Kaburagi Kiyokata and Yamanaka Kodō in formation of Ugōkai in 1901. Prints in contemporary *ukiyo-e* style published by Akiyama Buemon; Sino-Japanese War prints published by Fukuda Kumajirō. Posthumous print in *New Ukiyo-e Beauties*, 1924.

Ikeda Yōson　池田遙邨

1895–1988. B. Okayama City. Studied oil painting with Matsubara Sangorō and Japanese-style painting with Takeuchi Seihō. Grad. 1924 Kyoto City Specialist School of Painting; taught Japanese-style painting there 1936–1948. Exhibited with Bunten, Teiten, and Nitten. Self-portrait woodblocks in 1950s. Appointed member of Japan Art Academy in 1951.

Ikegami Shūho　池上秀畝

1874–1944. B. Nagano prefecture. Son of Shijō-style painter Ikegami Shūka. Studied with Araki Kanpo. Exhibited bird and flower paintings at Bunten. Before World War II, illustrated newspaper novels. Woodblocks of *bijin-ga*.

Ikema Eiji　池間英治

B. 1933 in Tochigi prefecture. Grad. 1957 from liberal arts division of Utsunomiya University. Taught in a junior high school in Tochigi. Studied *mokuhan* with Kawakami Sumio. Exhibited in Tochigi prefectural exhibition in 1960 and with Banga-in from 1973; member from 1978. Prints include landscapes and still lifes.

Ikezumi Kiyoshi　生悦生喜由

B. 1913 in Tokyo. Attended Tokyo School of Fine Arts, design division. Active as free-lance designer after World War II. Works include hand-colored prints representing bridges, harbors, and commercial districts in a series entitled *Shops of Japan (Nihon no mise)*.

Imai Toshi 今井俊

B. 1941 in Gunma prefecture. Stayed in Mexico and U.S. 1972–1978. Studied with Hiratsuka Un'ichi in Washington D.C. 1981–1982. From 1974 *hanga* themes taken from customs, traditions, and festivals of Oaxaca, Mexico.

Imao Keinen 今尾景年

1845–1924. B. Kyoto. Original name Imao Isaburō. Also used the *gō* Yōsōsai, Ryōji Rakukyo, Shiyū, Eikanshi. Studied *ukiyo-e* painting with Umegawa Tōkyo and other Japanese styles with Suzuki Hyakunen. Professor at Kyoto Prefectural School of Painting from 1880. Member of Art Committee of Imperial Household from 1904; member Imperial Art Academy from 1919. Important Japanese-style painter in Kyoto. Specialized in *kachō ga* with very realistic detail. Known for *Bird and Flower Albums by Keinen (Keinen Kachō Gafu)*, 1891, a set of 4 volumes with 40 *moku-hanga* in each, published by Nishimura Sōemon, carved by Tanaka Jirokichi, and printed by Miki Jinzaburō. Unsigned prints attributed to Keinen appear in a 1930s' series by various artists.

Inagaki Akemi 稲垣朱実

B. 1933 in Tokyo. Grad. 1951 Tōyō Eiwa Women's High School (Tōyō Eiwa Jogakuin). Studied *mokuhan* with Kumagai Gorō 1963–1966 and Tajima Hiroyuki from 1968. Exhibited from 1964 with Nihon Hanga Kyōkai, from 1966 with Kokugakai, and with CWAJ. Member of Kokugakai from 1978. Prints include stark depictions of elegant, simple motifs, often trees, against a light background of perhaps water or snow.

Inagaki Nenjirō 稲垣稔次郎

See Inagaki Toshijirō.

Inagaki Seimatsu 稲垣清松

Exhibited with Nihon Hanga Kyōkai 1935–1941. At that time lived in Nagoya.

Inagaki Tomoo 稲垣知雄

1902–1980. B. Tokyo. Grad. Tokyo Higher Technical School. Studied *mokuhan* under Onchi Kōshirō and Hiratsuka Un'ichi from 1923. Also studied commercial arts with Hamada Masuji. Exhibited with Nihon Sōsaku-Hanga Kyōkai beginning 1924; member of Nihon Hanga Kyōkai from 1932. Member of Kokugakai, Shun'yōkai, and Ichimokukai. Contributed to *HANGA*, *Shi to hanga*, *Ichimokushū*, and *Kitsutsuki*. After World War II he specialized in highly stylized prints of cats. Represented in international competitions including Paris, Tokyo, and Lugano biennales.

Inagaki Toshijirō 稲垣稔次郎

1902–1963. B. Kyoto. Also called Inagaki Nenjirō. Grad. 1922 Kyoto City School of Fine Arts and Crafts. Became a designer of stencil patterns for fine kimonos. Exhibited in craft divisions of Bunten and Kokugakai; member of Kokugakai from 1941. Held several positions at Kyoto City College of Fine Arts. His work as a stencil-dyed fabric designer was designated an Intangible Cultural Property

in 1962. In the 1950s he designed multicolor *hanga* which have the stylized quality of his textile designs but were printed from single woodblocks at Mikumo Mokuhansha in Kyoto.

Inano Toshitsune 稲野年恒

1859–1907. B. Kaga province. Original name Inano Takayuki. Studied in Tokyo under Tsukioka Yoshitoshi and later in Kyoto under Kōno Bairei. Moved to Osaka where he worked as an illustrator for newspapers. Teacher of Kitano Tsunetomi.

Inokuma Gen'ichirō 猪熊弦一郎

B. 1902 in Takamatsu, Kagawa prefecture. Enrolled in Tokyo School of Fine Arts in 1922. Studied with Fujishima Takeji. Member of Nihon Hanga Kyōkai 1933–1938. Went to Paris in 1938; studied with Henri Matisse and exhibited at Salon des Indépendents. Influenced by Hasegawa Kiyoshi, he began to produce lithographs in Paris. Returned to Japan in 1940. Became known as an oil painter. Lived in New York 1955–1973. Representative examples of late prints deal with relationships between squares and circles.

Inoue Hoshiko 井上星子

B. 1932 in Tokyo. Grad. 1956 Tokyo University of Science. Studied *hanga* with Ōhashi Hiroaki. Exhibited in group shows and with Banga-in from 1977; member from 1980. Prints include highly stylized depictions of young women relating to nature as in viewing a field of flowers or holding a nest with young birds.

Inoue Katsue 井上勝江

B. 1932 in Niigata prefecture. Studied oil painting with Fukuda Shinsei and *mokuhan* with Munakata Makka. Active in design of packaging and screens. Member of Banga-in from 1967. Prints include large decorative images of flowers, sometimes with children and birds, in black and white.

Inoue Toyohisa 井上豊久

B. 1914 in Kyoto. Grad. 1933 Ritsumeikan University. Studied with Tokuriki Tomikichirō. Exhibited with Kyoto Sōsaku-Hangakai in 1933, Kokugakai, and Nihon Hanga Kyōkai in 1930s. Represented in the *sōsaku-hanga* exhibitions in Paris in 1934 and U.S. in 1936. Exhibited with Kokugakai in 1937. Member of Nihon Hanga Kyōkai from 1946. Solo exhibition in 1949 and at Grenchen in 1958. Still active in 1985. Subjects include still life, large flowers, Kyoto scenes, and prints of crudely cut Buddhist sculptures. See Tsuyahisa.

Inoue Yōsuke 井上洋介

B. 1931 in Tokyo. Grad. Musashino College of Art. Works include *Landscape with Girl (Otome fūkei)*.

Inui Futoshi 乾太

B. 1939 in Tatsuno, Hyogo prefecture. Acquainted with Munakata Shikō. *Mokuhan* technique self-taught. Unaffiliated with organizations. Prints depict country landscapes and scenes from daily life.

Inuzuka Taisui 犬塚苔翠

Works include large flower prints in Western style published by Kawaguchi in 1929. On some a round seal appears beneath the signature with Inuzuka written in *hiragana*.

Ise Monsui 伊勢門水

B. 1859 in Nagoya. Original name Mizumo Uemon. Amateur painter of *nō* and *kyōgen* subjects. Published *Pictures of Kyōgen (Kyōgen ga)*, 1919, a collection of humorous sketches reproduced by woodblock.

Ishida Michihiko 石田道彦

B. 1922 in Saitama prefecture. Studied with Onchi Kōshirō. Contributed to *Ichimokushū* in 1950. Became member of Nihon Hanga Kyōkai in 1951. While working at a department store, exhibited with Nihon Hanga Kyōkai. In 1979 published a set of prints entitled *My Scenery (Watashi no fūkei)*.

Ishii Hakutei 石井柏亭

1882–1958. B. Tokyo. Given name Mankichi. Son of Japanese-style painter and lithographer Ishii Teiko. Elder brother of Ishii Tsuruzō. First studied Western-style painting with Asahi Chū; then, after Asahi Chū went to Europe, went to Europe with Nakamura Fusetsu. Beginning 1904, he studied with Fujishima Takeji at Tokyo School of Fine Arts. Before going to Paris in 1910 Hakutei was very active in *sōsaku-hanga* movement. As an editor of the magazine *Myōjō*, he was responsible for publication of Yamamoto Kanae's landmark *Fisherman* in 1904. Participated in publication of *Heitan* and served as editor for many issues of *Hōsun*, often designing woodcuts or making lithographs for the magazine. Designed 9 prints in a proposed set of *bijin-ga* entitled *Twelve Views of Tokyo (Tokyo jūnikei)*, 1910–1916, carved by Igami Bonkotsu. Hakutei self-carved and self-printed *Kiba*, depicting a famous floating lumber yard, in 1914 shortly after his return from Paris. Otherwise he depended upon professional carvers and printers. In 1917–1918 contributed 3 sets of 5 prints each to *Japan Scenery Prints (Nihon fūkei hanga)*. Became associate member of Nihon Hanga Kyōkai in 1939; by then he was a well-known painter exhibiting with Shin Bunten and a member of Imperial Art Academy. Active in forming several organizations including Japan Watercolor Society (Nihon Suisaigakai) in 1913, Nikakai in 1914, and Issuikai in 1936.

Ishii Ryōsuke　石井了助

B. 1897 in Kumamoto prefecture. Grad. 1926 Tokyo School of Fine Arts. Studied printmaking with Yamamoto Kanae. Exhibited with Nihon Sōsaku-Hanga Kyōkai 1928–1929, Shun'yōkai 1928, and Nihon Hanga Kyōkai 1931, 1933, 1934. Member of Nihon Hanga Kyōkai 1939–1960; member of Nippankai from 1960. Contributed to *Kitsutsuki* in 1930, *Toki no hito hanga* in 1933, and *One Hundred Views of New Japan (Shin Nihon hyakkei)* in 1940. Subjects include landscapes and traditional customs.

Ishii Tekisui　石井滴水

1882–1945. B. Tokyo. Worked at a rice shop. Studied with Kaburagi Kiyokata. Made *moku-hanga* illustrations from ca. 1905.

Ishii Tsuruzō　石井鶴三

1887–1973. B. Tokyo. Younger brother of Ishii Hakutei. Studied painting with Koyama Shōtarō at Fudōsha and sculpture with Katō Keiun at Tokyo School of Fine Arts; grad. 1910. Member of Shun'yōkai and Japan Watercolor Society. Became well known as sculptor and painter exhibiting at Bunten, Teiten, and Inten. Active in *sōsaku-hanga* movement throughout his career. Exhibited at first Nihon Sōsaku-Hanga Kyōkai show in 1919; member of Nihon Sōsaku-Hanga Kyōkai from 1921; founding member of Nihon Hanga Kyōkai and president for ca. 30 years beginning 1944. Cooperated with Yamamoto Kanae in children's free art movement and farmers' art movement giving a short course in sculpture at Ueda City for many years. Contributed to *Heitan, Han geijutsu, Dessan,* and *Japan Scenery Prints (Nihon fūkei hanga)*. Sometimes used letters "TU" or "TUR" carved in the blocks of early prints as signatures. He also provided woodblock illustrations for novels and newspapers including a series for *Asahi shinbun* in 1938 on a novel on Miyamoto Musashi. Appointed member of Imperial Art Academy. Professor of sculpture at Tokyo School of Fine Arts from 1944. Worked with lithograph and stencil as well as woodblock. Prints range over many subjects but usually involve people. Although sometimes carved by others, they have a characteristic direct expressiveness.

Ishikawa Bihō　石川美峰

D. 1969. Japanese-style painter. Exhibited with Bunten and Teiten. Artist of imperial household.

Ishikawa Toraji　石川寅治

1875–1964. B. Kochi. From age 17 studied with Koyama Shōtarō at Fudōsha. Participated in formation of Taiheiyōgakai in 1902. Traveled in Europe and U.S in early 1900s. Exhibited paintings at Bunten, Teiten, and the Panama-Pacific Exposition in San Francisco in 1915. In 1943 became head of the school of Taiheiyōgakai; withdrew in 1947 to become founding member of Shigenkai, a society to exhibit Western-style painting. In 1950 became an adviser to Nitten. Prints include Inland Sea landscapes in the 1930s and a set of 10 nudes in 1934.

Ishiwata Kōitsu 石渡江逸

B. 1897 in Tokyo. Given name Shōichirō. Studied design, Japanese-style painting, and fabric dyeing. Brother-in-law Igusa Senshin was one of his teachers. Established a reputation in the 1920s as fabric designer for the Nozawaya department store in Yokohama. Became interested in *hanga* through Kawase Hasui. In 1930 took the art name Kōitsu and devoted himself to prints. Published one set of prints of small-town or neighborhood genre scenes with Watanabe Shōzaburō in 1931. Other works include *Collection of Pictures of Toys (Omocha e shū)*, ca. 1935, and *Hot Spring Landscapes (Onsen fūkei)*, ca. 1940. Later works, sometimes combining woodblock and stencil, often published by Katō Junji.

Ishiwatari Kōitsu 石渡江逸

See Ishiwata Kōitsu.

Ishiwatari Shōichirō 石渡庄一郎

See Ishiwata Kōitsu.

Ishizaki Shigetoshi 石崎重利

B. Aichi prefecture. Studied with Hiratsuka Un'ichi. Exhibited with Nihon Sōsaku-Hanga Kyōkai from 1924; member of Nihon Hanga Kyōkai from 1932. Represented in the exhibition sent to U.S. in 1936. Contributed to *HANGA* in 1930, *One Hundred Views of New Japan (Shin Nihon hyakkei)* in 1940, and *Kitsutsuki hangashū* in 1942, 1943.

Ishizuka Kan 石塚＿＿＿

Contributed to a set of small actor prints published by Nigao-dō in 1915.

Isoda Mataichirō 磯田又一郎

B. 1907 in Kyoto. Grad. Kyoto City Specialist School of Painting. Studied Japanese-style painting with Kikuchi Keigetsu and Uda Tekison. Contributed to *Twelve Views of Japan (Nihon jūni fūkei)*, 1947, published by Unsōdō in Kyoto.

Isomi Teruo 磯見輝夫

B. 1941 in Kanagawa prefecture. Grad. 1973 with an advanced degree from *hanga* department of Tokyo University of Arts. Studied with Yamaguchi Kaoru, Komai Tetsurō, Higuchi Karoku. Exhibited with Nihon Hanga Kyōkai, Nichidō, and various private galleries. Member of Nihon Hanga Kyōkai from 1981. Works include very large roughly cut black and white figure compositions.

Itō Ben 伊藤勉

See Itō Ben'ō.

Itō Ben'ō 伊藤勉黄

B. 1917 in Shizuoka prefecture. Original name Itō Ben; changed in 1977. Member of group which published *Yūkari* in 1935; founding member of Shizuoka Hanga Kyōkai; member of Nihon Hanga Kyōkai from 1951 and Kokugakai. Represented at various international shows in Israel, U.S., Switzerland, and elsewhere in 1950s. For 5 years beginning in 1969 experimented with new techniques and

exhibited only in private shows. *Hanga* printed with oil pigments and sometimes employ stencils.

Itō Kazuo　伊藤一雄

B. 1939 in Hokkaido. Grad. 1964 Hokkaido University of Liberal Arts. Studied *mokuhan* with Abe Sadao from 1963. Exhibited in Hokkaido 1963–1974 and with Nippankai from 1964 and New Century Art Association from 1966. Member of Nippankai from 1970. Participated in international exhibitions in Spain, Switzerland, Italy, France, and Greece. Taught at Hokkaido University of Education for 6 years and short courses at the University of California every year 1975–1981. Prints frequently represent Hokkaido landscapes.

Itō Kennosuke　伊藤健之典

B. 1913 in Yokka-ichi, Mie prefecture. Lived in Fukuoka. Studied woodblock printing with Ujiyama Teppei. Exhibited with Zōkei Hanga Kyōkai and from 1940 with Kokugakai. Member of Nihon Hanga Kyōkai 1952–1960.

Itō Masando　伊藤真人

B. 1905 in Akita prefecture. Given name Ichirō. Grad. 1926 Akita Normal School. Studied with Yamamoto Kanae, Onchi Kōshirō, Hiratsuka Un'ichi, Nagase Yoshio, Maekawa Senpan, Ishikawa Toraji, and Ishii Tsuruzō. Member of Nihon Hanga Kyōkai from 1952. Also exhibited with Japan Watercolor Society and in solo exhibitions. Received Akita prefecture culture prize. Still exhibiting in 1982. Subjects, including landscapes, still lifes, and scenes of workers in traditional settings, often show the cold or snow of Akita.

Itō Masato　伊藤真人

See Itō Masando.

Itō Masumi　伊藤真澄

B. 1923 in Shimane prefecture. Grad. 1945 Kyoto University Medical School. Exhibited with Kokugakai and Nihon Hanga Kyōkai in 1962 and 1966. Member of Kokugakai; associate member of Nihon Hanga Kyōkai 1967–1979. Images printed over black in a technique similar to that of Ono Tadashige.

Itō Nisaburō　伊藤仁三郎

Studied at Kyoto City Specialist School of Painting. Studied with Tsuchida Bakusen. Flower prints and scenes of Kyoto, including a 5-story pagoda, published from ca. 1910 by Uchida.

Itō Ren　伊藤廉

1898–1983. B. Aichi prefecture. Grad. 1924 from Western-style painting division of Tokyo School of Fine Arts. Went to Europe shortly thereafter; returned to Japan in 1930 and joined other painters in founding Dokuritsu Bijutsu Kyōkai (Independent Fine Art Association). Later a member of Kokugakai. Professor of oil painting at Tokyo School of Fine Arts. After retirement taught at Aichi Art University and founded a *hanga* study room there.

Itō Ryōsaku 伊藤龍作

See Itō Ryūsaku.

Itō Ryūsaku 伊藤龍作

B. 1941 in Kyoto. Grad. 1964 Kyoto City College of Fine Arts. Known as Western-style painter. Member of Shun'yōkai. Exhibited *hanga* with Shun'yōkai 1976–1983 and in Italy, U.S., Korea, France, and Brazil. Works include untitled abstractions.

Itō Shinsui 伊東深水

1898–1972. B. Tokyo. Original name Itō Hajime. Started working in drawing department of a Tokyo printing company at age 12; then studied with Kaburagi Kiyokata. Well known as Japanese-style painter; exhibited at Bunten, Teiten, and Nitten. Discovered by Watanabe Shōzaburō in 1916; Watanabe and Shinsui collaborated for 25 years; Watanabe exported hundreds of Shinsui prints. Shinsui's landscape series *Eight Views of Lake Biwa (Ōmi Hakkei)*, 1917–1918, inspired Kawase Hasui, another prolific collaborator with Watanabe. Shinsui's early prints of *bijin-ga*, among his finest, include the series *Twelve Figures of New Beauties (Shin bijin jūni sugata)*, 1922–1923. After the 1923 Kantō earthquake he continued to make many prints of *bijin-ga* including 2 series of 12 prints each entitled *Collection of Modern Beauties (Gendai bijin shū)*, 1929–1931 and 1931–1936. Concurrently exhibited Japanese-style paintings and created book and magazine illustrations. Also produced several sets of landscapes of Japan including *Twelve Views of Ōshima (Ōshima jūnikei)*, 1937–1938, *Three Views of Mt. Fuji (Fuji sankei)*, 1938–1939, and prints of Indonesia where he was briefly posted during Pacific War. During bombing of Tokyo he evacuated to Komoro in Nagano prefecture which he made the setting of *Ten Views of Shinano (Shinano jikkei)*, 1948. A few Shinsui prints were also published by Isetatsu, the Yomiuri Newspaper Company, and Katsumura. In 1952 his woodblock designing skill was designated an Intangible Cultural Property and a special commemorative *moku-hanga* entitled *Tresses* was issued. Appointed to Japan Art Academy 1958; awarded Order of the Rising Sun 1970.

Itō Sōzan 伊藤総山

B. 1884. *Kachō* prints from 1909. Published by Watanabe Shōzaburō 1919–1926 with interruption due to 1923 earthquake.

Itō Takashi 伊藤孝之

B. 1894 near Hamamatsu. Studied Japanese-style painting with Kaburagi Kiyokata and at Tokyo School of Fine Arts and with Yūki Somei. Exhibited paintings at Teiten. Landscape prints, totaling ca. 50, were published by Watanabe Shōzaburō 1922–1930s. In early works he experimented with compositions printed in few colors; later prints made in full color.

Itō Takayuki 伊藤孝之

See Itō Takashi.

Itō Yasu 伊藤廉

See Itō Ren.

Itō Yoshio 伊藤弥四夫

B. 1929 in Akita prefecture. Grad. 1949 from art department of Akita Normal School. Studied with Fukita Fumiaki. Member of Modern Art Association. Combined woodblock with stencil.

Itō Yūhan 伊藤雄半

Act. 1930s. Published by Nishinomiya Yosaku. Landscape prints of Miyajima printed in soft blue tones.

Iwahashi Eien 岩橋英遠

B. 1903 in Hokkaido. Original name Iwahashi Hideto. In 1924 went to Tokyo and studied Japanese-style painting with Yamanouchi Tamon. Active in founding two Japanese-style painters associations: Shin Nihon-ga Kenkyūkai in 1934 to explore new types of Japanese painting and Rekitei Fine Arts Association in 1938. Exhibited with Inten from 1934. Professor at Tokyo University of Arts 1958–1970. Appointed member of Japan Art Academy. Prints include *Mountain* and *Golden Fan.*

Iwajima Shūichi 岩島周一

See Iwashima Shūichi.

Iwajima Tsutomu 岩島勉

Exhibited with Nihon Hanga Kyōkai 1940–1943. Contributed to *Kitsutsuki hangashū* 1942–1943. Membership in Nihon Hanga Kyōkai confirmed in 1952; withdrew in 1953.

Iwami Reika 岩見礼花

B. 1927 in Tokyo. Grad. 1955 from Sunday art program at Bunka Gakuin. Studied doll making as apprentice with Hori Ryūjo. Influenced by Onchi Kōshirō whose work she saw at Bunka Gakuin; also by various printmakers, including Shinagawa Takumi and Sekino Jun'ichirō, who conducted workshops she attended. Began exhibiting with Nihon Hanga Kyōkai in 1953; became member in 1955. In 1957 with Yoshida Chizuko, Shishido Tokuko, and others cofounded Joryū Hanga Kyōkai, an association of nine professional women printmakers. From 1964 devoted herself exclusively to printmaking; exhibited with Kokugakai, Joryū Hangakai, CWAJ, Tokyo, Bradford, Paris Biennale, and elsewhere. Prints deal with elements of nature—earth, water, fire, wind, sky—predominantly in black and white with elegant use of gold leaf, embossing, and impressions from driftwood she gathers from the beach near her home in Kanagawa prefecture.

Iwashima Shūichi 岩島周一

B. 1918 in Gifu prefecture. Studied with Mori Dōshun. Exhibited at Nitten. Member of Tōkōkai; at one time member of Banga-in. Active in art circles in Gifu prefecture.

Iwashima Tsutomu 岩島勉

See Iwajima Tsutomu.

Iwashita Hiroshi 岩下洋

B. 1917 in Tokyo. Also known as Iwashita Yō. Grad. Tama College of Fine Arts. Member of Kōfūkai and Banga-in. Taught at Tama College of Fine Arts. Exhibited with Kokugakai. Known as stencil artist but also made *moku-hanga* rich in textile patterns, folk art quality, and humor.

Iwashita Yō 岩下洋

See Iwashita Hiroshi.

Iwata Kakutarō 岩田覚太郎

B. 1902 in Aichi prefecture. Studied with Matsuoka Eikyū at Tokyo School of Fine Arts. Studied *mokuhan* with Hiratsuka Un'ichi and Maekawa Senpan. Exhibited with Nihon Hanga Kyōkai; member from 1940. Contributed to *Akebi*, 1938–1942, and to *Kitsutsuki hangashū*, 1943. In 1960 exhibited at Aichi prefectural museum with Tsukuda Masamichi, Satō Hiroshi, Suzuki Kanji, and Satō Nobuo. Still exhibiting with Nihon Hanga Kyōkai in 1981. Subjects include delicate still lifes of flowers, fruits, vegetables, and fish. Used the romanization KAKU carved in the block as a signature on early prints.

Iwata Kiyoshi いわたきよし

B. 1940 in Aichi prefecture. Self-taught printmaker. Member of Kokugakai from 1972; associate member of Nihon Hanga Kyōkai 1967–1971. Represented at Krakow, Northwest, and Grenchen. Used woodblocks with stencils and sometimes fluorescent inks to create prints with extensive intricate patterns. Since 1970 he has produced *hanga* by electronic copy machines, computer, video, and synthesizer. Also known as a poet.

Iwata Masami 岩田正巳

1893–1988. B. Niigata prefecture. Grad. from Japanese-style painting division of Tokyo School of Fine Arts. Studied with Matsuoka Eikyū. Exhibited at Teiten, Nitten, and Inten. Prints carved by Yamagishi Kazue and published by Shin Yamato-e Moku-Hanga Kankōkai. Specialized in prints of people, birds, and flowers. Used the seal Masami *hitsu*.

Iwata Sentarō 岩田専太郎

1901–1974. B. Asakusa district of Tokyo. After failure of father's business lived for awhile in Kyoto. Studied *yūzen* design and dyeing. In 1919 returned to Tokyo and studied with Itō Shinsui. Began newspaper and magazine illustrating in 1920 with work appearing in *Kuraku*, *Mainichi shinbun*, and *Shūkan asahi*. By 1930 he

was a well-known illustrator. Formed the Federation of Publishing Artists (Shuppan Bijutsuka Renmei) in 1950. Woodblocks of his works, including *bijin-ga* and dating 1930s–1970s, published by Shinbi Shoin, Takamizawa, Adachi, Katō Junji, and Watanabe Shōzaburō. Sometimes used the signature Sentarō and a red circular seal with curved line through the center.

Jacoulet, Paul

1902–1960. B. Paris. Dates given are from his tombstone, but birth is also reported as 1896. Father sent to Tokyo as a teacher; from age 4 Paul Jacoulet lived in Japan. Self-taught as an artist, he produced 166 known prints. With the exception of a few published by Katō Junji in 1934 these were self-published; carved by Yamagishi Kazue and Maeda Kentarō. Subjects include South Sea islanders, Mongolians, Manchurians, Koreans, and Ainu as well as Japanese. His decorative colorful style is a hybrid of Oriental and Occidental features.

Jikkyō　実郷

Russo-Japanese War prints published by Katsuki Yoshikatsu.

Jinbo Tomoyo　神保朋世

B. 1902 in Tokyo. Studied with Hirezaki Eihō and Itō Shinsui. Illustrator for novels and traditional stories in *Kōdan kurabu* and *Kokumin shinbun. Moku-hanga* of *bijin-ga.*

Jō　襄

Numerous long narrow vertical *kachō* prints are signed Jō or Yuzuru and attributed to Jō. From the prints it seems likely that he is a Japanese-style painter. Further identification is uncertain. (In the names Nakae Yuzuru and Takashi Yuzuru there is an extra radical in Yuzuru.) For signature and seal see Chapter 7.

Jōkata Kaiseki　定方塊石

Designed a series of 12 landscapes of Mt. Fuji ca. 1929. Carved by Kawatsura Yoshio.

Jōsatsu Hideo　常察英雄

See Tsunemi Hideo.

Kabashima Katsuichi　樺島勝一

1888–1965. B. Nagasaki prefecture. Woodblock illustrator for magazines and newspapers, especially illustrations for novels of military adventures.

Kaburagi Kiyokata　鏑木清方

1878–1973. B. Tokyo. Son of Jōno Saigiku, a noted journalist and theater critic. Studied with Tsukioka Yoshitoshi and Mizuno Toshikata. Founded Ugōkai in 1901 for *ukiyo-e* and Japanese genre painters; society dissolved in 1912. Founded Kinreisha, an organization for Japanese-style painters, in 1917. Appointed member of Imperial Art Academy in 1929. Also exhibited paintings at Bunten and Teiten. Appointed to Art Committee of Imperial Household in 1938. Began his

career ca. 1901 with illustrations for serialized novels in newspapers; established his reputation with illustrations for the Shun'yōdō edition of the immensely popular novel *Demon Gold (Konjiki yasha)*. His wife served as model for some of the scenes. Many illustrations printed by woodblock; single-sheet prints published by Satō Shōtarō in 1909. Although very successful as an illustrator, Kiyokata focused on paintings of nostalgic genre scenes after 1910. Publishers, however, continued to make *moku-hanga* from his paintings. Influential teacher and mentor of many *shin-hanga* artists including Itō Shinsui and Kawase Hasui. Received Order of Cultural Merit in 1954.

Kachiki Sadao 勝木貞夫

See Katsuki Sadao.

Kadono Seiji 角野誠治

B. Otaru in Hokkaido. Went to Tokyo in 1938. Exhibited with Nihon Hanga Kyōkai in 1938, 1940, 1942; member from 1943. Prints are principally scenes of Hokkaido.

Kadota Tsuyoshi 門田剛

B. 1924 in Ishikawa prefecture. Grad. Ishikawa Prefectural Normal School. Exhibited with Kōfūkai from 1948. Member of Nippankai and Jiyū Bijutsu Kyōkai. Cats and birds are frequent subjects of his prints.

Kadowaki Shun'ichi 門脇俊一

B. 1913 in Kagawa prefecture. Studied in Europe. Exhibited *moku-hanga* in 1963 at Nihonbashi Mitsukoshi department store.

Kagekawa Hiromichi 景川弘道

B. 1914 in Tottori prefecture. Exhibited woodblocks and wood engravings with Banga-in and at solo and international exhibitions. Member Japan Fine Art Association. Serial publications of *One Hundred Views of Europe*, 1976, and *One Hundred Views of Hokkaido*, 1978, all apparently designed by woodcut.

Kagoshima Ippei 鹿児島一平

B. 1934 in Kagoshima prefecture. Grad. 1957 Tama College of Fine Arts, oil painting section. Studied with Kubo Sadajirō. Exhibited at Southern Japan Art Exhibition in 1950, Modern Art Exhibition 1953, 1954, Blue Horse Society (Sōki-kai) 1973, and solo exhibitions. Self-published *Kagoshima Ippei's Print Collection*, perhaps hand-printed. Subjects usually taken from Japanese traditional events or imaginary festivals.

Kaiseki 塊石

See Jōkata Kaiseki.

Kaji Haruhiko 加地春彦

1920–1948. Studied with Kawakami Sumio. Exhibited with Nihon Hanga Kyōkai 1941–1947; member from 1944. Memorial exhibition of 30 works was held in conjunction with Nihon Hanga Kyōkai exhibit in 1949.

Kajita Hanko　梶田半古

1870–1917. B. Tokyo. Given name Jōjirō. Son of famous metalsmith, Masaharu. Studied with Nabeta Gyokusai and Suzuki Kason. Assisted Okakura Kakuzō in founding Japan Youth Painting Association (Nihon Seinen Kaiga Kyōkai) and Japan Academy (Nihon Bijutsuin). In 1898 was a dean in the Toyama prefectural art school in Takaoka City; then returned to Tokyo. At turn of the century he was working as a staff illustrator for *Yomiuri shinbun* and contributed many illustrations for the serialized novel *Demon Gold (Konjiki yasha)* by Ozaki Kōyō.

Kakihara Toshio　柿原俊男

B. 1895 in Sendai. Studied painting at the Aoibashi branch of the school of Hakubakai and *mokuhan* with Hiratsuka Un'ichi. Member of Nihon Hanga Kyōkai 1932–1953. Contributed to *Kitsutsuki* in 1930, *Shin Nihon hyakkei* in 1940, and *Kitsutsuki hangashū* in 1942, 1943. Sometimes used the romanized signature KAKI carved in the block.

Kakō　嘉香

Signature on a plum blossom print can be read Kakō. For signature and seal see Chapter 7.

Kamei Genbei　亀井玄兵衛

See Kamei Tōbei.

Kamei Tōbei　亀井藤兵衛

1901–1977. B. Wakayama prefecture. Given name Eiichi; used the name Kamei Tōbei until 1953 when he changed to Kamei Genbei. Studied at Kyoto City Specialist School of Painting with Kawabata Ryūshi and Yamada Kōun. Exhibited *hanga* at Teiten and Kokugakai. Founding member of Kyoto Sōsaku-Hanga Kyōkai in 1929, member of group that published *Taishū hanga*. Contributed to *Taishū hanga*, *Tsuge*, and various series of Kyoto scenes published before World War II by Uchida. Also made single-sheet prints. Among his works of this period is a multicolor depiction of a flapper relaxing with a cigarette at 9:30 A.M. —reminiscent of Utamaro's courtesans depicted at every hour. From 1937 Kamei exhibited Japanese-style painting with Seiryūsha; became associate member in 1942 and full member in 1950. Associated with Tokuriki Tomikichirō and Kotozuka Eiichi in Kōrokusha, a branch of Matsukyū, Tokuriki's publishing company which subsidized their self-carved prints. Prints also published by Uchida.

Kamisaka Sekka　神坂雪佳

1866–1942. B. Kyoto. Designer of ornaments. Woodblock albums *A Thousand Butterflies (Chō Senrui)*, 1903, and *World of Things (Momoyo-gusa)*, 1909, published by Yamada Naozō of Unsōdō in Kyoto. *Poems and Pictures (Uta-e)*, a tribute to Kōetsu, published in 1934. These are books of multicolor *moku-hanga* in a revived *rinpa* style.

Kamoshita Chōko　鴨下晁湖

1890–1967. B. Tokyo. Given name Nakao. Lived in Kyoto. Studied *yamato-e* and Japanese-style history painting with Matsumoto Fūko at Tokyo School of Fine Arts. Exhibited with Bunten and Teiten. Illustrator of old-fashioned stories and historical novels. Act. 1920s–1930s. Member of Modern Publishing Artists Federation. Woodblock prints include *Maiko*, 1933, and other *bijin-ga* published by Takamizawa. Contributed to *New Ukiyo-e Beauties*, 1924.

Kan Kan'ya　潅観也

B. 1923 in Toyama prefecture. Grad. Komazawa University. Exhibited with Nihon Hanga Kyōkai, Banga-in, Kokugakai, and in solo exhibitions. At one time a member of Modern Art Association and Banga-in.

Kanamori Kan'yō　金森観陽

1882–1931. B. Toyama prefecture. Studied with Otake Etsudō. Exhibited with Bunten. Illustrator of novels in 1920s.

Kanamori Yoshio　金守世志夫

B. 1922 in Toyama prefecture. Studied *mokuhan* from Nagase Yoshio's book *To People Who Want to Make Prints (Hanga o tsukuru hito e)* and then with Munakata Shikō, who evacuated to Toyama in 1945 and lived there until 1951. First exhibited with Kokugakai in 1950. In 1950 with Munakata Shikō and others founded *Etchū hanga*. Exhibited in 15 U.S. museums with Munakata in 1958. Member of Banga-in, Kokugakai, and Nihon Hanga Kyōkai. Among his prints are numerous simplified landscapes in which fanciful objects such as feathers, flowers, butterflies, or knights on horseback float over mountains and lakes.

Kanashima Keika　金島桂華

1892–1974. B. Hiroshima prefecture; worked in Kyoto. Studied with Takeuchi Seihō from 1911. Exhibited Japanese-style paintings in Bunten, Teiten, Shin Bunten, and Nitten. Noted for animal paintings. Appointed member of Japan Art Academy in 1959. Works include bird and flower prints.

Kaneko Seiji　金子誠治

B. 1914 in Hokkaido. Studied with Narita Gyokusen. Exhibited with Nihon Hanga Kyōkai in 1937 and Zōkei Hanga Kyōkai in 1940. Member of Otaru Print Association.

Kanō Kōga　狩野光雅

1897–1953. B. Wakayama prefecture. Given name Mitsumasa. Grad. 1919 Tokyo School of Fine Arts. Student of Matsuoka Eikyū. Exhibited in Teiten. Prints carved by Yamagishi Kazue and published by Shin Yamato-e Moku-Hanga Kankōkai.

Kanō Mitsumasa　狩野光雅

See Kanō Kōga.

Kanō Tomonobu 狩野友信

1843–1912. B. Edo. Used the *gō* Isseisai and Shunsen. Son of Kanō Nakanobu, eighth-generation head of Hamachō Kanō line. After the early death of his father he studied with Kanō Shōsen'in of the Kobikichō Kanō; after Meiji Restoration, studied with Charles Wirgman and at Foreign Literature Investigating Office. Became assistant professor at Tokyo School of Fine Arts in 1888. Prints made by artisans from his late Kanō-style paintings.

Kanō Tsuguyasu 加納告保

B. 1928 in Hyōgo prefecture. Given name Tamotsu. Grad. Tottori Normal School. Studied with Munakata Shikō. Member of Modern Art Association; associate member of Nihon Hanga Kyōkai from 1970. Exhibited with Banga-in and Nihon Hanga Kyōkai. Art teacher at junior high school in Tottori.

Kanokogi Takeshirō 鹿子木孟郎

1874–1941. B. Okayama prefecture. Studied with Matsubara Sangorō and Koyama Shōtarō. After a sojourn in France returned to Kyoto and participated with Asai Chū in establishing Kansai Academy of Fine Arts (Kansai Bijutsuin). Contributed to *Heitan* and published the *manga* magazine *Hi Bijutsu Gahō* (Non-Art News) for 3 issues.

Kan'yō 観陽

See Kanamori Kan'yō.

Karhu, Clifton

B. 1927 Minnesota of non-Japanese heritage. Grad. 1952 Minneapolis School of Art. Lived in Japan much of his adult life. Active as painter in oils, watercolor, and *sumi* before taking up *mokuhan* in early 1960s. Member of Nihon Hanga Kyōkai. Also exhibited in solo *hanga* exhibitions from 1964. *Karhu Print Collection (Karhu hangashū)* published by Unsōdō in 1975. Prints often depict scenes of typically Japanese buildings with strong pattern and color. Although his orientation is traditional, he has mastered the arts of carving and printing rather than relying completely on artisans as *ukiyo-e* artists did.

Kasamatsu Kazuo 笠松一夫

B. 1906. Attended Tokyo School of Fine Arts. Taught elementary school. Illustrator of magazines and newspapers. Self-taught printmaker. Exhibited with Nihon Hanga Kyōkai intermittently 1927–1946; member 1943–1953. Exhibited at Teiten.

Kasamatsu Mihoko 笠松三保子

B. 1932. Rural and seaside scenes and colorful landscapes. Signed Mihoko.

Kasamatsu Shirō 笠松紫浪

B. 1898 in Tokyo. Given name Shirō (with different characters). Studied Japanese-style painting with Kaburagi Kiyokata. Exhibited paintings in Bunten, Teiten, Tatsumi Gakai, and Kyōdokai. Member of Seikinkai. Encouraged by

Kaburagi Kiyokata he began designing woodblock prints for Watanabe Shōza-burō in 1919. Published many prints with Watanabe in 1930s and *Eight Views of Tokyo* and bird and animal prints with Unsōdō in 1950s. In later years carved and printed many of his own blocks but did not promote his prints through affiliations and exhibitions.

Kasen 華泉
See Ōhira Kasen.

Kashiwagi Sumiko 柏木澄子
Exhibited with Nihon Hanga Kyōkai and CWAJ in 1960s. Prints signed Sumiko.

Katano Setsuko 片野節子
B. 1940 in Saitama prefecture. Grad. 1965 Bunka Gakuin. Member of Banga-in. Exhibited at Ban'inten, Kanagawa Hanga Andepandanten, Beijing, and Nanjing. Subjects taken from nature.

Kataoka Tamako 片岡珠子
B. 1905 in Sapporo. Grad. 1926 Women's Specialist School of Fine Arts. Studied with Yasuda Yukihiko. Trustee of Inten. Japanese-style painter specializing in *bijin-ga*. Awarded Order of Cultural Merit in 1989.

Katatani Mika 片谷美香
B. 1918 in Kanagawa prefecture. Grad. Women's Specialist School of Fine Arts. Studied oil painting with Fukuzawa Ichirō and *mokuhan* with Tajima Hiroyuki. Member of Women's Painting Society. Exhibited with Women's Print Association in 1963, Nichidō in 1970, Nihon Hanga Kyōkai in late 1960s, and in many solo exhibitions. Spatial relations and relations within patterns of small circles are among the themes of her prints.

Katō Chōichi 加藤長一
B. 1917 in Tokyo. Studied at Kawabata Painting School. Grad. 1941 Tokyo School of Fine Arts. Studied with Fujishima Takeji. Member of Hakuhōkai (White Phoenix Society). Exhibited with Nihon Hanga Kyōkai from 1940; member from 1944.

Katō Eizō 加藤栄三
1906–1972. B. Gifu. Grad. 1931 Tokyo School of Fine Arts. Studied with Yūki Somei. Japanese-style painter. Exhibited prints at Shin Bunten. In 1959 appointed member of Japan Art Academy.

Katō Masao 加藤まさを
1897–1977. B. Shizuoka prefecture. Studied at Rikkyō University. Woodblock illustrations in 1920s and 1930s including 12 front covers for *Nursery Rhymes—Small Musical Pieces (Dōyō Shōkyoku)*, 1930.

Katō Shinmei 加藤晨明

B. 1910 in Nagoya. Given name Kiyoshi; also known as Katō Shunmei. Studied with Watanabe Kishun and from age 25 with Nakamura Gakuryō. Painter of traditional and modern beauties. Exhibited from ca. 1938 in Teiten and Nitten. *Moku-hanga* of *bijin-ga* and flowers published from late 1940s to ca. 1958 by Takamizawa. *Maiko* published by Kōdansha.

Katō Shunmei 加藤晨明

See Katō Shinmei.

Katō Tadashi 加藤正

B. 1926. Represented at Tokyo International Biennale. Member of Nihon Hanga Kyōkai 1962–1970. Lecturer at Tokyo College of Art and Design.

Katō Takeo 加藤武夫

B. 1930 in Aomori City. Studied with Satō Yonejirō. Founding member of Aomori Print Association in 1955; active in publication of *Aomori hanga*. Exhibited with Nihon Hanga Kyōkai from 1951 and Banga-in from 1955. Member of Banga-in from 1969. Personally produced 2 volumes of hand-printed *moku-hanga* of scenes of Aomori in 1973.

Katō Tarō 加藤太郎

1915–1945. B. Tokyo. Grad. 1938 Tokyo School of Fine Arts; participated in first *mokuhan* class taught by Hiratsuka Un'ichi. Studied oil painting with Kobayashi Mango. Exhibited with Nihon Hanga Kyōkai in 1937 and 1938; member from 1944. Contributed to *Ichimokushū*. Worked with Onchi Kōshirō, Sekino Jun'ichirō, Yamaguchi Gen, and Sugihara Masami on the limited edition *moku-hanga* book, *Natural History Notes (Hakubutsufu)*. Drafted into World War II and died of tuberculosis as an indirect casualty. Honored by Nihon Hanga Kyōkai with a special posthumous exhibition in 1946.

Katō Tetsunosuke 加藤哲之助

Exhibited with Nihon Hanga Kyōkai intermittently 1933–1940. Works include *Fifteen Pictures of Sapporo (Sapporo jūgo zu)*, 1935. Contributed to *Satoporo*.

Katō Yasu 加藤八州

B. 1907 in Tokyo. Grad. 1929 Kyoto College of Crafts and Textiles. Illustrator of children's books. Studied printmaking with Hiratsuka Un'ichi. Also influenced by Onchi Kōshirō and Kawanishi Hide. Exhibited with Kokugakai from 1943. Member of Nihon Hanga Kyōkai from 1947. Many solo exhibitions in Japan and abroad including a show of 120 Japanese fish in 1965 in Osaka. Prints often depict scenes influenced by European travels.

Katsuhira Tokushi 勝平得之

1904–1971. B. Akita. Family members were farmers and papermakers. A carver of dolls before taking a short course in woodcarving under auspices of farmers' art movement in 1928. Otherwise self-taught and in his early years had never

seen an artist at work. Exhibited with Nihon Sōsaku-Hanga Kyōkai in 1928 and 1929; member of Nihon Hanga Kyōkai 1932–1960 and Nippankai from 1960. Also exhibited with Kōfūkai, Kokugakai, Shun'yōkai, and Shin Bunten and Nitten. Contributed to *Han geijutsu* in 1933. Prints deal with festivals and customs of Akita. Works also include the limited edition book, *Story of a Buckeye*, with 52 prints and *Eight Views of Senshū Park*, 1933–1935. Awarded Akita Prefecture Culture Prize in 1951. Frequently signed prints with the first character of his given name carved in the block.

Katsuhira Tokuyuki 勝平得之
See Katsuhira Tokushi.

Katsui Mitsuo 勝井三雄
B. 1931 in Tokyo. Grad. 1955 from art department of Tokyo University of Education; studied photography and design in postgraduate course there. Studied printmaking with Takahashi Masato and Murai Masanari. Worked at Ajinomoto company. From 1961 active as graphic designer but also made individual prints, principally serigraphs of geometric linear designs. In 1979 the Riccar Museum arranged to have 6 of his designs executed by Adachi Woodblock Institute; these were exhibited at the Riccar.

Katsuki Sadao 勝木貞夫
1910–1935. B. Tokyo. With Itō Shigeo and others founded *Bakuchiku* in 1929. Worked as farmer; active in proletarian art movement. Member of a caricature artists' group. Sometimes signed his prints KATU carved in the block. Died after a fall from a theater construction site.

Katsuki Yasuo 香月泰夫
See Kazuki Yasuo.

Kawabata Gyokushō 川端玉章
1842–1914. B. Kyoto. Family of lacquer artists. Given name Takinosuke. Studied Shijō-style painting with Nakajima Raishō; then studied Western-style painting briefly with Charles Wirgman but returned to working in the Japanese tradition. Became professor of Shijō-style painting at Tokyo School of Fine Arts. Later opened the Kawabata Painting School, a preparatory school for students seeking admission to Tokyo School of Fine Arts. Posthumous *moku-hanga* may have been made from his works as late as the 1930s.

Kawabata Ryūshi 川端龍子
1885–1966. B. Wakayama. Given name Shōtarō. Studied at schools of Hakubakai and Taiheiyōgakai. Painted in the Western manner until 1912 when he took up Japanese-style painting after seeing collection of traditional Japanese works at the Museum of Fine Arts, Boston. Worked with Yamamoto Kanae in 1917 at Seiwadō, the printing company of Kanae's late teacher. His prints of that period were colorful in a flat, decorative style and included mechanically printed woodblock illustrations for newspapers and children's stories. Member of

Museikai and Saikō Nihon Bijutsuin until 1928; founding member of Sangokai. In 1929 became founding member of Seiryūsha, an independent organization to promote Japanese-style painting. Awarded Asahi Culture Prize in 1930 and Order of Cultural Merit in 1959. Blocks for his prints reportedly were carved by Fukazawa Sakuichi.

Kawabata Yanosuke　川端弥之助

1893–1981. B. Kyoto. Grad. Keiō University. Studied in Paris 1922–1925 under Charles Guerin. Member of Kyoto Sōsaku-Hanga Kyōkai and Shun'yōkai. Taught at Kyoto City School of Fine Arts and Crafts. Essentially an oil painter who occasionally made *moku-hanga*.

Kawachi Mieko　河内美栄子

B. 1947 in Gunma prefecture. Grad. 1971 Sōkei Art School. Studied 4 years with Yoshida Hodaka and Matsumoto Akira. Exhibited with Nihon Hanga Kyōkai from 1967, CWAJ from 1968, Nichidō, and in solo and group shows. Represented at Grenchen. Member of Nihon Hanga Kyōkai from 1978. Her crisply executed prints often depict carefully placed people or flowers accentuated by negative space.

Kawachi Seikō　河内成幸

See Kawachi Shigeyuki.

Kawachi Shigeyuki　河内成幸

B. 1948 in Yamanashi prefecture. Grad. from oil painting department of Tama College of Fine Arts. Exhibited with Nihon Hanga Kyōkai and Nichidō 1976, Grenchen 1979, and Norwegian Biennale 1982. Member of Nihon Hanga Kyōkai from 1976. In prints of the 1970s black and red predominate, reflecting forces and tensions in urban life through pulleys, levers, and other symbolic structures. *Highway II*, 1978, representative of this decade, shows a wooden bench incongruously situated in the middle of a highway which stretches beneath a pedestrian overpass into infinity.

Kawachi Yūko　河内ゆう子

B. 1930 in Toyama prefecture. Studied with Munakata Shikō and Kanamori Yoshio. Member of Banga-in; active in Banga-in activities in the Hokuriku region. Also exhibits with Kokugakai and in solo shows. Prints of traditional subjects have a *mingei* flavor reminiscent of Mori Yoshitoshi.

Kawada Shigeo　川田重男

B. 1941 in Tokyo. Grad. 1959 from metal craft department of Kyoto City Fushimi High School. Exhibited with Nihon Hanga Kyōkai from 1968, Nichidō in 1970, Krakow in 1972, and in several solo shows. Member of Nihon Hanga Kyōkai from 1973. Makes silkscreen, mimeograph, and metal-plate prints as well as woodcuts. Among his *moku-hanga* are landscape prints with train coaches in the background.

Kawahara Hideo　河原英雄

B. 1911 in Hyōgo prefecture. Studied with Hagiwara Hideo. Exhibited with Kokugakai from 1951, Nihon Hanga Kyōkai from 1956, CWAJ in 1965, and represented at Northwest in 1962. Member of Nihon Hanga Kyōkai from 1963. Image of a gull is a recurring motif used with varying techniques and emphases, sometimes realistically, sometimes in elegant abstract patterns. Known chiefly for lithographs but has also made *moku-hanga*.

Kawai Gyokudō　川合玉堂

1873–1957. B. Aichi prefecture. Given name Yoshisaburō; also used the *gō* Gyokushū early in his career. Studied with Mochizuki Gyokusen and Kōno Bairei in Kyoto and with Hashimoto Gahō in Tokyo. Exhibited Japanese-style paintings at Bunten and Teiten. Member of Imperial Fine Art Academy and Art Committee of the Imperial Household. Professor at Tokyo School of Fine Arts. Received Order of Cultural Merit in 1940.

Kawai Kenji　河合健二

B. 1908 in Kyoto. Grad. 1928 Kyoto City Specialist School of Painting. Studied with Nishimura Goun. Exhibited Japanese-style painting at Nitten. Works include contribution to *Twelve Views of Kyoto (Kyoto jūni fūkei)* published by Unsōdō in 1948 and *Lake Biwa in Four Seasons (Shiki Ōmi ko)*.

Kawai Unosuke　河合卯之助

1889–1968. B. Kyoto. Grad. 1908 Kyoto City School of Fine Arts and Crafts; grad. 1911 Kyoto City Specialist School of Painting. Studied Japanese-style painting under his uncle Kawai Shūsai and Takeuchi Seihō. Created designs for Nishijin weavers. Began producing *moku-hanga* and etchings ca. 1912. In 1916 published a self-carved *moku-hanga* collection entitled *Iraho*. In 1926 published *Kawai Unosuke Ceramic Collection (Kawai Unosuke tōga shū) by mokuhan* and lithograph. Active in *sosaku-hanga* exhibitions in the early 1920s. Founding member of Kyoto Sōsaku-Hanga Kyōkai in 1929; member of Nihon Hanga Kyōkai 1931–1933. Contributed to *Shi to hanga*. Later became a ceramic artist. His softly colored prints ca. 1914 clearly reflect use of the round chisel then popular with *sōsaku-hanga* artists.

Kawakami Boshirō　川上暮四郎

See Kawakami Kureshirō.

Kawakami Kureshirō　川上暮四郎

B. 1901 in Tokyo. Grad. 1923 from school of Taiheiyōgakai. Studied with Fukamizu Shōsaku and Akiyama Iwao. Act. late 1950s–1973. Rather roughly cut prints include depictions of farm women in traditional costumes of Ōhara.

Kawakami Sumio　川上澄生

1895–1972. B. Yokohama. Grad. 1916 Aoyama Gakuin High School. Self-taught as an artist—encouraged by observing in workshop of Gōda Kiyoshi (1862–1938) who had studied wood engraving in Europe and practiced the technique in

Japan. Lived in Canada, western U.S., and Alaska in 1917–1918. An early print was shown in second Nihon Sōsaku-Hanga Kyōkai exhibition in 1920. In 1921 became instructor of English in Tochigi Prefectural Utsunomiya Middle School where he remained until 1942. Printmaking activity began in earnest in 1923 as he strove to preserve his memories of the Meiji heritage largely destroyed in the great Kantō earthquake. He collected old objects and old foreign books, especially those used to teach English to the Japanese, and filled his prints with nostalgic renditions of exotic foreign objects remembered from childhood. Exhibited with Kokuga Sōsaku Kyōkai in 1924; became member in 1925. Became member of Nihon Sōsaku-Hanga Kyōkai in 1929; founding member of Nihon Hanga Kyōkai. Exhibited *hanga* with Shun'yōkai and Kokugakai in 1930s. Contributed to *Shi to hanga, Dessan, HANGA, Kaze, Han geijutsu, Kasuri, Mura no hanga, Shiro to kuro,* and *Kitsutsuki.* In addition to many single-sheet prints he produced a total of 33 limited edition books by *mokuhan* including *Blue Beard (Aohige),* 1927, *English Alphabet (Egeresu iroha),* 1929, *Picture Cards (Toranpu-e),* 1939, *Lamp,* 1940–1941, *Southern Barbarian Ship Diary (Nanban Senki),* 1942, *Slide (Gentō),* 1943, *Careless Bride, (Heppiri Yomego),* 1944, *Squash Princess (Urihime),* 1945–1947, *Children's Silver Cards (Ginmenko),* 1950–1952, and *Great Cherry Blossoms (Taiju Zakura),* 1958–1972. Many of these were hand-printed as well as self-carved. He and his wife evacuated to Hokkaido in 1945 and remained until 1949. Awarded Tochigi prefecture prize for his contribution to culture in 1949. Began to win general recognition in 1960s after Japan Folk Art Society exhibited 200 of his works in 1958. A large memorial retrospective was held at Tochigi Prefectural Art Museum in 1974; another exhibition at the Riccar Art Museum in 1974 or early 1975. *Nanbanesque Behavior,* 1945, depicting a courtesan and a foreigner smoking long pipes while reclining on a brass bed, is typical of his imaginative and often humorous romantic images of the impact of foreigners on Japan. This, like many of his late works, was printed with a single block in black and colored by hand.

Kawakita Kahō 川北霞峰

1875–1940. B. Kyoto. Studied with Kōno Bairei and later with Kikuchi Hōbun. Exhibited Japanese-style paintings at Bunten. Often painted scenes of Japanese legends.

Kawame Teizō 河目悌三

1889–1958. B. Aichi prefecture. Grad. Tokyo School of Fine Arts. From ca. 1925 worked as children's illustrator frequently using woodblock.

Kawamura Kiyoshi 河村清

B. 1915 in Shimonoseki, Yamaguchi prefecture. Studied Western-style painting with Kumagai Morikazu at the school of Nikakai. Studied woodblock printing with Takada Kazuo. Exhibited with Nihon Hanga Kyōkai 1953–1963 and Banga-in from 1955. Member of Banga-in. Subjects include European or American cityscapes.

Kawanishi Hide 川西英

1894–1965. B. Kobe. Given name Hideo. Father of Kawanishi Yūzaburō. First inspired to make prints by Yamamoto Kanae's *Small Bay of Brittany* which he saw in a shop window. Grad. 1915 from Kobe business school. Worked as postmaster in a small branch office in his home so that he would have time to make prints. Exhibited with Nihon Sōsaku-Hanga Kyōkai from 1923, with Kokugakai from 1931, and at yearly solo exhibitions. Became member of Nihon Hanga Kyōkai in 1932 and Kokugakai in 1935. Represented in Lugano in 1956. Contributed to *Han, Han geijutsu, Taishū hanga, HANGA, Kasuri,* and *Kitsutsuki*. His prints, usually executed in large areas of strong color and without lines, relate to life in Kobe. Among his works are *Twelve Customs of Shōwa Beauties (Shōwa bijin fūzoku jūnitai)*, 1929, published by Sawada Ishirō, *Kobe Scenes in the Twelve Months (Kobe jūnikagetsu fūkei)*, 1931, *Scenery of Kobe (Kobe fūbutsu)*, 1933–1935, *One Hundred Kobe Prints (Hanga Kobe hyakkei)*, 1935, an invaluable record of the city's architecture and flavor at that time, *Scenes from a Port Town*, 1941 (10 prints), and *One Hundred Views of Kobe (Kobe hyakkei)*, 1962. Awarded Hyōgo Prefecture Culture Prize in 1949 and *Kobe shinbun* Peace Prize in 1962.

Kawanishi Yūzaburō 川西祐三郎

B. 1923 in Kobe. Son of Kawanishi Hide. Grad. 1947 from economics department of Kansai Gakuin. Exhibited with Nihon Hanga Kyōkai from 1942; member from 1943. Exhibited with Kokugakai from 1943; member from 1971. Exhibited *moku-hanga* at Shin Bunten in 1942. Represented in international competitions including Pistoia 1968. Works include *Eight Views of Osaka (Osaka hakkei)*, 1971, and several series on European cities. His colorful, decorative prints are similar in style to those of Kawanishi Hide but more cosmopolitan.

Kawano Kaoru 河野薫

1916–1965. B. Otaru in Hokkaido. Studied at Kawabata Art School. Exhibited with Nihon Hanga Kyōkai in 1944, but soon taken prisoner of war in Siberia. Resumed exhibiting with Nihon Hanga Kyōkai in 1949; member from 1954. Resumed exhibiting with Kokugakai in 1952; member from 1961. Moved to Tokyo in 1958. Participated in international competitions and solo exhibitions in Tokyo, New York, Seattle, Chicago, and elsewhere. Works include many highly textured abstract representations of children.

Kawara Kanji 河原侃二

B. 1897 in Hyōgo prefecture. Studied *hanga* with Maekawa Senpan. Worked at various jobs related to theater and cinema. Made *moku-hanga* casually from early 1930s and seriously during war years. Member of Nihon Hanga Kyōkai 1954–1973.

Kawarazaki Shōdō 河原崎奨堂

1889–1973. Flower prints published by Unsōdō include *Peony, Hydrangea,* and *Chrysanthemum*, ca. 1955. These are unsigned but sealed with the *kanji* Shōdō reading from right to left.

Kawasaki Kyosen　川崎巨泉

Lived in Osaka. Japanese-style painter. Designed *Collection of Pictures of Tumblers (Okiagari-koboshi gashū)*, 1925, and *Collection of Crests (Dozoku monyō shū)*, 1931, published by Kido Tatsudō. Contributed to *HANGA* in 1924.

Kawase Hasui　川瀬巴水

1883–1957. B. Tokyo. Given name Bunjirō. Studied as a boy with Aoyagi Bokusen and Araki Kan'yū and as an adult with Okada Saburōsuke and Kaburagi Kiyokata. Exhibited Japanese-style paintings with Ugōkai and Kyōdokai. Inspired by Itō Shinsui's *Eight Views of Lake Biwa*, which he saw at a Kyōdokai exhibition. Sought affiliation with Watanabe Shōzaburō by preparing sketches for prints resulting in initial prints of 4 scenes of Shiobara Hot Springs in 1918 and ultimately a lifetime of collaboration. Watanabe published over 100 prints designed by Hasui between 1918 and the 1923 earthquake, among them 2 series entitled *Souvenirs of Travel (Tabi miyage)*, 1919 and 1923, and *Twelve Tokyo Subjects (Tokyo jūni dai)*, 1919. During this period Hasui was also commissioned to design 8 prints of the villa and garden of Baron Iwasaki Koyata; the prints were used as souvenirs for the baron's guests. The blocks for all of these were lost in the fires following the 1923 earthquake. Hasui went on to design a total of ca. 416 landscapes working up to the time of his death. Most were published by Watanabe Shōzaburō. Kawase also worked with other publishers including Kawaguchi in 1929, Doi Teikichi in 1931, Iida in 1932, and Shiota Takezō in 1935. In 1953 the Committee for Preservation of Intangible Cultural Treasures, in recognition of the collaborative techniques involved in producing *shin-hanga*, commissioned Hasui to create a new print entitled *Snow at Zōjōji Temple* with assistance from artisans. The process was carefully documented by Narazaki Muneshige. Hasui was named a Living National Treasure in 1956. Various seals used before the earthquake; usually a small red circular seal with three teardrop strokes afterward.

Kawashima Riichirō　川島理一郎

1886–1971. B. Tochigi prefecture. Went to U.S. in 1905; grad. 1910 Corcoran Art School. Studied in Paris, beginning in 1911 at Academie Julian and Academie Colarossi. Exhibited at Salon d'Automne and Salon des Indépendents. Revisited U.S. in 1915. Back in Japan in 1919 he was active as a watercolorist and in establishing a Western-style painting division in Kokugakai. Influenced by Matisse, Dufy, and Friesz. Member of Japan Art Academy. Professor at Women's Specialist School of Fine Arts. Woodcut illustrations before World War II.

Kayama Kotori　香山小鳥

1891–1912. B. Nagano prefecture. Made *moku-hanga* from ca. 1907. Moved to Tokyo where he added poetry writing to his enthusiasm for *moku-hanga*. Became close friend of Tanaka Kyōkichi. One self-carved landscape print was posthumously published in the sixth issue of *Tsukubae* in 1915 with a note of recommendation from Tanaka Kyōkichi. Same print was also shown posthumously in the

first Nihon Sōsaku-Hanga Kyōkai exhibit in 1919 through recommendation of Onchi Kōshirō.

Kayama Saburō 加山三郎

1898–1956. B. Kanagawa prefecture. Grad. technical school. Contributed to *Shiro to kuro* and exhibited with Nihon Sōsaku-Hanga Kyōkai in 1929 and Nihon Hanga Kyōkai in 1931. Worked for a shipbuilding company and later managed a construction company. A 1932 print representing a nude woman reclining on a brass bed is completely Western in style.

Kazuki Yasuo 香月泰男

1911–1974. B. Yamaguchi prefecture. Studied at Kawabata Painting School. Grad. 1936 Tokyo School of Fine Arts; studied with Fujishima Takeji. Exhibited oil paintings with Kokugakai while working as teacher. Drafted into army in 1943; interned in Siberia until 1947. Member of Kokugakai 1940–1962. From 1955 made lithographs and metal-plate prints as well as *moku-hanga*. Published a *moku-hanga* collection entitled *Nice* in 1974.

Keigetsu 契月

See Kikuchi Keigetsu.

Keigetsu 桂月

See Matsubayashi Keigetsu.

Keinen 景年

See Imao Keinen.

Keith, Elizabeth

1887–1956. B. England. Traveled to Tokyo in 1915 to visit a relative. Intrigued with the Orient, she remained until 1924, making several trips to Korea, China, Philippines, and throughout Japan. First won recognition with a collection of caricatures of Japanese and foreign residents published in 1917 to benefit the Red Cross. In 1920 Watanabe Shōzaburō saw an exhibition of watercolors from a recent trip to Korea and urged her to translate the painting *East Gate, Seoul by Moonlight* into a print. This and other prints made under Watanabe's supervision were highly successful in Japan, at the Royal Academy and Beaux Arts Gallery in London, and in Paris. Keith took up color etching in 1926 or 1927 after these exhibitions. Back in Japan from 1931 until the late 1930s, studied carving and printing for 2 months with Yoshida Hiroshi and produced four prints, among them two Philippine subjects and *Japanese Carpenter*. Later she apparently reinstituted her working relationship with Watanabe. A solo show in Tokyo in 1956 included 59 woodblock prints and 8 color etchings. Lived in England in her late years. Fellow of Royal Society of Arts. Books of illustrated travel accounts include *Eastern Windows*, 1928, and *Old Korea*.

Kida Yasuhiko _____

B. 1944 in Kyoto. Studied at Kyoto City College of Fine Arts. Influenced by Munakata Shikō. Exhibited in CWAJ shows. Prints are usually black and white and show people in daily activities, folk festivals, or night spots with humor and deliberate naivete.

Kidokoro Shō 城所祥

1934–1988. B. Hachiōji section of Tokyo. Grad. 1957 from commerce department of Waseda University. Had no formal art training but learned to use wood tools from his father, a furniture maker. Exhibited with Nihon Hanga Kyōkai and Modern Art Association from 1958. Member of Nihon Hanga Kyōkai from 1960. Participated in international biennales including Tokyo, Paris, São Paulo, and Northwest. Taught at Musashino College of Fine Arts, Musashino Technical School, and at yearly workshops at Kanazawa College of Fine Arts. From 1961–1965 he used only one block for each print, progressively cutting and printing; abandoned that method in 1967. Practiced wood engraving and published two books of wood engravings, *Revelation (Mokuji)*, 1968, and *Birds (Tori)*, 1971. In 1973 made prints of the flora of Hachiōji for 60 sliding doors of Kifukuji, a new Shingon temple in Nakano. Joined Nomi no Kai, a group for wood engraving artists, in 1977. Traveled in Europe 1977–1978. Prints are frequently still lifes with apples or other subjects from daily life.

Kidokoro Yoshimi 城所祥

See Kidokoro Shō.

Kikuchi Chūtarō 菊地鋳太郎

1859–1944. B. Edo. Studied with Kunisawa Shinkurō. Grad. 1882 from Kōbu Bijutsu Gakkō, the Meiji government's technical art school. In 1895 served as juror for Meiji Fine Arts Society. Member of Hakubakai from 1896.

Kikuchi Hōbun 菊地芳文

1862–1918. B. Osaka. Adopted into Kikuchi family; given name Tsunejirō. Studied with Kōno Bairei. Taught at Kyoto City School of Fine Arts and Crafts. Leading Kyoto painter of landscapes and *kachō*. Exhibited at Bunten and Teiten. Bird and flower prints.

Kikuchi Keigetsu 菊地契月

1879–1955. B. Nagano prefecture. Original name Kikuchi Kanji. Studied *nanga* painting with Utsumi Kichidō and Shijō painting with Kikuchi Hōbun by whom he was later adopted. Traveled in Europe 1922–1923. Exhibited with Bunten. Taught at Kyoto City School of Fine Arts and Crafts and at Kyoto City Specialist School of Painting. Member of Art Committee of Imperial Household, Imperial Art Academy, and Japan Art Academy. *Bijin-ga* include *Smiling Maiko*, ca. 1950.

Kikuchi Ryōji 菊地良爾

B. 1920 in Akita prefecture. Studied Japanese-style painting with Kawai Gyokudō. Prints of customs of Akita published by Watanabe Shōzaburō.

Kikuchi Ryūchi 菊地隆知

B. 1930 in Yamagata prefecture. Exhibited with Nihon Hanga Kyōkai from 1956. Member of Banga-in, Hanga Konwakai, and Ōgenkai. Prints include depiction of an early spring snow in what appears to be rural Yamagata. Uses the *kanji* "Ryū" from his given name as a seal.

Kikuchi Shunji 菊地俊治

B. 1944 in Hakodate, Hokkaido. Grad. 1967 Musashino College of Fine Arts. Exhibited oil painting with Kokugakai from 1968 and New Production Association (Shin Seisaku Kyōkai). Exhibited *moku-hanga* with Banga-in 1970. In 1977 traveled extensively in Mexico and Central America. Included among his works are roughly cut prints based on Mexican landscapes or artifacts.

Kikuchi Yūichi 菊地友一

Landscapes published by Adachi Hanga Kenkyūsho in 1950s.

Kikuchi Zenjirō 菊地善二郎

B. 1911 in Shiga prefecture. Lived in a town on the old Tōkaidō. Studied in Kyoto. Active in Shin Hanga Shūdan in 1933 and in Zōkei Hanga Kyōkai. Contributed to *Shin hanga*. Drafted into World War II; died while in service. Black and white prints of proletarian subjects or scenes in his home town. Sometimes used the signature ZEN carved in the block.

Kikukawa Taka 菊川多賀

1910–1991. B. Sapporo. Given name Takako. Studied woodblock with Kiyohara Hitoshi, Japanese-style painting with Katayama Nanpu. Exhibited painting frequently at Inten. Prints of *kokeshi*-like children made after World War II. Probably carved and printed by artisans.

Kimura Akirō 木村晃郎

See Kimura Mitsuo.

Kimura Hanbei 木村版兵

Exhibited with Nihon Hanga Kyōkai in 1943; contributed to *Ichimokushū* in 1944.

Kimura Kōrō 木村晃郎

See Kimura Mitsuo.

Kimura Mitsuo 木村晃郎

B. 1916 in Yokohama; lived in Fukuoka. Also known as Kimura Akirō or Kōnō. Studied with Sakamoto Hanjirō. Member of Nihon Hanga Kyōkai 1952–1970, Shun'yōkai, and New Structure Society (Shin Kōzōsha). Also exhibited with CWAJ in 1960s.

Kimura Seitarō 木村清太郎

Grad. Kansai Academy of Fine Arts. Exhibited with Kyoto Sōsaku-Hanga Kyōkai in 1933. Member of the group that produced *Kōhan* in 1935.

Kimura Sōhachi 木村荘八

1893–1958. B. near Ryōgoku Bridge, in Tokyo. From the age of 19 studied at the school of Hakubakai; met Kishida Ryūsei and together founded Fyūzankai in 1912. Also founding member of Sōdosha in 1915 and Shun'yōkai in 1922. Exhibited paintings with Nikakai, Shun'yōkai, and Kokugakai. Also known as writer on music and theatrical scenery and costumes in the magazines *Seikatsu* and *Gendai no yōga*. Illustrated newspaper serials including a novel by Nagai Kafū. In the Fyūzan period he made disparaging comments about *moku-hanga*, but later designed *Ruined Capital Picture Album (Kōto zufu)*, 1924, a group of prints carved by Nomura Toshihiko dealing with destruction by the 1923 earthquake. He also briefly published a magazine called *Hanga* in 1927 and a humorous print of cats impersonating women in a public bath, ca. 1953. Other works, also carved by Nomura, were published by Katō Junji.

Kimura Yoshiharu 木村義治

B. 1934 in Tokyo. In 1954 began study with Sasajima Kihei. Exhibited with Banga-in 1957 and with Kokugakai from 1965. Member of Banga-in from 1962 and Kokugakai from 1978. Prints often depict owls and other birds in bright color.

Kinchō 金蝶

Published by Uchida. Prints depict typical Japanese decorative motifs including a flower cart and flower arrangements.

Kinoshita Giken 木下義謙

B. 1898 in Tokyo. Grad. Tokyo Higher Industrial School. Studied in France 1928–1932. Member of Nikakai and Issuikai. Contributed to *One Hundred Views of Great Tokyo (Dai Tokyo hyakkei)*, 1932.

Kinoshita Mokutarō 木下杢太郎

1885–1945. B. Shizuoka prefecture. Original name Ōta Masao. An extremely versatile man—painter, playwright, poet, doctor of medicine, writer of mysteries and books on sculpture and Chinese art. Member of Pan no Kai and friend of many early *sōsaku-hanga* artists. His prints, made as illustrations for some of his books, were carved by Igami Bonkotsu. In 1941 received France's Legion d'Honeur for contributions to dermatology.

Kinoshita Tomio 木下富雄

B. 1923 in Yokka-ichi, Mie prefecture. Grad. 1941 Nagoya City Crafts High School. Sent to Manchuria for 2 years as a lens polisher. Learned the art of carving seals from his wife. In 1956, inspired by the work of Hiratsuka Un'ichi, began to design prints of Yokka-ichi scenery and carve jagged lines with a flat chisel. Exhibited with Nihon Hanga Kyōkai from 1957, Kokugakai from 1958; member

of Nihon Hanga Kyōkai from 1959 and Kokugakai. Represented in many international competitions including Northwest 1960, Philadelphia International Prints Exhibition 1963, and the Tokyo Biennale 1962 and 1968. In his mature style he developed images of highly abstracted heads composed of characteristic jagged lines. These were printed as needed, the same blocks sometimes printed in different colors and dated when printed.

Kishida Ryūsei 岸田劉生

1891–1929. B. Tokyo. Studied painting at the school of Hakubakai with Kuroda Seiki and etching with Bernard Leach. Entered oil painting in Bunten in 1910. Contributed to *Hakutō* in 1910. Became enthusiastic about contemporary European art through *Shirakaba* ca. 1911. Founding member of Fyūzankai in 1912. Switched attention to the work of Dürer and other Northern Renaissance artists ca. 1915. Member of Sōdosha 1915–1922 and Shun'yōkai 1922–1925. From ca. 1921 influenced by Sung and Yuan dynasty Chinese paintings and *ukiyo-e*. Was critical of *hanga* in a statement printed in a Sunday *Osaka asahi shinbun* in 1913. But beginning in 1918 designed several covers for *Shirakaba* carved by Yamagishi Kazue and more than 30 designs for book covers carved by Igami Bonkotsu. Also designed individual prints published by Katō Junji. The best known of these is a portrait of his daughter Reiko, *Reiko zō*, 1925.

Kishimoto Hiroshi 岸本擴

Exhibited with Nihon Hanga Kyōkai in 1932 and 1933. Member of the group that published *Yūkari* in Shizuoka in 1935.

Kishinobu Masayoshi 岸信正義

B. 1921 in Tottori prefecture. Grad. Fukuoka Prefecture Kokura Normal School. Worked in educational administration. *Mokuhan* self-taught. Solo exhibitions yearly from 1960 in the Tottori area. Member of Banga-in and New Century Fine Arts Association (Shinseiki Bijutsu Kyōkai). Principal subjects are Mt. Daisen in snow and children.

Kita Takeshirō 喜多武四郎

1897–1970. B. Tokyo. After studying at Kawabata Painting School, entered the school of Saikō Nihon Bijutsuin in 1918 and studied sculpture with Tobari Kogan, who urged him to experiment with prints. Exhibited in the first Nihon Sōsaku-Hanga Kyōkai exhibition and contributed to *Shi to hanga* in 1923 but did not continue making *hanga* after the Taishō period.

Kitagawa Kazuo 北川一雄

Studied with Kaburagi Kiyokata. Produced 4 landscape prints, including *Bamboo Grove*, 1919, with Watanabe Shōzaburō before the 1923 earthquake; possibly others later.

Kitagawa Tamiji 北川民次

1894–1989. B. Shizuoka prefecture. After attending Waseda University went to U.S. in 1913 where he studied with John Sloan at the Art Students' League. In

1923 wandered around Mexico and South America. From 1925 to 1936 worked in art education for children in Mexico. After return to Japan in 1936, became a member of Nikakai in 1937 and established reputation as a painter. Charter member of Banga-in. Revisited Mexico in 1955. Worked in various print media; known particularly for black and white woodcuts and wood engravings on Mexican themes.

Kitamura Imazō 北村今三

Act. 1920s. In 1929 formed Sankōkai in Kobe with Kawanishi Hide and Harumura Tadao. Participated in 6 exhibitions of Sankōkai, the last in 1936. Member of Nihon Hanga Kyōkai from 1939. Contributed to *HANGA*, *Han geijutsu*, *Tsuge*, and *One Hundred Views of New Japan (Shin Nihon hyakkei)*, 1939. Died during World War II. Style is characterized by simple carving and strongly influenced by Kawanishi Hide.

Kitamura Kinjirō 北村謹次郎

B. 1904 in Kyoto. Studied with Tokuriki Tomikichirō. Exhibited with Nihon Hanga Kyōkai in 1932–1933, Kokugakai, and Kyoto Sōsaku-Hanga Kyōkai in 1933.

Kitani Chigusa 木谷千種

See Kotani Chigusa.

Kitani Chitane 木谷千種

See Kotani Chigusa.

Kitano Tsunetomi 北野恒富

1880–1947. B. Kanazawa. Given name Tomitarō. Studied with Inano Toshitsune. From 1901 an illustrator for an Osaka newspaper. From 1910 exhibited paintings with Bunten and from 1914 with Inten; became member of Saikō Nihon Bijutsuin in 1917. In 1918 created and probably self-published *Spring and Fall in the Pleasure Quarter (Kuruwa no shunjū)*, a set of 4 prints, one for each season. Contributed to *New Ukiyo-e Beauties*, 1924. Established Hakuyōsha (White Radiance Company), a combined school and publishing house. Taught many children. Became leader in Osaka art circles. Provided *mokuhan* covers for the satirical magazine *Dai Osaka* in 1920s. Designed *ōkubi-e* prints of *bijin-ga* with rich mica backgrounds. On *Heron Maid*, 1925, the carver and printer are noted respectively as Matsuno and Yamane.

Kitaōji Rosanjin 北大路魯山人

1883–1959. B. Kyoto. Moved to Kita Kamakura in 1917; lived there the rest of his life. From 1925 to 1936 he operated Hoshigaoka, a gourmet restaurant in Tokyo, for which he made all the pottery. Best known for modern pottery based on historical styles. Also a painter, lacquer artist, calligrapher, engraver of seals, collector, gourmet, and printmaker. Announced his fiftieth ceramic exhibition with a self-portrait on a large woodblock poster.

Kitaoka Fumio　北岡文雄

B. 1918 in Tokyo. Drew from plaster casts at Hongō Painting Institute at night while still in middle school and later at Dōshūsha, the school of Kobayashi Mango. Admitted to Tokyo School of Fine Arts in 1937. Studied oil painting with Fujishima Takeji; member of the adjunct *moku-hanga* class of Hiratsuka Un'ichi. Grad. 1941 from Western-style painting division. Contributed to *Kitsu-tsuki hangashū*, 1942, 1943. In 1944 was evacuated from Tokyo to Fujino; in January 1945 went to Manchuria where he worked until October 1946 in the Northeast Asia Cultural Development Society. He reflected on his ardous journey back to Japan through communist-held territory in *Trip to Native Country (Sokoku e no tabi)*, 1947. In this set of 17 black and white prints his style was strongly influenced by Chinese social realist prints. This influence was balanced by association with Onchi Kōshirō in Ichimokukai. Contributed to *Ichimokushū* in 1947 and 1948. Became a member of Nihon Hanga Kyōkai in 1943 and Shun-'yōkai in 1951. Studied wood engraving at L'École Nationale des Beaux-Arts Française 1955–1956; taught at Minneapolis Museum school of art, 1964–1965, and at Pratt Graphic Arts Center in New York. Held solo exhibitions in Tokyo and in Soviet Union in 1971, Taipei in 1978, and Beijing in 1980; participated in international biennales in Tokyo, São Paulo, Lugano, and Ljubljana. After passing through realistic and abstract stages, Kitaoka's mature style embraces both realistic representation and abstraction in carefully designed and often brightly colored landscapes.

Kitazawa Shūji　北沢収治

B. 1890 in Nagano prefecture. Original name Moriyama Shūji; known as Kitazawa Shūji after 1929. Studied lithography and etching. Worked as a schoolteacher. Member of Nihon Sōsaku-Hanga Kyōkai; founding member of Nihon Hanga Kyōkai. Exhibited with Shun'yōkai and Kokugakai. Exhibited woodcuts at Nihon Sōsaku-Hanga Kyōkai shows 1919–1928 using the name Moriyama Shūji. Contributed to *HANGA* in 1926, to *Han geijutsu* in 1932, and to *One Hundred Views of New Japan (Shin Nihon hyakkei)* in 1939. Specialized in scenery prints of Shinshū.

Kiwamura Sōjirō　木和村創爾郎

1900–1973. B. Matsuyama, Ehime prefecture. Grad. 1924 Kyoto City Specialist School of Painting. Studied Japanese-style painting with Nishiyama Suishō. Self-taught printmaker. Exhibited at Nitten and Nihon Hanga Kyōkai. Member of Nihon Hanga Kyōkai 1948–1960. Contributed to *Ichimokushū* in 1949. Founding member of Nippankai in 1960. Exhibited with Kokugakai. Works include scenic prints of the Tokyo-Hakone area.

Kiyohara Hitoshi　清原ひとし（斉）

1896–1956. B. Ibaraki prefecture. Art name Sei used for paintings. Studied with Matsumoto Fūko from 1915; then with Katayama Nanpū. Exhibited Japanese-

style painting at Inten. Prints of *kokeshi*-like children in late 1940s published by Katō Junji. Signed prints with his given name in *hiragana*.

Kiyoharu　清春

See Yokouchi Kiyoharu.

Kiyomiya Akira　清宮彬

See Seimiya Hitoshi.

Kiyooki　清興

Studied with Kobayashi Kiyochika. Designed Russo-Japanese War prints.

Kiyota Yūji　清田雄司

B. 1931 in Fukuoka prefecture. Grad. 1956 Kyoto City College of Fine Arts. Founding member of Shūdan Zōkei, a society of realistic artists, in 1969. Self-published *Kiyota Yūji Woodblock Picture Collection I and II (Kiyota Yūji mokuhan gashū)*, 1960. Prints include depictions of crowds of people and groups of farm houses.

Kiyotada　清忠

See Torii Kiyotada.

Koana Ryūichi　小穴隆一

1894–1966. B. Nagasaki. Also known as Oana Ryūichi. Studied at the school of Taiheiyōgakai. Exhibited oil paintings with Taiheiyōgakai, Nikakai, and Shun'yōkai. Worked as book designer. Exhibited *hanga* at the *Kamen* show in 1914 and at Nihon Sōsaku-Hanga Kyōkai exhibition in 1921.

Kobashi Yasuhide　小橋康秀

B. 1931 in Kojima, Okayama prefecture. Grad. 1955 from ceramics department of Kyoto College of Crafts and Textiles. Studied *mokuhan* with Hiratsuka Un'ichi. Exhibited with Kokugakai 1953, 1954. Became associate member of Nihon Hanga Kyōkai in 1954. Lived in U.S. from 1959; took up permanent residence in 1965. Active in ballet and sculpture in New York.

Kobayakawa Kiyoshi　小早川清

1896–1948. B. Hakata, Fukuoka prefecture. Studied with Kaburagi Kiyokata. Exhibited Japanese-style painting with Kyōdokai, Teiten, and Seikokai; solo exhibition at Matsuzakaya department store in 1934. In 1930–1931 designed and self-published series of 6 *moku-hanga* entitled *Modern Fashionable Styles (Kindai jisei shō)*; carved by Takano Shichinosuke and printed by Ono Tomisaburō. Other prints include *Revue* published by Hasegawa and other modern *bijin-ga* published by Hasegawa, Watanabe, and Ensendō. Twelve prints were included in the 1936 Toledo exhibition. Reprints published by Takamizawa ca. 1955.

Kobayakawa Shūsei　小早川秋声

1884–1973. B. Kobe. Grad. Kyoto City Specialist School of Painting. Studied with Yamamoto Shunkyo and Taniguchi Kōkyo. Practiced Japanese-style paint-

ing while serving as monk at a Honganji temple in Kyoto. Print entitled *Atami Spring Evening*, 1935, published by Adachi. Also prints of Fudō Myōō and Kannon.

Kobayashi Asaji　小林朝治

1898–1939. B. Nagano prefecture. Also known as Kobayashi Tomoji. Grad. 1921 Kanazawa Medical School. Began exhibiting with Nihon Sōsaku-Hanga Kyōkai while working in Ehime prefecture in 1927 and with Nihon Hanga Kyōkai from 1931. Member of Nihon Hanga Kyōkai 1936–1939. Opened practice as an eye doctor in Nagano in 1932 and organized a creative print group in the Shinano area. Contributed to *Han geijutsu*, *Kasuri*, *Chōkokutō*, and *Kunugi*. Committed suicide by jumping from a suspension bridge reported to be the highest in Asia. His print for *One Hundred Views of New Japan (Shin Nihon hyakkei)* was published posthumously. Memorial exhibition of 15 prints held at the 1939 Nihon Hanga Kyōkai show.

Kobayashi Hidetsune　小林秀恒

1908–1942. B. Tokyo. Studied with Yamakawa Shūhō and Ikeda Shūho. Known for woodblock illustrations in novels.

Kobayashi Keisei　小林敬生

B. 1944 in Shimane prefecture. Grad. 1968 International Specialist School of Fine Arts in Kyoto. Studied with Ueno Isaburō. While a student he was influenced by the wood engraving of Hiwazaki Takao, who was only 3 years his senior. Also studied oil painting with Miyanaga Takehiko. Exhibited with Kokugakai 1970–1978, Nihon Hanga Kyōkai from 1970, Nichidō, and CWAJ from 1971. Works, predominantly wood engravings, include representations of small natural and man-made objects and large forms suggestive of nuts or boulders from which various organic objects emerge.

Kobayashi Kiyochika　小林清親

1847–1915. B. Edo. Given name Katsunosuke. Son of a military retainer of the Tokugawa family. Studied briefly with Kawanabe Gyōsai and Shibata Zeshin; may have acquired a concern for the effect of light from the photographer Shimooka Renjō in Yokohama. May also have known the Western painter Charles Wirgman. Best-known prints, 1876–1881, depict scenes of the assimilation of Western influences—often dramatically lit by the moon, fire, or fireworks. From the early 1880s he turned to political and social satire. Worked for a number of comic journals and newspapers, among them *Marumaru chinbun* for which he made cartoons for 18 years. Also made woodblock illustrations and landscape prints. Working for 6 different publishers, designed ca. 80 battle triptychs during Sino-Japanese War. Also designed a few prints of Russo-Japanese War scenes. Active until the year before his death. Among his publishers were Fukuda Kumajirō and Matsuki Heikichi.

Kobayashi Kiyomitsu 小林清光

May have been the son of Kobayashi Kiyochika. Contributed to *Shi to hanga*, *HANGA*, and *Kitsutsuki*. Exhibited with Nihon Sōsaku-Hanga Kyōkai 1927–1929.

Kobayashi Kokei 小林古径

1883–1957. B. Niigata. Given name Shigeru. Studied as a boy with Kajita Hanko. Traveled in Europe 1922–1923. Exhibited painting in Bunten from 1907 and in Inten. Appointed member of Imperial Art Academy in 1937 and Art Committee of the Imperial Household in 1944. Taught Japanese-style painting at Tokyo University of Fine Arts 1944–1951. In 1950 received Order of Cultural Merit. Known as a leading Japanese-style painter of genre scenes and *bijin-ga*.

Kobayashi Shōkichi 小林鐘吉

1877–1946. B. Tokyo. Grad. 1903 Tokyo School of Fine Arts. Studied with Kuroda Seiki. Founding member of Kōfūkai in 1912. Exhibited with Hakubakai, Kōfūkai, and Bunten while teaching at a mission school for women. Created woodblock illustrations.

Kobayashi Tokusaburō 小林徳三郎

1884–1949. B. Fukuyama, Hiroshima prefecture. Original name Fujii Yoshitarō. Studied with Kuroda Seiki at Tokyo School of Fine Arts; grad. 1909. Exhibited painting at Inten in 1919 and Shun'yōkai in 1923. Founding member of Fyūzankai in 1912. Exhibited set of 3 *moku-hanga* of acrobats at the Fyūzankai show, contributed *moku-hanga* to *Fyūzan*, and continued making expressionist *moku-hanga* after Fyūzankai disbanded. Studied French at Tokyo Foreign Language School; grad. 1918. Taught in a Tokyo high school 1924–1933. Also stage manager for Shimamura Hōgetsu art theater 1916, 1917. Member of Shun'yōkai from 1926 and Nikakai. Subjects range from fish and still lifes to people and landscapes.

Kobayashi Wasaku 小林和作

1888–1974. B. Yamaguchi prefecture. Studied Japanese-style painting at Kyoto City Specialist School of Painting and Western-style painting with Kanokogi Takeshirō and Umehara Ryūzaburō. Member of Shun'yōkai 1927–1934; later became a member of Independent Fine Arts Association (Dokuritsu Bijutsu Kyōkai).

Kōbun 耕文

See Tsukioka Gyokusei.

Kodama Kibō 児玉希望

1898–1971. B. Hiroshima prefecture. Original name Kodama Shōzō. Studied with Kawai Gyokudō. Exhibited with Teiten from 1921 and Nitten. Member of Nihon Nanga-in and Saikō Nihon Bijutsuin. In 1950 with Itō Shinsui organized Jitsugetsusha.

Kodama Sadahei 児玉貞平

1898–1941. B. Oita prefecture. Studied at Aoibashi branch of the school of Hakubakai. Exhibited with Nihon Sōsaku-Hanga Kyōkai and Nihon Hanga Kyōkai intermittently 1929–1940; member Nihon Hanga Kyōkai from 1932. Contributed lithograph to *Kitsutsuki* in 1930. In 1941 Nihon Hanga Kyōkai had a special memorial display of his works.

Kodama Takamura 児玉篁

Exhibited with Nihon Hanga Kyōkai through 1930s. Contributed to *HANGA* in 1930 and *Kitsutsuki* in 1931.

Kodō 古洞

See Yamanaka Kodō.

Kōgyō 廣業（広業）

See Terazaki Kōgyō.

Kōgyo 耕漁

See Tsukioka Kōgyo.

Kōho 晃甫

See Hiroshima Shintarō.

Kōhō 耕峯

A narrow vertical print of a garden with stone lantern bears two seals of one character each which can be read together as Kōhō. The print was published by Nishinomiya in Tokyo. See Chapter 7 for signature. The name Kiroku and the dates 1875–1925 have been associated with Kōhō and may be the family name and dates of the artist. He is also known as Shoda Kōhō.

Koide Narashige 小出楢重

1887–1931. B. Osaka. Studied with Kuroda Seiki and Nagahara Kōtarō at Tokyo School of Fine Arts; grad. 1914. Also studied with Matsuoka Eikyū and Shimomura Kanzan; studied in France in 1921. Member of Nikakai. Founded the Shinanobashi Western-Style Painting Institute in Osaka and taught oil painting. From ca. 1926 worked as illustrator for novels in the *Osaka asahi shinbun*. Concentrated on nudes toward the end of his life. Posthumous woodcuts include *Birth of Goddess of Beauty*.

Koido Fujimasa 小井戸藤政

Participated in Nihon Hanga Kyōkai exhibitions 1940–1942. Contributed to *Akebi* during the same period. Became associate member of Nihon Hanga Kyōkai in 1944. Died while in military service.

Koito Gentarō 小絲源太郎

1887–1978. B. Tokyo. Studied at the school of Hakubakai and with Fujishima Takeji at Tokyo School of Fine Arts. Exhibited paintings at Bunten, Teiten, and Nitten. Member of Saikō Nihon Bijutsuin. Designed *moku-hanga* in 1930s.

Koizumi Kishio　小泉癸巳男

1893–1945. B. Shizuoka. Son of a former Tokugawa retainer and calligrapher. Learned block carving from Horikoshi Kenkichi who produced calligraphy manuals for his father. Studied painting with Maruyama Banka and Ishii Hakutei at Japan Watercolor Institute. While earning his living as a carver of woodblock illustrations for newspapers, he met Tobari Kogan who encouraged him to make self-designed *moku-hanga*. Active in Nihon Sōsaku-Hanga Kyōkai from 1919; founding member of Nihon Hanga Kyōkai. In 1920 produced *Scenery Prints of New Tokyo (Shin Tokyo fūkei hanga)*, a set of 12 prints. Very active in carving and printing his own prints as well as carving blocks for other artists. Wrote *How to Carve and Print Woodblocks (Mokuhan no horikata to surikata)*, 1924. Personally designed and carved *One Hundred Pictures of Great Tokyo in Shōwa (Shōwa dai Tokyo hyakuzue)*, 1928–1937, with some substitution of new prints in 1940. These were published by Asahi Press. Contributed to *One Hundred Views of New Japan (Shin Nihon hyakkei)* in 1938 and to *Shi to hanga, Kimi to boku, HANGA*, and *Hanga* (1929). Evacuated from his home in Tokyo during World War II; became ill and died before returning. Had finished 23 of *Thirty-Six Views of Mt. Fuji (Fugoku sanjū-rokkei)* at the time of his death. Frequently used the second *kanji* in his family name as a signature.

Kojima Torajirō　児島虎次郎

1881–1929. B. Okayama prefecture. Studied at Tokyo School of Fine Arts, where he was a classmate of Yamamoto Kanae, and with Kuroda Seiki. *Moku-hanga* dating from ca. 1907 include *Garden of Consciousness (Nasake no niwa)*. Went to France in 1908 where he studied briefly with Edmond-François Aman-Jean. Also studied in Belgium and made two other trips to France in 1919 and 1922. Went to China in 1926. Exhibited at solo exhibitions only. Worked at the Ōhara Museum in Kurashiki assisting with the Western collection. Friend of Yamamoto Kanae and correspondent during Kanae's years in France.

Kojima Zentarō　小島善太郎

1892–1984. Member of Fyūzankai. Contributed to *One Hundred Views of Great Tokyo (Dai Tokyo hyakkei)*, 1932.

Kokunimasa　小国政

See Utagawa Kokunimasa.

Kōkyō　耕擧（耕挙）

Designed Russo-Japanese War prints in 1904. Published by Matsuki Heikichi.

Komatsu Hitoshi　小松均

1902–1989. B. Yamagata prefecture. In 1920 attended Kawabata Painting School in Tokyo. Studied with Tsuchida Bakusen. Exhibited Japanese-style paintings with Kokugakai, Teiten, and Inten. Member of Saikō Nihon Bijutsuin. From 1963 produced ca. 25 *moku-hanga* but not satisfied with results. In 1968 switched

to study of etching with Furuno Yoshio. Etchings include a hand-colored series on the Mogami River.

Komori Soseki　小森素石
Act. Taishō. *Kachō* published by Kawaguchi.

Komura Settai　小村雪岱
1887–1940. B. Saitama prefecture. Adopted by Yasunami family and took the name Yasunami Taisuke in 1909 but retained the name Komura Settai for his professional work. Studied with Arai Kanpo in 1903. In 1904 entered the Japanese-style painting division of Tokyo School of Fine arts where he studied with Shimomura Kanzan; grad. 1908. Also studied with Matsuoka Eikyū. Worked for several years for *Kokka* magazine copying old pictures. Painted in a modern *yamato-e* style. In 1924 was asked by Tokyo School of Fine Arts to copy several picture scrolls including *Kitano tenjin engi*. From 1933 he became well known for popular illustrations for *The Tale of Osen*. His style in these was influenced by reproductions of black and white drawings by Aubrey Beardsley and color prints by Harunobu. A small number of woodcuts of Settai's illustrations were published by Takamizawa during his lifetime; others were published posthumously by Adachi Toyohisa.

Kon Junzō　今純三
1893–1944. B. Aomori prefecture. In 1910 studied with Nakamura Fusetsu and Mitsutani Kunishirō at school of Taiheiyōgakai and in 1912 with Okada Saburō-suke at Hongō Painting Institute. Grad. 1913 Waseda Higher Technical School. Exhibited paintings in Bunten and Teiten. Worked backstage in the art theater in 1918. Returned to Aomori after the 1923 Kantō earthquake and began teaching art in the normal school. Known principally for etchings, but also made lithographs and *moku-hanga*. As a resident print artist in Aomori, he was a strong influence on Sekino Jun'ichirō, Munakata Shikō, Satō Yonejirō, and other young Aomori artists. Returned to Tokyo in 1939 and became a factory worker. Because of his love of balalaika music, Munakata Shikō made a print of a bodhisattva playing a balalaika as a gift for his memorial service.

Kōnan Shiro　江南史朗
See Enan Shirō.

Kondō Kōichiro　近藤浩一路
1884–1962. Studied with Kuroda Seiki at Tokyo School of Fine Arts and in France. Watercolor and *manga* artist. Woodblock illustrations before World War II.

Kondō Kōtaro　近藤孝太郎
1897–1949. B. Aichi prefecture. Grad. Tokyo Higher Business School. Worked for Nihon Yūsen Company in Tokyo. In 1920 while in New York on business he started painting with oils. In 1921 he left Nihon Yūsen Company and went to Paris where he was influenced by cubism. Back in Japan after the 1923 earth-

quake he taught art at Okazaki Junior High School and Okazaki Women's High School. Founded the poetry and *hanga* magazine *Shisaku* for which he produced cubist *hanga*. Also a prime mover in publication of *Shijima*. From 1933 active in labor movement and at one point arrested. After 1937 he worked at Ishikawa-jima shipbuilding company; after World War II joined the communist party. In 1948 worked in a labor union culture office. Among his works are cubist prints and prints depicting proletarian workers.

Kondō Shiun　近藤紫雲

Studied Japanese-style painting. Made *bijin-ga* and woodblock illustrations for novels from ca. 1923 until shortly before World War II. Contributed to *New Ukiyo-e Beauties (Shin ukiyo-e bijin shō)*, ca. 1923.

Kondō Takayoshi　近藤孝祥

B. 1937 in Hyōgo prefecture. Grad. 1960 Osaka University of Liberal Arts. Exhibited painting with Nikikai 1957–1971. Exhibited *hanga* with Sōsaku-Hanga Kyōkai, a creative print society founded in Osaka in 1976, and Tō no Kai. Member of both groups. Subjects include landscapes and genre scenes.

Konishi Seiichirō　小西誠一郎

B. 1919 in Kyoto. Studied oil painting and design under Igaki Kahei. *Mokuhan* self-taught. Exhibited *sōsaku-hanga* in Kyoto from 1950 and with Banga-in from 1954. Also exhibited with Shin Seisaku Kyōkai, Dokuritsu Bijutsu Kyōkai, and in numerous solo shows. Represented in modern Japanese print exhibitions in Moscow and Kiev in 1961. Prints include self-carved, self-printed scenes of Kyoto.

Kōno Kaoru　河野薫

See Kawano Kaoru.

Kōno Michisei　河野通勢

1895–1950. B. Isezaki, Gunma prefecture. Also known as Kōno Tsūsei. Studied with his father Kōno Jirō, a Western-style painter and photographer. Influenced by Kishida Ryūsei, he joined Sōdosha in 1915. Also exhibited with Kokugakai, Nikakai, Shun'yōkai, and Bunten. Member of Nihon Hanga Kyōkai from 1931 and exhibited intermittently 1933–1937. Worked as newspaper illustrator. *Mokuhanga* include depictions of the 1923 earthquake and a stage scene, ca. 1926.

Kōno Tsūsei　河野通勢

See Kōno Michisei.

Konobu　小信

See Hasegawa Konobu.

Konoe Tadamaro　近衛忠麿

B. 1902 in Kyoto. Grad. Kyoto University. Worked as chief priest of Kasuga Shrine in Nara. Made *hanga* from ca. 1924. Very knowledgeable about woodblock and used movable wooden type to print the works of the poet Aizu

Yaichi. Also collaborated in 1930 with Kawai Unosuke on *Iraho*, a self-designed, self-printed collection of *moku-hanga*.

Kōsaka Gajin 上坂雅人

1877–1953. B. Kyoto. Given name Masanosuke; changed to Masayuki and then to the art name Gajin after World War II. Began his career as an elementary school teacher in 1901. Studied Japanese-style painting in Kyoto with Kōno Bairei and Yamamoto Shunkyo. After moving to Tokyo in 1907, studied European painting at the schools of Hakubakai and Taiheiyōgakai while working in a commercial embroidery studio. From 1922 exhibited with Nihon Sōsaku-Hanga Kyōkai. Appointed by Ministry of Education to advise in compilation of school art textbooks in 1931. Exhibited with Kokugakai. Member of Nihon Hanga Kyōkai from 1948 and Zōkei Hanga Kyōkai. Early prints were realistic landscapes similar to those of Hiratsuka Un'ichi. In 1945 Kōsaka's Tokyo home, including his early prints, was destroyed in an air raid and he evacuated to Sendai. There he radically changed his style from conservative carving and printing to a wet monochrome ink technique on unsized paper; reported to have learned this technique from Matsuo Jun'ichirō. Gajin's late prints of soft-edge intuitive images won enthusiastic recognition particularly abroad where similarities of his style to concurrent abstract expressionist painting were appreciated. Solo exhibitions in Los Angeles 1950 and Paris 1952; retrospectives in Europe and U.S. in 1956.

Kōsaka Masayuki 上坂雅之

See Kōsaka Gajin.

Kosaka Ryūji 小坂龍二

1912–1972. Member of Zōkei Hanga Kyōkai ca. 1937 and Kokugakai. According to 1962 Watanabe catalog, two of his works, *A Scene at Kamikōchi, Japan Alps* and *White Birch*, were produced in the Watanabe workshop. Later prints include *Red Stone Series* and *Blue Stone Series*. In the former, shapes are derived from the ancient Japanese comma-shaped stone known as the *magatama*; in each print the same shape is repeated. The *Blue Stone Series* uses stone shapes more freely in a casual arrangement against backgrounds suggestive of water or grasses.

Koseki Tetsuo 古石哲夫

B. 1922 in Toyama prefecture. Grad. 1941 Fukui Normal School. Taught at a middle school. Member of Asian Artists Friendship Association. Exhibited in solo and group exhibitions and at Republic of China International Print Exhibition. Subjects include country houses and landscapes.

Kōsetsu 光雪

B. ca. 1887 in Osaka or Kyoto. Original name Mineuchi Tetsuji. Studied Japanese-style painting with Yamamoto Shunkyo. *Maiko Viewing Cherry Blossoms at Gion*, 1924, published by Satō Shotarō in Kyoto.

Koshino Yoshirō　越野義郎

1906–1975. B. Takaoka, Toyama prefecture. A physician who studied *hanga* with Munakata Shikō. Founding member of Banga-in. Exhibited at Nitten and solo exhibitions.

Kosugi Hōan　小杉放庵

See Kosugi Misei.

Kosugi Misei　小杉未醒

1881–1964. B. Nikko, Tochigi prefecture. Given name Kunitarō. Early *gō* Misei; later changed to Hōan; also used the art name Shikyō Enka. Studied Western-style painting with Ioki Bunya. In 1898 went to Tokyo and in 1899 entered school of Hakubakai. In 1900 studied with Koyama Shōtarō at Fudōsha. Founding member of Taiheiyōgakai in 1902. Reported the Russo-Japanese War in newspaper illustrations in 1904. Contributed lithographs, etchings, and *moku-hanga* to *Heitan* in 1905 and to *Hōsun*. Was in France in 1913 with his close friend Yamamoto Kanae. Exhibited with Bunten, Inten, Shun'yōkai. Head of Inten's Western-style painting division. Contributed delicate, whimsical scenes to *Japanese Scenery Prints (Nihon fūkei hanga)*, 1918. Also known as an essayist. Late in life concentrated on Japanese-style painting.

Kotani Chigusa　木谷千種

1890–1945. B. Osaka. Given name Eiko. Studied with Kitano Tsunetomi, Ikeda Shōen, and Kikuchi Keigetsu. Known as Japanese-style painter of women; exhibited at Bunten and Teiten. Woodblock *bijin-ga* published by Nishinomiya. Used the signature Chigusa with a long ovoid vertical seal.

Kōtō　耕＿＿

Studied with Ogata Gekkō. Prints include a double triptych depicting a panoramic view of the victory of Port Arthur in Russo-Japanese War; published by Kimura Hōkichi in Tokyo in 1904.

Kotozuka Eiichi　琴塚英一

B. 1906 in Osaka. Grad. 1930 Kyoto City Specialist School of Painting. Exhibited prints with Shun'yōkai from 1932, Teiten from 1934. Member of Nihon Hanga Kyōkai from 1938. Exhibited Japanese-style painting with Seiryūsha from 1931; member from 1950. Series of Kyoto scenes, including *Eight Snow Scenes of Kyoto* published by Uchida, and series of flower prints made with Tokuriki Tomikichirō and Kamei Tōbei published by Unsōdō. Associated with these two artists in Kōrokusha, a subsidiary of Tokuriki's publishing company which subsidized their *sōsaku-hanga*.

Kōyō　廣陽（広陽）

See Omura Kōyō.

Kozaki Kan 小崎侃

B. 1942 in Kumamoto prefecture. Grad. 1966 from sculpture department of the school of Taiheiyōgakai. Exhibited in Nagasaki Prefectural Exhibitions 1960–1966 and with Kokugakai, Jiyu Bijutsu Kyōkai, Nihon Bijutsukai, Taiheiyō Bijutsukai, and Nichidō. Member of Taiheiyō Bijutsukai. Works include naively carved fanciful black and white prints in which a woman hovers over the landscape. Sometimes carves his given name in the block in either *kanji* or roman script.

Kubo Mamoru 久保守

B. 1905 in Sapporo. Studied at Kawabata Painting School; grad. Tokyo School of Fine Arts. Traveled to Europe 1930–1931. Exhibited oil paintings at Bunten and Teiten and *moku-hanga* with Nihon Sōsaku-Hanga Kyōkai in 1928–1929. Committee member of Japan Artists League. Professor at Tokyo University of Art.

Kumagai Gorō 熊谷吾良

B. 1932 in Hirosaki, Aomori prefecture. Grad. 1956 from Western-style painting department of Musashino College of Fine Arts. Member of Nihon Hanga Kyōkai 1961–1971 and Kokugakai. Participated in Tokyo and Northwest biennales in 1960s. Prints include semiabstract compositions with varied shapes and textures derived from still life.

Kumagai Morikazu 熊谷守一

See Kumagaya Morikazu.

Kumagaya Morikazu 熊谷守一

1880–1977. B. Gifu prefecture. Classmate of Aoki Shigeru and Yamashita Shintarō at Tokyo School of Fine Arts; grad. 1904. Member of Nikakai from 1916; founding member of Nikikai in 1947. Prints of simplified and flatly depicted flowers, animals, and people published by Katō Junji. Also made silkscreen prints.

Kume Kōichi 久米宏一

B. 1917 in Tokyo. Before World War II studied at the school of Taiheiyōgakai while teaching at an elementary school. Made woodblocks of children's pictures. Published *Karikare* with Ōta Kōji and others. Also made metal plate prints.

Kumeda Keizō 粂田恵造

Exhibited with Nihon Hanga Kyōkai intermittently 1931–1939. Contributed to *Hanzō*, *Shin hanga*, and *Shiro to kuro*.

Kunimasa IV 国政四世

See Baidō Hōsai.

Kunimatsu Ichiryūsai 国松一竜斎

See Utagawa Kunimatsu.

Kunisada III 国貞三世

See Baidō Hōsai.

Kurata Hakuyō 倉田白羊

1881–1938. B. Urawa, Saitama prefecture. Given name Shigekichi. Studied with Asai Chū and Kuroda Seiki. Grad. 1901 Tokyo School of Fine Arts. Became member of Taiheiyōgakai in 1902. Exhibited at first Bunten in 1907. Member of *Hōsun* group; experimented with both self-carved *moku-hanga* and lithographs for the magazine. Member of Nihon Sōsaku-Hanga Kyōkai; founding member of Shun'yōkai in 1922. Worked in Ueda City in Nagano prefecture as head of education program in Yamamoto Kanae's farmers art movement. In later years did mostly oils of farm villages.

Kurita Yū 栗田雄

1895–1961. B. Shizuoka prefecture. Studied Western-style painting at the school of Saikō Nihon Bijutsuin. Exhibited with Nihon Sōsaku-Hanga Kyōkai from 1920; member from 1921. Founding member of Nihon Hanga Kyōkai. Contributed to *Han geijutsu* and *HANGA*. He was in Europe 1930–1931. Concentrated on painting after his return to Japan, exhibiting with Shun'yōkai, Inten, and Teiten. Prints are highly textured suggesting that he used a small gouge as if it were an impressionist's brush.

Kuriyama Shigeru 栗山茂

B. 1912 in Shizuoka prefecture. Changed his name in 1937 to Matsunaga Shigeru. Worked as a junior high and high school teacher. In 1929 with Ogawa Tatsuhiko and Nakamura Gaku established Dōdosha. Exhibited with Nihon Hanga Kyōkai from 1931 and Kokugakai from 1932. From 1932 also studied with Onchi Kōshirō and Hiratsuka Un'ichi. Member of Nihon Hanga Kyōkai from 1936 as Kuriyama Shigeru; membership confirmed in 1939 as Matsunaga Shigeru. Exhibited in 1982 under the name Kuriyama Shigeru. A founder of *Yūkari*. Contributor to *Shiro to Kuro* from 1930 and to *Kasuri*. Worked in Manchuria and China 1939–1948. Member of Kokugakai from 1958. Exhibited in many foreign countries. Active in folk art movement. Landscape prints in the 1930s and in *One Hundred Views of New Japan (Shin Nihon hyakkei)*, 1940. Prints of the 1970s include numerous design motifs derived from folk art, sometimes executed from paper relief blocks.

Kurogi Ikutomo 黒木郁朝

See Kuroki Ikutomo.

Kurogi Sadao 黒木貞雄

See Kuroki Sadao.

Kuroki Ikutomo 黒木郁朝

B. 1945 in Miyazaki. First son of Kuroki Sadao. Exhibited with Nihon Hanga Kyōkai, Kokugakai, and other shows. Represented in Ibiza. Lives in rural Miyazaki and uses a goat as a repeated motif in his prints.

Kuroki Sadao 黒木貞雄

1908–1984. B. Nobeoka, Miyazaki prefecture. Grad. 1931 Miyazaki Normal School. Studied Western-style painting at Kawabata Painting School. Studied *hanga* in a short course with Hiratsuka Un'ichi in Oita in 1934 and with Onchi Kōshirō. Exhibited with Nihon Hanga Kyōkai from 1935 and Kokugakai from 1936; member of both groups. Exhibited once with Shin Hanga Shūdan. Contributed to *Kitsutsuki hangashū*, 1943, and to *Picture Notes on Native Customs of Japan (Nihon minzoku zufu)*, 1946. Awarded Miyazaki prefecture culture prize in 1951. Still exhibiting in 1982. Landscape prints suggest heavy oil paint in vigorously repeated strokes. Sometimes used the signature SA or the first *kanji* of his given name on early prints.

Kurosaki Akira 黒崎彰

B. 1937 in Manchuria. Grad. 1962 Kyoto College of Crafts and Textiles. Exhibited widely in Japan, U.S., and Europe. Member Nihon Hanga Kyōkai from 1969. Represented in Krakow, Ljubljana, Paris, Bradford, Norway, Tokyo, and other biennales. Among his early prints were series including *Holy Night* (22 prints) and *Allegory* (18 prints). His imagery in the 1970s involved truncated flights of stairs in surrealist settings among boxes and balls; evolved into nonobjective abstractions with deep saturation of red color.

Kurosaki Yoshisuke 黒崎義介

1905–1984. B. Nagasaki. Studied at Kawabata Painting School. Worked as children's illustrator from ca. 1927. Member of Japan Children's Art Society.

Kurozaki Akira 黒崎彰

See Kurosaki Akira.

Kusaka Kenji 日下賢二

B. 1936 in Tsuyama, Okayama prefecture. Studied with Nagare Kōji. Exhibited with Kokugakai in 1961. Member of Nihon Hanga Kyōkai from 1963. Represented in competitive print biennales including Ljubljana, São Paulo, Florence, Xylon, and Tokyo. Early prints depicted objects in deep space. These were followed by boldly colored abstractions in which decorative dynamic movement is expressed through abstract forms and shapes in intense colors.

Kusaka Satomi 日下里美

B. 1935 in Tsuyama, Okayama prefecture. Studied with Nagare Kōji, Shimozawa Kihachirō, Munakata Shikō. Exhibited at solo shows and with Banga-in from 1955, Nihon Hanga Kyōkai 1967–1969, Kokugakai, and CWAJ. Member of Banga-in 1956–1966. Founded a correspondence course known as Nihon Moku-Hanga Kyōkai in 1972. Prints include detailed depictions of landscapes, nymphs, and goddesses taken from ancient Japanese myths in the *Kojiki*, *Nihon shoki*, and *Manyōshū*.

Kyōkatsu 郷活

Russo-Japanese War prints published by Matsuki Heikichi.

Kyōko 鏡湖

Russo-Japanese War prints published by Hasegawa Enkichi. Seal: Manda in *hiragana*.

Mabe Tokio 間部時雄

1885–1968. B. Kumamoto prefecture. Grad. 1905 Kyoto Higher Crafts School (now known as Kyoto College of Crafts and Textiles). Studied oil painting with Asai Chū. Traveled in Europe 1920–1925; studied etching. Upon return to Japan became a member of Hakujitsukai. Exhibited in Teiten, Shin Bunten, and the Nihon Sōsaku-Hanga Kyōkai show in 1928. Member of Yōfū Hangakai and founding member of Nihon Hanga Kyōkai; withdrew in 1939. Known for etchings but also made woodcuts.

Mabuchi Hikaru 馬淵晃

B. 1929 in Kanagawa prefecture. Grad. Kantō Gakuin. Member of Taiheiyō Bijutsukai. Prints often depict brightly colored flowers and mountain landscapes. Sometimes uses the character for his given name as a seal.

Mabuchi Tōru 馬淵聖

B. 1920 in Tokyo. Son of the wood engraver Mabuchi Rokutarō. Grad. 1941 from craft design section of Tokyo School of Fine Arts. Exhibited with Zōkei Hanga Kyōkai; member of Nihon Hanga Kyōkai 1954–1960. Joined Nippankai 1960. Rejoined Nihon Hanga Kyōkai 1982. Member and judge of Kōfūkai. Represented at Tokyo International Print Biennale in 1962. Taught at Hiroshima University. Plates sometimes composed of many small pieces of thin wood adhered like mosaics. Prints often deal with landscape, still life, *haniwa*, or pottery.

Maeda Fumio 舞田文雄

See Maita Fumio.

Maeda Kanji 前田寛治

1895–1930. Grad. from Aoibashi branch of school of Hakubakai. Exhibited at Teiten and with Nikakai. Associated with proletarian art movement. Prints of laborers in the 1930s.

Maeda Kōichi 前田光一

B. 1936 in Tokyo. Exhibited with Nihon Hanga Kyōkai 1961–1979 and Shun'yōkai 1980.

Maeda Masao 前田政雄

1904–1974. B. Hakodate City, Hokkaido. Wanted to be an artist from childhood. Met Hiratsuka Un'ichi at an exhibition in Hakodate in 1923. In 1924 went to Tokyo. Grad. 1925 Kawabata Painting School. Lived near Hiratsuka and became his student along with Azechi Umetarō and Shimozawa Kihachirō. Assisted Hiratsuka with administration of the print division of Kokugakai. Exhibited with Kokugakai: oil paintings from 1927, oil paintings and *hanga* in

the 1930s, and *hanga* only in the 1940s. Member of Nihon Hanga Kyōkai from 1932 and Kokugakai from 1943. Member of Hiratsuka's Yoyogi-ha group in 1939. Contributed to *HANGA*, *Kitsutsuki* in 1930, *Kitsutsuki hangashū* in 1942 and 1943, and *Ichimokushū* in 1947–1950. Represented in Tokyo International Print Biennale and numerous other exhibitions at home and abroad. Works include many landscapes, *Eight Views of Hokkaido (Hokkaido hakkei)* in the 1930s and *Famous Gates of Edo*, 1937. Noted for skilled technique in carving and printing. Frequently used the first *kanji* of his given name as a seal.

Maeda Morikazu　前田守一

B. 1932 in Hamamatsu, Shizuoka prefecture. Studied with Yokoyama Yoshiaki at Shizuoka University. In 1952 attracted to the prints of Yamaguchi Gen. In 1955 exhibited oil painting with Modern Art Association and had solo exhibition of small *moku-hanga*. Exhibited with Tokyo International Print Biennale in 1957, Nihon Hanga Kyōkai in 1959, and Modern Art Association in 1964. Member of Nihon Hanga Kyōkai from 1964. Demonstrated woodblock technique at conferences in USSR and northern Europe. His prints of landscapes are highly patterned and somewhat abstract. Has sometimes signed prints in Western script but written from right to left.

Maeda Seison　前田青邨

1885–1977. B. Gifu prefecture. Given name Renzō. Studied with Kajita Hanko and in Europe 1922–1923. From 1914 active with Saikō Nihon Bijutsuin group. Appointed member of Imperial Art Academy in 1935. Artist of the Imperial Household. After 1951 taught at Tokyo University of Fine Arts. A leading Japanese-style painter after World War II; received *Asahi shinbun* culture prize and Order of Cultural Merit in 1955. Blocks for prints, including depictions of flowers and Mt. Fuji, carved by Ōkura Hanbei.

Maeda Tōshirō　前田藤四郎

1904–1990. B. in Akashi City, Hyōgo prefecture; lived in Osaka. Grad. 1927 Kobe Higher Business School. Entered a company as commercial artist. Taught himself *hanga* techniques by working with linoleum. Contributed to MAVO during 1924–1925 and exhibited with Shun'yōkai in 1929. In 1930 he joined Sankōkai in Kobe and founded Yōdosha in Osaka; published two issues of *Yōdo* in 1931, 1933. Member of Nihon Hanga Kyōkai from 1932 and Shun'yōkai. During World War II worked at Northeast Asia Cultural Development Center in Manchuria. In 1980 with Gima Hiroshi formed Tō no Kai in Osaka. Contributed to *Yōdo*, *Tsuge*, *Han geijutsu*, *Kitsutsuki*, and *One Hundred Views of New Japan (Shin Nihon hyakkei)*. Exhibited in international competitions beginning 1950 in Paris, Mexico, and Tokyo. Known for fantastic, surrealist linoleum prints as well as *moku-hanga*. Sometimes used the signature T. Maeda or Mae on early works. Late works, influenced by *bingata* dyeing from Okinawa, are nonrepresentational and highly textured.

Maekawa Bunrei 前川文嶺

1837–1917. B. Kyoto. Given name Shishū. Japanese-style painter specializing in figures and *kachō*.

Maekawa Senpan 前川千帆

1888–1960. B. Kyoto. Original name Ishida Shigezaburō; took the name Maekawa from a relative on his mother's side after father's death in 1905. Younger brother of Asaga Manjirō. In 1905 entered Kansai Bijutsuin; studied with Asai Chū and then with Kanokogi Takeshirō. Went to Tokyo in 1911; began drawing cartoons for *Tokyo Puck (Tokyo pakku)* in 1912. Influenced by 1911 exhibition of Minami Kunzō's prints, began making *moku-hanga*. Exhibited with Nihon Sōsaku-Hanga Kyōkai from 1919; member from 1924. *Yogo Lake in Snow*, 1924, is a representative work of this period. He continued to make a living as a cartoonist, traveling all over the country to sketch local people and customs. Made a reputation in early Shōwa as the creator of *Hasty Bear (Awatemono no Kumasan)*, a series of comics in the *Yomiuri shinbun* Sunday edition about a clumsy bear. Exhibited prints at Teiten in 1927, 1928, 1931 and Shun'yōkai in 1929, 1931, 1935. Founding member, regular exhibitor, and stalwart supporter of Nihon Hanga Kyōkai 1931–1960. Member of Gendai Manga Kyōkai. Contributed to *Han geijutsu, Chōkokutō, Kasuri, Bakuchiku, Dessan, Shiro to kuro, HANGA, Kaze,* and *Jissen hanga*. Also exhibited at Shin Bunten in 1937, 1938, 1942, 1944, at São Paulo in 1953, at Tokyo Biennale in 1957. Made his living as *hanga* artist from 1953. Due to controversy over membership in more than one *hanga* organization, withdrew from Nihon Hanga Kyōkai shortly before his death in 1960. Briefly a member of Nippankai. His affectionate depictions of Japanese manners and customs are in many single prints and albums including a series of 5 vols. of *Hot Spring Notes (Yokusen fu)*, 1944–1959, and *Leisure Time Leisure Books (Kanchū kanbon)*, 1945–1960. Usually signed his prints with one or more of the *kanji* for his name but also used the first three letters of Senpan.

Maekawa Shishū 前川＿＿＿

See Maekawa Bunrei.

Maekawa Toshiharu 前川利春

B. 1927 in Tokyo. Studied oil painting 1947–1952 at Tama College of Fine Arts and Bunka Gakuin. Began making *moku-hanga* in 1976. Exhibited with Nihon Hanga Kyōkai and Kokugakai, 1976–1979, and in solo and international shows. Works include abstractions.

Maita Fumio 舞田文雄

B. 1904 in Iwata prefecture. Family of publishers of woodblock picture calendars. Exhibited with Nihon Hanga Kyōkai in 1936 and with Kokugakai, but essentially remained in Iwata producing more than 1,000 prints of subjects dealing with local landscape and traditions. Member of Nihon Hanga Kyōkai from 1980.

Maki Haku　巻白

B. 1924 in Ibaraki prefecture. Original name Maejima Tadaaki. Grad. 1945 Ibaraki Normal School. Learned printmaking at monthly gatherings organized by Onchi Kōshirō. Member Nihon Hanga Kyōkai from 1958 and Modern Art Society. In the late 1950s and early 1960s experimented with natural grain of wood which he accentuated with wire brush and other tools. Later worked with cement relief built up on blocks of wood or cardboard. Participated in first and second Tokyo International biennales in 1957 and 1960, Pistoia, and other international exhibitions. Prints often deeply embossed with designs derived from Chinese characters or pottery shapes and enriched with a prominent red seal.

Makino Munenori　牧野宗則

B. 1940 in Shizuoka prefecture. From 1960 studied with the traditional *mokuhan* printer Urata Giichi. Exhibited in solo shows, with Shizuoka print group, and abroad. Works include patterned abstract landscapes of sunsets or night scenes.

Makino Taeko　牧野妙子

B. 1936 in Tokyo. Wood engraver. Works include a print collection, *Written Recollections of a Dead Person (Shisha shō tsuisō)*, 1978.

Makino Torao　牧野虎雄

1890–1946. B. Takeda City, Niigata prefecture. Studied at Tokyo School of Fine Arts with Kuroda Seiki and Fujishima Takeji; grad. 1913. Exhibited with Bunten and Teiten. Active in forming Kaijusha and Ōgensha. Participated in formation of Tama College of Fine Arts; taught oil painting. Made woodcuts in early 1940s. Subjects frequently flowers.

Maruyama Banka　丸山晩霞

1867–1942. B. Nagano prefecture. Studied with Honda Kinkichirō. After traveling in Europe and U.S. in 1900 he worked to establish Taiheiyōgakai. Exhibited with Taiheiyōgakai and Bunten. A founder of Japan Watercolor Society. *Hanga* include woodcut illustrations in the magazine *Mizu-e* and *Mountain Flowers*, 1921.

Maruyama Hiroshi　丸山浩司

B. 1953 in Tochigi prefecture. Grad. 1979 Tokyo School of Fine Arts. Studied with Fukita Fumiaki, Noda Tetsuo, and Kawachi Shigeyuki. Exhibited in group and solo shows and with Nichidō 1977, CWAJ 1977–1981, and Ljubljana 1978. Member of Nihon Hanga Kyōkai from 1980. Prints of the 1970s featured wide bands of deftly printed color undulating across dark backgrounds.

Maruyama Yōichi　丸山要一

Contributed to *Kitsutsuki* 1930, and *Shiro to kuro* 1933.

Masada Eizō　政田英三

B. Kyoto. Grad. 1931 Kyoto City Specialist School of Painting. Participated in Kyoto Sōsaku-Hanga Kyōkai exhibition in 1933. Member of group which produced the magazine *Kōhan* in 1935.

Mashiko Hiroshi　益子洋

B. 1910. Grad. Tochigi Normal School. Exhibited in prefectural shows and in Nitten's watercolor division. Contributed to *Mura no hanga* 1933, and *Shin hanga* 1935.

Masumi Tadao　真澄忠夫

Exhibited with Dōdosha group in Shizuoka in 1933. Contributed to *Hanga za.*

Masuzawa Sōichirō　増沢荘一郎

B. 1914 in Okaya, Nagano prefecture. Studied with Takei Takeo. Exhibited with Nihon Hanga Kyōkai in 1954. Active in Nihon Hanga Kyōkai in the Nagano region. Member of Daiichi Bijutsu Kyōkai. Subjects relate to animism and ancient pottery.

Matsubara Naoko　松原直子

B. 1937 in Tokushima prefecture; lived in Kyoto from age 4. Studied at Kyoto City College of Fine Arts with Frau Lizzi Ueno; grad. 1960. Influenced by Munakata Shikō and close association with Shintō through her father, the chief Shintō priest of Kenkun Shrine in Kyoto. In 1961 received a Fulbright travel grant to study in U.S.; in 1962 received MFA degree from Carnegie Institute of Technology in Pittsburgh. Spent a semester at Royal College of Art, London. Back in Japan she taught at Frau Lizzi's International Design Institute. In 1962 she became assistant to chairman of the graphic arts department at Pratt Institute in Brooklyn. Exhibited with Banga-in in 1963, at Cincinnati Museum in 1971, in an exhibition with Munakata Shikō which circulated in Canada in 1976–1977, and in solo exhibitions in Japan, Holland, Germany, Canada, and elsewhere. Lives in Canada. Member of Royal Canadian Academy. Her vigorously carved prints deal with both Japanese and North American subjects.

Matsubara Sadatsugu　松原貞嗣

B. 1904 in Aomori prefecture. Studied with Munakata Shikō. Began making *hanga* ca. 1930. Member of Banga-in. Still exhibiting in 1985. Prints include a representation of children of various races playing together.

Matsubayashi Keigetsu　松林桂月

1876–1963. B. Yamaguchi prefecture. Original name Itō Atsushi. Studied with Noguchi Yūkoku in Tokyo. Exhibited *nanga* paintings in Bunten and Nitten. President of Nihon Nanga-in and Nihon Bijutsu Kyōkai. Appointed member of Japan Art Academy and Art Committee of the Imperial Household. Awarded Order of Cultural Merit in 1959. Prints made shortly after 1900.

Matsuda Reikō 松田黎光

Woodcuts of Korean customs ca. 1931.

Matsui Kenji 松井謙治

B. 1937 in Tokyo. Grad. 1963 Meiji University. Studied *hanga* with Ono Tadashige 1963–1970 and oil painting with Fuse Teijirō. Exhibited with Taiheiyō Bijutsukai.

Matsuki Manji 松木満史

1906–1971. B. Aomori prefecture. Given name Mitsushi. Exhibited with Nihon Sōsaku-Hanga Kyōkai 1928–1929 and Nihon Hanga Kyōkai 1932–1939. Contributed to *Chōkokutō* in 1932. Recipient of Aomori culture prize. Early friend of Munakata Shikō and Sekino Jun'ichirō.

Matsuki Masatoshi 松木雅俊

Exhibited *moku-hanga* with Nihon Sōsaku-Hanga Kyōkai 1928–1929 and Nihon Hanga Kyōkai 1940–1943. Associate member of Nihon Hanga Kyōkai from 1944.

Matsuki Tōru 末木東留

See Arai Tōru.

Matsumoto Akira 松本旻

B. 1936 in Osaka. From 1952 apprenticed to Mitsumoto Kaichi, a relative and *ukiyo-e printer.* Moved to Tokyo in 1957 and worked as an artisan printer for Watanabe Shōzaburō for 2 or 3 years. Hospitalized with tuberculosis. Began making prints by various techniques including *moku-hanga* combined with silkscreen or lithograph in 1960s. Exhibited with Nihon Hanga Kyōkai from 1962; member 1965–1971. Other exhibitions include Shell, Northwest, and Krakow 1970, Frechen 1974, Ljubljana 1975, and Tokyo Biennale 1976. Professor at Women's College of Fine Arts. Many of his *hanga* feature fabric patterns in women's clothing and other patterns including print from English-language newspapers.

Matsumoto Furuhisa 松本古寿

B. 1910 in Oita prefecture. Studied with Takeda Yoshihei. Member of Nippankai, Hakujitsukai, and head of Oita prefecture *hanga* society. Act. mid-1960s. Prints depict local traditions in Oita.

Matsumoto Koju 松本古寿

See Matsumoto Furuhisa.

Matsumura Matsujirō 松村松次郎

First exhibited with Nihon Sōsaku-Hanga Kyōkai and Shun'yōkai in 1928 and Nihon Hanga Kyōkai in 1932. Member of Nihon Hanga Kyōkai from 1936. Contributed to *Shi to hanga* in 1924 and *Hanga* in 1927. Compiled set of prints by Onchi Kōshirō, Koizumi Kishio, Asahi Masahide, and Miyao Shigeo in 1929. Lived in Manchuria in 1939; interned in Siberia; later activities unknown. Prints include expressionistically carved large heads of farming and fishing people and street scenes. Sometimes used the letters "MA" as a signature in the 1920s.

Matsumura Sugijirō 松村杉次郎

B. 1901. Grad. Tokyo School of Fine Arts. Began exhibiting *hanga* in 1921. Contributed to *Shi to hanga* in 1923 and 1925.

Matsunaga Shigeru 松永茂

See Kuriyama Shigeru.

Matsune Yoshio 松根嘉夫

B. 1918 in Osaka. Studied at Akamatsu Western Painting Institute and with Suzuki Hirotaka. Exhibited with Bunten and Nigenkai. Active in Osaka print group.

Matsuo Jun'ichirō 松尾醇一郎

1904–1945. B. Kyoto; moved to Tokyo in 1922. Brother was sent to prison in conjunction with March 15 communist incident. While trying to rescue his brother in 1936 he met Ono Tadashige. Began making *moku-hanga* and entering Shin Hanga Shūdan and later Zōkei Hanga Kyōkai exhibitions. Became member of Nihon Hanga Kyōkai in 1944. According to Hatano Orizō he was seen in November 1945 but was very depressed. Hatano invited him to his evacuation place, but Matsuo did not answer and the next morning had disappeared. Reported to have originated the damp printing technique which Kōsaka Gajin practiced after the war.

Matsuo Shōsuke 松尾少輔

B. Aomori prefecture. Sculptor who exhibited woodcuts with Nihon Hanga Kyōkai intermittently 1940–1947; associate member from 1944. Withdrew in 1960 and joined Nippankai.

Matsuoka Eikyū 松岡映丘

1881–1938. B. Hyōgo prefecture. Given name Teruo. Studied with Hashimoto Gahō and Kobori Tomone. Grad. 1904 Tokyo School of Fine Arts; eventually taught there. Active in promoting Shinkō Yamato-e Moku-Hanga Kai. Exhibited at Bunten and Teiten. Member of Imperial Art Academy. Painted in a modern *yamato-e* style. Landscape prints published by Shin Yamato-e Moku-Hanga Kankōkai ca. 1930.

Matsuoka Toshiyuki 松岡敏行

B. 1921 in Shimonoseki, Yamaguchi prefecture. Grad. 1944 from Japanese-style painting department of Tokyo School of Fine Arts. In 1949, while teaching school, began making *hanga* covers for children's poetry books. Exhibited with Nihon Hanga Kyōkai from 1955; member from 1958. Exhibited in international exhibitions in U.S. and Italy. *Hanga* instructor in Kita Kyushu.

Matsushita Chiharu 松下千春

Exhibited with Nihon Hanga Kyōkai in 1933; associate member from 1944. Contributed to *Shiro to kuro*, *Han geijutsu*, and *Jun*. Member of Takei Takeo's Han no Kai in 1930s.

Matsushita Yoshio 松下義雄

Member of Shin Hanga Shūdan and Zōkei Hanga Kyōkai. Contributed to *Shin hanga* 1933–1935. Exhibited landscape print with Nihon Hanga Kyōkai in 1935. Sometimes carved given name and initial of family name in the block.

Matsushita Yoshitarō 松下芳太郎

B. 1908 in Osaka. Exhibited with Shin Hanga Shūdan in 1932. Published *Shin hanga* with Ono Tadashige. Later studied etching with Nishida Takeo and exhibited with Ōgenkai. Member of Ōgenkai and Shūdan Han.

Matsutani Shōun 松谷昇雲

See Yamamoto Shōun.

Matsuzaki Uichi 松崎卯一

Exhibited with Nihon Hanga Kyōkai 1936. Contributed to *Hanga Nagasaki* in 1934. Published *Eight Views of New Nagasaki (Shin Nagasaki hakkei)*.

Migita Toshihide 右田年英

1863–1925. B. Oita prefecture. Original name Migita Toyohiko. Studied print-making with Tsukioka Yoshitoshi and Western-style painting with Kunisawa Shinkurō. Designed actor prints and Sino-Japanese War prints in 1890s; also woodblock *bijin-ga* and newspaper illustrations. Prints include *Twelve Aspects of Beautiful Women (Bijin jūnishi)*, 1901, and *The First Land Battle (Rikujō no daiissen)*, 1904, both published by Akiyama Buemon.

Mikami Masatoshi 三上正寿

B. 1915 in Miyagi prefecture. Studied Japanese-style painting with Tanaka Ichian. Worked as an illustrator. Known for watercolors and woodcuts. Member of Banga-in.

Mikami Tomoharu 三上知治

See Mikami Tomoji.

Mikami Tomoji 三上知治

1886–1974. B. Tokyo. Studied with Koyama Shōtarō at Fudōsha and at school of Taiheiyōgakai. Exhibited oil paintings at Bunten and Teiten. Member of Taiheiyōgakai. Worked for *Kokumin shinbun* company.

Miki Suizan 三木翠山

1887–1957. B. Kinashi, Hyōgo prefecture. Given name Saiichirō. Studied with Takeuchi Seihō. Exhibited Japanese-style paintings at Bunten, Teiten, Shin Bunten, and Nitten. Six figure prints and 8 landscapes published by Satō Shō-tarō in 1924; included in Toledo exhibition in 1930. These were carved by Maeda, printed by Ōiwa.

Minagawa Chieko　皆川千恵子

B. 1924 in Kyoto. Grad. Kyoto City Specialist School of Fine Arts. Studied with the Japanese-style painter Nishiyama Suishō. *Moku-hanga*, including *Maiko*, ca. 1940, published by Kyoto Hanga-in.

Minagawa Taizō　皆川泰蔵

Among his works are *Landscape with Bird* published by Mikumo Mokuhansha in Kyoto and *Minka*, a traditional steep-roofed farm house.

Minami Kunzō　南薫造

1883–1950. B. near Inland Sea in Hiroshima prefecture. Son of a physician. Grad. 1907 in Western-style painting from Tokyo School of Fine Arts. Studied in Europe 1908–1910. Became friendly with Tomimoto Kenkichi while in England; made woodcuts with him after return to Japan in 1910. An exhibition of Minami's woodcuts in 1911 was probably the first solo exhibit of woodblock prints ever held in Japan. Very influential in attracting others to *moku-hanga*. Exhibited paintings at Bunten and served as a Bunten judge after 1916. Known as a watercolorist. Taught painting at Tokyo School of Fine Arts in late 1930s sharing an office with Hiratsuka Un'ichi. Became honorary member of Nihon Hanga Kyōkai in 1939 when the organization had a special showing of his prints. His self-carved softly colored woodcuts depict scenes from Europe or the Inland Sea.

Minamiya Otohiko　南屋音彦

Contributed intermittently to *Shiro to kuro* 1930–1932 and to the special issue of *Shin hanga* on greeting cards in 1935.

Mineshima Naoji　峯島尚志

See Mineshima Takashi.

Mineshima Takashi　峯島尚志

Participated in Nihon Sōsaku-Hanga Kyōkai exhibitions 1919–1927. Contributed *mokuhan* illustrations to *Mizu-e*.

Mineuchi Tetsuji　峰内鉄二

See Kōsetsu.

Minowa Kazutomo　三ノ輪一巴

B. 1919 in Tokyo. Grad. Waseda University. Studied with Munakata Shikō. Exhibited at solo exhibitions and with Banga-in. Member of Banga-in.

Mitani Toshiko　三谷十糸子

B. 1904 in Hyōgo prefecture. Grad. Tokyo School of Fine Arts. Studied with Nishiyama Suishō. Exhibited at Teiten, Shin Bunten, and Nitten. Taught at Women's College of Fine Arts; president of that college 1951–1975. Made illustrations for serialized novels before World War II.

Mitō 美稲

See Bitō.

Mitsutani Kunishirō 満谷国四郎

1874–1936. B. Okayama prefecture. Studied with Koyama Shōtarō. Studied in France in 1900. Founding member of Taiheiyōgakai. Returned to Paris 1911–1913 and studied under Jean-Paul Laurens. Friendly with Yamamoto Kanae in Paris. Later traveled in China and redirected his style toward flat areas of color. Lithographs of Russo-Japanese War and woodcut illustrations carved by Igami Bonkotsu.

Miura Daisaku 三浦第朔

Member of group that produced *Minato* and designed cover for the first issue in 1926. Also contributed poems and a single-color *moku-hanga* to the third issue in 1927. Exhibited with Nihon Sōsaku-Hanga Kyōkai in 1929.

Miwa Chōsei 三輪晁勢

1901–1983. B. Niigata prefecture. Original name Miwa Noburō. Grad. Kyoto City Specialist School of Painting. Studied with Dōmoto Inshō. Exhibited with Teiten from 1927. Became a Nitten judge in 1951. Subjects include landscapes, people, birds, and flowers.

Miwa Eiko 三輪映子

B. 1937 in Aomori prefecture. Grad. 1962 from literature department of Waseda University. From 1975 exhibited with Banga-in. Member of Banga-in. Creates water imps and other fanciful subjects by *mokuhan* in individual prints and picture books.

Miyachi Karoku 宮地嘉六

1884–1958. B. Saga. Known as novelist interested in proletarian literature. In the Taishō period he designed a collection of black and white woodcuts entitled *Print Collection of Miyachi Karoku (Miyachi Karoku hangashū)*.

Miyagawa Shuntei 宮川春汀

1873–1914. B. Aichi prefecture. Original name Watanabe Morikichi. Studied under Watanabe Shōka and later Tomioka Eisen. Illustrator of newspapers, magazines, and books 1895–1907. Dealt with customs of women and children at play. *A Pictorial Mirror of Tokyo* was published by Matsuki Heikichi in 1903.

Miyagawa Sōhei 宮川草平

Act. 1930s. Details from Kyoto subjects in *rinpa* style; elaborately printed.

Miyaji Karoku 宮地嘉六

See Miyachi Karoku.

Miyake Katsumi 三宅克巳

1874–1954. B. Tokushima prefecture. Studied with Soyama Yukihiko and Harada Naojirō; from 1897 to 1899 took art classes at Yale University. Back in

Japan became known as watercolor painter. Founding member of Kōfūkai and contributor to *Kōfū*, the society's magazine in 1912. Exhibited at Bunten, Teiten, and Shin Bunten. Judge at Teiten. Appointed member of Japan Art Academy in 1951. Made lithographs as well as woodblocks.

Miyake Kōhaku　三宅凰白

1893–1957. B. Kyoto. Given name Seiichi. Grad. Kyoto City School of Fine Arts and Crafts in 1912 and Kyoto City Specialist School of Painting in 1915. Served in the army. Studied with Yamamoto Shunkyo from 1926. Exhibited with Teiten, Bunten, and Nitten. Taught at Kyoto City Specialist School of Painting 1926–1949. After 1951 taught at Kōka Women's Junior College until his death. Woodcuts include genre scenes, festivals, and *nō* actors.

Miyake Kokki　三宅克巳

See Miyake Katsumi.

Miyake Ōhaku　三宅凰白

See Miyake Kōhaku.

Miyamoto Kyōshirō　宮本匡四郎

B. 1915 in Ibaraki prefecture. Member of Shūdan Han. Published *Collection of Ex Libris (Ex Libris sakuhin shū)* and other print and poetry collections including *Print Board (Hangi)*, 1959, *Nude Chorus*, and *Metamorphosis*.

Miyamoto Saburō　宮本三郎

1905–1974. B. Komatsu, Ishikawa prefecture. Went to Tokyo in 1920. Studied with Fujishima Takeji and Yasui Sōtaro at Kawabata Painting School. Exhibited oil painting with Kōfūkai in 1923, Nikakai in 1927; member of Nikakai from 1936. Studied in France 1938–1939. Worked as army illustrator from 1940. Taught at Kanazawa University of Fine Arts and Crafts 1946–1950; after travel in Europe 1952–1953, taught at Tama College of Fine Arts 1953–1965. Withdrew from Nikakai to become founding member of Nikikai in 1947. President of Japan Artists' League in 1958. Appointed member of Japan Art Academy in 1966. Made *mokuhanga* from ca. 1953. Late in life he published *Twelve Titles of Maiko (Maiko jūnidai)* with blocks carved and printed by artisans.

Miyao Shigeo　宮尾しげを

1902–1983. B. Asakusa district of Tokyo. Given name, Shigeo, was originally spelled in *kanji*. Studied *manga* with Okamoto Ippei. Became well known for the comic *Dango Kushinosuke* and other caricatures for children in Taishō and early Shōwa periods. Learned *mokuhan* by self-study. Actively producing *moku-hanga* from 1925; member of Nihon Hanga Kyōkai from 1953; withdrew in 1960 to join Nippankai. Act. 1929–1930 with Asahi Masahide in publication of magazine *Hanga*. Also contributed to *Shiro to kuro* and *HANGA*. Showed prints at Teiten, Shin Bunten, Nitten, and the 1960 Tokyo Biennale. He was a scholar of Edo culture with special interest in *bunraku* and early short novels, a trustee of the *ukiyo-e* society, and recipient of a government award for his contribution to the

preservation of folk dancing and folk songs. His prints reflect both his training as a cartoonist and his interest in traditional arts. Among the best-known prints is *Night Train (Yogisha)*, 1929, in which heavily clothed sleepers are huddled on the wooden benches of an old third-class train.

Miyashita Chōko 宮下晁湖

See Kamoshita Chōko.

Miyashita Tokio 宮下登喜雄

B. 1930 in Tokyo. Son of a metal dealer. Grad. 1951 from literature department of Meiji University. Studied *mokuhan* with Hiratsuka Un'ichi 1946–1948 and metal plate printing with Komai Tetsurō and Sekino Jun'ichirō 1950. Exhibited with Shun'yōkai from 1957. Member of Nihon Hanga Kyōkai from 1955 and Japan Copper-Plate Artist Association. From the 1960s represented in several international print biennales including Tokyo 1960–1968, Ljubljana 1965, 1968, São Paulo 1967, Lugano 1968, and Bradford 1970, 1972. Early prints, before 1962, depicted the waterfront region of Tokyo where Miyashita was born. A related print of the Thames is dated 1980, but later prints are characterized by rugged lines made by soldering wires onto a zinc plate and printing, sometimes in combination with photoengraving, against brilliantly colored backgrounds printed by woodblock.

Miyata Saburō 宮田三郎

B. 1924 in Nagano prefecture. Grad. 1945 Nagano Normal School. Many solo exhibitions. Active in print education and head of Tokyo Hanga Institute. Works include a series *Scenes of Shinshū (Shinshū fūkei)* and 12 albums of Japanese scenery *(Nihon no fūkei)*.

Miyata Takehiko 宮田武彦

B. 1907 in Tokyo. Grad. Tokyo School of Fine Arts. Studied with Okada Saburōsuke. Member of Shun'yōkai. Exhibited in Teiten and Shin Bunten and with Kōfūkai. Worked as illustrator of contemporary novels.

Mizaki Yukio 身崎幸雄

Member of Nihon Hanga Kyōkai 1949–1955. Contributed to *Ichimokushū*.

Mizouchi Heiichirō 水内平一郎

B. 1909 in Kyoto. Grad. 1926 Kyoto City School of Fine Arts and Crafts. Worked as lacquer artist. Contributed to *Shiro to kuro* in 1933 and *Kyōdo gangu hangashū* (a collection of prints on folk toys) in 1934.

Mizufune Rokushū 水船六州

1912–1980. B. Kure, Hiroshima prefecture. Admired the prints of Edvard Munch while still in middle school. Grad. 1936 from sculpture department of Tokyo School of Fine Arts; also studied printmaking with Hiratsuka Un'ichi there. Founding member of Shin Hanga Shūdan in 1932; Zōkei Hanga Kyōkai in 1937. Exhibited with Nihon Hanga Kyōkai from 1933. Contributed to *Shin hanga*.

Exhibited sculpture at Shin Bunten and Nitten and is best known in Japan as a sculptor. Member of Nihon Hanga Kyōkai. Began exhibiting prints widely in 1955. Participated in Tokyo International Print Biennales beginning in 1960. Spent 1961–1962 in U.S. Subjects are frequently birds and objects associated with the sea. Employs thick, opaque watercolor with light colors frequently applied over dark.

Mizuno Kohō　水野孤芳

1862–1928. B. Edo. Studied with Honda Kinkichirō. Active in establishment of Meiji Fine Arts Society in 1888. Published the art and craft magazine *Hanakago* (Flower Basket); 2 issues only. Then became actor in the "new theater." At turn of the century his illustrations for books were produced sometimes by *mokuhan*, sometimes by lithography.

Mizuno Shinsō　水野深艸

Contributed to *Twelve Views of Japan (Nihon jūni fūkei)* published by Unsōdō in Kyoto in 1947.

Mizuno Toshikata　水野年方

1866–1908. B. Tokyo. Given name Kumejirō. Studied woodblock printing with Tsukioka (Taiso) Yoshitoshi from age 13. Also studied ceramic painting with Yamada Ryūto and *nanga* painting with Shibata Hoshū and, after Hoshū's death, with Watanabe Shōtei. Became a porcelain painter at age 20. In 1887 succeeded Yoshitoshi as illustrator for *Yamato shinbun*. Designed prints of battle scenes of Sino-Japanese War. At turn of the century was designing illustrations, including fashion plates for a department store. Frequent subjects were women and children in traditional garden settings. Series entitled *Ancient Beauties (Kodai bijin)*, 1906–1907, published by Sātō Shōtarō. Teacher of Ikeda Shōen, Ikeda Terukata, and Kaburagi Kiyokata.

Mizushima Nihofu　水島爾保布

B. 1884. Commonly called Shichiku. Studied with Kubota Kinsen. Grad. Tokyo School of Fine Arts. Contributed to *Pictures in Famous Places in Osaka and Kobe (Hanshin meisho zue)*, 1916. Wrote and illustrated *Fifty-Three Stations of the Tōkaidō—The Inland Sea (Tōkaidō gojūsan tsugi—Setonaikai)*, 1920; 29 woodblock prints and 49 line illustrations. Specialized in *kamishibai* (paper picture shows), comics, and pictures of social customs. Possibly active with early *sōsaku-hanga* circles.

Moji Kiyomi　門司清美

Member of Banga-in. Prints of flowers in 1970s.

Mori Dōshun　守洞春

1909–1985. B. Takayama, Gifu prefecture. Studied with Onchi Kōshirō, Ryōji Chōmei, and Saitō Yori. Contributed to *Shiro to kuro* in 1930. From 1937 exhibited with Bunten, Tōkōkai, and Nihon Hanga Kyōkai. Member of Nihon Hanga Kyōkai 1943–1960. Member of Nippankai. Contributed to every set of

Ichimokushū 1944–1950 and to *Picture Notes on Native Customs of Japan (Nihon minzoku zufu)*, 1946. Prints include humorous depictions of festivals and customs.

Mori Ichijō 森一城

B. in Osaka. Also known as Mori Kazuki. Studied *hanga* with Matsune Yoshio. Active in Osaka print circles; exhibited with Nigenkai.

Mori Kazuki 森一城

See Mori Ichijō.

Mori Manabu もりまなぶ

1925–1977. B. Saitama prefecture. Grad. 1944 Tokyo Higher Craft School. Exhibited with Banga-in and at various independent shows. Represented at Tokyo Biennales 1957, 1960, 1962 and in overseas exhibitions. Used frottage and other media as well as woodblocks. Prints include abstract combinations of shapes.

Mori Masamoto 森正元

Published by Adachi in 1950s.

Mori Tōshun 守洞春

See Mori Dōshun.

Mori Yasu 森泰

B. 1922 in Kyoto. Grad. 1941 Kyoto Prefectural First Women's High School. After specializing in Japanese-style painting, held her first solo exhibitions of prints in 1957. Participated in Tokyo Biennales in 1957, 1960, 1962. Traveled to New York in 1960 as guest of Japan Society; remained 2 years in U.S. Associate member of Nihon Hanga Kyōkai from 1958; withdrew in 1970. Taught at Osaka University of Arts. Album of prints entitled *Morning (Asa)* self-published in 1958. Prints reflect strong identity with the nature of wood and the cutting tools.

Mori Yoshitoshi 森義利

B. 1898 in Tokyo. From age 15 studied painting and illustration with Yamakawa Shūhō and design for *yūzen* dyeing with Yamakawa Saihō, father of Yamakawa Shūhō. Grad. 1923 from Japanese-style painting division of Kawabata Painting School. Influenced by Yanagi Sōetsu, Serizawa Keisuke, and the folk art movement from 1942. Worked for 30 years as a designer and dyer of kimono fabrics. In 1955 turned to *hanga*, working usually with stencils but occasionally with woodblocks. Member of Kokugakai from 1949, Banga-in from 1955, and Nihon Hanga Kyōkai from 1982. Represented in numerous international competitions including Ljubljana, Barcelona, and Tokyo biennales. Subjects are often workers at traditional tasks, festivals, exotic imagery of Buddhism, or folk art. Style is bold in *mingei* taste.

Moriguchi Hayato 森口隼人

Among his works are two woodblock albums, *Wooden Horse (Mokuba)*, 1930, and *Wooden Rabbit (Mokuto)*, 1931.

Morikane 守兼

Bijin-ga in *Twenty-Four Examples of Charming Figures* published by Shinbisha in early Shōwa.

Morikawa Sobun 森川曽文

1847–1902. Lived in Kyoto. Given name Eiken. Member of Kyoto Art Association and active in Kyoto Japanese-style painting groups. *Moku-hanga* of his *kachō-ga* may be posthumous.

Morikawa Yoshio 森川喜夫

B. 1925 in Toyama prefecture. Exhibited in prefectural and solo exhibitions, Nitten, and Ōgenkai. Member of Nippankai. Act. 1960s.

Morimoto Kiyoshi 森本木羊子

B. 1898 in Kumamoto prefecture. Original name Mori Yoshio. Studied with the seal carver Nogawa Kenshō. From 1952 exhibited every year with Banga-in and other groups. Member of Banga-in. Subjects often derived from Buddhism, architecture, or literature and include *Kudara Kannon of Hōryū-ji*, *Thirty-Three Pilgrimages in the Western Country*, and *Osaka Castle*.

Morimoto Mokuyoshi 森本木羊子

See Morimoto Kiyoshi.

Morisawa Kenzō 森沢謙三

Lived in Kyoto. Studied with Tokuriki Tomikichirō. Exhibited with Nihon Hanga Kyōkai and Kyoto Sōsaku-Hanga Kyōkai in 1933. Contributed to *Print Small Works Collection (Han shōhinshū)* under Tokuriki's direction.

Morita Kōhei 森田曠平

B. 1916 in Kyoto. Studied Japanese-style painting with Kobayashi Kahaku and Yasuda Yukihiko. Member of Saikō Nihon Bijutsuin. Prints of *nō* masks and women.

Morita Michikazu 森田路一

B. 1903. Exhibited intermittently with Nihon Hanga Kyōkai 1932–1941; associate member from 1944.

Morita Sai 森田沙伊

B. 1898 in Sapporo. Grad. 1923 from Japanese-style painting department of Tokyo School of Fine Arts. Exhibited at Teiten, Shin Bunten, and Nitten. Member of Saikō Nihon Bijutsuin. In 1975 appointed member of Japan Art Academy. Prints published by Mikumo Mokuhansha in Kyoto and Kōdansha.

Morita Tsunetomo 森田恒友

1881–1933. B. Osato, Saitama prefecture. Went to Tokyo in 1898. Studied first with Koyama Shōtarō at Fudōsha. Grad. 1906, same class as Yamamoto Kanae, from Tokyo School of Fine Arts. Studied with Nakamura Fusetsu. While a student influenced by Aoki Shigeru. Designed numerous lithographs, etchings,

and woodcuts as member of groups that published *Heitan* and *Hōsun*, 1907–1911. Member of Pan no Kai 1908–1911. Became known for illustrations and *manga* in various newspapers. Went to Europe in 1914. A member of Yamamoto Kanae's circle in Paris and Brittany. Influenced by Cezanne and Daumier. After his return to Japan was temporarily a member of Saikō Nihon Bijutsuin and Nikakai but withdrew from both to become founding member of Shun'yōkai. Contributed 2 sets of 5 prints each to *Japan Scenery Prints (Nihon fūkei hanga)*, 1917. In his late years devoted himself to Japanese-style ink painting.

Moritani Rikio 森谷利喜雄

Exhibited with Nihon Sōsaku-Hanga Kyōkai 1919–1922 and 1929; associate member from 1929. Contributed to *HANGA* intermittently 1925–1928. Among his prints are small studies of nature.

Moritani Tokio 森谷利喜雄

See Moritani Rikio.

Moriya Rikio 森谷利喜雄

See Moritani Rikio.

Moriyama Shūji 森山収治

See Kitazawa Shūji.

Morozumi Osamu 両角修

B. 1948 in Nagano prefecture. Grad. 1974 Tama College of Fine Arts. Exhibited with Nihon Hanga Kyōkai and at Nichidō in 1972; Krakow and Miami international print biennales in 1975. Member of Nihon Hanga Kyōkai from 1975. Prints depict organic three-dimensional forms in deep space through a technique employing dents made in the woodblocks by nail points of various sizes.

Motoyama Michiko 元山道子

B. 1934 in Tokyo. Grad. 1956 from Western-style painting division of Women's College of Fine Arts. Exhibited *moku-hanga* from 1960s; member of Nihon Hanga Kyōkai from 1972. Among her prints are hard-edge abstractions of anatomical forms including blood cells.

Mukai Junkichi 向井潤吉

B. 1901 in Kyoto. Son of a palace carpenter. Studied at Kansai Bijutsuin, Hongō Painting Institute, and Kawabata Painting School. Studied in France 1927–1930. Exhibited with Nikakai; member from 1936. Founding member of Kōdō Bijutsu Kyōkai in 1945. Worked in China and Philippines as a war artist. Best-known woodblocks are scenes of rural Japan.

Munakata Makka 棟方末華

B. 1913 in Aomori. Influenced by Munakata Shikō (no relation) and Hiratsuka Un'ichi; began making *hanga* in 1941 and exhibited with Nihon Hanga Kyōkai, Zōkei Hanga Kyōkai, and Shin Bunten. Also exhibited in U.S., France, Germany, China, and yearly solo exhibitions after World War II. Founding member

of Banga-in 1952; president 1974. Became member of Nihon Hanga Kyōkai in 1946; resigned in the 1960 controversy over membership in more than one *hanga* society. Contributed to *Kitsutsuki hangashū* 1942, 1943. Officer in Nihon Ukiyo-e Kyōkai. Active in Musashino Culture Society and other educational, historical, and restoration societies.

Munakata Shikō 棟方志功

1903–1975. B. Aomori prefecture. Began self-study of oil painting and in 1920 organized Seikōkai (Blue Light Group) to hold exhibitions twice a year. First went to Tokyo in 1924. Inspired to make *moku-hanga* by seeing a Kawakami Sumio print in 1926. Studied briefly with Hiratsuka Un'ichi in 1928. Exhibited prints with Kokugakai from 1930; member 1932–1953. Member of Nihon Hanga Kyōkai 1932–1938. Exhibited early paintings at Hakujitsukai, Bunten, and Teiten. Met Yanagi Sōetsu in 1936; from that time was strongly supported by Yanagi, Kawai Kanjirō, and Hamada Shōji of the folk art movement. From 1937 dealt frequently with Buddhist subjects. Contributed to *Shiro to kuro, Han geijutsu, Kitsutsuki, Chōkokutō, Hōsun hanga,* and *Han.* At the peak of Tokyo bombing in 1945 he evacuated to Toyama prefecture. Founded the *hanga* artist society Nihon Hanga-in (Banga-in) in 1952. First prizes at Lugano in 1952, São Paulo in 1955, and Venice in 1956. His spontaneously carved black and white prints became well known and widely honored. In 1959–1960 visited U.S. and held solo exhibitions in various cities. In 1961 granted the rank of Hokkyō by Hōrinji Temple, Kyoto, and in 1962 the rank of Hōgen by Nisseki Temple in Toyama prefecture. Received Medal of Honor in 1963, *Asahi shinbun* culture prize in 1965, and Order of Cultural Merit in 1970.

Murai Masanari 村井正誠

B. 1905 in Ogaki, Gifu prefecture. Grad. 1928 Bunka Gakuin. Studied with Ishii Hakutei and Arishima Ikuma. Lived in Paris 1929–1933. Founding member of Free Artists Society in 1937, Modern Art Society in 1950, and Japan Abstract Art Club with Onchi Kōshirō in 1953. Taught at Bunka Gakuin. Represented at São Paulo in 1951, 1963, 1967 and at many national and international exhibitions. In 1972 received culture prize of Wakayama prefecture. Works often composed of simple abstract shapes equally well suited to silkscreen, lithograph, or woodblock. With a slight preference for woodblock because the color penetrates the paper, he turns over his compositions to professional silkscreen, lithograph, or woodblock printers.

Murakami Hōko 村上鳳湖

1880–1956. B. Ehime prefecture. Studied with Matsumoto Fūko and Kawai Gyokudō. Exhibited paintings at Bunten from 1907. Prints made ca. 1910.

Murakami Kagaku 村上華岳

1888–1939. B. Osaka. Lived in Kyoto and after 1926 in seclusion in Kobe. Original name Takeda Shin'ichi. Studied at Kyoto City School of Fine Arts and Crafts with Takeuchi Seihō. Grad. Kyoto City Specialist School of Painting.

Exhibited with Bunten. Founding member with Tsuchida Bakusen in 1918 of Kokuga Sōsaku Kyōkai, forerunner of Kokugakai. Facsimile woodblock prints made from his works.

Murakami Sadao　村上貞雄

B. Osaka. Grad. 1930 Kyoto City Specialist School of Painting. Studied *mokuhan* with Tokuriki Tomikichirō. Employed in art section of Takashimaya department store. Participated in Kyoto Sōsaku-Hanga Kyōkai exhibition in 1933 and other *sōsaku-hanga* exhibitions in Kansai.

Murakami Tomoharu　村上友晴

B. 1938 in Tokyo. Grad. 1961 Tokyo University of Art. Exhibited at numerous shows in Tokyo and international exhibitions and at Guggenheim Museum, New York, in 1964. Makes lithographs and etchings as well as *moku-hanga*.

Murayama Kankō　村山観光

1901–1935. B. Shizuoka City. Went to Tokyo in 1924. Studied at Kawabata Painting School. Member of Nihon Sōsaku-Hanga Kyōkai from 1927 and Nihon Hanga Kyōkai from 1932. Exhibited at Kokugakai and in 1931 at Teiten. Contributed to *Kitsutsuki* in 1930. Works shown posthumously at the 1936 Nihon Hanga Kyōkai exhibition.

Muro Junji　室順治

See Abe Jirō.

Mushanokōji Saneatsu　武者小路実篤

1885–1976. B. Tokyo. Family of a viscount of Meiji aristocracy. Attended Gakushūin, the school for children of peers and other high-ranking families. In 1908 published his first book, *Areno*, and in 1910 joined with friends from Gakushūin in founding the magazine *Shirakaba*; contributed essays on art and other subjects. In 1918 founded Atarashiki Mura (New Village), a utopian colony in which artists, writers, and others were to be self-sufficient through farming. Left Atarashiki Mura in 1926 but remained its spiritual leader. Continued writing plays, essays, and poetry. Founded the literary magazine *Daichōwa*. Exhibited painting with Kokugakai in 1929 and painted many *shikishi* throughout his life. In 1951 received Order of Cultural Merit; in 1952 appointed member Japan Academy. Prints of flowers, fruits, and landscapes carved by Yoshimori Sasahiro and published in 1950s by Kensetsusha and Mikumo Mokuhansha. These were signed Saneatsu and sealed Musha.

Mutō Kan'ichi　武藤完一

B. 1892 in Gifu. Studied at Kawabata Painting School under Fujishima Takeji; grad. 1915. Taught at Oita Normal School from 1925. Began producing *mokuhanga* after a short course with Hiratsuka Un'ichi. Took part in proletarian art movement and exhibited with Shin Hanga Shūdan. Exhibited with Nihon Hanga Kyōkai from 1931; member 1938–1960. Member of Nippankai from 1960. Mainstay of magazine *Etching* 1932–1944 and founding member of Japan Etching

Society in 1940. Published *Hori to suri* in 1931; changed the title to *Kyūshū hanga* in 1933 and continued until 1938. Active in promoting *hanga* in secondary schools. Contributed to *Shin hanga, Han geijutsu, Kasuri, Chōkokutō, Hori to suri, Kyūshū hanga,* and *Kitsutsuki hangashū.* Received Oita culture prize in 1950. Sometimes signed prints of 1930s "K.M." or with the first *kanji* in his given name.

Mutō Katei 武藤嘉亭

B. 1910 in Tokyo. Studied painting with Yamakawa Shūhō and printmaking with Kawase Hasui. Exhibited *nihon-ga* at Nitten. Began making prints with Watanabe Shōzaburō in 1954; 5 prints listed in Watanabe's 1962 catalog.

Mutō Rokurō 武藤六郎

B. 1907 in Gifu prefecture. Studied Japanese-style painting at Tokyo School of Fine Arts with Gōkura Senjin; grad. 1934. Learned printmaking techniques through student activities. Exhibited *moku-hanga* with Nihon Hanga Kyōkai 1931–1936. Founding member of Shin Hanga Shūdan in 1932 and Zōkei Hanga Kyōkai in 1937. Contributed to *Shin hanga.* Prints often depict street scenes of 1930s. Worked as teacher after World War II and became well known as a dye and paper craftsman in folk art movement. Member of Banga-in from 1961. Among his works are a handmade book of prints called *Image (Gūzō),* 1952, and numerous *moku-hanga* of street scenes.

Nabei Katsuyuki 鍋井克之

1888–1969. B. Osaka. Studied Japanese-style painting under Suzuki Shōnen and Western-style painting under Kuroda Seiki and Okada Saburōsuke at Hakuba-kai. Studied under Fujishima Takeji and Wada Eisaku at Tokyo School of Fine Arts; grad. 1915. Exhibited painting with Nikakai. Studied in Europe 1922–1923. On his return became member of Nikakai and was active in various Osaka art organizations. Founded Shinanobashi Western-Style Painting Institute in 1938. In 1947 helped organize Nikikai. *Moku-hanga* illustrations before World War II.

Nagachi Hideta 永地秀太

1873–1942. B. Yamaguchi prefecture. Studied with Matsuoka Hisashi. Grad. school of Meiji Art Society. Act. 1902 in formation of Taiheiyōgakai. After travel abroad taught at Tokyo Higher Craft School. Contributed print to *New Modern Print Collection (Shin jidai hangashū)* in 1936. *Moku-hanga* of *bijin-ga.*

Nagachi Shūta 永地秀太

See Nagachi Hideta.

Nagae Haruyoshi 長永治良

1893–1960. B. Kyoto. Studied with Kikuchi Keigetsu. Designer of Nishijin brocade. From mid-1920s made self-carved, self-printed *moku-hanga.* Participated in Nihon Hanga Kyōkai exhibition in 1935.

Nagahara Kōtarō　長原孝太郎

See Nagahara Shisui.

Nagahara Shisui　長原止水

1864–1930. Given name Kōtarō. Studied at Tokyo School of Fine Art with Kuroda Seiki. Exhibited with Hakubakai, Bunten, and Teiten. Friendly with Emil Orlik. Contributed *mokuhan* illustrations carved by Igami Bonkotsu to *Kōfū*. Published the *manga* magazine *Tobae*.

Nagai Hyōsai　永井瓢斎

Given name Eizō. Contributed to *Pictures of Famous Places in Osaka and Kobe (Hanshin meisho zue)*, 1916. Worked for Osaka Asahi Shinbun Company. *Haiku* poet. Still active in 1943.

Nagai Iku　永井郁

Published by Kyoto Hanga-in 1956 and after. Subjects include *bijin-ga* and mythological spirits.

Nagai Kazumasa　永井一正

B. 1929 in Osaka. Attended sculpture department of Tokyo University of Arts in 1951. Active and exhibiting graphic designer. Also represented as *hanga* artist at Warsaw International Poster Exhibition and Tokyo Biennale in 1968. Prints often created without color by deep embossing achieved with zinc plates. Has also made woodblocks.

Nagai Kiyoshi　永井潔

Western-style painter. Member of Modern Art Association and Japan Fine Art Society. Founding member of Nihon Hanga Undō Kyōkai in 1949. Still active in 1972.

Nagare Kōji　永礼孝二

B. 1905 in Okayama prefecture. Studied with Okada Saburōsuke. Made *hanga* beginning 1930s. Member of Banga-in and Nihon Hanga Kyōkai from 1952; in 1960 withdrew and joined Nippankai.

Nagare Shirō　永礼資郎

B. Okayama prefecture. Exhibited intermittently with Nihon Hanga Kyōkai 1932–1943; member from 1946. Home destroyed during World War II and afterward lived in Tsuyama.

Nagase Yoshio　永瀬義郎

1891–1978. B. Ibaraki prefecture. Studied Western-style painting with Kuroda Seiki at the school of Hakubakai. In 1910 entered Tokyo School of Fine Arts to study sculpture; soon transferred to Kyoto City Specialist School of Painting, where he studied Japanese-style painting with Araki Jippo. With Hasegawa Kiyoshi and Hiroshima Shintarō published *Seihei* in 1912; changed its name to *Kamen* in 1913 and continued publication until 1915, providing *moku-hanga* covers and illustrations. In 1916 the same groups formed Nihon Sōsaku-Hanga Club

and held one of the first exhibitions of *sōsaku-hanga*. Exhibited *hanga* with Nika-kai in 1914 and Kokuga Sōsaku Kyōkai in 1919. Participated in first Nihon Sōsaku-Hanga Kyōkai exhibition in 1919. Member of Nihon Sōsaku-Hanga Kyōkai and founding member of Nihon Hanga Kyōkai; withdrew but reinstated in 1954; withdrew again in 1960 to join Nippankai. In 1922 published *To People Who Want to Make Prints (Hanga o tsukuru hito e)*, an influential book on woodblock technique. Studied in France 1929–1936 and exhibited at Salon d'Automne. Sent to China for brief period as war artist in 1939. Guest exhibitor at Banga-in annual show. Represented in Tokyo International Print Biennale and numerous print exhibitions abroad. Early prints were highly expressionis-tic. After his return from France and until his death he experimented in various styles and techniques. Sometimes combined stencil with woodblocks.

Nagase Yoshirō　永瀬義郎
See Nagase Yoshio.

Nagata Kazuhiko　長田一彦
B. 1941 in Toyama prefecture. Studied printmaking with Kanamori Yoshio. Exhibited frequently in Toyama from 1974. Member of Banga-in. Subjects include shells, birds, and references to ancient Egypt.

Nahatame Uichi　那波多目卯一
Prints published by Takamizawa in 1950s.

Naka Kazuya　中一弥
B. 1911 in Osaka. Studied with Oda Tomiya. Woodblock illustrations before World War II.

Naka Kyōzaburō　仲郷三郎
Poet and critic active in Kobe literary circles. Also made woodblocks.

Nakada Kazuo　中田一男
See Nakata Kazuo.

Nakae Yuzuru　中江譲
Lived in Kobe. Exhibited with Nihon Hanga Kyōkai in 1940–1941. Associate member from 1944.

Nakagawa Isaku　中川伊作
B. 1899 in Kyoto. Grad. Kyoto City School of Fine Arts and Crafts in 1918 and Kyoto City Specialist School of Painting in 1921. Studied with Kikuchi Keigetsu. Act. 1929 in formation of Kyoto Sōsaku-Hanga Kyōkai; participated in society's exhibitions. Member of Nihon Hanga Kyōkai from 1932. Also exhibited prints at Kokugakai. From mid-1920s interested in antiques and made his living as an antique dealer; president of Oriental Antique Art Study Group in 1936. Act. 1949–1951 in preservation of art and culture of Okinawa. In 1960s lectured on Japanese painting and modern prints at University of California and in San Francisco area. Works include contributions to *Han geijutsu*, *One Hundred Views*

of *New Japan* (*Shin Nihon hyakkei*), entries in numerous international exhibitions after World War II, and two books on fabric of Okinawa, *Nanpō kafu*, 1941, with color woodblock illustrations, and *Ryūkyū orimono*, 1952. His prints of women, made in the 1930s, are noteworthy for accurately depicted textile patterns.

Nakagawa Kazumasa　中川一政

1893–1991. B. in Tokyo. Self-taught Western-style painter. Exhibited with Nika-kai, Fyūzankai, and from 1922 with Shun'yōkai. Contributed design (carved by Sekino Jun'ichirō) to *Ichimokushū* in 1947. *Moku-hanga* for book illustrations carved by Fukuzawa Sakuichi. Many unconventional literary works. Traveled widely in Europe, North and South America. Received Order of Cultural Merit in 1975. A print of a lily in a painted vase, made in 1961 in his seventieth year, is bright and freely executed in the fauve spirit.

Nakagawa Kigen　中川紀元

1892–1972. B. Nagano prefecture. Given name Kigenji. Studied with Ishii Haku-tei and Masamune Tokusaburō at the school of Taiheiyōgakai and in sculpture department of Tokyo School of Fine Arts. Studied briefly with Henri Matisse in France in 1919. After return to Japan he formed a fauve group called Action in 1923. Exhibited with Nikakai. Founding member of Nikikai in 1947. Painted in both Japanese and Western styles. *Moku-hanga* date from 1930s and early 1940s. Sometimes published by Katō Junji. Subjects include various versions of Kan-non, the Buddhist *bosatsu* of mercy, depicted in sketchy fauve style.

Nakagawa Norimoto　中川紀元

See Nakagawa Kigen.

Nakagawa Yūtarō　中川雄太郎

1910–1975. B. Ihara, Shizuoka prefecture. Began making *moku-hanga* ca. 1929. Pioneer of *sōsaku-hanga* activity in Shizuoka area and strong supporter of *hanga* at grass roots level; promoted and participated in many exhibitions in late 1920s and early 1930s. In 1930 published *Kaketa tsubo* and later helped with production of *Kasuri* and *Yūkari*. Founding member of Dōdosha in 1931. Exhibited with Kokugakai and Nihon Hanga Kyōkai in 1933; member of Nihon Hanga Kyōkai from 1938. Contributed to *Kasuri*, *Yūkari*, *Han geijutsu*, and the second *Kitsutsuki hangashū*. After World War II was very active in *hanga* education. In 1949 published *Hanga Notes* (*Hanga techō*) and in 1954 *Shizuoka hanga*. Awarded a cul-ture prize by Shizuoka prefecture in 1968. After his death a posthumous exhibi-tion was sponsored by the Shizuoka Print Society at Matsuzakaya department store in 1976. Sometimes signed his prints of 1930s with YUT carved in the block.

Nakahara Jun'ichi　中原淳一

1913–1988. B. Kagawa prefecture. From 1932 illustrations, including woodcuts, for girls' magazines.

Nakahara Shirō 中原獅郎

B. 1900 in Yamagata prefecture. Grad. Kyushu University Medical School. Studied printmaking with Etō Masao. Several group and solo exhibitions in 1970s. Member of Banga-in and Taiheiyō Bijutsukai. In addition to *moku-hanga* he created prints by making relief sculptures in clay, firing the clay, and making rubbings from the resulting tiles. Subjects usually related to Buddhism.

Nakajima Kiyoshi 中島潔

B. 1943 in Manchuria. Self-taught poster artist and illustrator. Act. from mid-1960s. *Moku-hanga* include *bijin-ga*.

Nakamura Chūzō 中村仲蔵

See Nakamura Gaku.

Nakamura Daizaburō 中村大三郎

1898–1947. B. Kyoto. Grad. Kyoto City Specialist School of Painting. Studied with Nishiyama Suishō. Juror for Teiten. Genre painter specializing in *bijin-ga*. Woodblock illustrations of modern customs and beauties in newspapers and magazines.

Nakamura Fusetsu 中村不折

1866–1943. B. Edo. Given name Sakutarō. Studied with Koyama Shōtarō and taught at school of Meiji Art Society before going to France in 1901. Studied with Jean-Paul Laurens 1901–1905. Member of Taiheiyōgakai from 1905; member of Art Committee of Imperial Household. Frequently painted historical subjects. Also made illustrations of actors and humorous pieces in Japanese styles. Noted for calligraphy and books on painting. A *moku-hanga* book, *Fusetsu Collection of Pictures Illustrating Haiku (Fusetsu haigashū)*, published 1910.

Nakamura Gaku 中村岳

B. Shizuoka prefecture. Given name Nakazō or Chūzō. Worked as postal employee. Active in formation of Dōdosha and publication of *Yūkari*. Contributed to *Shiro to kuro* and *Kitsutsuki hangashū*, 1943. Participated in Nihon Hanga Kyōkai show in 1940 and Kokugakai exhibitions. Associate member of Nihon Hanga Kyōkai from 1944.

Nakamura Gakuryō 中村岳稜

1890–1969. B. Shizuoka prefecture. Given name Tsunekichi. Studied *yamato-e* with Kawabe Mitate. Grad. 1912 Tokyo School of Fine Arts. Member of Saikō Nihon Bijutsuin 1915–1950. After 1950 active in Nitten. Designed woodblock illustrations for novels. Member of Japan Academy from 1947. Received Order of Cultural Merit in 1962.

Nakamura Ken'ichi 中村研一

1895–1967. B. Fukuoka prefecture. Grad. 1920 Tokyo School of Fine Arts. Studied in France 1923–1928; influenced by Maurice Chaumiere. Exhibited at Teiten. Member of Kōfūkai. Active in Yōfū Hangakai and founding member of Nihon

Hanga Kyōkai. Woodcuts of scenery and *bijin-ga* as well as lithographs in 1930s. Member of Japan Art Academy.

Nakamura Nakazō　中村仲蔵

See Nakamura Gaku.

Nakamura Takuji　中村琢二

B. 1897 in Fukuoka prefecture. Grad. Tokyo University. Studied painting with Yasui Sōtarō. Exhibited with Nikakai, Issuikai, and Nitten. Member of Issuikai board. Member of Japan Art Academy.

Nakamura Tatsu　中村辰

Works in the style of Munakata Shikō. Prints include *The Flautist*, 1968.

Nakamura Teii　中村貞以

1900–1982. B. Osaka. Illustrator. Studied with Kitano Tsunetomi. Woodblock illustrations of modern beauties and customs.

Nakamura Tsune　中村彝

1887–1924. B. Mito; lived in Tokyo. Studied at school of Hakubakai under Kuroda Seiki and at school of Taiheiyōgakai. Also studied under Nakamura Fusetsu and Mitsutani Kunishirō. Exhibited Western-style paintings with Taiheiyōgakai and Bunten. Served as a judge for these organizations and Teiten.

Nakamura Yoshio　中村義夫

Watercolorist. *Moku-hanga* in mid-1920s after seeing creative prints while abroad.

Nakamura Zensaku　中村善策

1901–1983. B. Otaru. Studied at Kawabata Painting School. Exhibited paintings with Nikakai, Issuikai, and Nitten. Contributed self-carved prints in 1938 to *Tansei*, a magazine he also published. Landscape prints in early 1940s.

Nakanishi Yoshio　中西義夫

B. 1899 in Nagano prefecture. Studied with Yamamoto Kanae. Exhibited with Nihon Sōsaku-Hanga Kyōkai 1928–1929. Member of Nihon Sōsaku-Hanga Kyōkai and founding member of Nihon Hanga Kyōkai; withdrew in 1937. Taught *mokuhan* in Yamamoto Kanae's farmers' art movement school. Contributed to *Kitsutsuki* in 1931.

Nakano Kihei　中野喜平

Associate member of Nihon Hanga Kyōkai 1944. Contributed to *Kitsutsuki hangashū* in 1942.

Nakano Yōichi　中野洋一

B. 1944 in Kagoshima prefecture. Grad. 1963 Kobe Murano Technological High School. Studied etching with Noma Denji from 1967, *mokuhan* with Yuki Rei in 1971, and wood engraving with Hiwazaki Takao. In 1970 and 1971 exhibited with

Nihon Hanga Kyōkai and CWAJ. Personally published *Small Islands (Chiisana shima)*, a collection of *moku-hanga*, in 1974.

Nakao Yoshitaka 中尾義隆

B. 1911 in Ehime prefecture. Studied woodblock printing with Azechi Umetarō. In 1940 exhibited an oil painting with Kokugakai. Made cement prints until 1955; after 1955 woodblocks usually printed with oil-base inks. Member of Nihon Hanga Kyōkai from 1948. Exhibited cement prints and *moku-hanga* with Kokugakai from 1949; member from 1960. Contributed to *Ichimokushū* in 1946 and 1949. Participated in Tokyo Biennale in 1962. Prints published by Graphic Art Society of New York on three separate occasions in 1960s. Among his prints are representations of people and objects in simplified abstract form.

Nakata Kazuo 中田一男

Act. ca. 1924 in operation of Osaka Hanga Kōbō; specialized in self-carved, self-printed ex-libris woodblocks of his own design. These were introduced to the general public in *Zōshohyō no hanashi*, a book on the history of bookplates by Saitō Shōzō in 1929. Nakata published his own book on bookplates in 1930. In 1932 he renamed his studio, calling it Zuansha. Exhibited in first Nihon Hanga Kyōkai show in 1931. In 1932–1934 contributed to *Chōkokutō*, *Hanga za*, and almost monthly to *Han geijutsu* and *Shiro to kuro*. Also contributed to first 4 issues of *Akebi* in 1940–1941. Died ca. 1945. Subjects include landscapes, still lifes, a self-portrait, and folk toys as well as bookplates.

Nakayama Shūko 中山秋湖

Made *bijin-ga* in early 1920s including 2 contributions to *New Ukiyo-e Beauties (Shin ukiyo-e bijin awase)*, 1924.

Nakayama Tadashi 中山正

B. 1927 in Niigata prefecture. Studied oil painting at Tama College of Fine Arts. Began making *moku-hanga* in 1950s. Exhibited *moku-hanga*, metal plate prints, and lithographs in solo shows with Nihon Hanga Kyōkai, Japan Art Society, Avant-Garde Art Association, and other organizations; international competitive and solo shows in Poland, U.S., Italy, and elsewhere. Member of Shūdan Han. His early prints, often depicting cranes, were followed by rhythmically stylized horses, flowers, or young girls in decorative and curvilinear patterns with extensive printing in gold. Often signs prints with the date and T. Nakayama in bold, cursive Western script.

Nakazawa Hiromitsu 中沢弘光

1874–1964. B. Tokyo. Grad. 1900 Tokyo School of Fine Arts special course. Studied with Soyama Sachihiko, Horie Masaaki, and Kuroda Seiki. Active in formation of Hakubakai and Kōfūkai. Exhibited at Bunten and Teiten. Contributed *moku-hanga* to *Kōfū*, the magazine of Hakubakai. Made book covers and illustrations. A print entitled *Woman Tying Paper Fortune (Omikuji o musubu onna)* is dated 1905. A mermaid print carved by Yamagishi Kazue and printed by

Nishimura Kumakichi in the early 1920s was probably self-published. Also contributed to *Complete Collection of Chikamatsu*, 1923. *Inn at Gion (Gion no yado)*, 1935, and Tokyo scenes of that period published by Katō Junji. Nakazawa was honored in the 1950s for meritorious service to culture. Sometimes used the first character of his given name in a square or circle as a seal.

Nanryō　南陵

See Torii Kiyotada VII.

Narazaki Eishō　楢崎栄昭

1864–1936. Used the art names Fuyō 1916–1922 and Eishō 1922–1936. Learned copper-plate printing at a government printing office as assistant to the Italian artist Chiossone. Woodblocks published by Watanabe Shōzaburō include *Interior of Asakusa Temple*, *New Diet Building*, *Meiji Shrine*, and *Rissekiho Beach, Korea*.

Narazaki Fuyō　楢崎扶陽

See Narazaki Eishō.

Narita Gyokusen　成田玉泉

Exhibited with Nihon Hanga Kyōkai 1937–1939. Later a member of Banga-in.

Narita Shintarō　成田一太郎

Exhibited with Nihon Hanga Kyōkai 1931–1933, 1936. Contributed to *Shin hanga* in 1935.

Narita Taimei　成田泰明

B. 1921 in Hokkaido. Studied oil painting from 1965 with Takahashi Hokushū. Began making *moku-hanga* in 1976. Solo exhibitions in Asahikawa area. Prints in *sumi* from veneer with additional *sumi* added by brush to back of the paper. Prints often include Buddhist images in female form with Buddhist accessories and words from a sutra.

Narita Yukio　成田幸雄

Member of Aomori *sōsaku-hanga* study group. Contributed *moku-hanga* of Aomori scenery to *Mutsu* in 1931 and *Chōkokutō* in 1932.

Natori Kazue　名取一枝

B. 1924 in Harbin, Manchuria. Studied with Ebihara Kinosuke, Shimozawa Kihachirō, and Ono Tadashige. Exhibited in southern Japan, with Banga-in, and internationally at Krakow and in a circulated exhibition in East Germany. Member of Nihon Bijutsukai and Dai Chōwakai.

Natori Shunsen　名取春仙

1886–1960. B. Tokyo. Given name Yoshinosuke. As a young man looked up to Hirafuku Hyakusui, 11 years his senior. Studied Japanese-style painting with Kubota Beisen and in 1906 exhibited at Inten. Studied at Tokyo School of Fine Arts. Beginning 1908 worked for some time as illustrator for *Asahi shinbun*.

Became associate member of Saikō Nihon Bijutsuin in 1918. Withdrew from Japanese-style painting in 1919 and turned his attention to theatrical subjects; became secretary of the Theatrical Painters Association of Japan (Nihon Gekiga Kyōkai). Became a member of Museikai. A few actor prints were published by Watanabe Shōzaburō beginning in 1916 including *Ganjirō in the Role of Kamiya Jihei*, 1916, and *Baikō in the Role of Otomi*, 1917. After a lapse of several years Watanabe published a series of 36 actor prints, *Portraits of Actors in Various Roles*, 1925–1929, one print designed for each month. This series was shown at the first Toledo Museum exhibition in 1930. It was augmented by 15 additional prints, *Shunsen's Portrait Collection (Shunsen nigao shū)*; 5 of which were shown at the second Toledo Museum exhibition in 1936. The total issue of 51 prints extended into 1931. On the actor prints Shunsen used a variety of seals including a leaf, dual seals reading Shun and Sen, and single seals reading Shunsen, Natori, Shun, Kachichō, Kachichō Tei, Kachichō Sai-in, Shinkai, and Taishidō. Watanabe also published 3 *bijin-ga* by Shunsen 1925–1930 and another series of 30 prints entitled *Portraits of Contemporary Actors in Kabuki Plays*. Prints of dancers were published by Katō Junji. Late in life Shunsen and his wife committed suicide by poison.

Neichi Ryōzō　根市良三

1914–1947. B. Aomori. Childhood friend of Sekino Jun'ichiro and coproducer of a schoolboy *hanga* magazine with Sekino and Satō Yonejirō. Grad. art department of Bunka Gakuin. Studied with Ishii Hakutei and Onchi Kōshirō. Exhibited with Kokugakai and intermittently with Nihon Hanga Kyōkai 1931–1944; member from 1944. Contributed to *Jun, Shin hanga, Chōkokutō, Han geijutsu*, and the 2 issues of *Ichimokushū* in 1944 and 1946. After his death his family established a prize at the yearly Nihon Hanga Kyōkai exhibitions in his name.

Nemoto Kagai　根本霞外

1899–1975. B. Tokyo. Studied *nanga* painting with Matsubayashi Keigetsu. Learned *mokuhan* from Maekawa Senpan as a hobby. Exhibited intermittently with Nihon Hanga Kyōkai 1935–1954; member 1938–1960. Freely cut bird, flower, and insect prints.

Nii Hiroharu　新居広治

B. 1911 in Tokyo. Also known as Arai Kōji. Studied with Okada Saburōsuke and Maeda Kanji. After World War II founded Hanga Undō Kyōkai with Ueno Makoto and Takidaira Jirō. Participated with Takidaira Jirō in producing *Story of Hanaoka (Hanaoka monogatari)*, a series of prints on forced labor from Chinese mine workers. At one time member of Ōgenkai and Nihon Bijutsu Kyōkai.

Niimi Takashi　新美孝

B. 1904. Grad. Kyoto City Specialist School of Painting. Member of Kyoto Sōsaku-Hanga Kyōkai, Jiyū Bijutsu Kyōkai, and Kokugakai.

Nishi Tadashi 西真

B. 1933 in Kyoto. Grad. 1955 from Japanese painting section of Kyoto City College of Fine Arts. Started making serigraphs ca. 1968 but soon switched to *moku-hanga*. Teacher at Saga Fine Arts Junior College. Exhibited widely in Tokyo and Kyoto and in Paris and New York in 1970. Demonstrated woodblock technique in Sydney. Sometimes combined woodblock with lithography.

Nishigai Kazuko 西貝和子

B. 1932 in Shimizu, Shizuoka prefecture. Grad. 1954 from design department of Bunka Gakuin; grad. 1956 from art department. Studied with Yoshida Masaji and Shinagawa Takumi. Exhibited *moku-hanga* and zinc-plate prints with Nihon Hanga Kyōkai and Modern Art Club from 1954 and with Joryū Hangakai. Member of Nihon Hanga Kyōkai from 1958. Represented in Tokyo International Print Biennale.

Nishihara Hiroshi 西原比呂志

B. 1912 in Matsumoto, Nagano prefecture. Studied under Saitō Yori and Kumaoka Yoshihiko and at Kawabata Painting School and school of Taiheiyō-gakai. Exhibited with Bunten, Teiten, and Nihon Hanga Kyōkai. Associate member of Nihon Hanga Kyōkai from 1953. Founding member of New Cooperative Fine Art Society (Shinkyō Bijutsukai). Illustrated children's books. Recipient of Education Ministry and Health and Welfare Ministry awards. Decorative prints of children published by Katō Junji in 1950s. Often used given name in *hiragana* as a signature.

Nishijima Katsuyuki 西嶋勝之

B. 1945 in Yamaguchi prefecture. Studied *mokuhan* at Mikumo publishing house in Kyoto 1964–1968. Exhibited with Kyoto Independents 1965–1970 and in solo and group shows. Experimented with stencil dyeing and printing 1969–1972. From 1972 focused on limited edition *sōsaku-hanga* woodblocks taking subjects from old traditional buildings. Prints include a series *Sixty-Nine Stations of the Kiso Kaidō* and Kyoto street scenes.

Nishikawa Fujitarō 西川藤太郎

See Nishikawa Tōtarō.

Nishikawa Tōtarō 西川藤太郎

B. 1906 in Tokyo. Studied at school of Taiheiyōgakai; grad. 1930 Kawabata Painting School. Studied children's illustrating with Takei Takeo; learned *mokuhan* by self-study. Member of Japan Children's Picture Society and Han no Kai (Hazelnut Society). Exhibited wood engravings at Nihon Hanga Kyōkai from 1936; member from 1965. Contributed to *Shiro to kuro* in 1937. Still exhibiting in 1982. Subjects of late wood engravings include buildings and sculptures of Nara.

Nishikawa Yoshiari 西川義有

B. 1930 in Iwate prefecture. Grad. 1958 Musashino College of Fine Arts. Exhibited with Taiheiyō Bijutsukai and Shun'yōkai. Member of Taiheiyō Bijutsukai.

Nishimura Goun 西村五雲

1877–1938. B. Kyoto. Given name Genjirō. Studied with Kishi Chikudō and Takeuchi Seihō. Exhibited paintings at Bunten and Teiten. Member of Imperial Art Academy. Teacher of Japanese-style painting at Kyoto City Specialist School of Painting. Subjects include flowers, fish, animals, birds, *bunraku* puppets. Carved by Yamagishi Kazue, printed by Nishimura Kumakichi. Used his art name Goun in signatures and seals.

Nishimura Hodō 西村蒲堂

Act. 1930s. *Kachō*, animal, and landscape prints published by Takemura Hideo.

Nishiyama Hideo 西山英雄

B. 1911 in Kyoto. Grad. Kyoto City Specialist School of Painting; studied with Nishiyama Suishō. Exhibited in Bunten and Teiten. Prints include *Twelve Views of Kyoto (Kyoto jūnikei)* published by Unsōdō in 1948.

Nishiyama Suishō 西山翠璋

1879–1958. Born and worked in Kyoto. Given name Usaburō. Studied with father-in-law Takeuchi Seihō. Grad. 1899 Kyoto City School of Arts and Crafts. Became head of Kyoto City Specialist School of Painting. Exhibited in Teiten, Bunten, and Inten. Member of Imperial Art Academy and Imperial Household Art Committee. Received Order of Cultural Merit in 1957.

Nishizawa Tekiho 西澤笛畝

1889–1965. B. Tokyo. Original name Ishikawa Kōichi. Adopted into Nishizawa family upon marrying daughter of family. Studied with Araki Kanpo and then with Araki Jippo. Exhibited paintings with Bunten from 1915 and with Nitten. In 1935–1936 traveled to South Pacific to study local sculpture. Member of National Commission for Protection of Cultural Properties. Known for his studies of dolls. Designed *Collection of Woodblock Prints of the Taishō Earthquake (Taishō shinsai moku-hangashū)*.

Nitta Jō 新田穫

1905–1949. B. Wakayama prefecture. Exhibited with Nihon Hanga Kyōkai in 1932, 1934, 1935. Contributed to *Shin hanga*, 1932. In 1937 created *hanga* collection called *Scenes of Southern Kishū (Nanki fūkei)*. Sometimes signed his prints N or JN carved in the block.

Nitta Minoru 新田穫

See Nitta Jō.

Noda Kyūho 野田九浦

1879–1971. B. Tokyo. Given name Dōsan. Studied Japanese-style painting with Terazaki Kōgyō and Western-style painting at Hakubakai. Grad. Tokyo School of Fine Arts. Exhibited at Bunten. Worked for *Asahi shinbun* in Osaka. Associated with Kitano Tsunetomi in Osaka. Contributed to *Pictures of Famous Places in Osaka and Kobe (Hanshin meisho zue)*, 1916. Returned to Tokyo in 1917.

Noda Tetsuya 野田哲也

B. 1940 in Kumamoto prefecture. Grad. 1960 Tokyo University of Arts; completed graduate program 1965. Member of Nihon Hanga Kyōkai 1969–1971. In 1969 traveled for 8 months around the world. From 1977 taught at Tokyo University of Arts. Exhibited widely in Japan and at international competitive biennales including Tokyo in 1968 and 1976, Krakow in 1970 and 1974, Norway in 1974 and 1978, Frechen, 1976, and Ljubljana in 1977. Among his works are prints as a pictorial diary with images often derived from his travels or the daily activities of his family. His method has involved enlarged mimeographed photographs reproduced through an electrically scanned stencil and applied with silkscreen over a woodblock-printed background.

Noguchi Sanshirō 野口三四呂

Exhibited with Nihon Hanga Kyōkai 1931–1932. Contributed to *Shiro to kuro* in 1933, *Shin hanga* in 1935, and the collection of prints of toys from various regions published by *Han geijutsu* in 1934.

Noma Hitone 野間仁根

1901–1979. B. Ehime prefecture. Went to Tokyo in 1919. Studied at Kawabata Painting School; grad. 1925 from Western-style painting division of Tokyo School of Fine Arts. Studied with Nagahara Kōtarō and Nakagawa Kigen. Exhibited paintings with Nikakai; member from 1929. In 1955 withdrew from Nikakai and with Suzuki Shintarō founded Ichiyōkai. Worked as an illustrator. Started production of *moku-hanga* in 1927; focused on birds and animals when evacuated to Ehime during World War II. Expressionistically carved and printed works include *Monkey*, 1949.

Nomiyama Masao 野見山正雄

B. Fukuoka prefecture. Studied at Suzuki Chikuma school in Tokyo. *Haiku* poet who began making *hanga* ca. 1960 under tutelage of Sekino Jun'ichirō. Exhibited with Banga-in. Produced several collections of *hanga* including *Spider Lily (Manjushage)*, *Pegasus (Tenba)*, and *Yamato*.

Nomiyama Shuchō 野見山朱鳥

See Nomiyama Masao.

Nomura Hiroshi 野村博

B. 1923 in Nagoya. Grad. Musashino College of Fine Arts. Worked as journalist until 1962. Member of Nihon Hanga Kyōkai 1961–1968. Etcher, lithographer, and Western-style wood engraver. Represented in several international competitions including Ljubljana, Lugano, and Tokyo.

Nomura Kōzō 野村候三

B. 1909 in Tokyo. Grad. 1930 Aoyama Normal School. Exhibited oil paintings and *hanga* at Kokugakai and New Classic Fine Arts Society. Member of Kokugakai. After World War II exhibited with Shin Kōzōsha. Member of Banga-in

and Shun'yōkai. Published a children's book, *Horse and Steam Engine (Uma to Jōkisha)*, 1948, with *hanga* illustrations.

Nomura Kunio 野村邦夫

Lived in Gunma prefecture. Associate member of Nihon Hanga Kyōkai from 1968. Subjects include crudely constructed buildings and people.

Nomura Toshihiko 野村俊彦

B. 1904 in Tokyo. Received professional training as woodblock carver; also studied with Kimura Sōhachi. Exhibited *moku-hanga* with Nihon Sōsaku-Hanga Kyōkai from 1927, Shun'yōkai from 1928, Teiten, and Nihon Hanga Kyōkai. Member of Nihon Sōsaku-Hanga Kyōkai, Nihon Hanga Kyōkai from 1932, and Nippankai after 1960. Participated in Nihon Hanga Kyōkai exhibition in Paris in 1934. Contributed to *Print Collection of Great Tokyo (Dai Tokyo hangashū)* in 1929, *Kitsutsuki* in 1930, *Hanga shi*, and two of the magazines called *Hanga* (1927 and 1929). Carved blocks for others including Ishii Tsuruzō and Kimura Sōhachi. Subjects include scenes of downtown Tokyo in 1920s and 1930s.

Nomura Yoshimitsu 野村芳光

Lived in Kyoto. A late member of Utagawa School; taught by his father, Nomura Yoshikuni (Yoshikuni III), 1855–1903, and his grandfather. His great-grandfather, Yoshikuni I, was a pupil of Kuniyoshi. Yoshimitsu also studied panoramic scenery painting with a French painter who had come to Kyoto in 1891. Yoshimitsu established his own school at an early age. Became known for his panoramic views of the war in Satsuma and the attack on Port Arthur during Sino-Japanese War. Also noted for making the scenic backdrop for more than 20 years for annual cherry blossom dance pageant in Kyoto known as the Miyako Odori. *Famous Places Around Kyoto (Kyōraku meisho)*, a set of 6 prints, was published in an edition of 200 in 1931 by Satō Shōtarō. Also reported to have designed actor prints. Prints introduced in the U.S. through Toledo Exhibition in 1936.

Nouet, Noel

Nouet, a French citizen, was director of La Maison Franco-Japonaise and a lecturer at Tokyo University. Also a skillful pen and ink artist. Works included *Ten Views of Tokyo*, 1936, and individual prints *Gate of Zōjōji Temple* and *Kikyō Gate of the Emperor's Palace*, 1935, published by Doi.

Nozaki Saburō 野崎三郎

Exhibited with Nihon Sōsaku-Hanga Kyōkai in 1929. Contributed to *Kitsutsuki* in 1930. In 1934 started *Creative Print Collection of One Hundred Views of Tokyo (Tokyo hyakkei sōsaku-hangashū)* to be published by Nakajima Jūtarō. Not clear whether he was the sole artist or whether the series was completed.

Nozaki Shinjirō 野崎信次郎

B. 1923 in Tottori prefecture. Exhibited with Kōfūkai in 1961, Daiichi Bijutsu Kyōkai in 1964, Sōgenkai in 1965, Kokugakai 1965–1984, Shin Seiki Bijutsu

Kyōkai 1969, Nihon Hanga Kyōkai 1969–1984, and CWAJ 1972, 1977, 1982. Became member of Banga-in 1963 and Nihon Hanga Kyōkai 1974. Also a member of Kokugakai. Works with silkscreen as well as wood. Subjects include non-representational images and mountain landscapes abstracted into angular or rhythmic patterns.

Nozu Sakichi 野津佐吉

B. 1907 in Matsue, Shimane prefecture. Grad. from art department of Nihon University. Studied lithography and etching with Oda Kazuma, *moku-hanga* with Hiratsuka Un'ichi and Onchi Kōshirō. Exhibited with Nihon Hanga Kyōkai in 1935. Member Kokugakai, Ōgenkai, and Daiichi Bijutsu Kyōkai. Taught drawing at a secondary school; taught art education at Tokyo Education University and Tokyo University of Fine Arts. Member of Japan Water Color Society and Sōjukai (Blue Tree Society). Contributed to *Kitsutsuki hangashū* in 1942 and 1943. *Reading*, 1949, was printed in a stippled technique. Sometimes signed prints with first character of his given name carved in the block.

Oana Ryūichi 小穴隆一

See Koana Ryūichi.

Obata Chiura ———

Lived in U.S. Designed prints of American landscapes and figures in Japanese style. California and Yosemite scenes are included among his prints. Published by Takamizawa.

Obata Kōji 尾畑孝司

See Obata Takashi.

Obata Minoru 小畑稔

Exhibited with Nihon Sōsaku-Hanga Kyōkai in 1922 and Nihon Hanga Kyōkai in 1931–1932.

Obata Takashi 尾畑孝司

B. 1938 in Fukuoka prefecture. Grad. 1963 Musashino College of Fine Arts. Influenced by Munakata Shikō, Yamaguchi Nagao, and Ono Tadashige. Exhibited with Banga-in, Kokugakai, and in solo exhibitions. Member of Han no Kai. Subjects include horses, nudes, and landscapes but principally birds.

Obata Tsutomu 小畑勉

B. 1936 in Hyōgo prefecture. Grad. 1956 from oil painting department of Tama College of Fine Arts. Studied with Suematsu Masaki. Later switched from oil painting to *hanga*. Exhibited with Nihon Hanga Kyōkai; member from 1970. Works in various media including *mokuhan*, stencil, silkscreen, and mimeograph. Among his prints are boxlike images related to deep space and compositions derived from close observation of patterns in nature.

Oda Kazuma 織田一麿

1881–1956. B. Tokyo. Studied painting with Kawamura Kiyoo and lithography with Kaneko Masajirō. Also learned lithograph technique from his brother, a lithograph technician in Osaka. Active member of *Hōsun* group 1909–1911. In 1916–1917 produced a set of 20 lithographs on Tokyo scenery, *Tokyo fūkei hangashū*, and in 1917–1919 a similar set on Osaka scenery, *Osaka fūkei hangashū*, both exhibited in 1918. Founding member of Nihon Sōsaku-Hanga Kyōkai in 1918, Yōfū Hangakai in 1930, and Nihon Hanga Kyōkai in 1931. Evacuated to Toyama prefecture 1945–1949. Known principally as lithographer but also made self-carved, self-printed *moku-hanga* and in the 1920s designed woodblocks published by Watanabe Shōzaburō. Keenly interested in *ukiyo-e* and published several works on *ukiyo-e* including *Eighteen Studies of Ukiyo-e (Ukiyo-e jūhachi kō)* and *Ukiyo-e and the Art of Illustration (Ukiyo-e to sashi-e geijutsu)*, 1931. Sometimes signed prints with his given name or first syllable of his given name in *hiragana*.

Oda Tomiya 小田富彌

B. 1896 in Okayama prefecture. Worked in Osaka. Studied Japanese-style painting with Kitano Tsunetomi. Illustrator for novels in magazines and newspapers. Act. ca. 1924. Full-length and *ōkubi-e* prints of *bijin-ga* published by Osaka Mokuhansha and Hakuyōsha in 1930s.

Odagiri Seiichi 小田桐清一

B. 1924 in Aomori prefecture. Studied with Satō Yonejirō. Exhibited with Banga-in from 1955 and in numerous Aomori regional exhibitions. Received Aomori prefectural art and culture award in 1983. Prints include landscapes with traditional temple buildings.

Odake Chikuha 尾竹竹波

1878–1936. B. Niigata prefecture. Given name Somekichi. Pupil of Kawabata Gyokushō. Japanese-style paintings exhibited in Bunten and Teiten.

Ōfude Toshio 大筆敏夫

Exhibited with proletarian art movement. Designed a set of prints of modern *bijin-ga* published by Katō Junji.

Ōgaki Yōichi 大垣陽一

B. 1927 in Hokkaido. Attended Musashino College of Fine Arts. Studied with Matsumi Yaozō. Exhibited in more than 15 solo exhibitions from 1964 and with Nippankai from 1974. Member of Nippankai and Nihon Bijutsuka Renmei. Uses stencil techniques as well as *mokuhan*. Prints of flowers and landscapes sometimes made as diptychs.

Ogasawara Toshiharu 小笠原俊春

B. 1942 in Aomori prefecture. Exhibited with Banga-in, Sōjukai, Sōkikai, and Gendai Bijutsuka Kyōkai.

Ogata Gekkō　尾形月耕

1859–1920. B. Edo. Names include Tai or Nagami Masanosuke and *gō* Gekkō, Kagyōsai, Meikyōsai, Nen'yū, and Rōsai. Took the name Ogata because a descendant of Ogata Kōrin requested that he inherit the name. Self-taught Japanese-style painter, printmaker, illustrator, and decorator of pottery and lacquer. Member of Meiji Fine Art Society. Assisted Okakura Kakuzō in founding Japan Youth Painting Association (Nihon Seinen Kaiga Kyōkai) in 1891. Many prints in late nineteenth century. Series entitled *Beauties at Famous Places (Bijin meishō awase)*, 1901–1906, published by Matsuki Keikichi. Selections from *One Hundred Views of Mount Fuji* won a gold medal at St. Louis World's Fair in 1904. Another print from the same series dated 1916.

Ogawa Sen'ō　小川千甕

1882–1971. B. Kyoto. Given name Tasaburō. Studied with Asai Chū and at Kansai Art Academy. Moved to Tokyo in 1908; in Europe 1912–1914. After return to Japan exhibited Western-style paintings at Nikakai and Japanese-style paintings at Inten. Later practiced *nanga* painting. Woodblocks in early 1920s include *Boat*, ca. 1921, a depiction of a gondola.

Ogawa Sen'yō　小川千甕

See Ogawa Sen'ō.

Ogawa Tatsuhiko　小川龍彦

1910–1988. B. Shizuoka prefecture. Active printmaker from ca. 1927. Associated with Dōdosha. Member of Nihon Hanga Kyōkai from 1941. Working with Yokoi Kōzō and others he announced *Shi ga bō*; published *Marumero* and *Yūkari*, the latter surviving for 29 issues (1931–1935). Also contributed prints to *Kasuri*, *Shiro to kuro*, and *Han geijutsu*. Worked in a travel bureau in Shizuoka. Active in Japan folk art movement and influenced by Yanagi Sōetsu. Burned to death in a house fire.

Ogawa Usen　小川芋銭

1868–1938. B. Edo. Given name was originally Tarō; later changed to Mokichi; also referred to as Sōjū Usen. Studied Western-style painting with Honda Kinkichirō. Became *manga* artist and illustrator. Worked for *Yomiuri shinbun* and *Heimin shinbun* companies. Member Japan Fine Art Academy from 1917. Works include *Three Idiots (Sangusha)*, an album of *moku-hanga* and *haiga*, published in 1912.

Ogishima Yasuji　荻島安二

1895–1939. B. Yokohama. Grad. Keiō University. Known as sculptor. Also made self-carved, self-printed *moku-hanga* and *moku-hanga* for machine printing.

Oguchi Ichirō　小口一郎

1914–1979. B. Tochigi prefecture. Worked as a sign painter. Active in Nihon Hanga Undō Kyōkai in 1950s. Published a *hanga* collection related to places of work. *People Who Yelled in the Field (No ni sakebu hitobito)*, a print dealing with

copper mine pollution, won a special award at an international print exhibition in Berlin in 1970.

Oguchi Katsumi 小口克美

B. 1928 in Nagano prefecture. Studied with Takei Takeo. Member of Shinshū fine arts society; associate member of Nihon Hanga Kyōkai from 1951. Among his prints are depictions of tangled tapes or ribbons.

Ogura Yuki 小倉遊亀

B. 1895 in Ōtsu, Shiga prefecture. Studied Japanese-style painting with Yasuda Yukihiko. Exhibited with Inten from 1926. Became first woman member of Saikō Nihon Bijutsuin in 1932. In 1954 received Education Minister's prize for fostering the arts; in 1956 won the *Mainichi shinbun* art prize. In 1976 became member of Japan Art Academy; in 1978 received Order of Cultural Merit. Recognized as outstanding woman artist. Facsimile *mokuhan* prints.

Ohara Hōson 小原豊邨

See Ohara Shōson.

Ohara Ken 小原憲

Exhibited with Nihon Sōsaku-Hanga Kyōkai 1927–1929. Participated in exhibition sponsored by *Shi to hanga* in 1924; contributed to *HANGA* in 1930.

Ohara Koson 小原古邨

See Ohara Shōson.

Ohara Shōson 小原祥邨

1877–1945. B. Kanazawa. Original name Ohara Matao. Studied with Shijō-style painter Suzuki Kason. Under the name Koson made Russo-Japanese War prints in 1904 and many small *kachō* prints published by Matsuki Heikichi of Daikokuya for export. In 1912 changed name to Shōson and dedicated himself to painting but may have designed a few more prints for Daikokuya under the name Koson. In 1926 resumed *kachō hanga* production. Published chiefly by Watanabe Shōzaburō but also by Nishinomiya Yosaku and Sakai-Kawaguchi. Hundreds of Shōson bird prints exported to U.S. Used the name Hōson on works published by Sakai-Kawaguchi.

Ōhashi Gekkō 大橋月皎

B. 1895 in Tokyo. Member of Japan Illustrators Association. *Ukiyo-e* style actor prints published by Kyoto Hanga-in.

Ōhashi Hiroaki 大橋弘明

B. 1931 in Tokyo. Studied with Sasajima Kihei. Member of Kokugakai. Worked as broadcasting critic. Exhibited with Kokugakai in 1970s.

Ōhashi Kōkichi 大橋孝吉

B. 1898 in Kyoto. Grad. 1917 Kyoto City School of Fine Arts and Crafts. Studied Japanese-style painting at Kyoto City Specialist School of Painting; grad.

1920. Moved to Tokyo and entered Western-style painting department at Kawabata Painting School. Studied in Europe 1924–1927. Exhibited painting with Shin Bunten, Kokuga Sōsaku Kyōkai in 1927, and Kokugakai in 1928. Most productive period as printmaker was in years between return to Japan and ca. 1933; designed both European and Japanese scenes.

Ōhira Kasen　大平華泉

1900–1983. Given name Masao. Studied with Matsubayashi Keigetsu. *Bijin-ga* prints, including *Twenty-Four Sections of Tokyo* and *Twenty-Four Examples of Charming Figures*, published by Shinbisha in Taishō and early Shōwa.

Ōiwa Chūichi　大岩忠一

B. 1891 in Aichi prefecture. Member of Nihon Hanga Kyōkai 1932–1953. An elementary school principal active in art education in Aichi prefecture, especially in promoting children's *hanga*. Taught *hanga* in farmers' art movement school. Contributed to *One Hundred Views of New Japan (Shin Nihon hyakkei)* in 1939.

Oka Shikanosuke　岡鹿之助

1898–1978. B. Tokyo. From age 14 studied sketching with Okada Saburōsuke. Grad. 1924 from Western-style painting section of Tokyo School of Fine Arts. Lived and studied in France 1924–1939. Exhibited with Shun'yōkai from 1941 and with Modern Artists' Society. Went to France again 1959–1961. Member of Shun'yōkai. Member Japan Art Academy from 1968. Received Order of Cultural Merit in 1972. Works include lithographs and woodcuts of flowers, birds, and fish.

Okada Kōichi　岡田行一

B. 1907 in Tokyo. Grad. Bunka Gakuin. Studied with Ishii Hakutei and Arishima Ikuma. Exhibited at Teiten and Nitten. Member of Issuikai. *Moku-hanga* published by Unsōdō.

Okada Saburōsuke　岡田三郎助

1869–1939. B. Saga prefecture. Studied at private painting school of Soyama Yukihiko. Also assimilated the plein-air style of Kuroda Seiki and Kume Keiichirō. Exhibited Western-style painting at National Industrial Exhibition in 1895. Began teaching at Tokyo School of Fine Arts in 1896. Active with Kuroda Seiki and Kume Keiichirō in establishing Hakubakai in 1896. Went to France in 1897; studied painting with Raphael Collin and also engraving. In 1901 returned to Japan and resumed teaching at Tokyo School of Fine Arts. In 1912, with Fujishima Takeji, established the Hongō Painting Institute. Credited with introducing color etching to Japan. Principally known as metal-plate artist but had close associations with *moku-hanga* artists and contributed *moku-hanga* to *Kōfū*, the magazine of Hakubakai, and *Complete Collection of Chikamatsu*, 1923. Founding member of Yōfū Hangakai, an association of etchers and lithographers, in 1930. Returned to France in 1930; discussed with Hasegawa Kiyoshi the possibility of an exhibition of modern Japanese prints in Paris. To facilitate

such an exhibition urged members of Yōfū Hangakai and Nihon Sōsaku-Hanga Kyōkai, as well as independent artists, to unite to form Nihon Hanga Kyōkai in 1931; became president. In 1937 became member of Imperial Art Academy and was awarded Order of Cultural Merit.

Okada Tatsuo 岡田龍夫

An anarchist activist in the early Taishō period. Contributed linoleum prints to *MAVO* and *moku-hanga* to *Kimi to boku*. In 1925 made *hanga* illustrations for Hagiwara Yasujirō's novel *Death Sentence*. In 1928 published *Keisei Gahō* (Creative Picture Report), a short-lived revival of *MAVO*. Style influenced by European constructivism.

Okamoto Kiichi 岡本帰一

1888–1930. B. Hyōgo prefecture. Studied with Kuroda Seiki at school of Hakubakai. Exhibited *moku-hanga* with Fyūzankai in 1912. After dissolution of Fyūzankai he organized Seikatsusha (Livelihood Group) with Kishida Ryūsei, Kimura Sōhachi, and Takamura Kōtarō. Contributed self-carved *moku-hanga* to *Hakutō* and *Fyūzan*. His self-carved *moku-hanga* were issued as single prints and also used as illustrations in the magazine *Kindai no yōga* ca. 1913. Founded New Drama Society (Shingeki Kyōkai) with Hatanaka Reiha and worked on stage scenery. Later an illustrator of children's stories for popular magazines. Prints sometimes used by Onchi Kōshirō as book illustrations.

Okamoto Shinjirō 岡本信治郎

B. 1933 in Tokyo. Exhibited with Japan Independents from 1956, Nikikai from 1958, and at Japan Museum of Modern Art in 1966. Represented in exhibitions in U.S., Mexico, Argentina, Switzerland, and elsewhere. Silkscreen as well as woodblock. Prints are often humorous in a slightly unsettling way like images in dreams.

Okamura Kichiemon 岡村吉右衛門

B. 1916 in Shimane prefecture. Studied with Yanagi Sōetsu and Serizawa Keisuke, a fabric artist associated with folk art movement. Member of Banga-in.

Okano Sakae 岡野栄

1880–1942. B. Tokyo. Studied at school of Hakubakai and Tokyo School of Fine Arts. Exhibited with Kōfukai. Illustrator and *manga* artist.

Ōkawa Yasuo 大川泰央

B. 1941 in Tokyo. Worked as graphic designer. Member of Banga-in, Japan Education Print Society, and Shichisaikai (Seven Color Association). Prints include fanciful abstractions evoking surrealist images of Joan Miro.

Ōkōchi Nobuhiro 大河内信敬

1903–1968. B. Tokyo. Studied at Hongō Painting Institute; grad. Meiji University. Contributed to *Kimi to boku* in 1922. Member of Kōfūkai and Shinjukai. Participated in Nihon Hanga Kyōkai exhibition in 1931. From 1933 exhibited at

Teiten and Shin Bunten. Went to Europe in 1937. After his return in 1938, devoted his attention to painting.

Ōkubo Hajime 大久保一
B. 1911 in Nagasaki prefecture. Studied Western-style painting at Osaka Nakanoshima Institute and printmaking with Kawanishi Hide. Exhibited with Shin Hanga Shūdan and Zōkei Hanga Kyōkai. Contributed to *Shin hanga*. After World War II he returned to his native place and worked as a teacher.

Ōkubo Kazu 大久保一
See Ōkubo Hajime.

Ōkubo Yutaka 大久保担
B. 1924 in Tokyo. Grad. 1941 from business school. Studied lithography with Oda Kazuma. Exhibited both lithographs and woodcuts with Nitten, Ōgenkai, Nippankai, and New Century Fine Art Association as well as in solo exhibitions. Member of Nippankai from 1961. Works include landscape prints with large bright forms presented from unusual vantage points.

Okuda Gensō 奥田元宋
B. 1912 in Hiroshima prefecture. Original name Genzō. Studied with Kodama Kibō. Exhibited with Shin Bunten from 1936. Became a Nitten judge in 1955. Active member of Jitsugetsusha. Member of Japan Art Academy. Subjects of prints often Japanese or Chinese mountains.

Okuda Kiichirō 奥田輝一郎
See Okuda Teruichirō.

Okuda Teruichirō 奥田輝一郎
Exhibited with Nihon Hanga Kyōkai 1932–1937. Contributed to many issues of *Shiro to kuro* in 1930s. Sometimes signed prints TERU carved in the block.

Okui Tomoko 奥井友子
B. 1930 in Toyama prefecture. Studied with Munakata Shikō and Kanamori Yoshio. Member of Banga-in. Also exhibited with Kokugakai.

Okumura Dogyū 奥村土牛
1889–1990. B. Tokyo. Given name Yoshizō. Studied with Kajita Hanko and Kobayashi Kokei. Exhibited paintings with Inten from 1927. Taught at Tokyo University of Arts 1944–1951. Appointed member of Japan Fine Art Academy and Japan Art Academy. In 1962 received Order of Cultural Merit. Subjects include still lifes and flowers.

Okumura Hiroshi 奥村博史
1889–1964. B. Fujisawa, Kanagawa prefecture. Husband of Hiratsuka Raichō, a feminist activist. From 1909 studied with Ōshita Tōjirō at school of Japan Watercolor Society. After Ōshita's death he switched to oil painting. In 1912 contributed *moku-hanga* to the feminist magazine *Seitō* (Blue Stocking). From early

Shōwa exhibited paintings with Nikakai continuously. Became member of Japan Watercolor Society in 1925; studied metal crafting from 1933. In later years showed at solo exhibitions.

Okumura Kōichi　奥村厚一

1904–1974. Born and worked in Kyoto. Grad. Kyoto City Specialist School of Painting. Studied with Nishimura Goun. Japanese-style landscape painter. Exhibited Japanese-style paintings in Teiten, Shin Bunten, and Nitten. Professor at Kyoto City University of Arts. Also taught at Saga Fine Arts Junior College. Prints include *Twelve Views of Kyoto (Kyoto jūni fūkei)* published by Unsōdō in Kyoto in 1948. Some titles in English.

Okuse Eizō　奥瀬英三

1891–1975. B. Mie prefecture. Studied at school of Taiheiyōgakai. Studied with Nakamura Fusetsu. Exhibited Western-style paintings at Teiten and Nitten. Member of Taiheiyōgakai and Shigenkai. Works include *Quiet Prospect of Southern Kishū*, 1936.

Okuyama Gihachirō　奥山儀八郎

1907–1981. B. Yamagata prefecture. Studied under Kōsaka Gajin in 1923. From 1927 exhibited regularly with Nihon Sōsaku-Hanga Kyōkai. In 1928 produced commercial advertisements for the Japan Wool Company from *moku-hanga*. Also designed *moku-hanga* labels for Nikka whiskey and ca. 40 different poster designs printed by Uchida Hidekichi with a watercolor printing machine. In 1931 founded Tokyo Advertisement Art Association (Tokyo Kōkoku Bijutsu Kyōkai); name later changed to Tokyo Kōkoku Sakka Kurabu (Tokyo Advertising Creator's Club). During 1923–1933 also studied with Ishii Kendō, an authority on *ukiyo-e*. Contributed to *One Hundred Views of Great Tokyo (Dai Tokyo hyakkei)*, 1932. In 1942 founded Shin Hanga Kyōkai with Azechi Umetarō and Takayama Uichi. Also active in Nihon Hanga Hōkōkai, the wartime organization in which *shin-hanga* and *sōsaku-hanga* artists worked together in the hope of obtaining materials for their work. At one time his prints were published by Kyoto Hanga-in. In 1946 he established a publishing firm known as Nihon Hanga Kenkyūsho (Japan Print Institute) to promote popularity of *hanga* after the war. The company made facsimile reproductions of Hiroshige prints and possibly other *ukiyo-e* from recut blocks. In 1948 Nihon Hanga Kenkyūsho dissolved; in 1954 Gihachirō established a workshop known as Okuyama Hanga Kōbō in Matsudo where he published his own landscape prints and made facsimile prints from Japanese and Chinese ink paintings and works of Western artists. Gihachirō's son Gijin was in charge of carving in the Matsudo studio and in 1973 took over the management. *Yoroi Bridge* from early in Gihachirō's career, and *Yagiri Ferry Landing in Snow*, 1972, are representative of his more than 1,000 prints.

Okuyama Gijin 奧山義人

B. 1934 in Tokyo. Learned carving technique from his father Okuyama Gihachirō and printing from Sakakura Seijirō at Nihon Hanga Kenkyūsho, a publishing firm the elder Okuyama founded in 1946. That company was dissolved and in 1954 another studio was opened in Matsudo; Gijin was in charge of carving and, after his father's retirement, manager of the studio. Gijin's personal prints, ca. 50, deal with everyday life of common people and intricately detailed landscapes.

Okuyama Yasuo 奧山康夫

Exhibited with Nihon Sōsaku-Hanga Kyōkai in 1929 and Nihon Hanga Kyōkai 1931–1933. Contributed to *Kitsutsuki* in 1930 and 1931 and to *Shiro to kuro* in 1933. Sometimes signed his prints YAS or YASUO carved in the block.

Ōmoto Yasushi 大本靖

B. 1926 in Hokkaido. In 1948 studied at Asagaya Fine Arts Institute (Asagaya Bijutsu Kenkyūsho). Studied *mokuhan* with Kitaoka Fumio. Grad. 1951 Meiji University. Exhibited in solo shows and with Nihon Hanga Kyōkai in 1954 and Modern Art Association in 1960. Member of Nihon Hanga Kyōkai from 1973; active in the association's activities in Hokkaido area. Demonstrated woodblock technique at Purdue University, Indiana University, and elsewhere in U.S. in 1980. Works with silkscreen as well as woodblocks. *Moku-hanga* often deal with trees and the textures of nature in Hokkaido scenes.

Ōmura Kōyō 大村廣陽（広陽）

B. 1891 in Hiroshima. Grad. Kyoto City Specialist School of Painting. Studied with Takeuchi Seihō. Showed Japanese-style paintings at Bunten and Teiten. Prints of Kyoto scenes published by Kyoto Hanga-in.

Onchi Kōshirō 恩地孝四郎

1891–1955. B. Tokyo. Fourth son of Onchi Tetsuo. Learned calligraphy from his father, tutor of three young princes who were to marry the Emperor Meiji's daughters. Grad. 1904 Banchō primary school; grad. 1909 from the middle school for German studies in Tokyo. After failing examination to enter Daiichi Kōtōgakko (First High School), studied oil painting at Aoibashi branch of school of Hakubakai. In December 1909 sent his impressions of the recently published book *Yumeji Picture Collection, Spring Volume* to the artist, Takehisa Yumeji. Encouraged by Yumeji, Onchi entered Tokyo School of Fine Arts in 1910, studying first oil painting and then sculpture. In 1911 he withdrew from the school and through his friendship with Yumeji obtained job as a book designer with Kawamoto Kamenosuke of Rakuyōdō. In 1912 he was readmitted to Tokyo School of Fine Arts. In October 1913, with fellow students Tanaka Kyōkichi and Fujimori Shizuo, he began planning the print and poetry magazine *Tsukubae*; personally created numerous abstract prints and directed publication of 7 issues 1914–1915. Collaborated with Tanaka Kyōkichi during the last months of the latter's terminal illness on illustrations for *Howling at the Moon (Tsuki ni hoeru)*, a

book of poems, by Hagiwara Sakutarō; published 1917. In 1916 joined the poets Muroo Saisei and Hagiwara Sakutarō in producing the poetry magazine *Kanjō*; Onchi contributed cover designs, poems, and *moku-hanga*. *Kanjō* continued publication for 32 issues until November 1919. In 1917 Onchi published his first collection of prints, *Happiness (Kōfuku)*. In 1919 he participated in the first Nihon Sōsaku-Hanga Kyōkai exhibition and in 1921 began publication of the general art magazine *Naizai* with Ōtsuki Kenji and Fujimori Shizuo. Over the years Onchi was also active in producing and promoting other poetry and print magazines to which he contributed poems, prints, graphic design, and articles promoting the idea that printmaking is a legitimate expressive and creative medium, not merely a means of reproduction. Contributed prints to *Minato*, *Kaze*, *Shi to hanga*, *Dessan*, *HANGA*, *Shiro to kuro*, *Han geijutsu*, and *Kitsutsuki* and to numerous collective series. Member of Nihon Sōsaku-Hanga Kyōkai and founding member of Nihon Hanga Kyōkai; a leader and mentor in both associations. Also exhibited prints in Teiten and Kokugakai. By 1927 Onchi had established a reputation as a book designer. In 1928, in the wake of Lindbergh's transatlantic flight, was engaged by a newspaper company to go up in a plane and record his impressions of flight. The resulting book, *Sensations of Flight (Hikō kannō)*, 1934, became a seminal work in book design in Japan. Beginning 1935 he edited for 9 years and 103 issues the monthly magazine *Shosō* (Window of Writing). This magazine on the art of the book set the standard of excellence for Japanese graphic design. He also personally designed over 1,000 books for publishers creating suitable letters for the cover of each one. Also published several books of his own poems or prose with illustrations, among them *Fairy Tale of the Sea (Umi no dōwa)*, 1932, and *A Diary of Random Thoughts (Zuisō nikki)*, 1935. In 1949 received the first prize offered in Japan for book design. In the midst of his busy professional career in 1938 he contributed to *One Hundred Views of New Japan (Shin Nihon hyakkei)*. From 1939 throughout World War II and after, he maintained Ichimokukai, a monthly meeting of *hanga* artists. Active in progressive art organizations after the war including League of Japanese Artists (Nihon Bijutsuka Renmei), Japan Abstract Art Club (Nihon Abusutorakuto Āto Kurabu), and International Print Association (Kokusai Hanga Kyōkai). A major force in the *sōsaku-hanga* movement and the leading abstract print artist of his time in Japan. Sometimes used the signature ONZI on early prints.

Onda Akio 恩田秋夫

B. 1924 in Tokyo. Grad. 1956 from Western-style painting department of Musashino College of Fine Arts. Studied *mokuhan* with Munakata Shikō and Western-style painting with Noguchi Yatarō. Exhibited oil paintings with Independent Fine Art Association 1951–1955. Worked as an assistant for Munakata Shikō at Musashino College of Fine Arts 1963–1968. Exhibited *moku-hanga* in solo exhibitions from 1965. Member of Banga-in. Works are printed in *sumi* on *washi* and painted by hand from the back. Subjects include classic *haiku* poems, children's daily life, and Buddhism.

Ōnishi Kōzō 大西耕三

B. 1920 in Kanagawa prefecture. Self-taught artist. Member of Banga-in. Also exhibits in solo and group shows. Subjects taken from nature and landscapes.

Ōnishi Yasuko 大西靖子

B. 1942 in Kanagawa prefecture. Grad. 1964 from English literature section of Aoyama Gakuin University. Exhibited with Banga-in and in solo exhibitions. Works include *Shadows (Kage tachi)*, 1983, a collection of poems and *moku-hanga*, and large abstract flower prints.

Ōno Bakufū 大野麦風

1888–1976. B. Tokyo. Moved to Kansai after the 1923 earthquake. Exhibited oil painting at Teiten in 1929. Honorary member of Hyōgo prefecture academy of fine arts. Member of Taiheiyōgakai. Produced many landscape and fish prints including *Great Japanese Fish Picture Collection (Dai Nihon gyorui gashū)*, 1940, published by Kyoto Hanga-in; blocks were carved by Matsuda and Kikuda; printed by Shinagawa, Nagae, Uchida, and Ōno.

Ono Chikutō 小野竹桃

Self-taught Japanese-style painter. Exhibited paintings at Teiten and *moku-hanga* with Nihon Sōsaku-Hanga Kyōkai 1919–1921.

Ōno Ryūtoku 大野隆徳

See Ōno Takanori.

Ono Tadaaki 小野忠明

B. 1903 in Hirosaki, Aomori prefecture. Grad. Hirosaki Industrial High School. Self-taught printmaker. From 1942 exhibited with Nihon Hanga Kyōkai and Kokugakai. Associate member of Nihon Hanga Kyōkai from 1944. Contributed to *Kitsutsuki hangashū* in 1943. Participated in Tokyo International Print Biennale exhibitions.

Ono Tadashige 小野忠重

1909–1990 B. Tokyo. Grad. 1941 from department of Japanese and Chinese languages of Hōsei University Higher Normal School. Studied at Hongō Painting Institute 1924–1927. Active in proletarian art movement in 1929; founding member of Shin Hanga Shūdan in 1932 and Zōkei Hanga Kyōkai in 1937. Member of Nihon Bijutsukai. Made *hanga* ca. 1929–1971. Exhibited with Nihon Hanga Kyōkai from 1936. Member of Nihon Hanga Kyōkai but withdrew when organization did not honor his request that it accept all members of Zōkei Hanga Kyōkai as members. Founding member of Japan Print Movement Society (Nihon Hanga Undō Kyōkai) in 1949. Represented in Tokyo International Print Biennale in 1957 and modern Japanese print exhibition in the USSR in 1961. Published and contributed to *Shin hanga*; contributed to *HANGA*. Professor at Tokyo University of Fine Arts, Aichi University of Fine Arts, Hiroshima University, and Utsunomiya University. Contributed significantly to the literature on *hanga* through a book on Chinese prints and several publications on modern

prints in Japan including *Modern Japanese Prints (Kindai Nihon no hanga)*, 1971. Ono's early prints were roughly carved to express the feeling that *hanga* were for the masses. His later prints retain the vigor of rough cutting but are enriched by sonorous color achieved by printing light opaque colors over dark.

Ōno Takanori 大野隆徳

1882–1945. B. Chiba prefecture. Studied Western-style painting with Horie Masaaki. Grad. 1911 Tokyo School of Fine Art. Made *sōsaku-hanga* in early Taishō. Studied in Europe 1922. Showed paintings at Bunten and Teiten. Member of Kōfūkai. Died in a fire during bombing of Tokyo.

Ōnuki Yoshiichirō 大貫芳一郎

Studied with Okada Saburōsuke. Exhibited *Landscapes of Kuji* at Teiten in 1931 and continued exhibiting yearly with Nihon Hanga Kyōkai 1931–1936.

Ōnuma Chiyuki 大沼千遊亀

Moku-hanga of *bijin-ga* published ca. 1958.

Orlik, Emil

1870–1932. Began career as a lithographer and member of Vienna separatist movement. In 1900 he went to Japan to study woodblock printing. In 1903, upon return to Europe, became a teacher in the Berlin Arts and Crafts School. Although the Japanese woodblock process was already understood in theory in Germany, it was not used for personal artistic statements until Orlik's return from Japan. Orlik's influence also spread to avant-garde European expressionism through his friendship with Ferdinand Hodler (1853–1918). Orlik's article on bookplates published in *Myōjō* in 1900 sparked a lively interest in *mokuhan* bookplates that persisted through the 1930s. Among Orlik's woodblocks are *Spring*, 1900, made in Japan, and a portrait of Hodler, 1904.

Osakabe Tatsuo 刑部達雄

B. 1932 in Hamana county, Shizuoka prefecture. Grad. 1954 from education department of Shizuoka University. Worked as a teacher. Exhibited with Nihon Hanga Kyōkai from 1954 and with Kokugakai. Metal-plate and stencil prints as well as woodblock.

Osaku Seiji 小作青史

See Ozaku Seishi.

Osanai Eiichi 小谷内栄一

B. Tokyo. Exhibited with Nihon Hanga Kyōkai from 1931; member 1932–1941.

Ōsawa Tetsumo 大澤鉄面 （大沢）

Lived in Osaka. Participated in first and second Nihon Sōsaku-Hanga Kyōkai exhibitions 1919–1920.

Ōshima Hiroyoshi　大島弘義

B. 1932. Member of Nippankai. Prints include richly colored abstractions of everyday objects combined with large birds.

Ōshiro Sadao　大城貞夫

1908–1981. Lived in Hamamatsu and Kyoto. Studied design at Hamamatsu Technical School. Exhibited with Dōdosha in 1938 and with Nihon Hanga Kyōkai intermittently 1937–1946. Member of Dōdosha, Nihon Hanga Kyōkai from 1946, Kyoto Sōsaku-Hanga Kyōkai. Taught at Hamamatsu Technical School. Also worked as a fabric designer. Subjects include rural people and scenery.

Ōta Fumiyoshi　太田ふみよし

B. 1921 in Abashiri, Hokkaido. Studied with Abe Kōun. Exhibited with Nihon Hanga Kyōkai, Nippankai, and Banga-in. Member Banga-in. Prints include mountain vistas.

Ōta Gakō　太田雅光

1892–1975. Member of illustrators' associations. According to one source a *kabuki* actor print by Ōta was published by Watanabe Shōzaburō ca. 1945. *Present-Day Stars from the Stage,* ca. 1950, and *Figures from the Stage in Shōwa* published by Banchōrō.

Ōta Giichi　太田義一

Western-style painter. Exhibited at Bunten in 1919. Made woodblock illustrations for *Hōchi shinbun* before World War II.

Ōta Kōji　太田耕士

B. 1900 in Hyōgo prefecture. Studied at Hongō Painting Institute. Studied printmaking with Onchi Kōshirō and lithography with Oda Kazuma. Active in proletarian art movement. Exhibited with Zōkei Hanga Kyōkai; member of Nihon Hanga Kyōkai 1944–1972. Founding member of Japan Print Movement Association in 1949. Participated in publication of *Karikare* 1938–1941. Contributed to *Ichimokushū* in 1947. Active in establishing Japan Education Print Association in 1951 and promoting print education for children.

Ōta Kōshi　太田耕士

See Ōta Kōji.

Ōta Masamitsu　太田雅光

See Ōta Gakō.

Ōta Saburō　太田三郎

1884–1969. B. Aichi prefecture. Went to Tokyo at age 17. Studied Western-style painting with Kuroda Seiki at school of Hakubakai and Japanese-style painting with Terazaki Kōgyō. Exhibited painting with Bunten from 1910. Active as *moku-hanga* artist ca. 1912–1915. Prints of this period include *Women's Bath,* 1913, and *Cafe Woman,* 1914. Also designed *Asagiri,* a book of poems and small prints,

1912, probably printed by woodblock with addition of lithograph. Reported to have stopped making *hanga* because someone criticized his prints as poor imitations of Takehisa Yumeji. After study in France, 1920–1922, where he was influenced by fauvism and cubism, he concentrated on painting. Drew newspaper magazine illustrations under the name Kimishima Oshikore. Member of Education Ministry's exhibition committee. Taught at Nanzan University. After World War II became head of Aichi prefectural museum.

Ōtake Isao 大竹功雄

B. 1943 in Kanagawa prefecture. Member of Ōgenkai. Subjects taken from festivals and landscapes.

Otake Kazue 尾竹一枝

1893–1966. Eldest daughter of Japanese-style painter Otake Etsudō; wife of Tomimoto Kenkichi. Grad. Women's Specialist School of Fine Arts. Contributed woodblock covers for ca. 6 issues of magazine *Seitō* in 1914 under the pseudonym Beniyoshi. Also carved blocks for her husband's prints. A pioneer woman *sōsaku-hanga* artist.

Ōtani Kazuyoshi 大谷一良

B. 1933 in Tokyo. Grad. 1933 Tokyo Foreign Language University, Spanish language section. Studied printmaking with Azechi Umetarō. Exhibited with Nihon Hanga Kyōkai, Kokugakai, and in solo shows. Published a collection of *hanga* called *Mountains at Night (Yoru no yamatachi)*, 1979–1980, and other collections of essays, poems, and prints.

Ōtsubo Ken'ichi 大坪憲市

B. 1917 in Hyōgo prefecture. Studied with Murakami Gyojin and Kamoi Rei. Exhibited oil paintings with Kobe Independents. A judge, seeing his painting, commented that his style was suited to *hanga*. Started making *moku-hanga* in 1966. Member of Sōsaku-Hanga Kyōkai and Tō no Kai. Subjects based on *nō* drama and landscapes.

Ōtsuki Bun'ichi 大月文一

B. 1897 in Kyoto. Grad. from painting department of Kyoto City School of Fine Arts and Crafts. Studied *moku-hanga* with Takeda Shintarō. Participated in Nihon Sōsaku-Hanga Kyōkai exhibitions 1923–1924. Contributed to *HANGA* in 1924. Working as a teacher in Kyoto, he actively promoted teaching of *hanga* in schools. With Takeda Shintarō published a collection of prints as a guide for children. Sometimes used the letters "B" and "O" reading from top to bottom as signatures on prints.

Ōtsuki Genji 大月源二

Member of Issuikai. Made woodblock illustrations before World War II.

Ōuchi Kōhō 大内香峰

B. 1941 in Hokkaido. Grad. 1963 Tamagawa University. Self-taught wood engraver. Exhibited with Ōgenkai, CWAJ, Asia Modern Art, and China International Prints exhibitions. Principal subjects are farm houses, folk tools, and rural landscapes.

Ōuchi Makoto 大内マコト

1926–1989. B. Kawasaki. Grad. from Kanagawa Prefectural Craft School. Started making prints ca. 1968. Exhibited with Nihon Hanga Kyōkai and in solo and group shows and at Pistoia 1968, Miami 1973, and Ibiza 1978, 1980, and 1982. Etched images of *kabuki* actors and geometric volumes often combined with woodblock-printed color.

Ōuchi Seiho 大内青圃

1898–1981. B. Tokyo. Given name Tadashi. Grad. 1922 from sculpture department of Tokyo School of Fine Arts. Studied with Mizutani Tetsuya and Takamura Kōun, sculptors of Buddhist images. Studied seal engraving, as used in Buddhist documents, from his father, Ōuchi Seiran, a teacher of Buddhist studies; studied painting from an elder brother. Sculptor of Buddhist images, sometimes interpreting details freely. Member of Nihon Sōsaku-Hanga Kyōkai from 1926; founding member of Nihon Hanga Kyōkai. Member of Reorganized Japan Fine Art Academy from 1927. Appointed member of Japan Art Academy 1969. Contributed to *Shiro to kuro*, *Toki no hito hanga*, *Shin hanga*, and *Han geijutsu*. Prints sometimes rubbings from woodcut blocks.

Ōyama Chūsaku 大山忠作

B. ca. 1922 in Fukushima prefecture. Family of traditional fabric dyers. In 1940 entered Tokyo School of Fine Arts. Studied with Yamaguchi Hōshun. Drafted into the army 1943. Exhibited Japanese-style paintings with Nitten from 1946. Became a judge in 1960. Appointed member of Japan Art Academy. His works are infused with devotion to traditional Japanese patterns and motifs. Prints include *Four Seasons* and other landscapes published by Unsōdō.

Oyamatsu Takashi 小山松隆

B. 1945 in Yamagata prefecture. Grad. 1971 Tokyo University of Arts. Studied with Ono Tadashige, Komai Tetsurō, and Noda Tetsuya. Exhibited in group and solo shows in Japan and international competitions in Bradford, England, 1976, and elsewhere. Subjects include women and sports.

Ozaki Kunijirō 尾崎邦二郎

1909–1979. B. Shizuoka. Grad. Waseda University. Began making *hanga* in 1931. Exhibited with Nihon Hanga Kyōkai and contributed to *Han geijutsu*, *Shiro to kuro*, and *Hanga za*.

Ozaki Shirō 尾崎志郎

Associate member of Nihon Hanga Kyōkai from 1973. Prints include depictions of roughly textured farm buildings and storehouses.

Ozaku Seishi 小作青史

B. 1936 in Tokyo. Grad. 1960 Tokyo University of Arts. Studied with Hasegawa Ryūho, Komai Tetsurō, Wakita Kazu, and Onnaya Kanzaemon. Exhibited with Nihon Hanga Kyōkai and at several international competitions including Krakow 1968 and Florence 1974. Member of Nihon Hanga Kyōkai from 1965 and Jiyū Bijutsu Kyōkai.

Ozaku Taishi 小作青史

See Ozaku Seishi.

Ozawa Yūjirō 小沢勇寿郎

B. 1939 in Tochigi prefecture. Grad. 1964 from sculpture section of Musashino College of Fine Arts. Exhibited prints with Nihon Hanga Kyōkai, CWAJ, and in solo exhibitions. Published series of prints *Japanese Gods (Nihon no kamigami)*, 1978. Other prints deal with temple architecture. Sometimes uses first character of his given name as seal.

Rakuzan Kōshisei 楽山篁子生

See Tsuchiya Rakuzan.

Ran Shigeyuki 蘭繁之

Pub. miniature books which included *moku-hanga*.

Ryōji Chōmei 料治朝鳴

1899–1982. B. Okayama prefecture. Given name Kumata. In 1930s published *Shiro to kuro*, *Han geijutsu*, and other small magazines, including 3 devoted to folk toys. Contributed to these magazines and to *Mura no hanga*. After 1934 did illustrations for various publishers. Exhibited with Nihon Hanga Kyōkai. Encouraged unknown artists and artists from rural areas.

Ryōji Kumata 料治熊太

See Ryōji Chōmei.

Ryōkō 陵岡

See Chapter 7 for signature and seal. Possibly Ayaoka 綾岡, 1817–1887.

Ryūkei 柳蛙

See Utagawa Kokunimasa.

Saeki Rusuo 佐伯留守夫

Grad. from sculpture division of Tokyo School of Fine Arts. Studied *hanga* with Kawakami Sumio. Contributed to *Katana* in 1930. Active in Shin Hanga Shūdan.

Saitō Ioe 斎藤五百枝

1881–1965. B. Chiba prefecture. Studied at school of Hakubakai; grad. Tokyo School of Fine Arts. Studied with Okada Saburōsuke. Woodblock print illustrations before World War II.

Saitō Jirō 斉藤治良

See Abe Jirō.

Saitō Kiyoshi 斎藤清

B. 1907 in Sakamoto, Fukushima prefecture. Moved to Otaru in Hokkaido at age 5; later apprenticed to a sign painter. From an early age operated a successful sign painting business in Otaru. Studied drawing with Narita Gyokusen in Otaru. Infatuated with the art world, he sold his business and moved to Tokyo in about 1932. Studied Western-style painting at Hongō Painting Institute. Exhibited oils with Hakujitsukai, Nikakai, Kokugakai, and Tōkōkai. Began making *hanga* by cutting and printing progressively from a single block because he liked the effect achieved by printing. But, like most Western-oriented young artists at that time, he thought he had to be an oil painter to be successful. After exhibiting with Nihon Hanga Kyōkai in 1936 and the acceptance of a *moku-hanga* in the print division of Kokugakai in 1937, he began to think seriously about *hanga*. At the invitation of Ono Tadashige he joined Zōkei Hanga Kyōkai in 1938. In the same year he began the *Winter in Aizu* series, a group of prints of the snow country in which he lived as a child. He first exhibited the Aizu prints in 1942 under wartime conditions in the upstairs gallery of a brush and paper store. Entered employment with Asahi Newspaper Company in 1943. A chance meeting with Onchi Kōshirō at the Asahi office led to an invitation to Ichimokukai and membership from 1944 in Nihon Hanga Kyōkai. In 1946 or 1947, shortly after the end of the war, he exhibited with Hiratsuka Un'ichi and Kawanishe Hide in a new gallery opposite the Imperial Hotel. At that show he sold his first print. In 1948 he exhibited at the Salon Printemps, an exhibition sponsored by Americans as a benefit for Japanese artists. Became a member of Kokugakai in 1950. In 1951 he received first prize at São Paulo for *Steady Gaze*, 1950. Because the Japanese works for the exhibition arrived late his print was in competition against Japanese oil painting and *nihon-ga*. This award to a woodblock print in an international exhibition awakened the Japanese art establishment—which had been indifferent if not hostile to *hanga*—to the respect which modern prints enjoyed abroad. Saitō also won a major prize at the international competition in Ljubljana in 1956. Visited the U.S. in 1956 under auspices of the State Department and Asia Foundation; from that time exhibited widely throughout U.S. and Europe and made a living from prints. Attracted to the use of wood grain in the work of Gauguin and Munch in the 1940s. In 1954 on a visit to Katsura palace in Kyoto he discovered the orderly beauty of architecture and compared it to the intellectual organization he had seen in Mondrian paintings. This led him to search for the essentials of nature and express them in flat areas of color and texture in bold and graceful designs. His prints are especially appreciated abroad.

Saitō Shin'ichi 斎藤真一

B. 1922 in Okayama prefecture. Studied with Ihara Usaburō, Terauchi Manjirō, and Fujita Tsuguharu. Grad. Tokyo School of Fine Arts. Known for etchings, lithographs, and woodcuts of blind women.

Saitō Toyosaku 斎藤豊作

1880–1951. B. Saitama prefecture. Grad. 1905 Tokyo School of Fine Arts extension course in Western-style painting. Studied in Paris 1906–1912 under Raphael Collin. Married the French artist Camile Saranson. Exhibited with Kōfūkai and Bunten; founding member of Nikakai 1914. Exhibited with Nikakai for the last time in 1919; then returned to France for the rest of his life. Woodcuts, including acrobats and jugglers, made in early Taishō.

Saitō Yori 斎藤与里

1885–1959. Given name Yoriji. Studied with Asai Chū and in Paris 1906–1909 under Jean-Paul Laurens. Founding member of Fyūzankai. Exhibited at Bunten, Teiten, and Taiheiyōgakai. Later a founding member of Tōkōkai. Designed woodblock poster advertising the first Fyūzankai exhibition; carved by Seimiya Hitoshi.

Sakada Taiichi 坂田泰一

See Sakata Taiichi.

Sakaguchi Minoru 坂口実

B. 1910 in Saitama prefecture. Grad. 1930 Saitama Normal School. Studied Western-style painting with Terauchi Manjirō, Ishikawa Toraji, and Satake Toku. Exhibited in 1960s and 1970s with Nihon Hanga Kyōkai and in solo exhibitions. Member of Nihon Hanga Kyōkai from 1975 and Kokugakai. Late prints are highly patterned illustrations of the *Tales of Genji*.

Sakamoto Hanjirō 坂本繁二郎

1882–1969. B. Kurume. Went to Tokyo in 1902 with his friend Aoki Shigeru; entered Fudōsha and studied with Koyama Shōtarō. In 1904 studied at school of Taiheiyōgakai. While drawing cartoons for *Tokyo Puck (Tokyo Pakku)* he met Yamamoto Kanae and Ishii Tsuruzō with whom he worked on *Hōsun* 1909–1911; contributed lithographs and drawings for woodcuts. With Yamamoto Kanae he published a collection of woodcuts, *Stage Figure Sketches (Sōga butai sugata),* in 1911. Participated in formation of Nikakai in 1914. Contributed 5 designs to *Japan Scenery Prints (Nihon fūkei hanga),* a series published by Nakajima Jūtarō in 1918. Studied at Academie Colarossi in France 1921–1924. Returned to Kurume. Became a highly respected Western-style painter. Awarded Order of Cultural Merit in 1956. *Five Views of Aso,* 1950, and *Three Horse Pieces,* 1951, published by Katō Junji. From recut blocks, Katō Junji also posthumously published his prints from the *Japan Scenery Prints* series under the title *Five Scenes from Tsukushi (Tsukushi gokei)* in 1970 and 6 prints from the *Stage Figure Sketches* series in 1971 under the title *Butai Sugata.*

Sakamoto Isamu 坂本勇

B. 1931 in Fukushima prefecture. Grad. 1961 Musashino College of Fine Arts Junior College. Member of Nippankai from 1965 and Shin Seiki Bijutsu Kyōkai

from 1966. Prints, often featuring landscapes and traditional buildings, include *Heart of Japan (Nihon no kokoro)* and *Four Seasons in Fukushima (Fukushima shiki)*.

Sakamoto Yoshinobu 坂本義信

B. Kōchi prefecture. Made *hanga*, including *Thirty Views of Kōchi*, ca. 1925, while working as teacher. Contributed to *Han geijutsu* special issues on folk toys in 1934.

Sakata Taiichi 坂田泰一

B. 1925 in Wakayama prefecture. Grad. 1947 Wakayama Normal School. Studied with Hasegawa Tomisaburō. Exhibited with Banga-in from 1971, New Century Fine Art Association in 1972, and in Switzerland and Italy. Member of Banga-in from 1974. Subjects range from *Early Spring (Sōshun)*, depicting an orderly allée of bare-branched trees, to the confusion of a firefighting scene.

Sakata Yasukazu 坂田泰一

See Sakata Taiichi.

Sakauchi Hiroshi 坂内宏

See Bannai Kōkan.

Sasai Toshio 笹井敏雄

B. Niigata prefecture. Grad. Takada Normal School. Studied woodblock printing with Shimozawa Kihachirō and Hiratsuka Un'ichi. Officer in Banga-in. School principal in Niigata prefecture.

Sasajima Kihei 笹島喜平

B. 1906 in Mashiko, Tochigi prefecture. Grad. 1927 Aoyama Normal School. Worked as a teacher until 1945. Close friend of Hamada Shōji. Studied independently with Hiratsuka Un'ichi in 1935 and Munakata Shikō in 1936. Exhibited with Shun'yōkai and Kokugakai in 1930s. Member of Nihon Hanga Kyōkai 1948–1952. Founding member of Banga-in 1952. Reinstated in Nihon Hanga Kyōkai in 1958 but withdrew again in 1960. Joined Nippankai. Many solo exhibitions and represented in Tokyo Biennale 1957–1966 and São Paulo Biennale 1967. After 1962 worked only on religious subjects. Style involves deep embossing by forcing damp paper into the grooves of a carved woodblock under pressure on an etching press and then applying ink by tampons on the raised surface. Sometimes uses first character of family name printed in red as a seal.

Sasaki Kō 佐々木孔

See Sasaki Takashi.

Sasaki Takashi 佐々木孔

1907–1974. Active in proletarian art movement. Member of Nihon Hanga Kyōkai from 1938. Contributed to *Kitsutsuki hangashū* in 1943. An etcher but apparently also made woodblocks.

Satō Hiromu 佐藤宏

See Satō Hiroshi.

Satō Hiroshi 佐藤宏

B. 1923 in Yokka-ichi, Mie prefecture. Grad. 1941 from drafting department of Nagoya City Industrial Specialist School. Exhibited with Nihon Hanga Kyōkai and Kokugakai in 1950s; member of both groups and Graphic Arts Club. Exhibited at international competitions in Tokyo in 1957 and Krakow. His works include large semiabstract images executed in sharp and graded lines and placed against a background of roughly parallel lines.

Satō Kimiharu 佐藤公春

B. 1929 in Oita prefecture. Exhibited with Hakujitsukai, Nihon Hanga Kyōkai, and in international competitions. Member of Hakujitsukai.

Satō Sadaichi 佐藤貞一

Woodblocks of Korean scenes in 1930s.

Satō Taisei 佐藤太清

B. 1913 in Kyoto. Given name Minoru. Attended Tokyo Foreign Language School. Studied Japanese-style painting with Kodama Kibō. Exhibited with Shin Bunten from 1943, Nitten from 1947. Nitten judge from 1957. Taught at Musashino College of Fine Arts.

Satō Yonejirō 佐藤米次郎

B. 1915 in Aomori prefecture. Younger brother of Satō Yonetarō. Studied with Shimozawa Kihachirō, Hiratsuka Un'ichi, and Munakata Shikō. In 1930 with his brother organized Aomori Sōsaku-Hanga Study Society. From 1936 exhibited with Nihon Hanga Kyōkai and Kokugakai. Member of Nihon Hanga Kyōkai 1943–1960. Joined Nippankai in 1960. Presently member of Banga-in. With his brother published *Chōkokutō*, *Mutsu goma*, and *Aomori hanga*. Contributed to *Shin hanga* intermittently 1932–1945. In 1955 helped establish Aomori Print Society. Received Aomori Prefecture culture prize.

Satō Yonetarō 佐藤米太郎

B. Aomori City. Elder brother of Satō Yonejirō with whom he organized Aomori Sōsaku-Hanga Study Society in 1930. Learned *mokuhan* technique from Hiratsuka Un'ichi and Munakata Shikō. With Satō Yonejirō published *Mutsu* and *Chōkokutō* in 1931. Later participated in publication of *Mutsu goma* and *Aomori hanga*. Contributed to *Shiro to kuro* in 1932. Member of Nihon Hanga Kyōkai from 1948 until his death in 1958.

Seichō 清澄

Signature and seal that can be read Seichō appear on a print of a cat. See Chapter 7.

Seiko　静湖

Signature that can be read Seiko appears with a small seal on a print of a crow. See Chapter 7.

Seimiya Akira　清宮彬

See Seimiya Hitoshi.

Seimiya Hitoshi　清宮彬

1886–1969. B. Hiroshima. Also known as Seimiya Akira and Kiyomiya Akira. Studied Western-style painting at school of Hakubakai with Kuroda Seiki and wood engraving with Gōda Kiyoshi. Contributed to *Hakutō* in 1910. Founding member of Fyūzankai in 1912 and Sōdosha in 1915. Contributed self-carved prints to *Fyūzan*. Founding member of Nihon Hanga Kyōkai in 1931. Print presented to French National Library by request at time of the 1934 *sōsaku-hanga* exhibit in Paris. Prints of *Fyūzan* period are strongly influenced by fauvism. Later works reflect his study of Chinese woodblock technique.

Seimiya Naobumi　清宮質文

B. 1917 in Tokyo. Son of Seimiya Hitoshi. Grad. 1941 from Western-style painting department of Tokyo School of Fine Arts. Participated in extracurricular etching class of Tanabe Itaru. Took up printmaking after World War II. Exhibited with Shun'yōkai from 1954; member 1957–1977. Exhibited at Gendai Nihon Bijutsuten in 1966. Represented in international biennales in Tokyo and Ljubljana. Published print collection called *Dark Setting Sun (Kurai Yūhi)* in 1972. Prints suggest vaguely organic shapes in undefined space.

Seino Katsumi　清野克美

B. 1916 in Yamagata prefecture. Studied at Surugadai Western-Style Painting Institute and with Fujita Tsuguharu. Represented in Tokyo Biennale. Member of Modern Art Kyōkai.

Sekido Isaburō　関戸伊三郎

B. 1914 in Tokyo. Also known as Sekido Jinsaburō. Grad. Tokyo School of Fine Arts. Studied with Ishii Hakutei. Member of Sōdosha and Issuikai. Prints published by Takamizawa in 1950s.

Sekiguchi Shungo　関口俊吾

Contributed in 1932 to *One Hundred Views of Great Tokyo (Dai Tokyo hyakkei)*. Prints from watercolors published by Kaneda Shōten (Nihon Hanga Kenkyūsho).

Sekino Jun'ichirō　関野準一郎

1914–1988. B. Aomori. From boyhood knew Munakata Shikō as a charismatic painter a few years his senior. Sekino made woodblock prints with friends while still in middle school. Studied etching in Aomori with Kon Junzō. Contributed to *Chōkokutō* in 1932, *Shin hanga* in 1935. Exhibited with Nihon Hanga Kyōkai from 1932. Moved to Tokyo in 1939 after winning a 1936 Teiten prize for an etch-

ing. Studied etching at Etching Institute of Nishida Takeo and oil painting and drawing at a private painting school. Studied woodblock with Onchi Kōshirō and Maekawa Senpan for whom he worked from time to time as a printer. Became member of Nihon Hanga Kyōkai in 1938 and Kokugakai in 1940. Contributed to every set of *Ichimokushū*. Represented in international competitions at Tokyo, Northwest, Ljubljana, and elsewhere. Won wide acclaim in the U.S. after World War II for *moku-hanga*. Traveled in U.S. in 1958 under auspices of Japan America Society; taught at Oregon State University in 1963. Taught at Kobe University in 1965. Awarded medal by Imperial Household Agency in 1981. Sekino was a prolific printmaker in styles ranging from detailed portraits in the late 1940s and early 1950s to semiabstract prints with greater emphasis on pattern and design after mid-1950s. Among his late works are *Fifty-Three Stations of the Tōkaidō*, *Collection of Aomori Folk Toys*, *Collection of Famous Japan Folk Toys*, *Old Capital*, and *Prints of the Narrow Road to the Deep North*.

Senda Kōji 泉田康治

B. 1908 in Toyama prefecture. Grad. Takaoka Crafts School. Later studied with Maekawa Senpan and Munakata Shikō. Exhibited with Kōfūkai and Nitten. Member of Nippankai.

Senda Yasuharu 泉田康治

See Senda Kōji.

Shiba Hideo 柴秀夫

1907–1979. B. Ibaraki prefecture. Self-taught painter and printmaker. Founding member of Shin Hanga Shūdan in 1932 and Zōkei Hanga Kyōkai in 1937. Contributed to *Shin hanga* in 1932; exhibited with Nihon Hanga Kyōkai in 1935. Produced for only a short while. Prints strongly influenced by fauvism. Sometimes signed H.S. carved in the block.

Shibata Osamu 柴田治

B. 1932 in Fukuoka prefecture. Grad. 1956 Fukuoka University of Liberal Arts. Made *moku-hanga* while a student but switched to lithographs. Exhibited with Jiyū Bijutsu Kyōkai, Nihon Hanga Kyōkai, Japan Fine Art Society, and solo exhibitions.

Shigeta Hiroshi 繁田博

B. 1921 in Shizuoka City. Member of Nihon Hanga Kyōkai from 1952 and Shizuoka Prefecture Hanga Kyōkai. Member of Shizuoka Prefecture Poetry Society.

Shima Seien 島成園

1892–1970. B. Sakai City, Osaka. Given name Narie. Daughter of the painter Shima Eikichi. Studied Japanese-style painting with Kitano Tsunetomi. Exhibited with Bunten at age 21. Painter of *bijin-ga* in half-Western, half-Japanese manner. Withdrew from painters' circles while living in various Japanese cities to which her husband was transferred as a bank employee but returned to Osaka after World War II and resumed painting. Had a solo exhibition at Osaka

Daimaru and continued working until year of her death. An active creator of *bijin-ga* prints. Contributed to *New Ukiyo-e Beauties (Shin ukiyo-e bijin awase)*. Works self-published or published by Hakuyōsha.

Shima Tamami 島珠実

B. 1937 in Hirosaki, Aomori prefecture. Grad. 1958 Women's College of Fine Arts. Member of Banga-in. Received travel grant from College Women's Association of Japan in 1962. Prints of 1960s often feature rhythmic fanciful birds.

Shimada Kaname 島田要

B. 1885 in Marugame, Kagawa prefecture. Worked as teacher in Osaka. Exhibited with Nihon Sōsaku-Hanga Kyōkai in late 1920s. Member of Nihon Hanga Kyōkai 1932–1954. Contributed to *Shin hanga* in 1935. Linoleum cuts as well as woodblocks. Prints often depict laborers or poor farmers.

Shimada Shōzō 島田章三

B. 1933 in Kanagawa prefecture. Grad. 1958 Tokyo University of Arts. Exhibited oil painting with Kokugakai in 1957 and in other exhibitions. Started making *hanga* ca. 1970 working with metal-plate prints and lithographs as well as woodblocks. Member of Kokugakai. Professor at Aichi University of Fine Arts. Woodblock prints, possibly carved and printed by artisans, include *Woman's Figure* and *Lady's Portrait*.

Shimizu Kōichi 清水孝一

B. 1895 in Tokyo. Studied at Kawabata Painting School and with Nagase Yoshio. Exhibited with Nihon Sōsaku-Hanga Kyōkai from 1927 and Nihon Hanga Kyōkai 1931–1935. Member Nihon Hanga Kyōkai 1931–1941. Contributed to *HANGA* in 1927, *Kitsutsuki* issue 2 in 1930, and *Shin hanga* in 1935. Exhibited with Taiheiyōgakai, Shun'yōkai, and Teiten. Printed for various *sōsaku-hanga* artists and for Japan Modern Creative Print Collection *(Nihon gendai sōsaku-hanga taishū)*, 1927–1928, published by Hasegawa Tsuneo of Nihon Hangasha. Contributed to *One Hundred Views of New Japan (Shin Nihon hyakkei)* in 1939.

Shimizu Kon 清水崑

1912–1974. B. Nagasaki. Illustrator and *manga* artist. Well known for cartoons of water imps.

Shimizu Masahiro 清水正博

B. 1914 in Tokyo. Studied with Ono Tadashige. Founding member of Shin Hanga Shūdan and committeeman of Zōkei Hanga Kyōkai. In mid-1930s exhibited with Nihon Hanga Kyōkai; later withdrew in protest against its refusal to automatically accept all members of Zōkei Hanga Kyōkai. Exhibited with Kokugakai; committee member of the *hanga* division of Ōgenkai. Contributed to *Shin hanga* and *Kitsutsuki*. Injured in China during World War II. Postwar prints reflect severity of that experience. Scenes of *shita-machi* and the Sumida River as well as other urban landscapes and seascapes. Prints of 1930s sometimes signed MAS carved in the block.

Shimizu Miezō 清水三恵三

1893–1962. B. Yokka-ichi, Mie prefecture. Grad. 1919 from sculpture department of Tokyo School of Fine Arts. *Nihon-ga* selected for exhibition at Teiten. Worked as illustrator for book covers and newspaper novels. Designed a *bijin-ga* series, *Twelve Months of Chikamatsu (Chikamatsu jūni-kagetsu)*, ca. 1930. Signed prints with the characters of his given name.

Shimizu Takejirō 清水武次郎

B. 1915 in Wakayama prefecture. Grad. 1935 Wakayama Normal School. Exhibited with Nihon Hanga Kyōkai and Kokugakai. Associate member Nihon Hanga Kyōkai 1949; withdrew 1967.

Shimizu Tōru 清水遠流

B. 1938 in Toyama prefecture. Self-taught *hanga* artist. Sets of prints include *Snow Country (Yukiguni)*, 1971, *Four Seasons in Japan (Nihon no shiki)*, 1973–1974, and *Autumn in Paris (Pari no aki)*, 1974. Style is detailed and descriptive.

Shimoyama Tsutomu 下山力

B. 1945 in Kyoto. Grad. 1967 from design department of Musashino College of Fine Arts. Exhibited with Nihon Hanga Kyōkai from 1972 and CWAJ from 1973. Landscapes, particularly Spanish landscapes, are usual subjects.

Shimozawa Kihachirō 下澤木鉢郎 （下沢）

1901–1984. B. Hirosaki, Aomori prefecture. Family name originally Shimoyama; changed to Shimozawa in 1935. First exhibited at Teiten in 1924. Friendly with Hiratsuka Un'ichi and knew Ishii Hakutei and Umehara Ryūzaburō through him. Also introduced Munakata Shikō, whom he knew from Aomori, to Hiratsuka. Member of Nihon Sōsaku-Hanga Kyōkai and Nihon Hanga Kyōkai 1931–1952. Member of Kokugakai and the Yoyogi group clustered around Hiratsuka in late 1930s. Founding member of Banga-in. Contributed to *Han, Han geijutsu,* and *Kitsutsuki hangashū.* Exhibited in first Tokyo Biennale, 1957. Many landscape prints, including *Twelve Views of Aomori (Mutsu jūnikei)* and *Hokkaido Series.* Also published the book *Komae Village (Komae Mura)*, 1943, a limited edition of 50 copies with poems and 3 *moku-hanga.*

Shimura Tatsumi 志村立美

1907–1980. B. Takasaki, Gunma prefecture. Given name Sentarō. Lived in Yokohama from 1910. Studied from 1921 with Yamakawa Saihō, a designer, and after 1924 with Yamakawa Shūhō, the son of Saihō. Illustrator for serialized newspaper novels from 1925. Exhibited paintings with Kyōdokai in 1927 and Seikinkai in 1938. Contributed to *One Hundred Views of Great Tokyo (Dai Tokyo hyakkei)*, 1932. *Bijin-ga* are among his works. *Hanga* published in limited editions by Katō Junji of Nihon Hanga Kenkyūsho ca. 1948–1952.

Shinagawa Takumi 品川工

B. 1908 in Kashiwazaki, Niigata prefecture. Grad. 1928 Tokyo Prefectural Crafts School, metal sculpture section. Studied *moku-hanga* with Onchi Kōshirō. Mem-

ber of Nihon Hanga Kyōkai from 1947 and Kokugakai. Contributed to *Ichimokushū*, 1947. Represented in international exhibitions including Ibiza 1969, Krakow 1975, and elsewhere. Creates in various media including photograms and frottage. *Moku-hanga* include large abstract compositions printed in bright clear colors.

Shin'ei 新栄
Actor prints in late 1920s. Published by Matsuki Heikichi.

Shinkai Yosaku 新開与作
B. Kyoto. Grad. 1934 Kyoto City School of Arts and Crafts. Studied *mokuhan* with Tokuriki Tomikichirō. Member of Tanryokukai (Red-Green Society), a group associated with Tokuriki, and contributed to *Collection of Small Prints (Han shōhin shū)*, a publication of that group.

Shishido Tokuko 宍戸徳子
B. 1930 in California. Entered California College of Crafts in 1948; grad. 1952. Exhibited from 1953 with Nihon Hanga Kyōkai and from 1955 with Graphic Arts Club. Member of Nihon Hanga Kyōkai from 1954. Studied at school of Boston Museum of Fine Arts 1957–1959 and at Stanford University. Founding member of Women's Print Association in Japan 1956. Showed in Tokyo Biennale in 1960 and in New York, San Francisco, and Paris. Known principally for copper-plate prints but also makes *moku-hanga*. Her images suggest abstractions of kimono-clad figures often in mirror-image pairs.

Shōdō 奨堂
See Kawarazaki Shōdō.

Shūhō 秋方
Signature can be read Shūhō followed by a seal. See Chapter 7.

Shuku Sanpō 粛粲宝
B. 1902 in Niigata prefecture. Original name Mizushima Taichirō. Grad. Tokyo School of Fine Arts. Studied with Kaburagi Kiyokata and Kobayashi Kokei. Exhibited *nihon-ga* and *suiboku* paintings at Teiten and Inten. Works include a set of *moku-hanga* of fish and river scenes of the 12 months.

Shūzan 宗山
See Terazaki Kōgyō.

Sobun 曽文
See Morikawa Sobun.

Sōjū Usen 草汁芋銭
See Ogawa Usen.

Sone Kiyoharu 曾根清治
B. 1930 in Kagawa prefecture. Grad. 1951 Kagawa University. Studied with Kadowaki Shun'ichi. Exhibited paintings with Daiichi Bijutsu Kyōkai from

1961; member from 1966. Self-carved, self-printed *moku-hanga* are fanciful and humorous.

Sora Mitsuaki 空充秋

B. 1933 in Hiroshima. Grad. 1957 Tama College of Fine Arts. Worked for Sears Roebuck and Company in Tokyo 1957–1961. Toured Mexico and U.S. 1963–1964. Created stone sculpture for Olympic village in 1964 and landscape garden using stone sculpture for Bunkyō Women's University in Hiroshima in 1965. Solo exhibitions of *moku-hanga* almost yearly at Yōseidō Gallery from 1962. Prints often depict strong interlocking organic or geometric shapes.

Sōzan 宗山

See Terazaki Kōgyō.

Sueki Tōru 末木東留

See Arai Tōru.

Suga Tatehiko 菅楯彦

1878–1963. B. Tottori prefecture. Given name Tōtarō. Studied Tosa-style painting from his father. Painted history and customs in *yamato-e* style. Exhibited in Nitten. Member of Osaka Art Society. Prints carved by Yamagishi Kazue, printed by Nishimura Kumakichi. Used the *kanji* seal Tatehiko.

Sugafuji Kasen 菅藤霞仙

1891–1955. B. Hiroshima prefecture. Exhibited with Nihon Hanga Kyōkai 1932–1938, Shun'yōkai, and Shin Hanga Shūdan. Associate member of Nihon Hanga Kyōkai in 1955. Wrote an article on *hanga* in a children's encyclopedia.

Sugihara Masami 杉原正巳

1913–1946. B. Shizuoka prefecture. Studied woodblock with Hiratsuka Un'ichi in extracurricular class at Tokyo School of Fine Arts; grad. 1938. Member of Nihon Hanga Kyōkai from 1943. Contributed to *Ichimokushū*. With Onchi Kōshirō, Yamaguchi Gen, Kato Tarō, and Sekino Jun'ichirō created a limited edition book, *Natural History Notes (Hakubutsu-fu)*. Died of tuberculosis as indirect casualty of the war.

Sugimoto Yoshio 杉本義夫

B. 1905 in Wakayama prefecture. In 1929 studied with Nitta Jō. Act. 1932 in Kumano Kitsutsuki Society. Exhibited with Nihon Hanga Kyōkai in 1932.

Sugiyama Masayoshi 杉山正義

Exhibited with Dōdosha in Shizuoka 1929. Contributed to *Yūkari*, *Han geijutsu*, and *Hanga za*.

Suita Bunmei 吹田文明

See Fukita Fumiaki.

Suita Fumiaki 吹田文明

See Fukita Fumiaki.

Sukegawa Yoshikatsu　助川義勝

B. 1945 in Fukushima prefecture. Grad. 1969 Fukushima University. Exhibited with Nikikai in 1968, Shin Kōzōsha from 1972, and Shūdan Han from 1975. Member of Shin Kōzōsha. Works include more than 100 *moku-hanga* in a series on Tibetan mandalas.

Sumitomo Yū　住友雄

B. Takayama, Gifu prefecture. Friend of Mori Dōshun. Exhibited with Nihon Hanga Kyōkai from 1939; member from 1943. Also exhibited with Shimeikai in Kyoto.

Suwa Kanenori　諏訪兼紀

1897–1932. B. Kobe. Exhibited with Nihon Sōsaku-Hanga Kyōkai from 1921; member of Nihon Sōsaku-Hanga Kyōkai and charter member of Nihon Hanga Kyōkai. Exhibited *hanga* at Teiten in 1927. Worked as designer for the Shiseidō company. Contributed to *Shi to hanga*, *Shiro to kuro*, *HANGA*, *Han geijutsu*, *Kitsutsuki*, and *Mura no hanga*. Had 12 works in *One Hundred Views of New Tokyo (Shin Tokyo hyakkei)* in 1929. Died of appendicitis. Works shown posthumously at second Nihon Hanga Kyōkai exhibition in 1932.

Suzuki Gyosui　鈴木御水

B. 1898 in Akita prefecture. Studied Japanese-style painting with Itō Shinsui. Worked as an illustrator.

Suzuki Hiroshi　鈴木廣（広）

B. 1933 in Aomori prefecture. Grad. 1967 Nihon University, economics department. Studied printmaking with Munakata Makka and Satō Yonejirō. Member of Banga-in and Aomori Print Society. Works include landscapes, buildings, and festival scenes of northern Honshū.

Suzuki Kanji　鈴木幹二

B. 1921 in Aichi prefecture. Attended Tokyo Normal School. Exhibited with Kokugakai and Nihon Hanga Kyōkai in 1950s; member of Kokugakai from 1955 and Nihon Hanga Kyōkai from 1959. Exhibited with CWAJ in 1960s. Represented in international exhibitions at Northwest, Krakow, and elsewhere. Works include woodblocks of natural scenes in which incredibly fine crossed lines create areas of light and dark.

Suzuki Kason　鈴木華邨

1860–1919. B. Kobe. Given name Sōtarō. Studied Tosa, *ukiyo-e*, and Shijō-style painting; eventually developed a personal style. Exhibited bird and flower paintings and landscapes in Bunten. Illustrator for *Yomiuri shinbun* and the journal *New Novel (Shin shōsetsu)*.

Suzuki Kenji　鈴木賢二

B. 1906 in Tochigi city. Studied in sculpture section of Tokyo School of Fine Arts. Active in proletarian art movement. Exhibited with Zōkei Hanga Kyōkai

in 1942; later a member of Shūdan Han. Contributed to *Katana*. Founding member of Japan Print Movement Association in 1949. Prints, mostly in black and white, include proletarian subjects and humorous compositions of children at play.

Suzuki Kinpei 鈴木金平

B. 1895 in Yokka-ichi, Mie prefecture. In 1911 entered school of Hakubakai at Aoibashi. Later studied with Nakamura Tsune. Exhibited with Hakubakai and Fyūzankai. Member of Ōgensha and served as juror for that organization. From ca. 1935 printed many works for Kishida Ryūsei and Makino Torao.

Suzuki Masatoshi 鈴木正俊

B. 1917 in Tokyo. Studied with Kitaoka Fumio. Member of Banga-in. Prints include mountain landscapes and seascapes.

Suzuki Shingo 鈴木信吾

B. 1944 in Manchuria. Grad. 1966 from economics department of Rikkyō University. Lived in France 1973–1981. Exhibited with Nihon Hanga Kyōkai and Nichidō and in various international and solo exhibitions. Member of Nippankai. Principally a wood engraver of landscapes and still life with art deco flavor. Works include *Collection I*, a frontal depiction of the shelves of dishes in a European hutch.

Suzuki Shintarō 鈴木信太郎

1895–1989. B. Hachiōji area of Tokyo. Studied with Kuroda Seiki at school of Hakubakai and with Ishii Hakutei. Exhibited at Bunten in 1916 and from 1921 at Nikakai. Member of Nikakai 1922–1955. Withdrew from Nikakai to participate in establishing Ichiyōkai. Member of Japan Art Academy. Woodcuts and lithographs from mid-1920s through 1960s. Among his subjects are dolls in European folk costumes.

Suzuki Shōnen 鈴木松年

1849–1918. B. Kyoto. Given name Hyakutarō. Son and pupil of Suzuki Hyakunen. Studied at Kyoto Prefecture School of Painting; began teaching there in 1886. Painted the dragons in the main building of Tenryū-ji and landscape screens in the Ryōgen-in of Daitoku-ji, both in Kyoto. Bird and flower prints.

Suzuki Takeo 鈴木建夫

Active in Shin Hanga Shūdan. Contributed to *Shin hanga* in 1933. Exhibited with Nihon Hanga Kyōkai 1933–1936. At that time lived in Tokyo.

Suzuki Toshiyasu 鈴木敏靖

B. 1937 in Shizuoka prefecture. Self-studied *mokuhan*. Member of Banga-in; exhibited with that group from 1977. Also exhibited at Kanagawa 1980–1982, China International Prints Exhibition 1983, Ibiza 1984, and solo exhibitions.

Abstract works range from orderly advancing and receding planes to grossly distorted anthropomorphic shapes in space.

Suzuki Tsuyoshi 鈴木力

Lives in Niigata prefecture. Exhibited with Nihon Hanga Kyōkai beginning 1967; member from 1971. Prints depict female nudes.

Suzuki Yōichi 鈴木洋一

B. 1939 in Yamagata prefecture. Grad. 1962 Yamagata University. Studied *mokuhan* with Munakata Makka. Member of Banga-in. Also works in mezzotint, lithograph, and silkscreen but woodblock is his major medium. Subjects include market scenes and landscapes.

Tagawa Ken 田川憲

1906–1967. B. Nagasaki. Given name Ken'ichi. Grad. 1924 Nagasaki Business School. Studied in 1928 at Kawabata Painting School in Tokyo. Learned woodblock printing from Onchi Kōshirō. Produced *moku-hanga* from 1932. Returned to Nagasaki in 1934 and established a Nagasaki print association. Spearheaded the publication of *Hanga Nagasaki*. Member of Nihon Hanga Kyōkai from 1941. While stationed in China 1941–1942 he organized a Shanghai print society and teaching institute and published a Shanghai *hanga* magazine. Returned to Japan in 1945 and to Nagasaki in 1949. In 1956 received Nagasaki prefectural culture award. Works include scenes of Nagasaki influenced by Kawakami Sumio.

Taisui 苔翠

See Inuzuka Taisui.

Tajima Hiroyuki 田嶋宏行

1911–1984. B. Tokyo. Grad. 1932 Nihon University; grad. 1934 from Western-style painting division of Tokyo School of Fine Arts. Also studied *mokuhan* with Nagase Yoshio and fabric dyeing with Hirokawa Matsugorō. Strongly attracted to dada and surrealism. Made his first print in 1946. Joined Bijutsu Bunka Kyōkai in 1946, a group instrumental in bringing back abstract and surrealist painting suppressed during World War II. Stopped printing 1950–1952 to write short stories and poetry. Member of Nihon Hanga Kyōkai from 1963. Represented in Tokyo Biennale in 1964, Northwest, Seoul, and other international competitions. In late works used shellac, torn paper, dyes, and other materials in conjunction with woodblocks for low-relief printing of complex textures in sonorous colors.

Takada Kazuo 高田一夫

1906–1982. B. Tokuyama, Yamaguchi prefecture. In 1920 joined Yahata Steel Co. From 1932 made *moku-hanga*; exhibited with Nihon Hanga Kyōkai and Kokugakai. From 1938 temporarily a war correspondent for *Asahi shinbun*. Member of Nihon Hanga Kyōkai 1943–1960. Print of workers in 1954.

Takagi Shirō 高木志朗

B. 1934 in Hirosaki, Aomori prefecture. Attended Musashino College of Fine Arts but left because there was no instruction in printmaking. Studied *mokuhan* independently with Amano Kunihiro. Exhibited with Nihon Hanga Kyōkai from 1957 and Kokugakai from 1958. Member of Nihon Hanga Kyōkai from 1961. Represented in international competitions in Tokyo 1957, 1964, Grenchen 1958, Krakow 1968, São Paulo, and elsewhere. At one time all of his prints were sold by S. Watanabe Color Print Company. Before 1971, Indian reds and ochres predominated in imaginative abstracted landscapes; after 1971 green was added as well.

Takagi Yoshio 高木義夫

B. 1923 in Tokyo. *Bijin-ga* inspired by Itō Shinsui. Published by Watanabe.

Takahashi Fumimitsu 高橋史光

See Takahashi Shikō.

Takahashi Hiroaki 高橋弘明

1871–1945. B. Asakusa district of Tokyo. Original name Takahashi Katsutarō; used the art name Shōtei 1907–1922, Hiroaki or Kōmei after 1922. Studied Japanese-style painting with his uncle Matsumoto Fūko. In 1891 with Terazaki Kōgyō organized Japan Youth Painting Society (Nihon Seinen Kaiga Kyōkai). Illustrated textbooks and newspaper novels. Began designing woodblocks for Watanabe Shōzaburō for export in 1907 and produced ca. 500 prints before September 1923. The blocks for all were destroyed in the fire which swept through Watanabe's workshop on the heels of the great Kantō earthquake. Hiroaki then resumed work for Watanabe and created ca. 250 more designs for scenery prints and the small greeting cards with which Watanabe rebuilt his export business. Prints of nudes and other subjects were published by Fusui Gabō in the 1930s. According to one report Hiroaki, visiting his daughter in Hiroshima in August 1945, was killed by the atomic bomb.

Takahashi Isao 高橋勲

B. 1941 in Osaka. Grad. Kyoto City University of Arts. Associate member of Nihon Hanga Kyōkai from 1972. Exhibited with CWAJ.

Takahashi Junko 高橋淳子

B. 1927 in Saitama prefecture. Grad. Kyōritsu Women's Specialist School. Studied with Ōkubo Sakujirō. Member of Nihon Hanga Kyōkai. Exhibited at international competitions in Tokyo and Paris. Also makes metal-plate prints.

Takahashi Katsuyoshi 高橋克芳

B. 1931 in Tokyo. Grad. 1954 Tokyo University of Art. Exhibited with Modern Art Association from 1962 and in group and solo shows. Member of Modern Art Association. *Moku-hanga* include several prints of vast space and prints of grasses and small plants in thin delicate lines.

Takahashi Kiyoshi 高橋清

B. 1904. Grad. Tokyo University. Studied woodblock with Onchi Kōshirō while working as government official. Member of Nihon Hanga Kyōkai 1951–1964.

Takahashi Kōmei 高橋弘明

See Takahashi Hiroaki.

Takahashi Osamu 高橋脩

B. 1935 in Kyoto. Grad. 1958 Kyoto University of Liberal Arts. Began making *moku-hanga* in 1964. In 1978 resigned teaching job and devoted full time to printmaking.

Takahashi Rikio 高橋力雄

B. 1917 in Tokyo. Son of a Japanese-style painter. Learned oil painting from his uncle, Imaizumi Toshiji. Studied with Onchi Kōshirō for 6 years (1949–1955) until Onchi's death. Member Nihon Hanga Kyōkai from 1952 and Kokugakai and Graphic Art Club. Represented in international competitions at Tokyo and Krakow. Lived in California for 2 years in 1960s. Extensive series of large, softly colored abstracts inspired by gardens of Kyoto. Style strongly influenced by Onchi; prints self-carved and self-printed in keeping with the Onchi ideal.

Takahashi Saburō 高橋三郎

B. 1906 in Gifu prefecture. Grad. Fukuoka Normal School. Worked as a teacher. Act. 1953 in formation of Keiseiha Bijustsuka Kyōkai (Formative Symbol Artist Association), a group of painters many of whom were also teachers. Studied *moku-hanga* with Munakata Shikō. Member of Banga-in exhibiting with that group from 1956.

Takahashi Shikō 高橋史光

Lived in Kyoto. Studied Japanese-style painting with Kikuchi Keigetsu. Prints published by Kyoto Hanga-in.

Takahashi Shin'ichi 高橋信一

B. 1917 on Sado island, Niigata prefecture. Grad. 1938 Niigata Normal School. Worked as art teacher on Sado Island. Member of Nihon Hanga Kyōkai from 1961 and Kokugakai. Represented in numerous international competitions including Xylon, Pistoia, Northwest, Krakow, and the 1960 *sōsaku-hanga* exhibition at Chicago Art Institute. Well known in Japan for his own prints and also for a *hanga* society on Sado Island which has encouraged farmers, fishermen, and other locals to make prints. His *Main Street*, 1959, abstractly suggests an aerial view of a city.

Takahashi Shōtei 高橋松亭

See Takahashi Hiroaki.

Takahashi Tadao 高橋忠雄

Exhibited intermittently with Nihon Hanga Kyōkai 1931–1940. Contributed to *Shin hanga* in 1935, *Kitsutsuki hangashū* in 1942.

Takahashi Tasaburō　高橋太三郎

B. 1904. Studied with Tsuchida Bakusen. Grad. Kyoto Technical School of Painting. Influenced by Nagase Yoshio. Exhibited with Nihon Hanga Kyōkai 1935–1936 and with Teiten and Kyoto Sōsaku-Hanga Kyōkai. At one time published by Kyoto Hanga-in. After World War II joined Tokuriki Tomikichirō and Kamei Tōbei in Kōrokusha, a subsidiary of Tokuriki's publishing company Matsukyū, which subsidized creative prints by the three men.

Takahashi Teruo　高橋輝雄

B. 1913 in Aichi prefecture. Grad. 1936 from a Buddhist school. Studied at Kyoto Independent Art Institute (Kyoto Dokuritsu Bijutsu Kenkyūsho). Published woodblock books including *Woodblock Poem Collection (Mokuhan shishū)* and *Songs of Woodblock Prints (Moku-han no uta)*.

Takai Teiji　高井貞二

1911–1986. B. Tokushima prefecture. From 1930 exhibited with Nikakai. Served as war correspondent. Founding member of Action Art Association (Kōdō Bijutsu Kyōkai) in 1945. Later lived in U.S. Woodcut illustrations.

Takamori Shōzō　高森捷三

1908–1977. B. Ishikawa prefecture. Studied with Hayashi Shigeyoshi. Active in proletarian art movement. Prints of that time include depictions of people at work and industrial machinery.

Takamura Masao　高村真夫

1876–1953. B. Nagaoka. Studied with Koyama Shōtarō at Fudōsha and in Europe 1914–1916. A friend of Yamamoto Kanae who was also in Europe at that time. Exhibited with Taiheiyōgakai and Bunten. *Moku-hanga* included in *New Period Print Collection (Shin jidai hangashū)* in 1936.

Takamura Shinpu　高村真夫

See Takamura Masao.

Takane Kōkō　高根宏浩

Moku-hanga of *bijin-ga* published by Daireisha in 1930s.

Takao Chiyomitsu　高尾千代光

B. 1927 in Toyama prefecture. Grad. 1953 Musashino College of Fine Arts. Exhibited with Nihon Hanga Kyōkai, Nichidō, and solo exhibitions. Represented in Venice Biennale in 1968. Associate member of Nihon Hanga Kyōkai from 1963 to at least 1983; member of Genyōkai. Sometimes combined intaglio with woodblock. Also made serigraphs. Textured prints suggest fragmentation and disintegration.

Takasawa Keiichi　高沢圭一

See Takazawa Keiichi.

Takase Bunji　高瀬文治

Exhibited with Nihon Hanga Kyōkai 1933–1936. Contributed to *Shin hanga* in 1934. Prints sometimes signed B.T.

Takashi Yuzuru　高志譲

Exhibited with Nihon Hanga Kyōkai 1935–1938. At that time lived in Yokohama.

Takayama Uichi　鷹山宇一

B. 1908 in Aomori prefecture. From 1931 exhibited with Nikakai. Member of Nihon Hanga Kyōkai from 1933; exhibited surrealist *moku-hanga* through the 1930s. In 1940 became member of Fine Art and Culture Association. Member of reconstituted Nikakai after World War II. Worked for many years as a junior high school teacher in Aomori. Contributed to *Chōkokutō* beginning 1931. Often made only one copy of a print; very secretive about his work. Prints probably produced by reduction carving. In 1942 founded Shin Hangakai with Okuyama Gihachirō and Azechi Umetarō.

Takazawa Keiichi　高沢圭一

1914–1984. B. Gunma prefecture. In 1936 attended Nihon University. Later studied with Fujita Tsuguharu, a strong influence. Worked as a war reporter. Illustrations and covers for women's magazines and woodcuts of modern *bijin-ga* including a set entitled *Four Women*, 1966. These are signed with his given name in *kanji* and his family name in roman script.

Takeda Gentarō　竹田源太郎

B. 1900. Grad. from school of Taiheiyōgakai. Started career as a sculptor, then taught himself *mokuhan*. Member of Tōkōkai. Also exhibited at Nitten.

Takeda Saburō　武田三郎

1915–1981. B. Kagawa prefecture. Grad. Hōsei University. Studied with Hiratsuka Un'ichi. Exhibited with Nihon Hanga Kyōkai in 1935–1936. Member of Banga-in.

Takeda Shintarō　武田新太郎

B. 1886 in Nagano prefecture. Grad. 1913 Tokyo School of Fine Arts. Began making *hanga* ca. 1925. Pioneer in Kyoto Sōsaku-Hanga Kyōkai. Member of Nihon Hanga Kyōkai from 1932. Also exhibited with Teiten. Taught at Nara Normal School and in Kyoto. Act. 1920s promoting *hanga* in schools. Contributed to *Tsuge* in 1933, *Shin hanga* in 1935, *Han geijutsu*, *Kitsutsuki* in 1931, and *One Hundred Views of New Japan (Shin Nihon hyakkei)* in 1939. Used the signature SHIN.

Takeda Shinzaburō　竹田鎮三郎

B. 1935 in Aichi prefecture. Grad. 1958 Tokyo University of Arts. Studied with Kubo Teijirō. Represented in Tokyo Biennale in 1957. Lived in Mexico for more

than 20 years. *Moku-hanga* deal principally with Mexican subjects. Also made lithographs.

Takeda Takeo 武田建夫

B. 1913 in Tokyo. Grad. Tokyo University. Studied printmaking with Ono Tadashige and Kitaoka Fumio. From 1953 exhibited *moku-hanga* with Shun'yō-kai and Nihon Hanga Kyōkai. Member Shun'yōkai from 1961; associate member Nihon Hanga Kyōkai 1954–1970. Prints include scenes of European cities.

Takeda Yoshihei 武田由平

B. 1892 in Hida Takayama, Gifu prefecture. Grad. 1914 Gifu Normal School. Taught elementary school in Takayama. In 1920 began teaching *hanga* at Yamamoto Kanae's farmers' art movement institute. In 1929 moved to Nakatsu city in Ōita prefecture on Kyushu where he taught painting in high school and junior college. Member of Shin Hanga Shūdan, Hakujitsukai, Nihon Hanga Kyōkai 1936–1960 and Nippankai after 1960. Exhibited with Shun'yōkai. Contributed to *One Hundred Views of New Japan (Shin Nihon hyakkei)* in 1940 and *Kitsutsuki hangashū (Woodpecker Print Collection)* in 1943. Active in promoting *hanga* in schools.

Takehisa Yumeji 竹久夢二

1884–1934. B. Okayama prefecture. Given name Mojirō. Moved to Tokyo in 1901. Attended Waseda Business School. Self-taught as an artist. Contributed illustrations and small woodblocks to the socialist newspaper *Heimin shinbun*; the small woodblocks were printed along with type. In 1909 and 1910 he wrote and designed several popular poetry and picture books including one for each season. These were produced by mechanical processes. During this period he became a friend and mentor of Onchi Kōshirō. Beginning 1910 he also designed a postcard each month for the next 9 years. From 1914 to 1916 he operated a shop, Minatoya, stocked with various craft objects and prints of his own design. In this period he also designed *moku-hanga* illustrations for *Samisen Grass (Samisen-gusa)*, 1915, a book of poetry, and *Narrow Alley* (Roji no Hosomichi), 1919, a takeoff from a famous travelogue by the *haiku* poet Bashō. From ca. 1910 through 1920s Yumeji's paintings of languid beauties were extremely popular as illustrations for serialized newspaper and magazine novels, but he was not accepted in art or literary circles and his personal life was tempestuous. In 1932, tired, probably ill, and apprehensive about the growing militarism in Japan, he traveled to the U.S. and then to Europe in 1933. On return to Japan he checked into a sanitarium; died shortly thereafter of tuberculosis at age 50. Single-sheet prints in the 1914–1916 period were self-published. Posthumous prints of these, probably made from the original blocks, were published by Yanagiya in Osaka. Others prints derived from his illustrations were published by Katō Junji and in the 1980s by Matsunaga.

Takei Kichitarō 武井吉太郎

See Takei Yoshitarō.

Takei Takeo　武井武雄

1894–1983. B. Okaya, Nagano prefecture. Grad. 1919 in Western-style painting from Tokyo School of Fine Arts. Act. from ca. 1920 as illustrator of children's magazines including *Children's Country (Kodomo no kuni)* and *Red Horse (Akai uma)*. Founding member of Japan Children's Art Society in 1927. Founder of Han no Kai, a club of 50 people who exchanged self-carved, self-printed New Year cards with other members for more than 20 years. Member of Nihon Hanga Kyōkai from 1944 but did not exhibit with the society. Represented in the 1960 *sōsaku-hanga* exhibition at Chicago Art Institute. Contributed to *Ichimokushū*. Well known for self-published miniature books, a hobby beginning in 1935, made by woodblock and other print techniques. Had made a total of 266 books by 1980. Honored by Japanese government with Order of Purple Ribbon in 1959 for his illustrations for children; awarded Order of Rising Sun in 1967. Style ranges from detailed illustration to simple abstraction.

Takei Yoshitarō　武井吉太郎

Exhibited with Nihon Hanga Kyōkai 1954–1955; member from 1956. D. 1964. Special memorial display of his prints at Nihon Hanga Kyōkai exhibition in 1965.

Takenouchi Shun'ichi　竹之内俊一

An opera singer who performed at Kinryūkan in Asakusa and sketched backstage. Playful semiabstract figures and expressionist prints in the spirit of Tanaka Kyōkichi. Contributed to *Shi to hanga* in 1924. Published and contributed to *Katamari* in Taishō.

Takeuchi Keishū　武内桂舟

1861–1942. B. Edo. Son of a samurai in service of a lord of Kii province. Given name Ginpei. Studied Japanese-style painting with Tsukioka Yoshitoshi. Joined Ken'yūsha (Friends of the Inkstone), a literary group, and illustrated works by many of the group's members. Many illustrations for adult and children's magazines. See page 295, number 105, for seal.

Takeuchi Seihō　竹内栖鳳

1864–1942. B. Kyoto. Given name Tsunekichi. Studied Shijō-style painting with Kōno Bairei and Tsuchida Eirin. Encouraged by Ernest Fenollosa to establish Kyoto Young Artists' Institute in 1888; many students became distinguished artists. Impressed by the paintings of Corot and Turner while traveling in Europe 1900–1901. Became a leading Kyoto painter, a teacher at Kyoto City School of Fine Arts and Crafts, and a member of the Imperial Academy. Awarded Order of Cultural Merit in 1937. *Seihō's Practice Painting Album (Seihō shūgachō)* in 4 vols. was published by Yamada Naozō of Unsōdō in association with Murakami Kagaku in Kyoto in 1901. *Collection of Seihō's Masterworks (Seihō ippin shū)*, published by Unsōdō in 1937, is a portfolio of very large *hanga* printed under Seihō's direct supervision by various means including color woodblock, collotype, and color offset. Other woodcuts, including bird and animal sketches,

were carved by Ōkura Hanbei in the 1930s. Woodcuts of sketchy scenes published in 1940s.

Takeuchi Shun'ichi 竹内俊一

See Takenouchi Shun'ichi.

Takidaira Jirō 滝平二郎

B. 1921 in Ibaraki prefecture. Grad. 1938 from Ishioka agriculture school in Ibaraki. Decision to make prints was influenced by the *moku-hanga* of Iino Nobuya and Suzuki Kenji. In 1940 made two series, *Song of the Village (Sato no uta)* and *Story of a Rascal (Akudō monogatari)*. In 1941 exhibited with Zōkei Hanga Kyōkai; continued making prints after serving in army 1942–1946. Contributed to the *dōjin* magazine *Kokuga* in 1947. Helped to found Japan Print Movement Association (Nihon Hanga Undō Kyōkai) in 1949. In 1951 published in collaboration with Arai Kōji and Maki Daisuke *Story of Hanaoka (Hanaoka monogatari)*, a *hanga* series dealing with forced labor by Chinese in Hanaoka mine during World War II. In 1957 illustrated with *moku-hanga* a novel serialized by Nishino Tatsukichi in the communist newspaper *Akahata* (Red Flag); later published in China and sold more than 50,000 copies. Exhibited in Japan Independents show and Tokyo Biennale in 1968, in New York, and in China. Also known for illustrations in children's books and the Chinese art of paper-cut pictures. Member of Japan Fine Art Society (Nihon Bijutsukai).

Tamagami Tsuneo 玉上恒夫

B. 1922 in Tokyo. Grad. 1922 Tokyo Higher Craft School. Studied *mokuhan* with Mizufune Rokushū. Exhibited with Kokugakai from 1949. Member of Nihon Hanga Kyōkai 1957–1970 and Kokugakai. International competitions include Tokyo in 1957 and Grenchen in 1958. Represented in 1960 *sōsaku-hanga* exhibition at The Art Institute of Chicago. Used paper blocks in conjunction with woodblock. Also an etcher. Prints always depict people, sometimes fanciful.

Tamai Chūichi 玉井忠一

B. 1910 in Toyama prefecture. Member Nihon Hanga Kyōkai from 1957. Active in print activities in Takaoka. Represented in 1960 *sōsaku-hanga* exhibition at The Art Institute of Chicago.

Tamamura Hokuto 玉村方久斗

1893-1951. B. Kyoto. Given name Zennosuke; used the name Hokuto for Japanese-style paintings. Grad. Kyoto Municipal School of Fine Arts and Crafts. Studied with Kikuchi Hōbun. From 1923 active in MAVO, Sanka Zōkei Bijutsu Kyōkai, and proletarian art movement. Exhibited with Inten 1915–1923. Woodblock newspaper illustrations ca. 1935 printed directly from blocks. Multicolor prints of traditional Japanese subjects carved by Yamagishi Kazue, printed by Nishimura Kumakichi, published by Akashi Sanpaku. Also made lithograph collection called *Power and Nourishment of the City (Tokai no Dōryoku to Eiyō.)* Active in Shin Bijutsu Kyōkai and a novelists union.

Tamamura Takuya 玉村拓也

B. 1933 in Hokkaido. Grad. 1956 from art department of Hokkaido University of Liberal Arts. Exhibited with Nihon Hanga Kyōkai, Shun'yōkai, and Tokyo Biennale. Member of Nihon Hanga Kyōkai 1963–1970 and Hokkaido Fine Art Society. Published a poetry and print collection *Beckoning Birds (Shōchō)* in 1965. Abstract prints made by lithograph, silkscreen, and etching but principally by woodblock.

Tamamura Zennosuke 玉村善之助

See Tamamura Hokuto.

Tamaoki Noboru 玉置昇

B. 1930 in Gifu prefecture. Grad. 1950 Gifu University. Exhibited in prefectural exhibitions, solo shows, Shun'yōkai, and in Spain 1976. Member of Shun'yōkai. Works include abstractions printed in graded colors.

Tamura Kiyoshi 田村清

Member of the Aomori Sōsaku-Hanga Study Society. Contributed to *Mutsu* in 1932, *Mutsu goma* in 1933–1934, and *Kikan Aomori hanga* in 1939.

Tanaka Hisara 田中比左良

1890–1974. B. Gifu prefecture. Illustrator and *manga* artist. Contributed to *Baku-chiku* in 1929–1930. Used a seal derived from first syllable of his given name.

Tanaka Hisashi 田中久司

B. 1939. Associate member of Nihon Hanga Kyōkai from 1967; member in 1989.

Tanaka Ikkō 田中一光

B. 1930 in Nara. Grad. 1950 Kyoto College of Fine Arts. Became a leading Japanese graphic designer. Represented in international poster biennales in Warsaw in 1968 and 1970. Designed display of the government pavilion at EXPO '70 in Osaka. In 1979 the Riccar Museum invited him to submit 6 designs to be executed by Adachi Woodblock Institute. These were exhibited along with woodblocks of other leading graphic designers at the Riccar.

Tanaka Kyōkichi 田中恭吉

1892–1915. B. Wakayama. Studied with Nagahara Kōtarō and Kobayashi Shō-kichi at the Haramachi branch school of Hakubakai in 1910. In 1911 entered Tokyo School of Fine Arts, Japanese-style painting section. Exhibited a watercolor with Fyūzankai in 1912. With Onchi Kōshirō and Fujimori Shizuo planned the magazine *Tsukubae*. Although critically ill with tuberculosis, Kyōkichi contributed 10 prints and many poems to *Tsukubae*, published 1914–1915. Designed illustrations for Hagiwara Sakutarō's *Barking at the Moon (Tsuki ni hoeru)*, published in 1917 after his death. Posthumous exhibition of his prints in 1915.

Tanaka Ryō 田中良

1884–1974. B. Tokyo. Grad Tokyo School of Fine Arts. Studied with the Western-style painter Wada Eisaku. From ca. 1912 made woodcut illustrations for adult and children's publications. Also did stage sets.

Tani Akira 谷光

B. 1920 in Kumamoto prefecture. Grad. Kumamoto Normal School. Studied with Sasajima Kihei. Exhibited in prefectural and solo shows and with Banga-in. Member of Banga-in from 1980. Rubbings and silkscreen prints as well as *moku-hanga*. Woodblocks include numerous mountain landscapes. Style is characterized by deep embossing influenced by Sasajima Kihei.

Taniguchi Kōkyo 谷口香嶠

1864–1915. Original name Tsuji Tsuchinosuke; adopted by Taniguchi family. Studied with the Japanese-style figurative painter Kōno Bairei from age 21. Taught at Kyoto City School of Fine Arts and Crafts and Kyoto Specialist School of Painting. Works include *Heron Girl* published by Satō Shōtarō.

Taniguchi Kunbi 谷口薫美

Lived in Tokushima prefecture. Exhibited with Shin Hanga Shūdan and intermittently with Nihon Hanga Kyōkai 1940–1947. Contributed to *Shin hanga* in 1933 and *Ichimokushū* in 1944 and 1948. D. 1964. Prints sometimes signed KT or KUNBI T carved in the block.

Taniguchi Masami 谷口薫美

See Taniguchi Kunbi.

Taninaka Yasunori 谷中安規

1897–1946. B. Nara prefecture. Childhood in Seoul. Returned to Tokyo in 1915 for 4 years of middle school. Returned to Korea in 1921; back in Tokyo in 1922. Read Nagase Yoshio's book, *To People Who Want to Make Prints (Hanga o tsukuru hito e)*, and decided at age 25 to become a *hanga* artist. Participated in publication of the *dōjin* magazine *Moro monyō* in 1926 until it was discontinued after 2 issues. Studied with Nagase Yoshio beginning 1927. Exhibited with Nihon Sōsaku-Hanga Kyōkai beginning 1928. Member of Nihon Hanga Kyōkai from 1932. Exhibited with Kokugakai in 1932. Contributed to *Shiro to kuro* (a special collection of his works in issue 40), *Han geijutsu* (8 prints in a special issue in 1932), *Hōsun hanga*, and *One Hundred Views of New Japan* in 1940. Illustrated several novels by woodblock including the *Jiji shinpō* newspaper serialization of *Isōrō sōsō* by Uchida Hyakken, 36 issues. Yasunori lost his home in bombing of Tokyo in 1945; died of war-related malnutrition. Prints deal with his highly personal and fanciful perceptions.

Tasaka Ken 田坂乾

B. 1905 in Tokyo. Son-in-law of Ishii Hakutei. Studied oil painting with Arishima Ikuma, Yamashita Shintarō, and Ishii Hakutei. Studied *hanga* with

Nishida Takeo. Became member of Nihon Hanga Kyōkai in 1936. Known principally for lithographs.

Tasaki Hirosuke　田崎広助

1898–1984. B. Fukuoka. Grad. Kansai Bijutsu Gakkō. Studied with Western-style painters Sakamoto Hanjirō in 1921 and Yasui Sōtarō. Exhibited paintings with Nikakai. Founding member of Issuikai. Member of Japan Art Academy (Nihon Geijutsuin). Awarded Order of Cultural Merit in 1975. Expressionistically carved mountains are a predominant theme in his prints. Sometimes signed prints with the letters "H.T." or the *kanji* for Hirosuke carved in the block.

Tashima Hiroyuki　田嶋宏行

See Tajima Hiroyuki.

Tatsujū　辰重

See Yamanaka Kodō.

Tatsushige　辰重

See Yamanaka Kodō.

Tejima Keizaburō　手島圭三郎

B. 1935 in Hokkaido. Grad. 1957 Hokkaido University of Education. Showed *hanga* at Hokkaido exhibitions from 1965, Nihon Hanga Kyōkai from 1969, and Nichidō 1972–1974. Member of Nihon Hanga Kyōkai from 1979. Prints include black and white fantasies of young women and owls carved in a wood engraving technique.

Tenma Shōgorō　天間正五郎

Exhibited with Shun'yōkai in 1925 and with Nihon Hanga Kyōkai 1931–1933 and 1939; member 1932–1939; reinstated 1944–1952.

Terashi Katsujirō　寺司勝次郎

B. 1927 in Ōita prefecture. Grad. 1948 Ōita University. Exhibited oil painting with Nitten, Hakujitsukai, and prefectural shows. After receiving an award from the New Year card *hanga* competition in 1954, he concentrated on prints. Member of Hakujitsukai; founding member of Nippankai in 1960. Represented at international exhibitions in Spain, Switzerland, Italy, France, and Greece. Subjects include traditional rural houses and castles in a highly designed decorative style.

Terauchi Manjirō　寺内萬治郎

1890–1964. B. Osaka. Grad. 1914 Tokyo School of Fine Arts. Studied with Kuroda Seiki. Exhibited at Teiten and Bunten. Member of Kōfūkai and Japan Art Academy. Illustrator of poetry magazines and modern novels.

Terazaki Kōgyō 寺崎広業

1866–1919. B. Akita. Moved to Tokyo in 1888. Taught at Tokyo School of Fine Arts under Okakura Tenshin and left with him to found Nihon Bijutsuin. Returned to Tokyo School of Fine Arts after Okakura retired. Principally a painter but designed *mokuhan bijin-ga*, *kachō*, and Russo-Japanese War prints. Often used the name Sōzan (also pronounced Shūzan) on prints.

Teshima Keizaburō 手島圭三郎

See Tejima Keizaburō.

Tobari Kogan 戸張弧雁

1882–1927. B. Nihonbashi section of Tokyo. Given name Kamekichi. Studied English at a night school run by Katayama Sen, a Christian socialist. Encouraged by Katayama, went to U.S. in 1901. Worked and studied painting at Art Students' League in New York. Discovered that he had tuberculosis and returned to Japan in 1906. Met the Japanese sculptor Ogiwara Morie; beginning 1910 studied sculpture at the institute of Saikō Nihon Bijutsuin; became member 1911. Exhibited sculpture at Bunten. Supported himself by working as illustrator of novels. Produced his first *moku-hanga*, *Farmhouse in Autumn (Nōka no aki)*, in 1912 and *Rain at Senjū Great Bridge (Senjū Ōhashi no ame)* the following year. Ca. 15–18 prints bearing the imprint *New Brocade Pictures of the East (Shin Azuma nishiki-e)* began distribution in 1914; carved with a very traditional technique, perhaps by Koizumi Kishio or Tobari Kogan himself. With Ishii Hakutei and others he founded Japan Watercolor Society in 1913. Also a founding member of Nihon Sōsaku-Hanga Kyōkai in 1918; showed 12 prints in the group's first exhibition in 1919. In 1922 published *Sōsaku-Hanga and How to Make Them (Sōsaku-hanga to hanga no tsukurikata)*. Later known for small bronze sculptures. Four prints shown posthumously at the 1933 Nihon Hanga Kyōkai exhibition.

Tobita Shūzan 富田周山

1877–1945. B. Ibaraki prefecture. Given name Masao. Studied at Japan Academy and with Japanese-style painters Takeuchi Seihō and Kubota Beisen. Exhibited paintings at Bunten and Teiten. Became Teiten judge in 1924. Woodblock illustrations before World War II.

Tochigi Junko 栃木順子

B. 1932 in Kanagawa prefecture. Grad. 1956 Bunka Gakuin art department. Studied with Murai Masanari and Yoshida Hodaka. Exhibited with Modern Art Association from 1956, Nihon Hanga Kyōkai from 1963, and at a show of Japanese women print artists in Los Angeles in 1974. Member of Nihon Hanga Kyōkai from 1966. Also represented in international competitions including Tokyo and Ibiza. Progressed from black and white woodblocks to color woodblocks and then to silkscreen.

Toda Tatsuo　戸田達雄

Contributed to MAVO in 1925. Member of Issen Bijutsukai, founded in 1950. Linoleum cuts and lithographs as well as *moku-hanga*.

Tōkō　東江

Prints include *Ferry Landing at Ushibori*, 1933, published by Doi and another river scene dated 1950. The latter has a seal with the *kanji* "Sho" which suggests the publisher Watanabe Shōzaburō, but the seal appears to be an integral part of the signature and is unlike any other seal of Watanabe known to the authors. See Chapter 7.

Tokumitsu Masahiko　徳光真散彦

B. 1913 in Hiroshima prefecture. Grad. Kansai University. Member of Tōkōkai; exhibited from 1958. Represented in exhibitions in Switzerland, Italy, and other countries as well as Japan. Subjects include Buddhist images and old temples.

Tokuoka Shinsen　徳岡神泉

1896–1972. B. Kyoto. Given name Tokijirō. Studied at Kyoto Municipal School of Fine Arts and Crafts; grad. 1917 Kyoto Specialist School of Painting. Studied with Japanese-style painter Takeuchi Seihō. Exhibited paintings at Nitten. Member Japan Art Academy.

Tokuriki Tomikichirō　徳力富吉郎

B. 1902 in Kyoto. Grad. Kyoto City School of Fine Arts and Crafts and Kyoto City Specialist School of Painting in 1924. In 1928 entered the private school of Tsuchida Bakusen and made three study trips to Korea. Exhibited Japanese-style painting with Kokuga Sōsaku Kyōkai, forerunner of Kokugakai. In 1929 switched to *mokuhan*. Exhibited with Kokugakai, Nihon Hanga Kyōkai, Shun'yōkai, Teiten, Shin Bunten, Nitten, and in numerous solo exhibitions in Japan and abroad. Member of Nihon Hanga Kyōkai from 1932. Active in promoting *sōsaku-hanga* in Kyoto. Published *Taishū hanga* in Kyoto with Asada Benji and others. Contributed to *Han, Shin hanga*, and *Kitsutsuki*. Organized the Red Green Society (Tanryokukai) which put out *Collection of Small Prints (Han shōhinshū)*. Made many sets and series published before World War II by Uchida, Unsodo, and Kyoto Hanga-in. After World War II he established Matsukyū Publishing Company to produce and distribute his own prints and Kōrokusha, a subdivision of Matsukyū, for publication of self-carved, self-printed *hanga* by himself, Takahashi Tasaburō, and Kamei Tōbei.

Tomihari Hiroshi　富張広司

B. 1936 in Ibaraki prefecture. Grad. 1957 Ibaraki University. Started making *moku-hanga* in 1959. Exhibited with Nihon Hanga Kyōkai from 1961. Joined Shūdan Han in 1963. Exhibited with Shūdan Han in 1967, Northwest in 1969, and in numerous shows in Tokyo in 1970s. Member of Modern Art Association. Sent to U.S. as delegate artist from Japanese Ministry of Culture in 1978–1979. An interest in sculpture is reflected in suggestion of solidity in his abstract com-

positions of straight, curved, and wavy lines of varying thickness sometimes combined with flowers or organic shapes.

Tomimoto Kenkichi 富本憲吉

1886–1963. B. Andō village, Nara prefecture. Studied in design section of Tokyo School of Fine Art. In 1908 went to England to study work of William Morris; also traveled to India. Met Minami Kunzō in England; both men were active in self-carved, self-printed *moku-hanga* upon return to Japan in 1911. Created *moku-hanga* for the cover of *Takujō*, a publication of the Tanakaya craft shop, in 1914. In 1915 published *Collection of Tomimoto Kenkichi Designs (Tomimoto Kenkichi moyōshū)*. Later prints carved by his wife Otake Kazue. Influenced by Bernard Leach and Yanagi Sōetsu, became interested in ceramics and in 1915 moved to his native village, built a kiln, and devoted energy to porcelain. Joined Nihon Hanga Kyōkai in January 1931; withdrew the same year; became honorary member in 1939. In 1944 a series of 12 prints were issued by Katō Junji, sealed with first character of his family name. In 1944 Tomimoto became a professor at Tokyo School of Fine Arts; in 1950 became a professor at Kyoto City College of Fine Arts and in 1958 its principal. In 1955 designated the first Living National Treasure and in 1961 awarded Order of Cultural Merit, both for his work in porcelain.

Tomioka Eisen 富岡永洗

1864–1905. B. Nagano prefecture. Given name Hidetaro. Went to Tokyo to study drafting ca. 1877. Employed from 1878 by Army Staff Office as a civilian. In 1882 began studying with Kobayashi Eitaku. Resigned army position to become full-time illustrator. Many illustrations of *bijin-ga*, customs, and warriors.

Tomita Keisen 富田渓仙

1879–1936. B. Fukuoka; lived in Kyoto. Given name Shingorō. Studied Shijō-style painting with Tsuji Kakō; also studied Heian Buddhist painting and *nanga*. Exhibited paintings with Saikō Nihon Bijutsuin in 1915; became member in 1916. Also exhibited at Teiten and Bunten.

Tomozawa Yasuo 友沢恭男

B. 1932 in Tokyo. Studied *mokuhan* with Yoshida Masaji. Exhibited with Nihon Hanga Kyōkai in 1960s. Member of Nihon Hanga Kyōkai from 1968 and Modern Art Association.

Toneyama Kōjin 利根山光人

B. 1921 in Tokyo. Grad. 1943 Waseda University literature department. Worked in business and showed at independent exhibitions in 1950s. Also represented at São Paulo Biennale in 1959. Member of Nihon Hanga Kyōkai. Friendly with Kitagawa Tamiji and fond of Mexican and Mayan subjects. In 1963 traveled to Central America to collect rubbings of Mayan relief sculptures; awarded Order of Cultural Merit in 1972 by Mexican government in recognition of his book

The Popular Arts of Mexico. Also made lithographs. His *moku-hanga* include abstracted renditions of *haniwa.*

Torii Genjin　鳥居言人
See Torii Kotondo.

Torii Kiyomitsu (Torii IX)　鳥居清光
B. 1938 in Tokyo. Grad. 1962 Tokyo University of Arts, painting section. Studied with Torii Kotondo. From 1962 worked for Nissei Theater. From 1979 painted signs for Kabuki-za and made other designs for Imperial Theater. In 1982 designated Torii IX. First female master of the Torii School. Works include modern *bijin-ga* and *kabuki* subjects.

Torii Kiyotada (Torii VII)　鳥居清忠
1875–1941. B. Tokyo. Original name Saitō Chōkichi. Son of Torii Kiyosada; also known as Nanryō; father of Torii Kotondo. Studied Tosa painting with Kawabe Mitate. Produced Russo-Japanese War prints, actor pictures, and advertisements for Kabuki-za, Shintomi-za, and Meiji-za. Kabuki prints published by Oana Shūjirō at Shūbisha.

Torii Kotondo (Torii VIII)　鳥居言人
1900–1976. B. Nihonbashi district of Tokyo. Original name Saitō Akira. At age 15 adopted into Torii family as son of Torii Kiyotada (Torii VII) and given the name Genjin (Kotondo). Studied in 1914 with the *yamato-e* painter Kobori Tomone and in 1918 with Kaburagi Kiyokata. Worked on *kabuki* posters, billboards, etc., as member of Torii family and produced woodcuts and illustrations for *Entertainment Illustrated Magazine (Engei Gahō).* Also exhibited paintings of *bijin-ga* at Inten beginning 1925. Designed most of his *moku-hanga* in 1927–1933. Published by Sakai-Kawaguchi or Kawaguchi in 1920s and by Ikeda in 1930s. Prints of 1930s carved by Maeda and printed by Komatsu Wasakichi. In 1941, upon father's death, became Torii VIII and Kiyotada V. Lectured at Nihon University 1966–1972. Made total of 21 *bijin-ga* prints.

Torii Tadamasa　鳥居忠雅
See Ueno Tadamasa.

Toshihide　年英
See Migita Toshihide.

Toshikata　年方
See Mizuno Toshikata.

Totori Eiki　都鳥英喜
1873–1943. B. Chiba prefecture. Studied under Asai Chū; worked as his assistant. Helped organize Japan Youth Painting Association (Nihon Seinen Kaiga Kyōkai). From 1907 showed paintings at Bunten and Teiten. Founding member of Taiheiyōgakai. Exhibited *hanga* in Kyoto in 1924.

Toyama Usaburō 外山卯三郎

1903–1980. B. Wakayama prefecture. Grad. Kyoto University. Worked as an art critic. In 1925 launched *Satoporo* and provided woodcuts.

Toyohara Chikanobu 豊原周延

1838–1912. B. Takada, Niigata prefecture. Original name Hashimoto Chikanobu; also known as Yōshū Chikanobu. Became minor member of shogun's government. After Meiji Restoration studied under Toyohara Kunichika and took his surname. Specialized in newspaper illustrations and woodblock prints of historical subjects and women and children. Still active after 1900.

Toyokuni IV 豊国四世

See Baidō Hōsai

Toyokuni V 豊国五世

See Baidō Hōsai

Tsuchida Bakusen 土田麦遷

1887–1936. B. Heion village, Sado Island. Given name Kinji. Studied Japanese-style painting with Suzuki Shōnen and Takeuchi Seihō at Kyoto Specialist School of Painting. Studied in Europe 1921–1923. Act. 1918 with Murakami Kagaku in forming Kokuga Sōsaku Kyōkai, forerunner of Kokugakai. Member of Imperial Fine Art Academy. In 1921 published *Bakusen's Picture Collection (Bakusen gashū)* through Benridō in Kyoto; book contains both collotypes and woodblock facsimile prints of Bakusen's paintings. *Maiko* of Kyoto were a favorite subject. Nakamura Jizaemon and Ōiwa Tokuzō were both printers of Bakusen's works.

Tsuchiya Kenshō 土矢堅証

Contributed to *Shiro to kuro* and *Han geijutsu* in 1933. Member of Takei Takeo's Han no Kai in 1935.

Tsuchiya Kōitsu 土屋光逸

1870–1949. B. near Hamamatsu. Given name Kōichi. At age 15 went to Tokyo to study under Matsuzaki, a carver for Kobayashi Kiyochika. Kiyochika took him into his home where he remained studying for 19 years. Designed woodblock prints during Sino-Japanese War, 1894–1895, later worked as lithographer. After meeting Watanabe Shōzaburō at an exhibition of Kobayashi Kiyochika's prints, Kōitsu designed figurative landscape *moku-hanga* published by Watanabe, Kawaguchi, and Doi from 1932. Kōitsu's prints, like those of Kobayashi Kiyochika, are often characterized by dramatic use of light.

Tsuchiya Masao 土屋正男

B. 1913 in Tokyo. Began making *moku-hanga* ca. 1952 influenced by Munakata Shikō. Member of Banga-in and Shichisaikai. Published books or pamphlets on *hanga* including *Teaching Room of Prints (Hanga no kyōshitsu)*, 1974. Also made stencil prints.

Tsuchiya Rakuzan　土屋楽山

B. 1886. Worked in Kyoto. Many self-published *kachō* prints. Also used the name Rakuzan Kōshisei. In early 1950s sold his works along with a how-to book entitled *The Art of Rakuzan Tsuchiya, Famous Print Maker of Japan* through Foster Art Service, Inc.

Tsuchiya Yoshirō　土屋義郎

B. 1900 in Yamanashi prefecture. Studied with Kishida Ryūsei and Nakagawa Kazumasa. Member of Sōdosha, Shun'yōkai. Honorary head of Yamanashi prefecture art society. Contributed to *Hanga* in 1927.

Tsuda Kenji　津田健次

Lived in Tokyo. Exhibited with Nihon Sōsaku-Hanga Kyōkai in 1929 and with Nihon Hanga Kyōkai intermittently 1931–1943.

Tsuda Seifū　津田青楓

1880–1978. B. Kyoto. Given name Kamejirō. In 1897 entered a Kyoto dyeing and weaving school. Studied Japanese-style painting with Taniguchi Kōkyo; enrolled in Kansai Art Institute where he studied Western-style painting with Asai Chū and Kanokogi Takeshirō. In 1904, after military service, worked in design department of Takashimaya Department Store in Kyoto. Then mobilized for Russo-Japanese War in 1905. Studied in France 1907–1911, working for some time with Jean-Paul Laurens. Founding member of Nikakai; withdrew in 1933. Juror of Bunten. At some point, probably while working in Kyoto before the Russo-Japanese War, at the suggestion of Asai Chū, he designed and probably self-carved a number of blocks, which Yamada Naozō of Unsōdō published under the title *Small Art (Ko bijutsu)*. Also made many *moku-hanga* for book illustrations in the years immediately following his return from France. Participated in proletarian art movement in the 1920s. In later life returned to Japanese-style painting.

Tsuji Aizō　辻愛三

1895–1964. B. Osaka. Original name Terazawa Aizō. Studied first with Akamatsu Rinsaku in Osaka and in 1915 at school of Taiheiyōgakai. Exhibited Western-style painting at Inten in 1917 and with Kokuga Sōsaku Kyōkai and later Kokugakai. Member of Kokugakai. Prints in *HANGA* in 1927 carved and printed by Nomura Toshihiko. Taught at an Osaka art facility. Painted in both Japanese and Western styles. Turned his attention to glass painting ca. 1963.

Tsuji Hisashi　辻永

1884–1974. B. Hiroshima. Studied at school of Hakubakai and with Kuroda Seiki at Tokyo School of Fine Arts. Exhibited at Bunten, Teiten, and Nitten. Member of Kōfūkai and Japan Art Academy. *Moku-hanga* of his landscapes made after his death.

Tsuji Shindō 辻晋堂

1910–1981. B. Tottori prefecture. Member of Inten. Promoted self-carved woodblock printing in Kyoto as a teacher of sculpture at Kyoto City Specialist School of Fine Art, a position he held from 1950.

Tsukamoto Shigeru 塚本しげる

B. 1903 in Kyoto. Studied *mokuhan* with Nakamura Tsune and Makino Torao. Influenced by Onchi Kōshirō and Asahi Masahide. Contributed to *Shi to hanga* 1922–1925 and *HANGA* 1924. Exhibited at Bunten. Pioneer in the Kansai *sōsaku-hanga* movement with Kawai Unosuke.

Tsukamoto Tetsu 塚本哲

1901–1980. B. Shimane prefecture. Attended Osaka Bukkyō Gakuin. Grad. 1926 Tōyō University; later became professor of sociology there and at Kyoto Bukkyō University. Also a consultant to Japanese government and television industry. Studied *moku-hanga* with Suwa Kanenori. From 1936 exhibited with Kokugakai, Nihon Hanga Kyōkai, Bunten. Member of Nihon Hanga Kyōkai from 1943. Contributed to *Kitsutsuki hangashū* 1942, 1943, and *Ichimokushū* 1946–1948. Also known as a *haiku* poet.

Tsukimizato Shigeru 月見里シゲル

B. 1928 in Shizuoka prefecture. Studied *mokuhan* with Yamaguchi Gen. Member of Kokugakai; associate member of Nihon Hanga Kyōkai from 1958. Exhibited in New York in 1958, in Washington, D.C., in 1959, and with CWAJ in 1960s. Rubbings and copper-plate prints as well as woodblocks.

Tsukioka Gyokusei 月岡玉瀞

B. 1908 in Tokyo. Original given name Fumiko. Daughter of Tsukioka Kōgyo. Married name Inada Fumiko. Grad. 1929 Women's Specialist School of Fine Arts. Studied *yamato-e* painting with Matsuoka Eikyū. Succeeded her father as specialist in representations of *nō* drama; published a number of prints of *nō* plays of the Hōshō School and *Fifty Kyōgen Pieces (Kyōgen gojū ban)* under the art name Kōbun. Also published ca. 30 prints with Watanabe Shōzaburō beginning 1938.

Tsukioka Kōgyo 月岡耕漁

1869–1927. B. Tokyo. Original name Hanyū Sadanosuke. Lived in Kyoto. Studied with Tsukioka Yoshitoshi (Taiso Yoshitoshi) whom his mother married and whose name he took. Later studied with Matsumoto Fūko and Ogata Gekkō. Active at turn of the century. Four sets of *nō* drama prints published by Matsuki Heikichi 1898–1934; also *kachō*.

Tsukioka Ninkō 月岡忍光

B. Shizuoka prefecture. Contributed to *Yūkari* and *Shiro to kuro* in 1930s and *Akebi* 1940–1941. Exhibited woodblocks with Nihon Hanga Kyōkai intermittently 1936–1955; member from 1950.

Tsunemi Hideo　常察英雄

B. 1902 in Ehime prefecture. Also known as Jōsatsu Hideo. Active in proletarian art movement. Exhibited with Shin Hanga Shūdan ca. 1935. Also exhibited in the print section of Teiten. Contributed to *Shin hanga* in 1934.

Tsuruta Gorō　鶴田吾朗

1890–1969. B. Tokyo. Studied at school of Hakubakai and with Nakamura Fusetsu and Kurata Hakuyō at school of Taiheiyōgakai. Worked in advertising department of the Ajinomoto company in 1910. Print dated 1916 published by "Sketch Club." Traveled in Manchuria and Korea, settling into a job with a Korean newspaper in Seoul until 1920. From 1920 exhibited with Teiten, Nitten, and Taiheiyōgakai. In mid-1920s designed scenery prints and *bijin-ga* published by Katō Junji and Sakai-Kawaguchi. Traveled in Europe 1930. Between 1937 and 1940 contributed frequently to *Karikare*, a satirical print magazine, and served as artist for the army. After World War II helped establish the Japan Mountain-Woods Art Society (Nihon Sanrin Bijutsu Kyōkai) and painted 30 views of national parks.

Tsuruya Kōkei　弦屋光溪

B. 1946 in Chigasaki, Kanagawa prefecture. Original name Mitsui Gen. Grandson of Nakazawa Hiromitsu. Grad. Fuji Junior College. Began producing self-carved and self-printed *kabuki* actor prints in 1978. These were not favorably received at first, but thanks to the patronage and encouragement of Nagayama Takeomi, president of the Shōchiku Company which manages the Kabuki-za in Tokyo, Kōkei was able to continue making prints until he won public recognition. Makes about one print a month of an actor appearing at Kabuki-za; destroys each block after initial edition of fewer than 75 prints. All actor prints are sold in series at Kabuki-za. Designs inspired by Sharaku but also highly individual and often humorous. All are printed on very thin *ganpi* paper. Subjects, other than actors, include flowers and a series on eight kinds of hell. Sometimes signs Kōkei in *kanji* with or without a seal; sometimes includes an additional seal indicating number of prints in the edition and writes the print's number over the seal.

Tsutsui Toshimine　筒井年峰

Designed *mokuhan* illustrations for novels ca. 1909.

Tsuyahisa　艶久

An elaborate signature found on several prints can be read Tsuyahisa. Among the prints is one depicting a nude toweling herself after a bath; published by Happōdō of Kyoto. See Chapter 7. This may be Inoue Toyohisa.

Uchida Iwao　内田巌

1900–1953. B. Tokyo. Grad. Tokyo School of Fine Arts; studied with Fujishima Takeji. Studied in Paris. Illustrator before World War II.

Uchida Seima 内田静馬

See Uchida Shizuma.

Uchida Shizuma 内田静馬

B. 1906 in Okegawa, Saitama prefecture. Lived in Takeda. Grad. 1928 Tokyo Higher Crafts School. Studied at school of Shun'yōkai; exhibited with Shun'yō-kai. Member of Nihon Hanga Kyōkai from 1932. Contributed to *One Hundred Views of New Japan (Shin Nihon hyakkei)* in 1939. Published a technical book on woodblock printing. In late years a member of Nippankai.

Uchida Shōzaburō 内田庄三郎

1901–ca. 1980. Original name Uchida Saburō. Grad. 1920 Kyoto City School of Fine Arts and Crafts. Studied with Tokuriki Tomikichirō. Exhibited at first Kyoto Sōsaku-Hanga Kyōkai show in 1929. Represented at British International Print Biennale in 1968.

Uchida Tatsuji 内田達次

B. Shizuoka. Member of Dōdosha; exhibited 1930. Contributed to at least 9 issues of *Shiro to kuro*.

Uchima Ansei 内間安醒

B. 1921 in Stockton, California, of Japanese parents. Lived in Japan 1940–1959; has lived in New York since 1960. Began making prints while serving as inter-preter for Oliver Statler in his interviews with *sōsaku-hanga* artists in early 1950s. Member of Nihon Hanga Kyōkai from 1955. Exhibited with Banga-in 1958 and in numerous U.S. shows. Participated in international competitions including São Paulo 1959, Tokyo 1957, 1960, Grenchen 1958, 1961, 1970, Vancouver 1967, and Ljubljana 1973. His delicately colored abstract prints reflect the influence of Onchi Kōshirō.

Uda Tekison 宇田荻邨

1896–1980. B. Mie prefecture. Given name Zenjirō. Grad. Kyoto City Specialist School of Painting. Studied with Kikuchi Hōbun and Kikuchi Keigetsu. Exhib-ited Japanese-style paintings of people, birds, flowers, and landscapes at Bunten, Teiten from 1919, Shin Bunten, and Nitten. Before World War II produced news-paper illustrations.

Ueda Fujō 上田富丈

B. 1899 in Kobe. Studied with Kitano Tsunetomi, Onchi Kōshirō, and Muna-kata Shikō. Exhibited with Banga-in, Nihon Hanga Kyōkai, and in interna-tional exhibitions. Member of Japan Artists League.

Ueda Gagyū 上田臥牛

B. 1921 in Hyōgo prefecture. Grad. 1941 Kawabata Painting School. Studied Jap-anese-style painting with Kobayashi Kokei. Exhibited paintings with Inten, Shinkō Bijutsuin, Mainichi Modern Art Exhibit, Japan International Art Exhibit, and other groups. Started *mokuhan* as means of gaining greater insight

into Japanese-style painting. Subjects of prints include women divers, animals, and landscapes.

Uehara Konen 上原古年

1878–1940. B. Tokyo. Studied with Kajita Hanko and Matsumoto Fūko. Appointed member of Japan Fine Arts Academy. Served in Imperial Household and Foreign Ministry. At least 2 prints, *Night Scene at Dōtonbori, Osaka* and *Fading Lamp Light of a Pagoda,* published by Watanabe. Also woodblock illustrations.

Ueki Sumiko 植木須美子

B. 1921 in Niigata prefecture. Established Niigata Women's Hanga Society. Exhibited with Nihon Hanga Kyōkai and Kokugakai from 1968; member of Nihon Hanga Kyōkai from 1981. Prints present traditionally dressed women in tempestuous landscapes.

Uemura Atsushi 上村淳之

B. 1933 in Kyoto. Son of Uemura Shōkō and grandson of Uemura Shōen. Grad. 1957 from Japanese-style painting department of Kyoto City College of Fine Arts; continued in graduate school. Exhibited paintings with Shin Seisaku Kyōkai, in solo shows, and shows of Uemura family members. His paintings deal with various kinds of birds. *Moku-hanga* of birds are published by small companies and galleries.

Uemura Shōen 上村松園

1875–1949. B. Kyoto. Given name Tsune. Attended Kyoto Prefectural School of Painting. Studied with Suzuki Shōnen, Takeuchi Seihō, and Kōno Bairei. Exhibited in Bunten. Member of Imperial Art Academy and Art Committee of the Imperial Household. Painter of *bijin-ga.* Received Order of Cultural Merit in 1948, the first woman to receive this award. Self-published prints include *Waiting for the Moon (Machizuki)* based on a 1944 painting of the same name, *bijin-ga,* and ghosts. Prints often carved by Ōkura Hanbei or Yamagishi Kazue; printed by Nishimura Kumakichi or Satō Kanjirō. Used a very small signature and seal.

Uemura Shōkō 上村松篁

B. 1904 in Kyoto. Son of Uemura Shōen and Suzuki Shōnen. Exhibited with Teiten and Shin Bunten. In 1948 established Sōzō Bijutsu, an association of *nihon-ga* artists. Received Order of Cultural Merit in 1985. Among his works are bird and flower prints carved by Ōkura Hanbei, published by Unsōdō, Kyūryūdō, and Bijutsu Shoin.

Ueno Makoto 上野誠

1909–1980. B. Kawanakajima, Nagano prefecture. Original family name Uchimura; changed in 1936 to Ueno, family name of his wife. Father of Ueno Shū. Between 1927 and 1931 studied sketching with Yamamoto Toshiharu, Tsuda Seifū, Yasui Sōtarō, and Ihara Usaburō. In 1931 entered teacher training division of Tokyo School of Fine Arts. Became involved with communists, arrested, and

withdrew from school. Studied *mokuhan* with Hiratsuka Un'ichi for 5 years and produced prints while working in a factory. Contributed to *Aoi* and *Kunugi* in 1934 and *Kitsutsuki hangashū* in 1942. Became familiar with prints of Kathe Kollwitz in 1937; strongly influenced by them. Worked as elementary school teacher in Tokyo and junior high teacher in Kagoshima before World War II. Evacuated to Gifu and Nagano during the war; worked as full-time printmaker after the war. Exhibited with Kokugakai 1936–1944. In 1946 joined a workers union. Joined Japan Fine Art Society in 1948. Associate member of Nihon Hanga Kyōkai in 1954; full member from 1960. Founding member of Nihon Hanga Undō Kyōkai in 1949. Also maintained close ties with Chinese print societies. Participated in various international exhibitions in USSR, Yugoslavia, and China. In 1950s made several prints on effects of the atom bomb in Hiroshima; in 1961–1976 created a series on the atomic bomb in Nagasaki.

Ueno Nagao　上野長雄

1904–1974. B. Hyōgo prefecture. Studied Western-style painting with Nakayasu Tamotsu. *Mokuhan* self-taught. Exhibited paintings in Hyōgo prefecture shows and with Japan Watercolor Society. Exhibited *moku-hanga* in 1940 with Kokugakai and after World War II with Nihon Hanga Kyōkai and Shun'yōkai. Member of Nihon Hanga Kyōkai from 1953. Exhibited with CWAJ in 1960s. Late prints tend to be nonobjective.

Ueno Shū　上野道

B. 1939 in Tokyo. Son of Ueno Makoto. Grad. 1964 Tokyo University of Arts, oil painting section. Learned *mokuhan* from his father. Member of Nihon Hanga Kyōkai from 1971. Also shows in solo and group exhibitions in Tokyo. Prints include fanciful scenes or still lifes in surrealist space.

Ueno Tadamasa　上野忠雅

1904–1970. Original name Ueno Katsumi. Studied with Torii Kiyotada. Authorized by Torii family to use Torii name in 1949, becoming known as Torii Tadamasa. In 1940 met Watanabe Shōzaburō who advised him to select 18 paintings of *kabuki* makeup to be made into prints. Woodblock prints of these were published as *Eighteen Kabuki Makeups (Kabuki kumadori jūhachi ban)*, one a month for 18 months. Watanabe started a second series, *Zoku kumadori jūhachiban*, but it was discontinued after 7 prints because of war shortages. After the war Tadamasa designed popular billboards for the *kabuki* theaters in Tokyo. *Eighteen Kabuki (Kabuki jūhachi ban)*, a series of full-length portraits of actors in traditional roles, was published in 3 folios in 1952 by Shōkokusha; carved by Ōkura Hanbei and Nagashima Michio and printed by Shinmi Saburō. Another series, *Kabuki juhachiban no uchi*, 1952, published by Daireisha; carved by Maeda Kentarō; printed by Ono Hikojirō.

Ueno Takashi　うえのたかし

B. 1940 in Gifu prefecture. Original name Ueno Yoshitake. Grad. 1963 from art department of Gifu University. In 1960, while attending university, joined and

worked for the local theater. Studied with Sakai Norikazu and Hayakawa Kunhiko. From 1963 showed at Andepandan Exhibition; since 1974 in solo exhibitions. *Moku-hanga* subjects include people, landscapes, and still lifes.

Uezuki Yukio　植月行雄

B. 1926 in Okayama prefecture. Studied with Nagare Kōji. Worked as junior high school teacher. Member of Banga-in. *Moku-hanga* include highly stylized landscapes.

Ujiyama Teppei　宇治山哲平

1910–1986. B. Nichida, Oita prefecture. Given name Tetsuo. Grad. 1931 Nichida Crafts School. While a student influenced by Mutō Kan'ichi. Exhibited with Nihon Hanga Kyōkai from 1932, Kokugakai from 1935. Active in Shin Hanga Shūdan and Zōkei Hanga Kyōkai. Member of Kokugakai. In 1933 published *moku-hanga* collection called *Kyōdo (One's Birthplace)*. Contributed to *Shin hanga*. In 1934 moved to Fukuoka. After World War II concentrated on oil painting; in 1950 with Kazuki Yasuo founded Keiseiha Beijutsuka Kyōkai (Formative Symbol Artists Society). From 1961 a teacher and later president of Ōita Prefectural Junior Art College. Guest exhibitor with Banga-in. Prints of 1930s influenced by expressionism and fauvism; later works of 1970s evoke geometric abstractions of Kandinsky.

Umehara Eijirō　梅原永二郎

Works include *Flower Garden*, ca. 1960, an elaborately printed composition with addition of mica and collage.

Umehara Ryūzaburō　梅原龍三郎

1888–1986. B. Kyoto. Studied with Itō Yoshihiko and Asai Chū at Kansai Bijutsuin and in France 1908–1913 at Academie Julian and with Auguste Renoir. Also influenced by Gauguin, Matisse, and Nolde while in Europe. First exhibited in Japan under auspices of Shirakaba Society. Founding member of Nikakai in 1914; withdrew in 1918. Returned to France 1920–1921. Participated in establishment of Shun'yōkai in 1922 and reorganization of Kokugakai in 1928. Served as director of Kokugakai until 1951. Adviser to Banga-in. Appointed member of Imperial Art Academy in 1932. Member of Nihon Hanga Kyōkai 1931–1939; associate member after 1939. Professor at Tokyo University of Fine Arts. Received Order of Cultural Merit in 1952 and Asahi Culture Prize in 1956. *Moku-hanga* are principally of nudes. Some carved by Hiratsuka Un'ichi and published by Ishihara Ryūichi; others published by Katō Junji. Color sometimes added by stencil.

Unno Mitsuhiro　海野光弘

1939–1979. B. Shizuoka prefecture. Grad. Shizuoka Business High School. *Mokuhan* self-taught. Active as rural artist. Associate member of Nihon Hanga Kyōkai from 1969; member of Shizuoka Print Society. Works include unidealized representations of country life.

Urata Kanetaka　浦田周社

B. 1939 in Shizuoka prefecture. Son of a traditional *mokuhan* printer. Exhibited with Nihon Hanga Kyōkai in 1975 and with Shizuoka prefectural *hanga* exhibitions and Hakujitsukai.

Urushibara Mokuchū　漆原木虫

1888–1953. B. Tokyo. Original name Yoshijirō. Studied *mokuhan* as a youth. At age 19 went to London to demonstrate carving and printing at British exposition in 1908. Remained in Europe until 1934 teaching Japanese woodblock carving and printing. Carved and printed numerous prints from designs of horses, flowers, and landscapes by Frank Brangwyn R.A. Also designed his own prints, many of picturesque European scenes. Exhibited in the U.S. after 1945.

Usami Ichirō　宇佐美一郎

B. Shizuoka prefecture. Member of the Dōdosha group. Exhibited in second Dōdosha *sōsaku-hanga* show in 1930 and thereafter. Contributed to *Yūkari*.

Ushijima Issui　牛島一水

B. 1881 in Kumamoto prefecture. Member of Japan Cartoon Artists Society. Journalist with *Hōchi shinbun*. Japanese-style painter, *manga* artist, illustrator.

Ushijima Ken　牛島憲

See Ushijima Noriyuki.

Ushijima Noriyuki　牛島憲之

B. 1900 in Kumamoto. Grad. 1928 Tokyo School of Fine Arts, Western painting division. Member of Tōkōkai, Sōgenkai. Exhibited painting at Teiten. Member of Nihon Hanga Kyōkai from 1946. Contributed to *Ichimokushū* and to the Nihon Hanga Kyōkai exhibition in 1946 under the name Ushijima Ken. Thereafter became known for simplified landscape prints in soft greens and blues. Professor at Tokyo University of Fine Arts. Received a medal for contribution to culture.

Ushiku Kenji　牛玖健治

B. 1922 in Chiba prefecture. Grad. Western-style painting department of Tokyo School of Fine Arts. Studied sculpture at the same school after it became Tokyo University of Arts. Member of Nihon Hanga Kyōkai from 1958, Modern Art Club, and Graphic Art Club. Exhibited in solo shows and international exhibitions in Japan and abroad. Known for etchings but also made *moku-hanga*. Wide range of subjects including people, flowers, and abstractions.

Utagawa Kokunimasa　歌川小国政

1874–1944. Son of Baidō Hōsai; also known as Baidō Kokunimasa. Signed Sino-Japanese War prints Kokunimasa and Russo-Japanese prints Ryūkei. Fukuda Kumajirō published 1904 prints.

Utagawa Kunimatsu 歌川国松

1855–1944. B. Osaka. Original name Utagawa Toyoshige. Also used the *gō* Fuku-dō and Ichiryūsai. Studied with his father, Utagawa Kunitsura, an Osaka print-maker. Made *ukiyo-e* inspired illustrations for serialized novels.

Utagawa Kunisada 歌川国貞

See Baidō Hōsai.

Utagawa Yoshimune II 歌川芳宗二世

1863–1941. Given name Shūjirō. Youngest son of Utagawa Yoshimune I (1817–1880). Studied with Yoshitoshi; at age 13 known as Toshiyuki. Adopted by the Arai family. Succeeded his father in 1882 to become Yoshimune II and used his father's *gō* Isshōsai. Worked as illustrator and print designer.

Wada Eisaku 和田英作

1874–1959. B. Kagoshima prefecture. Grad. 1897 Tokyo School of Fine Arts. Studied with Kuroda Seiki, Soyama Yukihiko, and Harada Naojirō. In 1899 went to France; studied with Raphael Collins. Returned to Japan in 1903 and taught at several schools. Exhibited in Bunten and active in Hakubakai. Profes-sor at Tokyo School of Fine Arts and director 1932–1935. In 1943 received Order of Cultural Merit. *Moku-hanga* in *Kōfū* (the magazine of Hakubakai) and other magazines.

Wada Makoto 和田誠

B. 1936 in Osaka. Moved to Tokyo in 1945. Grad. 1959 Tama College of Fine Arts. Worked as graphic designer for company known as Light Publicity 1959–1968 and as freelance designer after 1968. Known for caricatures of prominent people. In 1979 the Riccar Museum engaged him to plan woodblock prints which were then executed by Adachi Woodblock Institute and exhibited at the Riccar; subjects included Humphrey Bogart, Louis Armstrong, and Marilyn Monroe.

Wada Sanzō 和田三造

1883–1968. B. Hyōgo prefecture. Studied at school of Hakubakai with Kuroda Seiki. Grad. 1904 from Western-style painting division of Tokyo School of Fine Arts. Studied in Europe 1907–1915; traveled to India and Burma. Friendly with Yamamoto Kanae while in France. Exhibited paintings at Bunten and with Hakubakai; judge of Bunten and Teiten. Appointed member of Imperial Fine Art Academy in 1927. Taught at Tokyo School of Fine Arts from 1932. Orga-nized the Color Standard Institute of Japan. Series of prints on occupations of Shōwa started in September 1938; interrupted by war shortages in 1943 after completion of 48; made 24 more 1954–1958. Published by the artist or Kyoto Hanga-in.

Wakayama Yasoji 若山八十氏

1903–1983. B. Hokkaido. Grad. 1926 from law department of Chūō University. Studied *mokuhan* with Onchi Kōshirō and Maekawa Senpan, Japanese-style

painting with Matsuzaki Osami, and Western-style painting with Ushijima Noriyuki. In 1941–1942 produced *hanga* with a mimeograph machine. In 1942 exhibited mimeograph *hanga* with Nihon Hanga Kyōkai, Kokugakai, and Shin Bunten, introducing the new field of mimeograph stencil prints. Member of Nihon Hanga Kyōkai from 1943. Employee of a print shop for the Navy Ministry during the war. Contributed prints to every issue of *Ichimokushū*.

Wakayama Yasouji 若山八十氏
See Wakayama Yasoji.

Wakita Kazu 脇田和
B. 1908 in Tokyo. Lived in Germany 1923–1930. Attended Berlin National Art School from 1925; grad. 1930. Studied with Max Raubeth and Oscar Bangeman. Exhibited with Taiheiyōgakai from 1932 and Kōfūkai and Teiten from 1933. Founding member of Shin Seisakuha Kyōkai in 1936. Home destroyed by bomb-related fire in 1945. Exhibited in São Paulo Biennale in 1950. Known principally for lithographs, etchings, and serigraphs, but also made *moku-hanga* early in his career.

Watanabe Kenkichi 渡辺謙吉
Participated in Nihon Sōsaku-Hanga Kyōkai exhibition in 1928 and Nihon Hanga Kyōkai exhibits in 1935–1936, 1938. Member of Hankō no Kai in 1935. At that time lived in Gifu.

Watanabe Kishun 渡辺幾春
B. ca. 1887. Studied with Japanese-style painter Yamamoto Shunkyo. Exhibited in Bunten and Teiten. Designed or contributed to a series of woodblock *bijin-ga* entitled *Contest of Beautiful Women of Shōwa (Shōwa bijo sugata kurabe)* ca. 1927.

Watanabe Kōtei 渡辺光亭
B. 1895. Studied with Kuroda Seiki and Oda Kazuma. Exhibited with Hakujitsu-kai, Kokugakai, and Nihon Hanga Kyōkai. Member of Nippankai.

Watanabe Kōzō 渡辺光三
Participated intermittently in Nihon Hanga Kyōkai exhibitions 1936–1943.

Watanabe Nobukazu 渡辺延一
1874–1944. Original name Shimada Jirō; also used the *gō* Yōsai and Yōsai Nobukazu. Studied with Toyohara Chikanobu. Russo-Japanese War prints published by Hasegawa Enkichi; prints of famous places in Tokyo.

Watanabe Seitei 渡辺省亭
1851–1918. B. Edo. Original name Yoshikawa Yoshimata; adopted into Watanabe family. Studied painting with Kikuchi Yōsai. Traveled in U.S. and Europe. Received silver medal for painting at Paris exposition of 1878. Well-known illustrator and painter of birds and flowers. Major influence on Mizuno Toshikata and Kaburagi Kiyokata. *Moku-hanga* include *Bird and Flower Picture Album*

(*Kachō gafu*), 1903, *Wild Ducks*, published by Nishinomiya, and a series of 22 bird and flower prints published by Ōkura in 1916.

Watanabe Shin'ya 渡辺審也

1875–1950. B. Gifu prefecture. Studied with Asai Chū at school of Meiji Fine Art Society. Active in the formation of Taiheiyōgakai. Worked as an illustrator.

Watanabe Shōtei 渡辺省亭

See Watanabe Seitei.

Watanabe Shōzō 渡辺省三

Participated in 10 Nihon Hanga Kyōkai exhibitions, 1931–1941; member from 1941.

Watanabe Susumu 渡辺進

B. 1900 in Tokyo. Staff member at farmers' art center. Exhibited with Nihon Sōsaku-Hanga Kyōkai from 1919 and Nihon Hanga Kyōkai until 1933. Also exhibited with Shun'yōkai 1924–1926. Member of Nihon Sōsaku-Hanga Kyōkai and founding member of Nihon Hanga Kyōkai.

Watanabe Toshiaki 渡辺俊明

B. 1937 in Shizuoka prefecture. Exhibited with Shizuoka prefecture print association in 1974. Associate member of Nihon Hanga Kyōkai from 1978.

Yagioka Shunzan 八木岡春山

1879–1941. B. Tokyo. Studied Sung and Yuan ink painting. Exhibited paintings at Bunten. Newspaper and magazine illustrator before World War II.

Yagiu Shūzaburō 柳生周三郎

Lived in Tokyo. Contributed to the *dōjin* magazine *Hanga* in 1922. Participated in Nihon Sōsaku-Hanga Kyōkai exhibition in 1922; Nihon Hanga Kyōkai exhibition in 1934.

Yajima Kenji 矢島堅士

1895–1973. B. Fukuyama, Hiroshima prefecture. Exhibited paintings in Teiten, Shin Bunten, and Nitten. Contributed at least 2 prints to *One Hundred Views of Great Tokyo (Dai Tokyo hyakkei)* published by Nihon Fūkei Hangakai through Kaneda Shōten Nihon Hanga Kenkyūsho in 1932. Individual facsimile *mokuhanga* also published by Kaneda Shōten.

Yamabayashi Fumiko 山林文子

B. 1910 in Osaka. Studied painting with Tsuchida Bakusen and printmaking with Maekawa Senpan and Kotozuka Eiichi. Exhibited with Nihon Hanga Kyōkai in 1935; member from 1940 and reinstated in 1953. Also exhibited with Shun'yōkai, Ichiyōkai, and Northwest exhibitions. Bird and flower subjects.

Yamada Akiyo 山田明代

Contributed to *Ichimokushū* 1947, 1948. Associate member of Nihon Hanga Kyōkai from 1952.

Yamada Basuke 山田馬助

Also known as Yamada Umasuke. Landscape prints in mid-1930s; carved by
Takano Shichinosuke, printed by Ono Tomisaburō, and published by Fusui
Gabō. Signed his prints YAMADA BASKE.

Yamada Shin'ichi 山田信一

Exhibited with Nihon Hanga Kyōkai 1943–1947; member from 1946.

Yamada Shōun I 山田昭雲初代

B. 1901 in Okayama prefecture. Father of Yamada Shōun II. Studied wood carv-
ing with Kagenobu and *mokuhan* with Munakata Shikō. A type of carving is
called *Shōun-bori* in his honor.

Yamada Shōun II 山田昭雲二代

B. 1925 in Okayama prefecture. Given name Masashi. Son of Yamada Shōun I.
Studied with his father and Munakata Shikō. At one time a member of Banga-
in. Known as a wood carver and master of *Shōun-bori*.

Yamada Umasuke 山田馬助

See Yamada Basuke.

Yamafuji Shōji 山藤章二

B. 1937 in Tokyo. Studied at Musashino College of Fine Arts. Leading designer
and comics artist. In 1979 invited by Riccar Museum to make 6 designs to be exe-
cuted by the Adachi Woodblock Institute. The resulting satirical cartoon *moku-
hanga* were exhibited by the Riccar.

Yamagata Komatarō 山形駒太郎

1886–1978. B. Kobe. Batik craftsman. Studied at school of Hakubakai. Exhibited
at Bunten and Teiten. Member of Kōfūkai. Wood engravings of his own design
in *Hakutō* in 1910.

Yamagishi Kazue 山岸主計

1893–ca. 1966. B. Nagano prefecture. Studied Western-style painting with
Kuroda Seiki and sculpture with Mutō Shūhō. Skilled woodblock carver and
artist. Worked 1906–1916 as woodblock carver for Yomiuri Shinbun Company.
In 1917 carved Tanaka Kyokichi's designs for *Barking at the Moon (Tsuki ni hoeru)*.
Also carved designs by Kishida Ryūsei for covers of *Shirakaba*. In 1926 carved
blocks for *Twelve Views of Japan (Yamato-e jūni kei)* by the Japanese-style painters
Matsuoka Eikyū, Yamaguchi Hōshun, and Yamamura Kōka. Traveled in U.S.
and Europe 1926–1929 under auspices of Ministry of Education observing and
demonstrating woodblock technique. Among his self-designed prints are *One
Hundred Views of Japan (Nihon hyakkei)*, 1929, *One Hundred Views of the World
(Sekai hyakkei)*, 1937, and *One Hundred Views of East Asia (Tōa hyakkei)*, 1937.
Founding member of Nihon Hanga Kyōkai in 1931. Also carved blocks for
Yokoyama Taikan, Takehisa Yumeji, Kaburagi Kiyokata, Yoshida Hiroshi, Paul
Jacolet, and book covers designed by Onchi Kōshirō.

Yamaguchi Gen 山口源

ca. 1896–1976. B. Shizuoka prefecture; moved to Tokyo at an early age. Given name Gengo. First sought information on *moku-hanga* technique from Fujimori Shizuo when both men were in Taiwan. Later he studied with Onchi Kōshirō. Employed various materials for printing nonobjective compositions as Onchi did. Exhibited with Nihon Hanga Kyōkai from mid-1930s; member from 1943. Contributed to every set of *Ichimokushū*. Exhibited with *Kokugakai*. Represented at Grenchen and awarded major prizes at Ljubljana in 1956 and Lugano in 1958. Abstract prints strongly influenced by Onchi. Sometimes used the name Gen in roman script as a signature.

Yamaguchi Hōshun 山口蓬春

1893–1971. B. Hokkaido. Given name Saburō. Grad. Tokyo School of Fine Arts in both Japanese-style and Western-style painting. Also studied with Matsuoka Eikyū. Interested in *yamato-e*. Exhibited paintings at Teiten, Inten, and Nitten. Woodblocks of landscapes in 1920s and 1930s published by Shin Yamato-e Moku-Hanga Kankōkai. Received Order of Cultural Merit in 1965.

Yamaguchi Kaoru 山口薫

1907–1968. B. Gunma prefecture. Grad. 1930 in Western-style painting from Tokyo School of Fine Arts. Traveled to Europe and Egypt returning in 1933. Exhibited in Teiten and with Nikakai and Kokugakai. Participated in founding of Shin Jidaisha (New Age Group), Jiyū Bijutsuka Kyōkai (Free Artists Society), and Modern Art Association. Taught at Tokyo University of Arts. Prints sometimes combine simplified buildings with broad space or sky.

Yamaguchi Kayō 山口華楊

1899–1984. B. Kyoto. Family of *yūzen* dyers. Given name Yonejirō. Studied Japanese-style painting with Nishimura Goun from 1912. In 1919 graduated from Kyoto City Specialist School of Painting. Exhibited painting with Bunten from 1918 and Teiten from 1920. Taught at Kyoto City Specialist School of Painting 1926–1945 and continued after the school's name was changed to Kyoto City Specialist School of Fine Arts, 1945–1949. In 1971 selected member of Japan Art Academy. In 1981 received Order of Cultural Merit. Prints of flowers were published by Unsōdō and Kōdansha.

Yamaguchi Ryōshū 山口良舟

Studied with Taniguchi Kōkyo. Prints of *nō* masks and *nō* actors published by Kyoto Hanga-in.

Yamaguchi Seion 山口晴温

B. 1926 in Aomori prefecture. Studied with Kawamura Seiichirō and Satō Yonejirō. Member of Banga-in; exhibited from 1953. Many *moku-hanga* illustrations for children's books and books on Aomori. Taught *mokuhan* to junior high school students and workers' groups. Self-published a hand-printed collection entitled *Snow Children (Yuki no ko)*, 1959.

Yamaguchi Sōhei 山口草平

1882–1961. B. Osaka. Studied Japanese-style painting with Nakagawa Rogetsu. Exhibited in Bunten and Teiten. Specialized in historical subjects. Made newspaper illustrations. Actor prints published by Yanagiya of Osaka.

Yamaguchi Susumu 山口進

1897–1983. B. Nagano prefecture. Moved to Tokyo in 1920 and studied with Kuroda Seiki and at Aoibashi Western Painting Institute while working as a school watchman. Later became school counselor and high school art teacher. Exhibited with Nihon Sōsaku-Hanga Kyōkai from 1920; member from 1928. Founding member of Nihon Hanga Kyōkai. Exhibited with Shun'yōkai and in Teiten. Contributed to *Shi to hanga, HANGA, Kasuri, Shin hanga, Han geijutsu,* and *Kitsutsuki.* Printed with oil-base inks in 1920s; later shifted to water-base paints. Experimented with many techniques including scratching wood to expose the grain and printing with excessive water. In 1945 forced by fires following the bombing of Tokyo to return to Nagano prefecture; remained after the war farming a small piece of land while continuing to make and exhibit prints. Specialized in dramatic mountain landscapes achieved through repeated printing on very moist paper. Sometimes used 3 mountain peaks in a seal to represent first *kanji* of his family name, literally "mountain."

Yamakawa Shūhō 山川秀峰

1898–1944. B. Kyoto. Given name Yoshio. Studied first with Ikegami Shūhō and then with Kaburagi Kiyokata. Exhibited Japanese-style paintings frequently in Teiten beginning 1919. Established Seikinkai (Blue Collar Society) in 1939 with Itō Shinsui. Worked as an illustrator. Series of prints of traditional Japanese dancers published in 1936. Prints of modern beauties published by Watanabe and Bijutsusha. Seal shaped like maple leaf.

Yamamoto Kanae 山本鼎

1882–1946. B. Okazaki, Aichi prefecture. In 1892 entered 5-year apprenticeship with Sakurai Torakichi; learned to reproduce Western-style illustrations by wood engraving. In 1902 entered Tokyo School of Fine Arts to study Western-style painting with Nagahara Kōtarō; grad. 1906. Credited with first *sōsaku-hanga.* This print, *Fisherman (Gyofu),* was published, with an explanation by Ishii Hakutei, in the magazine *Myōjō* in July 1904. Active in the production of *Heitan* in 1905 and with Ishii Hakutei, Morita Tsunetomo, Oda Kazuma, and others published *Hōsun* 1907–1911. Designed illustrations for *Hōsun* by woodblock and zinc-plate lithograph and carved blocks from illustrations drawn by other artists; these were mechanically reproduced in the magazine. In 1911 with Sakamoto Hanjirō produced 3 sets of hand-printed *hanga* called *Stage Figure Sketches (Sōga Butai Sugata):* depictions of actors in contemporary roles at the newly opened Imperial Theater. Studied oil painting in Europe 1912–1916. During the journeys to and from France and while he was there he designed most of the major prints of his career. Immediately upon return to Japan exhibited his Euro-

pean paintings at Inten in 1917 and published a book on how to paint in oils. In 1918, with Oda Kazuma, Tobari Kogan, and Terasaki Takeo, he founded Nihon Sōsaku-Hanga Kyōkai and planned the first exhibition to be held the following year. Showed most of the prints he had designed in Europe at the first Nihon Sōsaku-Hanga Kyōkai exhibition in 1919. Profoundly moved by experiences in Russia while returning to Orient via Trans-Siberian Railway. Reflecting his admiration for art movements seen in Russia, in 1918 he founded the farmers' art movement and in 1919 the children's free art movement. In order to work closely with these movements he made his home in Ueda City until 1935. Founding member of Shun'yōkai in 1922; editor of its magazine *Atorie* for many years. Although not active as a woodblock artist after 1920, he continued to be a strong advocate of *sōsaku-hanga* throughout his life. Participated in founding of Nihon Hanga Kyōkai in 1931; served as vice-president until incapacitated by a stroke in 1942.

Yamamoto Morinosuke 山本森之助

1877–1928. B. Nagasaki; lived in Tokyo. Studied with Kuroda Seiki and Asai Chū at Tokyo School of Fine Arts. Exhibited with Hakubakai and Bunten. With Nakazawa Hiromitsu founded Kōfūkai.

Yamamoto Shōun 山本昇雲

1870–1965. B. Kōchi City. Given name Mosaburō. Used the *gō* Shōkoku as an illustrator; since Shōkoku can be read as Matsutani, he is also known as Matsutani Shōun. At 13 moved to Tokyo to study *nanga* painting with Taki Watei. From 1902 exhibited Japanese-style paintings with Nihon Bijutsu Kyōkai and later in Bunten and Teiten. From age 20 worked as illustrator for *Fūzoku gahō*, a pictorial journal dealing with "popular places in Tokyo." *Moku-hanga* of traditional subjects including *bijin-ga*, *kachō-ga*, and landscapes published by Matsuki Heikichi.

Yamamoto Shunkyo 山元春挙

1871–1933. B. Ōtsu, Shiga prefecture. Given name Kin'emon. Studied in Kyoto with Nomura Bunkyō. Moved to Tokyo in 1885 to study with Mori Kansai. Judge and exhibitor in Bunten and Teiten. Later became a professor at Kyoto Specialist School of Painting and a founder of the modern Kyoto school of painters. Member of Imperial Art Committee and Imperial Fine Arts Academy.

Yamamoto Takemi 山本武美

B. Tokyo. Grad. Japanese-style painting division of Tokyo School of Fine Arts. Studied with Komura Settei. After World War II worked as a stage designer and illustrator. Prints of *bijin-ga*.

Yamamura Kōka 山村耕花

See Yamamura Toyonari.

Yamamura Toyonari　山村豊成

1885–1942. B. Shinagawa section of Tokyo. Given name Yoshitaka; used the art name Kōka for paintings, Toyonari generally for prints, although also occasionally Kōka. Studied with Ogata Gekkō. Grad. 1907 Tokyo School of Fine Arts in Japanese-style painting. Exhibited a painting at the first Bunten, 1907; also exhibited at Inten and with Ugōkai. Member of Saikō Nihon Bijutsuin from 1916. In 1916 Watanabe Shōzaburo saw painting of an actor at Inten and asked to make a print from it; followed this with a series of 12 ōkubi-e actor prints in 1920–1922. Other woodblocks including *Pelicans*, *Jar of Dahlias*, and *Parrot*, all 1924, were published by Watanabe. Also made lithographs. The series of actors and bird and flower woodblocks were shown at the Toledo Museum exhibition in 1930. Among the ca. 30 woodblocks Toyonari made during his lifetime, *Shanghai Cafe Dancers*, self-published in 1924, has a uniquely "roaring twenties" spirit.

Yamanaka Kodō　山中古洞

B. 1869 in Tokyo. Original name Satō Shō. Adopted by the Yamanaka family. Also used the gō Tatsushige or Tatsujū. Studied with Tsukioka Yoshitoshi, Kumagai Naohiko, Arihara Kogan. Participated with Kaburagi Kiyokata and Ikeda Terukata in forming Ugōkai in 1901. Exhibited paintings with Ugōkai and Kokugakai. Illustrated weekly newspaper magazines. *Mokuhan* works include *Notebook of Mountains and Waters (Sansui chō)*, 1901, published by Kobayashi Bunshichi; *Mother and Baby*, 1929, signed Tatsujū; *Inner Shrine at Ise*, 1937; *Illustration Manual (Sashi-e setsuyō)*, 1941, published by Unsōdō; and *bijin-ga* published by Watanabe in 1920s and 1930s. Late in life designed *moku-hanga* of movie actresses under the name Tatsushige.

Yamanouchi Jinken　山内神斧

See Yamauchi Shinken.

Yamaoka Beika　山岡米華

1868–1914. B. Tosa, Kōchi prefecture. Given name Naoki. Studied under Nagusa Ippo, Kawamura Ukoku, and Satake Eison. Also studied in China researching origins of *nanga* style. Served as Bunten juror. Active in promoting *nanga* style. Prints of flowers produced by artisans.

Yamashita Keisuke　山下慶助

1913–1977. B. Tokushima prefecture. Worked for *Mainichi shinbun* company 1930–1967. A few prints of Okayama City. Collection of prints entitled *Poster*.

Yamashita Shintarō　山下新太郎

1881–1966. B. Tokyo. Studied Western-style painting with Kuroda Seiki. Grad. 1904 Tokyo School of Fine Arts. Also studied French at Tokyo Foreign Language School. In France 1905–1907; studied with Raphael Collins and Fernand Cormon. Showed paintings at Teiten and Shin Bunten. Founding member of Nikakai in 1914; withdrew in 1935. Founding member of Issuikai in 1936. Returned to France 1931–1932. Awarded the Legion of Honor. Became member

of Imperial Fine Art Academy in 1936. Lithographs and woodblocks of scenes of Kyoto and Nara after World War II. In 1955 honored by Japanese government for contributions to culture.

Yamataka Noboru 山高登

B. 1926 in Tokyo. Grad. 1945 from literature department of Meiji University. Taught himself *mokuhan* while working for 37 years as editor for Shinchōsha. Exhibited with CWAJ every year from 1973. Held first solo exhibition at age 50. Since then has exhibited extensively. Specializes in scenes with buildings, particularly in contemporary Japan.

Yamauchi Kinzaburō 山内金三郎

See Yamauchi Shinken.

Yamauchi Shinken 山内神斧

1886–1961. B. Osaka. Given name Kinzaburō. Studied with Kajita Hanko in a class with Maeda Seison and Kobayashi Kokei. Contributed to *HANGA* in 1924. Also made lithographs.

Yamazaki Shōzō 山崎省三

1896–1945. B. Yokosuka. Studied painting at Nihon Bijutsuin and *mokuhan* with Nagase Yoshio. Member of Shun'yōkai. Exhibited at Bunten. Contributed to *One Hundred Views of Great Tokyo (Dai Tokyo hyakkei)* in 1932.

Yanagihara Fūkyo 柳原風居

Published by Watanabe Shōzaburō in 1921 and 1922.

Yanase Masamu 柳瀬正夢

1900–1945. B. Matsuyama. Studied at school of Japan Watercolor Society. Active as *manga* artist in the group that formed MAVO and in proletarian art movement. Contributed to *MAVO*.

Yasuda Hanpo 安田半圃

1889–1947. B. Niigata prefecture. Given name Tarō; *gō* Hanpo and Koken. Studied with Kodama Katei, Himeshima Chikugai, and Mizuta Chikuhō. From 1917 exhibited in Bunten and from 1921 with Japan Literati Painting Academy (Nihon Nanga-in) of which he was a founding member. Print of funeral procession of Emperor Meiji published in 1912 by Mukawa Unokichi. (The signature appears with a final character no longer in use but believed to be an alternate form of the character given here.)

Yasui Sōtarō 安井曾太郎

1888–1955. B. Kyoto. Studied with Asai Chū at Kansai Bijutsuin. Studied in Paris 1907–1914 with Jean-Paul Laurens and at Academie Julian. Returned to Japan; one of the leading Western-style painters of his generation. Founding member of Nikakai in 1914 and Issuikai in 1936. In 1935 appointed member of Imperial Fine Arts Academy. Exhibited prints with Nihon Hanga Kyōkai in 1930s; honorary member from 1939. Taught at Tokyo School of Fine Arts 1944–

1952. Adviser to Banga-in. Awarded Order of Cultural Merit in 1952. *Moku-hanga*, some carved by Hiratsuka Un'ichi, published 1932–1935 by Ishihara Ryūichi of Kyūryūdō and Katō Junji; several prints of women, landscapes, and still lifes. Used the first character of Sōtarō as a seal.

Yasumoto Ryōichi 安本亮一

1891–1950. B. Asakusa district of Tokyo. Grad. 1924 Tokyo School of Fine Arts in sculpture. Studied with Ikebe Hitoshi and Okamoto Ippei. Member of Japan Cartoon Artists Society. Exhibited with Nihon Sōsaku-Hanga Kyōkai in 1928 and with Shun'yōkai and Teiten. Contributed to *Hanga* (published by Asahi Masahide) in 1929, 1930. Prints deal with customs of *shitamachi*, the old section of Tokyo. In the 1930s characters of his given name sometimes carved in the block.

Yasunami Settai 安並雪岱

See Komura Settai.

Yazaki Chiyoji 矢崎千代治

1872–1947. B. Yokosuka. Grad. 1900 Tokyo School of Fine Arts. Exhibited with Hakubakai and in Bunten and Teiten. In 1903 traveled to Europe and North and South America. Became a pastel artist. Works include a 1917 *moku-hanga* entitled *Blast Furnace*.

Yokohori Kakujirō 横堀角次郎

1897–1978. B. Gunma prefecture. Studied with Kishida Ryūsei. Active in forming Sōdosha; also member of Shun'yōkai. Exhibited with Bunten. Contributed to *Hanga* in 1927 and *One Hundred Views of Great Tokyo (Dai Tokyo hyakkei)* in 1932. Works include pictures of Koishigawa.

Yokoi Kōzō 横井弘三

1888–1965. B. Nagano prefecture. *Moku-hanga* and lithographs, including a woodcut self-portrait, in an autobiography entitled *Great Folly (Dai gu)*. Associated with publication of *Shi ga bō*, a poetry and art *dōjin* magazine in Shizuoka.

Yokoo Tadanori 横尾忠則

B. 1936 in Hyōgo prefecture. Leading graphic designer. Has exhibited in graphics and print exhibitions in New York, Basel, Warsaw, Paris, Brno 1972, 1974, and the Tokyo Biennale in 1974. Sees woodblocks and graphic design as closely related. Limited-edition *moku-hanga* include delicately delineated nudes, landscapes in a busy linear technique, and figures in flat, patterned color.

Yokota Shichirō 横田七郎

B. 1906 in Fukushima prefecture. Grad. Taipei First Middle School. Studied sculpture with Satō Chōzan. *Mokuhan* self-taught. Exhibited in group and solo exhibitions from 1970. Subjects include people, landscapes, animals, and *sumō* wrestlers.

Yokouchi Kiyoharu　横内清春

1870–1942. Lived in Yokohama. Made 5 self-carved, self-printed, self-published prints. These include *Sanjō Bridge in Kyoto*, 1937, *Kannon Temple (Asakusa) in Rain*, 1935, and *Hieizan Temple, Kyoto*, 1940.

Yomogida Heiemon　蓬田兵衛門

1882–1947. B. Fukushima prefecture. Physician. While working in a clinic in early 1930s met Fukazawa Sakuichi and began producing landscape prints. Exhibited with Nihon Hanga Kyōkai 1940–1943; member from 1944. Member of Shin Hanga Shūdan and Zōkei Hanga Kyōkai. Contributed to *Shin hanga* in 1935. Works include landscapes with industrial and working-class overtones.

Yonehide　米英

Russo-Japanese War prints published by Matsuno Yonejirō.

Yonekura Masakane　米倉斉加年

B. 1934 in Fukuoka. Attended Seinan Gakuin University. Actor and producer of *shingeki* (new theater). Exhibited at international shows of children's books. *Moku-hanga* of modern *bijin-ga* published by Kyoto Hanga-in.

Yorozu Tetsugorō　萬鉄五郎

1885–1927. B. Iwate prefecture. Moved to Tokyo in 1903 and attended Waseda Middle School. Also studied with Nagahara Kōtarō at school of Hakubakai. In 1906 went to the U.S. with a missionary from Waseda. Returned to Japan in 1907 and entered Tokyo School of Fine Arts; grad. 1912 when impact of fauvism on Japanese students was at its peak. His graduation painting, a semireclining expressionist nude, caused an uproar. Founding member of Fyūzankai in 1912 and Shun'yōkai in 1922. Through exhibitions of these organizations and Nikakai and Inten he became well known as a leading expressionist painter. Began making black and white expressionist *moku-hanga* when Fyūzankai dissolved; continued after returning in 1914 to his native village in Iwate prefecture. Regarded printmaking as something he was driven to do. Sometimes made woodblocks as sketches from which he developed oil paintings. Yamamoto Kanae, who saw Tetsugorō's prints in 1917 or 1918, praised them highly and persuaded Tetsugorō to submit to the first Nihon Sōsaku-Hanga Kyōkai exhibition. In 1924 Tetsugorō exhibited *Ten Styles of Nudes in Woodblock (Ratai jūdai moku-hanga)*. Became a member of Nihon Sōsaku-Hanga Kyōkai and Nihon Hanga Kyōkai. Contributed to *HANGA*. From mid-1920s lived near Kamakura and painted seascapes in the *nanga* style. Died of pneumonia at age 44. Sometimes used the carved letters "T Y" or the *katakana* syllables "TETSU" of his given name as signatures on early prints.

Yōsai Nobukazu　楊斎延一

See Watanabe Nobukazu.

Yoshida Chizuko　吉田千鶴子

B. 1924 in Yokohama. Grad. 1941 from attached high school of Women's Specialist School of Fine Arts. Studied *mokuhan* with Kitaoka Fumio. Exhibited in a two-person show in 1952 with Yoshida Hodaka; married him in 1954. Mother of Yoshida Ayomi (b. 1958). Exhibited with CWAJ from 1953. Member of Nihon Hanga Kyōkai from 1954. Cofounder with Iwami Reika of Women's Print Association (Joryū Hanga Kyōkai) in 1956; exhibited with Joryū Hanga Kyōkai until 1965. Also a member of Shun'yōkai and Graphic Arts Club. In 1957–1958 traveled in U.S., England, France, Spain, Italy, and Asia. Represented in numerous international competitions. Among prints of the early 1960s, abstract studies in color and form predominate. In later works photoengraving is combined with woodblock. Butterflies, flowers, and shells are favored motifs.

Yoshida Fujio　吉田ふじを

B. 1887 in Fukuoka prefecture. Wife of Yoshida Hiroshi; mother of Yoshida Tōshi and Yoshida Hodaka. Accomplished painter who exhibited paintings with her husband in Europe and U.S. in the early years of the century and after the 1923 earthquake. Active *moku-hanga* artist from late 1920s through 1950s. Member of Shuyōkai.

Yoshida Hiroshi　吉田博

1876–1950. B. Kurume, Fukuoka prefecture. Original name Ueda Hiroshi. Studied with Yoshida Kasaburō, his adoptive father. Also studied with Tamura Sōritsu in Kyoto in 1893; went to Tokyo in 1894 to study with Koyama Shōtarō at Fudōsha. In 1899 traveled in the U.S. with Nakagawa Hachirō; exhibited paintings in New York, Boston, and elsewhere. Founding member of Taiheiyōgakai in 1902. Traveled in Europe 1903–1905. In 1907 he married Fujio, third daughter of the Yoshida family into which he had been adopted. He was a well-established landscape painter, exhibiting at Bunten and Teiten, before he began printmaking, and he continued to exhibit paintings throughout his career. During his travels, however, he learned of the West's admiration for Japanese prints and in 1920 made his first print, *The Secluded Garden of Meiji Shrine*, with Watanabe Shōzaburō. This was one of a total of 7 prints made with Watanabe before the 1923 earthquake; the blocks of all were destroyed in the fires following the quake. Hiroshi and Fujio traveled in the U.S. and Europe 1923–1925 painting and selling their paintings. Enthusiasm for his prints during this sojourn abroad persuaded him to establish his own print workshop upon return to Japan in 1925. Specialized in landscapes from his travels abroad and in Japan. Yoshida learned the skills of carver and printer and often carved his own blocks and personally supervised every stage of his prints. Most of his extensive production was sold abroad; he did not exhibit woodblock prints at Bunten until 1937. Served as a war correspondent in Manchuria in 1938 and 1940; produced his last print in 1946. The characters "JIZURI" (self-printed) are found in the margin of prints made during his lifetime and under his close supervision.

Yoshida Hodaka　吉田穂高

B. 1926 in Tokyo. Second son of Yoshida Hiroshi and Yoshida Fujio. Traveled extensively in U.S., Europe, and Middle East. Began making prints in 1950. Member of Nihon Hanga Kyōkai from 1952; member of Art Club and Graphic Art Club. In 1957 taught Japanese woodblock techniques at universities of Hawaii and Oregon and at Haystack Mountain School of Crafts. Has exhibited at the Tokyo Biennale, Lugano, Ljubljana, Krakow, Frechen, Ibiza, and others. Many of his prints of the 1950s and 1960s are abstractions; he later combined photoengraved images with woodblock.

Yoshida Masaji　吉田政次

1917–1971. B. Wakayama prefecture. Studied at Kawabata Painting School and in the Western-style painting department of Tokyo School of Fine Arts where he was also a member of the *moku-hanga* class taught by Hiratsuka Un'ichi. After graduation in 1942 he was inducted into the army, wounded in action, hospitalized for 6 months, and a prisoner of war for another 6 months before finally returning to Japan in 1946. Returned to Tokyo School of Fine Arts for a year of graduate study; then worked as a teacher. He was interested in abstraction and stimulated by abstract prints of Onchi Kōshirō and Kitaoka Fumio. Member of Nihon Hanga Kyōkai from 1951 and Modern Art Kyōkai 1954–1962. Exhibited in international competitions in Lugano, Zurich 1956, Krakow, São Paulo 1959, and Tokyo 1957. Subjects are often nonobjective; style is marked by short incisive parallel lines. Made etchings and stencil prints as well as *moku-hanga.*

Yoshida Masazō　吉田政三

1907–1974. B. Tokyo. *Haiku* poet who exhibited *moku-hanga* with Shin Hanga Shūdan 1932–1936. Contributed to *Shin hanga.* Used the name Emasu on his poems. Carved the letters "M," "M.Y.," "MAS," or *kanji* for MASA as signatures.

Yoshida Shōzō　吉田政三

See Yoshida Masazō.

Yoshida Shū　吉田修

B. 1929 in Hiroshima prefecture. Given name Osamu; also uses the *gō* Mokkei. Grad. 1953 Hiroshima University. Exhibited with Banga-in and Taiheiyō Bijutsukai. Member of Taiheiyō Bijutsukai from 1973 and Banga-in from 1974. Teacher at Hiroshima Industrial University. Copper-plate prints as well as *moku-hanga.*

Yoshida Tōshi　吉田遠志

B. 1911 in Tokyo. Studied oil painting with his father Yoshida Hiroshi and block carving with Maeda Yūjirō. Grad. 1935 from school of Taiheiyōgakai. Traveled widely in India, Europe, and U.S. Member of Nihon Hanga Kyōkai from 1952 and Graphic Arts Club. Represented in international competitions in Switzerland, Australia, Canada, Mexico, and elsewhere. Carries on the Yoshida work-

shop and tradition. In the early Shōwa period he worked in a realistic manner. After World War II he turned to nonobjective prints for several years but later returned to realistic rendition of subjects from nature. Coauthor with Yuki Rei of *Japanese Print-Making*, 1966.

Yoshihama Kikue　吉浜喜久江

B. 1933 in Tokyo. Studied at school of Taiheiyōgakai. Studied with Kondō Gorō. Began exhibiting painting with Taiheiyōgakai in 1959 and *moku-hanga* in 1972. Prints include mountain views in spring.

Yoshihara Hideo　吉原英雄

B. 1931 in Hiroshima prefecture. Studied at school of the Osaka Municipal Art Gallery. Exhibited with Nihon Hanga Kyōkai from 1958; member 1959–1969. Represented in international shows in Japan, U.S., Brazil, and Switzerland. Works include lithographs, serigraphs, and copper-plate prints as well as *moku-hanga*.

Yoshikawa Kanpō　吉川観方

1894–1979. B. Kyoto. Given name Kenjirō. Studied Japanese-style painting with Nishibori Tōsui from 1901; studied *ukiyo-e* from 1909. Entered Kyoto Specialist School of Painting in 1914; grad. 1918. Studied with Takeuchi Seihō. Made small *hanga* portraits of actors ca. 1916 to stimulate revival of *hanga* in Kansai. Exhibited paintings at Bunten in 1917. Held position in charge of stage design for the Shōchiku theater company. Postgraduate course at Kyoto City Specialist School of Painting completed in 1920. Founded study group on custom and tradition. In 1925 exhibited with Miki Suizan. After that did not exhibit but made prints and commissioned paintings. Known as a Japanese-style painter, writer, stage designer, and adviser to Shōchiku *kabuki* theater. Interested in music, particularly in playing the *biwa* and *kokyū*, stringed instruments of Chinese origin. Collector of *ukiyo-e* and author of several books, including one on *ukiyo-e* and publishing societies (1919) and 2 volumes on ghosts in pictures (1925). Between 1922 and 1924 a collection of actor prints as well as scenes of Kyoto riverbanks and *maiko* were published by Satō Shōtarō. Most if not all were carved by Maeda (probably Kentarō) and printed by Ōiwa. Ten were shown at the Toledo Museum in 1930.

Yoshikawa Kōyō　吉川恍陽

B. 1914 in Ishikawa prefecture. Exhibited with Avant Garde Art Association and other modern print shows. Member of Modern Art Kyōkai.

Yoshikawa Shin　吉川審

B. Tokyo. Original name Itō Shigeo. Member of the group that published *Bakuchiku* for 6 issues in 1929–1930. Showed many multicolor *moku-hanga* at proletarian art movement exhibition in 1930. Later history is not known.

Yoshikuni　美邦

See Bihō.

Yoshimoto Gessō 芳本月荘

1881–1936. Prints include *kachō* and a landscape with fishing boat and cliff against deep orange sky; published by Hasegawa and/or Nishinomiya with Hasegawa's seal sometimes appearing under the signature Gessō.

Yoshimoto Masayuki 吉本政幸

B. 1926 in Hiroshima prefecture. Studied with Asai Kiyoshi. Member of Nippankai and Tōkōkai. Published a *hanga* collection on handmade bells.

Yoshimune 芳宗

See Utagawa Yoshimune.

Yoshimura Kōki 吉村光希

B. 1910 in Wakayama prefecture. Grad. Taipei Normal School. Member of Banga-in. Also exhibited in solo shows and in Switzerland.

Yoshino Toshio 吉野順夫

B. 1930 in Chiba prefecture. Grad. 1958 from oil painting division of Tokyo University of Arts. Studied with Hayashi Takeshi. Exhibited with Nihon Hanga Kyōkai from 1964; member 1970–1981. Member Kōdō Bijutsu Kyōkai.

Yōshū Chikanobu 楊州周延

See Toyohara Chikanobu.

Yōshun 容春

A seal can be read Yōshun. See Chapter 7.

Yukawa Shōdō 湯川松堂

B. 1868 in Wakayama. Original name Ainosuke. Used the *gō* Rakuju. Studied with Suzuki Shōnen. Known as a *bijin-ga* artist; also painted a dragon at Osaka Shitennō-ji and a handscroll for the imperial family.

Yuki Rei 由木礼

B. 1928 in Tokyo. Original name Uemura Norio. Grad. 1952 from a French language school. Studied *mokuhan* with Shinagawa Takumi after seeing his work in the 1953 Kokugakai exhibition. Exhibited with Nihon Hanga Kyōkai from 1954 and Graphic Arts Club from 1956; member of Nihon Hanga Kyōkai from 1967 and Shun'yōkai. Exhibited with CWAJ from 1968. Represented in numerous international competitions. Teacher of English. Coauthor with Yoshida Tōshi of *Japanese Print-Making*, 1966. Works, often printed in subtle blue and green, include partial walls of buildings set in ambiguous space.

Yūki Somei 結城素明

1875–1957. B. Tokyo. Studied with Kawabata Gyokushō. Grad. 1897 Tokyo School of Fine Arts, Japanese-style painting section. Also studied Western-style sketching. Founding member of Museikai in 1900. In 1916 with Kaburagi Kiyokata, Hirafuku Hyakusui, and Matsuoka Eikyū founded Kinreisha. In 1902 became professor at Tokyo School of Fine Arts, an appointment he held until

1944. Lived in France 1923–1925. Upon his return published a set of prints pro-
duced by woodblock entitled *Life in Paris (Pari seikatsu)*.

Yutsuki Takezō 湯月武三

B. 1911 in Hiroshima. Exhibited with Taiheiyōgakai, Nihon Hanga Kyōkai, and
Banga-in.

Yuzuru 襄

See Jō.

Art Schools, Organizations, and Exhibitions

Art Schools

Akamatsu Western Painting Institute. See Akamatsu Yōga Kenkyūsho.

Akamatsu Yōga Kenkyūsho (Akamatsu Western Painting Institute). A private painting school in Osaka founded early in the century by Akamatsu Rinsaku.

Aoibashi Western Painting Institute. See Hakubakai Yōga Kenkyūsho.

Aoibashi Yōga Kenkyūsho (Aoibashi Western Painting Institute). See Hakubakai Yōga Kenkyūsho.

Asagaya Bijutsu Kenkyūsho (Asagaya Fine Arts Institute).

Asagaya Fine Arts Institute (Asagaya Bijutsu Kenkyūsho).

Bunka Gakuin (Culture Academy). A liberal arts school in Tokyo with an emphasis on visual arts.

Dōshūsha. A private painting school in Tokyo founded by Kobayashi Mango.

Fudōsha. A private painting school in Tokyo founded by Koyama Shōtarō in 1877. Active until ca. 1912.

Hakubakai Yōga Kenkyūsho (White Horse Western Painting Institute). School of Hakubakai 1896–1911. Encompassed branches at Aoibashi (Tameike) and Haramachi.

Hongō Kaiga Kenkyūsho (Hongō Painting Institute). A private painting school in Tokyo established by Okada Saburōsuke and Fujishima Takeji in 1912.

Hongō Painting Institute. See Hongō Kaiga Kenkyūsho.

Intānashonaru Bijutsu Senmon Gakkō (International Specialist School of Fine Arts). A technical art school in Kyoto.

International Specialist School of Fine Arts. See Intānashonaru Bijutsu Senmon Gakkō.

Joshi Bijutsu Daigaku (Women's College of Fine Arts). Established in 1949 by renaming Joshi Bijutsu Senmon Gakkō.

Joshi Bijutsu Senmon Gakkō (Women's Specialist School of Fine Arts). Established in 1900. Name changed in 1949 to Joshi Bijutsu Daigaku.

Kansai Academy of Fine Arts. See Kansai Bijutsuin.

Kansai Bijutsuin (Kansai Academy of Fine Arts). Established in Kyoto in 1905 by Asai Chū. This was preceded by his appointment to the Institute of Western Painting at Kyoto Higher School of Industry.

Kansai Daigaku (Kansai University).

Kansai Gakuin Daigaku (Kansai Gakuin University).

Kansai Gakuin University (Kansai Gakuin Daigaku).

Kansai University (Kansai Daigaku).

Kawabata Ga-Gakkō (Kawabata Painting School). A private school founded in 1909 by Kawabata Gyokushō in Tokyo.

Kawabata Painting School. See Kawabata Ga-Gakkō.

Kōbu Bijutsu Gakkō (Technical Fine Art School). Operated by the Meiji government 1876–1883 as a branch of the College of Engineering to educate artists in Western-style painting.

Kyoto City College of Fine Arts (Kyoto Shiritsu Bijutsu Daigaku). See listing under Kyoto City University of Arts.

Kyoto City School of Fine Arts and Crafts (Kyoto Shiritsu Bijutsu Kōgei Gakkō). A secondary school founded in 1901 and still active. It was preceded by:

> Kyoto Prefectural School of Painting (Kyoto-fu Ga-Gakkō) 1880–1891; founded by Kōno Bairei and Kubota Beisen.
>
> Kyoto Municipal School of Fine Arts (Kyoto-shi Bijutsu Gakkō) 1891–1894.
>
> Kyoto Municipal School of Fine Arts and Crafts (Kyoto-shi Bijutsu Kōgei Gakkō) 1894–1901.

Kyoto City Specialist School of Fine Arts (Kyoto Shiritsu Bijutsu Senmon Gakkō). See listing under Kyoto City University of Arts.

Kyoto City Specialist School of Painting (Kyoto Shiritsu Kaiga Senmon Gakkō). See listing under Kyoto City University of Arts.

Kyoto City University of Arts (Kyoto Shiritsu Geijutsu Daigaku). This is the present art university in Kyoto. Founded in 1969. It was preceded by:

> Kyoto City Specialist School of Painting (Kyoto Shiritsu Kaiga Senmon Gakkō) 1909–1945.
>
> Kyoto City Specialist School of Fine Arts (Kyoto Shiritsu Bijutsu Senmon Gakkō) 1945–1950.
>
> Kyoto City College of Fine Arts (Kyoto Shiritsu Bijutsu Daigaku) 1950–1969.

Kyoto College of Crafts and Textiles (Kyoto Kōgei Sen'i Daigaku).

Kyoto-fu Ga-Gakkō (Kyoto Prefectural School of Painting). See listing under Kyoto City School of Fine Arts and Crafts.

Kyoto Kōgei Sen'i Daigaku (Kyoto College of Crafts and Textiles).

Kyoto Prefectural School of Painting (Kyoto-fu Ga-Gakkō). See listing under Kyoto City School of Fine Arts and Crafts.

Kyoto-shi Bijutsu Gakkō (Kyoto Municipal School of Fine Arts). See listing under Kyoto City School of Fine Arts and Crafts.

Kyoto-shi Bijutsu Kōgei Gakkō (Kyoto Municipal School of Fine Arts and Crafts). See listing under Kyoto City School of Fine Arts and Crafts.

Kyoto Shiritsu Bijutsu Daigaku (Kyoto City College of Fine Arts). See listing under Kyoto City University of Arts.

Kyoto Shiritsu Bijutsu Senmon Gakkō (Kyoto Specialist School of Fine Arts). See listing under Kyoto City University of Arts.

Kyoto Shiritsu Kaiga Senmon Gakkō (Kyoto City Specialist School of Painting). See listing under Kyoto City University of Arts.

Musashino Bijutsu Daigaku (Musashino College of Fine Arts). Founded in Tokyo after World War II.

Musashino Bijutsu Daigaku Tanki Daigakubu (Musashino Junior College of Fine Arts).

Musashino College of Fine Arts. See Musashino Bijutsu Daigaku.

Musashino Junior College of Fine Arts (Musashino Bijutsu Daigaku Tanki Daigakubu).

Nihon Bijutsuin (Japan Fine Arts Academy). Founded by Okakura Kakuzō (Tenshin) in 1898. This became a center of Japanese-style painters who favored incorporating Western elements while retaining the essentially Japanese character of their work. In 1914 the name was changed to Saikō Nihon Bijutsuin (Reorganized Japan Fine Art Academy) and it became primarily an exhibiting association sponsoring the yearly show known as Inten.

Shinano Bridge Western-style Painting Institute. See Shinanobashi Yōga Kenkyūsho.

Shinanobashi Yōga Kenkyūsho (Shinano Bridge Western-style Painting Institute). Founded in Osaka by Koide Narashige and others in 1938.

Sōkei Bijutsu Gakkō (Sōkei School of Fine Arts).

Sōkei School of Fine Arts (Sōkei Bijutsu Gakkō).

Taiheiyō Bijutsu Gakkō. The school of Taiheiyōgakai 1929–1957. See also Taiheiyōgakai Kenkyūsho.

Taiheiyō Bijutsu Kenkyūsho. The current school of Taiheiyō Bijutsukai. Assumed this name in 1957. See Taiheiyōgakai Kenkyūsho.

Taiheiyōgakai Kenkyūsho. A private Western-style painting school run by Taiheiyōgakai 1904–1929. The school was named Taiheiyō Bijutsu Gakkō 1929–1957 and is currently known as Taiheiyō Bijutsu Kenkyūsho.

Tama Bijutsu Daigaku (Tama College of Fine Arts). Established after World War II.

Tama College of Fine Arts. See Tama Bijutsu Daigaku.

Technical Art School. See Kōbu Bijutsu Gakkō.

Tokyo Bijutsu Daigaku. See explanation under Tokyo Bijutsu Gakkō.

Tokyo Bijutsu Gakkō (Tokyo School of Fine Arts). Founded in 1887 by the government with Okakura Kakuzō (Tenshin) at its head to teach Japanese-style art and crafts. Western-style painting and sculpture were added in 1896. In 1944 the name was changed to Tokyo Bijutsu Daigaku (Tokyo College of Fine Arts). In 1949 Tokyo University of Arts (Tokyo Geijutsu Daigaku) was established, consisting of a music division and an art division which incorporated Tokyo Bijutsu Daigaku.

Tokyo Geijutsu Daigaku (Tokyo University of Art). Established in 1949 with divisions of art and music. The division of art corresponds to the former Tokyo School of Fine Arts.

Tokyo School of Fine Arts. See Tokyo Bijutsu Gakkō.

Tokyo College of Art and Design (Tokyo Zōkei Daigaku).

Tokyo Zōkei Daigaku (Tokyo College of Art and Design).

Women's College of Fine Arts. See Joshi Bijutsu Daigaku.

Women's Specialist School of Fine Arts. See Joshi Bijutsu Senmon Gakkō.

Organizations

Over the years there have been numerous local and regional printmakers' societies in addition to the organizations listed here.

Action. A group formed in 1923 by Nakagawa Kigen for the promotion of fauve painting. The following year it merged with MAVO and Miraiha Bijutsu Kyōkai to form Sanka Zōkei Bijutsu Kyōkai.

Action Art Association. See Kōdō Bijutsu Kyōkai.

Aomori Creative Print Study Society. See Aomori Sōsaku-Hanga Kenkyūkai.

Aomori Hangakai (Aomori Print Association). Founded 1955 by Katō Takeo, Satō Yonejirō, and others.

Aomori Print Association. See Aomori Hangakai.

Aomori Sōsaku-Hanga Kenkyūkai (Aomori Creative Print Study Society). Organized in 1930 by the brothers Satō Yonejirō and Satō Yonetarō. It was succeeded by Aomori Hangakai in 1955.

Art Committee of the Imperial Household (known as Teishitsu Gigeiin 1868–1945, Gyobutsu-gakari after 1945). In charge of all arts for the imperial household.

Avant-Garde Art Association. See Zen'ei Bijutsukai.

Banga-in. See Nihon Hanga-in.

Bijutsu Bunka Kyōkai (Fine Art and Culture Association). Established in 1939 by 40 Western-style artists with an interest in surrealism. Published the magazine *Bijutsu bunka* 1939–1941 and from 1950 to the present.

Blue Collar Society. See Seikinkai.

Blue Hakama Society. See Seikokai.

Blue Tree Society. See Sōjukai.

Central Fine Art Society. See Chūō Bijutsu Kyōkai.

Children's Land Association. See Dōdosha.

Chōryū Bijutsu Kyōkai (Tidal Stream Fine Art Association).

Chūō Bijutsu Kyōkai (Central Fine Art Society). Established in 1952; still active in 1989. Exhibition accepts prints.

Cormorant Society. See Ugōkai.

Creation Fine Art. See Sōzō Bijutsu.

Creative Painting Society. See Sōgakai.

Creative Print Association. See Sōsaku-Hanga Kyōkai.

Dai Chōwakai (Great Harmony Society). Founded in 1927 but dissolved after two exhibitions. Mushanokōji Saneatsu revived in 1962. Still active in 1989.

Daiichi Bijutsu Kyōkai (First Fine Art Society). Founded 1929 by oil painters. Crafts section added in 1952. Annual exhibitions, one for members and another for nonmembers, are open to prints.

Democrat Fine Art Association. See Demokurāto Bijutsu Kyōkai.

Demokurāto Bijutsu Kyōkai (Democrat Fine Art Association). Founded after World War II.

Dōdosha (Children's Land Association). A *sōsaku-hanga* society in Shizuoka founded in 1929 by Nakagawa Yūtarō and others.

Dokuritsu Bijutsu Kyōkai (Independent Fine Art Association). Founded in 1930 by 11 artists from Nikakai and one each from Kokugakai and Shun'yōkai. Advocated art for art's sake. Still active in 1989.

Eastern Light Society. See Tōkōkai.

Federation of Publishing Artists. See Shuppan Bijutsuka Renmei.

Fine Art and Culture Association. See Bijutsu Bunka Kyōkai.

First Fine Art Society. See Daiichi Bijutsu Kyōkai.

First Sun Society. See Ichiyōkai.

First Thursday Association. See Ichimokukai.

Formative Group. See Shūdan Zōkei.

Formative Print Society. See Zōkei Hanga Kyōkai.

Formative Symbol Artists Society. See Keiseiha Bijutsuka Kyōkai.

Free Artists Society. See Jiyū Bijutsuka Kyōkai.

Free Fine Art Society. See explanation under Jiyū Bijutsuka Kyōkai.

Fusain Society. See Fyūzankai.

Futurist Art Society. See Miraiha Bijutsu Kyōkai and explanation under MAVO.

Fyūzankai. Association of avant-garde artists founded in 1912 by Saitō Yori, Takamura Kōtarō, Kishida Ryūsei, and others to promote the individualism and self-expression of the fauves and postimpressionists. The founders called their association La Société du Fusain. The group held exhibitions in 1912 and 1913 and then disbanded.

Gendai Bijutsuka Kyōkai (Modern Artists' Association). Formed in 1946 by combining several societies of Western-style artists. Exhibition, called Genten, has a section for prints. Still active in 1989.

Gendai Hanga Kenkyūkai (Modern Print Study Society). Founded by Onchi Kōshirō and Kitaoka Fumio in 1950.

Gendai Manga Kyōkai (Modern Cartoon Association).

Genyōkai. See Taiyō Bijutsukai.

Graphic Arts Club.

Grass and Earth Society. See Sōdosha.

Great Harmony Society. See Dai Chōwakai.

Group of Trees. See Kaijusha.

Gyobutsu-Gakari. See Art Committee of the Imperial Household.

Hakubakai (White Horse Society). Association of Western-style painters organized by Kuroda Seiki and Kume Keiichirō in 1896 to promote plein-air academic painting as learned by its founders in France. The association sponsored exhibitions and ran a teaching institute which many print artists attended. Dissolved in 1911.

Hakuhōkai (White Phoenix Society).

Hakujitsukai (Midday Society). Organization established in 1924 by young painters and sculptors who shared the common experience of study abroad. The society held annual exhibitions, except during World War II, and was still active in 1989. Exhibitions open to prints and to nonmembers.

Han no Kai (Print Society). Founded by Ono Tadashige in 1960.

Han no Kai (Hazelnut Society). A group of 50 people who created and exchanged woodblock New Year cards for more than 20 years from 1935 under guidance of Takei Takeo. Members included Sekino Jun'ichirō, Kawakami Sumio, and Hatsuyama Shigeru.

Hanga Konwakai (Print Cordial Talk Society). Founded in December 1954 by Onchi Kōshirō, Ueno Makoto, Ono Tadashige, Hazama Inosuke, and other printmakers, along with Oda Isaburō, Ōshita Masao, Watanabe Tadasu, and other print enthusiasts to hold monthly meetings at Watanabe Color Print Company for the study of prints. From November 1955 held more than 100 monthly exhibitions of prints.

Hankō no Kai (Print Exchange Society). Active for 20 years or more from 1935 under guidance of Takei Takeo. May be the same as Han no Kai (Hazelnut Society).

Hazelnut Society. See Han no Kai.

Ichimokukai (First Thursday Association). A group of printmakers associated with Onchi Kōshirō 1939–1950. Published *Ichimokushū*.

Ichiyōkai (First Sun Society). Founded in 1955 by Noma Hitone and Suzuki Shintarō, former members of Nikakai. Exhibitions, including a *hanga* section, open to nonmembers. Still active in 1989.

Imperial Art Academy. See Teikoku Geijutsuin.

Imperial Fine Art Academy. See Teikoku Bijutsuin.

Independent Fine Art Association. See Dokuritsu Bijutsu Kyōkai.

International Fine Art Association (Kokusai Bijutsu Kyōkai).

International Print Association. See Kokusai Hanga Kyōkai.

Issen Bijutsukai (Top Line Fine Art Association). Organization of painters and sculptors established in 1950. Exhibitions from 1951 including *hanga*. Still active in 1989.

Issuikai. Organization of Western-style artists formed in 1936 by Arishima Ikuma, Ishii Hakutei, Tasaki Hirosuke, Yamashita Shintarō, and Yasui Sōtarō, all former members of Nikakai, "to honor pure and correct art." Limited to realist works. Still active in 1989.

Japan Abstract Art Club. See Nihon Abusutorakuto Āto Kurabu.

Japan Art Academy. See Nihon Geijutsuin.

Japan Artists League. See Nihon Bijutsuka Renmei.

Japan Cartoon Artists Society. See Nihon Mangaka Kyōkai.

Japan Children's Picture Association. See Nihon Dōga Kyōkai.

Japan Creative Print Association. See Nihon Sōsaku-Hanga Kyōkai.

Japan Education Print Association. See Nihon Kyōiku Hanga Kyōkai.

Japan Fine Art Academy. See Nihon Bijutsuin.

Japan Fine Art Association. See Nihon Bijutsu Kyōkai.

Japan Fine Art Society. See Nihon Bijustukai.

Japan Illustration Society. See Nihon Sashie Kyōkai.

Japan Literati Painting Academy. See Nihon Nanga-in.

Japan Mountain-Woods Art Society (Nihon Sanrin Bijutsu Kyōkai).

Japan Painting Academy. See Nihonga-in.

Japan Painting Association. See Nihongakai.

Japan Painting Society. See Nihon Kaiga Kyōkai.

Japan Print Association. See Nihon Hanga Kyōkai.

Japan Print Movement Association. See Nihon Hanga Undō Kyōkai.

Japan Print Public Service Association. See Nihon Hanga Hōkōkai.

Japan Print Society. See Nihon Hangakai.

Japan Print Study Society. See Nihon Hanga Kenkyūkai.

Japan Proletarian Artists Union. See Nihon Puroretaria Bijutsuka Dōmei.

Japan Theatrical Painters Association. See Nihon Gekiga Kyōkai.

Japan Watercolor Society. See Nihon Suisaigakai.

Japan Woodblock Print Academy. See Nihon Hanga-in.

Japan Youth Painting Association. See Nihon Seinen Kaiga Kyōkai.

Jitsugetsusha (Sun and Moon Institute). Association of Japanese-style painters organized in 1950 by Itō Shinsui and Kodama Kibō.

Jitsuzaisha Gurūpu (Realist Group).

Jiyū Bijutsu Kyōkai (Free Fine Art Society). See explanation under Jiyū Bijutsuka Kyōkai.

Jiyū Bijutsuka Kyōkai (Free Artists Society). Founded in 1937 by Murai Masanari, Yamaguchi Kaoru, and others to promote avant-garde art, including prints. In 1964 changed the name to Jiyū Bijutsu Kyōkai.

Joryū Gaka Kyōkai (Women's Painting Society). Founded in 1946. Annual exhibition accepting prints is still active in 1989.

Joryū Hanga Kyōkai (Women's Print Association). Organization of 9 professional women printmakers founded in 1956 including Iwami Reika, Minami Keiko, Shishido Tokuko, Kobayashi Donge, and Yoshida Chizuko.

Kaijusha (Group of Trees). Founded in 1920s by painters. Dissolved but reorganized in 1958 with addition of sculpture and ceramics. Name changed to Shin Kaijusha (New Group of Trees). Still holding annual exhibitions in 1989. Accepts *hanga*.

Kansai Bijutsuin (Kansai Fine Art Academy). Established in 1905 by Asai Chū in Kyoto.

Kansai Fine Art Academy. See Kansai Bijutsuin.

Keiseiha Bijutsuka Kyōkai (Formative Symbol Artists Society). Founded in 1953 by Ujiyama Teppei and Kazuki Yasuo.

Kinreisha. Organization for Japanese-style painters founded by Kaburagi Kiyokata and Hirafuku Hyakusui in 1916.

Knife Society. See Tō no kai.

Kōdō Bijutsu Kyōkai (Action Art Association). Organization of artists from Nikakai formed in 1945. Still active in 1989.

Kōfūkai. Association established in 1912 by Western-style painters formerly associated with Hakubakai. Still active in 1989.

Kokuga Sōsaku Kyōkai. See explanation under Kokugakai.

Kokugakai (National Picture Association). Organization founded in Kyoto in 1918 as Kokuga Sōsaku Kyōkai (National Painting Creation Association) by Japanese-style painters. In 1925 it added a section of Western-style painting; in 1928 all Japanese-style painters withdrew and name was changed to Kokugakai. A *hanga* room was provided in 1928 and a print section established in 1931. New members must be recommended by active members and wait 10 years between associate member and regular member status. Still active in 1989.

Kokusai Bijutsu Kyōkai (International Fine Art Association).

Kokusai Hanga Kyōkai (International Print Association). Formed by Onchi Kōshirō and others in 1953 to promote international exhibitions. The organization held a Japan-America exchange exhibit in 1957 and was then dormant for several years before uniting with Nihon Hanga Kyōkai in 1970.

Kōzōsha (Structure Society). Formed for sculptors in 1926. In 1928 added a painting division. Crafts and *hanga* added later. Changed name to Shin Kōzōsha in 1936. Still active in 1989.

Kyōdo Zugakai (Native Place Painting Society). Art education study group in Oita.

Kyōdokai (Native Place Society). Association of Japanese-style artists who had studied with Kaburagi Kiyokata.

Kyoto Bijutsu Kyōkai (Kyoto Fine Art Association). Organized in 1890.

Kyoto Creative Print Society. See Kyoto Sōsaku-Hanga Kyōkai.

Kyoto Fine Art Association. See Kyoto Bijutsu Kyōkai.

Kyoto Hanga Kyōkai (Kyoto Print Society). Founded in 1951 by Inoue Toyohisa.

Kyoto Print Society. See Kyoto Hanga Kyōkai.

Kyoto Sōsaku-Hanga Kyōkai (Kyoto Creative Print Society). Established in 1929 by Tokuriki Tomikichirō, Asada Benji, Asano Takeji, Kawai Unosuke, and others. Held exhibitions in 1929, 1932, 1933.

League of Artists Sympathetic to the USSR. See Soren Bijutsuka Dōmei.

Livelihood Group. See Seikatsusha.

MAVO. A society established in 1923 by Murayama Tomoyoshi and others to promote dada and surrealist ideas. In 1924 MAVO combined with Action and Miraiha Bijutsu Kyōkai to form Sanka Zōkei Bijutsu Kyōkai (Third Section Formative Art Association).

Meiji Bijutsukai (Meiji Fine Art Society). Founded in 1888 by Asai Chū and Koyama Shōtarō in reaction against the conservatism of Nihon Bijutsu Kyōkai. First exhibition in 1889. Dissolved in 1900 and reconstituted in 1902 as Taiheiyōgakai.

Meiji Fine Art Society. See Meiji Bijutsukai.

Midday Society. See Hakujitsukai.

Miraiha Bijutsu Kyōkai (Futurist Art Group). Founded in 1920. See MAVO.

Modan Āto Kyōkai (Modern Art Association). Formed in 1950. Exhibitions open to prints. Published *Modern Art* from 1961. Still active in 1989.

Modern Art Association. See Modan Āto Kyōkai.

Modern Artists' Association. See Gendai Bijutsuka Kyōkai.

Modern Cartoon Association (Gendai Manga Kyōkai).

Modern Print Study Society. See Gendai Hanga Kenkyūkai.

Museikai. Organization founded in 1900 by students of Kawabata Gyokushō including Yūki Somei, Hirafuku Hyakusui, Watanabe Kagai, Ōmori Keidō, Fukui Kōtei, Shimazaki Ryūō, and Ishii Hakutei to "uphold naturalism as opposed to the romanticism of the Nihon Bijutsuin" and promote fresh approaches to Japanese-style painting. Held exhibitions until 1913.

National Picture Association. See Kokugakai.

Native Place Painting Society. See Kyōdo Zugakai.

Native Place Society. See Kyōdokai.

New Age Group. See Shin Jidaisha.

New Artists Association. See Shin Bijutsuka Kyōkai.

New Century Fine Art Association. See Shin Seiki Bijutsu Kyōkai.

New Classic Fine Art Society (Shin Koten Bijutsu Kyōkai).

New Cooperative Fine Art Society. See Shinkyō Bijutsukai.

New Group of Trees. See explanation under Kaijusha.

New Japanese-style Painting Research Society. See Shin Nihon-ga Kenkyūkai.

New Japan Painting Association. See Shin Nihon-ga Kyōkai.

New Print Association. See Shin Hangakai.

New Print Group. See Shin Hanga Shūdan.

New Production Association. See Shin Seisaku Kyōkai.

New Production Group Association. See Shin Seisakuha Kyōkai.

New Structure Society. See Kōzōsha.

New Tree Association. See Shin Jukai.

New Yamato-e Woodblock Print Society (Shin Yamato-e Moku-Hanga Kai).

Nigenkai. Osaka group established in 1965. Includes Japanese-style and Western-style painting and *hanga*. Open to nonmembers. Annual exhibitions held in Tokyo Museum.

Nihon Abusutorakuto Āto Kurabu (Japan Abstract Art Club). Founded in 1953 by Murai Masanari, Onchi Kōshirō, Yamaguchi Gen, Yamaguchi Kaoru, and others for international exchange of abstract art.

Nihon Bijutsu Kyōkai (Japan Fine Art Association). Conservative group of Japanese-style painters begun in 1887 as an outgrowth of Ryūchikai (Dragon Pond Society); disbanded in 1961.

Nihon Bijutsuin (Japan Fine Art Academy). Established in 1898 by Okakura Kakuzō (Tenshin) and others as a school for the study of art and to hold exhibitions. Reorganized in 1914 after the death of Okakura by Yokoyama Taikan, Shimomura Kanzan, Imamura Shikō, and Yasuda Yukihiko who changed its name to Saikō Nihon Bijutsuin (Reorganized Japan Fine Art Academy). Exhibition known as Inten. Originally showed Western-style painting and sculpture as well as Japanese-style painting. Since 1961 Inten has shown only Japanese-style painting. Still active in 1989.

Nihon Bijutsuka Renmei (Japan Artists League). Founded in June 1949 for exhibition of Japanese and Western-style painting, prints, and sculpture.

Nihon Bijutsukai (Japan Fine Art Society). Established in 1946 "to create art among

the public, defend peace, oppose bureaucratic administration." Annual exhibitions held since 1948 or 1949 are called Andepandanten (Independent Exhibitions). Open to prints.

Nihon Dōga Kyōkai (Japan Children's Picture Association). Society of illustrators for children founded in 1927 by Takei Takeo, Hatsuyama Shigeru, and Murayama Tomoyoshi. Dissolved in 1941. Reestablished in 1962.

Nihon Geijutsuin (Japan Art Academy). Established in 1947 as a replacement for Teikoku Geijutsuin (Imperial Art Academy). This is an honorary institution of 100 life members of whom about half represent visual arts.

Nihon Gekiga Kyōkai (Japan Theatrical Painters Association).

Nihon Hanga Hōkōkai (Japan Print Public Service Association). An alliance of *shin-hanga* publishers and *sōsaku-hanga* artists who banded together in May 1943 in hope of obtaining materials for their work.

Nihon Hanga Kenkyūkai (Japan Print Study Society). Active in early 1930s under the leadership of Hiratsuka Un'ichi.

Nihon Hanga Kyōkai (Japan Print Association). Founded in 1931 by fusion of Nihon Sōsaku-Hanga Kyōkai and Yōfū Hangakai. The 28 members who joined from Nihon Sōsaku-Hanga Kyōkai were Asahi Masahide, Fujimori Shizuo, Fukazawa Sakuichi, Henmi Takashi, Hirakawa Seizō, Hiratsuka Un'ichi, Ishii Tsuruzō, Kawakami Sumio, Koizumi Kishio, Kurita Yū, Mabe Tokio, Maekawa Senpan, Moriyama Shūji, Nagase Yoshio, Nakanishi Yoshio, Oda Kazuma, Onchi Kōshirō, Ōuchi Seiho, Shimizu Kōichi, Shimozawa Kihachirō, Suwa Kanenori, Takegoshi Kenzō, Tanabe Itaru, Terazaki Takeo, Watanabe Mitsunori, Watanabe Susumu, Yamaguchi Susumu, and Yamamoto Kanae. This organization became the largest association of print artists in Japan. Members before 1960 were primarily woodblock artists; in the 1960s and 1970s they were increasingly lithographers, etchers, or serigraphers. New members are elected as associates; may not become regular members for several years. Annual exhibition is open through jury selection to all printmakers. Still active in 1989.

Nihon Hanga Undō Kyōkai (Japan Print Movement Association). Founded by Ono Tadashige, Ōta Kōji, Suzuki Kenji, Takidaira Jirō, Ueno Makoto, and others in 1949 to promote creation of new prints and exchange overseas. Active in the 1950s.

Nihon Hanga-in (Japan Woodblock Print Academy). Formed in 1952 by Munakata Shikō. In 1984 the organization, generally known as Banga-in, designated its name officially as Nihon Hanga-in. Munakata began identifying members in 1941, but because of the war the organization was not actually formed until 1952. Those identified with its early stages include Azechi Umetarō, Barbara Bubunova, Kanamori Yoshio, Kitagawa Tamiji, Koshino Yoshirō, Munakata Makka, Okui Tomoko, Sasajima Kihei, and Shimozawa Kihachirō. Advisers were Hazama Inosuke, Tomimoto Kenkichi, Umehara Ryūzaburō, and Yasui Sōtarō. Annual exhibitions, known as Ban'inten, are open to nonmembers. Still active in 1989.

Nihon Hangakai (Japan Print Society). Known as Nippankai. Formed in April 1960

by Munakata Shikō to promote exhibition of prints in Nitten. Members included Asai Kiyoshi, Mabuchi Tōru, Maekawa Senpan, Mutō Kan'ichi, and Nagase Yoshio. Still active in 1989.

Nihon Kaiga Kyōkai (Japan Painting Society). Founded by students of Okakura Kakuzō (Tenshin) in 1896.

Nihon Kyōiku Hanga Kyōkai (Japan Education Print Association). Founded by Ōta Kōji in 1951.

Nihon Mangaka Kyōkai (Japan Cartoon Artists Society). Founded by Ikeda Eiji and Okamoto Ippei in 1915.

Nihon Nanga-in (Japan Literati Painting Academy). Society of nanga-style painters founded in Kyoto in 1921.

Nihon Puroretaria Bijutsuka Dōmei (Japan Proletarian Artists Union). Founded in 1929.

Nihon Sanrin Bijutsu Kyōkai (Japan Mountain-Woods Art Society). Established after World War II by Tsuruta Gorō and others.

Nihon Sashie Kyōkai (Japan Illustration Society). Active before World War II. In 1950 was replaced by Shuppan Bijutsuka Renmei.

Nihon Seinen Kaiga Kyōkai (Japan Youth Painting Association). Founded in 1891 by Kajita Hanko with Okakura Kakuzō (Tenshin) as president. Became Nihon Kaiga Kyōkai in 1896.

Nihon Sōsaku-Hanga Kyōkai (Japan Creative Print Association). Founded in 1918 with leadership from Yamamoto Kanae. Fused in 1931 with Yōfū Hangakai to become Nihon Hanga Kyōkai.

Nihon Suisaigakai (Japan Watercolor Society). Founded in 1913 by Ishii Hakutei, Tobari Kogan, and Nakagawa Hiromitsu. Still active in 1989.

Nihonga-in (Japan Painting Academy). Organization of Japanese-style painters founded in 1938 as a successor to Nihongakai. Its purpose was to establish a place for exhibiting Japanese-style paintings in Tokyo. Still active in 1989.

Nihongakai (Japan Painting Association). Organization of Japanese-style painters founded in 1897 by Kaburagi Kiyokata. After 1938 known as Nihonga-in.

Nikakai (Second Division Society). Independent exhibiting association formed in 1914 in opposition to the conservatism of Bunten. Sympathetic to European avant-garde ideas and in the Taishō period promoted various styles imported from Europe. Artists in the group included Umehara Ryūzaburō, Yasui Sōtarō, Sakamoto Hanjirō, and Yorozu Tetsugorō. Dissolved during World War II. Revived after the war and still active in 1989; accepts prints.

Nikikai (Second Century Society). Founded in 1947 by 9 artists from Nikakai. Holds annual exhibitions. Still active in 1989.

Nineteen Thirty Association. See Sen Kyūhyaku Sanjū-Nen Kyōkai.

Nippankai (Japan Print Society). See Nihon Hangakai.

Ōgenkai. Organization of painters established as Ōgensha in 1933 by Makino Torao. Disbanded during World War II and reconstituted in 1947 as Ōgenkai. Annual exhibitions open by jury to nonmembers and to hanga.

Ōgensha. See Ōgenkai.

Original Creation Association. See Sōgenkai.

Original Sun Society. See Taiyō Bijutsukai.

Pacific Western-Style Painting Association. See Taiheiyōgakai.

Pan no Kai. A social group of artists and writers who met ca. 1909–1911. Its purpose was to unite the *ukiyo-e* spirit of the Edo period with the café spirit of the impressionist era in Paris.

Print Cordial Talk Society. See Hanga Konwakai.

Print Exchange Society. See Hankō no Kai.

Print Group. See Shūdan Han.

Print Society. See Han no Kai.

Proletarian Art League. See Puroretaria Bijutsu Dōmei.

Proletarian art movement. Popular socialist-oriented group which held 5 exhibitions between 1928 and 1932. It was then disbanded by the police.

Puroretaria Bijutsu Dōmei (or Renmei) (Proletarian Art League). Founded 1927.

Purple Clearness Society. See Shimeikai.

Realist Group (Jitsuzaisha Gurūpu).

Red Green Society. See Tanryokukai.

Red Leaf Society. See Shuyōkai.

Rekitei Bijutsu Kyōkai. Japanese-style painting association founded by Iwahashi Eien in 1938.

Rekitei Fine Arts Association. See Rekitei Bijutsu Kyōkai.

Revived Fine Art Academy. See Shinkō Bijutsuin.

Saikō Nihon Bijutsuin. See Nihon Bijutsuin.

Sangokai (Coral Society). Organization of Japanese-style painters founded in 1907 by Natori Shunsen, Okamoto Ippei, Itō Shinsui, and Kawabata Ryūshi.

Sanka Zōkei Bijutsu Kyōkai. See MAVO.

Sankōkai (Three Reds Society). Association of printmakers in Kobe organized by Kawanishi Hide, Harumura Tadao, and Kitamura Imazō in 1929. Held 6 exhibitions, the last in 1936.

Second Century Society. See Nikikai.

Second Division Society. See Nikakai.

Seikatsusha (Livelihood Group). Founded ca. 1912 by Kishida Ryūsei, Kimura Sōhachi, Okamoto Kiichi, and Takamura Kōtarō, all associated with Fyūzankai at about the same time.

Seikinkai (Blue Collar Society). Association of Japanese-style painters organized in 1939 by Itō Shinsui and Yamakawa Shūhō.

Seikokai (Blue Hakama Society). Group of Japanese-style painters active in 1930s under the leadership of Gotō Shintarō. ("*Hakama*" refers to the divided skirt for men's formal wear.)

Seiryūsha. Organization of Japanese-style painters founded in 1929 by Kawabata Ryūshi, Kotozuka Eiichi, and others who left Nihon Bijutsuin because they found its neoclassicism too aristocratic and confining. They favored art that would appeal to people in general. Dissolved in 1966.

Sekiyōkai. Organization of Japanese-style painters founded in 1914 by Imamura Shikō and Hayami Gyoshū; disbanded in 1916 after the death of Imamura Shikō.

Sen Kyūhyaku Sanjū-Nen Kyōkai (Nineteen Thirty Association). Group formed in 1926 by Saeki Yūzō, Kinoshita Takanori, and Maeda Kanji. Disbanded in 1930 and members joined Independent Fine Art Association.

Seven Color Association (Shichisaikai).

Shichisaikai (Seven Color Association).

Shigenkai. Founded in 1947 by Ishikawa Toraji and others in Taiheiyōgakai who wanted greater freedom. Still active in 1989.

Shimeikai (Purple Clearness Society). Founded in Kyoto ca. 1943.

Shin Bijutsuka Kyōkai (New Artists Association). Founded in 1954 to promote new forms of *nihon-ga*.

Shin Hanga Shūdan (New Print Group). Formed in 1932 by Ono Tadashige, Mizufune Rokushū, Shiba Hideo, Suzuki Kenji, and others as an outgrowth of proletarian art movement. The group reorganized in 1937 and changed its name to Zōkei Hanga Kyōkai.

Shin Hangakai (New Print Association). Founded in 1942 by Azechi Umetarō, Asahi Yasuhiro, Maekawa Senpan, Morita Michikazu, and others. Apparently did not survive the war.

Shin Jidaisha (New Age Group). Founded by Yamaguchi Kaoru and other Western-style painters in the 1930s.

Shin Jukai (New Tree Association). Founded in 1946. Small organization. No *hanga* section.

Shin Kaijusha (New Group of Trees). See Kaijusha.

Shin Koten Bijutsu Kyōkai (New Classic Fine Art Society).

Shin Kōzōsha. See Kōzōsha.

Shin Nihon-ga Kenkyūkai (New Japanese-style Painting Research Society). Founded by Iwahashi Eien in 1934.

Shin Nihon-ga Kyōkai (New Japan Painting Association). Founded in 1918 by Maruyama Banka and others.

Shin Seiki Bijutsu Kyōkai (New Century Fine Art Association). Established in 1955 by oil painters from Nitten.

Shin Seisaku Kyōkai (New Production Association). Formed in 1951 by merging of Shin Seisakuha Kyōkai and Sōzō Bijutsu.

Shin Seisakuha Kyōkai (New Production Group Association). Founded in 1936 by a group of 9 oil painters including Inokuma Gen'ichirō, Koiso Ryōhei, Ise Masayoshi, and Wakita Kazu. Later joined by sculptors, architects, and Japanese-style painters.

Shinkō Bijutsuin (Revived Fine Art Academy). Formed in 1937 by *nanga* painters who were formerly members of Saikō Nihon Bijutsuin. Their purpose was to create a new and vigorous type of *nanga*. Disbanded in 1942. Reorganized in 1951 as Shinkō Bijutsuin. Exhibitions called Shinkōten. Still active in 1989.

Shinkō Yamato-e Moku-Hanga Kai. Formed by Matsuoka Eikyū, Endō Kyōzō, and others in 1921 to revive *yamato-e* painting. Disbanded in 1931.

Shinkyō Bijutsukai (New Cooperative Fine Art Society). Founded 1957 by 40 artists from Shin Seiki Bijutsu Kyōkai, Nitten, and Tōkōkai.

Shūdan Han (Print Group). Founded in 1959 by Suzuki Kenji and others for artists who were not in Banga-in or Nihon Hanga Kyōkai.

Shūdan Zōkei (Formative Group). A society of realistic artists founded in Kyoto in 1969 by Kiyota Yūji.

Shunkōkai (Spring Red Association). A Kyoto group including Takeuchi Seihō, Tsuchida Bakusen, Nishimura Goun, Tomita Keisen, and others.

Shun'yōkai (Spring Principle Association). Formed in 1922 by Kosugi Misei, Morita Tsunetomo, Yamamoto Kanae, and others who withdrew from Inten to promote exhibitions of Western-style art. Had a print room from 1928. Published the magazine *Atorie* (Atelier). Still active in 1989. New members are considered associates for 5 years; then advance to junior and regular member status.

Shuppan Bijutsuka Renmei (Federation of Publishing Artists). Founded by Iwata Sentarō in 1950 as replacement for Nihon Sashie Kyōkai.

Shuyōkai (Red Leaf Society). Founded in 1918 for women Western-style painters.

Sōdosha (Grass and Earth Society). Founded in 1915 by Kishida Ryūsei, Kimura Sōhachi, and others. Dedicated to clear, detailed representation. Kishida Ryūsei was inspired by Van Gogh and Cezanne, but from them learned to regard nature in accord with demands of his own spirit. This led him to a minutely realistic approach which came to be known as the Sōdosha style.

Sōgakai (Creative Painting Society). Founded in 1974 by Japanese-style painters from Shin Seisaku Kyōkai.

Sōgenkai (Original Creation Association). Founded by Western-style painters in 1941. Annual exhibitions open to nonmembers and *hanga*.

Sōjukai (Blue Tree Society). Formed in 1964. Exhibitions open to prints. Still active in 1989.

Soren Bijutsuka Dōmei (League of Artists Sympathetic to the USSR). Sponsored Gendai Nihon Bijutsuten (Modern Japan Fine Art Exhibition).

Sōsaku-Hanga Kyōkai (Creative Print Association). Founded in Osaka ca. 1976.

Sōzō Bijutsu (Creation Fine Art). Organized in 1947 by Japanese-style painters led by Uemura Shōkō. Members joined Shin Seisakuha Kyōkai in 1951 to form Shin Seisaku Kyōkai.

Spring Principle Association. See Shun'yōkai.

Spring Red Association. See Shunkōkai.

Structure Society. See Kōzōsha.

Sun and Moon Institute. See Jitsugetsusha.

Sun Fine Art Society. See Taiyō Bijutsukai.

Taiheiyō Bijutsukai. See Taiheiyōgakai.

Taiheiyōgakai (Pacific Western-Style Painting Association). Founded in 1902 by Ishikawa Toraji, Maruyama Banka, Mitsutani Kunishirō, Nakagawa Hachirō, Ōshita Tōjirō, and Yoshida Hiroshi as a successor to the Meiji Art Society.

Name changed in 1957 to Taiheiyō Bijutsukai. Operates a painting school and holds annual exhibitions which include a *hanga* section.

Taiyō Bijutsukai (Sun Fine Art Society). Founded 1969. Renamed Genyōkai (Original Sun Society) in 1977. Genyōkai still active in 1989.

Tanryokukai (Red Green Society). A group associated with Tokuriki Tomikichirō in Kyoto ca. 1928.

Tatsumigakai. A society of Japanese-style painters. Inaugurated a *hanga* section at its annual exhibition in 1916.

Teikoku Bijutsuin (Imperial Fine Art Academy). Established by imperial order in 1919 for the purpose of choosing works to be shown at exhibitions sponsored by Ministry of Education. Replaced in 1937 by Teikoku Geijutsuin.

Teikoku Geijutsuin (Imperial Art Academy). Established in 1937 as a reorganization of Teikoku Bijutsuin with the addition of new divisions of music and literature. In 1947 Teikoku Geijutsuin became Nihon Geijutsuin (Japan Art Academy), an honorary institution of 100 life members.

Teishitsu Gigeiin. See Art Committee of the Imperial Household.

Third Section Formative Art Association. See MAVO.

Tidal Stream Fine Art Association (Chōryū Bijutsu Kyōkai).

Tō no Kai (Knife Society). Founded in 1957 in Osaka by Ōtsubo Ken'ichi.

Tōkōkai (Eastern Light Society). Oil painters' group established in 1932 by artists who withdrew from Teiten. Dissolved during World War II. Reorganized in 1947. Exhibitions open to nonmembers and *hanga*.

Top Line Fine Art Association. See Issen Bijutsukai.

Ugōkai (Cormorant Society). Organized in 1901 by Kaburagi Kiyokata and Hirezaki Eihō for *ukiyo-e* and Japanese genre artists. Dissolved in 1912.

Western-Style Print Society. See Yōfū Hangakai.

White Horse Society. See Hakubakai.

White Phoenix Society (Hakuhōkai).

Women's Painting Society. See Joryū Gaka Kyōkai.

Women's Print Association. See Joryū Hanga Kyōkai.

Yōdosha. Group of *hanga* artists organized in Osaka in 1930 by Maeda Tōshirō.

Yōfū Hangakai (Western-Style Print Society). Association of etchers and lithographers who organized in 1930 and disbanded after one exhibition to join with members from Nihon Sōsaku-Hanga Kyōkai and others to form Nihon Hanga Kyōkai in 1931.

Yoyogi Ha (Yoyogi Group). *Hanga* artists who gathered at Hiratsuka's house in the Yoyogi section of Tokyo in the late 1930s.

Zen'ei Bijutsukai (Avant-Garde Art Association). Founded in 1946 to promote surrealism. Exhibitions known as Komaten.

Zōkei Hanga Kyōkai (Formative Print Society). Established in 1937 by Ono Tadashige as an organization dedicated to the art of the print and a redirection from the social activism of Shin Hanga Shūdan. Functioned until activities were curtailed by World War II.

Exhibitions

The major international and Japanese print exhibitions and the shortened forms of their names are given here. Additional exhibitions are known by the names of sponsoring organizations.

Andepandanten. Exhibition of Japan Fine Art Society (Nihon Bijutsukai). Established 1946. First exhibition December 1948. Open to prints.

Ban'inten. Annual exhibition of Japan Woodblock Academy (Nihon Hanga-in, known as Banga-in). Established 1952.

Banska. Banska International Woodcut Biennale, Czechoslovakia. Established 1968.

Bradford. Bradford International Print Biennale, England. Established 1968.

Brno. Brno International Graphic Art Biennale, Czechoslovakia. Established 1964.

Buenos Aires. Buenos Aires International Print Biennale, Argentina. Established 1968.

Bunten. Ministry of Education Fine Arts Exhibition (Monbusho Bijutsu Tenran-kai). Established 1907; did not accept prints. In 1919 the name was changed to Teiten.

CCAC. California College of Arts and Crafts World Print Competition, San Francisco. Established 1973, continued in 1977, 1980, and 1983.

CWAJ. College Women's Association of Japan. Annual juried exhibition of prints established in 1956.

Florence. Florence International Graphic Art Biennale, Italy. Established 1968.

Frechen. Frechen International Graphics Biennale, Germany. Established 1970.

Gendai. Modern Japan Fine Arts Exhibition (Gendai Nihon Bijutsuten). Annual exhibition sponsored by an artists' league sympathetic to USSR (Soren Bijutsu-ka Dōmei). Open to prints from 1954; possibly earlier.

Genten. Annual exhibition of Modern Artists' Society (Gendai Bijutsuka Kyōkai). Established 1946. Open to prints.

Grenchen. Grenchen International Color Graphics Triennale, Switzerland. Established 1958.

Ibiza. Ibiza International Print Biennale, Spain. Established 1964.

Inten. Exhibition of Japan Fine Arts Academy (Nihon Bijutsuin). From 1898 to 1906 Inten was a yearly exhibition of paintings from Nihon Bijutsuin, the school established by Okakura Kakuzō. In 1914, after the school was discontinued, Inten was reinstituted as the exhibition of Reorganized Japan Fine Arts Academy (Saikō Nihon Bijutsuin) and showed both Japanese and Western-style painting and sculpture. In 1920 the Western-style painting section was dissolved and in 1961 the sculpture section was dissolved, leaving Inten devoted exclusively to Japanese-style painting after 1961.

International Miniature. International Miniature Print Competition, New York. Held every 4 years beginning ca. 1959.

Kanagawa. Kanagawa Independent Print Exhibition (Kanagawa Hanga Andepandanten). Unjuried. Established 1975.

Kokuten. Exhibition of Kokugakai (National Picture Association). Established 1919. Print room added in 1928; print section instituted in 1931.

Krakow. Krakow International Print Biennale, Poland. Established 1966.

Ljubljana. Ljubljana International Print Biennale, Yugoslavia. Established 1955.

Lugano. Lugano International Print Biennale, Switzerland. Established 1950; terminated 1968.

Miami Graphics Biennale. Established 1973; continued biannually in 1975, 1977, 1980, 1982.

Nichidō. Nichidō Hanga Grand Prix. Annual juried print exhibition sponsored by the Nichidō Gallery in Tokyo. Established 1970.

Nippanten. Annual exhibition of Nihon Hangakai (Nippankai). Established 1960.

Nitten. Nihon Bijutsu Tenrankai, annual exhibition of Japan Art Academy (Nihon Geijutsuin) 1946–1958. Successor to Shin Bunten. After 1958 Nitten became an incorporated entity, no longer under the jurisdiction of the Ministry of Education.

Northwest. Northwest International Print Exhibition held annually in Canada.

Norwegian Biennale. Norwegian International Print Biennale. Established 1972.

Paris. Paris International Print Biennale, France. Established 1968.

Philippine Biennale. Philippine International Print Biennale. Established 1972.

Pistoia. Pistoia International Graphic Arts Biennale, Italy. Established 1966.

São Paulo. São Paulo Biennale, Brazil. Established 1951.

Seoul. Seoul International Print Biennale, Korea. Exhibitions held 1970–1972 and reinstituted in 1981.

Shell. Shell Bijutsushō Ten (Shell Art Award Exhibition). Established 1956.

Shin Bunten. Replaced Teiten as exhibition of the Ministry of Education in 1937 and continued through 1943. Exhibitions were not held in 1944 and 1945 but were resumed in 1946 as Nitten.

Teiten. Teikoku Bijutsuin, the exhibition of the Imperial Art Academy, was sponsored by the Ministry of Education and succeeded Bunten in 1919. Teiten exhibited prints in a special room as part of the Western-style painting section from 1927. The last Teiten exhibition was in 1934. In 1935 there was no government-sponsored exhibition. Early in 1936 an exhibition was held but limited to Japanese-style painting, wood sculpture, and crafts. In autumn 1936, Bunten Shōtaiten, an exhibition by invitation only, was held. This was followed in 1937 by the first exhibition of Shin Bunten which then continued annually until replaced by Nitten in 1946.

Tokyo Biennale. Tokyo International Print Biennale, Japan. Established 1957. Second exhibition held in 1960; continued biannually through 1976. The last exhibition was in 1979.

Toledo. Exhibitions of *shin-hanga* were held at the Toledo Museum, Ohio, in 1930 and 1936. These were organized by Yoshida Hiroshi and Dorothy Blair, an American who had studied with Yoshida in Tokyo.

Venice. Venice Biennale, Italy. Established 1895.

Xylon. Xylon International Wood Engraving Triennale, Switzerland. Established 1957.

Dōjin Magazines

MANY *DŌJIN* OR COTERIE GROUPS published *sōsaku-hanga* prints in small magazines or folios from early in the century until World War II; a few even continued after the war. Although the distinction between magazines and series of prints is not always clear, series were generally preplanned in their entirety with artists and themes predetermined whereas magazines came out more or less regularly as long as their sponsoring groups could manage the production and financing. The pictures in the magazines were predominately hand-printed, but some were also printed in presses or by other photographic or mechanical means.

The inclusive publication dates given here for the magazines are based on examination of available issues or data but may not include all issues. In cases where copies of the magazines or reliable information about contents were available, we have provided brief descriptions of specific issues and lists of contributing artists and the issue numbers in which their works appear. The lists of contributing artists sometimes include names which do not appear in Chapter 2 because very little is known about the artists except that their prints appear in the magazines cited.

Akebi (Red Beauty). 1940–1942; 5 issues. Published in Pusan, Korea, by Shimizu Kanji with assistance from Akasaka Jirō. Contributors, who sent prints from various cities in Japan, included: Doi Meiun 2, Doi Tokutarō 3, Itō Masaaki 1–3, Kawabe Masame 1–4, Kawata Kakutarō, Koido Fujimasa 2–5, Nakata Kazuo 1–4, Noda Shigeyuki 1–5, Okabe Tadayuki 4, Okada Seiichi 1–3, Ono Masao 1–4, Oyama Kiyoshi 1–5, Satō Tatsuya 1–2, Shimizu Kanji 1–5, Uchiyama Ichirō 2, Umebayashi Shin'ichi 2–3, Yamaguchi Kōjirō.

Aoi (Hollyhock). September 1934. One issue. Published by a Nagano prefecture handicraft study group.

Aomori hanga (Aomori Prints). 1939–1969. Published by Aomori Sōsaku-Hanga Kenkyūkai 1939–1955 with leadership from Satō Yonejirō and Aomori Hanga Kyōkai 1955–1969 with additional leadership from Katō Takeo. Formerly known as *Mutsu goma*. From 1939 it was officially named *Kikan Aomori hanga* (Quarterly Aomori Prints) but popularly called *Aomori hanga*. Contributors included Fukushima Jōsaku, Katō Takeo, Kawakami Sumio, Munakata Shikō, Satō Yonejirō, Sekino Jun'ichirō, and Tamura Kiyoshi.

Bakuchiku (Firecracker). 1929–May 1930; 6 or 7 issues. The complete title of the publication was *Hanga kenkyūshi bakuchiku* (Print Study Magazine, Firecracker).

Published by Bakuchikusha under leadership of Konisho Taku. Hand-printed *hanga* are attached to sheets of heavy gray paper. In some issues names of prints and artists are in brown mimeograph under the prints; in the last issue a short piece about each print is on the opposite page. Contributors included: Akima Ken'ichi 4, 6, Hiratsuka Un'ichi 5, Iida Tsuneo 4, 6–7, Itō Shigeo 4, 6, Itō Tōichirō 3–4, Katsuki Sadao 4, 6, Konisho Taku 3–4, 6, Maekawa Senpan 7, Makise Michio 5, Mizukami Genzō 6, Onchi Kōshirō 5, 7, Sawaguchi Toshio 3–4, Shimada Hideo 4, Tanaka Hisara 4, 6, Tsuchiyama Hitoshi 5–6, and Yoshikawa Shin.

Baren (Printing Pad). 1955; at least 4 issues. Published in Shimane prefecture under leadership of Itō Hakubi. In issue 4, 1955, a total of 12 prints.

Bijutsu han (Art Prints). 1932–1934. Issues 1–10 were in 1932, issue 11 in 1933, and vol. 3, no. 8, in 1934. Contributors included Fujimori Shizuo, Hiratsuka Un'ichi, Kawakami Sumio, Onchi Kōshirō, and Sekino Jun'ichirō.

Bokushin (Greek God Pan). 1930; at least 8 issues. A poetry and *hanga* magazine published by Bokushinsha under direction of Sekiya Tadao. Contributors included Kitamura Tomitaka, Sakamoto Mitsuo, Sakamoto Yū, and Watanabe Hiroshi.

Buna no ki (Beech Tree). January–August 1934. Edited in Aomori by Satō Yonejirō of Mujinsha. Published by Handicraft Company.

Chōkokutō. See *Hanga shi chōkokutō.*

Dessin (Drawing). The name of this magazine is spelled on the front of each issue as "Dessan" in *katakana* and "Dessin" in Western letters. The magazine is also known as *Sobyō* (Rough Sketches). January 1926–June 1927; 7 issues. January 1928–September 1929; number of issues undetermined. January 1935–April 1935; 4 issues. From that time each copy of the magazine was accompanied by a leaflet. Resumed 1941–May 1942; 7 issues. October 1949–January 1950; 2 issues. March 1951–April 1951; 2 issues, leaflets only. Published by Sobyōsha under leadership of Asahi Masahide with the editorial office in his home. This was a magazine of articles but often included one or more original prints. After the first 2 issues, the next 5 issues were devoted to special topics: issue 3, study of rough sketches, issue 4, folk pictures made at Ōtsu, issue 5, ancient Korean pottery, issue 6, *ukiyo-e* painting, issue 7, *beni-e* (woodblock prints hand-painted with red from safflowers). Contributors included: Asahi Masahide 5, Fukazawa Sakuichi 1, Hiratsuka Un'ichi 1–2, Ishii Tsuruzō 2, Kawai Unosuke 1, Kawakami Sumio 1–2, Kimura Sōhachi 3, Koizumi Kishio 3, 5, Maekawa Senpan 2–3, 5, Nomura Toshihiko 3–5, Onchi Kōshirō 2, and Yorozu Tetsugorō.

Dozoku gangu hangashū (Print Collection of Folk Toys). April 1935–January 1936; 10 issues. Published by Shiro to Kurosha under the leadership of Ryōji Chōmei. This was apparently a continuation of *Kyōdo gangu hangashū* listed below.

Etchū hanga (Etchū Prints—Etchū is the old name for Toyama prefecture). 1950–1952. Published in Toyama by Munakata Shikō with assistance from Kanamori Yoshio and others. In 1952 publication was taken over by Nihon Hanga-in (Banga-in) and the name changed to *Nihon hanga.*

Ex Libris. May 1930, first issue. Published quarterly by Osaka Hanga Kōbō under direction of Nakata Kazuo.

Fyūzan (Japanization of French word for charcoal drawing). November 1912–June 1913; 6 issues. Title was originally *Hyūzan*; changed to *Fyūzan* before 1913. Published by Fyūzankai under leadership of Kitayama Seitarō. Contributors of *moku-hanga* included Okamoto Kiichi, Kobayashi Tokusaburō, and Seimiya Hitoshi.

Geibi (Art Beauty). May 1914–October 1914; 6 issues. Published by the art store Mikasa Bijutsuten. An art and literature magazine. Cover and illustrations made by woodblock.

Gendai hanga (Modern Prints). 1935; at least 11 issues. Editions limited to 50 copies. Issue 11 included one hand-printed work by Taninaka Yasunori and 9 original prints by Chinese artists.

Hakutō (White Knife—meaning the burin used in wood engraving). November 1910; one known issue and supplement. Published by Kikuchi Takeshi and modeled on *Hōsun*. This was a collection of self-carved prints and essays. It was not for sale. Contributors included Kikuchi Takeshi, Kishida Ryūsei, Mabuchi Rokutarō, Nakazawa Hiromitsu, Okamoto Kiichi, Seimiya Hitoshi, Wada Sanzō, Yamagata Komatarō, and Yatabe Shunji. The supplement was drawn by Nakazawa Hiromizu and carved by Mabuchi Rokutarō.

Han (Print). 1928–February or March 1929; 8 issues. Published by Katana Gabō under leadership of Hiratsuka Un'ichi and Maeda Masao. Six issues in 1928; the seventh issue was on New Year cards. Contributors included Asada Benji, Azechi Umetarō, Fukazawa Sakuichi, Hiratsuka Un'ichi, Kawanishi Hide, Munakata Shikō, Shimozawa Kihachirō, and Tokuriki Tomikichirō.

Han geijutsu (Print Art). April 1932–December 1936; at least 35 issues. Edition of 500. Price 50 sen. Published in Tokyo by Shiro to Kurosha, the company of Ryōji Chōmei. The magazines were essentially mechanically printed with one or more hand-printed works usually included in each issue. Most of the mechanically printed works were in black and white, but some were in two or three colors. Most of the issues also contained a few short essays on prints or artists. Many issues were on special themes: issue 5, mountains and sea; issue 6, hand printing; issue 7, small outdoor prints by Maekawa Senpan (linoleum cuts); issue 8, illustrations of shadow plays by Taninaka Yasunori; issue 9, one hundred *hanga* artists' New Year cards; issue 10, small prints of Hiratsuka Un'ichi (plus New Year cards by others); issue 11, snow; issue 12, Munakata Shikō; issue 13, cherry blossoms; issue 14, children's prints; issue 15, prints of native customs; issue 16, war prints; issue 17, Kawakami Sumio; issue 18, prints of Japanese native toys; issue 19, second issue on Japanese native toys; issue 20, third issue on Japanese native toys; issue 21, *sōsaku-hanga* New Year cards; issue 22, prints of Japanese votive horse pictures; issue 23, Japanese folk toys; issue 24, toys; issue 25, Kawanishi Hide; issue 26, bookplates; issue 28, Maekawa Senpan issue; issue 29, Fujimori Shizuo issue; issue 30, small prints of Shimura Tatsumi; issue 31, Onchi Kōshirō; issue 32, prints and poems of Ogawa Tatsuhiko; issue 33, prints of Katsuhira

Tokushi; issue 35, toys of eastern Kyūshū. Contributors included: Amiboshi Tone 6, 33, Asahi Masahide 1, Azechi Umetarō 3, Enan Shirō 2, 12, 16, 31, 33, Fujimori Shizuo 5, 10, Fukazawa Sakuichi 1, 8, 10, Furukawa Ryūsei 5, Hatsuyama Shigeru 1, 5, Hirakawa Seizō 1–2, Hiratsuka Un'ichi 1, 10, Hirokawa Matsugorō 10, Ishii Tsuruzō 1–2, 10, Kanda Hideo 12, Katsuhira Tokushi 8, 11, 33, Kawabe Atsushi 12, Kawakami Sumio 1, 2, 5, 8, 10–11, 13, 17, Kawanishi Hide 13, 25, Kitamura Imazō 5, Kitazawa Shūji 11, Kobayashi Asaji 13, Kobayashi Matsuo 6, Kurita Yū, Kuriyama Shigeru 1, Maeda Masao 8, Maeda Tōshirō 5, Maekawa Senpan 1, 5, 7, 10–11, 28, Munakata Shikō 5, 12–13, Mutō Kan'ichi 1, 8, 13, 35, Nakagawa Isaku 5, Nakagawa Yūtarō 5, Nakamura Gaku 1, Nakata Kazuo 8, Neichi Ryōzō 5, Ōba Chiaki 5, Ogawa Tatsuhiko 1–2, 11, 13, 32, Onchi Kōshirō 1, 5, 31, Ōuchi Seiho 1, 5, Ryōji Chōmei 5, 10–13, 16, Shimozawa Kihachirō 11, Shimura Tatsumi 30, Sugiyama Masayoshi 1, Suwa Kanenori 2, Takeda Shintarō 10, Taninaka Yasunori 2, 8, 11–14, 16, Tsukuda Masamichi 1, and Yamaguchi Susumu 5.

Han geijutsu dozoku gangu hangashū. See *Dozoku gangu hangashū.*

Han geijutsu kyōdo gangu hangashū. See *Kyōdo gangu hangashū.*

Han geijutsu omocha eshū. See *Omocha eshū.*

Han shōhinshū (Print Small Works Collection). Ca. 1928. Published by Tanryokukai in Kyoto under direction of Tokuriki Tomikichirō.

Hana (Flowers). 1921; possibly only 1 issue. Published by Asahi Masahide.

Han-e (Print Picture). 1938; probably 1 issue. Published in Takayama by Hida Han no Kai under direction of Mori Dōshun.

Hanga (Prints). November 1921–April 1922; 3 issues. Published by Hangasha under direction of Asahi Masahide in consultation with Koizumi Kishio, Nagase Yoshio, Oda Kazuma, Tobari Kogan, and Yamamoto Kanae.

HANGA (Prints—title written in Western capital letters). February 1924–April 1930; 16 quarterly issues. (Numbers 9 and 10 combined.) Published by Hanga no Ie in Kobe under the direction of Yamaguchi Hisayoshi. The issues were distributed to subscribers for 80 sen each. Probably no more than 300 subscribers. The earlier sets came out in folders; later ones were in printed envelopes; the last ones were sewn together along the spine. Each set contained about 10 prints mounted on backings of uniform size. The only written content was the table of contents and the purpose (stated in Japanese and English): to publish, exhibit, and encourage appreciation of *sōsaku-hanga.* Some of the *hanga* were handprinted; others were reproductions. The ratio was usually about 7 or 8 original prints and 2 or 3 reproductions. Contributors included: Akasawa Tetsutarō 12, Asahi Masahide 6, 9/10, Asano Takeji 16, Azechi Umetarō 14–15, Fujii Tatsukichi 4, Fujimori Shizuo 4, 14, Fujita T. 6–7, Fujiki Kikumaro 4, Fukazawa Sakuichi 3, 8–11, 13–15, Furukawa Ryūsei 13, Harumura Tadao, 2, 8, 9/10, Henmi Takashi 2, 7, Hirakawa Seizō 8, 11, Hiratsuka Un'ichi 3, 6–8, 11, 13, 15, Ikura Yoshio 11, Inagaki Tomoo 6, 9/10, 11, 14, Ishii Tsuruzō 2, Ishizaki Shigetoshi 16, Itō Yoshio 12, Iwakoshi Jirō 4, Kamei Tōbei 15, Kashino Yasuzō 9/10, Kawabata Yanosuke 16, Kawai Usaburo 2, Kawakami Sumio 3, 7–11, 13, 15, Kawakami Jōta

1, Kawanishi Hide 8, 11, 16, Kawasaki Kyosen 4, 9/10, Kitamura Imazō 2, 7, 11, 13, 15, Kobayashi Kiyomitsu 12, 15, Kodama Takamura 16, Koizumi Kishio 2, 7, 9/10, 12, Kosaka T. 2, 13, Kurita Yū 4, Mabe Tokio 14, Maeda Masao 11, Maekawa Senpan 2, 12, 14, 16, Makimura Tsuneyoshi 9/10, Miyao Shigeo 13, Moritani Tokio 6, 8, 14, Moriyama Shūji 4, 6, 9/10, 14, Munakata Shikō 16, Nagase Yoshio 6, 12, Nomura Toshihiko 8, Oda Kazuma 2, Ohara Ken 14, 16, Onchi Kōshirō 13, Ono Shōji 9/10, Ono Shuchiku 7, Ono Tameo 15, Ōtsuki Bun'ichi 3, 7, Shibue Shūkichi 3, Shimizu Kōichi 11–12, 15, Shimoyama Kihachirō 15, Sugafuji Kasen 15, Suwa Kanenori 3, 6, 9/10, 12, 14, Takeda Shintarō 16, Tobari Kogan 16 (title page), Tsukamoto Shigeru 3, Uchida Shizuma 16, Watanabe Susumu 4, Yamauchi Shinken 2, Yamaguchi Susumu 3, 6, 9/10, 12–13, Yamamoto Kanae 15 (title page), and Yorozu Tetsugorō 3.

Hanga (Prints). January 1927–March 1928; 13 issues. Published by Hangasha under direction of Kimura Sōhachi. Carved and printed by Nomura Toshihiko. Number 1 contained 6 small prints mounted on dark gray paper and enclosed in an ochre envelope. Designs contributed by Hisaizumi Kyōzō, Nomura Toshihiko, Tsuchiya Yoshirō, and Yokohori Kakujirō.

Hanga (Prints). February 1929–May 1930; 5 issues. Published by Sobyōsha directed by Asahi Masahide. Each issue consisted of original prints pasted to sheets of uniform size and assembled in a folio. Contributors included Asahi Masahide, Koizumi Kishio, Matsumura Matsujirō, Miyao Shigeo, Nomura Toshihiko, Hasegawa Katsusaburō, and Yasumoto Ryōichi.

Hanga (Prints). 1961–1968; 8 issues. Published annually by Hanga Tomo no Kai, a subdivision of Bijutsu Shuppansha. Although this was published after the era of the *dōjin* magazines, it is included here because of the similarity of title and content.

Hanga CLUB (Print Club). March or April 1929–April 1932; 16 issues. Published by Sōsaku-Hanga Club, the publishing company of Nakajima Jūtarō. The prints were originals pasted to sheets of uniform size. The *dōjin* group was composed of the same artists who were concurrently designing the *Shin Tokyo hyakkei* series: Fujimori Shizuo, Fukazawa Sakuichi, Henmi Takashi, Hiratsuka Un'ichi, Kawakami Sumio, Maekawa Senpan, Onchi Kōshirō, and Suwa Kanenori.

Hanga kenkyū (Print Research). March 1932 and March 1934; 2 issues. Published by Nihon Hanga Study Society under the leadership of Hiratsuka Un'ichi.

Hanga Nagasaki (Nagasaki Prints). February 1934–August 1935; 5 issues. July 1953–January 1963; 6 additional issues. Published by Tagawa Ken and a group including Matsuo Tatsuo in Nagasaki. Contributors of self-carved, self-printed *hanga* included Iwasaki Katsutarō 2, Kobayashi Takeo 2, Ōtsuka Yoshiharu 2, Tanaka Isao 2.

Hanga shi chōkokutō (Print Magazine Carving Knife). 1931–1932; at least 17 issues. Published in Aomori by Sōsaku Hanga Kenkyūkai with leadership of Satō Yonejirō. Editions limited to 30 copies. The first few issues in 1931 were apparently called *Mutsu*. In January 1933 the name was changed to *Mutsu goma*. Contributors to *Hanga shi chōkokutō* included: Fujii Sadako 16 (linoleum cut), Fuji-

moto Kenzō 12, Fukushima Jōsaku 10–12, 14–16, Gotō Tadao 10, Kakizaki Takuji 9, Kiuchi Kazuo 9, Kobayashi Asaji 12, 14–16, Kon Junzō 9–12, 14, 16 (etching), Maekawa Senpan 15, Matsuki Manji 15, Matsushita Chiharu 9, Munakata Shikō 12, 14, 16, Mutō Kan'ichi 12, 14–16, Nakata Kazuo 11–12, 14–16, Narita Yukio 11, Neichi Ryōzō 9, Noro Hitoshi 9–10, 14, 16, Ōmuan Issha 9, 11–12, Satō Yonejirō 9–12, 14–16, Satō Yonetarō 10–12, 14–16, Sekino Jun'ichirō 9–12, 14–16, Tamura Kiyoshi 9–12, 14–16, and Yamada Takeshi 10.

Hanga sō (Print Villa). January 1933–September 1936. Published by Hanga Sō of Hirai Hiroshi. Started with 1,000 copies; 3,000 copies by termination. Probably contained only mechanically reproduced woodblock images.

Hanga to shi (Prints and Poetry). January–May 1933; 3 issues. Published in Okayama prefecture by Danzuka Seiichi.

Hanga undō (Print Movement). 1949–1950. Published by Nihon Hanga Undō Kyōkai. Edited by Takidaira Jirō. Contributors included Iino Nobuya, Takidaira Jirō, Ono Tadashige, Ōta Kōji, and Suzuki Kenji.

Hanga za (Print Theater). November 1932–at least June 1934. At least 16 issues. Published in Shizuoka under direction of Ozaki Kunijirō. Mostly black and white prints, hand-rubbed and tipped in. Covers of handmade paper. Contributors included: Fukagawa Kōtarō 2, Kobayashi Sōji 15–16, Masumi Tadao 2, 14–16, Mizuno Yoshikuni 2, Munakata Shikō 14, Nakano Gorō 2, 14, Nakata Kazuo 15, Ogawa Tatsuhiko 2, 14, Ozaki Kunijirō 15–16, Shimizu Kōichi 2, Sugiyama Masayoshi 15, Tsukamoto Shigeru 2, 14–15, Uchida Tatsuji 2, and Urata Giichi 16.

Hanga zōhyō (Print Ex Libris). Ca. 1936; 10 issues. Published by Ryōji Chōmei of Shiro to Kurosha.

Hangashū (Hanga Collection). February 1936–April 1937; 4 issues. Self-published by Fujimoto Yoshio at Shimogawa elementary school in Nagano prefecture.

Hanzō (Print Friend). 1933; at least 2 issues. Published in Hirosaki. Contributors included Kumeda Keizō and Kurotaki Toshio.

Heitan (Peaceful Dawn). September 1905–April 1906; 5 issues. An art and literary magazine published by Heitansha under leadership of Ishii Tsuruzō, Ishii Hakutei, and Yamamoto Kanae. Other contributors included Hirafuku Hyakusui, Ishikawa Kin'ichirō, Kanokogi Takeshirō, Kosugi Misei, and Morita Tsunetomo. *Heitan* contained self-carved and self-printed woodblocks; presented first use of the term *tōga* for an image created with a knife and the word *hanga* in reference to an artistic print as distinct from a commercial reproduction.

Ho no ki (Ho Tree). 1933. At least 2 issues, the second in July. Published in Ōita prefecture under leadership of Ujiyama Teppei.

Hori to suri (Carving and Printing). 1931–March 1933; 7 issues. Changed name to *Kyūshū hanga* in September 1933 and continued until 1938. Published by Oita Normal School Print Study Society with leadership from Mutō Kan'ichi. Contributors included Harada Ganki, Harada Kazutoshi, Haya Toshima, Kanda Hideo, Katayama Hajime, Kodama Sadahei, Murakami Ayako, and Utsunomiya Yoshihiko.

Hōsun (Square Inch). May 1907–July 1911; 35 issues. Published by Hōsunsha with leadership from Ishii Hakutei, Morita Tsunetomo, and Yamamoto Kanae. They were joined by Hirafuku Hyakusui, Kosuge Misei, Kurata Hakuyō, Oda Kazuma, and Sakamoto Hanjirō. Most issues were in editions of 750 and sold for 20 sen each. This was a magazine of articles, poetry, cartoons, and illustrations and a vehicle for important literary figures including Kinoshita Mokutarō, Kitahara Hakushū, and Takamura Kōtarō. Many of the illustrations were created by the artists as woodblock prints, metal-plate prints, or lithographs and reproduced mechanically in the magazine. The woodblocks were usually carved by Yamamoto Kanae or other trained artisans. *Hōsun*, the only magazine of its kind in Japan at the time, was very influential because of its layout and fresh illustrations and the artists' creative use of printmaking techniques.

Jukai (Foliage Sea). March 1915. Published in Yokohama by Jukaisha. Probably 1 issue. Hand-printed. Contributors included Kamata Ryokuhō, Murata Tsuyuji, and Nagao Donkō.

Jun (Purity). Perhaps only 1 issue. Published in Aomori. Contributors included Matsushita Chiharu and Neichi Ryōzō.

Kaketa tsubo (Broken Jar). October 1930–July 1934; 23 issues. Published in Shizuoka by Ryūnan Art Study Society with leadership from Nakagawa Yūtarō.

Kamen (Mask). September 1913–June 1915; at least 4 issues. Published by Kamensha. Art and literary magazine published originally in October 1912 as *Seihai* (Holy Chalice) by Hinatsu Kōnosuke and a literary group at Waseda University. Taken over by Hirokawa Matsugorō. Woodblock covers and illustrations contributed by Hasegawa Kiyoshi, Nagase Yoshio, and Hiroshima Shintarō. This was printed directly from the artists' blocks by machine.

Karikare. May 1938–April 1941; 35 issues. Published by Tokyo Manga Study Society under guidance of Ōta Kōji. Other contributors included Matsushita Ichio, Onosawa Wataru, and Kume Kōichi.

Kasuri (Ikat Fabric). July 1934–August 1936. Six issues, but the last 3 were combined in no. 4. Published in Shizuoka by Kasurisha under leadership of Kuriyama Shigeru. Edition of 80. Price 50 sen. In addition to prints each issue has 7–11 pages of essays by print artists. The prints, several in 2 or 3 colors, appear to have been printed by hand. There are also a few swatches of cloth printed by Suzuki Shirō. Names of the prints and the artists are on inserts opposite each print. Contributors included: Aioigaki Akitsu 4, Enan Shirō 2, Fujimori Shizuo 1–2, 4, Fukazawa Sakuichi 2–4, Henmi Takeji 2, Hiratsuka Un'ichi 1, 3, Kawakami Sumio 1–4, Kawanishi Hide 2–3, Kobayashi Asaji 1–4, Kuriyama Shigeru 1–4, Maekawa Senpan 1–4, Matsuyama Midori 4, Mutō Kan'ichi 1–2, 4, Ogawa Tatsuhiko 1, 4, Nakagawa Yūtarō 1–4, Suzuki Shirō 2–4 (swatches of cloth), and Yamaguchi Susumu 1–4.

Katamari (Group). Taishō period. Magazine of self-carved prints published by Takenouchi Shun'ichi.

Katana (Knife). 1930; at least 7 issues. Contributors included: Daidōji Tōru 3, 7, Katō Kunio 3, Kawakami Jōta 3, 7, Kobayashi Jirō 3, Konishi Jirō 3, Minegishi Saburō

3, 7, Oguri Toshikazu, Ōhashi Takeshi 3, Saitō Tsunemasa 3, 7, Saitō Wasaburō 3, Sakamoto Yū 3, Suzuki Kenji, Takahashi Mamoru 3, 7, Taki Sakae 3, 7.

Kaze (Wind). October 1927–July 1928; 4 issues. April 1929–September 1929; 4 additional issues. This was formerly *Minato* and published by Sawada Ishiro of Ōa Geijutsusha. The number of prints in the first series varies from 5 to 11. Contributors to the first series included: Fujimori Shizuo 1, 3, Fukazawa Sakuichi 3, Henmi Takeshi 1, Hiratsuka Un'ichi 3, Kawakami Sumio 1, 3, Onchi Kōshirō 1, 3. Each issue in the second series features one artist but includes works by others as well. Issue 1 featured Onchi Kōshirō; printed by Nishimura Kumakichi; other contributors: Fujimori Shizuo, Fukazawa Sakuichi, Henmi Takashi, Hiratsuka Un'ichi, Kawakami Sumio, Maekawa Senpan, Suwa Kanenori. Issue 2 featured Maekawa Senpan; other contributors: Hiratsuka Un'ichi, Kawakami Sumio, Kawanishi Hide, Onchi Kōshirō, Suwa Kanenori, Tanaka Kyōkichi (posthumous), Tokuriki Tomikichirō. Issue 3 featured Kawakami Sumio; other contributors: Fujimori Shizuo, Henmi Takashi, Inagaki Tomoo, Miyazaki Yutaka, Onchi Kōshirō, Yamaguchi Susumu. Issue 4 featured Fujimori Shizuo; printed by Taguchi Kikumatsu; other contributors: Azechi Umetarō, Fukazawa Sakuichi, Kawakami Sumio, Maekawa Senpan, Onchi Kōshirō, Suwa Kanenori, and Yamaguchi Gen.

Keisei gahō (Formative Pictorial). October 1928. The magazine *MAVO* took the name *Keisei gaho*. One issue. Published by Okada Tatsuo.

Kikan Aomori hanga (Quarterly Aomori Prints). See *Aomori hanga*.

Kikan hanga (Print Quarterly). October 1968–1971; 12 issues. Also called *La Gravure*. Published by Bijutsu Shuppansha which took over an annual entitled *Hanga* and converted it into a quarterly. Although this did not come out until after the era of the *dōjin* magazines, it is included here because of its similarity in title and content. A limited edition of 500 copies was devoted mainly to one contemporary artist (various print media) with one original print by same. There was also a public issue presumably without an original print. Artists include Ai-Ō, Amano Kazumi, Hamada Chimei, Komai Tetsurō, Kurosaki Akira, Nagai Kazumasa, Noda Tetsuya, Onosato Toshinobu, Saitō Juichi, Sugai Kumi, and Yoshihara Hideo.

Kikan shin hanga (Quarterly New Prints). See *Shin hanga*.

Kimi to boku (You and I). November 1922–May 1923; at least 4 issues. Published every other month by Hayami Yasushi. This was a magazine of *hanga* and essays, originally called *Rōkan*. Price 50 sen. Contributors included Koizumi Kishio 1–4 and Ōkōchi Nobuhiro 1–4.

Kitsutsuki (Woodpecker). July 1930–June 1931; 3 issues. Unbound folios. Editions limited to 100. Published by Sōsaku Hanga Club of Nakajima Jūtarō under direction of *Kitsutsuki* editorial board: Fujimori Shizuo, Fukazawa Sakuichi, Henmi Takashi, Hiratsuka Un'ichi, Kawakami Sumio, Maekawa Senpan, Onchi Kōshirō, and Suwa Kanenori. As stated in the first issue, the *dōjin* group was composed of Asada Benji, Azechi Umetarō, Furukawa Ryūsei, Harumura

Tadao, Inagaki Tomoo, Ishii Ryōsuke, Itō Yoshiteru, Kakihara Toshio, Kamei Tōbei, Katsuhira Tokushi, Kawanishi Hide, Kobayashi Kiyomitsu, Kodama Sadahei, Maeda Masao, Maeda Tōshirō, Murayama Kankō, Matsuki Manji, Munakata Shikō, Nakanishi Yoshio, Nomura Toshihiko, Okuyama Yasuo, Shimizu Kōichi, Shimoyama Kihachirō, Takeda Shintarō, Tokuriki Tomiki-chirō, and Yamaguchi Susumu. In the first issue, published in July 1930, the board announced that *Kitsutsuki* would be published 6 times a year with special collections of individual artists twice a year, spring and fall. Each issue was to contain 10 prints, all hand-printed and 7 in color. The board also said that it would establish a *hanga* institute, offer short courses, and sell *hanga* tools at cost for the development and promotion of *hanga*. Hiratsuka Un'ichi's print of a woodpecker, made for the cover of the first issue, became the emblem of the magazine and was used for each issue. The second issue, published in September 1930, featured the Ginza; an attached note said the group consisted of 30 members. The third issue, published in June 1931, featured still lifes; an attached note said the group consisted of 20 members. The name *Kitsutsuki* was revived in 1942 by the Kitsutsuki Hanga Club, which published *Kitsutsuki hangashū*. (See Chapter 6). Contributors to *Kitsutsuki*: Azechi Umetarō 1-2, Harumura Tadao 3, Inagaki Tomoo 1-2, Ishii Ryōsuke 1, Kakihara Toshio 2, Kawakami Sumio 3, Kawanishi Hide 1, Kobayashi Kiyomitsu 3, Kodama Sadahei 2 (lithograph), Kodama Takamura 3, Maeda Masao 1, Maeda Tōshirō 3, Matsuki Manji 2, Munakata Shikō 3, Murayama Kankō 1, Nakanishi Yoshio 3, Nomura Toshi-hiko 1, Nozaki Saburō 2, Okuyama Yasuo 1-3, Onchi Kōshirō 1, Shimizu Kōichi 2, Suwa Kanenori 2, Takeda Shintarō 3, Tokuriki Tomikichirō 3, and Yamaguchi Susumu 1-2. In addition woodcut decorations were made for the first issue by Fujimori Shizuo, for the second by Henmi Takashi, and for the third by Ishii Tsuruzō.

Kōhan (Pleasure Prints). 1935. Published in Kyoto by a group which included Masada Eizō and Kimura Seitarō.

Kokuga (Carved Picture). 1947. Published by Suzuki Kenji. Contributors included Takidaira Jirō.

Kokusui (Essence of the Country). 1920.

Kunugi (Oak for Charcoal). 1934-1937; 10 issues. Published by Shinano Sōsaku-Hanga Study Society under direction of Kobayashi Asaji.

Kusabue (Grass Whistle). Published by Kuriyama Shigeru in Shizuoka. Absorbed by *Yūkari*.

Kyōdo (Native Place). 1932-at least April 1933. At least 6 issues. Published in Ōita prefecture by Ujiyama Teppei.

Kyōdo gangu hangashū (Print Collection of Native Toys). June 1934-March 1935; 10 issues. Published by Ryōji Chōmei of Shiro to Kurosha. Contributors included Aki Yasuichi, Akiyama Kikuzō, Funamoto Shigekazu, Inaba Kyōji, Katō Tei, Narumi Kaname, Natsume Kensuke, Noguchi Sanshirō, and Shimura Kazumi.

Kyūshū hanga (Prints of Kyushu). September 1933-May 1938; 17 issues. Published by

Kyushu Hanga Kyōkai with leadership of Mutō Kan'ichi. Formerly *Hori to suri.* Contributors included Takeda Yoshihei. Inspired by a lecture by Hiratsuka Un'ichi.

Marumero (Make it Round). Ca. 1930. Published in Shizuoka by Ogawa Tatsuhiko and Yokoi Kōzō. Absorbed by *Yūkari.*

MAVO (dada-type nonsense word). July 1924–August 1925; 7 issues. Published by Chōryūsha with leadership from Okada Tatsuo and Murayama Tomoyoshi. Linoleum prints and lithographs as well as woodcuts. Magazine inspired by dada and by the irrationality in Zen. Changed name in October 1928 to *Keisei gahō* (Formative Pictorial) and became the private publication of Okada Tatsuo. Contributors included Toda Tatsuo and Yanase Masamu.

Minato (Harbor). December 1926 or January 1927–July 1927; 5 issues. This was a magazine of poetry and prints published by Sawada Ishiro of Ōa Geijutsusha and edited by Onchi Kōshirō. Other contributors included Fukazawa Sakuichi, Kawakami Sumio, Sarashina Genzō, and Taniuchi Ichirō. In October 1927 the name was changed to *Kaze.*

Mokuhan (Wood Print). 1927; 4 issues. Published in Ōita by Kyushu Print Society. Revived with 2 additional issues between March 1929 and 1930. Published by Ōita Normal School print study group with leadership from Mutō Kan'ichi. Contributors included Akaike Satoru.

Moro monyō (words from Shingon Buddhist ritual). January 1926–February 1926; 2 issues. Published by Taninaka Yasunori. Hand-printed. Contributors included Iida Shōichi, Murai Tōru, Ueda Harunosuke, and Enomoto Kiyoshi.

Mura no hanga (Prints of the Village). January 1932–1935; at least 10 issues. Published by Mura no Hangasha in Utsunomiya with leadership from Kawakami Sumio. Editions usually limited to 25 copies with roughly 15 *sōsaku-hanga* in each issue, all printed by hand. Kawakami Sumio organized a *hanga* club of schoolteachers in Utsunomiya ca. 1925 calling the club Mura no Hanga. Although this club was apparently the *dōjin* group, the magazine drew upon other artists as well as club members. Contributors included: Asahi Masahide 6, Fukazawa Sakuichi 4, 6, 8, Hiratsuka Un'ichi 6, 8–9, Ikeda Shingo 3–9, Izawa Akira (Meisaku) 3–4, 6, 8, Kawakami Sumio 3–9, Kobayashi Matsuo 3–9, Kikuchi Hikaru 9, Kohoku Rojin 9, Mashiko Hiroshi 3–9, Matsuoka Isamu 3–10, Matsuzaki Shigenori 5–8, Ryōji Chōmei 6–9, Shinozaki Kiichirō 6, 10, Suwa Kanenori 4, and Usui Toshiyuki 9.

Mutsu (old name for Aomori). 1931; 2 issues. Published by Aomori Sōsaku-Hanga Kenkyūkai under Satō Yonejirō. See *Hanga shi chōkokutō* and *Mutsu goma.* Contributors included: Fukushima Jōsaku 2, Hamada Seiji 2, Itō Kyōichi, Kakizaki Takuji, and Tamura Kiyoshi 2.

Mutsu dozoku gangushū (Collection of Local Toys of Aomori). February 1935; 1 issue. Published by Aomori Sōsaku-hanga Study Society under direction of Sekino Jun'ichirō.

Mutsu goma (old name for Aomori horse). January 1933–June 1934; 13 issues. Revived October 1938–June 1939; 8 issues. Formerly *Hanga shi chōkokutō.* Published by Aomori Sōsaku-Hanga Kenkyūkai with leadership from Satō Yonejirō. Con-

tributors included Fukushima Jōsaku, Kakizaki Takuji, Kon Junzō, Nakata Kazuo, Satō Yonejirō, Sekino Jun'ichirō, and Tamura Kiyoshi.

Nevelon. April 1928–August 1928; 2 issues. Published by Morisusha under the leadership of Moriguchi Mototaka. Other contributors included Moriguchi Hikaru and Murakami Chikara.

Nihon hanga (Japanese Prints). July 1943–January 1945. Published by Nihon Hanga Hōkōkai. This was originally *Etching* and renamed by Hanga Hōkōkai in the hope of continuing to publish *hanga* during the war.

Nihon hanga (Japanese Prints). 1952. Successor to *Etchū hanga.* Published by Nihon Hanga-in (Banga-in). Folio of loose sheets wrapped in handmade paper.

Omocha eshū (Toy Picture Collection). March 1936–November 1936; 10 issues. Published by Shiro to Kurosha with leadership of Ryōji Chōmei. Continuation of *Dozoku gangu hangashū.*

Rōkan. See *Kimi to boku.*

Satoporo (Sapporo). June 1925–September 1929. Twenty-nine issues plus an appendix of Hokkaido scenes. Published by Satoporo Poetry Study Society with leadership from Aikawa Masayoshi, Sugano Risuke, and Toyama Usaburō. Edition of 150. Price 50 sen. The magazine contained poems as well as self-carved, self-printed woodcuts. Volume and issue numbers appear to be inconsistent. Print contributors included Hattori Kōhei, Itō Yoshiteru, Katō Tetsunosuke, Katsuhira Tokushi, Kikuchi Shōkichi, Kukida Shigeo, Masuda Hiroshi, Miyazawa Takashi, Nishimura Makoto, Sugano Risuke, and in the appendix Hasegawa Katsusaburō, Katō Kunio, Konishi Jirō, Oguri Toshikazu, Ōhashi Takeshi, Saitō Toshio, and Sakamoto Yū.

Seihai (Holy Chalice). 1912–September 1913. Published by Waseda University literary group which included Hinatsu Kōnosuke and Saijō Yaso. Covers were made by woodblocks by Nagase Yoshio and Hasegawa Kiyoshi. In 1913 the name was changed to *Kamen.*

Sen (Line). July 1930; 1 issue, possibly more. Poetry and print magazine intended as successor to *Kaze* published by Sawada Ishiro with leadership from Fujii Akio. Ten original prints including works by Fukazawa Sakuichi, Onchi Kōshirō, Shimizu Kōichi, Suwa Kanenori, Taninaka Yasunori, Yamagishi Kazue, Yamaguchi Gen, and Yamaguchi Susumu.

Sen (Line). 1930–ca. January 1931; at least 5 issues. Published as a small folio in Yamanashi prefecture.

Shi ga bō (Poetry/Picture House). Announced in Shizuoka by Ogawa Tatsuhiko and Yokoi Kōzō.

Shijima (Quiet). November 1926; 1 issue. Published in Okazaki. Contributors included Kondō Kōtarō.

Shin hanga (New Prints). June 1932–spring 1933; 8 issues. Beginning with issue 9, June 1933, the magazine became a quarterly, *Kikan shin hanga* (Quarterly New Prints). June 1933–December 1935; 10 additional issues, total of 18. Published by Shin Hanga Shūdan with leadership by Ono Tadashige. *Hanga* were hand-printed and tipped in, some in black and one color. From 10 to 16 prints appeared in

each issue in various formats but always with inexpensive type or mimeograph on humble paper in keeping with the socialist proclamations of Shin Hanga Shūdan. The subjects on the covers, such as the gas station on the first issue, suggest urban life. Several issues were devoted to special themes such as issue 15 on greeting cards and issue 12 on views of Tokyo. Issue 15 had 15 prints made for the magazine plus 22 *moku-hanga* greeting cards sent in by artists from various cities. Contributors included (artists of greeting cards are marked with *): Aki-yama Kikuzō 2, Arai Tōru 13, 15, 15*, Ebata Yoshiichi 3-4, 7-8, 11, 15, Fujimaki Yoshio 1, 3-5, 7, 9, 11-12, 15-16, Fujimori Shizuo 15*, Harada Ganki 1, Hirokawa Matsugorō 15*, Hori Kazue 12-13, Kawai Hikaru 11, Kikuchi Zenjirō 6-9, 11-12, 15, Kimura Gorō 15*, Kumeda Keizō 15*, Kuroki Sadao 15, Mashiko Hiroshi 15*, Matsushita Yoshio 7-9, 11, 15 (possibly lithographs), Minamiya Otohiko 15*, Mizufune Rokushū 7-9, 11-12, 15-16, Mutō Kan'ichi 1, 4, 9, 11-12, 15, 15*, Mutō Rokurō 1, 4-5, 8-9, 15, Narita Shintarō 15*, Neichi Ryōzō 15*, Nitta Jō 1-2, 4-5, 9, Noguchi Sanshirō 15*, Ōkubo Hajime 1, 3, 7-9, Ono Tadashige 1-4, 7-8, 11-12, 15-16, Ōuchi Seiho 15*, Oyama Ryoshū 15*, Satō Yonejirō 3, 5, 8, 15*, Saeki Rusuo 1, 7, Sekino Jun'ichirō 15*, Sekiya Tadao 3, Shiba Hideo 1-2, 4-5, 7-9, 12, 15, Shimada Kaname 15*, Shimizu Masahirō 7-12, 15, 15*, Suzuki Takeo 5, 7, 9, 12, Takahashi Tadao 15*, Takase Bunji 11, Takeda Shintarō 15*, Takeda Yoshihei 9, Takemura Atsujirō 2-5, Taniguchi Kunbi 8, 10-12, 15, Tō Takumaro 15*, Tokuriki Tomikichirō 15*, Tsunemi Hideo 11-12, Uchida Ikuo 5, 7, Ueda Ryūichi 1, 3, Ujiyama Teppei 11, 15, Watanabe Keiichi 15*, Yamaguchi Susumu 15*, Yomo-gida Heiemon 2-4, 8-9, 11, 15, 15*, Yoshida Masazō 1-5, 7, 9, 11, and Yoshihara Masamichi 1, 3-5, 7, 9.

Shinsekido (True Red Earth). 1948-1952; at least 4 issues. This was a craft magazine edited by Nagahama Jūtarō. Contributors of prints included Nagahama Jūtarō, Nakamura Naondo, and Nishimura Jun'ichi.

Shiro to kuro (Black and White). February 1930-August 1934; 50 issues. June 1935-November 1935; 4 additional issues. March 1937-July 1937; 5 additional issues. Published by Shiro to Kurosha with leadership from Ryōji Chōmei. Through issue 22 the editions were usually of 100; after that usually 60. Price 50 sen. In the first 50 issues printing was done by hand by the artists and prints were pasted onto the pages. Later issues were mechanically printed. Ryōji Chōmei thought of this as a magazine for amateurs, but leading *hanga* artists also con-tributed from time to time, especially after issue 20. Contributors to the first 50 issues: Aki Seiichi 39-40, 42-43, Amiboshi Tone 27-28, 30, 33, 35, 45, Enan Shirō 13-23, 26, 28, 31, 33-35, Fujimori Shizuo 33, 35, 37-38, Fujimoto Tōichirō 47, 49, Fukazawa Sakuichi 23, 25-26, 28, 37, Funaoka Tadayuki 1, Funamoto Shigekazu 12-18, 20-21, Gōda Kōichi 10, 12-13, 15-17, Hata Michiji 25, Hatsuyama Shigeru 16-17, 19-20, Hino Takaho 1, 3, Hirakawa Seizō 22, 25, Hiratsuka Un'ichi 33-34, 37, 43-44, Hirokawa Matsugorō 25-27, 31, 34-35, 37-40, 44-46, 49, Iga Machio 11, Inaba Kyōji 31, Ishii Tsuruzō 20-21, Katsuhira Tokushi 47, Kawabe Atsushi 36-37, 39, 42-43, 45, Kawakami Sumio 25, 28, 31, 33, 37-38, 42-44, 50, Kayama Saburō 30, Kibukuro Shudei 19, 21, Kobayashi Asaji 25-28, 30-40, 42-47, 49-50,

Kobayashi Matsuo 26–27, 30, 32, 40, 42, Kosaka Yoshitatsu 23, Kumeda Keizō 32, Kuriyama Shigeru 7, 9–21, 23, 25, 30, 33, Kuriyama Yayoi 19, Maekawa Senpan 16–17, 19–24, 26, 31–34, 44–46, 48–50, Maruyama Yōichi 38, Masaki Hiroshi 9–11, Matano Yoshio 1, 3, Matsushita Chiharu 26, 28, 38, Minamiya Otohiko 1, 3, 7, 9–21, Miyachi Karoku 15, Miyao Shigeo 14, 16–18, 20–21, Mizouchi Heiichirō 36–40, 42, Mori Dōshun 30–31, 34–36, 38–39, 42–43, Munakata Shikō 25–28, 31, 33, 48, Mutō Kan'ichi 20–25, 27–28, 30–32, 34–35, 37–38, 40, 42–50, Naka Heinosuke 43, 46, 48, Nakagawa Isaku 37, 39, Nakagawa Yūtarō 22–28, 30–31, 33–38, 40, 42–50, Nakai Yoshihiko 33, Nakajima Tōru 45, Nakamura Gaku 11–14, 16–21, 23, 30, Nakata Kazuo 23–25, 27–28, 30, 37–40, 42–43, 45–50, Neichi Ryōzō 37, Nishijima Tōru 43–44, 46, Noguchi Sanshirō 32, Ōba Chiaki 26–28, Obata Kenshō 31, Ogawa Tatsuhiko 7, 9–15, 18–28, 30–37, 39–40, 42–49, Okuda Kiichirō 25–28, 30–34, 36–37, 39–40, 42–48, 50, Okuyama Yasuo 31, Onchi Kōshirō 20, Ōuchi Seiho 9–10, 12–15, 18, 20–23, 25–26, Ozaki Kunijirō 40, Ryōji Chōmei 1–50 except 41, Satō Yonejirō 32, Satō Yonetarō 23, 25, 28, 31, 43, Sekino Jun'ichirō 32, 47–48, Shimoyama Kihachirō 27, Sugiyama Masayoshi 13, 15–20, 22–23, 30–31, Takeda Shintarō 34, Taninaka Yasunori 22–28, 30–31, 33–41, 43–45, 47, 50, Tsuchiya Kenshō 31, Tsukioka Ninkō 46–50, Tsukuda Masamichi 3, 9–13, 15–17, 19–25, Uchida Tatsuji 14–17, 19, 23, 26–28, Urabe Kihei 32, and Yokoi Kōzō 7, 10–12, 19, 32.

Shisaku (Experiment). June 1925–ca. May 1926; at least 5 issues. Published in Okazaki by Shisakusha with leadership from Kondō Kōtarō and contributions from Ono Eiji. The theme of the first issue was grassy meadows.

Shi to hanga (Poetry and Prints). 1922–ca. 1925. One issue edited by Onchi Kōshirō and produced by Ars Publishing Company in the fall of 1922. Resumed with issue 2 in March 1923 as a bimonthly or quarterly published by Shi to Hangasha with guidance from Asahi Masahide, Koizumi Kishio, and Onchi Kōshirō and continued for at least 13 issues. The magazine was in a format roughly 10 × 8 inches with ca. 36 pages in each issue. The covers were designed by *sōsaku-hanga* artists and printed in one color on buff paper. Each issue had 2 or 3 original color *moku-hanga* tipped in. These were supplemented by other original black and white prints. Some issues also contained a reproduction of a print by a Western artist. The poetry section had a border across the top and down the side of each page. These borders were consistent within one magazine but changed with each issue. The poetry was sensitively placed on the pages, each poem visually enhanced by ample uncluttered space around it. The latter pages of each issue contained articles by various members of the group dealing with such topics as history of Western prints and techniques of printmaking. Columns appeared regularly—"Fruit on the Table" (Takujō ka), "News" (Shōsoku), and "Impressions and Dreams" (Inshō to musō)—in which various members of the group expressed personal feelings. Contributors included: Asahi Masahide 2, Bessho Tsurukichi 2, Fujimori Shizuo 9, 11, 13, Fukazawa Sakuichi 9, 11, Henmi Takashi 9, 11, 13, Hiratsuka Un'ichi 2, 9, 13, Inagaki Tomoo 13, Ishii Tsuruzō 2, Itō Yoshiteru 8, Kawai Unosuke 9, Kawakami Sumio 9, 11, Kayama

Kotori 11, Kita Takeshirō 2, Kobayashi Kiyomitsu 8, Matsumura Matsujirō 13, Moritani Rikio 9, Nagase Yoshio 2, Ohara Ken 7, Onchi Kōshirō, 2, 9, 11, 13, Takenouchi Shun'ichi 8, Tanaka Kyōkichi 11 (posthumous), and Yamaguchi Kōka 11.

Shosō (Window of Writing). April 1935–June 1944; 103 issues. Published by Shimo Tarō of Aoi Shobō, edited and directed by Onchi Kōshirō. *Shosō* was a magazine devoted to the art of the book in both Asia and Europe. Each issue was essentially a collection of articles but many also contained an original print as a frontispiece and several illustrations made from woodblocks. Onchi planned each cover with original lettering, calligraphy, and design. Contributors of hand-printed *hanga*, in addition to Onchi, included Fujimori Shizuo, Fukazawa Sakuichi, Furukawa Ryūsei, Henmi Takashi, Hiratsuka Un'ichi, Kawakami Sumio, Kawanishi Hide, Maekawa Senpan, Munakata Shikō, Sarashina Genzō, Sekino Jun'ichirō, Takei Takeo, and Taninaka Yasunori.

Shumi no zōshohyō shū (Collection of Tasteful Bookplates). 1935–1940; 5 issues. Published by Mujinsha, Aomori, with leadership from Satō Yonejirō.

Sobyō (Rough Sketches). See *Dessin*.

Sōsaku-hanga gajōshū (Creative Print Greeting Cards). 1929–1932. Published by Kyūryūdō and later by Sōsaku-Hanga Club of Nakajima Jūtarō. One issue from 1931 contains 20 prints including 6 by Onchi Kōshirō. Other contributors included Hiratsuka Un'ichi, Inagaki Tomoo, Kawakami Sumio, and Maekawa Senpan.

Sōsaku-hanga sakuhin shū (Collection of *Sōsaku-Hanga* Works). 1931; 2 issues. Published by Hanga Study Society of the Japan Printing School, possibly in Kyoto.

Taishū hanga (Popular Prints). August and November 1931; 2 issues. Published in Kyoto by Taishū Hanga Kyōkai with leadership from Tokuriki Tomikichirō. Issue 1's cover depicts the head and shoulders of a modern woman in stylish cloche and lace collar by Tokuriki Tomikichirō. Issue 2's cover depicts a young woman in Western clothing by Asada Benji. Contributors included: Asada Benji 1–2, Hiratsuka Un'ichi 2, Kamei Tōbei 1, 2, Kawanishi Hide 1–2, Maeda Tōshirō 1, Maekawa Senpan 1, and Tokuriki Tomikichirō 1–2.

Takujō (On the Table). January 1914; 6 issues. Published by Tanakaya craft shop. Woodblock illustrations by Tomimoto Kenkichi.

Tansei (Red and Blue Paint). 1938; at least 9 issues. Published by Nakamura Zensaku.

Tatsu (Dragon). April 1941; at least 1 issue. Published in Shanghai by Tagawa Ken.

Tsuge (Boxwood). 1933; 3 issues. Edited by Nishigaki Binshō of Osaka and published by Kōyōsha of Kyoto; printer, Kataoka Teiji. Issue 1, with a cover design of a dandelion expressively carved and calligraphy by Takeda Shintarō, contains a total of 22 prints. Contributors to the first issue included Agehashi Kasen, Hibino Kōkyo, Hōkaku Ritsuko, Inagawa Seiichi, Kitamura Imazō, Kuranishi Masazō, Maeda Tōshirō, Nishigaki Binshō, Ojima Akinori, Ōta Masako, Ōtani Masayuki, Senba Michiko, Takeda Shintarō, Tanaka Hidesaburō, Tanaka Shingorō, and Wakahara Hokutai.

Tsukubae (Reflection of the Moon). September 1914–November 1915; 7 public issues. In 1913 Fujimori Shizuo, Onchi Kōshirō, and Tanaka Kyōkichi, all students at Tokyo School of Fine Arts, produced private editions of 6 issues of prints and poetry. Each artist carved blocks of his own design and printed a small number of each print. In September 1914 the first of 7 public issues appeared, directed and edited by Onchi Kōshirō and published by Kawamoto Kamenosuke of Rakuyōdō. The public issues in editions of 200 incorporated some designs from the private issues as well as additional designs. The blocks were printed by machine with oil-base ink. Although no more than 11 copies of any single issue were sold, this was a seminal work because of the direct expression of the artists' feelings through woodblock.

Yōdo (Land of Sheep). 1931; probably 2 issues. Published in Osaka by Maeda Tōshirō, Shimada Kaname, and others.

Yūkari (Eucalyptus). January 1931–August 1935. Published by Dōdosha in Shizuoka. From January 1931 until May 1932 directed by Ogawa Tatsuhiko. May 1932–July 1935, issues 8–29, directed by Nakagawa Yūtarō. Terminated in August 1935 with issue 30. Other contributors included Abe Kōji, Itō Ben, Kishimoto Hiroshi, Kosaka Yoshitatsu, Kuriyama Shigeru, Kuriyama Yayoi, Shimada Masamoto, Tanaka Giichi, Tsukioka Ninkō, and Usami Ichirō.

Yūkari-ki (Eucalyptus Tree). 1929. Published in Shizuoka by Nakamura Gaku. Absorbed by *Yūkari*.

Publishers, Carvers, and Printers

PUBLICATION OF MODERN JAPANESE WOODBLOCKS has ranged from complete publisher management to self-publishing by artists. In general, facsimile prints of Japanese-style works and *shin-hanga* were produced by publishers who engaged artisan carvers and printers. In making facsimile prints the artisans prided themselves on duplicating drawings or paintings as closely as possible. Some *shin-hanga* were facsimile prints made from Japanese-style paintings. Others were created under the direction of the publisher by the traditional publisher/artist/artisan system. In the latter case publishers exerted considerable aesthetic influence by the drawings they bought and through their supervision of the artisans. *Sōsaku-hanga* prints, on the other hand, were often self-carved, self-printed, and self-published by artists. Senior *sōsaku-hanga* artists also employed junior artists as printers. *Sōsaku-hanga* artists did, however, engage publishers for series publications, large editions, or *dōjin* magazines. In such cases the artists usually carved their own blocks. The basic difference between facsimile, *shin-hanga*, and *sōsaku-hanga* publishing was that in the latter the artists, not the publishers, made the aesthetic decisions.

In most cases carvers and printers were also free-lance artisans who worked for various individuals or publishers. This made it possible for companies that were engaged in usual printing activities to publish woodblocks concurrently by employing carvers and printers. Thus, large and prominent publishing houses and newspaper companies might buy the rights to paintings from artists and engage artisans to make limited-edition woodblock facsimiles. Prior to World War II there were, in addition, many small companies formed specifically for publishing one or two *dōjin* magazines. In the 1980s numerous art galleries also published limited-edition *moku-hanga*.

A professional carver or printer's training ordinarily entailed a five-year apprenticeship. There were in the late 1980s about 15 trained carvers in Tokyo and more in the Kansai area and about 100 trained block printers. Listed here is a selection of publishers, carvers, and printers who have been identified by their names on blocks or other means.

Publishers

Adachi Hanga Kenkyūsho. Tokyo. Founded in 1926 by Adachi Toyohisa (1902–1982). Specialized in fine reproductions of *ukiyo-e*, especially the works of Sharaku. Also made *moku-hanga* of works by contemporary artists.

Akashi Sanpaku. Tokyo. Act. after World War II.

Akiyama Buemon (or Take'emon). Proprietor of Kokkeidō. Act. 1901–1910.

Aoi Shobō. The company of Shimo Tarō in Tokyo. Published mostly limited-edition *sōsaku-hanga* books. Act. 1930s and 1940s. Company moved during World War II to Okayama prefecture and name changed to Nihon Aishokai.

Ars (Arususha). Tokyo. Publishing company of Kitahara Tetsuo. Act. ca. 1922 into the war years. Cooperative with projects of Onchi Kōshirō.

Baba Nobuhiko. Kyoto. Act. 1930s.

Banchōrō. Tokyo. Act. before World War II and perhaps through 1950s.

Benridō. Kyoto. Published albums of works by Kyoto painters before World War II.

Bijutsusha. Tokyo. Published *shin-hanga* in 1920s and 1930s. Word "rumi" sometimes on seal in hiragana.

Bun'endō. Act. 1915 under direction of Kanao Tanejirō. Known for fine books. Also published collections of prints.

Daikokuya. Tokyo. Company of Matsuki Heikichi. The names Kinnosuke and Kinjirō are also associated with Daikokuya.

Daireisha. Tokyo. Published *bijin-ga* in 1930s; also actor prints in 1950s.

Darumaya. Act. ca. 1918.

Doi Teiichi (or Sadaichi). Tokyo. Act. 1930s. Doi Eiichi, son of Doi Teiichi, carried on the business. Doi watermark with publisher's cartouche sometimes present.

Ensendō. Tokyo. Published *shin-hanga* in 1930s.

Fugaku Shuppansha. Tokyo. Publishing company started immediately after World War II by Uemura Masuro, formerly with Takamizawa. Published sets of *sōsaku-hanga* prints in 1945 and 1946.

Fukuda Kumajirō. Tokyo. Published Kobayashi Kiyochika 1904–1905 and other Russo-Japanese War prints.

Fusui Gabō. Tokyo. Act. 1930s.

Gahōsha. Tokyo. Act. 1920s.

Hakuyōsha. Osaka. Founded by Kitano Tsunetomi for publishing some of his own prints and *shin-hanga* of his students.

Hanga no Ie. Operated by Yamaguchi Hisayoshi in Kobe from ca. 1924 for publication of *sōsaku-hanga*.

Hanga Sō. Tokyo. A small shop operated in Ginza from January 1933 until September 1936 by Hirai Hiroshi. Specialized in printing limited-edition books from blocks carved by *sōsaku-hanga* artists.

Happōdō. Kyoto.

Hasegawa Enkichi. Active in Russo-Japanese War years.

Hasegawa Shōten (shop). Sometimes appears in conjunction with Nishinomiya Yosaku.

Hasegawa Tsuneo (or Jōsei). See Nihon Hangasha.

Hirai Hiroshi. See Hanga Sō.

Hōjudō. Produced *shin-hanga* in 1930s.

Ibunkaku. Kyoto. Act. 1979.

Iida. Tokyo. Act. 1930s.

Ikeda. Tokyo. Act. 1930s.

Inoue Kichijirō. Tokyo. Active in publication of Russo-Japanese War prints.

Isetatsu. Tokyo. Produced a few prints by Itō Shinsui and Kawase Hasui in 1925–1926.

Ishihara Ryūichi. See Kyūryūdō.

Ishihara Tadao. See Mikumo Mokuhansha.

Ishiyama. Published sōsaku-hanga prints ca. 1930.

Isozawa Jirō. See Yaponna Shobō.

Kaikōsha. Osaka. Act. 1930s.

Kaneda Shōten. Tokyo. In 1954 Kaneda Nobutake, representing the company, indicated that Okuyama Gihachirō was in charge of production and that the company's purpose was to make hanga from original paintings of contemporary artists.

Kánsai Bijutsusha. Kyoto or Osaka. Act. ca. 1939.

Katō Hanga Kenkyūsho. Tokyo. Founded in 1930 by Katō Junji (also known as Kato Junzō). Published prints by contemporary artists.

Katsuki Yoshikatsu. Published war prints 1904–1905.

Katsumura. Tokyo. Published a few Itō Shinsui prints.

Kawaguchi. Tokyo. A partner in Sakai and Kawaguchi, which dissolved ca. 1931. Kawaguchi also published independently with the firm name Kawaguchi Bijutsusha.

Kensetsusha. Probably Kyoto. Published facsimile moku-hanga.

Kido Tatsudo. Osaka. Produced facsimile moku-hanga in 1920s.

Kikuchi Yoshimaru. Probably Tokyo. Started, but did not complete, a series of Shunsen portraits of actors in 1920s.

Kimura Hōkichi. Tokyo. Active in producing Russo-Japanese War prints.

Kobayashi Bunshichi. Tokyo. Print publisher and exporter of reproductions of ukiyo-e and other facsimile prints at turn of the century. His personal collection of ukiyo-e, probably the finest in Japan at the time, was destroyed in the fire following the 1923 earthquake. Watanabe Shōzaburō worked for Kobayashi Bunshichi before opening his own business.

Kōdansha. Tokyo. Well-known book publisher occasionally publishes hand-printed facsimile prints.

Kōetsudō. Tokyo. Act. 1970s.

Kōgeisha. Act. 1930s.

Kokkasha. Company founded in Tokyo in 1889 to publish the magazine Kokka, which contained a full-color facsimile woodblock print in every issue until 1956.

Kokkeidō. Company of Akiyama Buemon. Act. ca. 1894 through at least 1910.

Kokuya. Act. early in the century.

Kōryokusha. Kyoto. A subsidiary of the Matsukyū company. Formed in 1948 to provide financial backing for self-carved, self-printed works by Tokuriki Tomikichirō, owner Matsukyū, Takahashi Tasaburō, Kotozuka Eiichi, and Kamei Tōbei.

Kōyōsha. Kyoto. Act. 1930s.

Kyoto Hanga-in. Founded in 1935 to make prints and reproductions.

Kyūryūdō. Tokyo. Founded by Ishihara Ryūichi. Act. 1920s until into the 1960s. Worked with *sōsaku-hanga* artists.

Matsuki Heikichi. Tokyo. Act. 1890s–1920s. Proprietor of Daikokuya, which is also known as Ōhiro or Taihei of Ryōgoku.

Matsukyū. Kyoto. Company established after World War II by Tokuriki Tomiki-chirō for publishing his own prints.

Matsunaga Han. Tokyo. Active in producing facsimile prints in 1980s.

Matsuno Yonejirō. Tokyo. Published Russo-Japanese War prints.

Meiji Shobō. Tokyo. Distributed *hanga* under the name Nihon Hanga no Kai in 1954–1955.

Mikumo Mokuhansha. Kyoto. Founded 1942. Directed in 1962 by Ishihara Tadao.

Miraisha. Tokyo. Act. 1970s.

Mukawa Unokichi. Act. ca. 1912.

Murakami. Act. 1924. Published *bijin-ga*.

Nakajima Jūtarō. Tokyo. Founder of the publishing firm called Nihon Sōsaku-Hanga Club.

Nakamura. Nagoya. Act. 1930s. Employed 12 or more carvers and printers.

Narazawa Kenjirō. Tokyo. Act. 1904–1905.

Nezu Seitarō. Probably Osaka. Publisher of *shin-hanga* in 1930s.

Nigao-dō. Tokyo. Published set of 28 small actor prints in 1915.

Nihon Aishokai. See Shimo Tarō.

Nihon Hanga Kenkyūsho. Tokyo. Formed in 1946 by Okuyama Gihachirō to promote *hanga*. Apparently taken over in 1947 by Shimura Tatsumi. Dissolved in 1948 and Okuyama Gihachirō moved to Matsudo.

Nihon Hanga no Kai. See Meiji Shobō.

Nihon Hangasha. Tokyo. Founded by Hasegawa Tsuneo for printing and marketing prints from self-carved *sōsaku-hanga* blocks. Act. mid-1920s.

Nishinomiya Yosaku. Tokyo. Act. early in the century until after World War II. Sometimes associated with Hasegawa or Hasegawa Shōten (shop).

Ōa Geijutsusha. Tokyo. Founded by Sawada Ishirō. Published both *dōjin* magazines and *sōsaku-hanga* prints.

Oana Shūjirō. See Shūbisha.

Ōhiro of Ryōgoku. See Taihei at Ryōgoku.

Ōkura Magobei. Published prints of traditional Japanese subjects from late Meiji period into Taishō.

Ōkura Yasugorō. Act. 1916.

Onoda Mototsugu. Act. 1930s.

Osaka Hanga Kōbōsha. Small workshop run by Nakata Kazuo. Produced principally bookplates.

Osaka Mokuhansha. Published *shin-hanga* in 1930s.

Owariya. Osaka. Act. ca. 1930.

Rakuyōdō. Tokyo. Publishing company of Kawamoto Kamenosuke which published mainline magazines such as *Shirakaba* but also published *Tsukubae* in 1914–1915 from blocks carved by Onchi Kōshirō and others.

Ryūseikaku. Tokyo. Publishing house operated by Sawada Ishiro. Worked with Onchi Kōshirō on publication of *dōjin* magazines.

Sakai and Kawaguchi. Tokyo. Published *shin-hanga* in 1920s. Dissolved ca. 1931.

Satō Shōtarō. Kyoto. 1890s–1920s. Published reproductions of *ukiyo-e* and *moku-hanga* from paintings by traditional artists.

Sawada Ishirō. See Ryūseikaku and Ōa Geijutsusha.

Seikadō. Tokyo. Early name of the company of Nakajima Jūtarō; later called Sōsaku Hanga Club.

Shimo Tarō. Publisher of limited-edition books including many *moku-hanga*. His company called Aoi Shobō was based in Tokyo from mid-1930s until 1945 when he moved to Okayama prefecture and renamed the company Nihon Aishokai.

Shin Yamato-e Moku-Hanga Kankōkai. Tokyo. Published facsimile woodblocks from paintings by contemporary artists. Published particularly prints by Matsuoka Eikyū and his students and associates. Act. 1920s. Dissolved in 1931.

Shinbi Shoin. Published art books and an extensive collection of woodblock facsimiles of classic pictures 1905–1915. Later printed *shin-hanga*.

Shinbisha. Act. mid-1920s. Prints of *bijin-ga*.

Shiota Takezō. Tokyo. Published landscape *shin-hanga* in 1930s.

Shōbidō. Tokyo. Early name of Watanabe Mokuhan Bijutsu Gahō.

Shūbisha. Tokyo. Operated by Oana Shūjirō. Published actor prints, in 1920s.

Sōsaku-Hanga Kurabu (Club). Tokyo. Founded by Nakajima Jūtarō. Worked with *sōsaku-hanga* artists ca. 1917 until World War II.

Suiyōsō. Tokyo. Act. ca. 1960.

Taihei at Ryōgoku. Tokyo. Also called Ōhiro of Ryōgoku. Company of Matsuki Heikichi. Act. late Meiji period into 1920s.

Takamizawa Enji. B. Yokohama in 1890. Became interested in repairing prints in 1912 and studied with Yano Yūkichi, a leading print repairer. Learned to repair *ukiyo-e* so skillfully that experts thought they were newly found prints. His method sometimes involved washing out the old ink and reprinting with newly cut blocks. He apparently stopped repairing in 1918 and thereafter concentrated on facsimile *nishiki-e* from newly cut blocks. Could not work after contracting tuberculosis in 1926. D. 1927. After his death his brothers Masurō and Tadao and his son Takaaki operated Takamizawa Mokuhansha.

Takamizawa Mokuhansha. Tokyo. Company run by members of the Takamizawa family. Active in production of facsimile prints from late 1920s or early 1930s until the present.

Takegawa Unokichi. Tokyo. Act. early 1900s.

Takemura Hideo. Act. 1930s. Published prints of traditional Japanese subjects.

Tsunashima Kamekichi. Tokyo. Published war prints 1904–1905.

Uchida Bijutsu Hangashi (Uchida Bijutsu Shoshi). Kyoto. Founded 1919. Directed in 1962 by Uchida Kiichi.

Uemura Masurō. See Fugaku Shuppansha.

Unsōdō. Kyoto and Tokyo. Founded 1887. Yamada Naozō was manager in first decade of this century, Yamada Enji was manager in 1950s, and a member of the Yamada family was still active in the company in 1983. From 1890s until mid-

1930s the company manufactured pattern books of the highest order for artisans and manufacturers of textiles, lacquer, etc. It also produced fine art books with *moku-hanga* color plates. Later printed numerous series of prints of Kyoto subjects.

Watanabe Mokuhan Bijutsu Gahō. Tokyo. Founded by Watanabe Shōzaburō in 1906 under the name Shōbidō to make reproductions of *ukiyo-e*. In 1908 he initiated the publication of *shin-hanga* by the publisher/artist/artisan system. At the same time he compiled *Book of Ukiyo-e by Celebrated Artists (Mokuhan ukiyo-e taika gashū)* and *Collection of Masterpieces of Ukiyo-e (Ukiyo-e hanga kessaku-shū)*, both composed of facsimile prints from newly carved blocks. He continued producing both facsimile prints and *shin-hanga*. The company, known today as S. Watanabe Color Print Company, continues under direction of Watanabe Tadasu.

Yamada Naozō. See Unsōdō.

Yamaguchi Hisayoshi. See Hanga no Ie.

Yanagi-ya. Osaka. Act. Taishō period.

Yaponna Shobō. Tokyo. Active in publication of limited-edition books in 1930s under direction of Isozawa Jirō.

Yoneda Hanga Kōbō. Tokyo. Founded in 1950 by Yoneda Minoru.

Yoshida Studio. Tokyo. Established in 1925 by Yoshida Hiroshi to publish his own prints. Still active under direction of Yoshida Tōshi.

Yoshikawa Kōbunkan. Tokyo. Published *moku-hanga* reproductions of *ukiyo-e* in 1915 and 1916.

Carvers

Akiyama Kenkichi. Carved blocks for facsimile prints in the magazine *Kokka*.

Aoyanagi Takeo. Act. before and during World War II. Carved for Watanabe Shōzaburō.

Asai Hyōkichi. Carved for Watanabe Shōzaburō.

Chichida Hide. Act. Tokyo in 1930s.

Chikamatsu Otosu. Principal carver for Watanabe Shōzaburō beginning ca. 1906. Also Watanabe's father-in-law.

Fujikawa Saburō. Carved for Watanabe.

Gōda Kiyoshi. 1862–1938. Studied wood engraving and printing in Europe and upon return to Japan established a wood engraving shop in Tokyo.

Harada. Act. Tokyo in 1930s. Carved for Doi Teiichi.

Hasegawa Hanatarō and his son Hasegawa Shintarō. Both apprenticed with a senior Hasegawa who was the father of Hanatarō and grandfather of Shintarō.

Hata Kōji. Act. 1950s. Carved blocks for Uchida.

Hino Nobuyoshi. Kyoto carver who cooperated in producing the *dōjin* magazine *Taishū hanga* in 1931.

Hirai Kōichi. Act. Tokyo for more than 30 years beginning ca. 1914.

Hirakawa Seizō. Carved for Watanabe.

Horikoshi Kan'ichi. Carver of calligraphy texts and teacher of Koizumi Kishio.

Igami Bonkotsu. 1875–1933. Studied with Ōkura Hanbei I. Worked for the Hakuba-kai magazine *Kōfū* ca. 1905. Carved blocks for many artists including Okada Saburōsuke, Fujishima Takeji, Ishii Hakutei, Ishii Tsuruzō, Hirafuku Hyakusui, and Takehisa Yumeji. Often worked in collaboration with the printer Nishi-mura Kumakichi. He was friendly with *sōsaku-hanga* artists and the teacher of Hiratsuka Un'ichi who in turn taught carving skills to many *sōsaku-hanga* art-ists.

Iguchi Minoru. Act. ca. 1914.

Imura Shōnosuke (or Inomura Shōnosuke). Act. 1950s. Carved for Kaneda Shōten.

Itō Harutarō (or Itō Shuntarō). Act. 1950s. Carved for Kaneda Shōten.

Itō Susumu. Carved for Watanabe Shōzaburō in 1940s.

Kamo Katsunosuke. Act. Tokyo ca. 1910. Carved designs by Ishii Hakutei that were published in *Hōsun*.

Katsumura Shōzō. Act. before World War II. Carved designs by Takehisa Yumeji and Hasui published by Doi.

Kawatsura Yoshio. 1880–1963. B. Ōita prefecture. Used the name Tōzan and later Raizan. Attended Tokyo School of Fine Arts. Carved facsimile *moku-hanga* for Shinbi Shoin. Between 1942 and 1958 completed prints of the *Tales of Genji* owned by Tokugawa family.

Kikuta Kōjirō. Present head of Kikuta School of carvers in Kyoto. Members of the Kikuta family have been carvers since 1938.

Kimura Tokutarō. Noted carver in Meiji era. Carved blocks for the magazine *Myōjō* in 1900.

Koike Masazō. Act. Tokyo in Taishō era. Carved for Hashiguchi Goyō.

Kuboi. Act. early in the century.

Kuga Denkichi. Carved for Watanabe Shōzaburō in 1940s.

Maeda Kentarō. B. ca. 1891. Carved for Watanabe Shōzaburō, Katō Junji, and vari-ous artists. May also have carved for Satō Shōtarō.

Maeda Yūjirō. Act. Tokyo 1930s–1950s. Carved for Yoshida Hiroshi.

Matsuda Torazō. Act. Kyoto and Tokyo in 1950s. Carved for Kyoto Hanga-in.

Matsuno Katsumi. Act. Osaka ca. 1925–1930s.

Matsuoka Hisashi. Act. 1950s. Carved for Uchida.

Miyata Rokuzaemon. Carved for Watanabe Shōzaburō.

Monju Keitarō. Act. Kyoto in 1950s. Carved for Unsōdō.

Mori Kiyoshi or Mori Noriyoshi. Act. Kyoto in 1950s. Carved for Unsōdō.

Murase Kinji. Act. 1910s. Carved some of Tanaka Kyōkichi's works in *Tsukubae*.

Nagashima Michio. Carved for both Tokyo and Kyoto branches of Unsōdō. Act. late 1940s and early 1950s.

Nakamura Suekazu. Act. 1950s. Carved for Uchida.

Nomura Toshihiko. B. 1904 in Tokyo. Act. before World War II. A *sōsaku-hanga* art-ist who also carved blocks for other *sōsaku-hanga* artists.

Ōkura Hanbei. Members of the Ōkura family have been carvers for several genera-tions. Ōkura Hanbei II d. 1925. Another Ōkura Hanbei worked for Takamizawa

and Unsōdō in 1950s. Ōkura Hanbei IV was active and training apprentices in 1989.

Ōkura Kenji. Carved for Watanabe.

Sakakura Seijirō. Carved for Kaneda Shōten and Watanabe Shōzaburō. Act. 1950s.

Satō Jurokichi. Carved for Watanabe in 1950s.

Shibamura Shin'nosuke. Act. Tokyo in 1940s and 1950s. Carved for Tokyo branches of Kyoto Hanga-in and Unsōdō.

Somekawa Kanzō. Act. ca. 1920.

Takano Shichinosuke. Act. 1920s and 1930s. Carved for Hashiguchi Goyō and Watanabe Shōzaburō.

Tsumura. Probably Kyoto. Carved for Dōmoto Inshō.

Tsuzuki Tadasaburō. Act. late 1920s. Carved for Nakajima Jūtarō.

Umezawa. Carved war prints in 1904.

Urushibara Mokuchu. 1888–1953. Woodblock artist, carver, and printer. Went to Britain in 1908 and remained in Europe until 1934. Known especially as carver and printer for Frank Brangwyn.

Yamada Gaijirō (or Sonejirō). Carved blocks of *shin-hanga*, probably in Osaka. Act. 1920s and 1930s.

Yamada Jukichi. Carver for Watanabe.

Yamagishi Kazue. Carver for various artists including Paul Jacoulet. Act. ca. 1915 into 1950s. Also carved, printed, and self-published his own works.

Yamaguchi Umesaburō. Studied with the respected *ukiyo-e* repairman Yano Yūkichi ca. 1915. Act. Tokyo in 1950s. Carved for Katō Junji.

Yamana Ryōkō. Act. ca. 1925 into 1930s. Carved for Nezu Seitarō.

Yamana Yoshimitsu.

Yashita Chūichi. Act. 1950s. Carved for Takamizawa.

Yoshimori Sasahiro. Act. 1920s and 1930s. Carved for Kensetsusha.

Printers

Akimoto Shōjirō. Act. ca. 1920. Printed for Hashiguchi Goyō.

Edagaki Takejirō. Printed for Watanabe.

Fujii Shunosuke. Act. 1940–1950. Printed for Adachi Institute of Woodblock Prints and Watanabe Shōzaburō.

Fujinami Ginzō. Act. ca. 1912.

Hayakawa Isamu. Act. Kyoto in 1950s. Printed for Kyoto Hanga-in.

Hirai Kōichi. Act. ca. 1913 until after World War II. Printed for Takehisa Yumeji and Onchi Kōshirō.

Hiroshige Akira. Printed for Mikumo Mokuhansha in 1950s.

Honda Tetsunosuke. Act. Tokyo in 1934–1960.

Hosokawa Kenjirō. Act. Kyoto in 1950s. Printed for Uchida.

Ikegami Toshio. Printer of facsimile prints in the magazine *Kokka*.

Imai Danshi. Act. 1920s.

Inotsume. Printed for Watanabe Shōzaburō.

Itagaki Takejirō. Printed for Watanabe and other publishers.

Itō Toraji. Act. Tokyo in 1950s. Printed for Tokyo branch of Kyoto Hanga-in.

Iwase Kōichi. Act. 1960s.

Kataoka Teiji. Act. 1930s, probably in Kyoto.

Kinoshita Hatsutarō. Printer for Adachi Institute of Woodblock Prints.

Kobayashi Sōkichi. Act. 1950s and early 1960s in Tokyo.

Kobayashi Yoshiaki. Traditional printer. Act. ca. 1970.

Koike Tetsutarō. Act. ca. 1918. Often worked with the carver Yamagishi Kazue.

Komatsu Wasakichi. Son of Komatsu Munenori, also apparently a printer. Act. 1929. Printed for Adachi Institute of Woodblock Prints and Kawaguchi.

Kowada Misao. Printed for Mikumo Mokuhansha in Kyoto in 1950s.

Maruyama Hō. Printed for Watanabe.

Matsumoto Akira. Printed for Watanabe in late 1950s.

Matsuno Kassui. Kyoto printer in 1920s.

Mitsumoto Kaichi. Traditional printer. Act. ca. 1950 in Osaka.

Miura Kitarō. Printed for Watanabe.

Nagae Otojirō. Kyoto. Act. 1950s. Printed for Kyoto Hanga-in.

Naitō Saburō. Act. Kyoto in 1950s. Printed for Uchida.

Nakajima Shigeyasu. Printed for Watanabe Shōzaburō.

Nakamura Jizaemon. Kyoto. Act. ca. 1920.

Nakamura Sanjirō. Printed for *sōsaku-hanga* artists in 1930s.

Negita Mannen. Act. Kyoto in 1950s. Worked for Uchida.

Nishimura Kumakichi. B. 1862. Member of first generation by that name. Nishimura Kumakichi II act. ca. 1911–1930. Often worked with the carver Igami Bonkotsu.

Ogawa Fusakichi. Act. Tokyo 1930s–1950s. Worked for Yoshida Hiroshi and Paul Jacoulet.

Ōiwa Tokuzō. Kyoto. Act. 1920s. Printed for Satō Shōtarō.

Okazoe Tatsuo. Printed for Watanabe Shōzaburō.

Okuse Eiza. Act. ca. 1936.

Ono Chiyozō. Printer in Kyoto in 1950s. Worked for Kyoto Hanga-in.

Ono Fukutarō. Worked for Watanabe.

Ono Gintarō. Worked for Watanabe as early as 1917 or possibly earlier; still active in 1948.

Ono Hikojirō. Printed for Watanabe Shōzaburō and Daireisha ca. 1950.

Ono Tomisaburō. Also known as Ono Tomi. Act. 1930s–1950s. Worked for Watanabe, Takamizawa, and other publishers. Also printed for artists who self-published their own works.

Ono Yoshitarō. Act. ca. 1920. Printed for Hashiguchi Goyō and Watanabe Shōzaburō.

Onodera Yoshizō. Act. Tokyo in 1940–1955.

Ōta Toshikazu. Act. Kyoto in 1950s. Worked for Unsōdō.

Ōtsu Kazuki. Printer for Saitō Kiyoshi from ca. 1970.

Saitō Komurasaki. Probably in Osaka. Printer of *shin-hanga* in 1930s.

Sato Kanjirō. Probably in Kyoto.

Shibamura Shin'nosuke. Printed for Unsōdō in late 1940s.

Shimizu Kōichi. B. 1895. A *sōsaku-hanga* artist and owner of a frame shop who printed for other *sōsaku-hanga* artists.

Shinagawa. Kyoto. Act. 1950s. Probably in charge at Kyoto Hanga-in. Used a large round decorative seal derived from the name Shinagawa. This seal found on prints signed and sealed by known artists is sometimes, but not always, associated with a stamped mark "Shinagawa-ban," "suri Shinagawa Tomo," or in English "Shinagawa's Wood Block Print" and the name and address of Kyoto Hanga-in.

Shinmi Saburō. Act. Tokyo in 1940s–1950s. Printed for Unsōdō.

Shinohara Keiji. Trained in Kyoto under Uesugi Keiichirō and Uesugi Takeshi. Demonstrated printing in the U.S. in 1980s.

Somekawa Chūjirō. Act. ca. 1920. Worked for Hashiguchi Goyō.

Sugimoto Shinjirō. Act. Kyoto in 1950s. Printed for Unsōdō.

Suzuki Kinpei. Artist who from ca. 1935 printed numerous works for individual artists including Kishida Ryūsei and Makino Torao.

Taguchi Kikumatsu. Act. 1920s.

Takagi Shōji. Act. 1980s.

Takamura Masanosuke. Act. 1950s.

Takei Kiyoshi. Worked for Takamizawa in 1950s.

Takenaka Saburō. Act. Kyoto in 1950s. Printed for Unsōdō.

Takizawa. Printed for Watanabe Shōzaburō.

Tamura Sennosuke. Act. Tokyo in 1920s.

Toda Hiroshi. Act. Kyoto in 1950s. Printed for Unsōdō.

Toda Senzō. Printed for Watanabe and others.

Toyoda Shinzō. Printed for Adachi Institute of Woodblock Prints.

Tsuzuki Tadasaburō. Act. ca. 1929. Printed from *sōsaku-hanga* blocks for Nakajima Jūtarō of Sōsaku-Hanga Club.

Uchikawa Matashirō. Act. 1934–1951. Printed for Watanabe and individual artists including Paul Jacoulet.

Uesugi Keiichi. Fourth generation of Kyoto family of printers. Act. 1970s.

Uesugi Takeshi. Third generation of Kyoto family of printers. Active in 1970s.

Urata Giichi. Traditional printer. Act. late 1930s–1960s.

Urushibara Mokuchū. 1888–1953. Lived in Europe 1908–1934. Known for his own prints and as printer of works of Frank Brangwyn.

Wakayama Hikojirō. Printed for Watanabe Shōzaburō.

Yamana. Act. Osaka. Printer of *bijin-ga*.

Yashida Takesaburō. Act. ca. 1940. Printed for *sōsaku-hanga* artists.

Yokoi. Act. Tokyo in 1930s. Printed for Doi.

Yokoyama Bunji. Act. Tokyo in 1950s. Printed for Katō Junji.

Yoneda Minoru. Act. 1970s.

Yoshimori Sasahiro. Act. 1950s.

Yoshizō. Act. 1940s and 1950s.

Notes on Selected Prints and Series

THIS CHAPTER is divided into two sections. The first includes names of series and individual prints by single artists. These are listed alphabetically by artists' names. Presented here are complete lists of the prints of Itō Shinsui and Kawase Hasui and the actor series of Natori Shunsen. If dates are known, the prints are in chronological order with series preceding single prints. Also included in the first section are notes on sets of prints by individuals that were advertised but may not have been completed. The second section of the chapter presents notes on series made by multiple artists. These are listed chronologically by date rather than alphabetically by artist.

Traditionally *ukiyo-e* prints were made in unlimited editions and printing continued as long as demanded by sales. Watanabe Shōzaburō and other publishers who produced *shin-hanga* were torn between the advantages of printing all they could sell and Western collectors' preference for limited editions. Early *shin-hanga* were sometimes made in editions of two or three hundred, but the individual prints were seldom numbered and editions were sometimes expanded. Individual early *sōsaku-hanga* were usually made in very small editions because there was no market for them. Sets and series, however, were usually in editions of one hundred with the prints sometimes numbered. After World War II, print artists increasingly followed the Western practice of specifying editions and numbering prints.

Whenever the names of prints appear on the prints and are known to the authors, the names are translated as closely as possible from the Japanese. In other instances choices have been made from various names by which specific prints are known. Dimensions, when they are known, are approximated to the closest centimeter with height preceding width.

Works of Individuals

Asahi Masahide

New Edition of Modern Women's Styles (Shinpan imayō onna fūzoku), 1930. Self-carved. Prints include *Cool Breeze* and *Summer Evening*.

Asano Takeji

Noted Views in the Kyoto-Osaka Area (Kinki meisho fūkei), 1947. This is a set of 9 self-carved prints.

Azechi Umetarō
> *Ten Scenes of Iyo (Iyo jikkei)*, 1936.

Fujimori Shizuo
> *Twelve Views of Great Tokyo (Dai Tokyo jūnikei)*, 1933–1934. This includes a view of the city for each month.

Hashiguchi Goyō
> Goyō designed his first woodblock print, *Bathing*, in 1915 for publication by Watanabe Shōzaburō. After that, from 1918 until his death in February 1921, Goyō hired artisans and personally supervised the carving and printing of his blocks. During this period carvers included Koike Masazō and Takano Shichinosuke and printers included Akimoto Shojirō and Somekawa Chujirō. Goyō's completed prints were:
> > *Bathing*, 40 × 26.5, Oct. 1915
> > *Rain at Yabakei*, 37 × 49.5, Mar. 1918
> > *Woman in Makeup*, 54 × 38, Apr. 1918
> > *Mt. Ibuki in Snow*, 23 × 38, Jan. 1920
> > *Evening Moon in Kobe*, 28 × 43, Jan. 1920
> > *Sanjō Great Bridge, Kyoto*, 28 × 44, Jan. 1920
> > *Woman Holding Tray*, 38 × 25, Jan. 1920
> > *Woman Holding Lipstick*, 38 × 26, Feb. 1920
> > *Woman Combing Hair*, 44 × 22, Mar. 1920
> > *Long Undergarment*, 46 × 25, May 1920
> > *Woman in Summer Garment*, 45 × 29, June 1920
> > *Woman After Bath*, 44 × 29, July 1920
> > *Ducks*, 28 × 44, Aug. 1920
> > *Hot Spring Inn*, 44 × 25, Jan. 1921

After Goyō's death his brother who inherited the blocks and drawings had certain partially developed prints completed by Maeda Kentarō, carver, and Hirai Kōichi, printer. These included:
> > *Woman Washing Her Face*, dated July 1920
> > *Woman Washing Her Hair*, dated July 1920
> > *Two Women After Bathing*, dated July 1920
> > *Woman with Cage of Glowworms*, dated July 1920
> > *Woman of the Hot Spring Inn*, dated Aug. 1920
> > *Hand Mirror*, dated Sept. 1920
> > *Woman Cutting Her Toenails*, dated Oct. 1920
> > *Woman Folding a Kimono*, dated Oct. 1920

Hashimoto Okiie
> *Picture Collection of Japanese Castles (Nihon no shiro gabunshū)*, 1944, published by Katō Hanga Kenkyūsho.
> *Ten Views of Old Castles (Kojō jikkei)*, 1946, published by Katō Hanga Kenkyūsho.

Picture Collection of Famous Castles of Japan (Nihon no meijō gashū), 1962, published by Nihon Jōkaku Kyōkai.
Flower Series (Hana rensaku), 1974.

Hiratsuka Un'ichi

Scenes of Tokyo After the Earthquake (Tokyo shinsai ato fūkei), 1923–1927, published by Yamaguchi Hisayoshi of Hanga no Ie in Kobe. Twelve prints. Edition of 50.

1. *Remains of a Clothing Factory*
2. *Azuma Bridge*
3. *Suzaki Pleasure Quarter*
4. *Seiroka Hospital in Tsukiji, 1923*
5. *Fudō Daishi Shrine*
6. *Shiba Great Gate, 22 × 28.5, April 1925*
7. *Sumō Wrestling Place, 1925*
8. *Fukagawa Lumber Yard*
9. *Asakusa Kaminari Gate, 1925*
10. *Nicholai Cathedral*
11. *Wadakura Gate*
12. *Ochanomizu*

Eight Views Around the Moat (Horibata hakkei). This series was advertised by Nakajima Jūtarō on a sheet accompanying a *Kitsutsuki* folio in 1930 or 1931. Nakajima noted that the prints, in a limited edition of 100, would sell for 4 yen each and that *Sakurada Gate* was already completed and the others listed here would follow soon:

Sakurada Gate
Tayasu Gate of Kudan
Overview of Kanda
Babasaki Gate
Karakikyō Gate
Benkei Bridge
Take Bridge
Nijū Bridge
Hanzō Gate

Ishii Hakutei

Twelve Views of Tokyo (Tokyo jūnikei), 1910–1916, carved by Igami Bonkotsu, printed by Nishimura Kumakichi. Only 9 were completed, 2 before Hakutei's departure for Europe and the rest after his return. Each of various sections of the city is represented by a *geisha* with the locale identified by a picture on the wall behind the figure.

1. *Yoshichō, 1910*
2. *Yanagibashi, 38 × 25, 1910*
3. *Nihonbashi*
4. *Shibaura*

 5. *Mukōjima*
 6. *Shitaya*
 7. *Asakusa*, 38 × 26
 8. *Akasaka*
 9. *Shinbashi*, 39 × 26, 1914

Ishikawa Toraji
 Ten Nudes, 1934. Self-published, carved by Yamagishi Kazue.
 1. *Blue Cockatoo*
 2. *Sound of a Bell*
 3. *Black Cat*
 4. *Standing Nude*
 5. *After the Bath*, 48 × 37
 6. *Morning*
 7. *Reading*, 37 × 48
 8. *Resting*
 9. *Leisure Time*
 10. *La Danse*

Itō Shinsui
 All Itō Shinsui prints listed here were published by Watanabe Shōzaburō except
 those by publishers indicated by asterisks:
 * published by Isetatsu
 ** published by Katsumura

 Eight Views of Lake Biwa (Ōmi hakkei), all ca. 30 × 20 cm, 1917–1918
 1. *Miidera Temple*, 1917
 2. *Yakase Bridge*, 1917
 3. *Awazu*, 1917
 4. *Hira*, 1917
 5. *Ishiyama Temple*, 1917
 6. *Chinese Bridge at Seta*, 1918
 7. *Pine at Karasaki*, 1918
 8. *Katada Ukimidō*, 1918

 Twelve Figures of New Beauties (Shin bijin jūni sugata), all ca. 42 × 25 cm, 1922–1923
 1. *Makeup*, 1922
 2. *Rouging the Lips*, 1922
 3. *Cool Evening*, 1922
 4. *Lady in Yukata*, 1922
 5. *Woman of Ōshima Island*, 1922
 6. *Bathing in Early Summer*, 1922
 7. *Chirping of Insects*, 1923
 8. *Snowy Night*, 1923
 9. *Thinking of Approaching Spring*, 1923

10. *Face Powder*, 1923
11. *Kotatsu*, 1923
12. *Dancing*, 1923

First Collection of Modern Beauties (Gendai bijin shū dai isshū), all ca. 42 × 25 cm, 1929–1931

1. *Lady in Yukata*, 1929
2. *Hooking a Mosquito Net*, 1929
3. *Rouging the Lips*, 1929
4. *A Fresh Collar*, 1929
5. *Gifu Paper Lantern*, 1930
6. *After a Bath*, 1930
7. *Hot Spring*, 1930
8. *Shrine in Snow*, 1930
9. *Hand Mirror*, 1931
10. *Gathering Shellfish at Low Tide*, 1931
11. *Early Summer Rain*, 1931
12. *Hunting Fireflies*, 1931

Second Collection of Modern Beauties (Gendai bijin shū dai nishū), all ca. 42 × 25 cm, 1931–1936

1. *Autumn Full Moon*, 1931
2. *Cloudy Moon*, 1931
3. *Foot Warmer*, 1931
4. *Fireworks*, 1932
5. *Maiko*, 1932
6. *Beauty in a Snowstorm*, 1932
7. *Red Plum Blossoms*, 1933
8. *Dressing Hair*, 1934
9. *Firefly*, 1934
10. *Washing Hair*, 1936
11. *Pedicure*, 1936
12. *Apple of the Eye*, 1936

Twelve Views of Ōshima (Ōshima jūnikei), all ca. 42 × 25 cm, 1937–1938

1. *Mount Mihara on a Summer Day*, 1937
2. *Midday*, 1937
3. *Dawn*, 1937
4. *Ascetics' Grotto*, 1937
5. *Sandhills in the Morning*, 1937
6. *Spring Tide*, 1937
7. *Drawing Water on a Dim Moonlight Night*, 1938
8. *Windy Evening*, 1938
9. *Desert of Mt. Mihara*, 1938

 10. *Sand Ski Slope*, 1938
 11. *Sea Breeze*, 1938
 12. *Cloudy Day*, 1938

Eight Views of Izu (Izu hakkei), all ca. 42 × 25 cm, 1938–1939
 1. *Shirahama in the Morning*, 1938
 2. *Evening Glow at Shirahama*, 1938
 3. *Early Spring at Yoshida*, 1938
 4. *Evening at Ukuzu*, 1938
 5. *Night Rain at Tago Beach*, 1939
 6. *Evening Glow at Ajiro*, 1939
 7. *Afternoon at Shirahama*, 1939
 8. *Charcoal Making at Hino*, 1939

Three Views of Mt. Fuji (Fuji sankei), all ca. 50 × 35 cm, 1938–1939
 1. *From Miharashidai, Hakone*, 1938
 2. *From Mito Beach, Izu*, 1938
 3. *From Near Numazu*, 1939

Three Still Lifes (Seibutsu sandai), all ca. 50 × 35 cm, 1939
 1. *Loquat*, 1939
 2. *Melon and Peaches*, 1939
 3. *Morning Glory*, 1939

Sketches from South Sea Islands (Nan'yō no suketchi), all ca. 42 × 25 cm, 1943
 1. *In the Suburbs of Macassar, Celebes*, 1943
 2. *Evening Glow at a Riverside, Borneo*, 1943
 3. *Street Scene at Jakarta, Java*, 1943

Ten Views of Shinano (Shinano jikkei), 1948
 1. *Twilight on Snow, Komoro*, 1948
 2. *Spring Twilight, Komoro*, 1948
 3. *Morning at Kanbayashi*, 1948
 4. *Early Spring, Chikuma River*, 1948
 5. *Shore of Lake Nojiri in Autumn*, 1948
 6. *Kitasaku Takigawara*, 1948
 7. *Spring at the Base of Mt. Asama*, 1948
 8. *Frost Scene*, 1948
 9. *Tsutsujigahara, Early Spring*, 1948
 10. *Early Spring, Karuizawa*, 1948

One Hundred Views of Kamakura (Kamakura hyakkei). Apparently only 3 prints of this series were made.
 1. *Mountain Road to Kuzuhara*, 42 × 25, 1953
 2. *Meigetsudani Shrine in Spring*, 42 × 25, 1953
 3. *Zeniarai Benten Shrine in Spring*

Individual Prints

Before the Mirror, 43.5 × 29, 1916
Courtesan, 45 × 25, 1916
Dawn at Akashi, 50 × 35, 1916
Evening at Tamagawara, 30 × 20, 1917
Mud-Carrying Boat, 50 × 35, 1917
Sunshine and Shower, 50 × 35, 1917
Spring, 45 × 25, 1917
High Noon, 45 × 25, 1917
After a Bath, 1917
Ferryman, 30 × 20, 1918
Dawn, 42 × 25, 1919
Rainy Season, 42 × 25, 1919
Kandachimae, 42 × 25, 1920
Setting Sun in Autumn, 42 × 25, 1921
Minstrel at Ikenohata, 39 × 24, 1921
Rainbow, 42 × 25, 1921
Woman with Undergarment Sash, 42 × 25, 1921
Mad Man on a Roof, 42 × 25, 1921
After Snow, 42 × 25, 1921
Portrait of Elizabeth Keith, 50 × 35, 1922
Woman with Marumage Hairstyle, 42 × 25, 1924
*Snowy Night**, 42 × 25, 1925
*Intermission**, 42 × 25, 1925
*Refreshing**, 42 × 25, 1925
*Snowy Day**, 42 × 25, 1926
*Rain in Autumn**, 42 × 25, 1927
Under Kimono, 42 × 25, 1927
Black Neckband, 42 × 25, 1928
Eyebrow Pencil, 42 × 25, 1928
Bright Autumn, 50 × 35, 1930
Shawl (Supplement for Yomiuri Newspaper), 42 × 25, 1930–1931
Musume Dōjōji Temple, 45 × 25, 1932
*Early Summer***, 42 × 25, 1933
*Beauty in Makeup***, 1935
Playing Battledore and Shuttlecock, 50 × 35, 1938
Snowy Morning, 50 × 35, 1939
Spring Scene at Takaragawa, Okutone, 50 × 35, 1940
Snow Scene at Honmonji Sanmon Gate, Ikegami, 50 × 35, 1940
Snow in Spring, 42 × 25, 1941
Mt. Fuji at Dawn, Yamanaka Lake, 50 × 35, 1941
A Summer Resort at Noon, 50 × 35, 1941
A Japanese Woman, 42 × 25, 1942
Shinbashi Station of Seventy Years Ago, 50 × 35, 1942

Evening Glow on Mt. Fuji, 50 × 35, 1944
Okoso Hood, 50 × 35, 1950
Kagamijishi, 50 × 35, 1950
Tresses, 52 × 38, 1953
Hand Mirror, 50 × 35, 1954
Whispering, 50 × 35, 1954
Back Stage, 50 × 35, 1955
Green Garden, 50 × 35, 1956
Clean Autumn, 50 × 35, 1956
Woman After a Bath, 50 × 35, 1960
Woman in Western Clothes, 50 × 35, 1960
Four prints, each entitled *Clock and Beautiful Woman* (published by Hotta Clock Shop), 42 × 25, 1964

Kawakami Sumio

New Eight Views of Japan, Nikkō Region (Nihon shin hakkei hanga, Nikkō no bu), 1929. Published by Nakajima Jūtarō, carved by Tsuzuki Tadasaburō. Kawakami's cover print, the table of contents, and the colophon all say that this is the first of a series of *New Eight Views of Japan*. Strangely, there are only 5 prints in this group.

1. *Kegon Falls*
2. *Sacred Bridge*
3. *Yōmeimon*
4. *Ganman Scenic Region*
5. *Lake Chūzenji*

Kawanishi Hide

Twelve Customs of Shōwa Beauties (Shōwa bijin fūzoku jūnitai), 1929, published by Sawada Ishirō of Ōa Geijutsusha.
Kobe Scenes in the Twelve Months (Kobe jūnikagetsu fūkei), 1931.

January: *New Year's Day in Shinkaichi*, 16 × 27
February: *Snow at Rokkō Mountain*, 16 × 27
March: *Spring Evening at Fukuhara*, 16 × 27
April: *Cherry Blossoms at Suma*, 16 × 27
May: *Fresh Green at Ōkurayama*, 16 × 27
June: *Early Summer at the Port*, 16 × 27
July: *Cool Breeze, Minatogawa Park*, 16 × 27
August: *Sea Bathing at Tenjin Beach*, 16 × 27
September: *Full Moon at Mt. Suwa*, 16 × 27
October: *Autumn at Nunobiki Waterfall*, 16 × 24
November: *Autumn Color at Mt. Matatabi*, 16 × 24
December: *End of the Year at Motomachi*

Scenery of Kobe (Kobe fūbutsu), 1933–1935.
One Hundred Kobe Prints (Hanga Kobe hyakkei), 1935.

Scenes from a Port Town, 1941. Ten prints.
One Hundred Views of Kobe (Kobe hyakkei), 1962.

Kawase Hasui

Except where noted by asterisks and other symbols, all works by Kawase Hasui listed here were published by Watanabe Shōzaburō. Other publishers are indicated as follows:

 * Kawaguchi and Sakai
 ** Kāto Junji
 *** Kansai Bijutsusha
 # Bijutsusha
 ## Tokyo Shōbidō
 ### Doi Teiichi
 @ Hōjudō
 @@ Isetatsu

Twelve Tokyo Subjects (Tokyo jūni dai), 1919–1921
1. *Shinkawa at Night*, 36.5 × 24, 1919
2. *Early Spring Rain at Sannō*, 36.5 × 24, 1919
3. *Komagata (Riverbank)*, 24 × 36.5, 1919
4. *Lingering Snow at Inokashira*, 24 × 36.5, 1920
5. *Upper Bridge of Fukagawa River*, 24 × 36.5, 1920
6. *Off the Coast of Shinagawa*, 24 × 36.5, 1920
7. *Daikon Riverbank*, 36.5 × 24, 1920
8. *Evening at Kiba*, 36.5 × 24, 1920
9. *Snow at Shirohige*, 24 × 36.5, 1920
10. *Evening Snow at Terashima Village*, 36.5 × 24, 1920
11. *Field in Toyama*, 36.5 × 24, 1920
12. *Atagoyama in Spring*, 36.5 × 24, 1921

Souvenirs of Travels (Tabi miyage), first series, 1919–1920
1. *Mishima River, Mutsu*, 36.5 × 24, 1919
2. *Mountain Temple at Sendai*, 36.5 × 24, 1919
3. *Tsuta Hot Spring, Mutsu*, 36.5 × 24, 1919
4. *Tsuta Swamp, Mutsu*, 36.5 × 24, 1919
5. *Senjōmaku at Lake Towada*, 36.5 × 24, 1919
6. *Katsura Island at Matsushima*, 24 × 36.5, 1919
7. *Asano River, Kanazawa*, 24 × 36.5, 1920
8. *Lake Kugushi, Wakasa*, 26.5 × 39, 1920
9. *Obama Beach at Horikawa*, 26.5 × 39, 1920
10. *Iwai Beach, Bōshū*, 24 × 36.5, 1920
11. *Stone Loading Boat, Bōshū*, 24 × 36.5, 1920
12. *Yūhi Waterfall at Shiobara*, 36.5 × 24, 1920
13. *Autumn at Arayu Hot Spring, Shiobara*, 36.5 × 24, 1920

14. *Nagare Pleasure Quarter, Kanazawa*, 36.5 × 24, 1920
15. *Kude Beach, Wakasa*, 36.5 × 24, 1920
16. *Koshiji in Autumn*, 24 × 36.5, 1920

Pictures of Mitsubishi Fukagawa Villa (Mitsubishi Fukagawa bettei no zu), commissioned by the Iwasaki family.
1. *Garden Seen from the Building*, 36 × 24, 1920
2. *Moonlight Night*, 36 × 24, 1920
3. *Night Rain on Pine Island*, 24 × 36, 1920
4. *Garden in Autumn*, 24 × 36, 1920
5. *Snow at the Pondside Guest Room*, 36 × 24, 1920
6. *Small Boat in Spring Rain*, 16 × 45, 1920
7. *Cool House at the Pine Pond*, 17 × 45, 1920
8. *Large Fountain* (full view), 16 × 45, 1920

Twelve Months of Tokyo (Tokyo jūnikagetsu), unfinished.
1. *Evening Snow at Sanjikken Canal*, circular, 26 diameter, Dec. 1920
2. *Evening Glow at Yanaka*, circular, 26 diameter, Jan. 1921
3. *Afternoon at Azabu Ninohashi*, circular, 26 diameter, Mar. 1921
4. *Spring Rain at Shiba Park*, circular, 26 diameter, Apr. 1921
5. *Ferryboat Landing at Tsukishima*, 36 × 26, Oct. 1921

Souvenirs of Travels (Tabi miyage), second series, 1921
1. *Miyazu at Tango*, 36.5 × 24, Jan. 17, 1921
2. *Kasuga Shrine at Nara*, 36.5 × 24, Feb. 12, 1921
3. *Nigatsudo at Nara*, 36.5 × 24, Feb. 12, 1921
4. *Morning at Osaka Dōtonbori*, 24 × 36.5, Feb. 14, 1921
5. *Takamatsu Castle in Sanuki*, 36.5 × 24, Feb. 15, 1921
6. *Snow on a Fine Day, Miyajima*, 36.5 × 24, Feb. 17, 1921
7. *Misty Night, Miyajima*, 36.5 × 24, Feb. 18, 1921
8. *Hashidate in Snow*, 24 × 36.5, Feb. 1921
9. *Arashi Canyon in Winter*, 36 × 24, Feb. 22, 1921
10. *Detail of the Byōdōin at Uji*, 36.5 × 24, Feb. 23, 1921
11. *Kiyomizu Temple in Rain*, 24 × 36.5, Feb. 25, 1921
12. *Ojiya Asahi Bridge*, 36 × 24, Aug. 14, 1921
13. *Niigata Gona Moat*, 36.6 × 24, Aug. 15, 1921
14. *Lake Kamo in Moonlight, Sado*, 24 × 36.5, Aug. 16, 1921
15. *Kamo Village, Sado*, 24 × 36.5, Aug. 17, 1921
16. *Aikawa Town, Sado*, 24 × 36.5, Aug. 18, 1921
17. *Ogi Harbor, Sado*, 36.5 × 24, Aug. 19, 1921
18. *Mano Bay, Sado*, 24 × 36.5, Aug. 19, 1921
19. *Irrigation Pipe, Sado*, 36.5 × 24, Aug. 21, 1921
20. *Ura Beach in Echigo*, 24 × 36.5, Aug. 27, 1921
21. *Night Rain at Terahaku*, 36.5 × 24, Aug. 27, 1921
22. *Shimohonda Town, Kanazawa*, 36 × 24, Sept. 6, 1921

23. *Kōshō Temple, Etchū Himi,* 36.5 × 24, Sept. 6, 1921
24. *Beach Hut, Etchū Himi,* 24 × 36.5, Sept. 6, 1921
25. *Yanagawa, Kōshū,* 36.5 × 24, Sept. 11, 1921
26. *Snowy Dawn at Ogi Harbor, Sado,* 24 × 36.5, Dec. 1921
27. *Ebisu Harbor, Sado,* 24 × 36.5, Dec. 1921
28. *West Mikawa Hill, Sado,* 24 × 36.5, Dec. 1921
29. *Sunset, Echigo Gōmoto,* 33 × 21
30. *Zōjōji Temple in Snow,* 37 × 23, Jan. 18, 1922

Selection of Scenes of Japan (Nihon fūkei senshū), 1922–1926
 Sakurajima, Kagoshima, 21 × 28.5, 1922
 Tochinoki Hot Spring, Higo, 28 × 21, 1922
 Kannon in Abuto, 28 × 20.5, 1922
 Kazusa in Hizen, 21 × 28, 1922
 Rice Storehouse in Karatsu, 21 × 28, 1922
 Bizan, Shimabara Harbor, 28 × 20.5, 1922
 Mt. Onsen Seen from Amakusa, 28 × 21, 1922
 Morning at Beppu, 28 × 21, 1922
 Kasuga Town, Kumamoto, 28 × 20.5, 1922
 Kaya Abyss of Nagato Channel, 20 × 28, 1922
 Okayama Castle, 28 × 21, 1922
 Amakusa Goryō, 28 × 21, 1922
 Sūfuku-ji Temple, Nagasaki, 28 × 21, 1922
 Senkō-ji Temple Hill, Onomichi, 28 × 21, 1922
 Kototsu River, Kagoshima, 28 × 21, 1922
 Daigoku-den, Kyoto, 28 × 21, 1922
 Snow at Kinkakuji, 28 × 21, 1922
 Ninety-nine Islands, Shimabara, 21 × 28, 1922
 Kabe Island, Hizen, 21 × 28, 1922
 Kyōhaku, Hizen, 28 × 21, 1922
 Hakozaki, Chikuzen, 28 × 21, 1922
 Anraku Hot Spring, Ōsumi, 28 × 21, 1923
 Kanaya Town, Nagasaki, 28 × 21, 1923
 Ezu Lake, Kumamoto, 28 × 21, 1923
 Iwafune, Bingo, 28 × 21, 1923
 Miyuki Bridge, Kumamoto Castle, 28 × 21, 1923
 Nonomiya, Kyoto, 28 × 21, 1923
 Kakise, Bungo, 28 × 21, 1923
 Dusk at the Kamo River, Kyoto, 28 × 21, 1923
 Kanahama, Hizen, 28 × 21, 1923
 Uchiyamashita, Okayama, 28 × 21, 1923
 Gion Bridge at Amakusa Hontō, 28 × 21, 1924
 Nezame Gorge at Kiso, 28 × 21, 1925
 Suhara, Kiso, 21 × 28.5, 1925

Morning at Mihogaseki, Izumo, 28 × 20.5, 1925
Yasuki Kiyomizu, Izumo, 28 × 20.5, 1926

Souvenirs of Travels (Tabi miyage), third series, 1924–1929
 1. *Kōzu, Osaka, 35.5 × 24, 1924*
 2. *Autumn Rainbow at Hatta, Kaga, 24 × 36, 1924*
 3. *Port of Mihogaseki, Izumo, 36 × 24, 1924*
 4. *Night Rain at Kinosaki, Tajima, 24 × 36, 1924*
 5. *Kintai Bridge, Suō, 24 × 36, 1924*
 6. *Snowfall at Nakayama, Hida, 24 × 36, 1924*
 7. *Cloudy Day at Matsue, Izumo, 36 × 24, 1924*
 8. *Crescent Moon at Matsue, Izumo, 36 × 24, 1924*
 9. *Cloudy Moon at Matsue, Izumo, 36 × 24, 1924*
 10. a) *Hinomisaki, Izumo, 24 × 36, 1924*
 b) *Hinomisaki, Izumo, 24 × 36, 1924*
 11. *Mt. Asahi Seen from Mt. Hakuba, 24 × 36, 1924*
 12. *Arifuku Hot Spring, Iwami, 36 × 24, 1924*
 13. a) *Seaside at Futomi, Bōshū, 36 × 24, 1925*
 b) *Seaside at Futomi, Bōshū, 36 × 24, 1925*
 14. *Ryūgashima, Oga Peninsula, 24 × 36, 1926*
 15. *Kojaku Grotto, Oga Peninsula, 36 × 24, 1926*
 16. *Kansa-no-Miya, Lake Tazawa, 36 × 24, 1926*
 17. *Gyozanoishi on Lake Tazawa, 24 × 36, 1927*
 18. *Karasu Marsh, Akita, 36 × 24, 1927*
 19. *Inlet of Hachirō, Akita, 36 × 24, 1927*
 20. *Tennō-ji Temple in Snow, Osaka, 36 × 24, 1927*
 21. a) *Tsuchizaki, Akita, 36 × 24, 1928*
 b) *Tsuchizaki, Akita, 36 × 24, 1928*
 22. *Village of Kamezaki, Owari, 36 × 24, 1928*
 23. *Hōrai Rocks in the River Kiso, 36 × 24, 1928*
 24. *Miyajima in Snow, 36 × 24, 1928*
 25. *Starry Night at Miyajima, 36 × 24, 1928*
 26. *West Park, Fukuoka, 36 × 24, 1928*
 27. *Morning at Beppu, 36 × 24, 1928*
 28. *Evening at Beppu, 36 × 24, 1929*

Twenty Views of Tokyo (Tokyo nijikkei), 1925–1930
 1. *Snow at Zōjōji Temple, Shiba, 36 × 24, 1925*
 2. *In the Precinct of Kanda Myōjin Shrine, 36 × 24, 1926*
 3. *New Ohashi, 36 × 24, 1926*
 4. *Ochanomizu, 36 × 24, 1926*
 5. *Sunshine After Snow at Asakusa Kannon Temple, 36 × 24, 1926*
 6. *Dawn at Daikon Riverbank, 36 × 24, 1927*
 7. a) *Kiyomizu Temple, Ueno, 36 × 24, 1928*
 b) *Kiyomizu Temple, Ueno, 36 × 24, 1928*

8. *Senzoku Pond*, 36 × 24, 1928
9. a) *Sunset at Ichinokura, Ikenoue*, 24 × 36, 1928
 b) *Sunset at Ichinokura, Ikenoue*, 24 × 36, 1928
10. a) *Sakurada Gate*, 24 × 36, 1928
 b) *Sakurada Gate*, 24 × 36, 1928
11. a) *Akashichō After Rain*, 24 × 36, 1928
 b) *Akashichō After Rain*, 24 × 36, 1928
12. *Yaguchi*, 36 × 24, 1928
13. *Moonlight on Arakawa River, Akabane*, 36 × 24, 1929
14. *Takinogawa*, 36 × 24, 1929
15. a) *Kikyō Gate*, 36 × 24, 1929
 b) *Kikyō Gate*, 36 × 24, 1929
16. a) *Shinobazu Pond in Rain*, 24 × 36, 1929
 b) *Shinobazu Pond in Rain*, 24 × 36, 1929
17. *Snow at Tsukishima*, 24 × 36, 1930
18. *Ōmori Seaside*, 24 × 36, 1930
19. *Moon at Magome*, 36 × 24, 1930
20. *Evening at Hirakawa Gate*, 24 × 36, 1930

Twelve Subjects of Children (Kodomo jūnidai); apparently only 2 of the proposed 12 prints were finished.
1. *Ball*, 36 × 24, Feb. 1931
2. *Doll*, 37 × 24, Apr. 1931

Selection of Views of the Tōkaidō (Tōkaidō fūkei senshū), 1931–1947
 Sengaku Temple at Shinagawa, 36 × 24, Jan. 1931
 Banyū River (a), 24 × 36.5, Jan. 1931
 Banyū River (b), 24 × 36.5, Jan. 1931
 Shinagawa, 36 × 24, Mar. 1931
 Fishing Village, Araimachi, Enshū, 36 × 24, Aug. 1931
 Lake Hamana, 24 × 36, Aug. 1931
 Pine Grove at Miho, 36 × 24, Sept. 1931
 Rain at Aishū Maekawa, 36 × 24, Feb. 1932
 Nagoya Castle, 36 × 24, May 1932
 Zuisenji Temple, Narumi, 36 × 24, June 1932
 Yui Town, Suruga, 36 × 24, Feb. 1934
 Lingering Snow at Hikone Castle, 36 × 24, Feb. 1934
 Okitsu Town, Suruga, 36 × 24, Mar. 1934
 Sengen Shrine, Shizuoka, 36 × 24, Mar. 1934
 Seto, Owari, 36 × 24, Mar. 1934
 Shinkawabashi at Handa, Owari, 36 × 24, Mar. 1935
 Horikawa, Nagoya (a), 36 × 24, Dec. 1935
 Horikawa, Nagoya (b), 36 × 24, Dec. 1935
 Dawn at Nihonbashi, 36 × 24, 1940
 Morning at Motoyoshiwara, 36 × 24, 1940

Evening at Tagonoura, 36 × 24, 1940
Sunset and Pines, Suzukawa Beach, 24 × 36, 1940
Mt. Fuji from Hara on the Tōkaidō, 24 × 36.5, 1942
Mt. Fuji in Moonlight from Oshino, 36 × 24, 1942
Shimada on the Tōkaidō, 24 × 36, 1942
Nissaka on the Tōkaidō, 24 × 36, 1942
Utsunoya on the Tōkaidō, 24 × 36, 1947
Mt. Fuji in Moonlight, Kawaibashi, 36 × 24, 1947
Evening at Abe River, 36 × 24, 1947

Collection of Scenic Views of Japan, Eastern Provinces (Nihon fūkeishū higashi Nihon hen)
Morning Sea at Mikuni, Shiribeshi, 36 × 24, Dec. 1932
Snow at Godaidō, Matsushima, 36.5 × 24, Jan. 1933
Shark in Sea at Hachinohe (a), 36.5 × 24, Jan. 1933
Shark in Sea at Hachinohe (b), 36.5 × 24, Jan. 1933
Senjōmaku at Lake Towada, 36 × 24, Jan. 1933
Rising Moon at Nakajima, Sapporo, 36 × 24, Mar. 1933
Mountain Temple Near Sendai, 36 × 24, Mar. 1933
Kanita, Aomori Prefecture, 36 × 24, Mar. 1933
Otaru Harbor, 36 × 24, Apr. 1933
Zaimoku Island at Matsushima, 36 × 24, May 1933
Setakamui Rock at Shiribeshi (a), 36 × 24, May 1933
Setakamui Rock at Shiribeshi (b), 36 × 24, May 1933
Autumn at Oirase, 36 × 24, June 1933
Fukakubo, Hachinoe, 36 × 24, June 1933
Nenokuchi, Lake Towada, 36 × 24, July 1933
Lake Tōyako, Hokkaido, 36 × 24, Nov. 1933
Aoba Castle, Sendai, 36 × 24, Dec. 1933
Futago Island, Matsushima, 24 × 36, Dec. 1933
Morning at Tsutanuma Pond, 36 × 24, 1933
Ōnuma Park, Hokkaido, 36 × 24, Mar. 1934
Evening Snow at Ishinomaki, 24 × 36, Mar. 1935
Hakkōzan Jōgakura, 36.5 × 24, May 1935
Ōwani Hot Spring, Aomori Prefecture, 24 × 36, May 1935
Konjikidō at Chūsonji Temple, Hiraizumi, 36 × 24, Oct. 1935
Takkoku Grotto, Hiraizumi, 36 × 24, Jan. 1936
Saishōin Temple, Hirosaki, 24 × 36, Feb. 1936

Collection of Scenic Views of Japan, Western Provinces (Nihon fūkeishū Kansai hen)
Rain at Kasuga Shrine, Nara, 36 × 24, Apr. 1933
Dawn at Dōtonbori, Osaka, 36.5 × 24, Apr. 1933
Night at Sōemonchō, Osaka, 36.5 × 24, Apr. 1933
Arashiyama in Spring, 36 × 24, Apr. 1933
Dawn at Futamigaura (a), 24 × 36.5, May 1933

Dawn at Futamigaura (b), 24 × 36.5, May 1933
Kamigamo in Winter, Kyoto, 36 × 24, June 1933
Chionin, Kyoto, 36.5 × 24, Aug. 1933
Phoenix Hall, Byōdōin, Uji, 36 × 24, Sept. 1933
Kiyomizu Temple, Kyoto, 36 × 24, Nov. 1933
Okayama Castle, 41 × 29, Feb. 1934
Nigatsudō, Nara, 24 × 36, May 1934
Kaigandera Beach, Sanuki, 24 × 36, May 1934
Hayama in Iyo, 36.5 × 24, Oct. 1934
Tile Making at Kikuma Beach, Iyo, 24 × 36, Oct. 1934
Yagumo Bridge of Nagata Shrine, Kobe, 36 × 24, Oct. 1934
Kōrakuen Garden, Okayama, 28 × 27, Nov. 1934
Bell Tower of Mt. Kōya, 36 × 24, Feb. 1935
Tonashi Gate at Matsuyama Castle, 36 × 24, Feb. 1935
Tadotsu, Sanshū, 36 × 24, Jan. 1936
Toyohama Beach, Sanshū, 36 × 24, Mar. 1936
Zentsū Temple, Sanshū, 36 × 24, Mar. 1937
Daimotsu, Amagasaki, 36 × 24, 1940
Dawn at Onomichi, 36 × 24, 1940
Murotsu, Suō, 24 × 36, 1940
Heian Shrine Garden, 36.5 × 24, 1941

Collection of Views from Moto-Hakone Minami Villa (Moto-Hakone minami sansō fūkeishū), special order by Iwasaki family
 Evening Mt. Fuji from Ashinoko, 21 × 33, summer 1935
 Moon from Akebi Bridge, 33 × 21, summer 1935
 Azelia Garden from the Veranda, 33 × 21, summer 1935
 Mt. Fuji from the Azalea Garden, 33 × 21, summer 1935
 Two Beauties in the Azalea Garden, 33 × 21, summer 1935
 Night Rain at the Lakeside Teahouse, 33 × 21, summer 1935

New Hundred Views of Tokyo (Shin Tokyo hyakkei), unfinished
 1. *Snow at Daimon Gate, Shiba*, 32 × 22, Feb. 1936
 2. *Spring Rain at Benkei Bridge*, 32 × 22, Apr. 1936
 3. *Moonlight at Honganji Temple, Tsukiji*, 32 × 22, May 1936
 4. *Central Market, Tsukiji*, 32 × 22, May 1936
 5. *Sumiyoshi Shrine, Tsukuda*, 32 × 22, May 1936
 6. *Spring in Hibiya Park*, 32 × 22, May 1936

*Eight Views of Korea (Chōsen hakkei)****, 1939
 1. *Sansen Rock on Mt. Kongō*, 39 × 27, 1939
 2. *Kakomon at Suigen*, 39 × 27, Aug. 1939
 3. *Heijō in Spring*, 39 × 27, 1939
 4. *Fukkoku Temple at Keishū*, 39 × 27, Sept. 1939
 5. *Rakka Rock of Fuyō*, 39 × 27, Sept. 1939

6. *Sōsekitei*, 39 × 27, Oct. 1939
7. *Sōkeirō of Hakuyō Temple*, 39 × 27, Nov. 1939
8. *Keikairō of Keijō*, 39 × 27, Nov. 1939

*Korean Views, Supplement (Chōsen fūkei tsuika)****, 1940
1. *West Gate at Suigen, Korea*, 24 × 36.5, 1940
2. *Botandai at Heijō, Korea*, 36 × 24, 1940
3. *Kyōhokurō at Kōshu, Korea*, 36 × 24, 1940
4. *Sen'in Temple, Chiizan, Korea*, 36 × 24, 1940
5. *Kaijō, Korea*, 36 × 24, 1940
6. *Rinkaitei, Keishū, Korea*, 36 × 24, 1940

Calendar Prints
Kasane Stage (commissioned by Kabuki-za), 8 × 34, Oct. 1934
Dawn at Shōjinko Lake with Pine (commissioned by railroad tourist office), 18 × 21, 1935
Evening at Kiyosu Bridge, 18 × 21, 1936
Cherry Blossoms in Evening, Tōshōgu, Ueno (commissioned by Tokyo city office of electric lighting), 32 × 9, 1936
Prints for Twelve Months (commissioned by Pacific Transport Lines, Inc.), 24 × 36, 1952

Jan. *Shiba Park, Tokyo*	July *Inland Sea*
Feb. *Base of Mt. Fuji*	Aug. *Enoshima Island*
Mar. *Ueno Park, Tokyo*	Sept. *Nara*
Apr. *Bamboo Grove, Tama River*	Oct. *Nara Park*
May *Himeji Castle*	Nov. *Lake Towada*
June *Arashiyama, Kyoto*	Dec. *Chūsonji Temple*

Posters
Miyajima Shrine in Snow (commissioned by railroad tourist office), 24 × 36, 1935
Ryohan (commissioned by Shiota), 41 × 25, 1935
Washington Monument, Potomac Riverside (commissioned by Shiota), 36 × 24, Aug. 1935
Aso Tourist Hotel, 25 × 15, 1948
Fujiya Hotel (commissioned by Fujiya Hotel), 21 × 39, 1949
Winter at Ashinoko Lake (a) (commissioned by Fujiya Hotel), 24 × 37, 1949
Winter at Ashinoko Lake (b) (commissioned by Fujiya Hotel), 24 × 37, 1949

Fan Prints
*Morning at Takamatsu***, 24 × 25
*Himeji Castle***, 24 × 25
*Seven Mile Beach***, 24 × 25
*Sarusawa Pond, Nara***, 24 × 25
*Moon at Matsushima***, 24 × 25
*After Snow at Miyajima***, 24 × 25

 *Kegon Waterfall, Nikkō***, 24 × 25

 *Nishikigaura, Atami***, 24 × 25

 *Evening Snow at Kinkakuji***, 24 × 25

 *Towada Lake***, 24 × 25

 *Okutama in Snow***, 24 × 25

 *Dawn at Mt. Fuji***, 24 × 25

Individual Prints

 Shiobara Okane Trail, 45 × 17, autumn 1918

 Shiobara Hataori, 45 × 16, autumn 1918

 Shiobara Salt Pot, 45 × 17, autumn 1918

 Dusk at Furukawa Riverbank, 17 × 45, early summer 1919

 Cloudy Day at Yaguchi, 45 × 16, early summer 1919

 Summer at Ikaho, 16.5 × 45, summer 1919

 Sendai Hyōtei Riverbank, 16 × 45, summer 1919

 Moon at Matsushima, 17 × 23, summer 1919

 Shiobara Arayu Trail, 16.5 × 45, autumn 1919

 Etchū Ioridani Pass, 45 × 21, 1923

 Snow at Daichi@@, 33 × 22, Feb. 1925

 Hamachō-gashi@@, 23 × 33, Aug. 1925

 Passing Spring, 37 × 24, 1925

 Kabukiza@@, 33 × 23, May 1926

 Lingering Snow at Sannō@@, 33 × 22, 1926

 Shiba Great Gate@@, 33 × 23, 1926

 Kegon Waterfall, Nikkō#, 36 × 24, 1927

 Karikachi-tōge#, 36 × 24

 Murotosaki, Tosa#, 24 × 36

 Taishō Pond, Kamikōchi#, 36 × 24

 Kannon Temple, Beppu#, 24 × 36

 Mt. Unzen, Hizen#, 24 × 36

 Temple Pagoda, Ikenoue, 45 × 21, 1928

 Snow at Benten Shrine, Inokashira, 48 × 34, 1928

 *Snow at Ueno Kiyomizudō**, 36 × 24, July 1929

 *Miyajima in Snow**, 36 × 24, July 1929

 *Snow at Ueno Tōshōgū Shrine**, 35 × 18, July 1929

 *Iris**, 36 × 24, July 1929

 *Pine After Snow**, 36 × 24, Aug. 1929

 *Benten Pond, Shiba**, 24 × 36, Aug. 1929

 *Snow at Benten Shrine Entrance, Inokashira**, 24 × 36, Oct. 1929

 *Futatsudō, Nikkō**, 36 × 24, Nov. 1929

 *Ushibori in Rain**, 38 × 27, Nov. 1929

 *Zōjōji Temple in Snow**, 24 × 36, Dec. 1929

 *River with Pine**, 1929

 Sacred Bridge, Nikkō##, 36 × 24, Apr. 1930

Yōmeimon Gate, Nikkō##, Apr. 1930
Row of Cryptomeria, Nikkō##, May 1930
*Evening at Itako**, 38 × 27, May 1930
Mito Beach, Izu (a), 25 × 37, summer 1930
Mito Beach, Izu (b), 25 × 37, summer 1930
Nijūbashi Bridge##, Aug. 1930
Morning Rain at Asakusa##, Sept. 1930
Late Autumn, Ichikawa, 36 × 24, Dec. 1930
Morning at Nijūbashi Bridge (a), 36 × 24, Dec. 1930
Morning at Nijūbashi Bridge (b), 36 × 24
*Evening at Ushibori**, 38 × 27, 1930
*Snow at the Sacred Bridge, Nikkō**, 23 × 36, 1930
*Chūzenji Lake, Nikkō**, 36 × 24, 1930
*Ōmiya in Rain**, 38 × 27, 1930
In Vicinity of Susono (a), 25 × 38, 1930
In Vicinity of Susono (b), 25 × 38, 1930
Tagonoura Bridge, 37 × 25, 1930
Hikawa Park, Ōmiya, 36 × 24, 1930
Minuma River, Ōmiya, 36 × 24, 1930
Teganuma Pond, 24 × 36, 1930
Ushibori, Ibaraki Prefecture, 24 × 36, 1930
Road at Nikkō, 36 × 24, 1930
Sanpōji Pond, Shakujii, 36 × 24, 1930
Great Buddha at Kamakura (a), 36 × 24, 1930
Great Buddha at Kamakura (b), 36 × 24, 1930
Kuonji Temple, Mt. Minobu (a), 36 × 24, 1930
Kuonji Temple, Mt. Minobu (b), 36 × 24, 1930
Seven Mile Beach, Sōshū, 24 × 36, 1930
Snow at Shrine Entrance (Hie Shrine), 36 × 24, Jan. 1, 1931
Snow at Shiba Park, 24 × 36, Jan. 1931
Honmonji Temple, Ikenoue, 36 × 24, Jan. 1931
Snow at Shinobazu Benten##, 36 × 24, Jan. 1931
Kiyosu Bridge (a), 24 × 36, Feb. 1931
Kiyosu Bridge (b), 24 × 36, Feb. 1931
Benkei Bridge, Akasaka, 36 × 24, Apr. 1931
Spring Night at Inokashira, 36 × 24, Apr. 1931
Flowering Apple Tree, Myōhonji Temple, Kamakura, 36 × 24, Apr. 1931
Dawn at Yamanaka Lake, 36 × 24, Apr. 1931
Morning at Tsuchiura, 36 × 24, Sept. 1931
Evening at Mt. Fuji, Kawaguchi Lake@, Sept. 1931
Rising Moon, Morigasaki@, Oct. 1931
Early Autumn at Urayasu, 24 × 36, Oct. 1931
Morning at Inubō, 36 × 24, Nov. 1931
Hachiman Shrine, Tsurugaoka, 49 × 32, Nov. 1931

Waves on Rocks, Kuroo, Bōshū@, Nov. 1931
Kegon Waterfall at Nikkō, 45 × 21, autumn 1931
Snow at Mukōjima, 36 × 24, Dec. 1931
Kisogawa, Inuyama#, 36 × 24, Dec. 1931
Winter Moon, Toyamagahara###, 36 × 24, Dec. 1931
Lake Towada#, 36 × 24
Fudō Temple, Meguro, 36 × 24, 1931
Utagahama, Chūzenji, 36 × 24, 1931
Moon at Gamō, 36 × 24, Jan. 1932
Evening Sun at Morigasaki, 36 × 24, Jan. 1932
Mt. Fuji After Snow, Tagonoura###, 36 × 24, Jan. 1932
Snow at Funabori###, 36 × 17, Jan. 1932
Evening with Snow, Edogawa### (a), 36 × 24, Feb. 1932
Evening with Snow, Edogawa### (b), 36 × 24, Feb. 1932
Rain on Lakeshore, Matsue, 24 × 36, Feb. 1932
Snow at Sekiguchi (a), 36 × 24, Mar. 1932
Snow at Sekiguchi (b), 36 × 24, Mar. 1932
Lingering Snow at Urayasu, 36 × 24, Mar. 1932
Morning with Mist, Yotsuyamitsuke###, 36 × 24, Mar. 1932
Spring Moon, Ninomiya Beach###, 36 × 24, Mar. 1932
Spring Snow, Kiyomizu, Kyoto###, 36 × 24, Apr. 1932
Pondside at Night, Shinobazu Pond###, 24 × 36, Apr. 1932
Spring Rain at Gokokuji###, 36 × 24, Apr. 1932
Lake Kawaguchi###, 36 × 17, Apr. 1932
Ferry Landing, Kuriwatashi, 36 × 24, May 1932
Wisteria at Kameido, 29 × 20, May 1932
Evening at Itako###, 36 × 17, June 1932
Spring Rain at Arakawa###, June 1932
Snowy Valley, Mt. Hakuba, 36 × 24, summer 1932
Evening Shower on Imai Bridge (a), 24 × 37, Aug. 1932
Evening Shower on Imai Bridge (b)
Dairai Shrine, Kumagai, 36 × 24, Aug. 1932
Izumo Honshō, 21 × 45, Aug. 1932
Snow at Itsukushima, 24 × 36, Nov. 1932
Nippara, Bōshū, 17 × 24, 1932
Autumn at Chūzenji, 24 × 17, 1932
Fuji River (a), 36 × 51, Feb. 20, 1933
Fuji River (b), 36 × 51, Feb. 20, 1933
Kenchōji Temple, Kamakura, 36 × 24, Aug. 1933
Shōgetsuin at Ito, Izu, 36 × 24, Sept. 1933
Mt. Kamagatake, Hida (a), 36 × 24, Dec. 1933
Mt. Kamagatake, Hida (b), 36 × 24
Mt. Kamagatake, Hida (c), 36 × 24
Hoshi Hot Spring, Jōshū, 36 × 24, Dec. 1933

Snow at Nezu Shrine, 36 × 24, 1933
Rain at Shuzenji, 36 × 24, 1933
Snow at Kiba, 36 × 24, Mar. 1934
Kamogawa, Bōshū, 36 × 24, Mar. 1934
Tamonji Temple at Hamahagi, Bōshū, 36 × 24, May 1934
Ishizuemachi, Niigata, 24 × 16, 1934
Snow at Koshigaya, 24 × 36, Feb. 1935
Cherry Blossoms at Night, Koganei, 31 × 26, Feb. 1935
Kawaguchi Lake (a), 29 × 38, Mar. 1935
Kawaguchi Lake (b), 29 × 38, Mar. 1935
Mt. Fuji from Satta Pass (a), 29 × 38, Apr. 1935
Mt. Fuji from Satta Pass (b), 29 × 38, Apr. 1935
Lake Ashinoko, Hakone (a), 35 × 51, early summer 1935
Lake Ashinoko, Hakone (b), 35 × 51, early summer 1935
Harunako Lake (a), 24 × 37, Oct. 1935
Harunako Lake (b), 24 × 37, Oct. 1935
Clouds at Sunset, 31 × 20, Dec. 1935
Moon at Lakeside, 31 × 20, Dec. 1935
Distant Clouds over the Sea, 31 × 20, 1935
Kominato, Bōshū, 24 × 48, Jan. 1936
Yugashima, Izu, 36 × 24, Apr. 17, 1936
Fudōzaka at Yamanaka Lake, 29 × 40, Nov. 1936
Morning in Open Field at Yamanaka Lake, 29 × 40, Nov. 1936
Mt. Fuji from Funatsu, 40 × 29, Nov. 1936
Mt. Fuji at Shigisawa (a), 24 × 36 copy, Nov. 1936
Mt. Fuji at Shigisawa (b), 24 × 36 copy, Nov. 1936
Yamanaka Lake, 32 × 23 copy, Nov. 1936
Moon at Itako, 31 × 20 copy, Nov. 1936
Ukijima Yanaginawa, Ibaraki, 36 × 24, Dec. 1936
Ukijima Tozaki, Ibaraki, 24 × 36, Dec. 1936
Evening at Aso, 36 × 24, Dec. 1936
Torii at Miyajima, 38 × 25, 1936
Evening at Miho, 17 × 37
Summer at Itako, 37 × 17
Habu Port, Ōshima, 36 × 24, Jan. 1937
Nagahama Beach, Mito, 38 × 25, Apr. 1937
Dōgashima Island, Izu (a), 25 × 38, Apr. 1937
Dōgashima Island, Izu (b), 25 × 38, Apr. 1937
Cape Ose, Izu, 25 × 38, Apr. 1937
Kakizaki Benten Shrine, Shimoda, 38 × 25, June 1937
Kishō at West Izu, 40 × 29, June 1937
Kazusa, Hizen, 25 × 38, July 1937
Yumoto Hot Spring, Nikkō, 36 × 24, July 1937
Senjōgahara, Nikkō, 25 × 38, Aug. 1937

Ninety-Nine Islands, Shimabara, 25 × 38, Aug. 1937

Kasugachō, Kumamoto, 38 × 26, Aug. 1937

Honryō, Amakusa, 38 × 25, Aug. 1937

Red Sunset, 23 × 32, Sept. 1937

Spring at Kintai Bridge, 29 × 20, Oct. 1937

Mt. Unzen Seen from Amakusa, 38 × 26, Nov. 1937

Crossing River at Dawn, 32 × 22, Nov. 1937

Triumphal Song, 23 × 32, Dec. 1937

A Dash, 23 × 32, 1937

Kawaguchi Lake, 18 × 25

Ritsurin Park, Takamatsu, 38 × 25, Dec. 1937

Park at Shiba Detached Palace, 25 × 38, Dec. 1937

Eitaibashi Bridge, 36 × 24, 1937

Evening at Kiyozumi Park (a), 26 × 38, Feb. 1938

Evening at Kiyozumi Park (b), 26 × 38, Feb. 1938

Snow at Kiyozumi Park, 26 × 38, Feb. 1938

After Rain at Sannō, 38 × 26, 1938

Moon at Kiyozumi Park, 36 × 24, 1938

Moon at Enoura, 25 × 38, Jan. 1939

Frosty Morning at Nagaoka, Izu, 25 × 38, Feb. 1939

Kannon at Abuto, Bingo, 38 × 25, Oct. 1939

Tomonotsu Benten Island, Bingo, 26 × 38, 1940

Nishikiura, Atami (a), 37 × 24, 1940

Nishikiura, Atami (b), 37 × 24, 1940

Site of Fukuoka Castle, 36 × 24, 1940

Dahlia, 36 × 24, 1940

Grapes and Apples, 24 × 37, 1940

Yutaki, Nikkō, 36 × 24, 1941

Sakunami Hot Spring, Miyagi, 36 × 24, 1941

Yamadera, Yamagata, 36 × 24, 1941

Kizaki Lake, Shinshū, 24 × 36, 1941

Matsubara Lake, Shinshū, 24 × 36, 1941

Takatsudo, Jōshū, 24 × 36, 1941

Higashi-Agano, Bushū, 24 × 37, 1941

Site of Takiyama Castle, Bushū, 36 × 24, 1941

Nenoyama, Bushū, 36 × 24, 1941

Tamiyamura, Saitama, 24 × 36, 1941

Ojiya, Echigo, 36 × 24, 1941

Yuzawa, Echigo, 24 × 36, 1941

Mt. Fuji After Snow (from Oshino), 34 × 47, 1942

Mt. Fuji at Oshino, 37 × 24, 1942

Kawaguchi Lake, Oishi, 37 × 24, 1942

Morning Glow of Mt. Fuji, 24 × 36, 1942

Namikiri, Shima, 36 × 24, 1942

Shikishima Dry Riverbed, Maebashi, 24 × 37, 1942
Early Autumn at Itako, 25 × 34
Namari Hot Spring, Iwate Prefecture, 24 × 33, 1943
Azuma Abyss, 33 × 24, 1943
After Snow at Yoshida, 34 × 47, 1944
Hirano in Autumn, 33 × 47, 1945
Yakuō Shrine, Mito, 33 × 47, 1945
Eboshi Rock, Kawarako, 24 × 35, 1945
Hirakata, Azumachō, 24 × 35, 1945
After Snow at Sekiyado, 25 × 34, 1946
Rain at Aniwa, Nagano, 24 × 33, 1946
Todorokichō, Mito, 35 × 24, 1946
Hataori, Shiobara (a), 36 × 25, 1946
Hataori, Shiobara (b), 36 × 25, 1946
Cherry Blossoms at Site of Shirakawa Castle, 24 × 36, 1946
Cloudy Day at Mizuki, Ibaraki, 25 × 33, 1946
Morning at Hot Spring Inn, Shin'yu, Shiobara, 25 × 37, 1946
Farm House in Autumn, Ayashi, Miyagi, 24 × 33, 1946
Iwai Bridge, Sakuyama, Yashū, 36 × 24, 1946
Hinuma, Hiroura, Mito, 24 × 36, 1946
Moon at Ayashi, Miyagi, 36 × 24, 1946
Onohara, Saitama, 24 × 34, 1946
Nogamichō, Saitama, 33 × 24, 1946
Evening at Minano, Chichibu, 24 × 33
Snow at Hinuma, Mito, 24 × 36, 1947
Moonlight Night at Miyajima, 36 × 24, 1947
Miyajima in Mist, 24 × 36, 1947
Mt. Inari, Nagano, 24 × 36, 1947
Tanikumi Temple, Minonokuni, 36 × 24, 1947
Bell Tower at Okayama, 36 × 24, 1947
Night at Atami, from Abe Inn, 36 × 24, 1947
Spring Evening at Kintai Bridge, 38 × 24, 1947
Night Rain at Kawarako, 35 × 25, 1947
Kasaimachi, Tochigi Prefecture, 34 × 24, 1947
Nagatoro, Chichibu, 24 × 33, 1947
Mt. Fuji from Hakone, 37 × 52, 1947
Late Autumn at Yamanaka Lake, 24 × 36, 1947
Gold-banded Lily (a), 24 × 36, 1947
Gold-banded Lily (b), 24 × 36, 1947
Carp Banner, Toyohama, Kagawa, 37 × 24, 1948
Konpira Shrine, Sanuki, 37 × 24, 1948
Spring Evening, Tōshōgu, Ueno, 36 × 24, 1948
Snow at Heian Shrine, Kyoto, 24 × 37, 1948

Momonoura, Ibaraki, 24 × 36, 1948
Watchtower at Kumamoto Castle, 37 × 24, 1948
Evening at Aso, 24 × 37, 1948
Morning at Yobiko, Hizen, 37 × 24, 1948
Matoba, Takehara, Hiroshima, 24 × 36, 1948
Tsushima Shrine, Aichi, 24 × 36, 1948
Nakayama-taira, Miyagi, 33 × 24, 1948
Evening Glow at Shirasagi Castle, 37 × 24, 1948
Kawarayu, Jōshū, 24 × 33, 1948
Sanzen'in Shrine, Ōhara, 36 × 24, 1949
Morning at Aonuma, Ura-bandai, 37 × 24, 1949
Yanagawa, Chikugo, 24 × 37, 1949
Mera, Bōshū, 25 × 37, 1949
Isohama, Ibaraki, 37 × 24, 1949
Corridor of Miyajima Shrine, 24 × 37, 1949
Saruiwa, Shiobara, 36 × 24, 1949
Ōno, Mito, 37 × 24, 1949
Spring at Daigo Temple, Kyoto, 25 × 37, 1950
Denpōin Temple, Daigo, Kyoto, 37 × 24, 1950
Mandarin Ducks (a), 24 × 36, Sept. 1950
Mandarin Ducks (b), 24 × 36, Sept. 1950
Wild Geese (a), 24 × 36, Oct. 1950
Wild Geese (b), 24 × 36, Oct. 1950
Matsumoto Kōshirō as Sekibei, 38 × 24, 1950
Evening Snow at Kiyomizu Temple, 37 × 24, 1950
Great Buddha Temple, Nara, 36 × 24, 1950
Kikōji Temple, Nara, 37 × 24, 1950
Hatsuse Temple, Yamato, 37 × 21, 1950
Tsubosaka Temple, Yamato, 36 × 24, 1950
Zaōdō, Yoshino, 24 × 37, 1950
Yoshino River Yanagi Ferry, 24 × 37, 1950
Mirotsu, Wakayama, 37 × 25, 1950
Kankaikaku, Wakayama, 24 × 36, 1950
Cape Abuto, 37 × 24, 1950
Kaizudera Beach, Iyo, 24 × 36, 1950
Hashikui Rock, Kushimoto, 24 × 37, 1950
Kaiun Bridge, Saga, 24 × 37, 1950
Onjuku, Chiba, 24 × 37, 1950
Autumn in Shiobara, 36 × 24, 1950
Ura-Bandai, 24 × 37, 1950
Arahama Shōfukuji Temple, Akō, 37 × 24, 1950
Evening at Byōdōin, 24 × 37, 1950
Kabukiza, 24 × 37, 1951

Yakushiji Temple, Nara, 37 × 24, 1951
Snow at Ginkakuji, 37 × 24, 1951
After Autumn Rain (Nanzenji Temple), 37 × 24, 1951
Senjunotaki, Akame, 37 × 25, 1951
Nakamura Utaemon as Yukihime, 37 × 24, 1951
Tōshōdaiji, Nara, 24 × 37, 1951
Kōfukuji Pagoda, Nara, in Rain, 37 × 24, 1951
Katsuura, Kii, 24 × 37, 1951
Ueno Hakuhō Castle, Iga, 24 × 37, 1951
Engetsu Island, Shirahama, 24 × 37, 1951
Evening Snow at Hōōdō (Byōdōin), 24 × 37, 1951
Lingering Snow at Senzoku Pond, 24 × 36, 1951
Iris Garden at Meiji Shrine, 36 × 24, 1951
Spring Rain at Sakurada Gate, 24 × 36, 1952
Spring Sunset at Ōtemon Gate, 36 × 24, 1952
Moon at Izura, Ibaraki, 24 × 37, 1952
Heirinji Temple, Nobidome, 36 × 24, 1952
Rain at Arashiyama Togetsukyō Bridge, 24 × 36, 1952
Morning at Nishidaira, Izu, 36 × 24, Dec. 1953
Full Moon at Matsuyama Castle, 36 × 24, Dec. 1953
Sacred Bridge at Nikkō, 24 × 36, Dec. 1953
Morning at Mito Beach, 36 × 24, Dec. 1953
Autumn at Funatsu, 24 × 36, 1953
Snow at Zōjōji Temple, 34 × 44, 1953
Sunshine After Snow at Yoshida, 24 × 36
Wadahama, Kagawa, 36 × 24, 1954
Kongō Village, Ibaraki, 24 × 36, 1954
Pagoda at Honmonji Temple, Ikenoue, 24 × 36, 1954
Waterfall at Fukuroda in Autumn, 36 × 24, 1954
Evening at Nakoso, 36 × 24, 1954
Fishing with Cormorants, Nagara River, 24 × 36, 1954
Rain at Hotaori, Shiobara, 46 × 18, Mar. 1955
Kawarabatake, Gunma, 24 × 36, 1955
Sunset at Nenoyama, 45 × 18, 1955
Morning at Okayama Castle, 36 × 24, 1955
Miyazaki Genzōji Temple, 36 × 24, 1955
Moon at Kasaoka, Okayama, 36 × 24, 1955
Shinojima, Chita Peninsula, 36 × 24, 1955
Hōryūji, 36 × 24, 1956
East Section of Hōryūji, 24 × 36, 1956
West Section of Hōryūji, 36 × 24, 1956
Snow at Ikenoue, 24 × 36, 1956
Snow at Miho, 36 × 24, Apr. 1957
Konjikidō, Hiraizumi, 36 × 24, May 1957

Kitaoka Fumio

Trip to Native Country (Sokaku e no tabi), 1947. Seventeen black and white prints chronicling Kitaoka's return to Japan through communist-occupied territory at the end of World War II.

Kobayakawa Kiyoshi

Modern Fashionable Styles (Kindai jisei shō), 1930–1931. A set of 6 prints, self-published, carved by Takano Shichinosuke, printed by Ono Tomisaburō. Edition of 100.

1. *Tipsy (Horo yoi)*, 44 × 27, Feb. 1930
2. *Powdering the Face (Keshō)*, 47 × 27, June 1930
3. *Pedicure (Tsume)*, 47 × 27, Feb. 1930
4. *Expression of Eyes (Hitomi)*, 47 × 27, Jan. 1931
5. *Black Hair (Kurokami)*, 49.5 × 28, Feb. 1931
6. *Lipstick (Kuchibeni)*, 49.5 × 28, Mar. 1931

Koizumi Kishio

One Hundred Pictures of Great Tokyo in Shōwa (Shōwa dai Tokyo hyakuzue), 1928–1940. Carved and printed by the artist; published by Asahi Press. Signed with the second *kanji* of the artist's family name. The prints are listed here in the order given by the artist. Those dated 1940 were modified after the series was otherwise complete.

1. *Bridges of Eitai and Kiyosu (Eitai to Kiyosu-bashi)*, Sept. 1928
2. *Spring Rain at Ikenohata (Harusame no Ikenohata)*, April 1929
3. *Mitsui and Mitsukoshi Department Stores (Mitsui to Mitsukoshi)*, May 1929
4. *Senjū Tank Street (Senjū tanku gai)*, June 1929
5. *Azaleas in Hibiya Park (Tsutsuji no Hibiya Kōen)*, May 1930
6. *Shibaura Drawbridge (Shibaura hane-age-bashi)*, Sept. 1930
7. *Shibahama Imperial Gift Park (Shibahama Onshi Kōen)*, Oct. 1930
8. *Waseda Dyeing Factory (Waseda some kōba)*, Nov. 1930
9. *Dawn Snow at Jingū Bridge (Gyosetsu Jingū-bashi)*, Jan. 1931
10. *Nakamise from Nio Gate (Niōmon yori Nakamise)*, Feb. 1931
11. *Plum Blossoms in Shiba Park (Baika no Shiba Kōen)*, Feb. 1931
12. *Night Scene of Ginza in Spring (Haru no Ginza yakei)*, Mar. 1931
13. *Spring Rain at Benkei Bridge (Benkei-bashi no harusame)*, May 1931
14. *Spring Snow at Hamachō Park (Hamachō Kōen shunsetsu)*, Feb. 1940
15. *Sekiguchi Large Falls (Sekiguchi ōtaki)*, July 1931
16. *Kanda Produce Market (Kanda Aomono Shijō)*, Aug. 1931
17. *Yamashita Entrance to Ueno Park (Ueno Kōen Yamashita-guchi)*, Sept. 1931
18. *Old Aoyama Palace (Kyū Aoyama Gosho)*, Oct. 1931
19. *Fall Festival at Yasukuni Shrine (Yasukuni Jinja akimatsuri)*, Oct. 1931
20. *Tsukiji Kachidoki Ferry Port (Tsukiji Kachidoki-watashi)*, Nov. 1931
21. *New Year's Day on Nijū Bridge (Shōgatsu no Nijū-bashi)*, Jan. 1932

22. *Edo Bridge and Its Neighborhood (Edo-bashi to sono fukin)*, Feb. 1932
23. *Sengakuji Temple in Snow (Yuki no Sengakuji)*, Mar. 1932
24. *Nichieda Shrine (Nichieda Jinja San'ō sama)*, Mar. 1932
25. *Sumida Park near Kototoi (Sumida Kōen Kototoi)*, Apr. 1932
26. *Third Azabu Regiment (Azabu Sanrentai)*, May 1932
27. *Togoshi Ginza station (Togoshi Ginza-eki)*, July 1940
28. *Kamedo Tenjin Shrine in May (Gogatsu no Kamedo Tenjin)*, May 1940
29. *Night Rain at Yanagi Bridge (Yanagi-bashi yau)*, June 1932
30. *Holy Bridge (Hijiri-bashi)*, July 1932
31. *Atago-yama Broadcasting Station (Atago-yama hōsōkyoku)*, Aug. 1932
32. *Anamori Fox God Shrine (Anamori Inari)*, Sept. 1932
33. *Memorial Hall for the Great Earthquake (Shinsai Kinendō)*, Sept. 1932
34. *Hundred Flowers Park (Hyakkaen)*, Oct. 1932
35. *Municipal Hall (Shisei Kaikan)*, Oct. 1932
36. *Tori Day Festival at Asakusa (Asakusa Tori-no-ichi)*, Oct. 1940
37. *Fall Color on the Taki River (Taki-no-gawa shūshoku)*, Dec. 1932
38. *Taishaku-ten Temple in Shibamata (Shibamata Taishaku-ten)*, June 1933
39. *Fukagawa Garbage Disposal Factory (Fukagawa jinkai shori kōjō)*, June 1933
40. *By the Pond of Shakujii Sanpōji Temple (Shakujii Sanpōji chihan)*, July 1933
41. *Central Weather Station (Chūō kishōdai)*, Sept. 1933
42. *Gōtoku Temple (Gōtoku-ji)*, Oct. 1933
43. *Row of Trees at Kishibojin Shrine (Kishibojin namiki)*, Nov. 1933
44. *Nihonbashi on Holidays (Shukusaijitsu no Nihonbashi)*, Jan. 1934
45. *The New Capital (Shingidō)*, Feb. 1934
46. *Night Scene at the Kabuki Theater (Kabuki-za yakei)*, Feb. 1934
47. *Komagata Bridge and the Steamship Port (Komagata-bashi to kisen hatcha-kujō)*, Mar. 1934
48. *Zoo in Spring (Haru no dōbutsu-en)*, Mar. 1934
49. *Flower Viewing Party at Asuka Mountain (Asuka-yama no hanami)*, Apr. 1934
50. *Night Cherry Blossoms at New Yoshiwara Center Street (Shin Yoshiwara Naka-no-machi yozakura)*, Apr. 1934
51. *Garden of the Arboretum (Shokubutsu-en no niwa)*, Oct. 1940
52. *Detached Palace* [old residence for crown prince] *(Rikyū [kyū tōgū gosho])*, June 1934
53. *Irises at Horikiri (Horikiri no shōbu)*, June 1934
54. *Suna-machi Townscape (Suna-machi fūkei)*, June 1934
55. *Inoue Philosophy Hall (Inoue Tetsugaku-dō)*, Sept. 1934
56. *Waseda University Town (Waseda Daigaku-machi)*, Sept. 1934
57. *Fall Color at Hanzō Gate (Hanzōmon no shūshoku)*, Sept. 1934
58. *Hibiya Chrysanthemum Tournament (Hibiya kikuka taikai)*, Nov. 1934
59. *Kokugi Hall for Spring Sumō Tournament (Harubasho no Kokugikan)*, Jan. 1935

60. *Riverside of Sukiya Bridge (Sukiya-bashi no kahan)*, Feb. 1935
61. *Shinjuku Town (Shinjuku-gai)*, Feb. 1935
62. *Prince Arisugawa Memorial Park (Arisugawa-no-miya Kinen Kōen)*, Feb. 1935
63. *Azaleas at Yotsuya-Mitsuke (Yotsuya Mitsuke no tsutsuji)*, May 1935
64. *Falling Star Pine at Zenyōji Temple (Zenyōji Hoshifuri no Matsu)*, June 1935
65. *Snow at a Riverside Lumber Yard (Kiba kawasuji no yuki)*, Feb. 1940
66. *River Fete at Ryōgoku (Ryōgoku no kawa-biraki)*, July 1940
67. *Shinagawa Battery, Edo Fort (Shinagawa hōdai, Edo no mamori)*, Aug. 1940
68. *Closed Gate at the Drainage Canal (Hōsuiro kōmon)*, Aug. 1940
69. *Meguro Fudō Temple Hall (Meguro Fudō-dō)*, Feb. 1940
70. *Kotohira Shrine (Kotohira Jinja)*, Oct. 1935
71. *Suzugamori Old Execution Ground (Suzugamori keijō-ato)*, Mar. 1940
72. *Jingū Picture Hall (Jingū Kaigakan)*, Nov. 1935
73. *Landscape of Nerima (Nerima fūkei)*, Nov. 1935
74. *Fukagawa Hachiman Shrine Battledore Festival (Fukagawa Hachiman hagoitaichi)*, Dec. 1935
75. *Snow Storm at Sakurada Gate (Sakurada-mon no fubuki)*, Feb. 1936
76. *Lingering Snow at Tokyo Municipal Office (Tokyo Shiyakusho zansetsu)*, Mar. 1936
77. *Spring Rain at Hirakawa Gate (Hirakawa-mon no harusame)*, Apr. 1936
78. *Tower and Cherry Blossoms at Yanaka Tenno Shrine (Yanaka Tennō-ji tō to sakura)*, Apr. 1936
79. *Pond at Suginami Zenpuku Shrine (Suginami Zenpuku-ji no ike)*, June 1936
80. *Outlook over Suwa Shrine (Suwa Jinja no miharashi)*, Aug. 1936
81. *Shower at Nezu Gongen Temple (Nezu Gongen no shūu)*, Sept. 1936
82. *Komazawa Golf Course (Komazawa gorufu rinkusu)*, Sept. 1936
83. *Entrance to Imperial Hotel (Teikoku Hoteru genkan)*, Nov. 1936
84. *Tokyo Station and Central Post Office (Tokyo eki to Chūō Yūbin Kyoku)*, Nov. 1936
85. *Snow on Red Gate of the Imperial University (Teikoku Daigaku akamon no yuki)*, Dec. 1936
86. *Drying Seaweed at Ōmori (Ōmori nori hoshi)*, Feb. 1937
87. *Haneda International Airport (Haneda Kokusai Hikōjō)*, Mar. 1937
88. *Subway in Spring (Haru no chikatetsu)*, Mar. 1937
89. *Cherry Blossoms at Tsukiji Honganji Temple (Tsukiji Hongan-ji no sakura)*, Apr. 1937
90. *Spring Color at the Natural History and Art Museums (Hakubutsukan to bijutsukan no shunshoku)*, Apr. 1937
91. *Fukagawa Seichō Garden (Fukagawa Seichō Teien)*, May 1937
92. *Otowa Gokokuji Temple (Otowa Gokoku-ji)*, May 1937

93. *Army Rifle Range* [old Toyama-ga-hara] (*Rikugun shageki-jō* [kyū Toy-ama-ga-hara]), June 1937
94. *Rainy Scene at Senzoku Pond* (*Senzoku-ike ujō*), July 1937
95. *Nanushi Falls at Ōji* (*Ōji Nanushi no taki*), Aug. 1937
96. *Senjū Suehiro Town* (*Senjū Suehiro-chō*), Aug. 1937
97. *Kasai Horie Town* (*Kasai Horie-chō*), Sept. 1937
98. *Tsukiji Fish Market* (*Tsukiji uogashi ichiba*), Oct. 1937
99. *Kanda Myōjin Shrine* (*Kanda Myōjin*), Nov. 1937
100. *Kabuto-chō Stock Market* (*Kabuto-chō torihikisho*), Dec. 1937

Kotozuka Eiichi

Eight Snow Scenes of Kyoto (*Kyoto yuki hakkei zoroi*), published by Uchida.

Maeda Masao

Ten Famous Gates of Edo, 1937.

Maekawa Senpan

Japan Scenery Prints, Karuizawa Region (*Nihon fūkei hanga, Karuizawa no bu*), 1929, published by Nakajima Jūtarō of Sōsaku-Hanga Club, carved by Tsuzuki Tadasaburō.

Old Karuizawa in Summer Holidays
Smoke from Asama Mountain
Distant View of Green Hotel from Sengadaki Road
New Road to Karuizawa in Early Spring
Mt. Hanare Covered with Larch Trees in Early Spring

This appears at first glance to be part of the original *Nihon fūkei hanga* series, but the last of the original series was published in April 1920, more than 9 years earlier. The use of the old title suggests that Nakajima intended to continue the earlier series with views of other sections of the country. This conjecture is substantiated by the notice on the contents sheet of the Maekawa set, which states that Kawakami Sumio's set on the Nikkō district had already been published. It seems that Nakajima was dreaming of a thriving business in regional landscape prints, but sets by Maekawa and Kawakami Sumio were apparently the only ones printed. Maekawa also planned a set on Beppu, but this did not materialize.

Outdoor Sketches (*Yagai shōhin*), 1928–1935. Maekawa created this series of 5 sets of black and white linoleum cuts as prints of affection (*shin'ai ban*). Each print, about 14 x 13 cm, depicts a figure engaged in outdoor work or recreation related to the print title.

Set 1, 1928

1. *Birds*	6. *A Parasol*
2. *Breeze*	7. *A Scorpion*
3. *Tennis*	8. *A Dog*
4. *A Butterfly*	9. *Sake*
5. *Flag*	10. *A Telescope*

Set 2, 1929–1931

1. *A Ball*
2. *Fishing*
3. *Sea*
4. *Relaxing*
5. *Boots*
6. *Pond*
7. *Kite*
8. *Jump Rope*
9. *Dancing*
10. *A Swing*

Set 3, 1931–1932, published as a special issue of *Han geijutsu* in 1932

1. *Flower Lantern*
2. *A Lark*
3. *Plum Blossoms*
4. *Snow*
5. *Fireflies*
6. *A Station in the Mountains*
7. *Mountains*
8. *Corn*
9. *Crescent Moon*
10. *Insect Net*

Set 4, 1932–1934

1. *The Deck*
2. *A Tumbler (Daruma)*
3. *A Sled*
4. *A Yard*
5. *Winter*
6. *Handbill*
7. *Dusty Wind*
8. *Hauling Sled*
9. *Dusk*
10. *Nursing*

Set 5, 1934–1935

1. *Tokyo Chorus*
2. *Skiing*
3. *River*
4. *A Stool*
5. *Flowers*
6. *Fatigue*
7. *Water*
8. *Bamboo-Wrapped Candies*
9. *Boy Scout*
10. *Mountain Hot Spring*

New Outdoor Sketches (Shin yagai shōhin), 1942. This album of multicolor woodblock prints was published by Shimo Tarō of Aoi Shobō. Each print, as in the linoleum *Yagai shōhin* sets, contains a single person in the setting indicated in the name of the print.

1. *Mountain Stream*, 18.5 × 18
2. *Path*, 15 × 15
3. *Lake*, 17 × 14
4. *Valley*, 16 × 15
5. *Mountain Path*, 14 × 14
6. *Meadow*, 16 × 15
7. *Mountain Village*, 15 × 15
8. *Path*, 15 × 15
9. *Mountain*, 16 × 15
10. *Plateau*, 16 × 15

Hot Spring Notes (Hanga yokusen fu), 1941, published by Shimo Tarō of Aoi Shobō. This, the first of a series, contains 20 prints (each about 21 × 21 cm) of different spas and large bathing pools. Sekino Jun'ichirō, who was working for Shimo Tarō at the time, carved some of the color blocks in Maekawa's style because Maekawa fell ill shortly before the scheduled publication date.

1. *Lake Tōya*
2. *Jōzan-kei*
3. *Aka-yu*
4. *Togatta*
5. *Aone*
6. *Matsu-no-yama*

7. *Nikkō Yunomoto*
8. *Kuronagi*
9. *Kawaji*
10. *Nashiki*
11. *Ikaho*
12. *Hoshi*
13. *Shima*
14. *Tokura*
15. *Kamisuwa*
16. *Nozawa*
17. *Bessho*
18. *Izusan*
19. *Tohi*
20. *Sikinejima*

More Hot Spring Notes (Zoku hanga yokusen fu), 1944. This second album of *Yokusen fu* was self-published probably because of wartime shortages.

1. *Aizu-yu-no-ue*
2. *Kazawa*
3. *Shimogamo*
4. *Shibuya Andai*
5. *Kutsukake*
6. *Yamada*
7. *Asama*
8. *Kanetsuri*
9. *Misasa*
10. *Okutsu Ōtsuri*
11. *Yubara Sunafuku*
12. *Yunotsu*
13. *Beppu Umijigoku*
14. *Shibaseki*
15. *Aso*
16. *Tochi no ki*
17. *Yu-no-ko*
18. *Unzen*
19. *Kirishima*
20. *Ibusuki*

More and More Hot Spring Notes (Zoku zoku hanga yokusen fu), 1952. This set and the two following bear the imprint of Nihon Aishokai, the name of Shimo Tarō's company after he moved to Okayama prefecture.

1. *Kamikōchi*
2. *Naka-no-yu*
3. *Shirahone*
4. *Hirayu*
5. *Wakura*
6. *Yuwaku*
7. *Yamashiro*
8. *Yamanaka*
9. *Katayamatsu*
10. *Ashihara*
11. *Ryūjin*
12. *Shirahama*
13. *Ume*
14. *Koshi-no-yu*
15. *Urashima*
16. *Yu-no-mine*
17. *Kawayu*
18. *Ki-no-saki*
19. *Yumura*
20. *Tōgō*

More, More, and More Hot Spring Notes (Zoku, zoku, zoku yokusen fu), 1956, published by Nihon Aishokai.

1. *Konbu*
2. *Noboribetsu*
3. *Yu-no-kawa*
4. *Asamushi*
5. *Tsuta*
6. *Ōsawa*
7. *Onikōbe*
8. *Sakunami*
9. *Naruko*
10. *Kamasaki*
11. *Obara*
12. *Iizaka*
13. *Tsuchiyu*
14. *Iwashiro Atami*
15. *Higashiyama*
16. *Semi*

17. *Hijiori* 19. *Senami*
18. *Yu-no-hama* 20. *Takase*

More, More, More, and More Hot Spring Notes (Zoku, zoku, zoku, zoku hanga yoku-sen fu), 1959, published by Nihon Aishokai.

1. *Akan* 11. *Gaga*
2. *Kawayu* 12. *Yahata*
3. *Onneyu* 13. *Itamuro*
4. *Shimofuro* 14. *Shiobara*
5. *Ōwani* 15. *Kiga*
6. *Dake* 16. *Yumoto*
7. *Ochiai* 17. *Kowakudani*
8. *Sugayu* 18. *Ubako*
9. *Yuze* 19. *Shuzenji*
10. *Ōyu* 20. *Atami*

Miki Suizan

Series on Kyoto subjects, 1924, published by Satō Shōtarō in Kyoto in editions of 200. Carved by Maeda; printed by Ōiwa.

Snow on Higashi Mountain, 40 × 26
Pleasure Boat on the Ōseki River, 39 × 27
Tea Ceremony at Cherry Dance, 39 × 27
Daimonji at Night from Kiya Street, 39 × 27
Moonlight at Nijō Castle, 39 × 27
Visiting Kiyomizu Temple, 39 × 26
Spring at Arashiyama, 26 × 39
Kiyomizu Temple on a Spring Night, 26 × 38
Early Summer on Hozu River, 26 × 38
Shower on the Kamo River, 26 × 38
Autumn at Tsūtenkyō, 26 × 39
Snow at Kinkakuji, 26 × 39
Cherry Blossoms at Mimuro, 26 × 39
Imperial Garden in Early Morning Snow, 26 × 39

Munakata Shikō

Ten Great Disciples of Buddha (Jūdai deshi hanga saku), 1939. Each print ca. 92 × 28 cm.

Mokkenren (Maudgalyagana)—gifted with control over supernatural forces
Kaseren (Katyayana)—noted for his grasp of Buddha law
Ubari (Upali)—compiler of monastic rules
Furuna (Purna)—chief preacher among the disciples
Anan (Ananda)—compiled the earliest sutra
Anaritsu (Aniruddha)—noted for charity
Subodai (Subhuti)—best at explaining the void
Kasho (Mahakasyapa)—master of discipline

Sharihotsu (Sariputra)—wisest of the disciples
Ragora (Rahula)—eldest son of the Buddha

Munakata included 2 additional prints so that the 12 prints could be mounted on a pair of 6-panel screens. The original blocks for these 2 were destroyed in the bombing of Tokyo in 1945 and recut after the war.

Fugen (Samantabhadra)—lord of the fundamental law
Monju (Manjusri)—guardian of wisdom

Natori Shunsen

Portraits of Actors in Various Roles, 1925–1929. Published by Watanabe Shōzaburō. Thirty-six prints; edition of 150. All ca. 37 × 25 cm.

Nakamura Kichiemon as Mitsuhide, 1925
Onoe Kikugorō as Motoemon in "Tenkajaya," 1925
Ichimura Uzaemon as Naoji, 1925
Onoe Baikō as Sayuri, 1925
Onoe Matsusuke as Kohyōe, 1925
Nakamura Ganjirō as Tōjūrō, 1925
Bandō Shūchō as Shizuka, 1925
Kataoka Nizaemon as Honzō, 1926
Ichikawa Sadanji as Narukami, 1926
Ichiikawa Sumizō as Gonpachi, 1926
Onoe Eizaburō as Okaru, 1926
Matsumoto Kōshirō as Umeo, 1926
Nakamura Utaemon as Yodogimi, 1926
Sanekawa Enjaku as Danshichi, 1926
Ichikawa Sanshō as a Sweetmeat Peddler, 1926
Nakamura Shikaku as Shizuka Gozen, 1926
Ichikawa Chūsha as Takechi Mitsuhide, 1926
Sawamura Sōjūrō as Narihira Reizō, 1927
Kataoka Ichizō as Benkei in "Benkei Jōshi," 1927
Ōtani Tomoemon as Kanshōjō, 1927
Ichikawa Ennosuke as Kakudayū, 1927
Ichikawa Kigan (Onoe Taganojō) as Otomi, 1927
Ichikawa Shōchō and Kataoka Gadō as Umegawa and Chūbei, 1927
Bandō Mitsugorō as Farmer Manbei, 1927
Nakamura Fukusuke as the Smuggler Sōshichi, 1927
Nakamura Jakuemon as Oshichi, 1927
Sawada Shōjirō as Hayashi Buhei, 1927
Morita Kan'ya as Genta Kagesue, 1928
Bandō Hikosaburō as Matsuōmaru, 1928
Ichikawa Sadanji as Sukune Tarō, 1928
Nakamura Fukusuke as Ohan, 1928
Bandō Jusaburō as Seigorō, 1928

Soganoya Gorō and Shōroku in "Hizakurige," 1928
Sawamura Gennosuke as Nikki Danjō, 1928
Nakamura Kaisha as Okaru in "Yoigoshin," 1928
Ichikawa Omezō and Nakamura Tokizō in "Tsurukame," 1929 (dated "1928")

Portraits of Actors. Fifteen prints published by Watanabe Shōzaburō apparently as supplements to the preceding series. All ca. 37 × 25 cm.

Matsumoto Kōshirō as the White-Bearded Ikkyū, 1929
Ichimura Uzaemon as Sukeroku, 1929
Onoe Kikugorō as Kanpei, 1931
Onoe Kikugorō as Omatsuri Sanshichi, 1931
Ichikawa Sadanji as Moroboshi Chūya, 1931
Nakamura Kichiemon as Otokonosuke, 1931
Onoe Baikō as Aburaya Okon, 1931
Ii Yōhō as Tamagawa Kiyoshi in "Tsuya Monogatari"
Kawai Takeo as Chōzan in "Tsuya Monogatari"
Kitamura Rokurō as Okō
Mizutani Yaeko as Tsubaki-hime ("La Traviata")
Inoue Masao as Rokubei in the Drama "Jihi Shinchō"
Hanayagi Shōtarō as Omiya in "Konjikiyasha"
Ōtani Tomoemon as Kōmoriyasu
Ōkochi Denjirō as Tange Sazen

Portraits of Contemporary Actors in Kabuki Plays published by Watanabe Shōzaburō. All ca. 37 × 25 cm.

Nakamura Utaemon as Hanako in "Musume Dōjōji"
Ichikawa Ebizō as Yoemon in "Kinegawa Zutsumi"
Nakamura Kichiemon as Chōbei in "Suzugamori"
Onoe Baikō as Okaru in "Chūshingura"
Matsumoto Kōshirō as Watanabe no Tsuna
Onoe Shōroku as Priest in "Tsuchigumo"
Nakamura Tomijūrō as Kamuro in the Dance of "Hane no Kamuro"
Ichikawa Ennosuke as Sanbasō in Black Kimono
Ichikawa Danshirō as Sanbasō in Blue Kimono
Ōtani Tomoemon as the Spirit of Snow
Bandō Mitsugorō as a Servant with a Sword
Ichikawa Jukai as Kimura Nagatonokami in "Kirihitoha"
Nakamura Kanzaburō as the Tobacconist Genshichi
Bandō Jusaburō as Yuranosuke in "Chūshingura"
Nakamura Ganjirō as Kamiya Jihei in "Kamiji"
Morita Kan'ya as Kitsune Tadanobu in "Yoshitsune Senbon Zakura"
Kataoka Nizaemon as Wakasanosuke in "Chūshingura"
Bandō Minosuke as Sadakurō in "Chūshingura"
Nakamura Tokizō as Yamauba Yaegiri
Nakamura Senjaku as Ohatsu in "Sonezaki Shinjū"

Ichikawa Sadanji as Yoshirō in the Dance "Modori-Kago"
Nakamura Fukusuke as Osome
Bandō Hikosaburō as Benkei in "Hashi Benkei"
Ichikawa Sanshō as Umeo in "Kurumabiki"
Nakamura Kichiemon as Kumagai Naozane in "Ichinotani Futaba-Gunki"
Nakamura Tokizō as Taruya Osen
Ichikawa Ebizō as Hayano Kanpei in "Chūshingura"
Nakamura Ganjirō as Oman
Ichikawa Arajirō as Kitamura Daizen
Hanayagi Jusuke as the Fox Spirit in "Kokaji"

Nomura Yoshimitsu
Famous Places Around Kyoto (Kyōraku meisho), 1931. Set of 6 prints published by Satō Shōtarō. Edition of 200. All ca. 21 × 34 cm.
Great Bell at the Temple of Chion-in (Chion-in shōrō)
Inari Hill at Fushimi (Fushimi Inari-yama)
Pagoda at Yasaka (Yasaka no tō)
Moon at Hirosawa (Hirosawa no tsuki)
Autumn Scenery at Takao (Takao shūkei)
Snow on the Banks of the Kamo River (Kamo tsutsumi no yuki)

Nozaki Saburō
Creative Print Collection of One Hundred Views of Tokyo (Tokyo hyakkei sōsaku-hangashū), 1934, published by Nakajima Jūtarō of Sōsaku-Hanga Club.

Ōhira Kasen
Twenty-four Examples of Charming Figures (Adesugata nijūshi kō), late 1920s, published by Shinbisha.
Twenty-four Sections of Tokyo, 1930s, published by Shinbisha. These are *bijin-ga*.

Okumura Kōichi
Twelve Views of Kyoto (Kyoto jūni fūkei), 1948, published by Unsōdō.

Onchi Kōshirō
Eight Styles of Contemporary Women (Kindai fujin hattai), ca. 1930.

Sakamoto Hanjirō
Five Views of Aso (Aso gokei), 1950, published by Kuga Isao of Sōjinsha with carving and printing at Katō Hanga Kenkyūsho under the supervision of Katō Junji. Printing by Yamagawa Bunji. Limited edition of 300. Average size of prints is 25 × 36 cm.
Nangōdani
Funkakō
Moon at Namino
Morning at Nekodake
Pasture

Fifty sets of the same subjects were printed in a smaller version, ca. 16.5 × 23 cm, by Kyūryūdō in 1962 with the title *Sakamoto Hanjirō gashū*; 300 more sets of about the same size were printed in 1964 and 130 more in 1971.

Three Horse Pieces (Uma sandai), 1951, published by Ishihara Michio of Mikumo Mokuhansha in an edition of 300; 100 signed by Sakamoto. The 3 prints, which are not titled, were later issued singly in editions of 300 and 700.

Sekino Jun'ichirō

Fifty-three Stations of the Tōkaidō (Tōkaidō gojūsan tsugi), 1960–1974. Self-carved and self-published; printed by Kobayashi Sōkichi, Yoneda Minoru, Iwase Kōichi. Prints are ca. 42.5 × 55 cm.

1. *Nihonbashi: Expressway*, July 1960
2. *Shinagawa: Tokyo Tower*, July 1960
3. *Kawasaki: Tama River*, Dec. 1960
4. *Kanagawa: Foreigners' Cemetery*, Jan. 1971
5. *Hodogaya: 1942 Steam Engine No. D51*, Jan. 1969
6. *Totsuka: Carp Streamers*, May 1963
7. *Fujisawa: Pampas Grass Road*, Jan. 1961
8. *Hiratsuka: Star Festival in July*, Aug. 1961
9. *Ōiso: Harvest Season*, June 1960
10. *Odawara: Daruma Market*, June 1960
11. *Hakone: Mt. Fuji over the Lake*, May 1974
12. *Mishima: Mishima Shrine*, Dec. 1969
13. *Numazu: Latticework Tile Wall*, Feb. 1964
14. *Hara: Roof-Tile Reflection of Mt. Fuji*, Oct. 1964
15. *Yoshiwara: Mt. Fuji and Cherry Blossoms*, May 1974
16. *Kanbara: Deep Snow*, July 1973
17. *Yui: Mt. Fuji Through the Window*, June 1967
18. *Okitsu: View from Seiken-ji*, Apr. 1974
19. *Ejiri: Shimizu Port*, Aug. 1972
20. *Fuchū: Abe River*, Oct. 1968
21. *Mariko: Grated-Yam Soup Shop*, July 1968
22. *Okabe: High-Speed Tunnel*, June 1973
23. *Fujieda: Wheat Field at Twilight*, Mar. 1962
24. *Shimada: Lone Road*, Apr. 1974
25. *Kanaya: Five-Storied Pagoda*, Mar. 1965
26. *Nissaka: Night-Weeping Stone*, Nov. 1960
27. *Kakegawa: Mountain-Top Kannon*, Nov. 1960
28. *Fukuroi: Annual Growth Rings*, Dec. 1960
29. *Mitsuke: Stone Embankment Along the River*, Nov. 1961
30. *Hamamatsu: Morning Factories*, Mar. 1961
31. *Maisaka: Morning Glow*, Dec. 1969
32. *Arai: Remains of the Barrier Compound*, Jan. 1974
33. *Shirasuka: Fishing Village*, Nov. 1966

34. *Futakawa: Moon at Zenith*, Dec. 1966
35. *Yoshida: Willow and Private Estate*, Dec. 1966
36. *Goyu: Scarlet Latticework*, Aug. 1969
37. *Akasaka: Lovesick Cats*, Apr. 1963
38. *Fujikawa: Farmhouses*, Nov. 1969
39. *Okazaki Castle and Sugō Bridge*, June 1969
40. *Chiryū: Roadside Pine Trees*, Apr. 1974
41. *Narumi: Snowflake Tie-Dye Wholesale Store*, June 1974
42. *Miya: Nagoya Castle*, June 1961
43. *Kuwana: Haiku Monument*, Nov. 1964
44. *Yokka-ichi: Oil Refinery Complex at Night*, Aug. 1969
45. *Ishiyakushi: Fall Colors*, Nov. 1969
46. *Shōno: White-Rain Downpour*, July 1962
47. *Kameyama: Samura Mansion*, Mar. 1964
48. *Seki: Lotus Pond*, Apr. 1969
49. *Sakanoshita: Morning at the Mountain Top*, Nov. 1969
50. *Tsuchiyama: Forest Road*, Aug. 1969
51. *Minakuchi: Twilight River*, Sept. 1961
52. *Ishibe: Wooden Grave Tablets*, Feb. 1967
53. *Kusatsu: Entrance to the teahouse*, Mar. 1961
54. *Ōtsu: Clear Day After Snowfall at the Lake*, Oct. 1966
55. *Kyoto: Sanjō Bridge in Snow*, Feb. 1973

Shimizu Miezō

Twelve Months of Chikamatsu (Chikamatsu jūnikagetsu), ca. 1930.

Tobari Kogan

New Brocade Pictures of the East (Shin Azuma nishiki-e), 1913–1918. An undetermined number of prints, perhaps 10 or 12, bear this imprint. It may have indicated a means of distribution rather than a series in the usual sense.

Tokuriki Tomikichirō

Eight Views of Tokyo (Tokyo hakkei), 1942.
Views of Tokyo in the Four Seasons (Shiki Tokyo fūkei).
Thirty Studies of Kyoto, published by Unsōdō.
Thirty-six Views of Mt. Fuji, published by Uchida.
Twelve Studies of Kyoto, self-published.
Noted Places of Kyoto, self-published.
Selections from Prints of Places of Historic and Scenic Interest, published by Uchida.
Four Seasons of Kyoto (Shiki Kyoto fūkei), published by Matsukyū.
One Hundred Print Scenes of Kyoto (Hanga Kyoto hyakkei), 1975.

Tomimoto Kenkichi

Set of 12 small prints, 1944, published by Katō Junji. Subjects include a thistle, round fan, moth, dyeing jar, nirvana, 2 prints of a pomegranate, 3 of earthenware pots, and 2 landscapes.

Tsuchiya Kōitsu
> *Views of Tokyo (Tokyo fūkei)*, 1935–1945. Published by Doi; carved by Harada; printed by Yokoi.

Tsuji Aizō
> *Reminiscent Landscapes (Kaiko fūkei)*, 1935. This is 150 prints of Meiji and Taishō scenes in Osaka.

Tsukioka Gyokusei
> *Fifty Kyōgen Pieces (Kyōgen gojū ban)*, ca. 1930.

Tsukioka Kōgyo
> *One Hundred Nō Dramas*, 1900–1905, published by Matsuki Heikichi.

Tsuruya Kōkei
> A complete catalog of the works to date of Tsuruya Kōkei is available in *The 100th Anniversary of the Kabuki-za Theater, Tsuruya Kōkei: Kabuki Actor Prints*, 1988, published by the Kabuki-za, Tokyo.

Ueno Tadamasa (Torii Tadamasa)
> *Eighteen Kabuki Makeups (Kabuki kumadori jūhachi ban)*, 1940–1941. Published one a month by Watanabe Shōzaburō.
> 1. *Makeup of Umeo*
> 2. *Makeup of Asagao Senpei*
> 3. *Makeup of the Demon of Heikurō*
> 4. *Makeup of the Monkey of Asahina*
> 5. *Makeup of Kugeare*
> 6. *Furtive Makeup of Kagekiyo*
> 7. *Red Makeup of Kintoki*
> 8. *Kajiwara Father and Son Makeup*
> 9. *Large-Eye Makeup of Sukeroku*
> 10. *Crow Makeup of Hinode*
> 11. *Makeup of Tsuchigumo*
> 12. *One-Line Makeup of Watōnai*
> 13. *Makeup of Two Tomomori*
> 14. *Makeup of the God Fudō*
> 15. *Two-Line Makeup of Matsuō*
> 16. *Sharp Pointed Makeup*
> 17. *Crab Makeup*
> 18. *Fox Makeup*

> *New Year's Fortune Sanbasō Makeup (Kotobuki sanbasō)* was made in addition to the preceding series. There were also 7 supplementary prints intended for *Zoku kumadori jūhachi ban*, a second series abandoned because of war shortages:
> 1. *Style of Makeup of Ichikawaryū*
> 2. *Makeup of Dōjōji in Principal Late Role*
> 3. *Makeup of Kuronushi*

4. *Shakkyō Lion Golden Makeup*
5. *Makeup of Gorō in Yauchi-Soga*
6. *Makeup of Benkei*
7. *Makeup of Sanbasō*

Eighteen Kabuki (Kabuki jūhachi ban), 1952, published in 3 folios by Shōkokusha. Carved by Ōkura Hanbei and Nagashima Michio, printed by Shinmi Saburō.

Eighteen Kabuki (Kabuki jūhachi ban no uchi), date undetermined, published by Daireisha; carved by Maeda Kentarō, printed by Ono Hikojirō.

Watanabe Seitei (Shōtei)
Twenty-Two Bird and Flower Prints (Nijūni kachō), 1916, published by Ōkura Yasu-gorō.

Yamagishi Kazue
One Hundred Views of Japan (Nihon hyakkei), 1929.
Flowers and Jars (Hana to tsubo), 1933; 50 prints.
One Hundred Views of the World (Sekai hyakkei), 1937.
One Hundred Views of East Asia (Tōa hyakkei), 1937.

Yamakawa Shūhō
Dancers, Ten Subjects (Odori jūdai), 1936.

Yamamoto Kanae
Woodblock prints produced between Yamamoto Kanae's departure for Europe in July 1912 and completion of *Brittany Woman* in 1920 are listed here with dates derived from circumstantial evidence. Those marked with an asterisk were in the 1919 Nihon Sōsaku-Hanga Kyōkai exhibition.
*Wild Chickens**, 18 × 15, 1912
*On the Deck**, 19.5 × 18.5, 1912
*Bathers of Brittany**, 14.5 × 21, 1913
Small Bay of Brittany, 14 × 21.5, 1913
Brittany Cove, 1913
Paris Suburb (wood engraving)*, 1913
*Rural Spring in France**, 1913
*Winter at Saint Martin**, 1915
*Children Outside a Castle**, 1917
Chinese Woman, 30.5 × 24.5, 1917
Moscow (small version)*, 13.5 × 15.5, 1918
Moscow (large version)*, 1918
Bathing, 34.5 × 23.5, 1918
Brittany Woman, 36 × 28, 1920

Yamamura Toyonari
Onoe Matsusuke IV as Kōmori Yasu, 1917, signed Kōka, was the first print by Toyonari published by Watanabe. This was followed by *Ichikawa Danshirō II as*

Henmi Tesshinsai, 1919, and *Matsumoto Kōshirō VII as Sekibei*, 1919, both signed Kōka. Watanabe then published *Twelve Actor Prints (Jūni yakusha-e)*, 1920–1922, signed Toyonari.

Nakamura Ganjirō I as Akane Hanshichi, 40 × 25, 1920
Ichikawa Shōchō II as Oman, 39 × 27, 1920
Matsusuke as Gorōji, 38 × 27, 1920
Kataoka Nizaemon XI as Kakiemon, 40 × 28, 1920
Matsumoto Kōshirō VII as Sukeroku, 39 × 27, 1920
Ichimura Uzaemon XV as the Gardner Kichigorō, 40 × 27, 1921
Morita Kan'ya XIII as Jean Valjean, 40 × 27, 1921
Kichiiemon as Hoshikage Tsuchiemon, 40 × 27, 1921
Nakamura Utaemon V as Owasa, 39 × 25, 1921
Ichikawa Ennosuke II as Hayami-no-Tōta, 39 × 26, 1921
Sawamura Sōnosuke I as Umekawa, 39 × 27, 1922
Bandō Mitsugorō VII as the Mute in "Sannin-Katawa", 42 × 27, 1922

After the 1923 earthquake Yamamura Toyonari made few if any actor prints other than *Actor in Chinese Play*, 1924.

Yoshida Hiroshi

A catalog of the works of Yoshida Hiroshi can be found in *The Complete Woodblock Prints of Yoshida Hiroshi* (Tokyo: Abe Publishing Company, 1987).

Series by Multiple Artists

1911 *Stage Figure Sketches (Sōga butai sugata)*
This was the joint work of Yamamoto Kanae and Sakamoto Hanjirō. Each man designed 6 prints. They were published in 3 booklets of 4 prints each in June, July, and September by Tokyo Print Society (Tokyo Hanga Kyōkai), an organization formed for this purpose. Carving was by Yamamoto Kanae and Iguchi Minoru; printing by Fujinami Ginzō. The prints were made as souvenirs of plays at the recently opened Imperial Theater to sell for 3 sen each. Sakamoto's 6 prints, each ca. 22.5 × 16 cm, were reprinted in 1971 in an edition of 300 by Kato Junji of Hanga Kenkyusho under the title *Butai Sugata*.

Sawamura Sōnosuke as Princess Minazuru
Sawamura Sōjūrō as Hanzawa Heikurō
Hatuse Namiko as Shizuko
Ichikawa Komatarō as Toyosaku
Sawamura Totsushi as Matsudaira Yosimine
Ichikawa Komazō as Anewa Heiji

1915 *New Portraits (Shin Nigao-e)*
This was a series of at least 5 albums with contributions by Fukuoka Seiran, Ishii Hakutei, Natori Shunsen, and others. The blocks were carved by Igami Bonkotsu.

1916 *Pictures of Famous Places in Osaka and Kobe (Hanshin meisho zue)*
This is a series of 30 prints, 6 by each of 5 artists, Noda Kyūho, Akamatsu Rin-saku, Mizushima Nihofu, Hata Tsuneharu, Nagai Hyōsai, published by Kanao Tanejirō of Bun'endō. Carver was Ōkura Hanbei II; printer, Nishimura Kuma-kichi II. A complete catalog of this series by C. H. Mitchell can be found in "Hanshin Meisho Zue—A Little-Known Shin Hanga Series" in *Essays on Japa-nese Art Presented to Jack Hillier*, edited by Matthi Forrer (London: Sawers, 1982).

1917–1920 *Japan Scenery Prints (Nihon fūkei hanga)*
This is a series of 50 prints by Ishii Hakutei, Ishii Tsuruzō, Morita Tsunetomo, Sakamoto Hanjirō, Hirafuku Hyakusui, and Kosugi Misei, published by Naka-jima Jūtarō and carved by Igami Bonkotsu. Each print carries the seal of the art-ist and, with the exception of the Mt. Bandai print in Set 2, has a title written on it. Many of the prints have different titles on the contents pages which accompanied each set. The date of publication is given on the colophon page of each set. The price was 2 yen per set. Set 6 was reprinted from recut blocks under the title *Tsukushi District (Tsukushi no bu)* by Katō Junji in 1970.

Set 1: Ishii Hakutei, *Hokuriku District*, Jan. 8, 1917
Katayama Tsu
Udetsu Harbor in Noto (Toyama)
Mt. Haku
Wakura in Noto
Kaga Mountains—Yamanaka

Set 2: Morita Tsunetomo, *Aizu District*, Feb. 11, 1917
Nippara
Mt. Bandai (or *Lake Onogawa*)
Aga River
Kawakami Spa
Wakamatsu Castle

Set 3: Hirafuku Hyakusui, *Tōhoku District*, Aug. 20, 1917
Morning Mist at Shiogama
Hiraizumi
Matsu Island
Naruko
Kasa Island

Set 4: Ishii Hakutei, *Shimosa District*, Oct. 1917
Funabashi in Chiba
Sawara
Inuwaka in Chōshi
Noda
Inba Marsh

Set 5: Morita Tsunetomo, *Amakusa District*, Dec. 25, 1917
 Ushibuka Harbor
 Tomioka
 Amakusa Islands
 Fishing Village at Futae
 Dango Island

Set 6: Sakamoto Hanjirō, *Tsukushi District*, May 18, 1918
 Sea of Fire
 Mt. Mizunawa
 Enobe
 Tsukushi Harbor (or *Kami Harbor*)
 Chikugo River

Set 7: Kosugi Misei, *Ryūkyū District*, Nov. 13, 1918
 Manko
 Toraozan Cemetery
 Nakayama Spring at Shurijō
 Futenma
 Bokka (or *Machinato*)

Set 8: Ishii Hakutei, *Chōsen* (Korea), Dec. 16, 1918
 Daidō River
 Keijō (Seoul)
 Mt. Kongō
 Foot of Mt. Kongō
 Jinsen (Inchon)

Set 9: Ishii Tsuruzō, *Tokyo Suburbs*, Dec. 16, 1919
 Arakawa Embankment
 Ōmori Station
 Nakagawa
 Itabashi
 Yoyohata

Set 10: Ishii Tsuruzō, *Japan Alps*, Apr. 15, 1920
 Mt. Hakuba Glacier
 Mt. Yari
 Mt. Mitsuga
 Mt. Hodaka
 Upper Stream of Tashiro River

ca. 1921 *Twenty-five Creative Print Views of the Capital (Teito nijūgo kei sōsaku-hanga)*
This series was advertised by Nakajima Jūtarō as a supplement to *One Hundred Views of New Tokyo (Shin Tokyo hyakkei)*. According to the advertisement, prints were to be distributed to subscribers at the popular price of 1 yen 50 sen each;

Hibiya Hall by Inagaki Tomoo and *Hijiri Bridge* and *Nikolai Cathedral* by Ishii Ryōsuke were already published and *Eitai Bridge* by Yamaguchi Susumu and *Hamachō Park* by Shimoyama Kihachirō were to follow shortly. Other participating artists mentioned were Nakanishi Yoshio, Nomura Toshhiko, Furukawa Ryūsei, and Shimizu Kōichi. Other mentioned scenes to follow were Gijidō Hall from Uchisaiwai-chō, Shōwa Avenue, Sumida Park, Ueno Art Museum, Nihonbashi from Suruga-chō, Ginza Avenue, a distant view of Kiyosu Bridge, Edo Bridge, and a night view from Ueno. This series was apparently not completed.

1923 *Complete Collection of Chikamatsu (Chikamatsu zenshū)*
This included prints of works by Kaburagi Kiyokata, Okada Saburōsuke, and Nakazawa Hiromitsu.

1924 *New Ukiyo-e Beauties (Shin ukiyo-e bijin awase)*
Twelve *ōkubi-e* prints, 1 for each month, published by Murakami. Each ca. 38 × 24 cm.

> January: Ikeda Terukata, *The Game of Poem Cards (Karuta)*
> February: Yamamura Toyonari, *Winter Sky (Samuzora)*
> March: Kitano Tsunetomi, *Lipstick (Kuchibeni)*
> April: Hirezaki Eihō, *Cherry Blossoms (Sakura)*
> May: Nakayama Shūko, *Spring Rain (Samidare)*
> June: Kondō Shiun, *Irises (Shōbu)*
> July: Shima Seien, *After a Bath (Yu agari)*
> August: Igawa Sengai, *Moon (Tsuki)*
> September: Kamoshita Chōko, *Slightly Tipsy (Horoyoi)*
> October: Nakayama Shūko, *Autumn Tints (Momiji)*
> November: Ikeda Shōen, *Calm Autumn Weather (Koharubi)*
> December: Hamada Josen, *Clear Weather After Snow (Yukibare)*

Ikeda Terukata and Ikeda Shōen had both died before this set was made.

1926–1927 *Contest of Beautiful Women of Shōwa (Shōwa bijo sugata kurabe)*
Contributors included Watanabe Kishun.

1927–1928 *Collection of Japanese Modern Creative Prints (Nihon gendai sōsaku-hanga taishū)*
Artists included Oda Kazuma, Ishii Tsuruzō, Onchi Kōshirō, Hiratsuka Un'ichi, Nagase Yoshio, and Maekawa Senpan, each of whom contributed 2 prints. Blocks were carved by the artists and printed by Shimizu Kōichi; the series published by Hasegawa Tsuneo of Nihon Hangasha. Yamamoto Kanae provided a preface.

1929 *Print Collection of Great Tokyo (Dai Tokyo hangashū)*
Artists included Kawakami Sumio, Onchi Kōshirō, and Nomura Toshihiko. Published by Hasegawa Tsuneo of Nihon Hangasha.

1929–1931 *Creative Print Greeting Card Collection (Sōsaku-hanga gajōshū)*

These were mounted New Year cards by members of the Takujō group published by Nakajima Jūtarō. Artists included Fujimori Shizuo, Fukazawa Sakuichi, Henmi Takashi, Hiratsuka Un'ichi, Kawakami Sumio, Maekawa Senpan, Onchi Kōshirō, and Suwa Kanenori. The Takujō group was concurrently making prints for *Shin Tokyo hyakkei* also published by Nakajima Jūtarō. One set of 20 cards was published in 1929, another set of 18 in 1931. There may have been others.

1929–1932 *One Hundred Views of New Tokyo (Shin Tokyo hyakkei)*

This series was published by the Takujō group through Nakajima Jūtarō of Sōsaku-Hanga Club. Participating artists, all members of Nihon Sōsaku-Hanga Kyōkai and founding members of Nihon Hanga Kyōkai in 1931, were Fujimori Shizuo, Fukazawa Sakuichi, Henmi Takashi, Hiratsuka Un'ichi, Kawakami Sumio, Maekawa Senpan, Onchi Kōshirō, Shimozawa Kihachirō, and Suwa Kanenori. Each print is ca. 24 × 18 cm or 18 × 24 cm.

Maekawa Senpan

 1. *Hyakkendana, Shibuya* Jan. 1929
 2. *Honjō Factory District*, May 1929
 3. *Yatsuyama, Shinagawa*, Aug. 1929
 4. *Tori-no-Ichi Fair*, Dec. 1929
 5. *Vegetable Market, Kanda*, May 1930
 6. *Lumber Yard, Fukagawa*, June 1930
 7. *Suijō Park*, Aug. 1930
 8. *Meiji-za*, Oct. 1930
 9. *Night Scene at Shinjuku*, July 1931
 10. *Miniature Golf*, Sept. 1931
 11. *Subway*, 1931
 12. *Gotanda Station*, Feb. 1932

Fujimori Shizuo

 13. *Atagoyama Radio Station*, Mar. 1929
 14. *Red Gate, Imperial University*, May 1929
 15. *Central Meteorological Observatory*, July 1929
 16. *Distant View of Nikolai Cathedral*, Sept. 1929
 17. *Tsukishima*, Nov. 1929
 18. *Hyōkei-kan in Spring Snow*, Feb. 1930
 19. *Kabukiza at Night*, June 1930
 20. *Hall of Imperial University*, Aug. 1930
 21. *Eitaibashi*, Dec. 1930
 22. *Yasukuni Shrine*, Apr. 1931
 23. *Earthquake Memorial Hall*, May 1931
 24. *Mitsukoshi Department Store*, Dec. 1931
 25. *Ueno Station*, Mar. 1932

Onchi Kōshirō

26. *Nijūbashi*, Mar. 1929
27. *Ueno Zoo, Early Autumn*, Sept. 1929
28. *Vicinity of British Embassy*, Oct. 1929
29. *Hōgaku-za*, Dec. 1929
30. *Dance Hall*, Mar. 1930
31. *Coffee Shop*, June 1930
32. *Imperial Palace Plaza*, July 1930
33. *Hibiya Open Air Concert*, Nov. 1930
34. *Inokashira Park*, Sept. 1931
35. *Tokyo Theater*, Dec. 1931
36. *Takehashi Bridge in Snow*, Mar. 1932
37. *Meiji Shrine*
38. *Tokyo Station*

Henmi Takashi

39. *Botanical Gardens, Ueno*, Mar. 1929
40. *Kagurazaka*, Sept. 1929
41. *Meiji Kaiga-kan*, Dec. 1929
42. *Hijiribashi Bridge*, Mar. 1930
43. *Reinanzaka*, Apr. 1930
44. *Rainy Day at Yotsuya-Mitsuke*, June 1930
45. *Imperial Hotel*, Oct. 1930
46. *Tokyo Metropolitan Art Museum*, Mar. 1931
47. *View of Park, Hongō Motomachi*, July 1931
48. *Toyamagahara*, Oct. 1931
49. *Avenue at Meiji Shrine*, Dec. 1931
50. *Kinshi Park*, Mar. 1932
51. *Ushigome-Mitsuke*

Hiratsuka Un'ichi

52. *Nihonbashi*, Feb. 1929
53. *Ueno Park*, Apr. 1929
54. *Akasaka Castle*, Sept. 1929
55. *Benkei Bridge*, Dec. 1929
56. *Shinobazu Pond in Snow*, Mar. 1930
57. *Asakusa Nakamise*, May 1930
58. *Kuromon Nobility Hall*, July 1930
59. *Sukiyabashi Bridge*, Oct. 1930
60. *Shinbashi*, May 1930
61. *Edogawa Park*, Sept. 1931
62. *Yoyogigahara*, Nov. 1931
63. *Yaesuguchi-dōri*, Dec. 1931

Kawakami Sumio

 64. *Aoyama Cemetery*, May 1929

 65. *Ginza*, Aug. 1929

 66. *Military Grand Parade*, Dec. 1929

 67. *At a Department Store*, Apr. 1930

 68. *Waseda University*, May 1930

 69. *Theater at Asakusa*, June 1930

 70. *View of Marunouchi*, Aug. 1930

 71. *Chrysanthemums, Hibiya Park*, Dec. 1930

 72. *Hamarikyū Park*, Dec. 1931

 73. *Fish Market*, 1931

 74. *Cloudy Day at Marunouchi*

 75. *Azabu San-Rentai*, Mar. 1931

Fukazawa Sakuichi

 76. *Shiba Zōjōji Temple*, Apr. 1929

 77. *Yanagibashi Bridge*, July 1929

 78. *Tsukiji*, Sept. 1929

 79. *Hamachō Park*, Nov. 1929

 80. *Kiyosu Bridge*, Feb. 1930

 81. *Kototoi Bridge*, May 1930

 82. *Shin Arakawa*, June 1930

 83. *Shinjuku*, Oct. 1930

 84. *Shōwa-dori*, May 1931

 85. *Sakashita Gate*, July 1931

 86. *Meiji Baseball Stadium*, Dec. 1931

 87. *Kyōbashi*, Apr. 1932

 88. *Senjū Great Bridge*

Suwa Kanenori

 89. *Shinbashi Enbujō*, Apr. 1929

 90. *Hibiya Park*, Oct. 1929

 91. *Mukōjima*, 1929

 92. *Marunouchi Naka-dōri*, Dec. 1929

 93. *Sakurada Gate*, Feb. 1930

 94. *Asakusa*, May 1930

 95. *Edobashi*, July 1930

 96. *Fukagawa Garbage Incinerator*, Nov. 1930

 97. *City Hall, Hibiya*, Aug. 1931

 98. *Shibaura Drawbridge*, Oct. 1931

 99. *National Diet Building*, Feb. 1932

 100. *Marunouchi: Tokyo Station*

A descriptive catalog of this series is available in "Shin Tokyo Hyakkei: The Eastern Capital Revisited by Modern Print Artists" by James B. Austin in *Ukiyo-e Art* 14 (1966).

ca. 1930 *Twelve Picture Views of Japan (Yamato-e jūnikei)*
Artists included Matsuoka Eikyū and Yamaguchi Hōshun. Probably published by Shin Yamato-e Moku-Hanga Kankōkai. Blocks were carved by Yamagishi Kazue.

1930 *Creative Prints of Twelve Months in New Kyoto (Sōsaku-Hanga Shin Kyoto jūnikagetsu)*
This series by Asada Benji, Asano Takeji, and Tokuriki Tomikichirō published by Uchida; distribution began in January 1930.

1931 *Theatrical Prints (Engeki hanga)*
These were sets of prints by Inagaki Tomoo, Munakata Shikō, and possibly others published by Nakajima Jūtarō of Sōsaku-Hanga Club. Included is a set of 5 small full-color prints by Inagaki Tomoo, each measuring ca. 9 x 14 cm, illustrating characters and setting of the drama *Flowers of Grief* which was performed at the Imperial Theater in March 1931. These were apparently intended for sale at the theater as souvenirs.

1932 *One Hundred Views of Great Tokyo (Dai Tokyo hyakkei)*
This series was published by Nihon Fūkei Hangakai through Nihon Hanga Kenkyūsho of Kaneda Shōten. The 20 or more contributors included Hashimoto Yaoji, Kinoshita Giken, Kojima Zentarō, Okuyama Gihachirō, Sekiguchi Shungo, Shimura Tatsumi, Yajima Kenji, Yamazaki Shōzō, and Yokohori Kakujirō.

1932 *Ten-Sen Prints (Jissen hanga)*
Portfolio published by Nakajima Jūtarō of Sōsaku-Hanga Club. Contributors included Azechi Umetarō, Fujimori Shizuo, Fukazawa Sakuichi, Maekawa Senpan, and Ōuchi Seiho.

ca. 1932 *Prints of Fifty New Kyoto Views (Shin Kyoto gojikkei hanga)*
This series was advertised and partially published by Nakajima Jūtarō of Sōsaku-Hanga Club. On a sheet accompanying *Kitsutsuki*, 1931, Nakajima advertised 3 forthcoming series of prints, including this one. He stated that this was to be a sister series to *One Hundred Views of New Tokyo*. Collectors were obliged to take the whole series of 50 prints at a cost of 2 yen each; each was to measure 21 x 27 cm; the edition would be limited to 50. He listed participating artists as Asada Benji, Asano Takeji, Kamei Tōbei, Nakagawa Isaku, Ōtsuki Bun'ichi, Takahashi Tasaburō, Takeda Shintarō, Tokuriki Tomikichirō, and Uchida Saburō, all members of the Kyoto Sōsaku-Hanga Kyōkai. According to the advertisement, 3 artists had already made prints for the series: Tokuriki Tomikichirō, *Nishi Ōtani*; Takeda Shintarō, *Kamigamo Sekkei*; and Asada Benji, *Shijō Bridge*. Other places listed for future prints were Uzumasa Satsuei-sho, Sosui, Hiē-zan Enbō,

Kyoto station, Heian Shrine, Sanjūsangendō, Shimabara, Tsūten-kyo, Takase-gawa, Hanami Kōji, Nijō Castle, and Ide-chō.

June 1932–May 1933 *People of the Times Prints (Toki no hito hanga)*
Two issues. Published by Nakajima Jūtarō of Sōsaku-Hanga Club. Loose prints of political figures in cardboard folders. Contributors included Ishii Ryōsuke and Ōuchi Seiho.

1933 *Hōsun Prints (Hōsun hanga)*
Portfolio published by Nakajima Jūtarō of Sōsaku-Hanga Club. Contributors included Azechi Umetarō, Fukazawa Sakuichi, Munakata Shikō, and Taninaka Yasunori.

1933–1934 *Views of New Kyoto (Shin Kyoto fūkei)*
Artists and prints of this series include:
Tokuriki Tomikichirō: *Evening at Nijō Palace; Snowy Morning at Kiyomizu Temple*
Asada Benji: *Snow at Kinkakuji; Spring at Sanjō Bridge*
Asano Takeji: *Slight Rain at Higashi Honganji; Moonlight, Arashiyama Park*

1936–1937 *New Modern Print Collection (Shin jidai hangashū)*
This series was assembled by Nihon Shin Hanga Kyōkai and published by Onoda Mototsugu. Two folios of prints of unrelated subjects with 1 print by each of 5 artists in each folio. All of the artists were members of Taiheiyōgakai. Artists in Set 1 were Ishikawa Toraji, Nagachi Hideta, Nakamura Fusetsu, Mikami Tomoji, and Tsuruta Gorō; those in Set 2 were Fuse Shintarō, Mitsu-tani Kunishirō, Okuse Eiza, Takamura Masao, and Yoshida Hiroshi.

1938–1941 *One Hundred Views of New Japan (Shin Nihon hyakkei).*
Self-published by members of Nihon Hanga Kyōkai. Fujimori Shizuo was editor for nos. 1–9 and Maekawa Senpan from no. 10. The first print was issued in December 1938 followed by groups of 3 at irregular intervals until 39 were issued. Publication ceased in 1941 because of the war. Other prints were completed but never published. Each print measures ca. 23 x 30 cm. The title of the series is stamped in the upper right margin of each print and the name of the print asso-ciation in the lower left margin. Most of the prints have a numeral stamped in red or black in the lower margin, presumably an impression number. Each edi-tion was about 50. Only a few of the prints carry the artist's signature, but most have small seals. Each print was apparently issued in a folder to which a label was attached. Each label gave the name of Nihon Hanga Kyōkai, name of the series, name of the artist, and a name for the place represented, sometimes with another name to clarify the location. Each print was accompanied by a tissue giving information about the print and a statement by the artist.
1. Maekawa Senpan, *Kishū Torohatchō*, Dec. 1938
2. Shimozawa Kihachirō, *Daisetsu Mountain* (Korea), Dec. 1938
3. Tokuriki Tomikichirō, *Dōtonbori* (Osaka), Dec. 1938

4. Hiratsuka Un'ichi, *Chidori Jō*, Jan. 1939
5. Kitazawa Shūji, *Mt. Asama* (Nagano), Jan. 1939
6. Kakihara Toshio, *Yokohama Harbor*, Jan. 1939
7. Yamaguchi Susumu, *Kamikōchi* (Nagano), Mar. 1939
8. Uchida Shizuma, *Takada City* (Niigata), Mar. 1939
9. Katsuhira Tokushi, *Oga Peninsula* (Akita), Mar. 1939
10. Kawanishi Hide, *Hyūga* (Aoshima), Apr. 1939
11. Shimizu Kōichi, *Sotobō* (Chiba), Apr. 1939
12. Asada Benji, *Lake Biwa*, Apr. 1939
13. Henmi Takashi, *Lake Itako*, May 1939
14. Kitamura Imazō, *Hanshin Park* (Hyōgo), May 1939
15. Asahi Yasuhiro, *Sanjō Bridge* (Kyoto), May 1939
16. Onchi Kōshirō, *East Gate* (Taipei)
17. Takeda Shintarō, *Hozu Rapids* (Kyoto), Aug. 1939
18. Maeda Masao, *Ogasawara* (Bonins), Aug. 1939
19. Fukuzawa Sakuichi, *Mt. Fuji*, Oct. 1939
20. Oiwa Chūichi, *Shizaki Kaigan* (Aichi), Oct. 1939
21. Kotozuka Eiichi, *Tōdaiji* (Nara), Oct. 1939
22. Koizumi Kishio, *Monkey Bridge*, Dec. 1939
23. Kobayashi Asaji, *Shiga Kōgen*, Dec. 1939
24. Azechi Umetarō, *Mt. Ishizuchi* (Ehime), Dec. 1939
25. Kawakami Sumio, *Nantai Mountain*, Feb. 1940
26. Takeda Yoshihei, *Yabakei* (Ōita), Feb. 1940
27. Kawanishi Hide, *Kobe*, Feb. 1940
28. Hiratsuka Un'ichi, *Heijō Botandai* (Korea), Apr. 1940
29. Ishii Ryōsuke, *Mt. Aso* (Kumamoto), Apr. 1940
30. Matsunaga Shigeru, *Ashinoko* (Hakone), Apr. 1940
31. Funasaki Kōjirō, *Kaibashima* (Karafuto), July 1940
32. Maekawa Senpan, *Kongō Mountain* (Korea), July 1940
33. Taninaka Yasunori, *Ōkawabata* (Tokyo), July 1940
34. Ishizaki Shigetoshi, *Miyajima*, Nov. 1940
35. Maeda Toshio, *Shirahama* (Wakayama), Nov. 1940
36. Onchi Kōshirō, *Unzen* (Nagasaki), Nov. 1940
37. Azechi Umetarō, *Iyo Kanjizai* (Ehime), June 1941
38. Inagaki Tomoo, *Nagatoro* (Saitama), June 1941
39. Shimozawa Kihachirō, *Lake Towada* (Aomori), June 1941

1941–1943 *Various Print Albums, Collection of Ten (Shosō hanga chō jū-renshū)*
This is a series of albums published by Shimo Tarō of Aoi Shobō in editions of 250 each. Nine artists participated, each making an album: Henmi Takashi, Hiratsuka Un'ichi, Kawakami Sumio, Kawanishi Hide, Maekawa Senpan, Oda Kazuma, Onchi Kōshirō, Sekino Jun'ichirō, and Takei Takeo. Each album is enclosed in a beige paper cover, 26.5 x 21 cm, printed front and back in one color from a block designed by the artist. The name of the series is given on

the first page. All except the Hiratsuka album were apparently mechanically printed.

Kawakami Sumio, *Coming and Going During "Civilization and Enlightenment" (Bunmei kaika ōrai)*. The term "Civilization and Enlightenment" refers to the decade of the 1870s when Japan was frantically imitating the West.

Kawanishi Hide, *Harbor Scenes (Kōto jōkei)*. This album features a rugged boat and colorful stateroom.

Maekawa Senpan, *New Sketches of the Field (Shin yagai shōhin)*. Opposite each print is a short prose selection about the place where Maekawa made the sketch. This is the same theme as Maekawa's 1928–1935 six sets of linoleum cuts entitled *Sketches of the Field*, but these are multicolor woodblocks. Dated July 25, 1942.

Henmi Takashi, *Sentimental Notes on Water (Suiin fu)*. This album shows a series of landscapes by ponds and streams or otherwise related to water. Dated December 21, 1942.

Onchi Kōshirō, *Insects, Fish, Shells (Mushi sakana kai)*. Dated March 1943.

Hiratsuka Un'ichi, *Pictures and Words on a Circuit of Izu Peninsula (Izu isshū gashi)*. Dated March 1943. Printed by Nakamura Sanjirō.

A lithograph album by Oda Kazuma and etching albums by Takei Takeo and Sekino Jun'ichirō were also included.

1942–1943 *Woodpecker Print Collection (Kitsutsuki hangashū)*
Two collections of 20 self-carved and self-printed *hanga* were published, each in an edition of 100, by Kitsutsukikai from Hiratsuka Un'ichi's address. The first *Kitsutsuki hangashū* collection was 11 years after the last issue of *Kitsutsuki*. Except for the leadership of Hiratsuka, Kitsutsukikai was also a new group of artists; held an exhibition in Seijūsha Gallery in 1942 and published the first album of self-carved, self-printed works shortly thereafter. Although the group disbanded because of the war, it managed to publish a second similar album in 1943. Contributors included: Azechi Umetarō 1, Ebata Yoshiichi 2, Hashimoto Okiie 1–2, Hiratsuka Un'ichi 1–2, Ishizaki Shigetoshi 1–2, Iwajima Tsutomu 1–2, Iwata Kakutarō 2, Kakihara Toshio 1–2, Kitaoka Fumio 1 2, Kuroki Sadao 2, Maeda Masao 1–2, Munakata Makka 1–2, Mutō Kan'ichi 2, Nakagawa Yūtarō 2, Nakamura Nakazō 2, Nakano Kihei 1, Nozu Sakichi 1–2, Ono Tadaaki 2, Sasajima Kihei 1, Sasaki Takashi 2, Shimozawa Kihachirō 1–2, Takahashi Tadao 1, Takeda Yoshihei 2, Tsukamoto Tetsu 1–2, and Ueno Makoto 1. The specific prints in the second collection were:

Ebata Yoshiichi, *Schoolboy with Telescope*
Hashimoto Okiie, *Hikone Castle*
Hiratsuka Un'ichi, *Great Wall of China*
Ishizaki Shigetoshi, *Hogo*
Iwajima Tsutomu, *Osaka Castle*
Iwata Kakutarō, *Landscape at Shima*

Kakihara Toshio, *View of Mt. Fuji from Musashino*
Kitaoka Fumio, *Father and Son on a Night Train*
Kuroki Sadao, *Flowering Grass*
Maeda Masao, *Yaguruma*
Munakata Makka, *Keyaki Tunnel at Baba Gate*
Mutō Kan'ichi, *Aburatsubo*
Nakagawa Yūtarō, *Scene by Water*
Nakamura Nakazō, *Little Girl*
Nozu Sakichi, *Woman in Yukata*
Ono Tadaaki, *Two Designs*
Sasaki Takashi, *Pottery Seller*
Shimozawa Kihachirō, *Spring Frost*
Takeda Yoshihei, *Wild Roses in Bloom*
Tsukamoto Tetsu, *Peony*

1944–1950 *First Thursday Collection (Ichimokushū)*
This was published as 6 self-carved, self-printed sets in editions of 100 by Ichimo-
kukai under the direction of Onchi Kōshirō.

Set 1, 1944
Frontispiece by Sekino Jun'ichirō, *Mother and Child* from an etching by
Yorozu Tetsugorō
Onchi Kōshirō, *Window Open to the Sea*, 35 × 28
Sekino Jun'ichirō, *Portrait of Onchi Kōshirō*, 35 × 28
Kawanishi Hide, *Bridge Across a Pond*, 21 × 15
Yamaguchi Susumu, *Mountain Climber*, 28 × 23.5
Yamaguchi Gen, *Firefly*, 35 × 28
Katō Tarō, *Four Leaves*, 35 × 28
Neichi Ryōzō, *Shells and Flowers*, 24 × 21
Sugihara Masami, *Potato Flower*, 35 × 28
Mori Dōshun, *Early Summer Garden*, 33 × 28
Azechi Umetarō, *Wife of a Coolie*, 37 × 27
Wakayama Yasoji, *New Green*, 35 × 27
Taniguchi Kunbi, *Mountain Gate*, 35 × 28
Kimura Hanbei, *Plum Tree*, 35 × 28

Set 2, 1946
Frontispiece by Sekino Jun'ichirō, *Crying Child* from design by Ishii Tsuruzō
Onchi Kōshirō, *Fairy Tale of the Sea*, 35 × 27.5
Hatsuyama Shigeru, *Tea Child*, 26 × 26
Sekino Jun'ichirō, *Snow in Yunoshima, Asamushi*, 35 × 28
Kawanishi Hide, *Jug*, 15 × 21
Azechi Umetarō, *Mountain*, 23 × 20
Tsukamoto Tetsu, *Ushikunuma*, 20 × 24
Yamaguchi Gen, *Water Glass with Flower*, 35 × 28

Mori Dōshun, *Spring Valley*, 16 × 18
Neichi Ryōzō, *Black Rose*, 16 × 22
Yamaguchi Susumu, *Lake Chūzenji*, 35 × 28
Wakayama Yasoji, *Spring*, 19 × 21
Ushijima Noriyuki, *Clouds*, 17 × 23
Saitō Kiyoshi, *Ginza*, 31 × 21
John D. Sheppard, *Carp for Boys' Day*, 22 × 14
Ernst Hacker, *Face*, 32 × 28
Alonzo Freeman, *Portrait* (Makoto Hirao), 27 × 22
Nakao Yoshitaka, *Friend Painting a Picture*, 15 × 10

Set 3, 1947
Frontispiece design by Yamaguchi Gen
Decoration on signature page designed by Nakagawa Kazumasa, carved by
Sekino Jun'ichirō
Onchi Kōshirō, *Fantasy for Marble Structure*, 34 × 27
Kawanishi Hide, *Still Life*, 7 × 10
Ōta Kōji, *Playing Children*, 20.5 × 26
Shinagawa Takumi, *Fish*, 35 × 27.5
Sekino Jun'ichirō, *Frog in a Beer Glass*, 35 × 27.5
Yamada Akiyo, *Jōnen Mountain*, 17 × 24
Azechi Umetarō, *Red Cover*, 21 × 13
Misaki Yukio, *Kibō*, 31 × 26
Tsukamoto Tetsu, *Still Life*, 28 × 22
Yamaguchi Gen, *Empty Hand*, 35 × 28
Wakayama Yasoji, *Sea*, 35 × 27
Maeda Masao, *Black Cat*, 14 × 17
Kitaoka Fumio, *Office*, 13 × 13
Mori Dōshun, *Praying Mantis*, 15 × 10

Set 4, 1948
Frontispiece design by Kitaoka Fumio, *Nude*
Decoration on signature page by Sekino Jun'ichirō
Onchi Kōshirō, *Allegory, Columbus's Egg*, 29.5 × 7.5
Yamaguchi Gen, *Leaves*, 35 × 27
Kitaoka Fumio, *Portrait* (Nagano Yoshio), 35 × 27
Hatsuyama Shigeru, *Wind*, 26 × 35
Tsukamoto Tetsu, *Flower and Butterfly*, 27 × 21
Ōta Kōji, *Snow Children*, 27 × 20
Inagaki Tomoo, *On the Table*, 28 × 20.5
Misaki Yukio, *At the Light of a Lamp*, 27 × 22
Sekino Jun'ichirō, *A Girl of the Sea*, 35 × 28
Wakayama Yasoji, *Shell*, 35 × 28
Azechi Umetarō, *Girl*, 25 × 177
Yamada Akiyo, *A Girl's Portrait*, 35 × 27

Taniguchi Kunbi, *Bunraku Doll's Head*, 35 × 27
Mori Dōshun, *Kikyō* (Flower), 19 × 16
Maekawa Senpan, *Shakujii Sanpōike* (Pond), 12.5 × 15
Yamaguchi Susumu, *Sesshu as a Youth*, 35 × 28
Maeda Masao, *Landscape*, 17 × 17

Set 5, 1949

Frontispiece design by Mori Dōshun
Sekino Jun'ichirō, *Portrait of a Child*, 35.5 × 27.5
Saitō Kiyoshi, *Little Girl*, 21 × 13.5
Wakayama Yasoji, *Butterfly*, 35 × 27
Yamaguchi Susumu, *First Snow at Kiso Mountain*, 21 × 26
Kitaoka Fumio, *Sorrow*, 35.5 × 27.5
Komai Tetsurō, *Gilko de Rais*, 14 × 10
Onchi Kōshirō, *Trivial Romance*, 35 × 28
Kiwamura Sōjirō, *Shibamata Taishakuten*, 17 × 19.5
Yamaguchi Gen, *Leaf*, 25 × 16
Maeda Masao, *Cat*, 11 × 15.5
Shinagawa Takumi, *Abstract*, 35 × 28
Inagaki Tomoo, *Coffee Mill*, 27 × 20
Yamada Akiyo, *Landscape*, 11 × 14
Taniguchi Kunbi, *Doll Heads*, 35 × 28
Mori Dōshun, *Silhouette*, 24 × 18
Tsukamoto Tetsu, *Iris*, 26 × 23
Nakao Yoshitaka, *Lime Factory*, 24 × 19

Set 6, 1950

Frontispiece by Sekino Jun'ichirō, *Wolves Howling at the Moon*
Onchi Kōshirō, *Lyric Number Nine*, 35 × 27.5
Hatsuyama Shigeru, *Nudes Dancing*, 25.5 × 26
Shinagawa Takumi, *Forms*, 35 × 27
Takei Takeo, *Composition of Life*, 19 × 14
Wakayama Yasoji, *Frozen Time*, 35 × 27.5
Kiwamura Sōjirō, *Fire God*, 35 × 28
Yamaguchi Gen, *Autumn Afternoon*, 35 × 27
Komai Tetsurō, *Radioactivity in My Room*, 20 × 16
Nakao Yoshitaka, *Ground Cherries*, 10 × 16
Sekino Jun'ichirō, *A Boy Clown*, 35 × 28
Kitaoka Fumiio, *Abstract*, 35 × 27.5
Taniguchi Kunbi, *Two Bunraku Heads*, 19 × 16
Yamaguchi Susumu, *Inakashibai*, 35 × 28
Tsukamoto Tetsu, *Dutch Lilies*, 35 × 27.5
Inagaki Tomoo, *Dog and the Moon*, 35 × 27.6
Yamada Akiyo, *Nude*, 20 × 16
Maeda Masao, *Komagadake*, 17 × 17

Mori Dōshun, *Girl in Front of a Mirror*, 23 × 19
Hashimoto Okiie, *Yaene on Hachijō Island*, 35 × 27.5
Ishida Michihiko, *Two Women*, 24 × 19
Ōta Kōji, *Face*, 24 × 21

1945 *Recollections of Tokyo (Tokyo kaiko zue)*

In a folder which accompanied the series, the title *Scenes of Last Tokyo—Fifteen Scenes of Last Tokyo in Original Woodcut* was given in English. The prints were published shortly after the end of World War II by Uemura Masuo of Fugaku Shuppansha, formerly of Takamizawa Mokuhansha. The artists, all from Nihon Hanga Kyōkai, were Azechi Umetarō, Hiratsuka Un'ichi, Kawakami Sumio, Maeda Masao, Maekawa Senpan, Onchi Kōshirō, Saitō Kiyoshi, Sekino Jun'ichirō, and Yamaguchi Gen. Printing was by Hirai Kōichi. Onchi, Hiratsuka, Maekawa, and Kawakami had also contributed to the *Shin Tokyo hyakkei* series finished in 1932. Their prints in the *Tokyo kaiko zue* series are from recut blocks of designs in *Shin Tokyo hyakkei*. These are marked with asterisks. All of the prints are ca. 24 × 18.5 cm.

Onchi Kōshirō: *Tokyo Station*; Nijūbashi*; Ueno Zoo**
Hiratsuka Un'ichi: *Akasaka Palace*; Sukiya Bridge**
Maekawa Senpan: *Factory Street at Honjō*; Night at Shinjuku**
Kawakami Sumio: *Night at Ginza*; Torii of Kudan*
Yamaguchi Gen: *Zōjōji (Temple); Meiji Shrine*
Azechi Umetarō: *Graveyard at Sengakuji*
Maeda Masao: *Red Gate, Tokyo University*
Saitō Kiyoshi: *Asakusa Kannon Temple*
Sekino Jun'ichirō: *Benkei Bridge*

1946 *Picture Notes on Native Customs of Japan (Nihon minzoku zufu)*

The artists of this set were Azechi Umetarō, Kawanishi Hide, Kuroki Sadao, Maeda Masao, Maekawa Senpan, Mori Dōshun, Saitō Kiyoshi, Sekino Jun'ichirō, Wakayama Yasoji, and Yamaguchi Gen. Published by Uemura Masuo of Fugaku Shuppansha, formerly of Takamizawa Mokuhansha. The prints were matted and presented in gray cardboard folders with names of artists and titles translated into English on accompanying sheets.

Maekawa Senpan: *Gion Festival; Festival in Urasa*
Mori Dōshun: *Tanabata Festival in Hida*
Saitō Kiyoshi: *Winter in Aizu*
Sekino Jun'ichirō: *Snow Room; Oiran Parade*
Kawanishi Hide: *Port Festival*
Azechi Umetarō: *Fighting Bulls of Iyo*
Kuroki Sadao: *"Iwatokagura" Play*
Maeda Masao: *Maid of Ōshima*
Wakayama Yasoji: *Drying Cuttlefish in Esashi*
Yamaguchi Gen: *Evening Bell in Amakusa*

1946 *Selection of Customs of Japanese Women (Nihon jozoku sen)*
The artists were Maekawa Senpan, Onchi Kōshirō, Kawanishi Hide, Sekino
Jun'ichirō, and Saitō Kiyoshi. This set was published in August, just a year after
the end of World War II, by Uemura Masuo of Fugaku Shuppansha. It included
2 leaflets, one in Japanese containing comments by the artists and the other in
English with explanatory descriptions. The Japanese text indicates that the
printing was done by Uemura Masuo and the Takamizawa workshop, suggesting
that Uemura, who had been an employee of Takamizawa before the war, still
had connections with the company. Prints measure ca. 24 × 18 cm. Price for 1 set
was 100 yen.
 Maekawa Senpan: *Maiko—A Young Geisha; Ōharame—Maid from Ōhara;
 Star Festival*
 Onchi Kōshirō: *After the Bath; Cherry Blossom Time*
 Kawanishi Hide: *Bar Girl of a Port Town*
 Sekino Jun'ichirō: *Home Life in Winter; Maid of Northern Japan*
 Saitō Kiyoshi: *Girls Trimming Colt's Foot; Peddler*

1947 *Twelve Views of Japan (Nihon jūni fūkei)*
The series, published by Unsōdō in Kyoto, consists of 2 prints each by Gotō
Sadanosuke, Isoda Mataichirō, Kawai Kenji, Mizuno Shinsō, Okumura Kōichi,
and Nishiyama Hideo. Carvers were Nagashima Michio and Shibamura Shin-
'nosuke; printer was Shinmi Saburō.

1948 *Twelve Views of Kyoto (Kyoto jūnikei)*
This series, published by Unsōdō in Kyoto, probably has 2 prints by each of the
same artists as *Twelve Views of Japan*.

1955 *Flowers (Hana)*
This is a total of 30 self-carved prints in 3 folios, 1 folio each by Tokuriki Tomiki-
chirō, Kamei Tōbei, and Kotozuka Eichi.

Selected Signatures and Seals

THE SIGNATURE on a modern Japanese print may indicate the family name of the artist, a given name, some part of a name, or an art name. The seal may be any of these, a studio name, or the publisher. Signatures are ordinarily in *kanji*, Chinese characters used in Japanese writing, although they may be in *kana*, the Japanese syllabary, or, in cases of Western-oriented artists, in Western script. Names may read from top to bottom, from left to right, or from right to left. Signatures may be carved in the block or written in Western fashion in the bottom margin. Seals are traditionally stamped in red ink, but for prints they may be carved in the block. As this selection of photographs and facsimiles shows, artists frequently indulge in creative liberties with their signatures and seals. In the listing of signatures and seals a question mark indicates that we have not deciphered the seal.

Various words preceding or following a name indicate the role of the person named:

e: picture. Indicates the artist.

ga: picture. Indicates the artist.

han: printing plate. Indicates the publisher.

hanken shoyū: copyright owner.

hanmoto: publisher.

hitsu: brush. Indicates the artist.

hori: carved. This often precedes the name of an artisan carver.

in: seal. May indicate either artist or publisher.

kō: workshop. Indicates the publisher.

saku: made. May indicate either artist or publisher.

suri: printed. This often precedes the name of an artisan printer. It is also sometimes found after the name of the artist on *sōsaku-hanga* prints.

tō: knife. Indicates the carver. This is sometimes found after the name of the artist on *sōsaku-hanga* prints.

Artists

1. Akamatsu Rinsaku. Seal: Akamatsu Rinsaku.

2. Asahi Masahide. Seal: Asahi.

3. Asano Takeji. Signature: T. Asano.

4. Asano Takeji. Signature: Takeji *tō*.

5. Asano Takeji. Signature: Takeji *ga*.

6. Asano Takeji. Signature: T.A.

7. Azechi Umetarō. Seal: U.

8. Azechi Umetarō. Signature: Azechi Umetarō.

9. Azechi Umetarō. Seal: U (stylized).

10. Azechi Umetarō. Seal: Ume.

11. Bitō. Signature: Bitō (or Mitō) *ga*. Seal: Satō Shōtarō *han*.

12. Daigō. Signature: Possibly Daigō (or Taigō) *ga*. Seal: Daigō *in*.

13. Dōmoto Inshō. Signature: Inshō. Seal: Inshō.

14. Ebata Yōichi. Signature: Yō. Eba.

15. Eijirō. Seal: Eijirō.

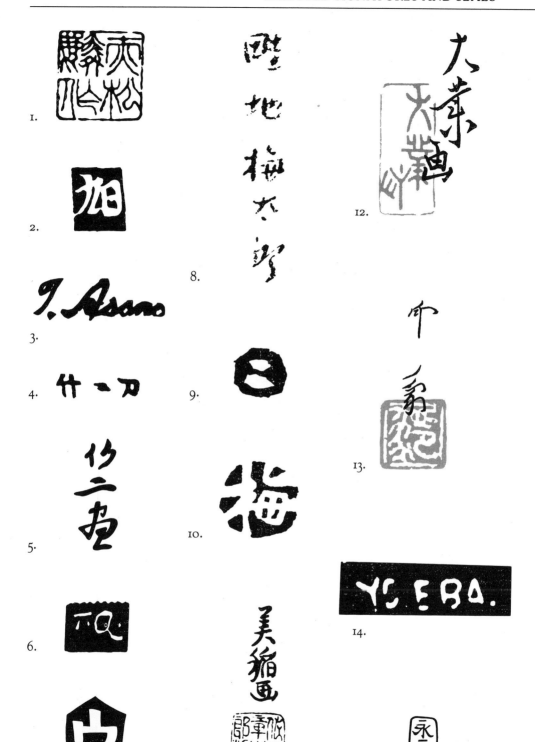

16. Endō Kyōzō. Signature: Kyōzō. Seal: Kyōzō *ga*.

17. Fujimori Shizuo. Seal: Shizu.

18. Fujimori Shizuo. Seal: Siz.

19. Fujimori Shizuo. Signature: S. Fudimori. Seal: Shizu.

20. Fujita Tsuguharu. Signature: Tsuguharu Foujita.

21. Fukazawa Sakuichi. Seal: Saku.

22. Furukawa Ryūsei. Seal: Ryū.

23. Furukawa Ryūsei. Signature: Ryūsei.

24. Hashiguchi Goyō. Signature: Goyō *ga*. Seal: Hashiguchi Goyō.

25. Hashiguchi Goyō. Signature: Goyō *ga*. Seal: Goyō.

26. Hashiguchi Goyō. Signature: Goyō *ga*. Seal: Go (five) with a leaf.

27. Hashimoto Okiie. Seal: Hashi.

28. Hata Tsuneharu. Seal: Hata.

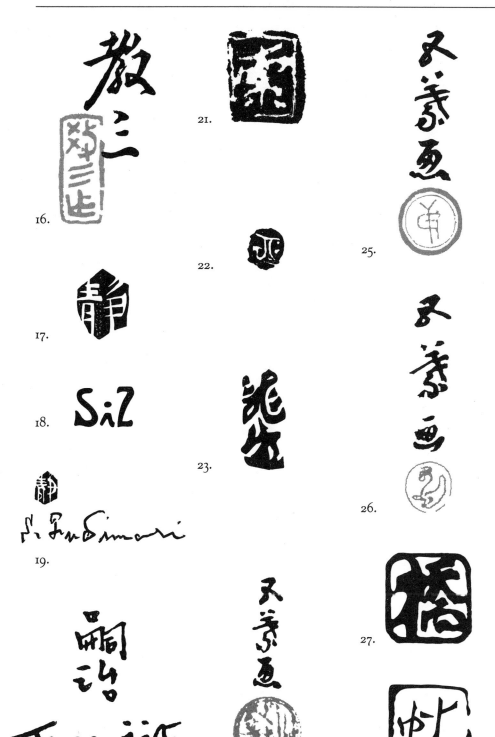

16.

17.

18.

19.

20.

21.

22.

23.

24.

25.

26.

27.

28.

29. Hatsuyama Shigeru. Signature: Shigeru. Seal: Shigeru.

30. Hirakawa Seizō. Seal: H.S.

31. Hirano Hakuhō. Signature: Hakuhō *ga*. Seal: Haku.

32. Hirano Hakuhō. Signature: Hakuhō *ga*. Seal: Hirano.

33. Hiratsuka Un'ichi. Seal: Un.

34. Hiratsuka Un'ichi. Seal: UN.

35. Hiratsuka Un'ichi. Seal: Un'ichi *in*.

36. Hiratsuka Un'ichi. Signature: Hiratsuka Un'ichi.

37. Hiratsuka Un'ichi. Seal: Un Hiratsuka.

38. Hisaizumi Kyōzō. Signature: Kyōzō. Seal: Kyōzō.

39. Hodō. Signature: Hodō. Seal: Takemura (publisher).

40. Hōtei. Signature: Hōtei. Seal: Hōtei.

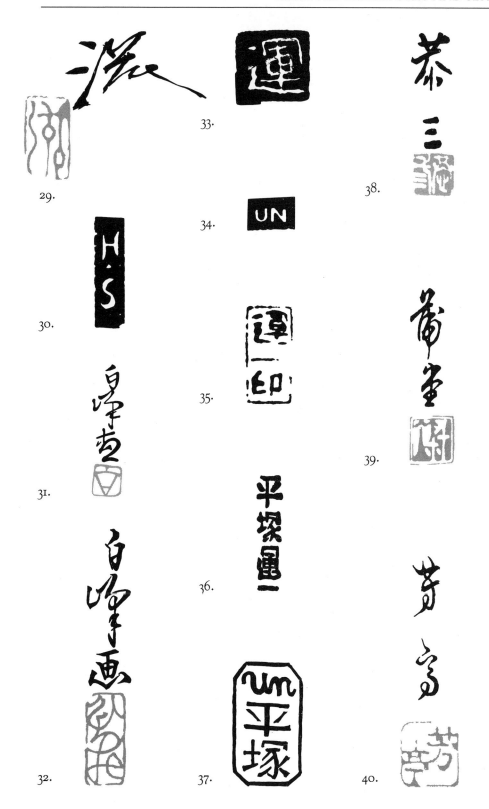

29.

30.

31.

32.

33.

34.

35.

36.

37.

38.

39.

40.

41. Ide Gakusui. Signature: Gakusui. Seal: Gakusui.

42. Inuzuka Taisui. Signature: Taisui. Seal: Inuzuka.

43. Ishii Hakutei. Signature: Hakutei. Seal: Bonkotsu *tō*.

44. Ishii Hakutei. Seal: Haku.

45. Ishii Tsuruzō. Signature: TU.

46. Ishii Tsuruzō. Signature: Tsuruzō *ga*.

47. Ishii Tsuruzō. Seal: T.

48. Ishikawa Toraji. Signature: Ishikawa. Seal: Tora.

49. Ishiwata Kōitsu. Seal: Kōitsu.

50. Isoda Mataichirō. Signature: Mataichirō *hitsu*.

51. Itō Shinsui. Signature: Shinsui. Seal: Tatsumi.

52. Itō Shinsui. Signature: Shinsui *ga*. Seal: Shinsui.

53. Itō Shinsui. Signature: Shinsui (reading from right to left).

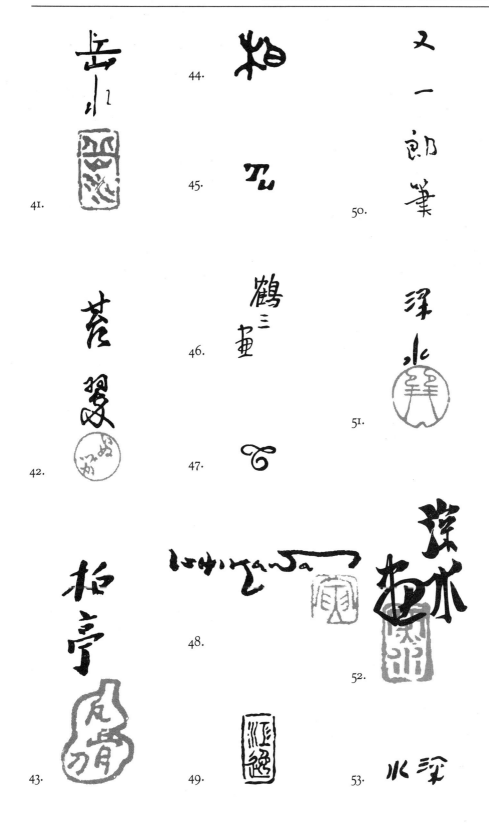

41.

42.

43.

44.

45.

46.

47.

48.

49.

50.

51.

52.

53.

54. Itō Shinsui. Signature: Shinsui *ga*. Seal: Itō.

55. Itō Sōzan. Signature: Sōzan. Seals: Sō and Zan.

56. Itō Takashi. Signature: Takashi. Seal: Takashi.

57. Itō Yūhan. Signature: Yūhan.

58. Jō. Signature: Jō *e*. Seal: Jō *in*.

59. Kaburagi Kiyokata. Signature: Kiyokata. Seal: Kiyokata.

60. Kajita Hanko. Signature: Hanko. Seal: Hanko.

61. Kajita Hanko. Signature: Hanko. Seal: Hanko.

62. Kakō. Signature: Possibly Kakō. Seal: Kakō.

63. Kamei Tōbei. Signature: Tō. Seal: *Jikoku* (self-carved).

64. Kamei Tōbei. Seal: Kame.

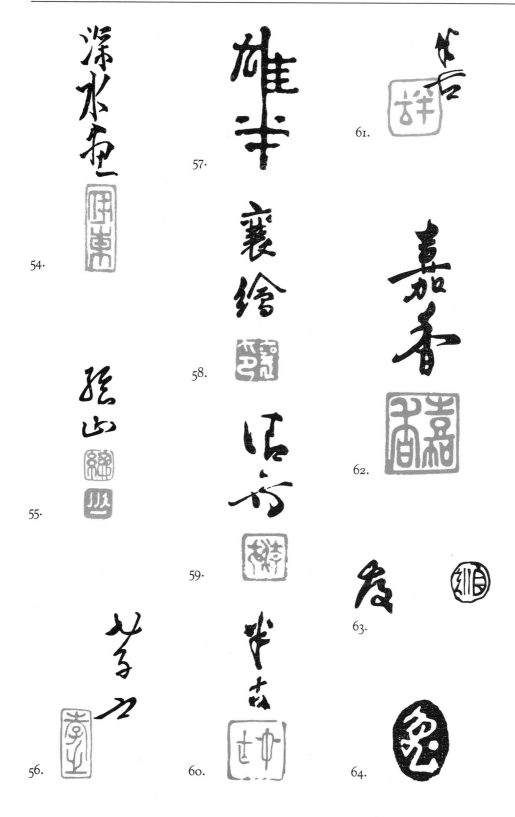

65. Kanō Kōga. Signature: Kōga. Seal: Kōga *saku*.

66. Kasamatsu Shirō. Signature: Shirō. Seal: Shirō *saku*.

67. Kasamatsu Shirō. Seal: Kasamatsu.

68. Katsuhira Tokushi. Seal: Toku.

69. Katsuki Sadao. Signature: Katu.

70. Kawai Gyokudō. Signature: Gyokudō. Seal: Gyokudō.

71. Kawakami Sumio. Seal: Sumio.

72. Kawakami Sumio. Seal: SK.

73. Kawakami Sumio. Seal: Sumi.

74. Kawakami Sumio. Seal: Sumi.

75. Kawakami Sumio. Seal: Sumi.

76. Kawakami Sumio. Seal: Sumio.

77. Kawakami Sumio. Signature: Sumi.

78. Kawanishi Hide. Signature: Hide. Seal: Hide.

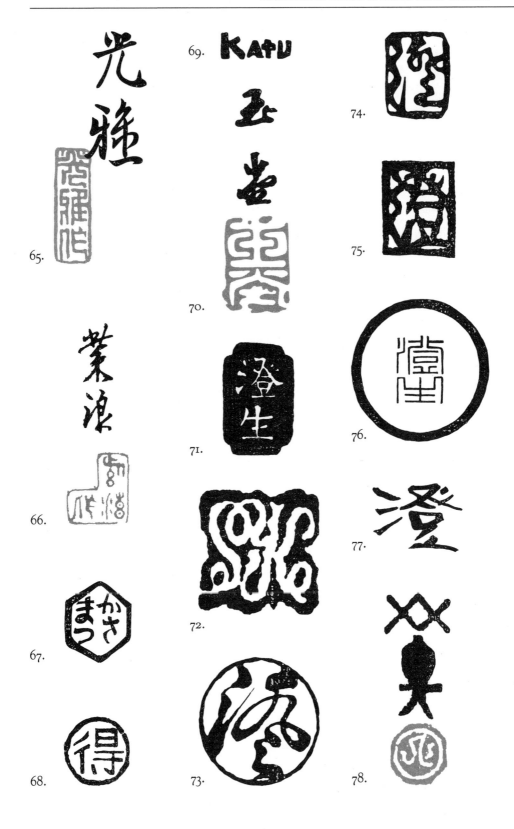

79. Kawase Hasui. Signature: Hasui. Seal: Sui.

80. Kawase Hasui. Signature: Hasui. Seal: Kawase.

81. Kawase Hasui. Signature: Hasui. Seal: Sui.

82. Kikuchi Zenjirō. Signature: Zen.

83. Kishida Ryūsei. Seal: Ryūsei.

84. Kitano Tsunetomi. Signature: Tsunetomi *hitsu.*

85. Kiyohara Hitoshi. Seal: Hitoshi.

86. Kiyohara Hitoshi. Signature: Hitoshi. Seal: Hitoshi.

87. Kobayakawa Kiyoshi. Signature: Kiyoshi. Seal: Kobayakawa.

88. Kobayashi Kiyochika. Signature: Kiyochika. Seals: Kiyo and Chika.

89. Kobayashi Kiyochika. Seal: Kiyochika.

90. Kōhō. Signature: Kōhō.

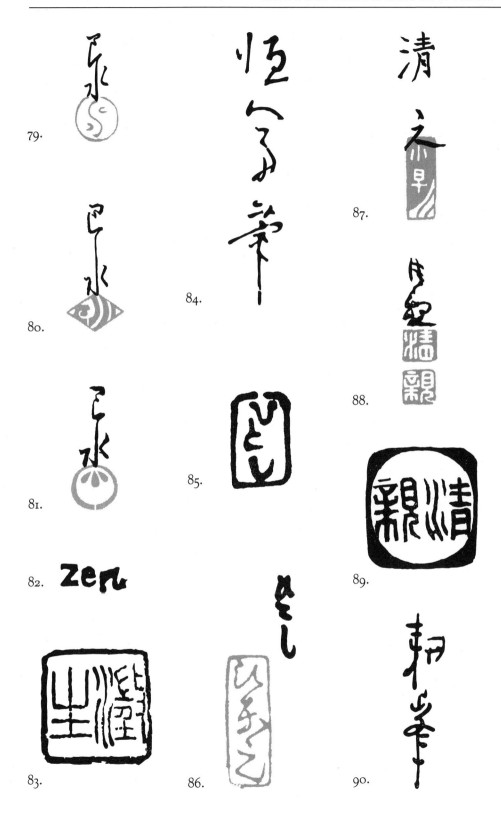

79.

80.

81.

82.

83.

84.

85.

86.

87.

88.

89.

90.

91. Koizumi Kishio. Signature: Izumi.

92. Komura Settai. Seal: Settai.

93. Kōsetsu. Signature: Kōsetsu. Seal: Satō *han*.

94. Kosugi Misei. Seal: Shikyō Enka (one of his *gō*).

95. Kotozuka Eiichi. Upper seal: Koto. Lower seal: Uchida *han* (publisher).

96. Maeda Masao. Seal: Masa.

97. Maeda Masao. Seal: Masa.

98. Maeda Masao. Signature: Maeda Masao.

99. Maekawa Senpan. Signature: Sen.

100. Maekawa Senpan. Signature: Maekawa Senpan.

101. Maekawa Senpan. Signature: Pan.

102. Maekawa Senpan. Seal: Senpan.

103. Maki Haku. Seal: Maki Haku.

104. Matsubara Naoko. Seal: Matsubara Naoko.

105. Takeuchi Keishū. Seal: Keishū.

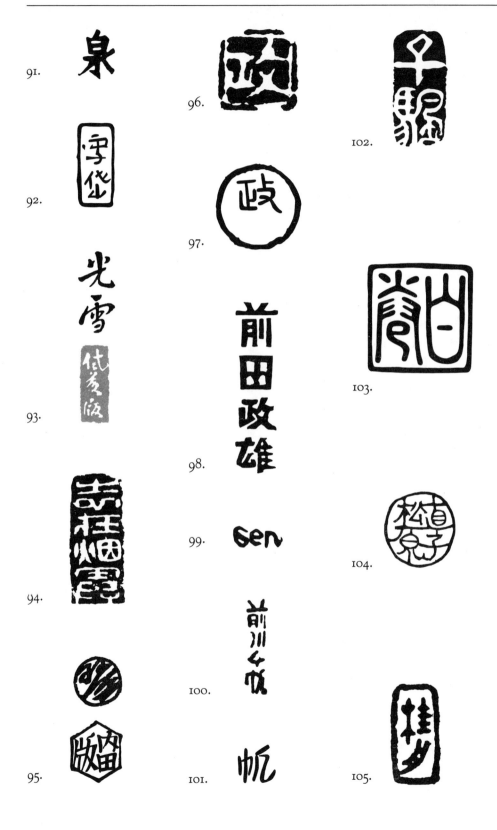

106. Matsuoka Eikyū. Signature: Eikyū. Seal: Eikyu *in*.

107. Miki Suizan. Signature: Suizan.

108. Mizushima Nihofu. Signature: Nihofu. Seal: Nihofu.

109. Mori Yoshitoshi. Seal: Yoshitoshi.

110. Mori Yoshitoshi. Seal: Yoshi.

111. Morita Tsunetomo. Seal: M.

112. Munakata Shikō. Seal: Kegon.

113. Munakata Shikō. Seal: Hōgan Munakata Shikō.

114. Mutō Kan'ichi. Seal: Kan.

115. Nagai Hyōsai. Seal: Hyō.

116. Nakagawa Isaku. Seal: Nakagawa.

117. Nakagawa Yūtarō. Signature: Yut.

118. Nakazawa Hiromitsu. Seal: Hiro.

119. Nakazawa Hiromitsu. Seal: Hiro.

120. Narazaki Eishō. Signature: Eishō.

121. Natori Shunsen. Signature: Shunsen *ga*. Seal: flower pattern.

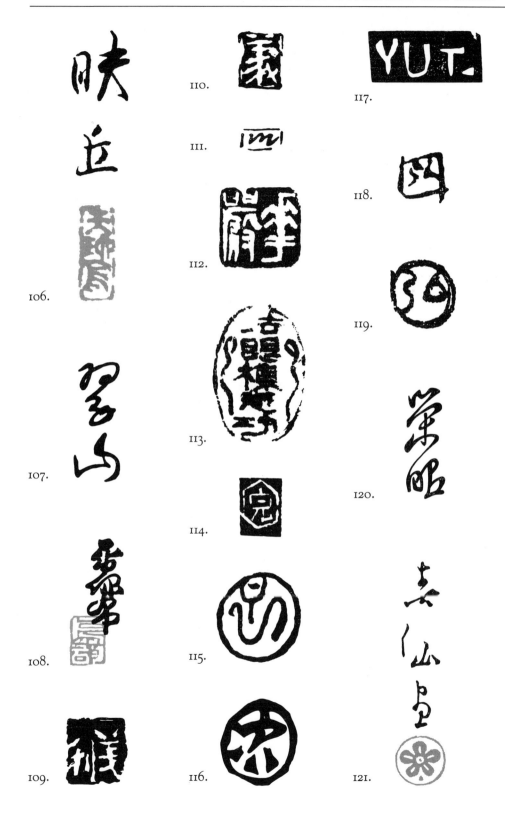

106.

107.

108.

109.

110.

111.

112.

113.

114.

115.

116.

117.

118.

119.

120.

121.

122. Natori Shunsen. Signature: Shunsen. Seal: Natori.

123. Natori Shunsen. Signature: Shunsen. Seal: Shunsen.

124. Natori Shunsen. Signature: Shunsen *ga*. Seal: leaf pattern.

125. Natori Shunsen. Signature: Shunsen *ga*. Seals: Shun and Sen.

126. Natori Shunsen. Signature: Shunsen. Seal: Shunsen.

127. Natori Shunsen. Signature: Shunsen. Seal: Natori.

128. Natori Shunsen. Seal: Natori.

129. Natori Shunsen. Signature: Shunsen. Seal: Kajichō.

130. Natori Shunsen. Signature: Shunsen *ga*. Seal: Taishidō.

131. Nishihara Hiroshi. Signature: Hiroshi. Seal: Hiroshi/child.

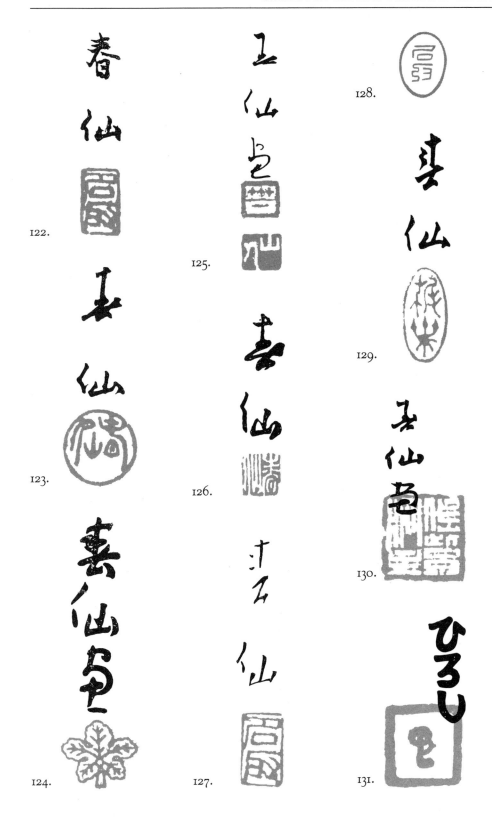

122.

123.

124.

125.

126.

127.

128.

129.

130.

131.

132. Nishimura Goun. Signature: Goun *saku*. Seal: Goun.

133. Noda Kyūho. Signature: Kyūho. Seal: Kyūho.

134. Nomura Toshihiko. Signature: Nomura Toshihiko.

135. Nomura Toshihiko. Seal: Toshihiko.

136. Nomura Yoshimitsu. Signature: Yoshimitsu. Seal: Satō Shō *han*.

137. Nomura Yoshimitsu. Signature: Yoshimitsu. Seal: Sankōkai.

138. Oda Kazuma. Seal: Kazuma.

139. Oda Kazuma. Signature: Kazuma *hitsu*. Seal: Oda.

140. Ogata Gekkō. Signature: Gekkō. Seal: Gekkō.

141. Ohara Hōson. Signature: Hōson. Seal: Hōson.

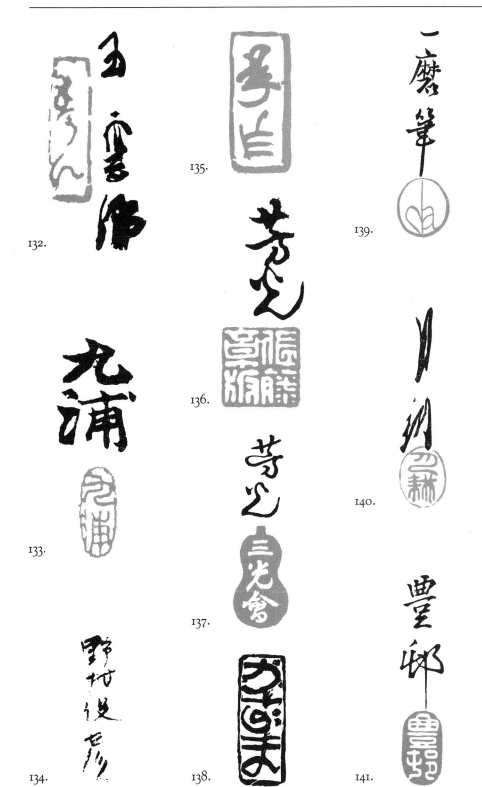

132.

133.

134.

135.

136.

137.

138.

139.

140.

141.

142. Ohara Koson. Signature: Koson. Seal: Koson.

143. Ohara Koson. Signature: Koson. Seal: Koson.

144. Ohara Koson. Signature: Koson. Seal: Koson.

145. Ohara Shōson. Signature: Shōson. Seal: Shōson.

146. Okamura Kichiemon. Seal: ?

147. Okuda Teruichirō. Signature: TERU.

148. Okuyama Gihachirō. Seal: Gi.

149. Okuyama Gihachirō. Signature: Gihachirō. Seal: Okuyama.

150. Omura Kōyō. Signature: Kōyō. Upper seal: ? Lower seal: Shinagawa (a printer or proprietor at Kyoto Hanga-in).

151. Onchi Kōshirō. Seal: K.

152. Onchi Kōshirō. Signature: K. Onzi.

153. Onchi Kōshirō. Signature: K. Onchi.

154. Onchi Kōshirō. Signature: Kō.

155. Ōno Bakufū. Seal: Bakufū.

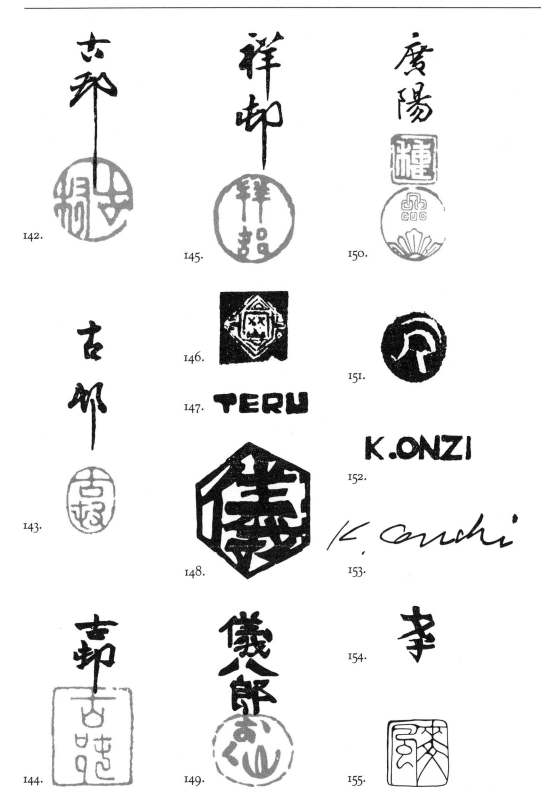

142.

145.

150.

146.

147. TERU

151.

152. K.ONZI

153. K. ouchi

143.

148.

154.

144.

149.

155.

156. Ōno Bakufū. Signature: Bakufū. B. Ohno.

157. Ryōji Chōmei. Seal: Ryōji *in*.

158. Ryōkō or possibly Ayaoka.

159. Saitō Kiyoshi. Seal: Kiyoshi.

160. Saitō Kiyoshi. Seal: Kiyoshi.

161. Saitō Kiyoshi. Seal: Kiyoshi.

162. Sasajima Kihei. Seal: Ki.

163. Seichō. Signature: Seichō. Seal: Seichō.

164. Seiko. Signature: Seiko.

165. Sekino Jun'ichirō. Seal: Jun.

166. Sekino Jun'ichirō. Seal: Sekino.

167. Shimozawa Kihachirō. Seal: Hachi.

168. Shūhō. Signature: Shūhō. Seal: Possibly Jindō.

169. Suwa Kanenori. Seal: S.

170. Takahashi Hiroaki. Signature: Hiroaki. Seal: Shōtei.

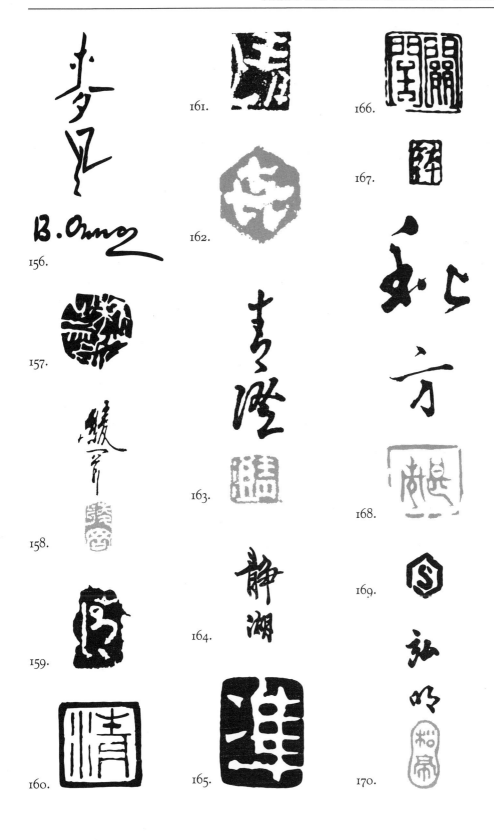

156.

157.

158.

159.

160.

161.

162.

163.

164.

165.

166.

167.

168.

169.

170.

171. Takahashi Hiroaki. Signature: Hiroaki. Seal: Hiroaki *saku.*

172. Takahashi Hiroaki. Seal: Hiroaki.

173. Takahashi Hiroaki. Signature: Hiroaki *saku.* Seal: Hiroaki.

174. Takeda Shintarō. Signature: Shin.

175. Takehisa Yumeji. Seal: Shūjin yama iku.

176. Takehisa Yumeji. Signature: Yumeji. Seal: Take.

177. Takehisa Yumeji. Seal: Take.

178. Takehisa Yumeji. Seal: Pattern.

179. Takeuchi Seihō. Signature: Seihō. Seal: Seihō.

180. Takeuchi Seihō. Seal: Seihō.

181. Takeuchi Seihō. Signature: Seihō. Seal: Seihō.

182. Takeuchi Seihō. Signature: Seihō *saku.* Seal: Kachūan.

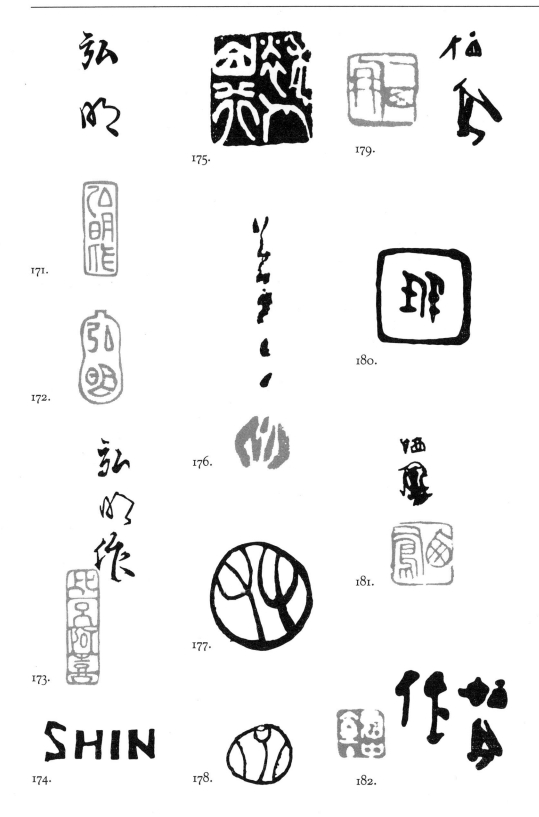

171.

172.

173.

174.

175.

176.

177.

178.

179.

180.

181.

182.

183. Tamamura Hokuto. Signature: Hokuto *saku*. Seal: Hokuto.

184. Tanaka Hisara. Seal: Hi.

185. Taniguchi Kōkyo. Signature: Kōkyo *ga*. Upper seal: Kōkyo *in*. Lower seal: Satō Shō *han*.

186. Tobari Kogan. Signature: Kogan. Seal: Kogan.

187. Tobari Kogan. Seal: Kogan.

188. Tōkō. Signature: Tōkō. Seal: Shō.

189. Tokuriki Tomikichirō. Signature: Tomikichirō *saku*. Seal: *Kiwame* (former censor seal).

190. Torii Kotondo. Seal: Kotondo.

191. Torii Kotondo. Signature: Kotondo *ga*. Seal: Kotondo.

192. Torii Kotondo. Seal: Torii.

193. Torii Tadamasa. Signature: Tadamasa. Seal: Tadamasa.

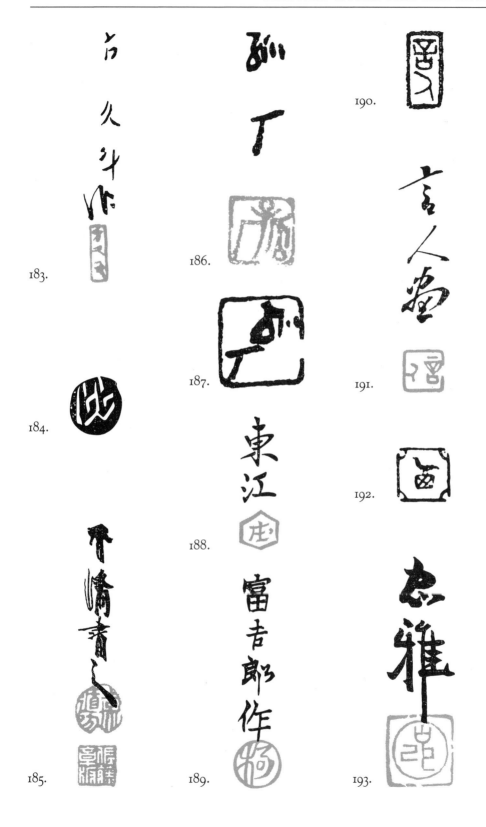

183.

184.

185.

186.

187.

188.

189.

190.

191.

192.

193.

194. Torii Tadamasa. Signature: Torii Tadamasa. Seal: Torii Rairyū.

195. Tsuchiya Kōitsu. Seal: *Shinsei* (genuine) Kōitsu.

196. Tsuchiya Kōitsu. Signature: Kōitsu. Seal: *Shin* (true).

197. Tsuchiya Kōitsu. Seal: *Shinsei* (genuine).

198. Tsuchiya Rakuzan. Signature: Rakuzan Kōshisei. Seal: ?

199. Tsuchiya Rakuzan. Upper seal: Kō *in*. Lower seal: Rakuzan.

200. Tsukioka Gyokusei. Signature: Gyokusei. Seal: Tsukioka.

201. Tsukioka Kōgyo. Signature: Kōgyo. Seal: Bokuun.

202. Tsuruta Gorō. Signature: Gorō.

203. Tsuruya Kōkei. Seal: Tsuruya Kōkei.

204. Tsuyahisa. Signature: Possibly Tsuyahisa or Toyohisa.

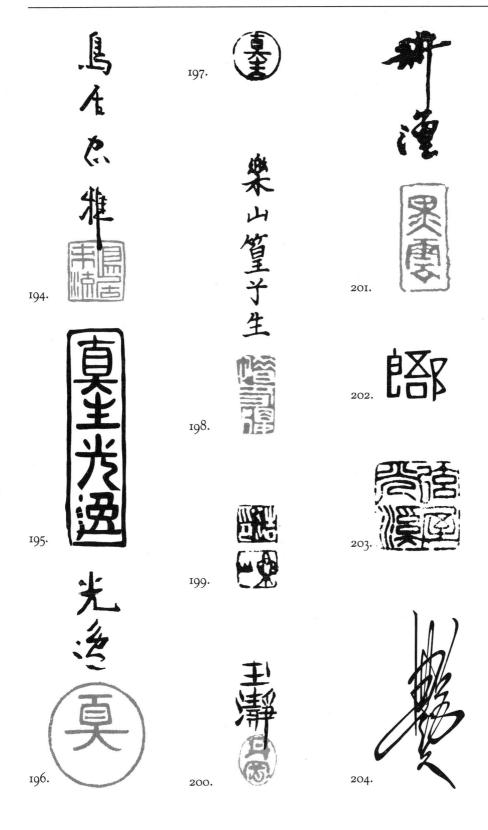

194.

195.

196.

197.

198.

199.

200.

201.

202.

203.

204.

205. Urushibara Mokuchū. Seal: Urushibara.

206. Urushibara Mokuchū. Seal: Mokuchū *han*.

207. Urushibara Mokuchū. Signature: Urushibara *ga*. Seal: Mokuchū.

208. Yamaguchi Gen. Seal: G.

209. Yamaguchi Ryōshū. Seal: Ryōshū.

210. Yamaguchi Susumu. Seal: Yamaguchi.

211. Yamakawa Shūhō. Signature: Shūhō. Seal: leaf pattern.

212. Yamamoto Kanae. Seal: Kanae.

213. Yamamoto Kanae. Seal: Kanae.

214. Yamamoto Shōun. Signature: Shōun. Seal: Shōun.

215. Yamamura Kōka. Signature: Kōka. Seal: Toyonari.

216. Yamamura Kōka. Signature: Kōka *ga*.

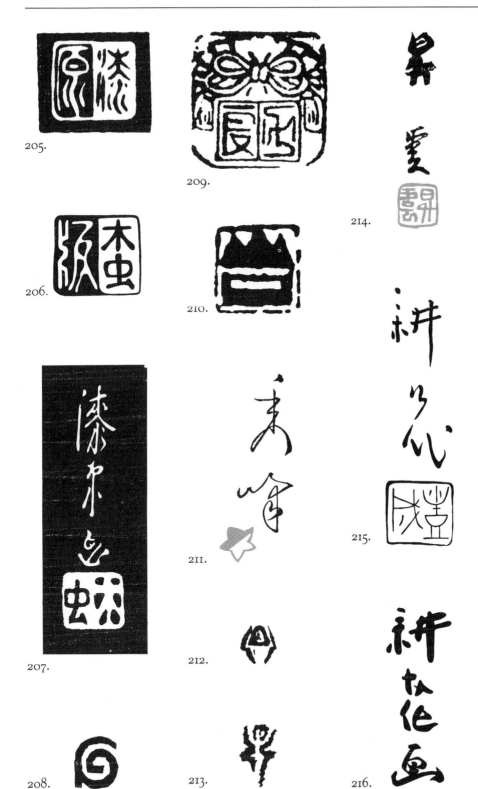

205.

206.

207.

208.

209.

210.

211.

212.

213.

214.

215.

216.

217. Yamamura Toyonari. Signature: Toyonari *ga*. Seal: Taisei.

218. Yamamura Toyonari. Signature: Toyonari *e*.

219. Yamamura Toyonari. Seal: Toyonari.

220. Yamaoka Beika. Signature: Beika. Seal: ?

221. Yasuda Hanpo. Signature: Hanpo. Seal: Hanpo *no in*.

222. Yorozu Tetsugorō. Seal: Tetsu.

223. Yoshida Fujio. Signature: Fujio. Upper seal: Fuji. Lower seal: O.

224. Yoshida Hiroshi. Signature: Yoshida. Seal: flower pattern.

225. Yoshida Hiroshi. Signature: Yoshida. Seal: flower pattern.

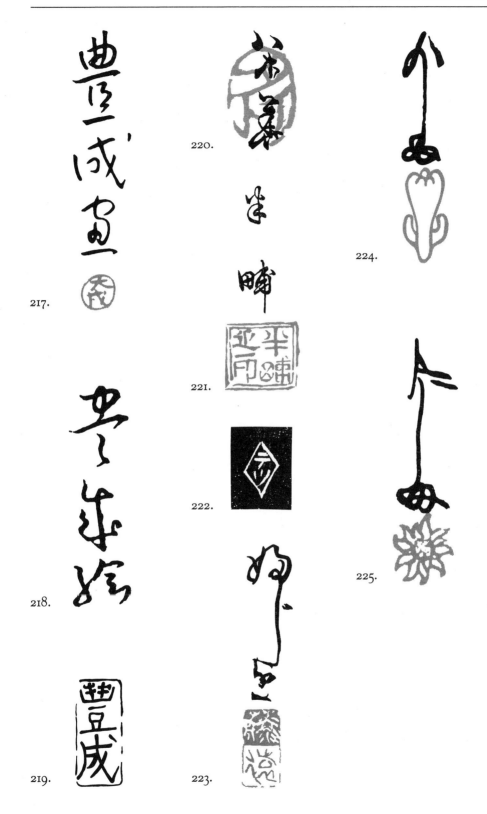

217.

218.

219.

220.

221.

222.

223.

224.

225.

226. Yoshida Hiroshi. Signature: Yoshida. Seal: Hiroshi.

227. Yoshida Masao. Signature: MAS.

228. Yoshida Tōshi. Signature: Tōshi. Seal: Yoshida Tōshi.

229. Yoshida Tōshi. Seal: Tōshi.

230. Yoshida Tōshi. Seal: Yoshida.

231. Yoshida Tōshi. Signature: Tōshi. Seal: Yoshida.

232. Yoshikawa Kanpō. Signature: Kanpō. Seal: Satō Shō *han*.

233. Yōshun. Seal: Possibly Yōshun.

Publishers

234. Doi Teiichi. Seal: *Hanken shoyū* (copyright owned by) Doi Teiichi.

235. Fusui Gabō. Seal: *Hanken shoyū* Fusui Gabō *hakkō*.

236. Katō Junji. Seal: *Hanmoto* Katō Junji.

237. Nishinomiya Yosaku: Signature: Nishinomiya Yosaku.

238. Satō Shōtarō. Seal: Satō Shō *han*.

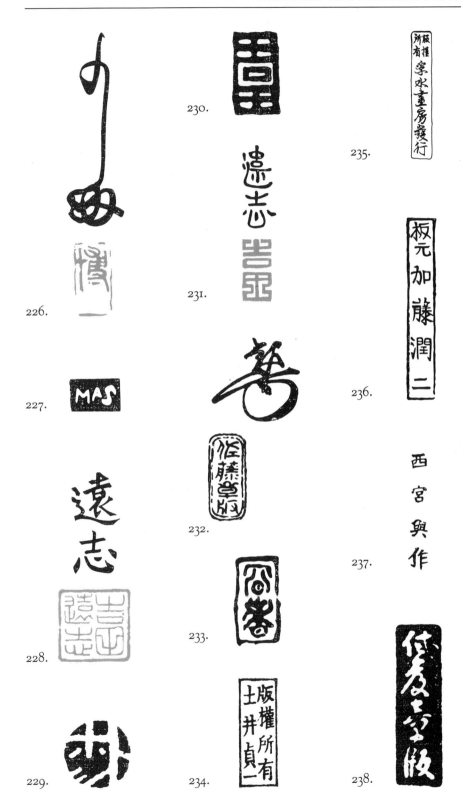

226.

227.

228.

229.

230.

231.

232.

233.

234.

235.

236.

237.

238.

239. Satō Shōtarō. Seal: Satō *han*.

240. Satō Shōtarō. Seal: Satō *kō*.

241. Satō Shōtarō. Seal: Satō Shō *han*.

242. Satō Shōtarō. Seal: Satō Shō *han*.

243. Shin Yamato-e Moku-hanga Kankōkai. Seal: Shin Yamato-e Moku-hanga Kankōkai.

244. Takamizawa. Seal: Adapted from the actor's seal of Uemura Kichizaburō.

245. Uchida. Seal: *Hanmoto* Uchida.

246. Uchida. Seal: Uchida *han*.

247. Uchida. Signature: Uchida Bijutsu Shoshi (art/book shop) *han*.

248. Unsōdō. Seal: *Gōmei gaisha* (mutually owned) Unsōdō *han*.

249. Watanabe Shōzaburō. Seal: Watanabe.

250. Watanabe Shōzaburō. Seal: Watanabe *ko*.

251. Watanabe Shōzaburō. Seal: Watanabe.

252. Watanabe Shōzaburō. Hanmoto Watanabe Hanga Ten (shop).

Sample Seals of Carvers and Printers

253. Small twin seals of carver and printer are often seen together. Top character, right seal: *hori* (carver) followed by the carver's name. Top character, left seal: *suri* (printer) followed by the printer's name.

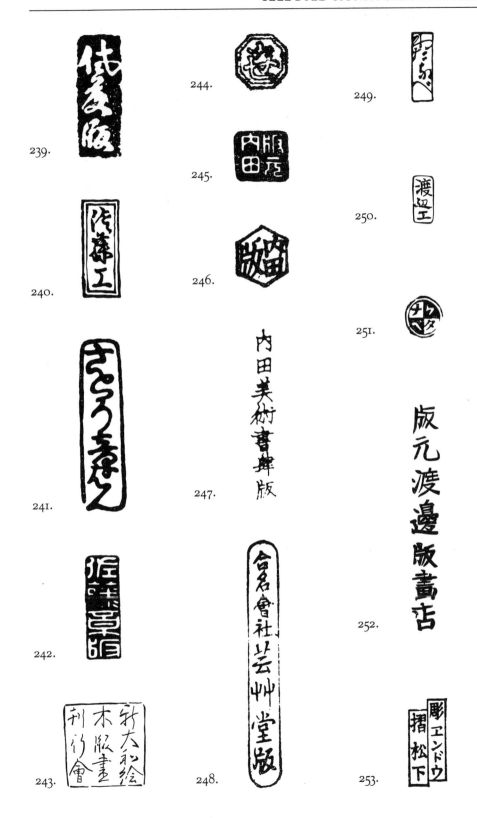

239.

240.

241.

242.

243.

244.

245.

246.

247.

248.

249.

250.

251.

252.

253.

254. Igami Bonkotsu. Seal: Bonkotsu *tō*.

255. Self-printed. Seal: *Jizuri* applied to the margin of Yoshida Hiroshi prints when he personally supervised the printing.

Sample Dates

256. Taishō *kyūnen hachigatsu*. Taishō period (1912–1926), ninth year, eighth month; August 1920. (Since each of these eras started with the reign of a new emperor, rather than on January 1, the first year of an era is counted with the previous period.)

257. Taishō *rokunen shichigatsu*. Reading from right to left: Taishō, sixth year, seventh month; July 1917.

258. Shōwa *kyūnen sangatsu saku*. Made in Shōwa (1926–1989), ninth year, third month; March 1934.

254.

255. 摺自

256. 大正九年 八月

257. 月七 年九正大

258. 昭和九年三月作

Chronology of Important Events

COMPLETE NAMES OF EXHIBITIONS are given in Chapter 3.

1900　January. Exhibition of Hokusai prints to commemorate fiftieth anniversary of the artist's death. The exhibition drew few people and attracted little attention.

Most illustrations in publications were reproduced by lithography or other Western technology. While Western-style wood engraving was widely used for reproducing Western-style illustrations, traditional woodblock printing persisted for reproduction of Japanese-style paintings. At the same time Western-oriented artists were dreaming of using woodblocks creatively to express their own ideas.

1902　January. An article in Myōjō by Ishii Hakutei was illustrated by woodblocks carved by Igami Bonkotsu.

1903　Publication of woodblock-printed pattern books by the Unsōdō company for textile designers and other craftsmen.

1904　January. A special issue of the magazine Bungakukai (Literature Society) on the customs of Tokyo had a mokuhan cover by Yūki Somei and frontispiece by Kaburagi Kiyokata.

July. The magazine Myōjō (Morning Star) published Yamamoto Kanae's self-designed, self-carved print Fisherman with explanatory notes by Ishii Hakutei. The publication of this print marks the beginning of the sosaku-hanga movement.

Woodblock triptychs and other prints illustrated life at the front in the Russo-Japanese War, but these were much less popular than such prints had been 10 years earlier in the Sino-Japanese War.

The socialist newspaper Heimen shinbun published mokuhan antiwar prints.

Multicolor woodblock illustrations for serialized novels were popular as supplements in newspapers and frontispieces. These continued until ca. 1930.

1905　May. Kōfū, the magazine of Hakubakai, began publication with a mokuhan frontispiece in each issue.

September. The *dōjin* magazine *Heitan* began publication. Featured self-designed, self-carved prints by Yamamoto Kanae, Ishii Tsuruzō, and others. Continued until April 1906.

The publishing company Shinbi Shoin made many fine color woodcut reproductions of paintings between 1905 and 1915.

Termination of Inten as the yearly exhibition of Nihon Bijutsuin, the school established by Okakura Tenshin. See 1914 for later activities of Inten.

1907 February. Yamamoto Kanae's article "Prints as Comfort" (Han no nagusame) began serialized publication in the magazine *Mizue*.

May. *Hōsun* began publication with self-designed woodcuts, wood engravings, lithographs, and metal-plate prints by Yamamoto Kanae, Morita Tsunetomo, Ishii Hakutei, and others. The prints were mechanically reproduced in the magazine. Continued until July 1911.

October. Bunten was established. Exhibitions continued until 1919.

Watanabe Shōzaburō began publication of prints by Takahashi Shōtei for export.

1908 December. Pan no Kai was founded as a social group of writers and artists interested in reviving the *ukiyo-e* spirit of Edo and combining it with the café spirit of Montmartre. Members from the *Hōsun* group included Yamamoto Kanae, Morita Tsunetomo, and Ishii Hakutei. Pan no Kai continued until 1911.

1909 December. Publication of *Yumeji Picture Collection Spring Volume (Yumeji gashū haru no maki)* by Takehisa Yumeji. Volumes for the other seasons followed in 1910.

December. Publication of *Hōsun* picture calendar with lithograph illustrations and a woodblock cover.

Ishii Hakutei's article on *sōsaku-hanga* published in *Encyclopedia of Art and Literature*.

1910 January. *Ukiyo-e* magazine *Konohana* (This Flower) published in Osaka. Continued publication in Osaka until July 1912.

April. Magazine *Shirakaba* (White Birch) began publication. Continued until autumn 1923.

November. The first 2 prints of Ishii Hakutei's *Twelve Views of Tokyo* were issued; 7 more published between 1914 and 1916.

November. One issue and supplement of the *dōjin* magazine *Hakutō* (White Knife) published.

1911 February. Hashiguchi Goyō received first prize in a poster contest sponsored by Mitsukoshi Gofukuten, forerunner of Mitsukoshi Department Store. His winning design was in *ukiyo-e* style.

March. Hakubakai dissolved.

June. *Sōga butai sugata*, a set of 4 prints of modern actors appearing at the new Imperial Theater, published by Yamamoto Kanae and Sakamoto Hanjirō. Continued with 2 more sets in July and September.

Exhibition of *hanga* by Tomimoto Kenkichi and Minami Kunzō. They had begun making woodblocks after observing Europe's enthusiasm for *ukiyo-e*. This was probably the first exhibition of contemporary prints ever held in Japan.

Shirakaba sponsored an exhibition of 190 prints of contemporary or recent European printmakers.

1912 April. The magazine *Gendai no yōga* (Modern Western Art) began publication.

July. Yamamoto Kanae left for Europe.

October. *Konohana*, which had ceased publication in Osaka in July, began publication in Tokyo; continued until June 1914.

October. First Fyūzankai exhibition. Advertising poster was a woodcut designed by Saitō Yori and carved by Seimiya Hitoshi.

October. The *dōjin* magazine *Seihai* (Holy Chalice) began publication by a literary group at Waseda University. Continued to September 1913 when name changed to *Kamen*.

November. The *dōjin* magazine *Fyūzan* began publication. Continued until June 1913.

1913 March. Second and last Fyūzankai exhibition.

June. Seimiya Hitoshi's article "Mokuhan hō" (The Way of Mokuhan) published in *Gendai no yōga*.

September. *Kamen* (Masks) began publication. *Mokuhan* cover and hand-printed inserts. Continued until June 1915.

Exhibition sponsored by *Kamen* included *moku-hanga* by Hasegawa Kiyoshi and Nagase Yoshio.

16 November. Comments of many *sōsaku-hanga* artists appear in double-page article on *hanga* in Sunday supplement of Osaka *Asahi shinbun*.

1914 January. *Takujō* (On The Table), a publication with woodblocks by Tomimoto Kenkichi, was issued by the craft shop Tanakaya. Continued for 6 issues.

February. Magazine *Gendai no yōga* had a special issue on *hanga*.

March. Taishō exposition exhibited works by the carver Igami Bonkotsu and the wood engraver Sakurai Torakichi.

March. The German magazine *Der Sturm* sponsored an exhibition in Tokyo of contemporary prints by European artists.

May. *Geibi* (Art Beauty), an art and literary magazine, published by the art shop Mikasaya. Included prints by Tomimoto Kenkichi and Fujii Tatsukichi. Continued until October.

September. *Dōjin* magazine *Tsukubae*, under direction of Onchi Kōshirō, began publication. Continued for a total of 7 issues until November 1915.

October. Began distribution of *Shin Azuma Nishiki-e* (New Brocade Pictures of the East) by Tobari Kogan.

October. First Nikakai exhibition.

October. Inten reconstituted as the yearly exhibition of Reorganized Japan Fine Arts Academy (Saikō Nihon Bijutsuin).

November. *Tsukubae* group exhibition at Minatoya, the craft shop of Takehisa Yumeji.

1915 March. *Dōjin* magazine *Jukai* published. Probably only 1 issue.

June. Magazine *Ukiyo-e* began publication.

October. Magazine *Chūō bijutsu* (Art of the Center) began publication. Continued until July 1929.

October. Hashiguchi Goyō's print *Yuami* (Bathing) published by Watanabe Shōzaburō.

December. Posthumous exhibition of Tanaka Kyōkichi's works at Hibiya Hall, Tokyo, arranged by Onchi Kōshirō, Fujimori Shizuo, and Ōtsuki Kenji.

A *mokuhan* booklet, *Tomimoto Kenkichi moyō shū* (Collection of Tomimoto Kenkichi Patterns), published by Tanakaya craft shop.

1916 April. Tatsumi Gakai, a Japanese-style painters' society, added a *hanga* section to its annual exhibition.

June. Poetry and print magazine *Kanjō* launched by Onchi Kōshirō with Muroo Saisei and Hagiwara Sakutarō. Continued until 1919.

July. Collaboration between Itō Shinsui and Watanabe Shōzaburō began with publication of *Taikyō* (Before the Mirror).

July. Yamamoto Kanae visited Russia on his return trip to Japan from France via Siberia. Remained until November.

November. Hasegawa Kiyoshi, Nagase Yoshio, and Hiroshima Shintarō founded Nihon Hanga Kurabu (Japan Print Club). Held 1 exhibition only.

December. Yamamoto Kanae returned to Japan from Europe.

1917 January. *Japan Scenery Prints (Nihon fukei hanga)*, a total of 10 sets of 5 prints each by Hirafuku Hyakusui, Ishii Hakutei, Ishii Tsuruzō, Kosugi Misei, Morita Tsunetomo, and Sakamoto Hanjirō, published by Nakajima Jūtarō. Last set issued April 1920.

April. *Ukiyo-e* magazine *Nishiki-e* began publication. Continued until 1923.

May. Watanabe Shōzaburō began publication of *Eight Views of Lake Biwa (Ōmi hakkei)* by Itō Shinsui.

Publication of the poetry book *Barking at the Moon (Tsuki ni hoeru)* by Hagiwara Sakutarō with *hanga* illustrations designed by Tanaka Kyōkichi.

Ex Libris Lovers Society (Zōshohyō Aikōkai) founded.

Magazine *Modern Art (Gendai no bijutsu)* began publication.

1918 January. Kokuga Sōsaku Kyōkai (National Art Creative Association) founded by Tsuchida Bakusen and other painters.

June. Nihon Sōsaku-Hanga Kyōkai (Japan Creative Print Association) founded by Yamamoto Kanae, Tobari Kogan, Oda Kazuma, and Terasaki Takeo.

December. Hasegawa Kiyoshi left for France.

Collaboration began between Kawase Hasui and Watanabe Shōzaburō.

1919 January. First Nihon Sōsaku-Hanga Kyōkai exhibition. Continued annually (except for 1925 and 1926) through 1929.

March. Special issue of the magazine *Mizue* on *sōsaku-hanga* with an article "Moku-hanga ni tsuite ni san" (Some Points About Woodblock Prints) by Onchi Kōshirō.

March. Yamamoto Kanae started the farmers' art movement.

April. First children's free art movement exhibition organized by Yamamoto Kanae.

September. Teikoku Bijutsuin (Imperial Fine Art Academy) founded to choose the works of art to be shown at government exhibitions sponsored by the Ministry of Education. Directed by Mori Ōgai. The ministry-sponsored exhibition known as Bunten became Teiten. Teiten continued as an annual exhibition through 1934.

October. Yamamoto Kanae founded the school of the farmers' art movement.

1920 Summer. Watanabe Shōzaburō held the first *shin-hanga* exhibition at the gallery of Shirokiya department store.

September. Western-style painters withdrew from Inten.

September. Futurist Artists Association (Mirai-ha Bijutsu Kyōkai) founded.

September. Koizumi Kishio distributed *Shin Tokyo fūkei hanga* (Print Scenes of New Tokyo), 12 prints.

1921 June. Watanabe Shōzaburō held the second *shin-hanga* exhibition at the gallery of Shirokiya department store.

June. Art and literary magazine *Naizai* launched by Onchi Kōshirō, Fujimori Shizuo, and Ōtsuki Kenji.

October. Japan Ukiyo-e Society founded. Began publication of *Ukiyo-e no kenkyū* (Study of *Ukiyo-e*).

October. Posthumous exhibition of works of Hashiguchi Goyō.

November. *Dōjin* magazine *Hanga* (directed by Asahi Masahide, Oda Kazuma, Yamamoto Kanae, and Koizumi Kishio) began publication. Continued until April 1922.

Tokyo National Museum opened.

1922 January. Shun'yōkai founded by painters who withdrew from Inten and were joined by members of Sōdosha.

Dōjin magazine *Shi to hanga* (Poetry and Prints) began publication. Continued until July 1925.

Publication of *How to Make Prints (Sōsaku-Hanga to hanga no tsukurikata)* by Tobari Kogan.

Publication of *To People Who Want to Make Prints (Hanga o tsukuru hito e)* by Nagase Yoshio.

1923 May. Exhibition of Matsukata collection of *ukiyo-e* held in Tokyo.

July. MAVO group formed.

September. Fires following the Kantō earthquake destroyed the blocks and prints in Watanabe Shōzaburō's studio and the *ukiyo-e* collection of Kobayashi Bunshichi.

1924 February. Magazine *Atorie* (Atelier) began publication.

February. *Dōjin* magazine *HANGA* published by Yamaguchi Hisayoshi in Kobe. Continued until April 1930.

June. Tobari Kogan's article "Technique of Prints" (Hanga no gijutsu) published in *Chūō bijutsu*.

July. MAVO magazine began publication. Continued until August 1925.

October. Exhibition sponsored by *Shi to hanga*.

Publication of *How to Carve and Print Woodblocks (Moku-hanga no horikata to surikata)* by Koizumi Kishio.

1925 26 January. "Charm of Self-Carved Woodblock Prints" (Jikoku mokuhan no miryoku) by Takamura Kōtarō published in *Yomiuri shinbun*.

January. Special issue of *Mizue* on *hanga*.

June. *Dōjin* magazine *Shisaku* began publication in Okazaki. Continued until ca. May 1926.

June. *Dōjin* magazine *Satoporo* began publication. Continued until September 1929.

October. "Concerning Expression and Carving of Prints" (Hanga no chōtō to hyōgen ni tsuite) by Hiratsuka Un'ichi published in *Chūō bijutsu*.

Distribution of *Shunsen Portrait Collection* by Natori Shunsen begun by Watanabe Shōzaburō.

1926 January. *Dōjin* magazine *Dessin (Dessan)* began publication. Discontinued in June 1927 but resumed publication intermittently until 1951.

May. Tokyo Metropolitan Museum opened.

November. *Dōjin* magazine *Shijima* began publication in Okazaki. One issue only.

December. *Dōjin* magazine *Minato* began publication. Continued until July 1927.

The book *Eighteen Studies of Ukiyo-e (Ukiyo-e jūhachi kō)* by Oda Kazuma published.

1927 January. *Dōjin* magazine *Hanga*, led by Kimura Sōhachi, began publication. Perhaps only 1 issue.

January. *Dōjin* magazine *Mokuhan* began publication in Oita. Continued for 2 issues. Revived with 2 more issues between March 1929 and March 1930.

January. Special issue of *Atorie* on *sōsaku-hanga*.

October. Teiten began to accept prints in the Western-style painting section.

October. Name of *dōjin* magazine *Minato* changed to *Kaze*. *Kaze* continued until July 1928; resumed in April 1929; ceased publication in 1930.

Collection of Japanese Modern Creative Prints (Nihon gendai sōsaku-hanga taishū) published by Hasegawa Tsuneo of Nihon Hangasha.

Publication of *Technique of Hanga (Hanga no gihō)* by Hiratsuka Un'ichi.

1928 April. Shun'yōkai opened a "*hanga* room" where prints could be shown but without the full status of a section for prints.

April. The Kokuga Sōsaku Kyōkai exhibition opened a "*hanga* room" where prints could be shown without full status in the exhibition.

July. Kokuga Sōsaku Kyōkai was renamed Kokugakai.

July. Onchi Kōshirō, with Kitahara Hakushū and Kitahara Masao, took the airplane ride which resulted in Onchi's book *Hikō kannō*, 1934.

September. "Hanga gihō zakkō" (Miscellaneous Thinking About Technique of Prints) by Hiratsuka Un'ichi published in *Mizue*.

October. Takujōsha (On the Table Group) founded. Held first exhibition. This group, consisting of Fujimori Shizuo, Fukazawa Sakuichi, Henmi Takashi, Hiratsuka Un'ichi, Kawakami Sumio, Maekawa Senpan, Onchi Kōshirō, and Suwa Kanenori, continued until 1932.

Dōjin magazine *Han* began publication. Continued for a total of 8 issues until February or March 1929.

1929 January. First prints made by members of the Takujō group for *One Hundred Views of New Tokyo (Shin Tokyo hyakkei)*. Series completed in April 1932.

February. The *dōjin* magazine *Hanga*, directed by Asahi Masahide and published by Sobyōsha, began publication. Continued for 5 issues until May 1930.

March or April. Nakajima Jūtarō began publication of the *dōjin* magazine *Hanga CLUB* organized by the Takujō group. The magazine continued until April 1932.

May. *Hanga* were granted full status at Kokugakai exhibitions. This meant that they were judged for entry and eligible for awards.

December. Yōfū Hangakai was founded as an organization especially for etchers and lithographers.

Sankōkai (Three Reds Society) founded in Kobe by Kawanishi Hide.

Dōjin magazine *Bakuchiku* began publication. Continued until May 1930.

Print Collection of Great Tokyo (Dai Tokyo hanga shū) published by Hasegawa Tsuneo of Nihon Hangasha with prints by Onchi Kōshirō, Nomura Toshihiko, and Kawakami Sumio.

"Kuro to shiro no hanga" (Black and White Prints) by Hiratsuka Un'ichi published in *Mizue*.

1930 January. Distribution began for *Creative Prints of Twelve Months in New Kyoto (Sōsaku-hanga shin Kyoto jūnikagetsu)* by Tokuriki Tomikichirō, Asada Benji, and Asano Takeji.

February. *Dōjin* magazine *Shiro to kuro* began publication. Continued for 50 issues until August 1934. Resumed June–November 1935 for 4 additional issues and March–July 1937 for 5 additional issues.

May. First Yōfū Hangakai exhibition.

May. Nakata Yoshio launched the publication *Ex Libris*.

July. First *Kitsutsuki* set published. Followed by 2 other sets: the second later in 1930, the third in 1931.

July. *Dōjin* magazine *Sen* published by Sawada Ishirō. Possibly only 1 issue.

Dōjin magazine *Sen* began publication in Yamanashi prefecture. Continued for at least 5 issues until ca. January 1931.

1931 January. Nihon Hanga Kyōkai founded by combining Nihon Sōsaku-Hanga Kyōkai, Yōfū Hangakai, and previously unaffiliated artists with Okada Saburōsuke as president.

August. First issue of the *dōjin* magazine *Taishū hanga* published in Kyoto. Second and last issue followed in November.

September. First exhibition of Nihon Hanga Kyōkai. These have continued annually, except in 1945, until the present.

Kokugakai established a regular section of the annual exhibition for *hanga* with judging by *hanga* artists. Placed Hiratsuka Un'ichi in charge.

The *Taishū hanga* group in Kyoto sponsored a print exhibit encouraging participation of artists throughout the country.

Exhibition of prints by members of the Takujō group.

Dōjin magazine *Hori to suri* began publication. Continued until March 1933.

Dōjin magazine *Hanga shi chōkokutō* began publication in Aomori. Continued until name changed to *Mutsu goma* in January 1933.

1932 March. Publication of first issue of *dōjin* magazine *Hanga kenkyū*. Second and last issue in March 1934.

April. Exhibition of prints published by Watanabe Shōzaburō at Shirokiya department store, Tokyo.

April. Shin Hanga Shūdan founded.

April. *Han geijutsu* began publication. Continued until December 1936.

June. *Dōjin* magazine *Shin hanga* began publication. Continued until spring 1933. In June 1933 *Shin hanga* became a quarterly *(Kikan shin hanga)* and continued until December 1935.

June. First set of *Prints of People of the Time (Toki no hito hanga)* issued; second in May 1933.

October. First Shin Hanga Shūdan exhibition.

November. Hirai Hiroshi opened Hanga Sō, a print store, in Ginza.

Distribution began for *One Hundred Views of Great Tokyo (Dai Tokyo hyakkei)*, a collection of prints by 20 or more Western-style painters.

Publication of *Hanga Real Manual (Hanga jisshū dokuhon)* by Asahi Masahide.

1933 January. *Dōjin* magazine *Mutsu goma* began publication in Aomori. Continued until June 1934. Revived October 1938–June 1939.

January. Hanga Sō began publication of limited-edition *hanga* books. Continued until September 1936.

March. *Report of Japan Print Association (Nihon hanga kyōkai kaihō)* began publication. Continued until August 1942.

September. The third Nihon Hanga Kyōkai exhibition was held as a preparatory show for the Paris exhibition which the group was planning.

September. Name of *Hori to suri* changed to *Kyūshū hanga*. Continued until May 1938.

October. Shin Hanga Shūdan exhibition included a special display of Chinese folk prints.

December. *Ukiyo-e geijutsu* had a special issue on contemporary prints.

Works of Itō Shinsui, Kawase Hasui, Natori Shunsen, and other *shin-hanga* artists were shown at Warsaw International Print Exhibition.

1934 January. Nihon Hanga Kyōkai exhibition *L'Estampe Japonaise Moderne et ses Origines* held in Paris. Continued until April.

June. *Collection of Prints of Native Toys (Kyōdo gangu hangashū)* published by Ryōji Chōmei. Continued until March 1935.

November. *Sense of Flight (Hikō kannō)* by Onchi Kōshirō published.

1935 April. *Collection of Prints of Folk Toys (Dozoku gangu hangahū)* published by Ryōji Chōmei. Continued until January 1936.

April. Magazine *Shosō* (Window of Writing), edited by Onchi Kōshirō, began publication. Continued until June 1944.

May. Extracurricular printmaking classes began at Tokyo School of Fine Arts. Hiratsuka Un'ichi taught *mokuhan*. Classes continued until 1944.

October. Nihon Hanga Kyōkai fourth exhibition was a preliminary show in preparation for planned exhibitions in U.S.

Exhibition of *One Hundred Pictures of Great Tokyo in Shōwa (Shōwa dai Tokyo hyakuzue)* by Koizumi Kishio. The series was completed in 1937 with modifications by the artist in 1940.

1936 March. Nihon Hanga Kyōkai exhibition shown in Geneva.

March. *Toy Picture Collection (Omocha eshū)* published by Ryōji Chōmei. Continued until November 1936.

May. Nihon Hanga Kyōkai exhibition shown in Madrid.

July. Nihon Hanga Kyōkai exhibition shown in San Francisco.

August. Nihon Hanga Kyōkai exhibition shown in Los Angeles.

September. Nihon Hanga Kyōkai exhibition shown in Chicago.

October. Japan Folk Art Museum (Nihon Mingeikan) opened in Tokyo.

October. Nihon Hanga Kyōkai exhibition shown in Philadelphia.

November. Nihon Hanga Kyōkai exhibition shown in New York.

December. Nihon Hanga Kyōkai exhibition shown in London. Continued into January.

1937 January. Nihon Hanga Kyōkai exhibition shown in Lyon.

March. Nihon Hanga Kyōkai exhibition shown in Warsaw.

May. Name of Shin Hanga Shūdan changed to Zōkei Hanga Kyōkai.

April. Nihon Hanga Kyōkai exhibition shown in Berlin.

June. First Zōkei Hanga Kyōkai exhibition. Exhibitions continued annually through 1941.

June. Imperial Art Academy (Teikoku Geijutsuin) replaced Imperial Fine Arts Academy (Teikoku Bijutsuin).

October. Shin Bunten replaced Teiten. Shin Bunten exhibitions continued until 1943.

1938 May. *Dōjin* magazine *Karikare* began publication. Continued until April 1941.

December. Nihon Hanga Kyōkai exhibition included a special display of works of Yamamoto Kanae and Oda Kazuma.

December. First prints produced for *One Hundred Views of New Japan (Shin Nihon hyakkei)*. Total of 39 prints issued with the last dated June 1941.

Formation of Ichimokukai by Onchi Kōshirō in 1938 or 1939.

1939 April. Onchi Kōshirō, Maekawa Senpan, and Nagase Yoshio sent to China as war artists.

June. Exhibition of works produced by Takamizawa Woodblock Company.

July. Exhibition of prints of Itō Shinsui.

July. Army Art Society formed and Holy War Art Exhibition held.

September. Okada Saburōsuke, president of Nihon Hanga Kyōkai, died.

November. Tobari Kogan memorial exhibition.

December. Nihon Hanga Kyōkai exhibition included a special display of works of Minami Kunzō and Tomimoto Kenkichi, posthumous works of Kobayashi Asaji, and prints of observations in China by Onchi Kōshirō, Maekawa Senpan, and Nagase Yoshio.

1940 October. Exhibition commemorating 2,600 years of Japanese history sponsored by Ministry of Education.

October. Takehisa Yumeji memorial exhibition.

November. Shin Hangakai founded by Maekawa Senpan, Azechi Umetarō, and others. First Shin Hangakai exhibition.

December. Nihon Hanga Kyōkai exhibition included a special display of works of Fyūzankai, *Tsukubae*, Tokyo Hanga Club, and children's *hanga*.

1941 April. "Live Artists" (Ikite iru gaka), an article by Matsumoto Shunsuke protesting the army's suppression of artists, published in *Mizue*.

July. Thirty art magazines were discontinued; only 8 permitted.

Ishii Tsuruzō became president of Nihon Hanga Kyōkai. Continued until 1972.

1942 Publication of *Print Technique (Hanga gihō)* by Ono Tadashige.

First *Kitsutsuki hangashū* issued.

1943 May. Japan Print Public Services Association (Nihon Hanga Hōkōkai) formed in the hope of obtaining art materials.

1944 June. Nihon Hanga Kyōkai exhibition included a special posthumous showing of Fujimori Shizuo's works.

September. All regular art exhibitions discontinued.

October. Nikakai dissolved.

November. Ministry of Education sponsored a special war art exhibition.

All art magazines abolished except *Bijutsu*.

First folio of *Ichimokushū* issued. Successive folios in 1946, 1947, 1948, 1949, 1950.

1945 *Recollections of Tokyo (Tokyo kaiko zue)* issued.

1946 March. Nitten replaced Shin Bunten. Nitten exhibitions have continued annually until the present.

March. *Picture Notes on Native Customs of Japan (Nihon minzoku zufu)* issued.

April. Nihon Hanga Kyōkai exhibition included a special memorial showing of works of Henmi Takashi and Katō Tarō.

August. *Selection of Customs of Japanese Women (Nihon jozoku sen)* issued.

August. Publication of *Atorie* resumed.

September. Publication of *Mizue* resumed.

September. Exhibitions of Nikakai, Inten, Issuikai, and Shin Seisaku Kyōkai revived.

William A. Hartnett began collecting *sōsaku-hanga*.

Japan Fine Arts Association (Nihon Bijutsukai) founded. Established annual independent exhibition within the next 3 years.

1947 April. Nihon Hanga Kyōkai exhibition included a special memorial display of works by Yamamoto Kanae, Taninaka Yasunori, Sugihara Masami, Fukazawa Sakuichi, Henmi Takashi, and Koizumi Kishio.

Publication of *Japan Print Technique (Nihon Hanga no gihō)* by Asahi Masahide.

Oliver Statler began collecting *sōsaku-hanga*.

1948 April. Nihon Hanga Kyōkai exhibition included a special memorial display of works of Neichi Ryōzō and showed the collections of William Hartnett and Oliver Statler.

A special issue of the magazine *Country of Beauty (Bi no kuni)* featured the print collection of William Hartnett.

1949 April. Highest award presented to Onchi Kōshirō at the first book design exhibition. This exhibition became an annual event.

April. The magazine *Ukiyo-e to hanga* began publication. Discontinued after 2 issues.

June. Munakata Shikō exhibition held at Japan Folk Art Museum (Mingeikan) in Tokyo.

June. Nihon Bijutsuka Renmei (Japan Artists League) formed.

October. Japan Print Movement Society (Nihon Hanga Undō Kyōkai) founded.

Publication of *Print Technique and Study (Hanga no gihō to kenkyū)* by Hiratsuka Un'ichi.

1950 Gendai Hanga Kenkyūkai founded by Onchi Kōshirō and Kitaoka Fumio.

1951 April. Nihon Hanga Kyōkai exhibition included a memorial display of works of Minami Kunzō.

May. Japanese Peoples' Print Exhibition shown in Beijing.

October. First São Paulo Biennale. Major awards to Saito Kiyoshi for a woodcut and Komai Tetsurō for an etching.

Shun'yōkai initiated a section for prints with Kitaoka Fumio and Komai Tetsurō in charge.

Nihon Kyōiku Hanga Kyōkai (Japan Print Education Association) founded.

1952 April. Major awards at Lugano to Munakata Shikō in woodblock and Komai Tetsurō in etching.

May. Nihon Hanga-in (Banga-in) founded by Munakata Shikō with Barbara Bubunova, Kitagawa Tamiji, Munakata Makka, Sasajima Kihei, and Shimozawa Kihachirō. Exhibitions continued annually.

December. National Museum of Modern Art opened.

Several exhibitions of modern *hanga* in U.S. sponsored by Nihon Hanga Undō Kyōkai and a New York *nisei* group.

1953 June. International Print Association (Kokusai Hanga Kyōkai) founded by Onchi Kōshirō and others to promote international exhibitions.

September. Publication of *Modern Japanese Prints (Nihon no gendai hanga)* by Onchi Kōshirō.

September. Second Japanese Peoples' Print Exhibition in Beijing.

Japan Abstract Art Club (Nihon Abusutorakuto Āto Kurabu) founded by Onchi Kōshirō and others.

1954 April. Nihon Hanga Kyōkai exhibition included a special memorial display of works of Kōsaka Gajin; also Western modern prints.

August. First national meeting on print education sponsored by Japan Print Education Society.

December. Hanga Konwakai (Casual Talk About Prints Society) founded by Onchi Kōshirō and others.

1955 July. Major award to Munakata Shikō at the São Paulo Biennale.

July. First Sun Society (Ichiyōkai) founded. Print section in annual exhibitions open to nonmembers.

October. Works of Onchi Kōshirō and Shinagawa Takumi exhibited in Philadelphia.

Third Japanese Peoples' Print Exhibition in Beijing. Published a selected collection of Japanese woodcuts.

Publication of *Print Technique (Hanga no gihō)* by Shimozawa Kihachirō and Sekino Jun'ichirō.

1956 January. Exhibition of 5 print artists of the Taishō period—Hashiguchi Goyō, Itō Shinsui, Kawase Hasui, Yamamura Kōka, and Yoshida Hiroshi.

April. Nihon Hanga Kyōkai exhibition included a special memorial display of prints of Onchi Kōshirō.

May. First Shell Art Award Exhibition. Continued annually.

June. Major award to Munakata Shikō at the Venice Biennale.

October. First exhibition of Women's Print Association (Joryū Hanga Kyōkai). Continued annually at least through 1961.

Publication of *Technique of Modern Prints (Gendai hanga no gihō)* by Ono Tadashige.

Publication of *Modern Japanese Prints: An Art Reborn* by Oliver Statler.

1957 March. Members of Nihon Hanga Kyōkai exhibited with the contemporary print society in Paris.

June. First Tokyo International Print Biennale. Continued in even years from 1960 to 1976. Terminated with eleventh and final exhibition in 1979.

June. Major awards to Saitō Kiyoshi and Yamaguchi Gen at Ljubljana.

1958 March. Major award to Yamaguchi Gen at Lugano.

June. Awards to Yamaguchi Gen, Fukita Fumiaki, and Takagi Shirō at Grenchen.

Printmaking included in the curriculum of Tokyo University of Arts.

1959 July. Exchange exhibitions of modern prints in Mexico and Japan.

August. First exhibition of recently formed Shūdan Han group.

November. Traveling exhibition of works of Munakata Shikō in Europe.

Publication of *Munakata* by Oliver Statler.

1960 January. Exhibition of *sōsaku-hanga* at The Art Institute of Chicago.

February. Awards to Sekino Jun'ichirō and Kinoshita Tomio at Northwest.

April. Nihon Hangakai (Nippankai) founded.

May. Second Shūdan Han exhibition.

August. First Nippankai exhibition. Continued annually.

November. Award to Hagiwara Hideo at Tokyo Biennale.

1961 April. Nihon Hanga Kyōkai exhibition included a memorial display of works by Maekawa Senpan.

June. Award to Sekino Jun'ichirō at Ljubljana.

1962 April. Awards to Hagiwara Hideo and Yoshida Hodaka at Lugano.

Exchange exhibitions of modern prints in Japan and Israel.

1963 February. Solo exhibition of works of Hiratsuka Un'ichi at Smithsonian Institute in Washington.

April. Nihon Hanga Kyōkai exhibition in Yugoslavia.

April. Award to Hagiwara Hideo at Ljubljana.

June. Exhibition of Taishō period prints sponsored by Japan Ukiyo-e Society.

Graduate studies in printmaking established at Tokyo University of Arts.

Japanese Woodblock Prints, Their Technique and Appreciation by Azechi Umetarō published in English.

1964 March. Awards to Amano Kazumi and Amano Kunihiro at Lugano.

May. Exchange modern print exhibitions in Beijing and Tokyo.

Publication of *Bangokudō*, an autobiography by Munakata Shikō.

Publication of *Technique of Prints (Hanga no gihō)* by Yoshida Hodaka and others.

1965 March. Award to Fukita Fumiaki at Northwest.

April. Award to Amano Kazumi at Xylon.

April. Nihon Hanga Kyōkai exhibition included memorial displays of works of Kawanishi Hide and Takei Yoshitarō.

1966 April. Nihon Hanga Kyōkai exhibition included memorial display of works of Kawano Kaoru.

Awards to Kusaka Kenji, Amano Kazumi, and Hagiwara Hideo at Tokyo Biennale.

1967 February. Award to Amano Kazumi at Northwest.

June. Awards to Amano Kazumi and Hagiwara Hideo at Ljubljana.

June. Award to Fukita Fumiaki at São Paulo Biennale.

Publication of *Essays on Prints (Hanga zuihitsu)* by Tokuriki Tomikichirō.

1968 April. Nihon Hanga Kyōkai exhibition included special display of prints of Tagawa Ken.

July. Award to Amano Kunihiro at Pistoia.

November. Awards to Kusaka Kenji and Noda Tetsuya at Tokyo Biennale.

Award to Takagi Shirō at Krakow.

Award to Hagiwara Hideo at Banska.

1969 April. Nihon Hanga Kyōkai exhibition included memorial display of prints of Furukawa Ryūsei.

Award to Fukita Fumiaki at Ljubljana.

Award to Amano Kunihiro at Xylon.

Awards to Iwata Kiyoshi and Matsumoto Akira at Northwest.

1970 October. Nichidō Hanga Grand Prix (juried print exhibition sponsored by Nichidō Gallery) founded. Continued annually.

November. Munakata Shikō received Order of Cultural Merit.

December. Awards to Kurosaki Akira and Funasaka Yoshisuke at Tokyo Biennale.

Award to Yoshida Chizuko at Grenchen.

Awards to Kurosaki Akira, Noda Tetsuya, and Matsumoto Akira at Krakow.

Award to Hiwazaki Takao at Florence.

Award to Hagiwara Hideo at Banska.

1971 January. Mainichi Newspaper Company major art award to Munakata Shikō and Ujiyama Teppei.

Award to Noda Tetsuya at São Paulo Biennale.

Award to Baba Kashio at International Miniature.

1972 June. Award to Yoshida Hodaka at Seoul.

Award to Kurosaki Akira at Florence.

Award to Fukazawa Shirō at Frechen.

Award to Yokoo Tadanori at Brno.

Award to Amano Kunihiro at Buenos Aires.

Award to Amano Kunihiro at Philippine Biennale.

Nihon Hanga Kyōkai exhibition included special fortieth anniversary display of works of Ishii Tsuruzō, Hasegawa Kiyoshi, Kawakami Sumio, Yamaguchi Susumu, Hiratsuka Un'ichi, Hazama Inosuke, Nagase Yoshio, Ōuchi Seiho, and Shimozawa Kihachirō; also a memorial display of works of Yoshida Masaji.

1973 Award to Yoshida Hodaka at first exhibition of California College of Arts and Crafts World Print Competition in San Francisco.

Nihon Hanga Kyōkai exhibition included memorial display of works of Ishii Tsuruzō, Hatsuyama Shigeru, and Kawakami Sumio.

1974 November. Award to Yokoo Tadanori at Tokyo Biennale.

Awards to Kurosaki Akira and Noda Tetsuya at Krakow.

Award to Matsumoto Akira at Frechen.

Award to Noda Tetsuya at Norwegian Biennale.

Award to Yokoo Tadanori at Brno.

Nihon Hanga Kyōkai exhibition included special displays in memory of Ueno Nagao and Maeda Masao.

1975 Award to Matsumoto Akira at Ljubljana.

Award to Fukita Fumiaki at Second Miami Graphic Biennale.

Award to Yoshida Hodaka at International Miniature.

Kanagawa Andepandanten (Kanagawa Independent Exhibition) founded. This is an open nonjuried show.

Nihon Hanga Kyōkai exhibition included memorial display of prints by Fukushima Ichirō.

INDEX OF ALTERNATE NAMES

In the major listing of artists and biographical data in Chapter 2, the names are given as the Japanese write them: with family names preceding given names. Japanese artists, however, may be known by several names including art names and various personal names rather than family names. These assorted names are alphabetized here opposite the names as given in Chapter 2 to afford a means of finding the biographical entry if only an art name or given name is known. For example, the name Goyō in this list refers to the artist who is generally known by his art name, Goyō. The location of his biography in Chapter 2 is indicated by the name Hashiguchi Goyō to the right of the colon. He is indicated here as Goyō Hashiguchi and in most instances family names are also included in the left columns, although they are not generally used in signatures of artists, because the names are often written in English with given names preceding family names. Thus, Saitō Kiyoshi is best known to Americans as Kiyoshi Saitō. He, like many other Western-oriented artists, often signs prints in Western script with the given name preceding the family name. He may, however, identify his work simply with a seal (stamped on the print or carved in the block) which reads Kiyoshi. Knowing only the name Kiyoshi, one can find in this list a number of Kiyoshi entries followed by their respective family names and indications of where they may be found in Chapter 2. There are also in this list a few alternate readings of names and entries by alternate family names which are not alphabetized in Chapter 2.

GLOSSARY

aisuki: a flat gouge.
aware: sadness related to the transience of life.

baren: a disk made of tightly twisted and coiled bamboo leaves backed by several layers of lacquered paper and covered with a bamboo leaf. A baren is used for applying pressure when printing with woodblocks.
bijin-ga: picture(s) of beautiful women.
bijutsu: art, fine arts, or visual art.
bijutsuin: art academy.
bijutsu-ka: artist.
bijutsukai: art society.
bijutsukan: art museum.
bingata: method of pattern dyeing established in Okinawa.
biwa: a Japanese lute-type instrument.
bokashi: gradation of color.
Bon dance: dancing at the Buddhist festival for the dead in midsummer.
bosatsu: a Buddhist saint; one who is worthy of nirvana.
bunjin-ga: literati painting.
bunraku: puppet theater.
byōbu: a folding screen.

daigaku: college or university.
daikon: a long white radish.
Dainichi-nyorai: cosmic Buddha.
deshi: student or apprentice.
dōjin: a coterie.

e: picture, drawing, or painting.
e-makimono: a picture handscroll.

fude bokashi: gradation of color achieved by shading pigment on a woodblock with a brush.
fūkei: scenery.
fukusei: reproduction.
fukusei hanga: print made as a reproduction of a painting or another print.
furitsu: under management of local government in Osaka and Kyoto.
furoshiki: a square of cloth used for wrapping and carrying objects or bundles.
fusuma: sliding door(s); often made of heavy paper and used as supports for paintings.

ga: picture, drawing, or painting. When used after a signature on a work of art it signifies that the signature is that of the artist.

gakkō: school.

ganpi: plant used in one type of handmade paper.

gashū: a collection of pictures.

geijutsu: art; the arts.

geijutsu-ka: artist.

gendai: present day, current.

gō: a professional name assumed by an artist.

gofun: opaque white pigment made from calcium carbonate.

haiga: abbreviated paintings that may accompany *haiku*.

haiku: seventeen-syllable poem.

hana: flower(s).

hanga: print(s).

haniwa: clay figures placed on burial mounds about 1,500 years ago.

hanmoto: a publisher, particularly a publisher of woodblock prints.

hanshita: drawing on thin paper which is reversed and glued to a block as a guide for cutting.

haori: jacket worn over a kimono.

haru: spring.

Heian period: early era during which the capital was in Kyoto (794–1185).

hiragana: cursive script of the Japanese syllabary.

hitsu: brush. When used after a signature on a work of art it signifies that the signature is that of the artist.

Hokuriku: a region located on north central Honshu and facing the Japan Sea.

jiden: autobiography.

jiten: dictionary.

Jizō: guardian deity of children; often seen in honorific form as O-Jizō.

jizuri: self-printed.

kabuki: traditional Japanese popular theater.

kachō: bird(s) and flower(s).

kachō-ga: pictures of birds and flowers.

kami-shibai: a picture story show, usually for children.

kana: general term that includes *hiragana* and *katakana*.

kanji: Chinese characters used in Japanese writing.

Kannon: the *bosatsu* of compassion.

Kanō: school of painters or their style; derived from Chinese ink painting.

Kansai: the Kobe/Osaka/Kyoto area.

Kantō: the Tokyo/Yokohama area.

katakana: straight-sided script of the Japanese syllabary; usually used for foreign words.

katsura: a kind of tree with fine-grained wood often used for woodblocks.

kindai: recent; the modern age.

kokeshi: a limbless wooden doll.

komasuki: a curved chisel.

koto: a stringed instrument with movable frets somewhat like a horizontal harp.

kōzō: mulberry fiber used in paper; paper made of mulberry fiber.

kyōgen: a comical skit performed between two *nō* plays.

kyōkai: association or society.

magatama: comma-shaped jewels.

maiko: dancing girl.

manga: caricature, cartoon.

Maruyama-Shijō: a school of painting which incorporates sketching from nature; founded by Maruyama Ōkyo in the eighteenth century.

Meiji period: the reign of Emperor Meiji (1868–1912).

meisho or *meishō:* any noted place.

mie: a pose, a posture often assumed by *kabuki* actors.

mingei: folk art.

mokuhan: woodblock printing process or technique.

moku-hanga: woodblock print.

Momoyama period: era in which all feudal lords were brought under the control of one *shogun* (1573–1603).

nanban: southern barbarians; used in reference to Europeans in Japan in the sixteenth and early seventeenth centuries.

nanga: Japanese paintings derived from the Chinese literati style.

nenpu: a chronology of events.

Nihon-ga: Japanese-style painting.

nisei: an American-born second generation of Japanese descent.

nishiki-e: a multicolor *ukiyo-e* type of print.

nō: a highly stylized Japanese drama little changed since medieval times.

obi: a broad waistband worn with a kimono.

odori: dance.

O-Jizō: see Jizō.

ōkubi-e: print of a large head.

Ōtsu-e: folk art pictures made in Ōtsu, a town on the Tōkaidō near Kyoto.

rinpa: a colorful, decorative style of painting developed by Tawaraya Sōtatsu and Ogata Kōrin in the Edo period.

sakuhin: works.

samisen: a three-stringed musical instrument.

sansui: landscape; literally mountains and water.

sensei: teacher or respected person.

Sharaku: famous designer of *ukiyo-e* actor prints.

shibori: a tie-dye technique.

Shijō: style of painting that developed in the Shijō section of Kyoto. The Shijō style developed from the Maruyama style and the two are often referred to jointly as the Maruyama-Shijō style.

Shikishi: square card for painting or calligraphy. Often used for gifts.

shin: new.

shina: a type of wood usually used as plywood for woodblocks.

Shinano: old name for what is now Nagano prefecture.

shingeki: new theater (as distinguished from *kabuki*).

shin-hanga: new prints in modified *ukiyo-e* style.

shin hanga: new prints.

Shinshū: alternate name for the old province of Shinano, now Nagano prefecture.

Shintō: the indigenous animist religion in Japan.

shita-machi: section of Tokyo near Asakusa Kannon Temple. This was the heart of Edo.

Shōwa period: the reign of Emperor Shōwa (Hirohito) (1926–1989).

shū: collection (often attached at the end of another word).

sōsaku: creative.

sōsaku-hanga: creative print.

suiboku: a painting in Chinese ink.

sumi: Chinese ink. This is stored as an ink stick and ground as used.

sumi-e: ink painting.

sumō: Japanese style of wrestling.

suzuri: stone for grinding an ink stick.

Taishō period: the early modern era between the Meiji and Shōwa periods (1912–1926).

tō: knife or carved.

Tōhoku: the northeast section of Honshū.

Tōkaidō: major eastern road in the Edo period from Kyoto to Edo.

torii: a high gate, often red with two curved crossbars, at the entrance to a sacred Shintō area.

torinoko: a form of handmade paper made from pulp of the *mitsumata* plant.

Tosa: school of painters in style derived from *yamato-e*.

Ueno: a section of Tokyo which includes Shinobazu Pond and Ueno Park, site of several museums.

ukiyo-e: a painting style and related woodblock prints popular in the Edo and early Meiji periods.

waka: a thirty-one-syllable poem.

washi: handmade paper.

yamato-e: traditional Japanese-style painting established in the Heian period.

yōga: Western-style painting.

yūgen: suggestion of profound mystery.

yukata: summer cotton kimono usually in a blue and white pattern.

yūzen: resist process for dyeing kimono fabric.

zenshū: complete collection.

BIBLIOGRAPHY

Abe Shuppan, ed. *Yoshida Hiroshi zen moku-hanga shū* [The Complete Woodblock Prints of Yoshida Hiroshi]. English adaptation by Paul Zito and Hayano Masako. Tokyo: Abe Shuppan, 1987.

Art Institute of Chicago. *Japan's Modern Prints—Sōsaku Hanga.* Exhibition catalog. Essay by Oliver Statler. Chicago: The Art Institute of Chicago, 1960.

Austin, James B. "Notes on the Early Days of Sōsaku Hanga." *Newsletter on Contemporary Japanese Prints.* Los Angeles: Juda Collection, 1973.

———. "Shin Tōkyō hyakkei: The Eastern Capital Revisited by Modern Print Artists." *Ukiyo-e Art* 14 (1966): 3–15.

———. "Tōkyō kaiko zue: Scenes of Last Tōkyō." *Ukiyo-e Art* 38 (1973): 1–8.

Baskett, Mary. "Shigeru Hatsuyama (1897–1973)." *Newsletter on Contemporary Japanese Prints.* Los Angeles: Juda Collection, 1974.

———. "Three Generations: Woodcuts by Un'ichi Hiratsuka, Shikō Munakata, and Naoko Matsubara." *Newsletter on Contemporary Japanese Prints.* Los Angeles: Juda Collection, 1971.

Bijutsu Hyōronsha, ed. *Bijutsu-jin nenkan 1960.* Tokyo: Bijutsu Hyōronsha, 1960.

———. *Bijutsu-jin nenkan 1967.* Tokyo: Bijutsu Hyōronsha, 1967.

———. "Gendai Nihon hanga sakka." *Bijutsu-jin nenkan 1971.* Tokyo: Bijutsu Hyōronsha, 1971.

Bijutsu Kōronsha, ed. "Gendai hanga sakka." *Bijutsu meikan 1977.* Tokyo: Bijutsu Kōronsha, 1977.

Bijutsu Kurabu, ed. *Geijutsuka meikan 1964.* Tokyo: Bijutsu Kurabu, 1964.

Bijutsu Nenkansha, ed. "Gendai hanga-ka meikan." *Bijutsu nenkan 1969.* Tokyo: Bijutsu Nenkansha, 1969.

———. "Gendai hanga-ka" and "Genzon sakka meikan." *Bijutsu nenkan 1989.* Tokyo: Bijutsu Nenkansha, 1989.

———. "Bijutsu techō." *Bijutsu nenkan 1989.* Tokyo: Bijutsu Nenkansha, 1989.

Blair, Dorothy, ed. *Exhibition of Modern Japanese Prints at the Toledo Museum of Art.* 2 vols. Toledo, Ohio: Toledo Museum of Art, 1930 and 1936.

Blakemore, Frances. *Who's Who in Modern Japanese Prints.* New York and Tokyo: Weatherhill, 1975.

Blakeney, Ben Bruce. *Yoshida Hiroshi: Print-Maker.* Tokyo: Foreign Affairs Association of Japan, 1953.

Brown, Louise Norton. *Block-Printing and Book-Illustration in Japan.* 1924. Reprint. Geneva: Minkoff, 1973.

Castile, Rand. *Shikō Munakata (1903–1975): Works on Paper.* New York: Japan Society, 1982.

Chibbett, D. G. *The History of Japanese Printing and Book Illustration.* Tokyo and Palo Alto: Kōdansha International, 1978.

Chūō Kōronsha. *Kawakami Sumio zenshū.* 14 vols. Chronology by Takeyama Hirohiko. Tokyo: Chūō Kōronsha, 1979.

Fogg Art Museum. *Japanese Twentieth Century Prints.* Catalog of exhibition of C. Adrian Rübel Collection. Cambridge, Mass.: Fogg Art Museum, 1966.

Forrer, Matthi, ed. *Essays in Japanese Art Presented to Jack Hillier.* London: Sawers, 1982.

Fujii Hisae, ed. "Onchi Kōshirō to *Tsukubae*." *Kindai no bijutsu* 35 (July 1976): 23–42.

Fujikake Shizuya. *Japanese Wood-Block Prints.* Tokyo: Japan Travel Bureau, 1954.

Fukunaga Shigeki. "Gendai Nihon hanga." *Kindai no bijutsu* 40 (1977): 1–99.

Haas, Robert, and Tomi Haas. "Reveries and Images of Sumio Kawakami." *Newsletter of Contemporary Japanese Prints.* Los Angeles: Juda Collection, 1972.

Hamada Taiji and Hosono Masanobu. *Itō Shinsui zenshū.* 6 vols. Tokyo: Shūeisha, 1981–1982.

Higuchi Ryōichi, ed. *Hanga-ka meiran: Meiji-matsu Taishō Shōwa.* Tokyo: Yamada Shoten, 1985.

Hillier, Jack. *The Art of the Japanese Book.* 2 vols. London: Sotheby's Publications, 1987.

Hillier, Jack, and Lawrence Smith. *Japanese Prints: 300 Years of Albums and Books.* London: British Museum Publications, 1980.

Hosono Masanobu. *Gendai bijutsu zenshū.* Vol. 5. *Itō Shinsui.* Tokyo: Shūiesha, 1979.

Ishida Yasuhiro. "Record of a Creative Print Artist, Furukawa Ryūsei." English summary. *Ukiyo-e Art* 43 (1974): 3–4.

Ishii Hakutei. *Hakutei jiden.* Tokyo: Chūō Kōron Bijutsu Shuppan, 1971.

Jenkins, Donald. *Images of a Changing World: Japanese Prints of the Twentieth Century.* Portland, Oregon: Portland Art Museum, 1983.

Johnson, Margaret K., and Dale K. Hilton. *Japanese Prints Today: Tradition with Innovation.* Tokyo: Shufunotomo, 1980.

Kaempfer, H. M., ed. *Ukiyo-e Studies and Pleasures, A Collection of Essays on the Art of Japanese Prints.* The Hague: Society for Japanese Arts and Crafts, 1978.

Kaempfer, H. M. and Jhr. W. O. G. Sickinghe, eds. *The Fascinating World of the Japanese Artist.* The Hague: Society for Japanese Arts and Crafts, 1971.

Katō Junzō, ed. *Kindai Nihon hanga taikei.* 3 vols. Tokyo: Mainichi Shinbunsha, 1975–1976.

Kawakita Michiaki. *Contemporary Japanese Prints.* Translated by John Bester. 2nd ed. Tokyo and Palo Alto: Kōdansha International, 1968.

———. *Hatsuyama Shigeru sakuhin-shū.* Tokyo: Kōdansha, 1973.

———. *Itō Shinsui.* Tokyo: Nihon Keizai Shinbunsha, 1973.

———. *Modern Currents in Japanese Art.* New York and Tokyo: Weatherhill/Heibonsha, 1974.

———. *Nihon hanga bijutsu zenshū.* Gendai hanga II. Vol. 8. Tokyo: Kōdansha, 1960.

———. ed. *Hiratsuka Un'ichi hanga-shū.* Tokyo: Kōdansha, 1978.

Keyes, Roger. *Break with the Past: The Japanese Creative Print Movement 1910–1960.* San Francisco: Fine Arts Museums of San Francisco, 1988.

Kitaoka Fumio. *Hangi no naka no fūkei: Kitaoka Fumio gabun shū.* Tokyo: Bijutsu Shuppansha, 1983.

————. "Sekino Jun'ichirō and His Work." English summary. *Ukiyo-e Art* 30 (1971): 5–6.

Kōdansha, ed. *Ukiyo-e Masterpieces in Western Collections,* Robert Muller Collection. (In Japanese with English titles.) See Narazaki Muneshige.

Kozaki Gunji. *Yamamoto Kanae.* Ueda City: Ueda City Yamamo Kanae Municipal Museum, 1981.

Kubo Sadajirō, ed. *Onchi Kōshirō hangashū.* Tokyo: Keishōsha, 1975.

Kuwayama, George. *Contemporary Japanese Prints.* Los Angeles: Los Angeles County Museum of Art, 1972.

Link, Howard A. *The Art of Munakata Shikō (1903–1975).* Typed catalog for exhibition. Honolulu: Honolulu Academy of Arts, 1983.

MacLean, J. A., and D. Blair. "Ten Printmakers of the Last Decade." *American Magazine of Art* 22 (August 1930): 443–449.

————. "Two Modern Japanese Printmakers." *American Magazine of Art* 20 (February 1929): 98–101.

Mason, Stanley. "Shikō Munakata." *Graphics* 29 (1973–1974): 542–551.

McClain, R., and Y. McClain. *Thirty-Six Portrait Prints by Sekino Jun'ichirō.* Eugene: University of Oregon Museum of Art, 1977.

————. *Woodblock Prints by Sekino Jun'ichirō: The Fifty-Three Stations of the Tōkaidō.* Eugene: University of Oregon Museum of Art, 1978.

Merritt, Helen. *Modern Japanese Woodblock Prints: The Early Years.* Honolulu: University of Hawaii Press, 1990.

Michener, James A. *Japanese Prints from the Early Masters to the Modern.* Rutland and Tokyo: Charles E. Tuttle, 1959.

————. *The Modern Japanese Print: An Appreciation.* Rutland and Tokyo: Charles E. Tuttle, 1970.

Miles, Richard. *The Prints of Paul Jacoulet.* London: Robert G. Sawers and Pacific Asia Museum, 1982.

Munsterberg, Hugo. *The Art of Modern Japan—From the Meiji Restoration to the Meiji Centennial 1868–1968.* New York: Hacker Art Books, 1978.

————. *The Japanese Print: A Historical Guide.* New York and Tokyo: Weatherhill, 1982.

————. "Shikō Munakata: A Personal Memoir." *Newsletter on Contemporary Japanese Prints.* Los Angeles: Juda Collection, 1972.

Murobushi Tetsurō. *Encyclopaedia of Prints: Hanga jiten.* (In Japanese.) Tokyo: Tokyo Shoseki, 1985.

Nakajima Tokuhiro. "Sosaku hanga shi *Shiro to kuro.*" *Kenkyū kiyō* 2 (1982): 61–65. Published by Hyōgo Kenritsu Kindai Bijutsukan.

Narazaki, Muneshige. *Hizō ukiyo-e taikan. Ukiyo-e Masterpieces in Western Collections.* Vol. 2. Robert Muller Collection. Tokyo: Kodansha, 1990.

Nihon Bijutsu Shuppansha, ed. "Gendai hanga-ka." *Geijutsu-ka nenkan 1988.* Tokyo: Nihon Bijutsu Shuppansha, 1988.

Nihon Hanga Kyōkai, ed. *Nihon gendai hanga beikoku ten junbi tenkan.* Tokyo: Nihon Hanga Kyōkai, 1935.

Nihon Keizai Shinbunsha, ed. *Meiji Taishō no meisaku hanga ten.* Osaka: Nihon Keizai Shin-bunsha, 1979.

Nihon Ukiyo-e Kyōkai, ed. *Genshoku ukiyo-e daihyakka-jiten.* Vols. 1 and 10. Tokyo: Taishū-kan Shoten, 1980–1982.

Ogura Tadao and Soga Tetsuo. *Genshoku gendai Nihon no bijutsu. Hanga.* Vol. 11. Tokyo: Sho-gakukan, 1978.

Oka Isaburō. Adapted by Osamu Ueda and C. H. Mitchell. "Prints of the Taishō Era." *Ukiyo-e Art* 4 (1963): 3–15.

———. *Taishō no onna, Hashiguchi Goyō ten.* Tokyo: Riccar Art Museum, 1976.

Olson, Eleanor. "Japanese Contemporary Prints." *The Museum* (Newark) 8 (4) (Fall 1956): 1–16.

Onchi Kōshirō. *Nihon gendai no hanga.* 1952. Translated by Ueda Osamu and C. H. Mitchell as "The Modern Japanese Print: An Internal History of the Sōsaku-Hanga Movement," *Ukiyo-e Art* 11 (1965): 3–24.

———. *Onchi Kōshirō hanga shū.* See Kubo Sadajirō.

Ono Tadashige. *Kindai Nihon no hanga.* Tokyo: Sansaisha, 1971.

———. *Nihon hanga bijutsu zenshū. Gendai hanga I.* Vol. 7. Tokyo: Kōdansha, 1962.

———. *Yamamoto Kanae hanga shū.* Ueda City: Ueda City Yamamoto Kanae Municipal Museum, 1970.

Ōnuma Nobuyuki and Kanamori Kazuko, eds. *Tsuruya Kōkei—yakusha-e moku-hanga.* Tokyo: Shōchiku Kabushiki Gaisha, 1988.

Pachter, Irwin S. and Takushi Kaneko. *Kawase Hasui and His Contemporaries: The Shin Hanga Movement in Landscape Art.* Syracuse: Everson Museum of Art, 1986.

Petit, Gaston. *Forty-Four Modern Japanese Print Artists.* 2 vols. Tokyo: Kōdansha, 1973.

Pinckard, W. H., Jr. *Twentieth Century Japanese Prints.* Darlinghurst, New South Wales, Australia: Brian Chester's Antiquarian, n.d.

Project Section of Cultural Services Improvement, Office of Educational Affairs, Fukushima, ed. *Saitō Kiyoshi.* (In Japanese with English titles.) Fukushima, 1981.

Read, Louisa. "Kawakami, a Modern Print-Maker." *Apollo* 101 (March 1975): 242–243.

Riccar Art Museum, ed. *Ichimokukai ten—Onchi Kōshirō to sono shūhen.* Essay by Sekino Jun'i-chirō. English adaptation by H. Schwarzenberger. Tokyo: Riccar Art Museum, 1979.

———. *Kindai Nihon bijin-ga ten.* Tokyo: Riccar Art Museum, 1982.

———. *Maekawa Senpan meisaku ten.* Essays by Yoshida Susugu and H. Schwarzenberger. Tokyo: Riccar Art Museum, 1977.

———. *Taninaka Yasunori hanga ten—kuro to shiro no shi.* Essay by Ryōji Kumata. Tokyo: Riccar Art Museum, 1976.

Sakamoto Akihiko, ed. *Sakamoto Hanjirō zenhanga shū.* Tokyo: Kabushiki Gaisha Zōsha, 1980.

Sekino Jun'ichirō. *Hanga o kizuita hitobito.* Tokyo: Bijutsu Shuppansha, 1976.

———. "Rensai jiden teki Nihon kindai hangashi." *La Gravure* (Spring 1969): 98–106; (Summer 1969): 96–104; (Fall 1969): 102–109; (Winter 1970): 102–109; (Spring 1970): 108–115.

Selz, Jean. *Foujita*. New York: Crown, 1981.

Shibuya Ward Shōtō Art Museum, ed. *Onchi Koshiro*. (In Japanese.) Tokyo: Shibuya Ward Shōtō Art Museum, 1982.

Shimizu Tōru, ed. *Ukiyo-e jinmei jiten oyobi gendai hanga-ka meikan*. Tokyo: Bijutsu Kurabu Shuppanbu, 1954.

Shinagawa Kiyomi. "The Late Sanzō Wada and His Works—Series of Occupations in Shōwa." English summary. *Ukiyo-e Art* 16 (1968): 39–42.

Smith, Henry D. *Kiyochika, Artist of Meiji Japan*. Santa Barbara: Santa Barbara Museum of Art, 1988.

Smith, Lawrence. *The Japanese Print Since 1900: Old Dreams and New Visions*. New York: Harper & Row, 1983.

Statler, Oliver. "Modern Japanese Creative Prints." *Monumenta Nipponica* 11 (2) (July 1955): 1–59.

———. *Modern Japanese Prints: An Art Reborn*. Rutland: Charles E. Tuttle, 1956.

———. "Rokushū Mizufune." *Newsletter on Contemporary Japanese Prints*. Los Angeles: Juda Collection, 1972.

———. *Shikō Munakata*. Rutland: Charles E. Tuttle, 1958.

———. *Umetarō Azechi*. Tokyo: Tōto Shuppan, 1959.

Suzuki Jūzō. *Nihon hanga bijutsu zenshū*. Supplement, *Nihon hanga benran*. Tokyo: Kōdansha, 1962.

Swinton, Elizabeth deSabato. "Hikō Kannō." *Archives of Asian Art* 30 (1976–1977): 85-102.

———. *In Battle's Light, Woodblock Prints of Japan's Early Modern Wars*. Worcester, Massachusetts: Worcester Art Museum, 1991.

———. *Onchi Kōshirō: Innovation and Tradition*. New York: Garland Press, 1986.

Takashina Shuji, J. Thomas Rimer, and Gerald D. Bolas. *Paris in Japan: The Japanese Encounter with European Painting*. Tokyo: Japan Foundation, Washington University in St. Louis, 1987.

Tottori Prefecture Museum, ed. *Kindai hanga no akebono*. Tottori: Tottori Prefecture Museum, 1988.

Ueno Makoto. "Nihon gendai hanga (sōsaku-hanga) to kokusai kōryū nenpyō." *Ukiyo-e geijutsu* 11 (1965): 35–40.

Watanabe Color Prints Co. *Catalog of Wood-Cut Color Prints by Contemporary Japanese Artists*. Tokyo: S. Watanabe Color Prints Co., 1962.

Watanabe Tadasu. "The Transition from Traditional Prints to the Modern Creative Prints." English summary. *Ukiyo-e Art* 11 (1965): 28.

———. *Watanabe Shōzaburō*. Tokyo: Watanabe Woodblock Art Shop, 1972.

———. ed. *Kawase Hasui moku-hangashū*. (Commentary by Narazaki Muneshige.) Tokyo: Mainichi Shinbunsha, 1979.

Yamakoshi Shūzō, ed. *Yamamoto Kanae no tegami*. Ueda City: Ueda City Education Committee, 1971. (Supplement, 1977.)

Yasuda Yojurō. *Shikō Munakata*. Essay by Oliver Statler. Rutland and Tokyo: Charles E. Tuttle, 1958.

Yoshida Tōshi. *Yoshida Hiroshi hanga shū*. Tokyo: Riccar Art Museum, 1976.

ABOUT THE AUTHORS

HELEN MERRITT is professor emeritus of the School of Art, Northern Illinois University, where she taught for 30 years. A specialist in Japanese art history, Professor Merritt received training in fine arts and art history at Northern Illinois University, Tokyo University of Fine Arts, and the Oriental Institute of Cambridge University. Among her publications is *Modern Japanese Woodblock Prints: The Early Years.*

NANAKO YAMADA was born in Manchuria and grew up in Hiroshima. After graduation from Tokyo Women's Christian College, junior college division, she moved to the United States, where she received bachelor's and master's degrees in art history at Northern Illinois University. She currently teaches Japanese language.